Michelangelo

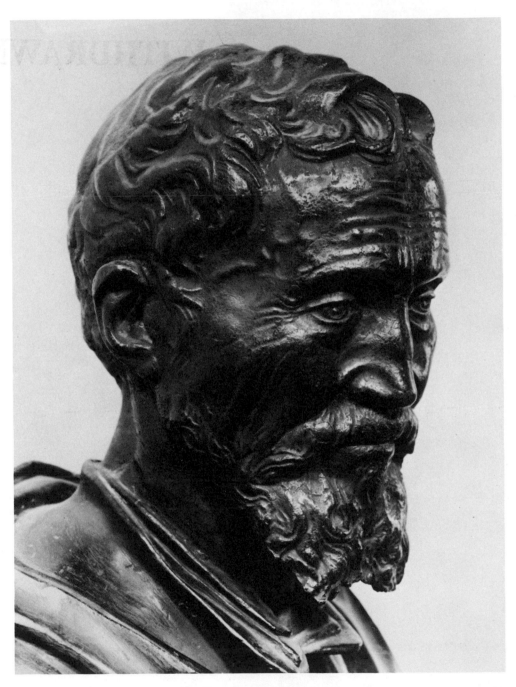

Frontispiece. Daniele da Volterra, portrait of Michelangelo.

Facing this page is the subject of our inquiry, Michelangelo Buonarroti, in his eighties as he was portrayed in bronze by his loyal friend and follower Daniele da Volterra. The bust serves well as a model for the modern biographer. Daniele has recorded a physical being with uncompromising exactitude—the mole on the wrinkled forehead, the bulging, tortuous vein crossing the temple, the flattened, once badly broken nose, the sunken cheeks, forked beard, pursed lips, and lined, leathery face. But we have also been left an intimate statement about a particular man which penetrates beyond the facts of his appearance. We are informed of Michelangelo's privateness, of the strength of his inward concerns, of his sadness, his wisdom, and his resolute control over whatever conflict or pain might lie within. Thus we apprehend not only what the eyes can perceive but what is concealed. It is Daniele's achievement in expressing the humanity beneath the surface that makes his subject plausible as the man who created a singular artistic universe of image, idea, and passion.

MICHELANGELO

A PSYCHOANALYTIC STUDY OF
HIS LIFE AND IMAGES

Robert S. Liebert, M.D.

Yale University Press
New Haven and London

Published with assistance from the foundation established in memory of Henry Weldon Barnes of the Class of 1882, Yale College.

Designed by Nancy Ovedovitz and set in VIP Goudy Old Style type. Printed in the United States of America by The Murray Printing Co., Westford, Mass.

Library of Congress Cataloging in Publication Data

Liebert, Robert S., 1930–
 Michelangelo, a psychoanalytic study of his life and images.
 Bibliography: p. 429
 Includes index.
 1. Michelangelo Buonarroti, 1475–1564. 2. Psycho-
analysis and art. 3. Arts—Italy—Biography. I. Title.
N6923.B9L53 700',92'4 [B] 82-7042
ISBNs 0–300–02793–1 (cloth) AACR2
 0–300–04029–6 (pbk.)

10 9 8 7 6 5 4 3 2

For Kathy and for
Dana, Emily, and Eric

Contents

Illustrations

Acknowledgments

I am a psychoanalyst, not an art historian. What follows could hardly have come into being were it not for the vast corpus of Michelangelo studies and the generosity of an interested group of historians of Renaissance art.

Above all, I must express my gratitude and indebtedness to Howard Hibbard and David Rosand. Over the decade that I have been interested in the subject of this book they have often been my informal mentors. With tact, good cheer, and curiosity about what my discipline could offer theirs, they have impressed me with the necessity to maintain the essential link between psychoanalytic speculation and archival fact, historical complexity, and contemporary artistic tradition. If in my discussion this link is less than constant, the fault is surely not theirs. In addition, Professor Hibbard read sections of the manuscript along the way and Professor Rosand, the final manuscript in its entirety.

In the course of this project I have been helped by many other people. I would like to single out for the expression of my appreciation James Beck, the late Rudolph M. Loewenstein, Robert Michels, Roy Schafer, and Martin H. Stein.

With respect to basic sources, I have relied exclusively on the translations of Michelangelo's letters by E. H. Ramsden, whom I thank for permission to use them. Besides the letters, Ramsden's two volumes, in their introductions, notes, and appendices, contain riches of data and critical reasoning about previously unsolved biographical problems.

I thank Creighton Gilbert not only for permission to use his translations of Michelangelo's poetry but also for his helpful comments on some of my earlier articles.

I also thank Alice Sedgwick Wohl, Hellmut Wohl, and the Louisiana State University Press for granting permission to quote from Mrs. Wohl's translation of *The Life of Michelangelo* by Ascanio Condivi (1553).

Two other Michelangelo studies that have always been close at hand must be acknowledged. Charles de Tolnay's magisterial five-volume work has been an essential presence. And Frederick Hartt's catalogue of the artist's drawings, which combines traditional connoisseurship with nontraditional speculation, has been of notable value.

The Michelangelo writings of James Ackerman, Erwin Panofsky, Leo Steinberg,

John Addington Symonds, and Johannes Wilde have been additional sources and influences of particular importance.

Gladys Topkis has been not simply my editor. She has been my good shepherd, and I shall always be grateful for her faith in this project and her literary judgment. I am also indebted to Barbara Folsom, who, with great care, guided my final manuscript into its present form and, along the way, solved a few enigmas about Michelangelo.

Looking at Michelangelo's art with my wife, Kathy, breathed life into it. She read every page of this book, and her literary sensibility became a vital presence in the text. Most particularly, she saw meanings in Michelangelo's poetry which had eluded me. For this and so much more I thank her.

I am also grateful to the Superintendencies of Fine Arts in Florence, Milan, Naples, and Rome, and to the Department of Art History of Columbia University, whose photographs form the larger part of the illustrations for this book. In addition, I would like to thank the following for their cooperation: Athens, National Archaeological Museum; Berlin, Staatliche Museen, Staatsbibliothek; Boston, Isabella Stewart Gardner Museum; Dresden, Gemäldegallerie; Florence, Bazzechi (courtesy of B. Mantura), German Archaeological Institute; Kromeríz, Archiepiscopal Palace; London, Trustees of the British Museum, Courtauld Institute Galleries, National Gallery (courtesy of the Trustees), Royal Academy of Arts, Wilton House; Madrid, Museo del Prado; Munich, Bayerische Staatsgemäldesammlungen; Norfolk, Holkham Hall; Oxford, Ashmolean Museum; Paris, Documentation photographique de la Réunion des musées nationaux, Louvre; Pineider; Pisa, Camposanto Monumentale; Rome, Fototeca Unione; Vatican, Vaticani Archivo Fotografico; Vienna, Lichtbeldwerkstätte "Alpenland"; Windsor, Windsor Castle, Royal Library (reproduced by gracious permission of H.M. Queen Elizabeth II).

Michelangelo

Chapter One

Introduction

My purpose in this book is basically twofold. First, I shall attempt to reconstruct, from the abundance of source material that has come down to us from the past, a portrait of Michelangelo that reveals his inner life. Second, I shall explore the contribution that psychoanalysis can offer to an understanding of the meaning of artistic images, as a natural complement to the scholarship of the art historian.

In the course of this undertaking, I will stress an intimate connection between the inner life of the artist and the unique character of his creative works. After all, we know Michelangelo only because of the fruits of his creativity. What follows is speculation, a narrative that attempts to move beyond plausibility to probable truth in establishing the complex and often contradictory elements that were the basis of Michelangelo's psychic life, and then to explain these in relation to his art.

In studying the life and works of an artist there need not be opposition between art historian and psychoanalyst. The responsibility of both is the search for truth by illuminating a particular dimension of the whole. A brief contrast between the two disciplines should place in perspective the path this book will follow.

Art historians are committed to answering a broad range of questions related to works of art. I shall elaborate on two of the principal ones, which are of particular relevance to our discussion—their concern with explaining works of art in terms of their meaning and in terms of their style. With respect to meaning, for several decades one of the principal models for Renaissance art history has been iconography. According to this model, interpretation is highly dependent on the general system of classification of works of art according to the time and place of their origin. Once the works have been so classified, the researcher knows where to find the intellectual sources that will yield the meaning of the specific images under consideration. On a more profound level, he may grasp what Panofsky (1939) calls "the essential tendencies of the human mind" (p. 16) of that epoch which are expressed by these images.

An example from Michelangelo studies, to which I shall return in chapter 10, should clarify the iconographical approach. Several eminent art historians (Panofsky, 1939; Tolnay, 1943–60, vol. 3), in searching for the meaning of Michelangelo's project for the tomb of Pope Julius II (1505), have turned to the texts of the influential late-quattrocento Florentine Neoplatonic philosophers Marsilio Ficino and Pico della Mirandola, with whom the sculptor is known to have been person-

1

ally acquainted. These art historians have concluded that both the individual statues and the overall architectural-sculptural plan for the tomb represent a coherent and deliberate programmatic statement of Neoplatonic philosophy. The implicit assumption in this method is that the meaning of images can be sufficiently explained by discovering the text that demonstrates their origins in the culture.

The focus on the meaning of images is complemented by attention to the style of the image. Style refers to the manner in which meaning is expressed through the organization of formal characteristics such as line, color, shape, light and shadow, texture, movement, and composition, which in concert give works of art their distinctive personality.[1] Style is employed by art historians in addressing individual works, the corpus of a particular artist, and schools or periods of art. Thus we can communicate significant elements in the formal structure of works through such terms as *Michelangelesque*, *High Renaissance*, or *Venetian coloring*. Beyond describing and defining styles, art historians try to understand the evolution of style as a temporal sequence, responsive to historical, political, economic, and cultural forces, and influenced by individual great artists.

In contrast, the psychoanalytic approach emphasizes the representation of unconscious and unresolved conflicts, often repressed and harking back to the artist's childhood, as additional fundamental determinants of both the form and the content of mature creative images.

Both the iconographical approach and traditional historical considerations of style often leave us dissatisfied in our quest to understand those distinctive and personal aspects of the image which enable a connoisseur, with relative certainty, to identify the artist who created it, no matter how commonplace the theme—in other words, to recognize its individual style. These approaches also leave us dissatisfied in the face of those leaps in artistic imagination that catalyze the evolution of visual representation. This dissatisfaction leads us to inquire whether the unconscious meaning of the image to the artist (as distinguished from his conscious intention) is not, in important instances, the necessary condition for understanding why an image is as it is, why the artist chose that particular artistic solution rather than another. Moreover, if we entertain the proposition that an essential component of a beholder's aesthetic experience is the symbolic substitution of the image for some earlier repressed wish-fulfilling or need-gratifying person or experience of his own (Fairbairn, 1938; Segal, 1952; Waelder, 1965), it

1. Meyer Schapiro (1953) has written of the place of style in art history: "To the historian of art, style is an essential object of investigation. He studies its inner correspondences, its life-history, and the problems of its formation and change. He, too, uses style as a criterion of the date and place of origin of works, and as a means of tracing relationships between schools of art. But the style is, above all, a system of forms with a quality and a meaningful expression through which the personality of the artist and the broad outlook of a group are visible. It is also a vehicle of expression within the group, communicating and fixing certain values of religious, social, and moral life through the emotional suggestiveness of forms. It is, besides, a common ground against which innovations and the individuality of particular works may be measured" (p. 287).

behooves us to consider the connection between the unconscious intention of the artist and the unconscious response of the beholder. My approach has been governed by the basic assumption that there are certain invariable laws of human behavior which operate in all individuals, irrespective of period and culture. These form a system that allows us to understand a person's life and creative acts in psychological terms, provided that we have (1) enough factual information about that individual's history and (2) data from the wellsprings of unconscious thought that lie hidden behind his consciously organized self-presentation and behavior.

Any biographer whose subject is long dead faces a fundamental problem. With what degree of confidence can he apply the psychoanalytic method, which is so reliant on a continuous, dynamic interaction between patient and analyst? In the clinical psychoanalytic situation, by contrast with biography, understanding of the patient's psychological functioning and behavior is achieved through explorations of his free associations, dreams, fantasies, and outward behavior, along with the nature of the affect that accompanies them. A crucial element in the process is the transference of repressed thoughts and feelings that originated with formative figures of the past onto the relatively neutral and anonymous person of the analyst —albeit in forms modified by intervening experiences and the present context. The understanding and resolution of this transference are central to the psychoanalytic process. Largely through the analyst's interpretations of the material presented, the patient's unconscious conflicts, forgotten experiences from the past, and emotions isolated from their basis in thought are brought into awareness. The outcome of this lengthy undertaking, if it is successful, is that the patient can understand the determinants of his character structure, self-representation, and troublesome behavior in a way that frees him from the necessity of reenacting unresolved conflicts from the past in a maladaptive way in the present.

In the clinical situation, the basis for therapy is the agreement between patient and analyst that the patient is resolving his conflicts in maladaptive patterns. In studying Michelangelo, however, we are most engaged with a highly adaptive means of resolving conflict—his art. That Michelangelo might be classified as neurotic in this or that respect is quite incidental. All behavior, whether it is personally adaptive and socially fulfilling or personally and socially maladaptive, represents the expression of intrapsychic conflict. What I am interested in exploring here is the nature of the artist's conflicts, their origins, and the forms of their expression through his art and in the conduct and subjective experiences of his life. To labor over diagnostic classifications would risk a reductionism that would obscure the fluidity and unique balance of Michelangelo's psychic life.

But Michelangelo is not alive to engage in a dialogue about the state of his psyche. We therefore lack an element critical to the clinical situation—evidence from the patient that confirms or at least supports our formulations, or forces us to modify them in response to new data. The pivotal question generated by the necessary absence of Michelangelo's participation in the drafting of his biography

is: how adequate are the available source materials in terms of revealing, on the one hand, the essential facts about his early history and life experiences and, on the other, the thoughts and feelings that underlay his public self-presentation? Assuming that the source materials are adequate for this purpose, the crucial question becomes: how valid is psychoanalytic theory as the explanatory instrument for the findings?

With respect to the adequacy of primary data about Michelangelo, we are indeed fortunate in having available the following materials: (1) a wealth of deeply personal statements by Michelangelo himself in the form of 480 letters written to family, friends, and patrons (Ramsden, 1963),[2] as well as 327 extant poems (Gilbert and Linscott, 1963); (2) two biographies by his personal friends— one by Giorgio Vasari (1568), the Florentine artist and great biographer of Italian Renaissance artists, who was an intimate of Michelangelo over the last fifteen years of his life, and the other, published in 1553, when Michelangelo was seventy-eight years old, by Ascanio Condivi, a young assistant to the artist;[3] (3) lengthy characterizations of him by contemporaries in the literary form of *dialogues* —one by Donato Giannotti (1546), a trusted friend who was a prominent Florentine republican living in exile in Rome after the fall of the Republic in 1530, the other by Francisco de Hollanda (1548), a Portuguese artist sent by his king to record and copy the masterpieces of art and architecture in Italy, who had several Sunday-afternoon visits with Michelangelo and Vittoria Colonna,[4] during which the artist expressed his views on art, aesthetics, and a range of other subjects; (4) some 800 letters from family and contemporaries written to Michelangelo (Barocchi and Ristori, 1965–79; and Frey, 1899), and among them about him; (5) contracts between Michelangelo and patrons as well as other documents pertaining to his artistic projects (Bardeschi Ciulich and Barocchi, 1970); (6) civic records pertaining to births, marriages, deaths, taxes, and other matters; (7)

2. All direct quotations from Michelangelo's letters are taken from E. H. Ramsden, and the numbering I have used here refers to this translation.

3. The first version of Vasari's biography was published in 1550. It was, however, greatly revised and expanded in 1568, incorporating Condivi's biography and Vasari's own notes made after 1550 based on intimate contact with Michelangelo and further research in the oral tradition. The later edition became the standard for Vasari's view of the artist. All quotations from Vasari in this book, unless otherwise identified, are from the 1568 edition.

Condivi's introduction to his biography suggests the now generally accepted origin of his work: it was undertaken at the directive of Michelangelo, who was distressed by the distortions and omissions in Vasari's 1550 version and wanted to set the record straight. Wilde (1978) argues persuasively that the elegant prose and overall style of Condivi's book were largely provided by Annibale Caro, a leading Florentine humanist. The one surviving letter from Condivi to Michelangelo seems inconsistent with the literary accomplishment of the biography. Caro had been consulted by Vasari in 1547 with respect to style in the latter's 1550 *Lives*. And three years after the publication of the biography of Michelangelo, it was Caro's daughter whom Condivi married. It seems, therefore, that Condivi's "biography" was the collaborative effort of its subject, a young author, and an active and experienced editor. See Wilde (1978, chap. 1) and H. Wohl (Introduction to Condivi, 1553) for further background to Condivi's biography.

4. See Gilbert (1962) and Summers (1972) for evaluations of the veracity of de Hollanda's dialogue. The relationship between Michelangelo and Vittoria is the subject of chapter 17.

documents revealing child-rearing patterns in fifteenth-century Florence; and (8) over 500 drawings by Michelangelo (Hartt, 1970). Among these drawings are a large number of rough sketches that simply express his thoughts at a given moment, with no other apparent purpose; these may be regarded as the artist's private musings. Many other sheets were preparations for planned works of sculpture, painting, or architecture. Some of them also contain details of seemingly unrelated images. Such doodles often serve as analogues to the free associations of a patient, revealing unguarded thoughts that illuminate his more private responses to the subject before him. Thus, we actually possess more information about the life of Michelangelo than we do about the life of any other artist before the nineteenth century.

In this book, Condivi's biography, which scholars agree is essentially a dictated "autobiography" by Michelangelo, will receive recurrent attention. Measured against all other data, as well as by standards of a careful commonsense reading, Condivi's work does not present an accurate account of the facts. Rather, it is an explanatory narrative in which consistent and repetitive distortions of a particular kind are present. It is useful to think of Condivi's account not simply as an "autobiography" but as an "autobiographical myth."[5] Of course, all autobiographies contain such dynamically determined distortions and omissions. The addition of the term *myth* here is intended to underscore the extent of the phenomenon. That is, Condivi's biography is mythical beyond what seems to be inevitable in any autobiography.

The genre of autobiographical myth is a special case of an individual's reconstruction of his personal history. Intended as a public presentation, it is coherent, internally consistent, and seemingly believable. However, it is marked by significant and consistent distortions in *fact* (not merely interpretation) and by omissions that are generated by unconscious conflict. To the extent that these conflicts shape the text, this version of the past is generally believed to be veristic by its author. It also tends to be accepted rather literally by his audience because of their collective unconscious need to accept the myth of a hero. In it, representations of the self and others are woven into a narrative which is a repository of an earlier set of fantasies and modes of thought that has been repressed. As such, the myth permits the reenactment of aspects of its repressed origins, but with the residues of unacceptable ideas and impulses successfully defended against. The effectiveness of the defense is strengthened by the public's relatively unquestioning acceptance of the author's account.

I return to the second question: how useful is psychoanalytic theory in helping

5. The concept of "autobiographical myth" evolved from Freud's (1899) description of "screen memories." Kris (1956) used the term *personal myth* to draw attention to the manner in which certain patients maintain dynamically significant distortions and omissions in their reconstruction of their past histories. More recently, Schafer (1980, 1980a) has perceptively explored elements of the narrative process in the telling of a life history, and Mack (1980) has discussed the affinity between psychoanalysis and biography, stressing the valuable potential of diaries and other autobiographical sources.

us to understand the biographical material that has been accumulated about Michelangelo? At this point a defense of the basic tenets of psychoanalytic theory would be a large undertaking and would lead us too far afield.

As rich as the data are concerning Michelangelo's life, I have been continuously confronted with the problem that we lack far more knowledge about his actual experiences than we possess. This is particularly true with respect to his childhood history. Thus, the reconstructions I offer, largely derived from psychoanalytic thought, are those I believe to be the most plausible of a number of alternatives, according to criteria that I will set forth. I encourage the reader to embark on the uncertain venture ahead and then, when finished, to ask whether the narrative made sense. Furthermore, do the diverse aspects of Michelangelo's private life, public life, and creativity, as they are known, fit together into an integrated and coherent whole? Does each period of his life and work emerge as continuous and understandably connected to both his immediate and remote past? Are the seeming inconsistencies in his behavior and his work convincingly reconciled? And, finally, are the distinctive aspects of the form and content of his images in sculpture and painting persuasively demonstrated to express definable aspects of the inner life of Michelangelo? To the extent that my inferences from the available data satisfy these demands, I have advanced my explanations from the realm of plausibility to that of probable truth.

A number of further methodological considerations have guided my approach and contributed to my conclusions. These considerations are tied to a governing concern with what constitutes sufficient evidence for certain conclusions. I note here three aspects of my method that will receive special attention: (1) the *repetition* of the same inner conflict in successive works by the artist; (2) the basis for the artist's choice of a *specific work from antiquity* as inspiration for the formal structure of a particular creation; and (3) the *interpretation* of the artist's unconscious motives that contribute to his distinctive creative solution.

In exploring the influence of developmental and psychodynamic forces in Michelangelo's life upon particular artistic images, I shall regard the repetition of the same psychological theme and internal conflict in successive works as a necessary criterion in establishing their connection. This is not a repetition in identity but in resemblance. Without the benefit of knowing the artist's thoughts, which could afford continuous affirmation or contrary evidence, we cannot attest to the strength of a connection on the basis of a single or even an occasional manifestation. We expect that underlying forces will be expressed repeatedly as a reflection of continuous internal pressure within the artist. This expectation grows out of the view that the manifest solution of the latent and unconscious conflict in the artist, the work of art, does *not* have the effect of "working through"—that is, of permanently altering the central mental representation of himself and others and bringing about basic changes in other aspects of his internal psychological organization and outlook. Thus, as each artistic endeavor inevitably fails in this respect, the underlying conflict will reappear. Each new artistic solution to it will be somewhat different from the previous one, but still motivated toward a similar end.

Although it is possible to regard a work of art as the artist's attempt to resolve unconscious conflicts and to express unacceptable wishes in disguised form, it should be emphasized that works of art are not to be equated with either neurotic symptoms or dreams. This issue may be beclouded by the fact that all three phenomena are manifest expressions of latent and conflicted dark motives; all three involve the compromise of an acceptable symbolic representation of unacceptable unconscious content.[6] The creative act, the neurotic symptom, and the dream all draw upon repressed, more primitive thought. It is, however, the artist alone who is able to make constructive contact with this conflicted material without being overwhelmed by it. Ernst Kris, in his landmark study *Psychoanalytic Explorations in Art* (1952), noted that the artist possesses the requisite strength in ego functions to allow him to make productive use of his relatively fluid shifts in levels of psychic operation. The work of art is actually the outgrowth of a continuously cycling biphasic process which involves, at first, *regression* to more primitive modes of thought and then the *synthetic* capacity to transform the dim awareness of the turbulent interior into a form that has the redeeming value of appearing real in itself as well as both communicative and pleasurable to the beholder. Kris introduced the term "regression in the service of the ego" to describe a crucial aspect of the creative process.[7] In contrast, symptoms and dreams are composed of personal symbols that are of little interest in and of themselves. They remain a private matter devoid of either aesthetic appeal or social usefulness. Placing the emphasis on the ego strengths of the artist, it can be said, in sum, that the artist is distinguished not by the specific nature or depth of his inner conflicts, nor by trauma in his early history. Rather, he is distinguished by his capacity to sublimate unacceptable drives by expressing them creatively in images. He is also pressed by a need to communicate with and be responded to by others through this symbolic medium.

The next aspect of my approach is one that seems to me to possess a previously untapped potential for understanding significant elements in many of Michelangelo's works. In the case of many of his paintings and sculptures, a specific work from antiquity which was known to him has been located and persuasively estab-

6. For example, in the *symptom* of fetishism, erotic interest is fixed on a material object or part of the body which is required for the attainment of sexual gratification. The fetish often symbolizes a fantasized female phallus. Its substitutive use effectively serves to allow pleasurable release while warding off the anxiety-laden fantasy of castration aroused by contact with the actual female genitals. A *dream* of helplessly standing by while one's boss is being attacked allows for the expression of hostile impulses toward the boss in a scenario that leaves the dreamer apparently free of responsibility for his own violent wishes. In *art*, a nude that meets certain aesthetic standards allows some degree of gratification for the impulses to exhibit (and view) forbidden body parts without guilt or shame.

7. As early as 1911, Freud addressed the dialectic within the artist between regressive and constructive forces: "an artist is originally a man who turns away from reality because he cannot come to terms with the renunciation of instinctual satisfaction which it at first demands. . . . He finds his way back to reality, however, from this world of fantasy by making use of special gifts to mold his fantasies into truths of a new kind, which are valued by men as precious reflections of reality" (1911, p. 224).

lished as the inspiration for the formal aspects of his creation. Once having traced the earlier source, we can examine those aspects of its narrative theme that probably struck dominant unconscious chords in Michelangelo, thus making it compelling to him as a model. In this way we come to be able to understand more fully the latent meaning of his derivative later creation, even though it was his conscious intention to produce a visual statement quite different from its progenitor. Using this method, we can explicate some of the deeper meanings of the image and clarify how it evolved in Michelangelo's mind into the final form that we now see.

Some art historians have been wary of inferences drawn from this approach, arguing, first of all, that most Renaissance artists tended to look to antique images as sources for their artistic solutions, in keeping with one of the main themes in the spirit of the Renaissance—that is, the discovery and rebirth of the idealized ages of ancient Greece and Rome. Second, it is suggested that the magnificence and compositional suitability of the antique image are sufficient to explain its utilization by later artists. This argument is analogous to explaining someone's statement, "I have nothing but *infection*, I mean *affection*, for my mother-in-law," by asserting that the similar structure of the words *infection* and *affection*, is sufficient to cause the parapraxis without attending to the unconscious conflict in the speaker over the meaning of the intended statement. Similarly with antique sources: their meaning and form are inextricably linked, and it will be illuminating to consider both as necessary determinants of the selection of those works as models by the later artist.

I next turn to a contrast between the approaches of the psychoanalyst and the art historian with respect to the issue of interpretation. Beginning with Freud's study of Leonardo (1910), there has been a small but growing number of applications of psychoanalysis in the areas of biography of artists and interpretation of works of art. Yet, when psychoanalysts have ventured into the area of art history, their reception has often been less than cordial. The differences between the two disciplines have largely revolved around the issue of what are to be considered the relevant evidence and methods for interpreting images.

This controversy is best illustrated by Meyer Schapiro's scholarly essay *Freud and Leonardo: An Art-Historical Study* (1956), in which he undertakes an almost point-by-point refutation of Freud's *Leonardo*. In addition to citing several errors in fact, Schapiro elaborates on the cultural sources and artistic precedents for the images that Freud endeavored to explain in terms of Leonardo's personal history and repressed memories. To a considerable extent, however, Schapiro has obscured what Gombrich (1954) and Kris (1952) have stressed—that the artist can express his private meanings only in the available forms and symbols of his time.[8]

It need scarcely be emphasized that inferences about artists' lives and interpre-

8. For comprehensive discussions of the conflict between art historians and psychoanalysts growing out of the Freud-Schapiro dialogue, see Eissler (1961) and Farrell (1963).

tations of their works must be rooted in solid historical ground, with the facts, as known, in proper order. Only then can the zealous biographer or interpreter be prevented from imposing his own tendentious attitudes on the reader. As Farrell (1963) has insisted, we want an explanatory narrative that not only removes the apparent inconsistencies and presents a coherent picture of the subject of our discussion but also is *true*.

In applying psychoanalytic knowledge to particular works of art, one may be tempted to circumvent confusion and complexity by reducing the problem to a few universal motives (as if we could fully understand Hamlet by giving proper attention to his Oedipal conflicts). Rather, it is essential to hold to the principle that all significant behavior, including works of art, is determined by many and diverse motivational themes. These motives are organized in a dynamic hierarchical structure which is continuously shifting in relation to internal (intrapsychic) factors and external pressures and opportunities. For example, the organization of motives determining a specific work could vary with the content of the work, where it fit into the artistic tradition of the day, whether it was to be painted or sculptured, the nature of the relationship between the artist and his patron, as well as other circumstances in the artist's life during the period in which the work was planned and executed.

The relationship between historical change and the emergence of a uniquely innovative artist, the high value of whose contribution continues to be recognized over the ages, remains highly elusive. But we must recognize that such a relationship does indeed exist. Again and again in the chapters that follow, the process by which the dominant concerns of an age interact with the thoughts of a single individual will be the subject of inquiry. As we shall see, many of Michelangelo's projects were unmistakably wedded to the vicissitudes of the political fortunes of Florence and Rome, as well as to the personal ambitions of his patrons. Although the emphasis of this book will be on Michelangelo's inner life, it must not be forgotten that this was the inner life of a particular child of a particular time and place.

I should say a few words here with respect to the organization of this book. It falls into two sections. Part 1 addresses Michelangelo's relationship with his family —ancestors, mother and mother surrogates, father, brothers, and one nephew of importance in the context of predominant patterns of family life and child rearing in his time. In these chapters the focus will be on presenting the important events and forces in Michelangelo's early development and then tracing the nature of these primary family ties throughout his lifetime. On the basis of this formative material I will develop a multilayered explanation of why Michelangelo was the person he was.

Part 2 will present him more fully as he was during his long adulthood. Where possible I will relate the psychological themes that emerge to the specific nature of the images that comprise Michelangelo's artistic corpus. The chapters, in general,

follow a chronological sequence. Each explores the relevant political-social background of the period, the external events in the life of the artist, and his subjective experience; and each offers an interpretive analysis of his works of art during those years. It is not my intention to provide a detailed compendium of his life or catalogue of his works. Thus, some works, including several popular ones, receive minor attention simply because they are of relatively little interest from a psychoanalytic perspective. This is particularly true of his architecture. Although Adrian Stokes (1951) has made a number of valiant attempts, I have not found any consistent and satisfactory way to apply the conceptual tools of psychoanalysis to the principles and structural forms of architecture. The problem is, in part, that the nature and form of buildings are governed not only by many technical considerations but also by social and economic factors and by patrons' demands—all of which curb the architect's free creative statement.

In trying to interpret Michelangelo's behavior and his art in situations where the supporting evidence is meager, I have often taken risks. That is, I have offered what seemed to me to be the most likely explanations under the circumstances— yet they may fade in the light of new facts or explanations that are more economical and consistent with other information about Michelangelo. It is my hope that the reader will consider these theories in a spirit of curiosity, venturing into halls that are dimly lit but nevertheless rewarding to enter.

PART I

ORIGINS

Chapter Two

Early Mothering

Michelangelo was born on March 6, 1475, in the small Tuscan village of Caprese, some fifty miles southwest of Florence. He was the second of five sons born to Lodovico and Francesca Buonarroti. The Buonarroti were, however, native Florentines.[1]

A formidable problem in the psychoanalytic study of Michelangelo is determining the role of his mother and her surrogates in his early life. In contrast to the documented knowledge about so many aspects of his life, information about his mother and her relationship with him is extremely sparse. It is useful, therefore, to gather what facts are known about his early mothering and then to fill in certain gaps with speculation. All we know is his mother's name, Francesca; that she was a daughter of Neri di Miniato del Sera and Bonda Rucellai, about whom we know nothing; that she married Lodovico in 1472; and that she died at age twenty-six, when her second-born was six years old. We do not know what she died of, whether her death was unexpected or followed a long illness. I presume the former, since Michelangelo's youngest brother was born that same year. The only reference to her in all of Michelangelo's writings is not very illuminating and occurs in a letter to his nephew Lionardo (no. 386), written when the artist was seventy-nine years old. There is a question not simply about the quality of the mother-son relationship but about whether there was even continuous contact between Michelangelo and his mother during the six years in which they coexisted.

In the Condivi biography the one reference to mothering tells us that Michelangelo was boarded at birth with a stonemason's family on the small Buonarroti farm, to wet-nurse. Condivi recounts:

> The wet nurse was the daughter of a stonemason and was also married to a stonemason. For this reason Michelangelo is wont to say, perhaps facetiously or perhaps even in earnest, that it is no wonder that the chisel has given him so much gratification, for it is known that the nurse's milk is so powerful in us that often, by altering the temperature of the body which has one propensity, it may introduce another, quite different from the natural one. [pp. 6–7]

1. The fact that Lodovico was finishing a six-month appointment to the office of mayor (*podestà*) of Caprese accounts for Michelangelo's birth site.

Condivi then describes Michelangelo's father's fierce opposition to his son's embarking on a career as an artist, which included beatings and his expressed contempt for works of art.

Vasari (1568) attributes a similar statement to Michelangelo: "Talking to Vasari one day, Michelangelo said, 'Giorgio, if I am good for anything it is because I was born in the good mountain air of your Arezzo and suckled among the chisels and hammers of the stone cutters'" (p. 258).

Thus Michelangelo describes himself as the passive object of the mystical power and active force of his foster-mother's milk, which he felt endowed him as a sculptor and stood in opposition to his natural mother and father as his procreative source and identification.

Because Michelangelo's experience of being boarded with a wet-nurse is so alien to our century yet so formative in his life, it is necessary to understand this part of his personal history in the context of the child-rearing practices of the time. In a comprehensive historical study, Ross (1974) established that it was the usual practice in fifteenth-century Italy to board an infant from a middle-class family with a wet-nurse. Ross's description deserves to be quoted in some detail.

> What were the infant's first contacts with the world outside the womb? Birth in the parental bed, bath in the same room, and baptism in the parish church were followed almost at once by delivery into the hands of a *balia*, or wet-nurse, generally a peasant woman living at a distance, with whom the *infant would presumably remain for about two years*, or until weaning was completed. Immediate separation from its mother, therefore, was the fate of the new-born child in the middle-class families of urban Italy. . . . It became wholly dependent for food, care and affection upon a surrogate, and *its return to its own mother was to a stranger in an alien home, to a person with whom no physical or emotional ties had ever been established.* [pp. 184–85; my italics]

Michelangelo's mystical belief in the properties of the milk itself were also in keeping with contemporary beliefs.[2] Thus, though lightly dropped, his remarks convey his thought that milk was "germ plasm"—the material basis of inheritance.

Unfortunately, we know no more about the stonemason's wife than we do about Michelangelo's natural mother. So, again, we are left with countless questions about her specific influence on Michelangelo and the nature of the maternal care he received. We can only draw inferences from his later personality structure, relationships with women, sexual orientation, and representations of women in his art—particularly the Madonnas and the Virgins with the dead Christ (Pietàs). One must bear in mind that wet-nurses were generally lower-class women, either grieving the loss of, or concurrently nursing, their own infants. They nursed on a business basis, often at the insistence of their financially overburdened husbands, and if they had older children of their own, had to face the almost inevitable resentment that the wet-nursing would provoke in them.

2. During the second half of the fourteenth century, a Tuscan merchant, Paolo da Certaldo, in advising great care in the selection of a wet-nurse, wrote: "Very often children draw from and resemble the nature of the milk they suck; and therefore be careful the wet-nurses of your children aren't proud and don't have other evil traits" (trans. Ross, 1974, p. 233).

As for Michelangelo's early life, we have little more to draw upon than the average expectable circumstances for a middle-class Florentine child. To that extent, our reconstruction is based upon probabilities strengthened by some facts. We assume that he remained with the stonemason's family in Settignano for approximately two years but had some contact with his parents, since it was their farm and lay just outside of Florence. There is no reason not to conclude that, once weaned, he rejoined his natural parents, who were then living with the family of his father's only brother in a very small communal household in the Santa Croce quarter of Florence. Michelangelo's mother may be presumed to have been reasonably healthy, as she bore three more sons during the four years following his birth. Between the time of his mother's death and his father's second marriage, when Michelangelo was ten years old, we again have no clear information as to his whereabouts.

Although ages are not explicit in Condivi's *Life,* all biographers infer a chronology that definitely places Michelangelo in the home of his father and stepmother from age ten on. Condivi implies that the father placed Michelangelo in a specially selected grammar school (the equivalent of our high school) at about age ten. This leaves open the possibility that he spent the previous four years following his mother's death at the farm in Settignano. If this were so, and the stonemason's family was still there, however, we might expect that this information would somehow have entered our body of knowledge through mention by Michelangelo in one form or another. My own speculation is that he lived with his father and brothers in the collective Buonarroti household in Florence during those years.[3]

Upon the remarriage of Michelangelo's father, his family continued to share the same household with Buonarroti's brother's family. Michelangelo's stepmother, Lucrezia, bore no children and died when he was twenty-two years old. There are no data to suggest that she ever played a significant role in his development.

To recapitulate my reconstruction of Michelangelo's first ten years: he was boarded with a wet-nurse of unknown character for perhaps as long as two years. His weaning was then associated with an abrupt separation from this mothering woman. At this time he returned to his natural mother and father, both of whom were relative strangers to him, as he was to them. His reentry into his mother's life, particularly as her second son, probably elicited minimal emotional investment on her part, inasmuch as she was subsequently pregnant for about half of the four years that remained to her. Thereafter, he was a member of a two-family collective household until ten years of age, with no known adequate maternal surrogate and a father who, apart from whatever grief he may have experienced following his wife's death, must have felt his five young sons to be a substantial burden.

3. Tolnay (1943–60, vol. 1) states it is "probable" that Michelangelo remained with the stonemason's family until age ten, at which time he entered the house of his father and uncle and began schooling. This conclusion, however, is presented without the support of facts or further argument and is therefore unpersuasive. In a study of Michelangelo's *Pietàs,* Oremland (1978) assumes, on the basis of psychological reasoning, that Michelangelo was returned to his mother at about age two.

We are now faced with the problem of translating this particular childhood history, or, to be more accurate, my version of Michelangelo's childhood, which was not unusual for the fifteenth century, into the constructs of twentieth-century theory and analysis. It must be assumed that, regardless of the norms and prevailing practices during the Renaissance, there are certain invariable laws of human behavior which include, on the one hand, universal psychobiological impulses and needs and, on the other, restraints and ethical concerns shared by all social orders. In each environment, however, certain predominant pathways of discharge and sublimation of drives and their derivatives are more or less accessible and acceptable. Therefore, in a given society, some patterns of resolution of conflict and behavior will be facilitated and others impeded (Hartmann et al., 1951).

Even by the standards of his own time Michelangelo's childhood was traumatic —marked by inconstant care when he was totally dependent, by abrupt losses of the persons responsible for his protection and nurturance, and by little experience with the continuity in attachments and the dependable and consistent environment that are necessary for the development of stable self and object representations.[4]

The First Madonna

Having outlined what is known and inferred about Michelangelo's early years, I now turn to the question of whether his childhood influenced his artistic images, and if so how, and whether these artistic solutions in turn yield insight into his inner experience of his personal history. As a preliminary effort in this direction, let us consider one of his earliest sculptures, *The Madonna of the Stairs* (fig. 2-1). This work commands attention, for it is Michelangelo's earliest artistic statement about mother and child.

The Madonna of the Stairs was completed when Michelangelo was sixteen and living in the household of Lorenzo de' Medici. Art historians are divided as to whether it is Michelangelo's first or second sculptured work.[5] This low relief is

4. "Stable self-representation" refers to an ongoing concept one has of oneself that is not primarily reliant on responses from the external world. This schema organizes contradictory conscious and unconscious images of the self—idealized, realistic, and devalued—into an integrated whole. If a stable core sense of self has been achieved, behavior patterns will be consistent, as well as adaptive to the shifting requirements of external reality. Actions will be consonant with one's values. Intimacy is possible without the fear of being engulfed by the other person.

"Stable object-representation" refers to an ongoing concept one has of the significant people in one's life which derives from early experiences with parental figures. If the earlier interactions were basically consistent and nurturant, the child develops a stable internal mental representation that comes to exist independent of the physical presence of the parenting figure. This formative mental representation, if positive, allows for an enduring attitude of realistic responses, relatively free of projection and distortion, in later relationships.

5. The other contender is the marble relief of the *Battle of the Centaurs* (fig. 2-2). Both Condivi and Vasari allude to a marble bust of a faun carved when Michelangelo was fourteen, a simple copy of a work that was available to him since he was then studying art at the school in the Medici

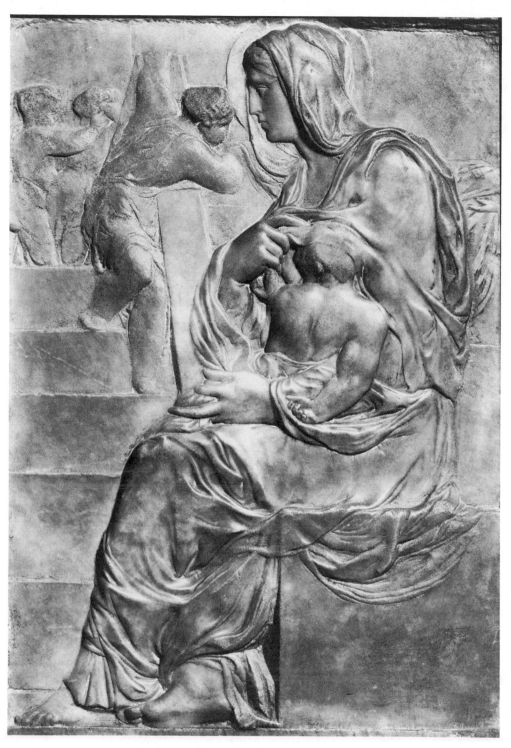

2-1. Michelangelo, *Madonna of the Stairs*.

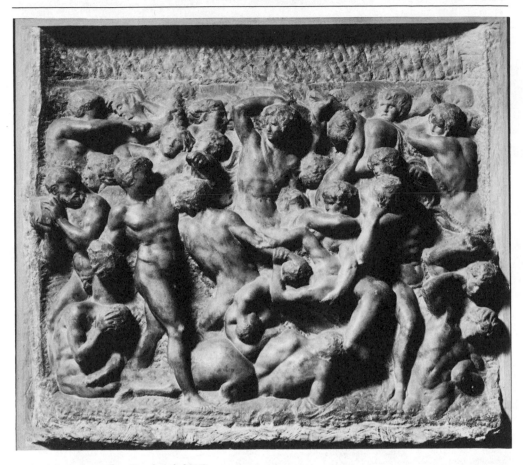

2-2. Michelangelo, *Battle of the Centaurs.*

striking for the originality with which the sculptor treated the most common subject in Renaissance art—particularly striking since, at the time, Michelangelo was very young, a student, and just learning the techniques of carving. Although the work bears some resemblance to an earlier fifteenth-century Madonna by Donatello (the *Pazzi Madonna,* fig. 2-3), it appears that Michelangelo drew his primary inspiration from ancient Greek marble grave reliefs, such as the Stele from Piraeus (fig. 2-4).

Michelangelo rejected the typical contemporary Tuscan model, in which the Madonna was almost always represented as a young bourgeoise and Jesus usually depicted as the blessing savior (as, for example, in Desiderio da Settignano's *Virgin and Child,* fig. 2-5). In these contemporary works the Virgin was rarely shown

Gardens. The faun is lost; the only known representation of it is in a seventeenth-century painting by Ottavio Vannini in the Pitti Palace in Florence. It almost certainly represents the artist's fantasy rather than the actual appearance of Michelangelo's faun. According to Condivi, the beauty of the bust attracted the attention of Lorenzo, who thereupon invited the young Michelangelo to live in his household in the Medici Palace.

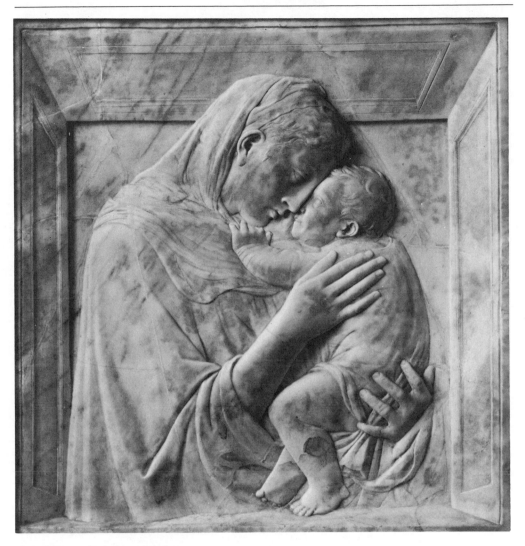

2-3. Donatello, *Pazzi Madonna.*

seated in profile and, with a single known exception,[6] never in a standing position. Rather, Michelangelo looked back in time to a particular genre of works in which a deceased woman is forever commemorated by her image in stone. The stelae, incidentally, often represent a dead mother being bade farewell by her child. Michelangelo's *Madonna* shares not only the position of the women of the stelae but also their mournful solemnity. Instead of the idealized maternal image of the Renaissance, in which the Virgin sometimes has her gaze averted in sad fore-knowledge of the tragic destiny of her son but is nonetheless in nurturing contact

6. The *Madonna of Maestro Andrea* (Rome, Ospedale di Santo Spirito).

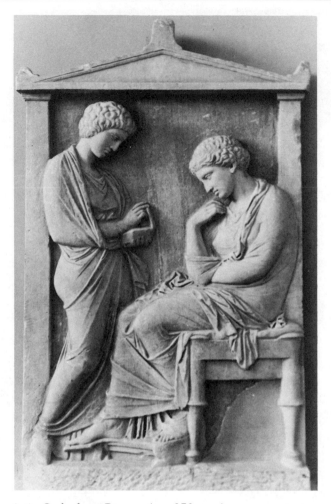

2-4. Stele from Piraeus (ca. 370 B.C.).

with him, Michelangelo's *Madonna* is stony and detached. Her appearance is all the more striking because of the circumstance depicted—nursing the child.

In this connection, a comparison of Michelangelo's *Madonna* and Donatello's *Pazzi Madonna* is particularly revealing. The hands of Michelangelo's Madonna do not touch the infant in nursing (Jesus must even support his own head at the breast), whereas in Donatello's work not only is the Virgin holding the child, but there is a mutuality both in their gaze and in their touching. Significantly, too, Michelangelo chose a motif of Jesus nursing at the breast (*Virgo lactans*), which had become quite rare in fifteenth-century Tuscan art. The absence of tactile contact in Michelangelo's *Madonna* is also of interest in light of the fund of knowledge that has been generated by careful, direct observational studies con-ducted over the past two decades of infants and their mothers. The investigators have consistently emphasized as the critical factor in healthy infant development,

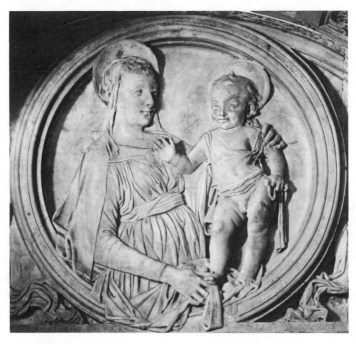

2-5. Desiderio da Settignano, *Virgin and Child.*

not the mode of feeding per se, but the mother's associated tactile stimulation and verbal comforting.[7]

As one studies this relief more closely, several other revealing ambiguities emerge. Jesus appears to be rising from his mother's womb to nurse at her breast. However, rather than nursing, he seems to be asleep. But it is the sleep of death, which is communicated by the symbolism of his pronated right arm. The arm in this attitude derives its meaning from the iconographical vocabulary of Roman sarcophagi. A similar pronated arm reappears sixty years later in the dead Christ of the Florence *Pietà* (see fig. 20-4), which Michelangelo intended for his own tomb. Moreover, for the first time in Renaissance art the early work shows the child Jesus with his back to the viewer, thereby both increasing the ambiguity of his meaning and emphasizing the primary role of the Madonna.

To interpret an artist's motivational currents on the basis of a single work is a hazardous undertaking. It is more fruitful to consider the work as just one part of the fabric of attempted solutions to the unconscious challenge of a particular

7. As early as the second month of life, institutionalized children who have been deprived of sufficient holding and touching along with their feeding were described as feeling "stiff and wooden" when they were picked up and held (Provence and Lipton, 1962, p. 56). Mahler et al., in discussing two- and three-month-olds, comment: "Contact perceptual experience of the total body, especially deep sensitivity of the total body surface (the pressure that the holding mother exercises) . . . play an important role in symbiosis. . . . Let us not forget what an important longing many fairly normal adults preserve for holding and being held" (Mahler et al., 1975, p. 45). Also see Shevrin and Toussieng, 1965, and Spitz, 1965.

motif. At this point in Michelangelo's adolescence, however, certain lines of thought are suggested by the innovations in the *Madonna of the Stairs* that might tentatively be brought together in the following formulation.

Michelangelo was attracted to the task of creating a figure who embodied the idealized, nurturing mother of the Christian world. In his search for this woman he was unconsciously compelled to reject the available contemporary repertoire and, instead, sought the image from the prehistory of Christianity—from a figure of a dead mother, remembered and preserved only by her presence in stone. This is not one of the several traditional Marys—sad yet maternal. Rather, she is cold and stonelike, and strikingly unresponsive to her child. She represents the fused image of Michelangelo's wet-nurse and natural mother, both of whom were forever lost to him. The yearning to recapture the lost sense of well-being in a symbiotic union with the breast remained an intense moving force within Michelangelo, as is indicated by the wet-nurse anecdotes in Condivi and Vasari. However, to yield to this regressive yearning was also to risk death—both in the union with the dead mothering one and in the unleashing of the impounded rage connected with the sense of abandonment so early in life. Thus, it was the power of these unresolved, traumatic childhood experiences and the continuing unconscious attitudes toward his mothering figures and their object representation that found sublimation in this remarkably innovative treatment of the Madonna.[8]

8. This formulation disregards the enigma of the four male children (three on the stairs and one almost off the right edge of the relief), who appear to be playing in peculiar counterpoint to the grave image of the Virgin and Jesus. Varying interpretations of their iconography have been offered (see Tolnay, 1943–60, vol. 1, for a summary). Two of the boys are holding a drapery behind the Virgin, and it is likely that they are connected to the motif of angels holding the holy shroud which appears in representations of the Deposition and the Pietà. However, how does one explain the two boys fighting at the top of the stairs? Was Michelangelo expressing some private thought through these four children? Are they the children of the stonemason's family playing while he was being nursed by their mother? Or do the two supporting the "holy shroud" (in which the crucified Christ is later to be wrapped) represent a different focus of identification for Michelangelo, expressing his wish that his younger brothers would die for usurping what nurturance was available from his mother after he returned to the family? These passing speculations are, of course, impossible to confirm. I would suggest, however, that the two boys who are rather incongruously fighting in this holy scene are expressions of the aggressive feelings engendered in Michelangelo when he addressed himself to this most maternal of themes.

Chapter Three

Ancestry and Birth

Since antiquity, writers have been intrigued by the origins of the extraordinary man. As a result, there is a long tradition in literature concerning the genealogy of Christ, the pagan gods, and creative mortals.[1] Inasmuch as Michelangelo's uncommon promise was recognized even in childhood, we naturally wonder about whom among his forebears he might have looked to and identified with as sources for the inspiration and early development of his creative potential. It is therefore not surprising that, in the opening paragraphs of Condivi's *Life,* one finds that Michelangelo not only contemplated his own origins but had Condivi present a public version that would be regarded as the truth for future ages. What is surprising, however, is that he clothed his ancestry in pure fantasy, maintaining that he was descended from the illustrious medieval Tuscan counts of Canossa. Research has revealed that no such tie to the Canossa line existed. Rather, Michelangelo's ancestry can be traced back only to one Bernardo Buonarroti, who died in 1228 (Symonds, 1893, vol. 1).

The Buonarroti were comfortably bourgeois through their family moneylending and exchange business until the middle of the fifteenth century, when Michelangelo's grandfather, Lionardo (1399–1458), lost the business. By the time of the artist's birth the family holdings had dwindled to little more than a small farm in Settignano, on a hill overlooking Florence. The utterly bewildering fact about Michelangelo's ancestry is that no talent or even interest in the arts was a known part of the Buonarroti legacy. If anything, Michelangelo's ties to his forebears seem manifest only in his acumen and unending concern with personal and family business matters.

The issue of Michelangelo's ancestry raises an interesting question: what psychological function might have been served for him by the fantasy of having ancestral origins in celebrated nobility? The discontinuity between Michelangelo's achievement and life as an artist and the achievements and lives of his forebears was, from all evidence, a source of disappointment and resentment for him. He lived in an age when great emphasis was placed on the importance of nobility of bloodline. In a series of letters written late in life to his only nephew, Lionardo, who

1. Kris and Kurz (1934), in a pioneering work, show how the legends and anecdotes that have been recorded about the lives of artists in all ages and cultures reflect the profound human response to the mystery and magic of image making. They illuminate the unconscious basis of the myths that recur again and again in writing about artists.

was contemplating the choice of a bride, Michelangelo advised that he give far more attention to her family line than to her wealth. More important, however, is the relation of Michelangelo's myth about his ancestry to the fragmented childhood of shifting parental figures and homes that he experienced. In advancing the myth of his noble origins we may speculate that Michelangelo was compensating for his disappointment by inventing what Freud (1909) and Rank (1909) have called a "family romance." This refers to the fantasy or conviction of having parents of nobler lineage than that of one's actual parents. The exalted ancestors possess the idealized qualities that the child once attributed to his own parents during infancy and early childhood. This particular myth of one's origins grows out of intense disillusionment with the later, more realistic perception of the parents, so discrepant from the earlier, idealized image. It also helps a person to separate himself from his dependent yearnings in relation to his parents and to diffuse the rage associated with the disappointment of those yearnings.[2]

In view of the early maternal loss and deprivation Michelangelo suffered, his specific choice of the counts of Canossa as ancestors was probably motivated in part by his desire to link himself to the Countess Matilda, known as the *gran contessa*. Matilda, as margrave, totally dominated Tuscany from 1076 to 1115. She had a powerful effect on the course of Italy's history by arbitrating in favor of Pope Gregory VII in the quarrel of thirty years' standing that he had with Emperor Henry IV of Germany, when the two came to her castle at Canossa in 1077.[3] Thus, Michelangelo appropriated as his own ancestor a woman who was both powerful and long-lived—a dramatic contrast to the reality of his own mother and maternal surrogate.

The same search for roots in a heroic past influenced Michelangelo's choice as models for his artistic style of the masters of the monumental style of Italy's past (Giotto, 1266–1337; Jacopo della Quercia, 1374–1438; Masaccio, 1401–28; and Donatello, 1382?–1466) and the Hellenistic masters of the *Laocoön* (ca. 100–80 B.C., fig. 10-3) and the *Belvedere Torso* (ca. 50 B.C., fig. 15-13). In striking contrast, contemporary Florentine schools, artists, and teachers had little apparent impact on Michelangelo's artistic development. Except for so scant a sign as the technique of crosshatching in drawing, there is nothing to suggest that Michelangelo began his formal career in art as an apprentice in the workshop of a leading contemporary artist, Domenico Ghirlandaio (1449–94). Nor is there visible influence of the generation of Florentine artists immediately preceding him—Leonardo, Botticelli, and Fra Lippi. Quite to the contrary, Michelangelo was partly able to leap forward in style by reaching significantly back in time.

To explore further the relation between Michelangelo's art and the inner forces

2. Although the "family romance" version of Michelangelo's genealogy was promulgated by Michelangelo himself, the widespread presence of the theme of family romance in writings of others about artists has been explored by Kris (1952) and Kris and Kurz (1934).

3. See Schevill (1936, pp. 49–62) for an account of Matilda's reign and the conflict between the pope and the emperor.

that led him to create a myth of his own origins, the most obvious place to turn is to a work by him in which the theme of ancestry plays a central role. Here we are fortunate. The lowest level of the program of frescoes for the Sistine Chapel ceiling consists of the *Ancestors of Christ*, in the fourteen lunettes above the windows on the side walls.[4]

As was often the case with his painted biblical narratives, Michelangelo's images of the Ancestors are a complete departure from the Scriptures (Matthew 1:1–25; Luke 3:23–38). In the written text the named figures are all male. In Michelangelo's conception about half are women, and none of the figures bears any apparent connection with what is presented about him or her in the Scriptures. Thus, to the extent that the figures follow no known literary or artistic precedent, they may all the more be considered projections of his artistic imagination.

What distinctive form, then, does Michelangelo's depiction of Christ's ancestors assume? Rather than a heroic vision, what is immediately apparent about all of these figures is their ghostly and isolated aspect, as seen, for example, in *Ruth and Obed* and *Boaz* (fig. 3-1). They exist outside of familiar time and space. Men and women inhabit the same architectural niche but are physically and emotionally estranged from and unrelated to one another. Ruth is weary and forlorn as she holds her sleeping child, Obed. He is swaddled in wrappings resembling burial shrouds. In the companion niche, Ruth's husband, Boaz, sits isolated in anguish, staring at a miniature caricature of his own head on his staff. How different in spirit these figures are from the story in the Old Testament, which serves to exalt the genealogy of the House of David! According to the Book of Ruth, Ruth and her mother-in-law, Naomi, lost their husbands in a plague. Naomi then returned to Bethlehem and Ruth devotedly accompanied her and took care of her. Boaz, a kinsman of Ruth's deceased husband, was so impressed by Ruth's devotion to Naomi that he married her. Their firstborn was Obed, who became the father of Jesse and a grandfather of King David.

It has been suggested by Kenneth Clark (1967) that the principal reason for the dearth of energy in Michelangelo's representation of the Ancestors is that this group of figures was painted in the final phase of his four-year Sistine labors. This explanation can be related to one of his lifelong patterns: no work of art in its last stages or after completion seemed to hold the excitement for Michelangelo with which he had originally invested it. Thus, a depressive tone obtrudes in the

4. Michelangelo painted in all sixteen lunettes in the chapel, but two have been destroyed. I shall refer to images from the Sistine ceiling throughout the book as well as in a chapter (11) devoted entirely to this work. The Sistine Chapel vault architecturally unifies a number of themes, most of them from the Old and New Testaments and not so obviously related to each other. The most familiar group are the nine "histories"—six panels with episodes from Genesis and three from the life of Noah. Then there are seven Prophets and five Sibyls sitting on thrones in the curved lower part of the vault. These are the largest figures in the entire fresco. In addition, there are four *Ignudi* framing each of the histories—twenty-four in all. The four corner spandrels contain heroic episodes from the salvation of the Jews. There are eight smaller spandrels that also contain ancestors of Christ as well as several other less prominent themes in the ceiling.

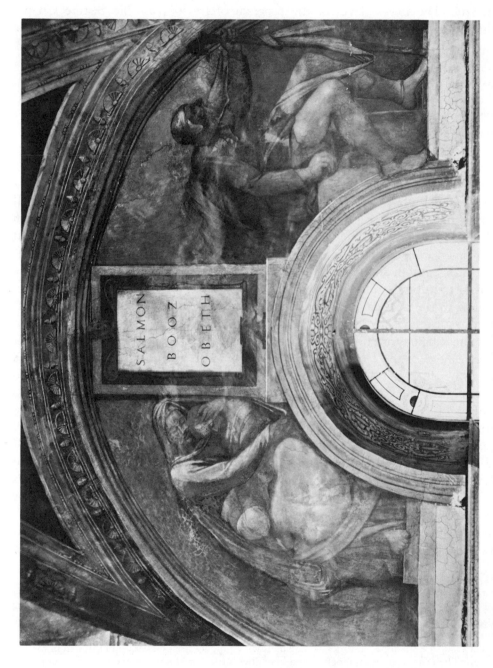

3-1. Michelangelo, Sistine Chapel ceiling: *Ruth and Obed and Boaz.*

imagery of the final phases of many of his works. In his sculpture this depression took the form of loss of interest, which contributed to the fact that more than half of the works were left uncompleted.

Returning to the Ancestors of Christ in the Sistine lunettes, Clark has argued that because they were the last part of the vault to be painted, depression was inescapable for Michelangelo and is clearly reflected in these figures.[5] If, however, we follow the generally accepted chronology of the painting of the ceiling (see Tolnay, 1943–60, vol. 2), the sequence in the work introduces a significant qualification into Clark's explanation. Specifically, Tolnay posits that cartoons for eight of the fourteen lunettes were executed between January 1511 and August of that year, while Michelangelo was completing the entire area of the ceiling that includes the last four histories. Tolnay infers that it had been the artist's original intention to paint the Ancestors along with the upper part of the vault (the ceiling). However, problems in the construction of the scaffolding necessary for the painting of the fresco required that separate scaffolds be erected for painting at the level of lunettes, after the completion of the higher, curved part of the ceiling.[6] Therefore, if indeed many of the Ancestors were in the cartoon stage while Michelangelo was at work on other parts of the ceiling, substantial weight is lent to the argument that it is the motif and not the place in sequence of the total project that accounts for the unique ghostlike character of the figures.[7]

In time the debate among scholars with respect to the chronology of the Sistine ceiling and the place of the lunettes in that sequence will be resolved. What is clear is that in his conception, as well as in his final execution of the theme of

5. In addition to the lonely and isolated character of these lost souls, the lunettes differ in style from the rest of the ceiling in that the effect of modeling is achieved by the subtle interplay of color tones rather than by alternating light and shadow on a precisely designed form. As Wilde (1978) observed: "These figures are not painted statues—they are rather pictures, or fragments of pictures, in the Venetian sense of the word" (p. 68).

6. See Gilbert (1980) for a convincing analysis of the method of scaffolding that Michelangelo employed in the painting of the Sistine Chapel ceiling.

7. The two significant departures from Tolnay's chronology of the ceiling have been proposed by Gilbert (1980) and Wilde (1978). My argument that it was the motif of the Ancestors and not the sequence of the work that accounted for the character of the figures is strengthened if Wilde is correct and weakened if Gilbert is correct. Wilde maintains, on the basis of both documents and stylistic considerations of the lunettes themselves and their integration into the entire ceiling program, that the first eight lunettes were painted, along with the first half of the ceiling, between 1508 and August 1510. In contrast to Gilbert, he obviously does not believe that the kind of scaffolding Michelangelo worked from would have precluded this sequence. In Gilbert's revision of the chronology, the date proposed for the completion of the entire ceiling section is August 1510 (which was the position taken by Wölfflin, 1890) rather than the generally accepted one of August 1511. Whereas Tolnay has Michelangelo preparing the cartoons for eight lunettes beginning in January 1511, concurrent with the painting of the second half of the ceiling, Gilbert concludes that the lunettes were both planned and painted later, beginning in June 1511. Moreover, according to Gilbert, the lunettes were the only part of the project receiving Michelangelo's attention at the time. The date of the beginning of work on the Ancestor cartoons has traditionally been based on a passage in a letter (Ramsden, letter 157) written by Michelangelo in 1523, in which he gave an account of some of his work for Pope Julius II, and which, in Gilbert's reading, yields different implications from those of other editors of the artist's letters.

ancestry—even Christ's[8]—Michelangelo was unable to generate the monumental power that infuses almost every other part of the ceiling fresco. In the last analysis, the subject evoked a new painterly approach but did not inspire him. On the contrary, it seems to have touched and merged with his own confused and conflicted feelings about his own ancestry. The result is a study in spiritual exhaustion.

8. In the last twenty years of Michelangelo's life, as we shall see, he increasingly and deeply identified himself with Christ.

Chapter Four

Michelangelo and His Father

In contrast with the paucity of information we have about Michelangelo's mother and "mothering" experience, it is our good fortune to have rich material available to us about his father, Lodovico. The nature of their relationship is most directly revealed in the many exchanges of letters preserved, in Condivi's biography, and in a twenty-three-stanza poem by Michelangelo commemorating the death of his father.

Lodovico was thirty-one years old when Michelangelo was born. He was one of the first generation after the loss of the comfortable economic status the Buonarroti family had enjoyed for many previous generations. At best, he could be regarded as a ne'er-do-well civil servant. This view of him is conveyed by Michelangelo in a passage in Condivi. When Michelangelo was fourteen years old, his father was summoned by Lorenzo the Magnificent, who insisted that Lodovico allow Michelangelo, whose talent Lorenzo had already recognized, to join his court and live in the Medici Palace. In the course of their meeting Lorenzo asked Michelangelo's father what his profession was. Lodovico is reported to have replied: "I never practiced any profession; but I have always up to now lived on my slender income, attending to those few possessions left to me by my forebears, seeking not only to maintain them but to increase them as much as possible by my diligence" (p. 13). Lorenzo then suggested that Lodovico look for a position in Florence that appealed to him and promised that he would use his power to secure it for him. Later, Lodovico returned and told Lorenzo: "'Lorenzo, I don't know how to do anything but read and write. Now, as Marco Pucci's colleague in the customs is dead, I would like to take his place, as it seems to me that I could serve suitably in that office.' The Magnificent clapped him on the shoulder and said, smiling, 'You will always be poor,' expecting that he would ask him for something greater" (p. 13).

Michelangelo's father worked as a clerk in the Customs Office for four years, until the Medici were expelled from Florence in 1494. Thereafter, he worked only intermittently, occasionally serving for a short term as mayor of some small Tuscan village. For the last three decades of his eighty-seven years, he was almost entirely supported by Michelangelo.

The image of a fumbling father, who must at times have been a source of embarrassment to his son, raises the question: what was the effect on Michelangelo of surpassing his father in worldly terms? What internal conflicts were gen-

erated by this imbalance? What pathways of successful resolution as opposed to expiatory inhibition and self-torment were dictated by the greatly disparate achievements in the lives of father and son? As we shall see, these questions emerged as conflicts in Michelangelo's life.

Another formative aspect of the father-son relationship concerns Lodovico's active attempts to discourage Michelangelo's interest in art. Condivi, after mentioning Michelangelo's ancestry and wet-nurse, skips to the time when he was approximately ten years old[1] and relates how Lodovico, by then aware of his son's superior intelligence, "desired that he should devote himself to letters" and therefore sent the boy to an especially selected grammar school. Michelangelo, however, was little interested in school and kept stealing away to draw and join the company of young painters. Eventually he was so possessed by what he encountered in the workshop of the Florentine master, Domenico Ghirlandaio, that:

> Michelangelo completely abandoned the study of letters. On this account *he was resented and quite often beaten unreasonably by his father* and his father's brothers, who, being impervious to the excellence and nobility of art, *detested it and felt that its appearance in their family was a disgrace.* Despite the very great distress this caused Michelangelo it was nevertheless not enough to turn him back; instead, he was emboldened and wanted to attempt the use of color. [p. 9, my italics]

Thus, the earliest recorded interaction between Michelangelo and his father dramatically defines the pursuit of a career as an artist as a rebellious and inferior undertaking within the context of the values and aspirations of the Buonarroti family.

From the forty-one letters of Michelangelo to his father that have been preserved, covering a span of thirty-two years, as well as from his father's letters in return, we see that over the years their roles became reversed. Michelangelo became the sustaining force—the "parent" to his father and brothers. The letters of the artist are most striking in that they are virtually devoid of any meaningful reference to an artistic project or aesthetic vision. Rather, details and advice on family business matters predominate, with some interweaving of more personal concerns about his own and his family's health and comfort. The letters also reflect intermittent family squabbles and occasional injured feelings. Again and again Michelangelo makes a point of mentioning his devotion and unending sacrifices on his family's behalf, often coupled with accusations of their ingratitude. Of more importance, always discernible is an unbreakable, ambivalent tie—the tension of a symbiotic bond which, as we shall observe, endlessly informs his painting and sculpture. To the end of his father's life Michelangelo, then in his fifties, awaited acknowledgment or appreciation of his filial sacrifices. Thus, in the last extant letter to his father, then seventy-nine years old, in response to some

1. In respect to historical gaps in the childhood years of his subject, Condivi's *Life* parallels two important inspirational models for Michelangelo's creative life—Jesus, in the Synoptic Gospels' version of his life, and Apollo, in Greek myth.

apparently resentful words from Lodovico over Michelangelo's advice regarding a business transaction, the artist pleads: "I've always entered into agreements and cancelled them as you wished; *I don't know what more you want of me*" (letter 154, my italics).

This plea for recognition of his devotion along with betrayal of his self-doubt recall Michelangelo's earlier letters. In 1507 from Bologna, in response to his father's disapproval of his having dismissed a young assistant while working on his bronze statue of Pope Julius II, Michelangelo wrote:

> I value your reproof, since I deserve to be reproved as a miserable sinner: no less than others, and perhaps more so. But I would have you know that I have done no wrong in this matter about which you reprove me, either to them or to anyone else, unless it be that I did more for them than I need have done. [letter 13]

Even allowing for the Renaissance convention of overstating one's imperfections and sinfulness, the consistency of this expressed attitude with other modes of Michelangelo's expression argues for its essential psychological truth. Within the context of Michelangelo's guilt-suffused relationship with his father the question that is fundamental to my approach again presents itself: are the distinctive qualities of Michelangelo's inner conflicts and personal interactions reflected in his artistic images? As the study of his works unfolds in the course of this book, many examples of his particular father-son conflicts will be presented.

To begin our inquiry it is instructive to look at the first of the nine "histories" that he painted on the Sistine Chapel ceiling—*The Deluge* (1508, fig. 4-1). It is significant that previous versions of this episode in the legend of Noah, which had received continuous artistic treatment since the early centuries of Christianity, always stressed the image of the ark. It was the canonical view that the events of the Old Testament presaged those of the New Testament. Thus, the ark had become firmly established as a symbol of Christ's sepulchre, from which he would rise and redeem mankind. Michelangelo was the first artist to relegate the ark to minor importance and, instead, to emphasize the sinners—humanizing them by conveying their intense suffering and tragic destiny. Among the many, two figures are given particular attention. They are the only ones set apart from the four densely packed groups. These two figures are deeply poignant—an aged, powerful father bears his fully grown, dead son in his arms (fig. 4-2). The father clasps his son to his body in a final embrace, while averting his gaze. Toward the end of his life Michelangelo returned to this motif in a directly personal way in the *Pietà* in the Florence Cathedral (fig. 20-4), in which the sinking body of the dead Christ is supported by the aged figure of Nicodemus—Michelangelo's self-portrait.

As in any radical break with tradition, the question arises of what inner conflicts and motives enabled the creator to stand outside the stream of accustomed thought and perception and to dictate his new personal vision. In the *Deluge*, Michelangelo introduces into his art a motif of fundamental importance—the yearning for and the cost of consummate union with a powerful father. This

4-1. Michelangelo, Sistine Chapel ceiling: *The Deluge.*

4-2. Detail of figure 4-1 (Father Carrying
His Dead Son).

theme, as we shall see, directly affected his art for decades and at times found expression in his letters. For example, in 1516, when his father was recovering from a near-fatal illness, Michelangelo wrote to his brother Buonarroto from the marble quarries at Carrara: "if there were any danger I should want to see him [his father] whatever happened, before he died, *if I had to die with him. . . . I have never exerted myself but for him,* in order to help him in his need, as long as he lives" (letter 113, my italics).

We can infer from the passion of this written statement at a time when his father's life was precariously balanced that Michelangelo had an insistent need to deny the negative component of his highly ambivalent feelings toward his father, which at other times were clearly expressed.

A recurrent pattern emerges throughout the years of correspondence, in which Lodovico appears to have engaged in some minor provocation or disregard of Michelangelo's instructions. These incidents served to loose an ever-present reservoir of resentment in the artist for never being affirmed as a loyal and totally devoted son. The following letter is particularly interesting in this respect because, despite Lodovico's advanced age at the time (seventy-seven years), the pattern of

Michelangelo's chafing at the cord that bound them continues much as before. Provoked by some apparently minor misunderstanding, Michelangelo wrote:

> I hear that you are complaining about me and saying that I've turned you out. . . . Never . . . since the day that I was born has it occurred to me to do anything, either great or small, opposed to your interest; and all the toils and troubles I've continuously endured, I've endured for your sake . . . when you were ill I talked with you and promised you that to the best of my ability I would never fail you as long as I live and this I reaffirm. . . . How can you go about saying that I turned you out? . . . I'll try to imagine that I've always brought shame and trouble upon you and this, as if I'd done so, *I ask your forgiveness. It matters more to me than you think. After all, I am your son!* [letter 149, October 1521, my italics]

Two recurring themes in this letter are especially worthy of note: abandonment, and lifelong filial sacrifice. Despite Michelangelo's maturity and fame, and his father's old age, he feels he must pleadingly remind his father that "after all, I am your son!" The accusation of "turning out" his father touches a particularly vulnerable nerve in Michelangelo, who himself felt and acted throughout his life as one who indeed had been "turned out." His sensitivity on this issue can be seen in an enraged letter to his nephew Lionardo, son of his younger brother Buonarroto. Michelangelo was sixty-one years old at this writing and in the throes of serious illness (the nature of which has never been ascertained). In the course of accusing Lionardo (perhaps with justification) of coming to see him in Rome primarily out of concern for his inheritance, the artist wrote: "You cannot deny you're like your father who turned me out of my own house in Florence" (letter 238, July 11, 1544). The event referred to is not known. The implication is that it took place when Michelangelo was an adult. However, since he was the financial as well as the emotional bulwark of his family, it seems quite doubtful that the reference to this event should be taken literally. It is, therefore, possibly a screen for the unconscious belief that he was displaced by Buonarroto, his junior by two years, when he returned to his parents' home from the stonemason's family at Settignano. In this connection we may consider the fact that Michelangelo left his home in Florence in 1534 (at age fifty-nine) to live in Rome and never returned to Florence in his remaining thirty years, despite his expressed intention to do so and the absence of any external reason not to for most of this period. This "self-exile" may have been largely determined by his need to reenact this aspect of his childhood as he later conceived of it—that is, as having been cast out. Living in Rome, however, was *his choice*. The pain of the past could be partially mastered by transforming what was earlier experienced passively into a later active decision of his own. This theme of being the "outcast," as we shall see, is another recurrent motif in his art.

The second theme evident in Michelangelo's last letter to his father—lifelong filial sacrifice—recurs throughout their correspondence. The following example is taken from the second preserved letter to his father, which Michelangelo wrote from Rome at age twenty-two. With respect to a small debt that Lodovico might incur, Michelangelo wrote:

Let me know what you agree to give him and I'll send it to you. Although I have very little money, as I've told you, I'll contrive to borrow it. . . . I have at times written to you so tetchily, for at times I'm very troubled by reason of the many things that befall those who live away from home. . . . I, too, have expenses and troubles. However, *what you ask of me I'll send to you, even if I should have to sell myself as a slave.*" [letter 3, my italics]

But nowhere is the theme of filial sacrifice stated more dramatically than in a letter written from Rome in October 1512, the month during which the Sistine Chapel ceiling was first opened to public view and acclaim. After his four years of Herculean labors, Michelangelo wrote to his father:

Be satisfied that you have bread to eat and can live in peace with Christ and poorly as I do here. For I lead a miserable existence and reck not of life nor honour that is of this world; I live wearied by stupendous labours and beset by a thousand anxieties. And thus have I lived for some fifteen years now and never an hour's happiness have I had, and *all this have I done in order to help you, though you have never either recognized or believed it—God forgive us all. I am prepared to do the same as long as I live, provided I am able.* [letter 82, my italics]

Over the years of increasing public adoration and intimate contact with the most powerful figures in Rome and Florence, letter after letter reaffirms Michelangelo's unrelenting, ambivalent bondage to his father. The letters suggest again and again that the means of pacifying his father was to provide money and material satisfaction and thereby to elevate the fallen honor of the Buonarroti family. Not the *David* that has stood as the pride of Florence in the Piazza della Signoria since the beginning of the sixteenth century nor any other achievement was ever experienced by Michelangelo as sufficient to discharge his family obligation during his father's lifetime.

Over the years Michelangelo accumulated considerable wealth. He then supported his family in a most comfortable manner in Florence and backed their business ventures, including opening a wool-trade shop for two of his brothers. His continuing generosity to his family and a few loyal friends[2] stands in contrast to his own life-style. Of this, Condivi wrote: "Michelangelo has always been very abstemious in his way of life, taking food more out of necessity than for pleasure, and especially while he had work in progress. . . . I have often heard him say, 'Ascanio, however rich I may have been, I have always lived like a poor man'" (pp. 105–06).

I would suggest that a significant force in determining Michelangelo's life of renunciation was the necessity to deny and undo his awesome success so as to expiate the guilt he felt at surpassing his father and brothers in worldly glory. The

2. Despite his oft-expressed suspicion of the motives of others, Michelangelo was capable of extraordinary generosity in making gifts of his art. Under circumstances that I will discuss, he gave the now-lost painting of *Leda and the Swan* to his assistant Antonio Mini, who was leaving his service after eight years (chap. 15). Michelangelo also gave the two Louvre *Slaves* to Luigi del Riccio in appreciation for the care he and his wife had given him when they took him into their home during a long illness in 1545–46 (chap. 19).

expiatory and begrudging quality that lay behind his dependability and material generosity to his family clearly emerges in a letter written to his father in 1512, shortly before Michelangelo set up the wool-trade shop for Buonarroto and Giovan Simone: "Now only one thing remains for me to do and that is to set up those brothers of mine in a shop, for I think of nothing else day or night. Then, it seems to me, *I shall have discharged my obligations; and if more life remains to me, I want to live it in peace*" (letter 76, my italics).

But Michelangelo's guilt, since it was continuously fed by unconscious sources, led to an ongoing situation in which he could never do or give "enough" to his family to lay his feelings to rest. The increasing economic and emotional dependence of his family on him had the effect of generating mounting contempt for them, along with outbursts of rage. This mental state resulted in part from Michelangelo's sense of his own unmet needs; there was no one to parent him as he did them. Only by feeling completely obligated to, and therefore persecuted by, his family could he make his underlying rage seem justifiable and suitable for the self-righteous expression that it repeatedly found. The sense of obligation and persecution is illustrated by the following passage from a letter to his father in 1521: "You have, besides, made trial of me, you and your sons, these thirty years" (letter 149).

Michelangelo's ascetic life-style is clearly reflected in his art. In contrast to his contemporaries, whose portraits, paintings, and sculptures of both sacred and pagan themes tended to have a lusher quality, Michelangelo by and large eschewed the representation of beauty through the decorative details of fine attire, jewelry, or even landscape.[3] Rather, until the beginning of the Pauline Chapel frescoes of *The Conversion of Paul* (fig. 19-2) and *The Crucifixion of Peter* (fig. 19-3) in 1542, he transcended the traditional Renaissance canons of beauty by stating them almost exclusively in representations of the idealized possibilities of the human nude.

Most of what we know of Michelangelo's father comes from his own representation of and response to him. We know from clinical work, however, that the subjective experience and view of a child may vary considerably from the consensual view of others. Therefore, it is informative to examine the letters written by Lodovico to Michelangelo. They, too, are filled with details of minor business matters and everyday affairs. In them we also find oscillations between irritable

3. A sole reference to landscape appears in a letter written when Michelangelo was eighty-one years old, after a brief stay at a reclusive monastery in the mountains of Spoleto ("Recently, at great inconvenience and expense, I have had the great pleasure of a visit to the hermits in the mountains of Spoleto, so that less than half of me has returned to Rome, because peace is not really to be found save in the woods"; letter 426). There are exceptions to the generalization regarding Michelangelo's avoidance of decorative details in his art. They are found in his drawings of ideal heads (*teste divine*—e.g., Ashmolean Museum, P 315 and British Museum, W 42), in which jewelry and elaborately braided coiffures are present; the decorative armor worn by the dukes Giuliano and Lorenzo on the Medici tombs (figs. 15-9 and 15-10); and in the details of architectural ornament.

demands and kindly paternal concern. Thus, at one extreme, in February 1500 he wrote to Michelangelo in Rome bitterly bemoaning his financial woes and the fact that Michelangelo was unable to assist him. He concludes the letter by exclaiming: "I have five sons and not one of them could give me a cup of cold water."

On the other hand, Lodovico also revealed himself as an anxious, hovering parent—an Italianate Polonius, preoccupied with his material relationship to the world and viewing the physical body almost as a capital investment to be carefully protected. Upon hearing of the lonely and impoverished life that his twenty-five-year-old son was leading in Rome (after the execution of the *Bacchus* and *Pietà* in St. Peter's), his father wrote to Michelangelo in 1500. After expressing his pleasure over the love he has observed Michelangelo bears his brothers, Lodovico continues:

> Buonarroto tells me that you live in Rome with great economy, or rather penuriousness. Now economy is good, but penuriousness is evil, for it is a vice displeasing to God and men, and moreover, injurious both to soul and body. So long as you are young, you will be able for a time to endure these hardships; but when the vigour of youth fails, then disease and infirmities make their appearance, for these are caused by personal discomforts, mean living, and penurious habits. As I said, economy is good; but above all things, shun stinginess. Live discreetly well, and see you have what is needful. Whatever happens, do not expose yourself to physical hardships: for in your profession, if you were to fall ill (which God forbid), you would be a ruined man. Above all things, take care of your head, and keep it moderately warm, and see that you never wash: have yourself rubbed down, but do not wash." [Symonds, 1893, 1: 80]

This letter suggests that Michelangelo's unrelenting concern with perfecting his representation of the idealized athletic male body had some of its roots in his exposure as a child to his father's preoccupation with the fragility of the body.

Within a few months of his death at age eighty-seven, Lodovico, in his last known letter to Michelangelo, expressed recognition and gratitude for what his son had been endeavoring to achieve all through the years:

> May God be thanked for His grace in having inspired you to be so charitable toward me, that I remain alive without having to beg or borrow, and if in truth I have been saved from hunger, it is thanks to God and then to you, who have shown me such kindness. May God reward you in this world and in the next.

He then asks Michelangelo out of his great charity to care for the children of his deceased brother, Buonarroti, "because they are our flesh and his. . . . I can say no more. May God be with you always" (Ramsden, 1963, 1:xxxvi).

Following the death of Lodovico in 1531, Michelangelo, then fifty-six years old, wrote a twenty-three-stanza poem in his father's memory. This poem, because it is free of concern with the particular situations that had dictated each individual letter, penetrates more deeply into Michelangelo's inner view of his father.

The poem opens conventionally with an expression of "great sorrow" and

"weeping woe." Michelangelo also speaks in passing of his closest brother, Buonar-
roto, who had died three years earlier during a plague. Then, in the fourth and
fifth stanzas, the contrast in Michelangelo's responses to the death of the two men
emerges:

> One was brother to me, you were our father;
> Love strains toward him, to you my obligation,
> I don't know which hurt strains or irks me further.
>
> My brother's painted in my recollection,
> And it carves you alive inside my heart,
>[4]

These lines suggest that Michelangelo's brother was successfully mourned and
could be recalled with love, whereas his father was permanently internalized
("carved") within him as a tormenting presence. Just as a young child's mental
representation of himself is not yet separate from that of his mother, so boundaries
were never firmly delineated between Michelangelo's mental representation of
himself and his internalized representation of his father. Certain areas of thought
forever remained an inner dialectic between the voice of his father and his own
voice. In this sense his father seemed to live on, still exerting control over him,
robbing him of the illusion of free will, yet secretly gratifying his passive and
receptive yearnings for endless parenting. Thus, Michelangelo felt bound by an
obligatory tie, but not by affection.

These lines also express precisely the difference between nonpathological and
pathological mourning. The sentiment about Buonarroto represents the former:
the mourner has a feeling of separateness, so that thoughts and images associated
with warm feelings do not possess him. In contrast, in writing of his father,
Michelangelo concedes that he will never be able to relinquish this inner presence
and remains tormented by it.

The stanzas that follow are attempts to master the feeling of loss by reasoning
that his father was old and that therefore the son should "feel less hurt" by his
death. But, "even though the soul consents to reason / It does so stiffly," and he is
left "filled/Far more with more depression later on." Michelangelo recognizes the
task in mourning and also recognizes his failure—how "stiffly" his conscious efforts
proceed in the face of the necessity to preserve his father "alive" within himself.
This portion of the poem remarkably anticipates Freud's formulations in *Mourning
and Melancholia* (1917), in which he observes: "Reality testing has shown that the
loved object no longer exists, and it proceeds to demand that all libido shall
be withdrawn from its attachments to the object. This demand arouses under-
standable opposition . . . people never willingly abandon a libidinal position"
(p. 244).

After several more stanzas in which Michelangelo attempts to come to terms

4. Gilbert and Linscott (1963, poem 84).

with his pain rationally, in the fifteenth stanza, strains of lifelong resentment begin to break through:

Since Heaven has now removed you from our burden,
Have some regret for me, who am dead while living,
Since through your means it wished me to be born.

Michelangelo's resentment at having to endure the living death of existence turns into open envy of his father in the next stanza:

You're dead of dying, and are made divine,
Nor do you fear a change in life or wish;
I hardly write it without envying.

Following this shift, the anxiety that seemed to infuse Michelangelo's daily waking thoughts is bitterly contrasted with his fantasy of the idealized state in which the father now resides.

There is no cloud can make your light grow dark,
On you, the different hours work no power,
Not bounded by necessity or luck.

The night does not deaden your splendor . . .

Thus, what was begun and intended as a son's loving memorial tribute is remarkably transformed in its course into bitterness, self-pity, and envy.

In the twentieth stanza, after various attempts to free himself from the pain of mourning and the psychological grip of his father, Michelangelo appears to accept the permanence of his simultaneous need for the father's continuing presence, on the one hand, and his frustration and feelings of estrangement, on the other. This same duality characterized the years of their lives together, in Florence or apart:

By having died my dying you will teach,
Dear father, and I see you in my thought
Where the world hardly ever lets us reach.

The effort at a final resolution dwells in the fantasy of eternal reunion with his father in Heaven, "near the holy seat":

Where by God's grace I imagine and assume
And hope to see you are, if reason draws
My cold heart out from the earthly slime.

In the following and final stanza, astonishingly, the last line is left unwritten:

And if the best of love in Heaven increases
Between father and son, as virtues all grow . . .

Like so many of his sculptures, the poem is unfinished and abandoned. Michelangelo could not complete the expression of loving unification in Heaven because of the powerful counterforce of his unconscious rage at his perceived abandonment

by his father. It may seem strange that the fifty-six-year-old artist, who had already spent many years away from Florence in Bologna, Rome, and the mountain marble quarries, should feel abandoned by his aged father. Nevertheless, this disparity between Michelangelo's capacity to function independently and his inner conviction that he could exist only if sustained by a powerful paternal force created a tension that continually dictated many of his artistic solutions. Although he wrote of "the best of love . . . between father and son," much of the poem belies the purity of that sentiment.

Moreover, the fantasy of union in death between father and son carried with it the dread of bodily disintegration that attended his concept of death. Despite his fears and his preoccupation with the possibility of continuing spiritual existence after death in this world, Michelangelo was never clear about his belief in the afterlife. His doubts were eloquently expressed by Walter Pater over a century ago:

> Michelangelo is the disciple not so much of Dante as of the Platonists. Dante's belief in immortality is formal, precise and firm almost as much as that of a child, who thinks that the dead will hear you if you cry loud enough. But in Michelangelo you have maturity, the mind of a grown man, dealing cautiously and dispassionately with serious things; and what hope he has is based on the consciousness of ignorance— . . . dumb inquiry over the relapse after death into the formlessness which preceded life, the change, the revolt from that change, then the correcting, hallowing, consoling rush of pity. [1871, pp. 101–02]

The intensity and complexity of Michelangelo's relationship with his father are reflected in his art. Three works in particular—*The Drunkenness of Noah* from the Sistine ceiling, the drawing of the *Children's Bacchanal,* and the painted panel of the *Holy Family* (Doni tondo)—contain images that are very similar in their formal elements yet suggest different, indeed contradictory, aspects of his relationship with and attitude toward his father.

In the clinical psychoanalytic situation, the more private and unconscious meanings of conventional and "planned" thoughts, presented through free association, can often be understood by observing how the same words, images, and emotions arise in other, seemingly unrelated contexts. In a comparable way, when an image employed by Michelangelo as part of a programmatic statement (such as the episodes selected for the Sistine Chapel ceiling *Legend of Noah*) reappears in other artistic contexts with different intended meanings, we infer an unconscious linkage. In this way, we gain access to the multiple levels of personal meaning and conflicting motives that underlie the repetition of that particular formal solution. Moreover, when this repetition occurs in Michelangelo's art it is especially meaningful in view of Condivi's assertion that replication was never found there: "Michelangelo had a most retentive memory, so that although he has painted so many thousand figures . . . he has never made one like to another, or in the same pose" (p. 76).

In the representation of *The Drunkenness of Noah* (fig. 4-3), from the three *Noah* histories on the Sistine Chapel ceiling, Michelangelo again departed both

from artistic precedent and the biblical source (Genesis 9:18–29). In the scriptural version, Noah, having planted the vineyard (see the left side of the panel), drank its fruit and then succumbed to the stuporous effects of the liquor. He was discovered by his son Ham, who, with his two brothers, reviled their father and covered his naked body in shame. This episode had traditionally been regarded as foretelling the Passion of Christ, in which he would be stripped naked on the Cross and mocked by mankind—his children. According to this interpretation, the wine cup by Noah's right side represents the wine of the Eucharist, which in turn symbolizes the blood from the wound in Christ's right side.

In Michelangelo's rendering, how oddly the sons react! It is immediately striking that one particular symbol of Noah's shame—his nakedness—is shared by his sons, who are also naked. Therefore, the narrative makes little sense. Whereas in Genesis the sons approach their father "backward . . . and saw not their father's nakedness" (Genesis 9:23), in the painting their approach is characterized by ambiguity and confusion. Even the facial expressions of the sons communicate apprehension rather than shame or contempt. These youths seem to reflect the medieval recognition of inevitable fate: "As I am you will be; look now and see yourself in me."[5]

Thus, the vision of the fallen father—the object of shame in the legend of Noah as well as in Michelangelo's much later recollections of his own father in Condivi's *Life*—must, at this earlier time (1508–09), be masked in the artist's mind, introducing confusion. The painted scene is void of any clear expression of derision or hostility. Yet so great is Michelangelo's art that the fresco is sustained by its compositional and sculptural magnificence.

In contrast with *The Drunkenness of Noah* is the most meticulously finished of all of Michelangelo's drawings, the *Children's Bacchanal* (fig. 4-4).[6] This drawing, executed over two decades later (1533), was a presentation from the artist to Tommaso de' Cavalieri.[7] The section of the drawing germane to my discussion is the right foreground (fig. 4-5), which in its composition is clearly reminiscent of *The Drunkenness of Noah.*

Here three prominent putti and one almost hidden one are cloaking a naked man, the only human adult in the drawing. In the general position of his body the man resembles the drunken Noah (and is also typical of the Christ of a Deposition or Entombment scene in Renaissance art). One of the putti holds a wine cup, thereby suggesting that the man has succumbed to the wine-making operation pictured in the right background (in which one putto is mirthfully producing fresh urine which, perhaps, will find its way into the brew). However, in contrast with the confused and anxious expressions of Noah's sons, the lewd band of children in the *Bacchanal* symbolizes that which is most base in mankind.[8]

5. Cited by Tolnay (1943–60, 2: 26).
6. The *Children's Bacchanal* is discussed in detail in chapter 16.
7. The relationship between Michelangelo and Tommaso is the subject of chapter 16.
8. See Panofsky (1939, pp. 221–23) for an elaboration of this interpretation within the framework of Neoplatonic thought of the time.

4-3. Michelangelo, Sistine Chapel ceiling: *The Drunkenness of Noah.*

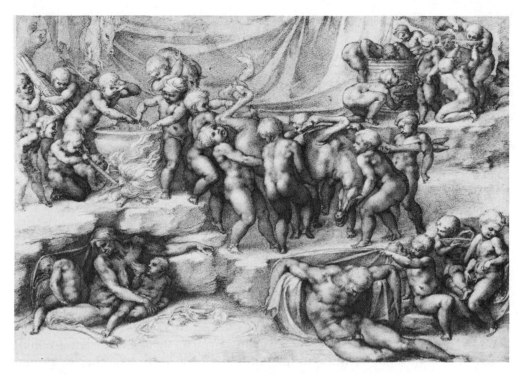

4-4. Michelangelo, drawing of the *Children's Bacchanal.*

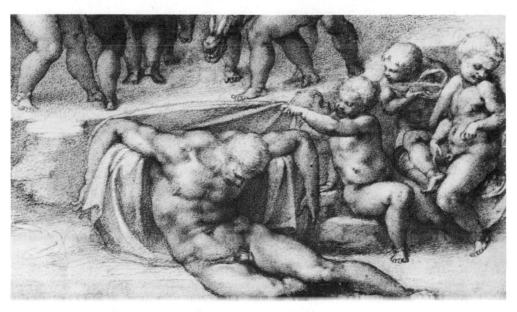

4-5. Detail of figure 4-4 (three putti and drunken man).

This drawing was done approximately two years after the death of Michelangelo's father. Inasmuch as no known text or source for the drawing exists, its inventiveness is all the more revealing of Michelangelo's own fantasies. Within the context of the whole drawing, and by their actions and expressions, the group of boys in the right foreground clearly conveys the sadism toward the drunken man that was suppressed in the earlier narrative of Noah and his sons.

A third painting, the *Holy Family* (Doni tondo)[9] (fig. 4-6), broadens our understanding of the conflict underlying the confusion in *The Drunkenness of Noah*. The *Holy Family* was painted in 1503–04, approximately five years before the Sistine Chapel *Noah*. Thus, the representation of Noah's sons can be said to derive from Michelangelo's own earlier composition in a different thematic context.

The *Holy Family* is composed on three seemingly separate planes. In the fore-plane are the Virgin, the Child Jesus, and Joseph. The Child Saint John is alone in the middle plane. Of concern in our present discussion is the trio of nude youths in the right background (fig. 4-7), the forerunners of Noah's three sons. The formal connection between the youths in the two works is clear: the Doni tondo youths are also linked by a flowing raiment. The figure on the left is pulling it over his right shoulder while turning his head back to his left, thereby placing his torso and head in a posture virtually identical to that of Noah's son Ham, on the left of the grouping in *The Drunkenness of Noah*. In both compositions the figure on the right embraces the center figure as these two are grouped in counterpoint to the figure on the left.

Despite this kinship in composition, there are certain striking differences between the groups in the two works. The youths in the *Holy Family* exude an androgyny and a calculated narcissism in their posturing that is absent in the sons in *The Drunkenness of Noah*. Scholars have long debated the meaning of the presence of these enigmatic youths in this sacred painting. They have been variously identified as shepherds, sinners, virtuous athletes ready to defend the church, wingless angels, mankind awaiting the coming of Christ, prophets from the Old Testament, and the ages of man.[10] D'Ancona (1968), in the most recent art-historical analysis of the work, concludes that the youths are homosexuals who, being sinners, are waiting at the baptismal font to have their bodies and garments purified.[11] The wide variety of interpretations it is possible to apply to these youths attests to the deliberate obfuscation of meaning that characterizes Michelangelo's art again and again. Each instance of it raises the question of whether the particular image contains a more personal and private meaning that required concealment behind ambiguity.

9. The *Holy Family* is explored in detail in chapter 7.

10. These interpretations are summarized by D'Ancona (1968).

11. Before D'Ancona's article, Leo Steinberg in an unpublished lecture had proposed an identification of the youths as angels engaged in homoerotic interplay, symbolizing the world before the coming of Christ (personal communication).

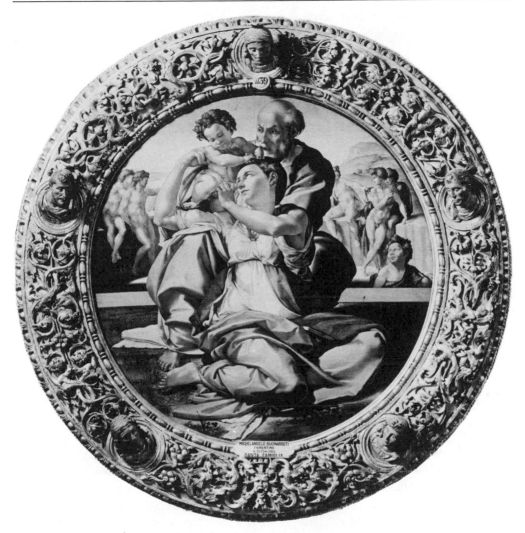

4-6. Michelangelo, *The Holy Family* (Doni tondo).

Speaking of the *Ignudi* on the Sistine Chapel ceiling, Clark (1964) has commented: "Michelangelo thought that there was nothing more beautiful than a naked young man, and that, since beauty was an attribute of God, it was quite appropriate to place them between God's work and his witnesses. . . . These figures are part of an imperative dream which he had already been forced to externalize (most inappropriately) in the background of the *Doni Tondo*" (p. 440).

Whatever iconographical statement one chooses to assign to these nude youths, they clearly attest to a highly androgynous conception of male beauty and to an erotic interaction among males. Thus, these figures, within their self-contained space of homoeroticism, reflect one of the pathways of resolution of Michelangelo's competitive and resentful feelings toward males, as well as his profound

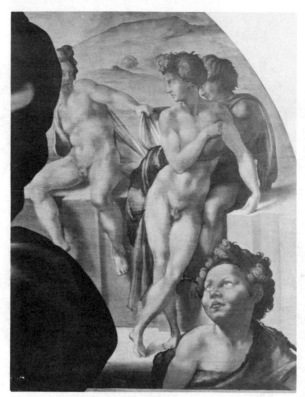

4-7. Detail of figure 4-6 (Child St. John and group of youths).

sense of abandonment in childhood. Although it is rooted in his earliest years and resulted largely from the particular history of his mothering, this nexus of fantasy involving the beauty of the young nude male became intimately connected to the artist's relationship with his father and various subsequent paternal surrogates. The process of transition in Michelangelo's early development, by which the usual needs for attachment to mothering figures were transferred to paternal ones, will be the subject of recurrent discussion throughout this book.

This transferral, however, did not free Michelangelo from strongly ambivalent feelings toward other men. He was left with homosexual longings that were a source of lifelong struggle. In chapter 16 I discuss at length Michelangelo's relationship with Tommaso de' Cavalieri, the twenty-three-year-old aristocratic Roman whom the artist met when he was fifty-seven years old and for whom he immediately developed a passion that surpassed all others during his life, as well as the subject of homosexuality in general in the artist's life. Significantly, Michelangelo met Tommaso shortly after his father's death. Until he was in his sixties, Michelangelo seemed to exist in a world unpopulated by women. That is, in all the documentation of his life, no woman is shown to have played a significant role between his childhood and his meeting with Vittoria Colonna in 1536, when he was sixty-one years old (see chap. 17).

The three works considered here are very similar in their formal, compositional elements. Yet they lend themselves to quite different interpretations. In each Michelangelo has returned to a basic theme and conflict, revealing different elements of fantasy and unconscious response. Thus, the images illustrate not only the complexity and contradictions in Michelangelo's relationship with his father but also the process by which these inner concerns informed his art and contributed to his unique solutions in dealing with familiar motifs in the art of the day.

Chapter Five

Michelangelo and His Brothers

Michelangelo had four brothers plus a nephew who was important to him. By exploring his relationship to each of them we can further understand the climate of the Buonarroti family and Michelangelo's conception of himself. They were all constant psychological presences in his life.

We know least about Michelangelo's oldest brother, Lionardo, born two years before the artist, in 1473. Lionardo became a Dominican friar in 1491 and a follower of Fra Girolomo Savonarola. It was during 1493–97 that Savonarola virtually seized control of Florence by preaching of his vision of the city as the place chosen by God for the Second Coming and the center for the regeneration of a Christian world that had fallen from grace under the "anti-Christ" pope, Alexander VI. Lionardo was casually referred to only once by Michelangelo, in a letter written to his father from Rome in 1497.[1] He is presumed to have died in 1510 or shortly thereafter, since the last information about him comes from that year. The briefness of his span in the life of the Buonarroti family had the effect of elevating Michelangelo to the position of "oldest" son.

Michelangelo's youngest brother, Sigismondo (1481–1555), seems to have been a simple soul who, after a number of years spent in various mercenary armies, settled down to working the family farm. He too never married. Over time he became a source of embarrassment to Michelangelo. Thus, in 1540, Michelangelo wrote to his nephew Lionardo: "Tell him [Sigismondo] from me that he does us little credit in making a peasant of himself" (letter 205). Again, in 1546, he wrote to Lionardo: "Get Gismondo to return to live in Florence, so that it should no longer be said here to my great shame that I have a brother at Settignano who trudges after oxen" (letter 272). There is, however, an earlier letter (1531) in which Sigismondo touchingly expresses his appreciation to Michelangelo for his help.

Michelangelo's "shame" over Sigismondo is significant in that, realistically, he hardly needed to worry that the world's opinion of him would be affected by the existence of a younger brother who was a simple farmer. In the face of this reality, the degree of Michelangelo's irrational concern once again attests to the unbreakable inner bond with his family, which was little altered by the geographical separation of the two brothers.

1. Ramsden (1963, letter 2).

The next to the youngest brother, Giovan Simone (1479–1548), also never married. We can infer from Michelangelo's letters that Giovan Simone experienced at least one manic-depressive episode. A number of the early letters suggest that he also had limited intelligence. For example, Michelangelo addressed him, either sarcastically or jokingly, in 1507 on the subject of the dreaded and recurrent problem of the plague: "You write me that a friend of yours, who is a doctor, has told you that the plague is a dangerous disease and that one may die of it. I'm glad to hear it" (letter 22). Much later, however, in a letter to his nephew in 1543, Michelangelo wrote: "Tell Giovan Simone that the new commentary on Dante by a Lucchese [Alessandro Vellutello] hasn't been well received by the people who know anything, so there is no need to pay attention to it. There's no other new one that I'm aware of" (letter 254). This indication of Giovan Simone's interest in Dante suggests that he was at least literate and probably of above average intellect; yet in the earlier years he was often the object of Michelangelo's vexation and condescension, responses that he was quite capable of provoking.

A series of letters written by Michelangelo from Bologna, spanning many months in 1507, suggests that Giovan Simone was then in the midst of a depressive episode and clearly conveys the artist's concern and support, as well as irritation. For example, in February he wrote to his brother Buonarroti: "As to Giovansimone . . . I'm pleased that he is betaking himself in your master's shop and that he is trying to get on. Encourage him to do this, because if this thing goes well, I hope to put you both in a good position" (letter 11). Then, in April, he wrote directly to Giovan Simone: "I will return home and do everything I have promised to do for you all, that is, to help you with what I have, in the way you wish and our father wishes. So keep up your spirits and apply yourself at the shop to the best of your ability, because I hope you will soon open a shop of your own" (letter 22). The following month Michelangelo wrote: "But keep up your spirits, because there is something greater—or rather, better—in store for you than you think" (letter 24). He expressed similar encouraging sentiments throughout the summer and into the fall.

These letters of Michelangelo exemplify his lasting deep concern for the well-being of his family—particularly in times of crisis. I conclude from the 1507 series of letters that Giovan Simone suffered a period of severe depression. As we know, commonly in the course of a manic-depressive illness the sufferer moves from the depressive stage into a manic phase, characterized by agitated excitement, often with bouts of impulsive, destructive acts. This appears to have been the case with Giovan Simone, judging from a pair of letters that Michelangelo wrote to his father and to Giovan Simone in 1509. To his father, Michelangelo wrote:

I learn . . . how Giovansimone is behaving. I have not had, these ten years, worse news than on the evening I read your letter, because I thought that I had arranged things for them in such a way that they were looking forward to setting up a good shop with the help I have promised them. . . . I realize that it is useless to help him [Giovan Simone] if he takes so much as the value of a straw out of the house, or does

anything else to displease you, I beg you to let me know, because I will try to get leave from the Pope and will come home and show him the error of his ways. [letter 48]

The letter to Giovan Simone reveals once again that the principal means by which Michelangelo asserted his position in the family was through material support:

I can tell you one thing for certain—that you possess nothing in this world; both your expense and the roof over your head I provide for you, and have provided for some time now, for the love of God, believing you to be my brother like the others. Now I'm certain that you are not my brother, because if you were, you would not threaten my father. On the contrary, you are a brute. [letter 49]

The letter continues with threats, including the artist's promise to ride back to Florence to destroy Giovan Simone's belongings and burn down his house. Michelangelo then goes on to say: "If you mean to behave and to honour and revere your father, I will help you like the others, and in a little while will arrange for you to set up a good shop." The letter concludes with a fierce expression of Michelangelo's sense of embittered martyrdom:

I cannot help but write to you another couple of lines to this effect—for twelve years now I have gone about all over Italy, leading a miserable life; I have borne every kind of hardship, worn myself to the bone with every kind of labor, risked my life in a thousand dangers, solely to help my family; and now, when I begin to raise it up a little, you alone must be the one to confound and destroy in one hour what I have accomplished during so many years and with such pain. [letter 49]

There are no data to suggest that Giovan Simone again suffered from the extremes of the cyclic illness. Rather, he seems to have settled into a mundane existence; but his continued oddness may be inferred from a letter Michelangelo wrote to his nephew upon Giovan Simone's death in 1548: "I would remind you that he was my brother, no matter what he was like, and that it cannot but be that I should be grieved and should wish that something should be done for the welfare of his soul" (letter 300).

The letter written at the time of Giovan Simone's unbridled behavior (no. 49) most clearly expresses how Michelangelo's endless monetary support and concern for the family's material welfare served to mask the begrudging and unconsciously withholding attitude he also bore them. His account of his life of hardship, humiliation, and risk "solely" to help his family is, of course, a distortion of reality, and portrays the subjective world of someone who received woefully inadequate parenting early in life. Michelangelo's pervasive sense of deprivation and rage tended to be activated by his assumption of these generous roles within the family.

Michelangelo's brother Buonarroto, two years the artist's junior, was clearly the most capable sibling and the one to whom the artist felt the warmest attachment. Until Buonarroto's death during the plague of 1528, he worked in the wool trade.

Michelangelo first arranged for him to apprentice in a large shop and then set him up in his own shop in 1513. The shop apparently failed in 1527.

Buonarroto was the only brother who married. His first wife died soon after their marriage, but from his second marriage three children were born. Two survived to adulthood—Francesca and Lionardo. From the correspondence between these two brothers a picture emerges of Michelangelo's deep and genuine affection, although often tinged by the same begruding and self-sacrificing attitude that characterized his interaction with all of his family. Thus, for example, in 1510, when Buonarroto was ill, Michelangelo, then in the midst of work on the Sistine Chapel ceiling, demonstrated his concern in a letter to his father: "I beg you, as soon as you get this, to let me know how he is, because if he is really ill I could ride post to Florence this coming week, although it might mean a great loss to me" (letter 53). In a letter written two days later, he again offers to ride home from Rome, "since men are worth more than money." But he also expresses his apprehension that if he leaves Rome without permission, "The Pope [Julius II] might be angry and I might lose what is due me" (letter 54). Thus, characteristically, he undercuts a generous offer by noting the personal sacrifice it might involve.

Michelangelo's letters to Buonarroto were often filled with big-brotherly advice. For example, in advising him whether or not to marry a young woman whose father had offered to advance a sizable sum of money to set him up in a shop, Michelangelo wrote:

> But look out that you are not cheated, because one never finds anyone ready to do something for nothing. . . . I tell you that all the offers he makes to you will be unfulfilled, except for the wife, once he has foisted her on you, and you will have more of her than you'll want. Again I tell you that I do not like your getting involved through avarice with men much more unscrupulous than yourself. Avarice is a deadly sin and nothing sinful can succeed. [letter 66]

Buonarroto did not marry this particular woman.

Occasionally, Michelangelo wrote Buonarroto about his own activities, although only rarely about his artistic endeavors. One exception, however, is an account of his casting in bronze the colossal statue of Pope Julius II seated on a horse, in Bologna in 1507 (letter 28). Frequently, Buonarroto was given instructions on how to manage Michelangelo's affairs back in Florence. In one such letter the artist wrote, "Do not leave my money in the hands of other people, for I do not trust a living soul" (letter 106). Letters to Buonarroto also exist in which Michelangelo gives vent to his despair when blocked in his activities—as, for example, when Medici Pope Leo X insisted that Michelangelo change quarries for his marble for the ill-fated project of the façade of the Church of San Lorenzo in Florence (letter 123).

Despite Michelangelo's concern and affection for Buonarroto, he hardly spared his brother from the familiar self-righteous and martyred outbursts when he felt either that his efforts were unappreciated or that his directives had been ignored.

One example expresses Michelangelo's disapproval of Buonarroto's bookkeeping methods with joint funds. After detailing the problem, he wrote:

> If you had the intelligence to realize the true state of affairs, you would not have said "I have spent so and so of mine," nor would you have come here to urge me about your affairs, seeing how I have always behaved toward you in the past. Instead, you would have said, "Michelangelo is aware of what he wrote to us, and if he has not now done as he said, there must be something to hinder him which we do not know about," and would have been patient. For it does no good to spur on a horse that is going as fast and faster than it can. [letter 92]

Then, in the next sentence, Michelangelo wrote, "But you have never known me and do not know me." In this single line he suggests his "secret self." The artist and his family only related to each other through a maze of business details, the superficial aspects of daily life, and mutual recriminations. In Michelangelo's correspondence, however, there is an almost sacred avoidance of references to his vision of the world, to his philosophical contemplation of the matters of human existence, to his inner life and fantasies. On the other side, his family seemed neither interested in nor capable of comprehending such matters. To survive, it would appear that Michelangelo could not allow them any entry into his private sanctuary, where in his aloneness he felt the life-force that was the wellspring of his genius and creativity.

The story of Michelangelo's relationship to his family must include his nephew, Lionardo (1519–99), and niece, Francesca (1517–?). Whereas 204 of the last 281 of Michelangelo's preserved letters were addressed to Lionardo, nothing of the much more limited correspondence between Francesca and the artist survives. Although Francesca did not approach the psychological importance that Lionardo held for their uncle, from the references to her in his letters to Lionardo it is clear that she was someone for whom he felt affection and concern. He never saw her after he left Florence in 1534, when she was seventeen years old. Three years later she married Michele di Niccolò Guicciardini, member of an old and aristocratic Florentine family. Michelangelo provided Francesca's dowry. Francesca and Michele had three children who survived into adulthood and another who died in infancy in 1547. On this occasion Michelangelo wrote to Lionardo, "I was as grieved about Guicciardino's baby as if it had been my own son. Encourage them to bear it patiently and commend me to them" (letter 288). When, in 1546, during an illness of Michelangelo, rumor reached Florence that he was dead (which was rectified within a few days) Francesca's husband wrote of her "terrible grief."

It was Lionardo who was to play a critical role as the link between the past and the future during Michelangelo's last thirty years. Lionardo was nine years old in 1528, when his father, Buonarroto, met his sudden death. The sole male carrier of the Buonarroti name into the next generation, he remained in Florence and in time acted as agent of Michelangelo's directives for the management of family affairs there. Beyond this, he became the focus for a host of attitudes that Michel-

angelo had always held toward his family. This merging of Lionardo with the others in his family is illustrated by Michelangelo's use of the phrase "forty years" in the following passage from a letter written in 1546, when Lionardo was twenty-six years old: "You have all lived on me for forty years now and not so much as a kind word have I ever had from you" (letter 262).

With his nephew, Michelangelo reenacted once again the pattern that had characterized his relationships with his father and brothers. That is, he lavished material support on Lionardo, which, along with his authoritarian stance, encouraged the younger man's dependency. Then Michelangelo often felt exploited and suspicious that any solicitude expressed by Lionardo was in the service of ensuring his sizable inheritance from his uncle. For Lionardo, whose father died when he was so young, followed by his aged grandfather three years later, his uncle Michelangelo, with all his fame and wealth, and his remoteness in Rome, unquestionably became an idealized paternal figure. For Michelangelo, Lionardo represented the sole and fragile link in the Buonarroti chain to the future.

Yet it seems there was very little Lionardo could do that did not elicit criticism from his uncle. For example, upon receiving a gift from Lionardo, Michelangelo wrote: "I have received three shirts together with your letter, and am very surprised that you should have them sent to me, as they're so coarse that there's not a peasant in Rome who wouldn't be ashamed to wear them" (letter 203).

From 1547 to 1553 Michelangelo wrote some forty-eight letters to Lionardo on the subject of his marriage—clearly an urgent matter for Michelangelo. Lionardo, as heir to his uncle's name and wealth, was a most eligible bachelor. During these six years he was exceedingly indecisive. Finally, in May 1553, he was married to Cassandra di Ridolfi, to his uncle's joy. It is clear from the letters that Lionardo had to overcome his own considerable resistance to the notion of being married. Michelangelo on several occasions tried to provide guidelines for Lionardo in his search for a suitable bride. What is most striking about his avuncular advice is that it was highly idiosyncratic for the times, expressing not only disregard for the dowry but lack of concern about the prospect of marrying a poor girl.[2] Thus, in 1551, he wrote:

> It seems to me that if you were to find a girl of noble birth, who is well brought up, of nice disposition, but very poor—which would be very conducive to a quiet life—you should marry her without a dowry for the love of God. I believe someone like this could be found in Florence, which would please me very much, because you would not be committed to airs and graces and you would be the means of bringing good fortune to others, as others have been to you, for you find yourself rich without knowing how. [letter 363]

2. Michelangelo's disregard of the dowry was an unusual attitude during the Renaissance. Customarily, a woman from the middle class whose family could not offer a dowry was destined for life in a convent. If a husband predeceased his wife, his family was obligated to return the amount of the dowry to the wife's family.

The letter goes on to note how Michelangelo has so radically elevated the family's fortunes, "and never have I found anything but ingratitude."

Despite his uncle's attitude, Lionardo negotiated for over four months with Cassandra's family after choosing her as his bride. The delay was a source of irritation to Michelangelo, as emerges in the following letter of March 1553:

> I gather from your last letter that you have renewed negotiations for the Ridolfi daughter. . . . This affair has gone on so long that I've grown weary of it, so that I no longer know what to say to you. . . . If it does not please you to take a wife—either this girl or anyone else—I leave the decision to you. I've attended to the affairs of all of you for sixty years; now I'm old and must think of my own. So decide about it as you think best, because whatever you do must be on your own account, not on mine, for I haven't long in this world. [letter 378]

Michelangelo was able to state his primary interest in the matter of Lionardo's marriage simply: "I'm very desirous that some descendent should survive you" (letter 365). He generously welcomed Cassandra into the family, and immediately after the wedding wrote to Lionardo: "I'm thinking of giving some token of the relationship. I'm told that a fine necklace of valuable pearls would be appropriate. I've set a goldsmith, a friend of Urbino's, to look for it and hope to find one, but don't say anything to her about it yet, and if you think I should do anything else, let me know" (letter 381). A few weeks later he wrote, "I've obtained two rings for Cassandra, a diamond and a ruby" (letter 382). A few months later he wrote a note thanking Lionardo and Cassandra for sending him eight fine linen shirts and added, "Offer her anything I can get in Rome or elsewhere, because I won't fail her" (letter 384).

When, the following April, Cassandra gave birth to a son, Buonarroto, Michelangelo joyfully wrote: "All this has afforded me the greatest delight. God be thanked for it, and may He make him a good man, so that he may do honour to the family and uphold it. Thank Cassandra on my behalf and commend me to her" (letter 388).

During Michelangelo's lifetime Lionardo and Cassandra had four more children who died at birth or shortly thereafter. The uncle shared in their grief and tried to console them. When the infant they had named after Michelangelo died, the artist wrote: "In your last letter I had the news of the death of Michelangelo. It has been as great a grief to me as it had been a joy—indeed much more so. We must bear it patiently in the belief that it is better than if he had died in old age" (letter 395). In all, Lionardo and Cassandra had seven children who lived into adulthood. The most notable, known as "Michelangelo the Younger," lived from 1568 to 1647. He was an accomplished poet and playwright. Through their firstborn, Buonarroto, the family directly descended until the death of Cosimo Buonarroti in 1858. Cosimo bequeathed the Casa Buonarroti and its contents to the City of Florence.

And so, during the last decades of the artist's life Lionardo became the symbol of the potential generativity of the Buonarroti line. Just as Michelangelo needed

to suspend truth and to believe that his antecedents were the counts of Canossa, so the immortality symbolized by his bloodline (rather than his art) extending into the infinite future was, for him, a compelling issue.

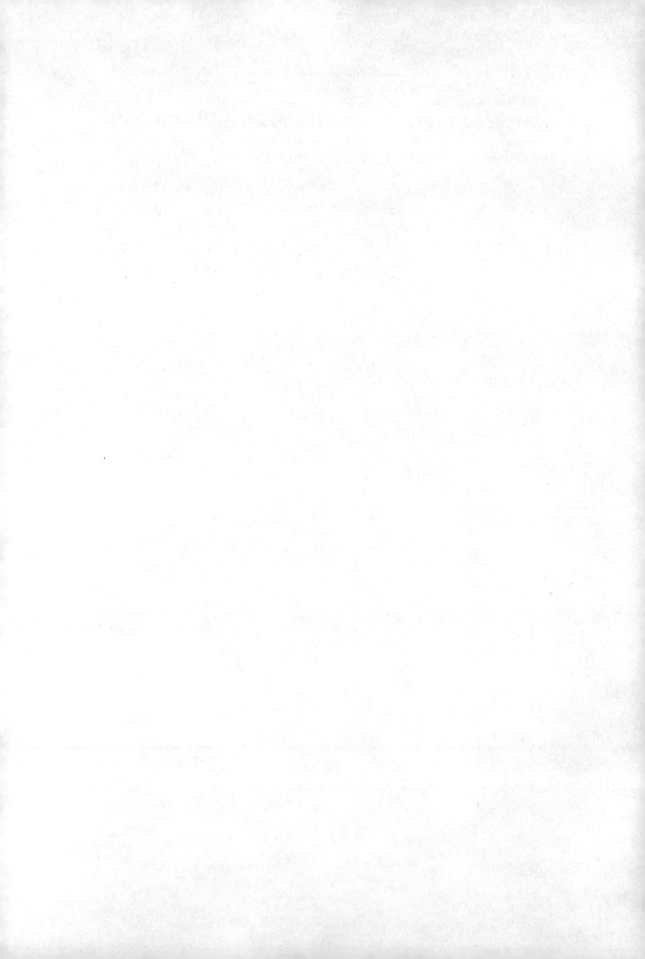

PART II

LIFE AND IMAGES

Chapter Six

From Student Years to the First Roman Period, 1492–1501

The decade explored in this chapter covers Michelangelo's seventeenth to twenty-sixth year. It begins with his completion of the two marble reliefs, the *Madonna of the Stairs* (fig. 2-1) and the *Battle of the Centaurs* (fig. 2-2), in 1491–92, while he was living in the household of Lorenzo de' Medici, and ends with his return to Florence in 1501, after a five-year stay in Rome. The treatment of these ten years will be concise because of the relative scarcity both of contemporary accounts of Michelangelo from this period and of his letters—only five of which survive. Furthermore, many of the major works completed at this time will be discussed in later chapters.

We recall from chapter 4 that at age thirteen, against his father's bitter opposition, Michelangelo left grammar school and began an apprenticeship in the busy workshop of the brothers Ghirlandaio. A year or so later he entered the sculpture school in the Medici Gardens, where his genius was recognized by Lorenzo the Magnificent. In 1492, soon after Michelangelo had carved the *Madonna* and *Centaur* reliefs, Lorenzo died at forty-three of a progressive and painful illness. His death brought to an end the two years of Michelangelo's residence in his household—the happiest in his life. The relationship between the young artist and Lorenzo is discussed in some detail in chapter 12, in the context of dominant themes in Michelangelo's fantasy life that contributed to the statue of the *Dying Slave*. Suffice it to note here that during these two years, until just after his seventeenth birthday, Michelangelo felt singularly chosen by the prince—not only deeply admired for his artistic promise but also sought after daily for the pleasure of his companionship.

It was during his teens spent in the Medici circle that Michelangelo thoroughly absorbed the teachings of the Neoplatonic philosophers who were centered there. Until he reached his sixtieth year, Neoplatonism was to be the ideological vocabulary through which Michelangelo expressed much of his artistic imagery and verse. I shall, therefore, introduce a brief summary of this current of thought.

Neoplatonism developed out of the wave of humanistic study based at the Accademia Platonica in Florence. The humanist movement received great impetus during the mid-century pontificates of two great popes, Nicholas V (1447–55) and Pius II (1458–64). Both pontiffs were eager to reconcile church dogma with the new learning from antique sources and employed hundreds of scholars and copyists in this pursuit. Whereas Aristotelian thought had been important to

Thomistic theology, in this new approach to antiquity the writings of Plato were to be reconciled and integrated with traditional Christianity. The central thinker in this school was Marsilio Ficino (1433–99), who was the first to translate all of Plato's works from Greek into a Western language. (The complete works were published in 1484.) Known as the Neoplatonists, these scholars conceived of man as basically good, although fallen as a result of Original Sin. The path to redemption was largely through intellectual discipline. Learning, whether sacred or secular, could only enhance the purity of man. The Neoplatonists considered the task of human existence to be an inner process wherein the soul strove to ascend to higher and higher degrees of knowledge and love, leading ultimately to a sense of communion with God. Ficino also reaffirmed the concept of "Platonic love" from Plato's *Symposium* and viewed pleasures of the flesh as antithetical to the ascension of the soul. The Neoplatonic concept of the purity of love profoundly influenced the poetry and literature of the sixteenth century.[1] Much of Michelangelo's poetry, as we shall see, is deeply rooted in Neoplatonic philosophy. Gilmore (1952) has stressed the belief in the potentialities of education and educational reform as a cornerstone of Neoplatonism. Acceptance of Neoplatonism by other than the intellectual elite, however, was limited by the very elements in Plato's philosophy scholars were striving to combine with Christian dogma—intellectuality and aristocratic elitism.

As we shall see, it was Michelangelo's close and complex relationship with subsequent generations of Medici (including two who became popes) that dictated many of his principal artistic and architectural accomplishments (and also prevented him from working on other projects to which he felt committed). It is appropriate, therefore, to introduce briefly the role of the Medici in Florentine history. In the four decades before Michelangelo's birth and during his youth, from 1434 to 1494, Florence was dominated by the powerful Medici family.

The government of Florence during the Medici period was basically oligarchical. Although Florence had the institutions and forms of democracy, those in power determined who ran the agencies of government, thereby creating a self-perpetuating system of ruling families. The Medici did not hold formal offices or titles. Rather, they functioned in a way more akin to the urban political bosses of early twentieth-century America than as direct rulers. The political resourcefulness and, at times, ruthlessness of the Medici coexisted with their deep commitment to the support of the humanist school of scholars and to the patronage of artists and architects.[2]

Lorenzo de' Medici, known as *Il Magnifico*, guided Florence's fortunes from 1469 until his death in 1492. We shall see that Lorenzo's formative effect on Michel-

1. See Robb (1935) for an excellent presentation of Neoplatonic philosophy and its application in Renaissance literature. Her book includes a chapter on Michelangelo's poetry.

2. The effective power of the Medici in Florence began in 1434 with the *pater patriae*, Cosimo de' Medici. Cosimo, who headed the family for thirty years until his death in 1464, founded the Accademia Platonica, which was to become the center of fifteenth-century Neoplatonic thought.

angelo during the latter's adolescence was an important force that carried a long-lasting impact.

Lorenzo is the most renowned of the Renaissance "princes" and exemplified Burckhardt's concept of the universal man. A brilliant international statesman, he negotiated pacts with other city-states which served to maintain a tenuous peace throughout Italy.[3] He was also a lyric poet of sufficient merit to be included in every anthology of fifteenth-century verse. He championed the translation of Greek classics and of the writing of contemporary scholarship in vernacular Italian rather than Latin, so as to make them widely available. Lorenzo significantly expanded the traditional Medici patronage of the arts and the humanists. He was himself a connoisseur and collector, and even ventured into architectural designing. Burckhardt (1860) summarized Lorenzo as follows: "Of all the great men who have striven to favour and promote spiritual interests few certainly have been so many-sided, and in none probably was the inward need to do so equally deep" (p. 229).

Although Lorenzo brilliantly maneuvered a peaceful equilibrium among the five principal Italian states during the last decade of his rule (which extended until Michelangelo was seventeen years old), Florence was nevertheless beset with internal crises, including the shaky solvency of the Medici bank. This failure, incidentally, has often been largely attributed to Lorenzo's lack of business acumen and poor judgment in the selection of people to run the decentralized international branches of the bank. Moreover, Florence was confronted with the threat of the mounting designs of the French to conquer Italy. It was at this precarious time that Lorenzo died.

Lorenzo the Magnificent was succeeded as head of the house of Medici by his son Piero (1471–1503), known to history as Piero the Unfortunate. His misfortune can be attributed both to the adverse moment in Florentine history at which he found himself cast in the role of leader and to his ineptness and arrogance, which made him unsuited to such an awesome task.[4] In any event, Michelangelo

Cosimo was also the patron of such giants as the sculptor Donatello and of Brunelleschi and Michelozzi, the architects of the most distinguished Renaissance buildings in Florence.

Following Cosimo's death, the guidance of the city and the management of the family's international banking interests passed to his eldest son, Piero. Piero suffered from severe gout and died from its complications five years after his father, in 1469. During his short span in power, he avidly maintained his father's commitment to the arts and to humanistic studies. Piero was succeeded by his twenty-two-year-old son Lorenzo ("the Magnificent").

3. Renaissance Italy was not the unified nation we know today. It consisted of five major city-states—Florence, Venice, Milan, Naples, and the Papal State—along with a few much smaller ones. Although they shared a common language, until the middle of the fifteenth century these states were in continuous conflict. Their frequent wars with one another took place within a peculiar framework of shifting alliances that preserved a fairly constant balance of power. The wars were largely fought by foreign mercenaries (*condottieri*) and were usually accompanied by famine and disease, which took a harsh toll.

4. The following description of Piero comes from the most significant contemporary history of Florence and Rome, written by Francesco Guicciardini (1561), a major participant in the political affairs of Florence from 1490 to 1534, the years covered by his book. Guicciardini wrote:

does not seem to have enjoyed the special favor of Piero during his two-year reign, in marked contrast to his position with Lorenzo.

Following Lorenzo's death, the seventeen-year-old Michelangelo moved back to his father's house. Soon, however, he returned to live again in the Medici Palace. It is symbolic of the ending of the glorious era of Medici patronage that during Piero's brief rule the only recorded commission given to Michelangelo was a snowman! According to Condivi, during a heavy snowfall Piero asked Michelangelo to decorate the center of the courtyard with one.[5]

After the death of Lorenzo a group of fire-and-brimstone preachers seized the imagination of the Florentine masses. From this group Fra Girolamo Savonarola rose as singularly commanding.[6] He was outspoken in his view of the Medici as the force of evil in the Florentines' midst, and viewed the impending invasion of Tuscany by the French under Charles VIII as heaven-sent liberation. As the French marched southward toward Florence, Piero hesitatingly tried to form defensive alliances with Venice and Naples. These diplomatic efforts foundered, with the result that at the critical moment Florence was unable to defend herself. In late October of 1494, Piero lost heart and went to the camp of the French king, where he signed a treaty handing over to the French most of the key fortresses in Tuscany. When Piero returned to Florence on November 9 and announced the terms of the treaty, an enraged assembly of Florentines, convinced that he had unnecessarily sold out the Republic, barred him from his palace. Later that day Piero fled Florence. The treasures of the Medici Palace were plundered.

Piero's outrageous behavior and arrogance incited the Florentines all the more: in many ways, his mode of acting had deviated from the mild and civilized behavior of his ancestors; whence, almost from his youth on, he had always been hated by all the citizens; and to such a degree, indeed, that his father, Lorenzo, aware of Piero's nature, had often lamented to his most intimate friends that his son's recklessness and arrogance would bring about the ruin of the house of Medici. [p. 57]

5. During the two years of Piero's rule, Michelangelo executed two sculptured works. The first was a wooden *Crucifix* which, according to Condivi, Michelangelo made for the Ospedale di Santo Spirito in exchange for permission from the prior to study anatomy by dissecting corpses. A wooden crucifix recently discovered in a corridor of the hospital is considered by some scholars to be the one by Michelangelo (see Lisner, 1964). Many others, with whom I agree, challenge this attribution because the boyish, softly modeled Christ is uncharacteristic of Michelangelo. The other work was a larger-than-life-sized statue of *Hercules*, which Michelangelo carved in 1493 out of a block of marble that he purchased for himself. The statue was bought by the powerful Strozzi family in Florence. In 1529 it was acquired by Francis I, king of France, who moved it to Versailles. The *Hercules* was apparently destroyed in 1713, under the reign of Louis XIV. No reliable copy of the work exists.

6. With the shift from agrarian to capitalist economy and the increasing secularization of thought that occurred during the Renaissance, the strains on the church to accommodate the changing nature of society were considerable. This crisis in the church resulted in the decline of the moral fabric of all levels of the ecclesiastical organization by the early fifteenth century. The movement for reform of the church took two divergent paths, both centered in and affecting Florence. One was a pietistic and mystical approach that harked back to the Middle Ages. The other was intrinsically tied to the ongoing humanistic scholarship.

Thus ignominiously, sixty years of Medici rule ended with the desecration of what had been the center of one of history's more civilized tyrannies.

In October, a month before the fall of the Medici, Michelangelo precipitously fled Florence for Venice and, after a very brief stay there, settled in Bologna for a year. The immediate stimulus for Michelangelo's flight is of great interest. Condivi relates that the young artist departed following a nightmare, reported to him by a friend, in which the deceased Lorenzo appeared and foretold Piero's doom. Inasmuch as Michelangelo was able to recount the dream in detail to Condivi sixty years later, and also considering the nature of the manifest content, it is quite possible that the dream was actually Michelangelo's own. The Condivi account reads as follows:

> Lorenzo de' Medici had appeared to him with a black robe, all in rags over his nakedness, and had commanded him to tell his son that he would shortly be driven from his house, never to return again. Piero de' Medici was so insolent and intemperate that neither the goodness of his brother Giovanni the cardinal [the future Pope Leo X] nor the courtesy and humaneness of Giuliano [the future Pope Clement VII] had as much power to keep him in Florence as those vices had to cause his expulsion. [p. 17]

Michelangelo exhorted his friend to relate the dream to Piero, this being Lorenzo's will. But his friend, fearing Piero, did not. Shortly thereafter, the friend reported to Michelangelo another dream in which: "Lorenzo appeared to him that night in the same garb as before and . . . , while he was awake and staring, he struck him a

The more regressive approach relied on the concept of divine guidance and the example of the sanctified individual who would reveal to others the operation of grace and divine plan. Through the moral reform that would follow, the ills of society could be healed. The principal figure associated with this movement was the Dominican friar Girolomo Savonarola. Savonarola, with his fiery oratory and fanatical zeal, dominated Florence for four years from 1493 to 1497. The masses embraced him as sent from heaven to cleanse the church and establish Florence as the model religious community on earth. Savonarola's teachings, incidentally, included the denunciation of many of the Renaissance canons of beauty in art. While he held sway, large bonfires of personal belongings that might be considered ostentatious ("vanities") were offered up by the population. Savonarola's reign came to an abrupt end in 1498 when he was publicly burned at the stake as a heretic. This occurred because Pope Alexander VI and the ruling families of Florence had simply had enough of him. Although Savonarola did appeal to elements of unreconstructed medieval thought in a large sector of Florence, he also intended to lead them back from the newer capitalist economy to feudal agrarianism. So, as Schevill (1936) has proposed, Savonarola, as the enemy of progress, had to be crushed by the bourgeois class for economic, not moral, reasons.

With respect to the question of the influence of Savonarola on Michelangelo, who was in his late teens when Savonarola reached the heights of his influence, Condivi wrote that Michelangelo had studied the writings of the friar, "for whom he has always had great affection and whose voice still lives in his memory" (p. 105). I find little evidence, however, that Savonarola had any significant impact on Michelangelo's art or thought. On the contrary, at that time he was very much under the influence of the opposite current attempting to modify church dogma—Neoplatonism. Ronald Steinberg (1977), in his study of the influence of Savonarola on Florentine art, also challenges the contention of Tolnay, Wind, and others that the Dominican preacher had made himself felt in Michelangelo's art.

great buffet on the cheek because he had not communicated to Piero what he had seen" (p. 17).

We cannot be certain why Michelangelo left Florence at this time or what these dreams meant to him. Therefore I will limit myself to a few points that seem clear. Whether the dreams were Michelangelo's or his friend's they suggest the artist's yearning to restore his relationship with Lorenzo, whom he had come to look upon as his first loving, adoptive father. The image of Lorenzo as unsuccessfully cloaking his nakedness brings up the issue of Michelangelo's unconscious homo-erotic ties to paternal surrogates, mentioned in chapter 4 in relation to his real father. Further, the dream depicts Piero in harshly negative terms that are consis-tent with contemporary descriptions of him (see n. 4 above). Piero thus was an "objectively" suitable target for Michelangelo's rage and contempt. If indeed the dreams were Michelangelo's own, Piero's presence in negative terms was probably dictated by the young artist's feeling that he was unprotected and unsupported by this unpleasant man, whose scant energies were largely consumed by the dire political situation. Finally, the dreams portended what was clearly in the air—that Piero was shortly to be routed by the Florentine populace. With the imminent end of the house of Medici, Michelangelo was faced with the prospect of being cast out, without a protective patron. Thus, as we shall see he did a number of times when he found himself in this kind of situation, Michelangelo mastered his anx-iety by acting first—in this instance by fleeing Florence shortly before the Medici were crushed.

In Bologna, where Michelangelo settled in late October of 1494, he soon came under the protective wing of one Giantrancesco Aldovrandi, a politically powerful and learned Bolognese in whose house he resided. The interesting psychological elements in the young artist's relationship with Aldovrandi are discussed in con-nection with the *Dying Slave* in chapter 12. At this point I shall simply note that with Aldovrandi's help Michelangelo secured commissions for three small works on the tomb of Saint Dominic at the Church of San Domenico Maggiore—an *Angel Bearing Candelabrum* (fig. 6-1), Michelangelo's only sculptured or painted angel with wings; *St. Proculus* (fig. 6-2), which, in its intense and determined facial expression presages the *David*; and *St. Petronius Holding a Model of Bologna*, which, despite its heavy drapery, conveys the power of the body beneath through its sense of movement and rotation of body parts. By winter of 1495–96, Michel-angelo had returned to Florence, where he remained until June of 1497.

While in Florence he carved a now-lost *St. John the Baptist* and a *Sleeping Cupid*. As Condivi tells it, Michelangelo was advised to bury his *Cupid* in the earth for a while to give it an aged finish, which would enable him to sell it for a good price as a recovered antique. The *Cupid*, says Condivi, was successfully passed off as an authentic antique and sold in Rome to Cardinal Raffaello Riario, a wealthy humanist and art connoisseur. When the cardinal learned of the fraud, he sent a representative to Florence to seek out the sculptor. The emissary was eventually directed to Michelangelo and, after viewing his drawings, persuaded him to come to Rome with the promise of an introduction to the cardinal.

Michelangelo arrived in Rome on June 25, 1496, and remained until May 1501. This "first Roman period" was interrupted only by a stay of an uncertain number of months at the marble quarries in the mountains of Carrara, beginning in March 1498,[7] in order to supervise the quarrying of the marble block that was to be used for the carving of the St. Peter's *Pietà*.

During the five years of this first Roman period Michelangelo executed two major works. The exceptional promise inherent in his teenage accomplishments in Florence and Bologna matured into the daring that characterizes his first major work, the *Bacchus* (fig. 6-3), and a technical virtuosity that he never again equalled, in the deeply moving *Pietà* of St. Peter's.

The *Bacchus* suggests that Michelangelo was strongly affected by his encounter with the antiquities that were to be seen in Rome. Cardinal Riario himself had a large collection of antiques at his palace, and elsewhere in Rome, ancient monuments and sarcophagi were in abundance, as well as several museum collections.

Michelangelo spent his first year in Rome at the court of Cardinal Riario. The cardinal conducted a school for artists at his palace, which probably resembled a small-scale version of the celebrated school at the Medici Gardens. Although the cardinal himself never commissioned a work by Michelangelo,[8] a week after the artist arrived he expedited the purchase of a large block of marble for the *Bacchus*, which was then commissioned to Michelangelo by Riario's close friend Jacopo Galli.

In the following chapter, in the course of discussing the *Holy Family*, I will explore Michelangelo's fascination—indeed identification—with Bacchus (the Roman name of the Greek god Dionysus). Bacchus was god of the fertility of nature and the liberating wisdom that derives from abandon to the irrational forces of the instincts. The impact on Michelangelo of his new exposure to antique statuary is apparent in the pose of the god. Michelangelo also captured the androgynous and seductive character of Bacchus, while at the same time emphasizing a naturalistic quality that is not antique in the soft modeling and clearly inebriated stance. The impish little satyr, munching on a bunch of grapes, extends the viewing arc to 180 degrees. With his slow-moving body torsion, the satyr joins with the S-curve of the profile silhouette of Bacchus to create a sensuous and melodious form. One senses Michelangelo's pleasure in abandoning himself to this creation. The tension between the pagan sensibility flowing through the *Bacchus*, which Michelangelo adamantly denied himself in the actual conduct of his life, and his sacred and ordered self, was to be established immediately thereafter in his first version of the Pietà.

7. See Tolnay (1943–60, 1: 146–47) for a persuasive dating of Michelangelo's stay at Carrara (which had been placed earlier by other authors).

8. According to Condivi, "the fact that the cardinal of S. Giorgio had little understanding or enjoyment of sculpture is made abundantly clear to us because in the whole time that Michelangelo stayed with him, which was about a year, he never worked on any commission whatever from the cardinal" (pp. 21–22).

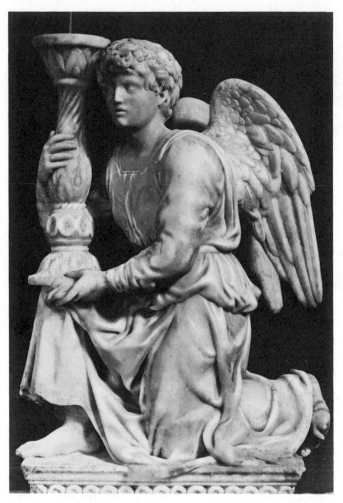

6-1. Michelangelo, *Angel Bearing Candelabrum.*

From a letter to his father written in July 1497, we infer that Michelangelo planned to return to Florence later that year, upon completion of the *Bacchus.* However, he received a commission the following month from Cardinal Jean Villiers de Ferenzac, the French ambassador to the Holy See, to carve a Pietà for his tomb. It was to be placed in the Chapel of the Kings of France in the old St. Peter's.[9] (I shall return to the St. Peter's *Pietà* in chapter 20 as part of an overall discussion of Michelangelo's three Pietàs.)

Condivi wrote that the Virgin in the St. Peter's *Pietà* (fig. 6-4), is "of such great and rare beauty that no one sees it who is not moved to pity" (p. 24). Indeed,

9. The group is sometimes called the *Madonna della Febbre,* a name that became attached to it when the work was transferred to the Cappella della Vergine Maria della Febbre because its original chapel had to be destroyed during the construction of the new basilica under Bramante's direction.

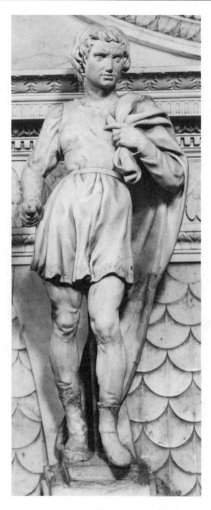

6-2. Michelangelo, *St. Proculus.*

never again was Michelangelo to carve or paint a woman that possessed the loveliness and delicacy of this image. Her eyes are averted from looking upon her son. Her facial expression is one of mute acceptance which rises above earthly pain. This is in counterpoint to the suppressed gesture of futility in her left hand, which must be considered one of the most simply poignant details in all of art.

Condivi went on to note that there were some critics (probably during the years of the Counter-Reformation) who complained that the Virgin appears too young in comparison with Jesus, a departure from the matronly Virgins of previous Pietàs. When young Condivi asked the Master about the youth of this figure, he replied:

Don't you know that women who are chaste remain much fresher than those who are not? How much more so a virgin who was never touched by even the slightest lascivious desire which might alter her body? Indeed, I will go further and say that this

6-3. Michelangelo, *Bacchus.*

freshness and flowering of youth, apart from being preserved in her in this natural way, may also conceivably have been given divine assistance in order to prove to the world the virginity and perpetual purity of the mother. This was not necessary with the Son, in fact rather the contrary, because in order to show that the Son of God truly assumed human form, as He did, and submitted to all that an ordinary man undergoes, except sin, there was no need for the divine to hold back the human, but it was necessary to let it follow its own course and order so that He would show exactly the age He was. Therefore you should not be surprised if, with this in mind, I made the Holy Virgin, mother of God, considerably younger in comparison with her Son than her age would ordinarily require, though I left the Son at His own age." [pp. 24–25]

Condivi's record of Michelangelo's explanation did not, however, end the matter. Scholars have questioned the surface meaning of such seemingly serious pro-

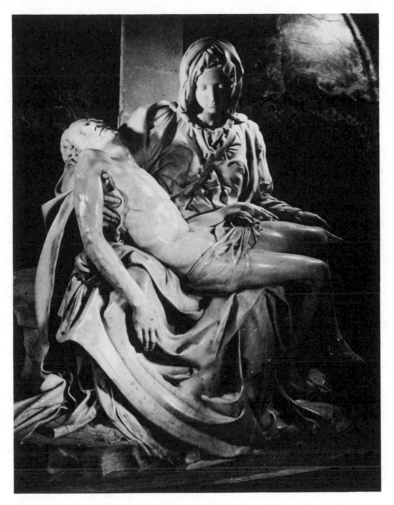

6-4. Michelangelo, St. Peter's *Pietà*.

nouncements by the artist. Even Vasari, in the first (1550) edition of the *Life of Michelangelo*, noted that Michelangelo's "manner of speech was very veiled and ambiguous, his utterances having in a sense two meanings." With respect to the specific explanation that Condivi accepted at face value as accounting for the youth of the Virgin, Wind (1968) tersely concluded that Michelangelo had "replied with a grim joke at the expense of old spinsters, which Condivi understood to be a new contribution to morals and theology" (p. 185).

The representation of the Virgin as so young does have some basis in religious writings.[10] The question remains, however: was this particular innovation dictated

10. In the writings of fourteenth- and fifteenth-century mystics such as Henry Suso and Saint Bernard of Siena, one finds the concept of Jesus returning as a child to his mother in death (see Tolnay, 1943–60, 1: 148).

by a more personal, intrapsychic motive or memory of Michelangelo's? Oremland (1978) has offered a highly interesting theory based on the special circumstances of Michelangelo's early childhood. His two mothering figures—the wet-nurse and his natural mother—were both lost to him while *they* were quite young. Thus, the image of the Virgin in this *Pietà* could be said to depict Michelangelo's unconscious hope that at the end of a tortured life (represented by Jesus) one can return to the idealized mother of early childhood as one remembers her, unchanged by the passage of time. Oremland's explanation of Michelangelo's treatment of the Virgin in this work is consistent with the relation that I suggested in chapter 2 between the images of the Virgin in the *Madonna of the Stairs* (fig. 2-1) and the ancient Greek grave-relief commemorating the early death of a mother from some distant past (fig. 2-4).

Some writers (for example, Hibbard, 1974) have argued that another work, the unfinished painted panel of the *Entombment* (fig. 6-5), also derives from the first Roman period. The work appears to have been done by two different painters, as the brushstrokes in the two figures on the left are all smooth, whereas the rest of the panel is painted with broad, visible strokes. The dating of about 1500 is based on a record of a commission by the Brothers of Sant'Agostino in Rome to Michelangelo for a painted panel. Both Cardinal Riario and Jacopo Galli were intimately involved in the affairs of this order and were, no doubt, influential in obtaining the commission. The *Entombment*, as Hibbard persuasively contends, is the only painting of unknown origin that could possibly be by Michelangelo's hand and could be linked with this commission.[11] Thus, it is assumed that the two figures on the left were done by Michelangelo, and the rest by an assistant at an undetermined later time.

We know very little about how Michelangelo lived during the five years of his first Roman period, beyond the fact that he must have devoted much time to carving the *Bacchus* and the *Pietà,* and that he probably maintained contact with

11. The *Entombment* is the subject of widely varying opinions among Michelangelo scholars. The attribution to Michelangelo is rejected by Wölfflin, A. E. Popp, and Tolnay. Tolnay (1943–60, 1: 237) favors the attribution of the work to Antonio Mini, Michelangelo's assistant, and dates it between 1523 and 1531.

Gould (1974) proposes that the panel was painted by Michelangelo in two periods. The first part, the two figures on the left, is dated at the beginning of the second Roman period, early in 1506, while Michelangelo was waiting for marble from Carrara before embarking on the tomb of Pope Julius II. Gould's thesis is largely based on the assumed resemblance of the figure immediately to Christ's right to the older son in the *Laocoön* group (fig. 12-6), excavated in Rome in 1506. Moreover, Gould feels that the scheme for the intertwining sling derives from the serpent in the *Laocoön.* He argues that, after ceasing to work on the painting because of the tomb project and the Sistine Chapel ceiling, Michelangelo resumed his efforts in 1515–16, or even later, with the intention of having it be the altarpiece for the chapel of his friend Pierfrancesco Borgherini. Gould concludes that the painting was ultimately abandoned because of Michelangelo's dissatisfaction with any solution for reconciling the designs and styles of the two periods.

Levey (1970) favors dating the work at the beginning of the second Roman period and believes that it was intended for a *tempietto,* which was to be included in the Tomb of Julius according to the first (1505) plan.

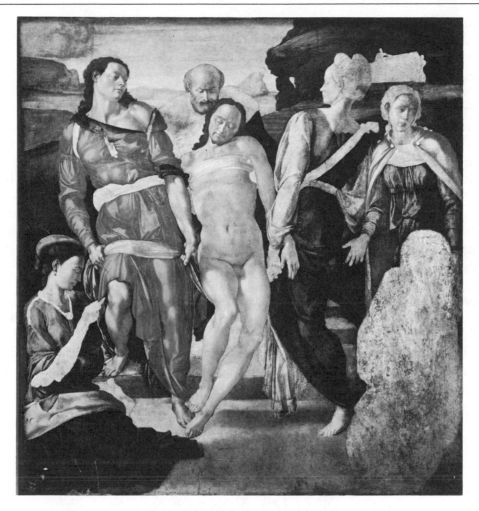

6-5. Michelangelo and assistant, *Entombment.*

the Riario-Gallo circle even after the year during which he lived at the cardinal's palace. We can infer that his style of life was difficult, austere, and private from the letter written in 1497 by Michelangelo to his father and one written by his father to him in 1500, both of which were quoted in chapter 4.

It would indeed seem likely that, as the *Bacchus* and the *Pietà* progressed they elicited great adulation of this young Florentine who had just burst onto the Roman scene. Yet Michelangelo appears not to have been lured by the temptations of the "good life" of the courts. Rather, he chose to lead an isolated existence in which inner thought and a consuming devotion to his sculptural work were predominant. Sustained by the ties to his family back in Florence, he probably felt like an outsider, a transient visitor awaiting the end of his wanderings and his return home.

The reasons why Michelangelo returned to Florence in May 1501 are not

clearly established. Condivi says in passing that "he had to return to Florence for family affairs" (p. 23). More likely he returned to begin work on his next project, fifteen statuettes for the Piccolomini altar in the Cathedral of Siena (fig. 6-6). In a letter of May 22, 1501, Michelangelo discusses aspects of the first (lost) draft of the altar contract. It is probable, as Hibbard (1974) suggests, that Michelangelo stopped in Siena on his way to Florence to meet with Cardinal Piccolomini, examine the altar, which had been constructed in 1485, and develop a preliminary plan. However, by 1504 he had carved only four of the statuettes, and the remaining eleven were turned over to other sculptors.

In 1503 Cardinal Piccolomini was elected pope and assumed the name Pius III. Death ended his pontificate only twenty-six days later. From what we know of Michelangelo's productivity in relation to his patrons' active encouragement and palpable support, I would postulate that with the death of Piccolomini a major incentive to continue these works was abruptly lost. Piccolomini's ascent to the throne of St. Peter's must have activated Michelangelo's fantasies regarding both the possibilities for work in the papal court and the protection that would be afforded him if he could continue producing for and pleasing the pope. But death was to intervene once again in Michelangelo's life, and his disappointment and diffuse anger were transformed into loss of interest.

Thus, in May 1501, at twenty-six, Michelangelo was back in Florence, established not merely as a mature artist but already as the preeminent sculptor in the whole of Italy.

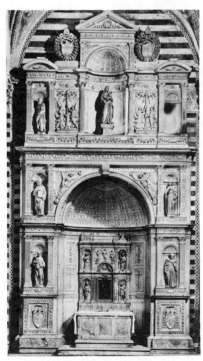

6-6. Piccolomini altar. Siena.

Chapter Seven

The Holy Family (Doni Tondo) and Related Early Works, 1501–1509

The Florence to which Michelangelo returned in 1501 was quite different from the city he had left five years earlier. The turbulence that surrounded the fall of the Medici had subsided and the grip in which Savonarola had held the citizens was no more. The conquering French king, Charles VIII, ironically, had died a few weeks before the execution of Savonarola in 1498, leaving Florence without the protection of the French that had prevailed during his reign. To survive, the Florentines had to revitalize their government and find their own resources once again. The revival proceeded well and the Republic was in the process of making major constitutional reforms by the turn of the century.[1] As a result, Michelangelo found a new optimism and stability on his return to the city at age twenty-six. He was to spend the next four years in Florence before being summoned back to Rome in 1505 by Pope Julius II.

In this chapter I shall examine the ways in which certain unconscious and unresolved conflicts surrounding Michelangelo's early maternal care were fundamental determinants of a number of images he created during a relatively brief period, the years 1501 and 1509. By limiting the time span, we can minimize the need to sort out the influence on his art of such factors as sociopolitical change, major leaps in artistic style, and Michelangelo's changing outlook in different stages of his life. It should be emphasized that the same unconscious conflicts continued to exert their shaping force throughout his creative life.

The psychoanalytic approach enables us to speculate on the developmental process underlying Michelangelo's splitting of the mental representation of his early maternal imago into contradictory images: an all-caring, idealized figure (the Madonna) and an abandoning, murderous figure (the Medea).[2] The illustrative

1. Some of the important changes were patterned after the Republic of Venice. For example, the gonfalonier of justice in Florence was to be given an appointment for life in the manner of the doge of Venice, although his duties remained essentially the same as before. By virtue of his lifetime tenure as head of state, he was destined to wield considerably greater power than he had earlier.

2. The concept of splitting has been used to convey varied meanings by different psychoanalytic writers (see J. Lustman, 1977, for a critical review of the topic). Here, splitting refers to the psychologically defensive process whereby separate and contradictory mental representations of both oneself and the same object alternate in one's consciousness. The organizing principle of each of these aggregate internal representations is its composition of elements of similar emotional qualities (Kernberg, 1966). For example, the psychic representation of "oneself" can be codified into ag-

works from the period of 1501–09 attest to the presence of these two conflicting mental representations of the mothering figure and to the attempt to reconcile and integrate them. The conflict in object representations coexists with a parallel split in Michelangelo's representation of himself in relation to "mother." This pair of contradictory self-representations may be called the idealized son and victim (Jesus) and the matricidal son (Orestes). The tension between these two polar representations, particularly the thrust toward subordinating the negative, more violent ones to representations closer to the ideal Michelangelo held for himself, left a distinctive imprint on Michelangelo's ultimate artistic solutions in many of his major works.

Finally, the psychoanalytic approach amplifies a basic element in the methodology of psychoanalytic iconography that was applied in the discussion of the *Madonna of the Stairs* (chap. 2). If the interpretation proposed earlier for this work has validity, we would insist on consistent and supporting evidence from later artistic treatments of the same or similar motifs. Hence, to test my initial hypothesis with respect to the *Madonna of the Stairs*, I turn to a number of such works—in painting, sculpture, and drawing—from the period 1501–09.

The Holy Family (Doni Tondo)

The Virgin in the *Holy Family* (Doni tondo) (fig. 7-1), from 1503–04, is Michelangelo's only painted Madonna and is totally different in conception from his five sculptured Madonnas. The painting was commissioned by Agnolo Doni, the scion of a prominent Florentine family—probably for his wedding.

This work, as we shall see, has certain seemingly deliberate enigmatic qualities and has therefore always defied an agreed-upon interpretation. In its round form,[3] and in its composition, which separates the Holy Family in the foreground from the nude youths in the background, the painting derives from Luca Signorelli's tondo of the *Virgin and Child* (fig. 7-2), painted for the Medici in Florence ten years before the Doni tondo. In the Signorelli tondo the background is a pastoral scene with four athletic shepherds in repose. Although Signorelli's shepherds exude a distinctly pagan and sensual beauty, they are there to signify the New Testament theme of the "select" to whom the birth of the Savior was announced

gregates that might be called "good me" and "bad me"; the psychic representation of "mother" can be split into the "good mother" and the "bad mother," each with the appropriate associated affects. Moreover, at any given time, similarly composed conceptions of self and object representations will accompany each other (i.e., when one feels good about himself he will feel good about his mother and vice versa). This conceptualization of splitting is akin to Melanie Klein's thesis of the split and alternation between the "depressive position" and the "paranoid position" (H. Segal, 1964). Stokes (1955) has drawn heavily on Klein's theory in his perceptive study of Michelangelo. In using the term *splitting*, we should be aware, as Roy Schafer has pointed out (personal communication), that the concept is poorly named. That is, we are often describing two separate psychic entities that in the course of development have never come together, rather than entities that were once integrated and then split apart.

3. In Italian, painting or sculptured relief that is round in form is known as a "tondo." The tondo was a traditional form for paintings commissioned for home decoration.

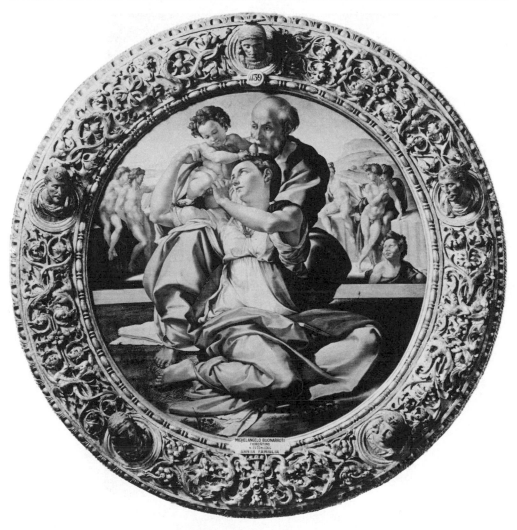

7-1. Michelangelo, *The Holy Family* (Doni tondo).

and who faithfully watch over their flocks, just as Jesus will come to care lovingly for his flock. In marked contrast, Michelangelo's background nudes have no such clear meaning or even connection with the primary theme of the Holy Family in the foreground or the child Saint John in the middle ground. As mentioned in chapter 4, D'Ancona (1968) concluded that the youths in the background are "homosexuals" who, as sinners, wait at the baptismal font for purification of their bodies and garments. Whether so explicit an interpretation is correct must remain an open question. However, the decidedly androgynous and homoerotic quality of the group is unmistakable. In Signorelli's tondo the background is thematically congenial and continuous with the foreground; in Michelangelo's painting, it stands in direct moral antithesis. Signorelli's shepherds have no need for moral

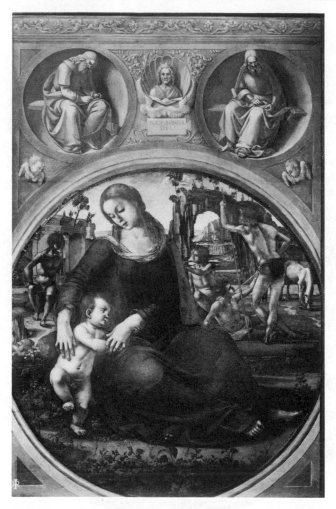

7-2. Luca Signorelli, *Virgin and Child.*

redemption, whereas Michelangelo's nudes, according to D'Ancona, are sinners awaiting purification. Thus, in a characteristic way, Michelangelo draws directly from an earlier model and then repudiates the inspiration by radically transforming the meaning of the original form.

The Doni tondo can be regarded as "painted sculpture" in the sense that the Holy Family trio of figures appears to be chiseled out of a marble block rather than created by the two-dimensional manipulation of color, light and shadow, and atmosphere. In this respect, as well as in its rugged intensity, the work is in direct confrontation with Leonardo da Vinci's serene and sublime ideal of beauty. Leonardo, aged fifty-one when Michelangelo began the Doni tondo, by this time had profoundly influenced the course of painting in Florence. In contrast to Leonardo's ideal (fig. 7-3), Michelangelo's Madonna is an earthy, masculinized wom-

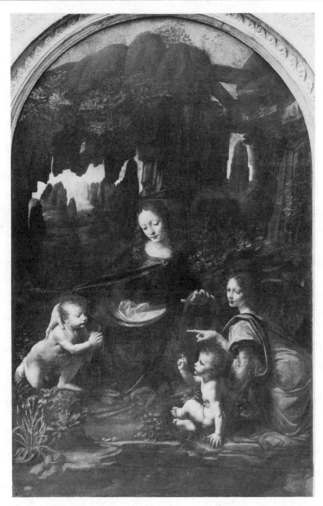

7-3. Leonardo da Vinci, *Virgin of the Rocks*.

an. For the first time in Renaissance art, her arms are bare, revealing their muscularity.[4]

The Christ child mounts her shoulder like a triumphant Olympian, wearing the traditional fillet of victory around his luxuriant curly hair. Joseph stands behind,

4. The great German art historian Heinrich Wölfflin refers to the Doni tondo as a "competition piece" (1899, p. 44) in recognition of Michelangelo's struggle with Leonardo. Another pathway in the evolution of the Doni panel can be traced by a series of drawings Michelangelo made in response to a particular cartoon by Leonardo (Hartt, 1970, drawings 9–14). Leonardo, after an eighteen-year absence from Florence, returned in 1500 and in the following year exhibited the now-lost version of the *Madonna with St. John and St. Anne* (fig. 7-4) for two days. According to Vasari, Leonardo's cartoon met with wild acclaim from huge crowds. We can easily imagine how the twenty-six-year-old Michelangelo, who as yet had no major works in Florence and had just returned from almost five years in Rome, would have bristled at the triumphant reception accorded Leonardo's *Madonna*.

handing over the child but still supporting him. This powerful figure of Joseph, rather than suggesting a simple carpenter, conveys an ancient wisdom. In all probability, he was inspired by portraits of Euripides from antiquity (Tolnay, 1943–60, vol. 1).

The child Saint John is alone in the middle plane, half-hidden behind the wall of the dry baptismal font. He appears to be about to embark on his life of lonely penitence in the desert. His head is posed to echo that of the Virgin, and his unearthly expression seems a mixture of awe and sadness. He also bears the crossed reed that foreshadows the Passion of Christ.

In the distal plane are the two groups of nude youths. As already mentioned, the homoerotic interplay among the three figures to the right is rather clear, while the two on the left idly observe them, leaning against each other with easy familiarity. The hairstyle of the standing figure on the left gives him a decidedly androgynous cast.

Thus far I have confined the issue of why Michelangelo's image of the Doni tondo took the form it did to the outcome of the conflict between two opposing impulses. On the one hand, he sought to incorporate something from the work of two contemporary but older Florentine masters—Signorelli's tondo, which hung in the Medici Palace, and Leonardo's cartoon, which was widely celebrated in Florence. On the other hand, he was inwardly compelled to repudiate their influence and to establish his own superiority. Given this conflict, can we say that the Doni Madonna is an unprecedented creation of Michelangelo, or that he sought the model for the form of the Virgin and Jesus from a more improbable source?

In this work, as in the *Madonna of the Stairs*, the model for the Madonna comes from a source with a pre-Christian theme, and one which therefore originally had an entirely different narrative meaning. Smith (1975) has persuasively argued that the source for the Doni Madonna was a mid-fifteenth-century marble tondo, in relief, of a *Satyr with the Infant Dionysus* (fig. 7-5) executed by a follower of Donatello, which stood then, as it does today, at the second-story level in the courtyard of the Medici Palace.[5]

Several parallels exist between the *Satyr* relief and the Doni Madonna: (1) both infants are placed on the shoulder; (2) the Satyr's left arm and the right arm of the Virgin are virtually the same, though in mirror-image position; (3) both infants balance themselves by placing a hand or hands on the head of the supporting adult; (4) the Virgin's limbs have a flattened, two-dimensional character, as if they were carved in relief like the Satyr; and (5) the horizontal band of stone that separates the Holy Family from the other figures is close to identical to the base on which the Satyr and Dionysus rest.

Michelangelo had the opportunity to view the *Dionysus* relief daily during the

5. The image of the Dionysus marble relief was, in turn, taken from a nearly identical image of the same theme in an antique sardonyx cameo that was recorded in the 1465 and 1492 inventories of the Medici collection. This cameo is now at the Museo Nazionale in Naples (Smith, 1975).

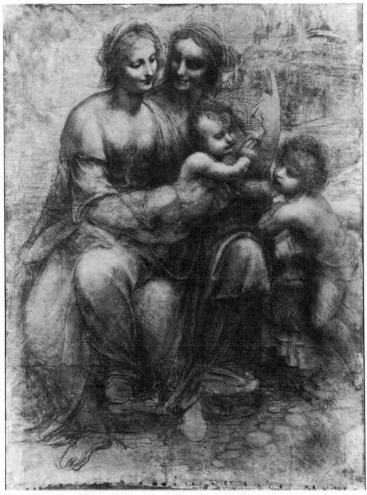

7-4. Leonardo da Vinci, cartoon for a *Madonna with St. John and St. Anne.*

two years he lived in the household of Lorenzo the Magnificent at the Medici Palace (1490–92). Moreover, it can be assumed that he knew the myth of Dionysus (see p. 65) by the time he painted the Doni tondo. It was during his first stay in Rome, while closely connected to the humanist circle of Cardinal Riario, that he executed the statue of *Bacchus* (1496–98, fig. 6-3). Additional proof that the image of this particular satyr deeply impressed Michelangelo can be found in one of the *Ignudi* on the Sistine Chapel ceiling (fig. 7-6), which is another direct quotation of the *Dionysus* relief. It may be further assumed that, as the *Dionysus* relief was done by an unknown follower of Donatello, Michelangelo's attraction to the work cannot be ascribed to a special interest in the works of that particular master.

Thus, when Michelangelo drew directly upon an antique source, was it simply because the unique form of the earlier model was suitable to his purpose, or was it

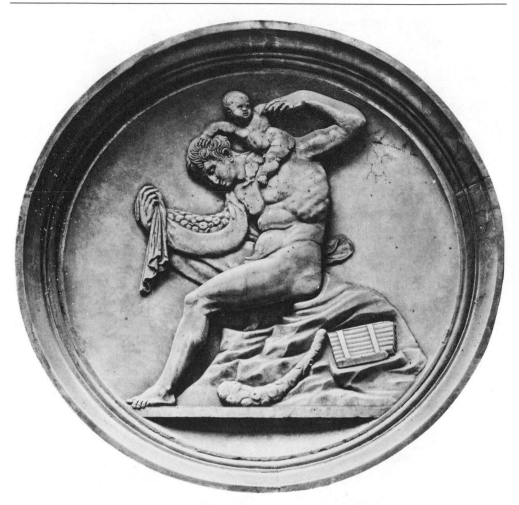

7-5. School of Donatello, *Satyr with the Infant Dionysus.*

the content or narrative meaning of the image that determined his choice of that
particular model from the large number available? If we adopt the latter assump-
tion, we have a possible key to the latent meaning of the final, manifest image of
the artist.

It next becomes important to try to determine: (1) whether the myth of Diony-
sus, as well as the specific element of an athletic young man holding Dionysus as
an infant, has significant features that resonated with Michelangelo's unconscious
conflicts and fantasies; (2) whether this connection can be advanced beyond the
more general, generic "Apollonian-Dionysian" inner struggle that it has become
conventional to ascribe to all great creative minds; and (3) why Michelangelo
utilized this source of inspiration at this particular time in his life, the year 1503
or 1504.

In the myth of Dionysus, several aspects of the god's birth and childhood stand
out as being of possible relevance to the question of why Michelangelo was drawn

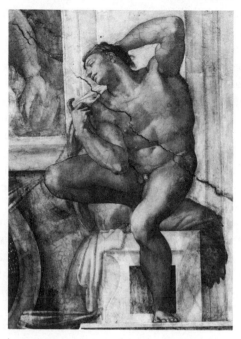

7-6. Michelangelo, Sistine Chapel ceiling: *Ignudo* over the *Libyan Sibyl.*

to the Dionysus tondo.[6] First is the story of his birth. Zeus, disguised as a mortal, impregnated the mortal woman Semele. Thereupon Zeus's wife, the goddess Hera, jealously plotted the destruction of her rival by tricking Semele into persuading Zeus to reveal his divinity, knowing the fatal consequence that would follow. He reluctantly did so by hurling a thunderbolt. This feat was more than Semele's human frailty could endure, and she burst into flames. Zeus, however, rescued the fetus from the dead Semele's womb and implanted it in his own thigh, where gestation ran full cycle and from which Dionysus was born.

The newborn Dionysus was immediately separated from his "mother-father," Zeus, and delivered to his first nurse, Ino, sister of the dead Semele. To protect the infant from Hera's relentless vengefulness, Ino disguised him as a girl and kept him in the women's quarters. Hera learned of Ino's deed, however, and punished her by driving her and her husband mad. There are several versions of what then ensued. In all of them, however, the tragic climax is Ino's inadvertent murder of

6. The material on the Dionysus myth in this section is condensed from Apollodorus (50 B.C.–A.D. 100?), Deutsch (1969), Euripides (ca. 415 B.C.), Graves (1955), Guthrie (1950), Otto (1965), Ovid (A.D. 8), Pomeroy (1975), and Rose (1959). Deutsch's monograph is particularly rich in psychoanalytic insight. We cannot determine precisely which versions of the episodes of the myth were familiar to Michelangelo. The Greek tragic dramatists were not translated into Latin until the middle of the sixteenth century. However, Greek scholars among the Humanists knew their works and may have spoken of them to the artist. Ovid was translated, widely read, and served as the general source during the Renaissance for pagan myths.

her own son and her suicidal plunge into the sea—and hence disappearance from the very early life of Dionysus.

The care of the child Dionysus was then entrusted to five divine nymphs, who faithfully carried out their charge. However, the child's education was delegated to an older and particularly debauched satyr, Silenus, who was nevertheless a repository of liberating wisdom.[7]

Consistent with his early role reversal and the chaotic atmosphere of his rearing, Dionysus entered manhood with a noticeably effeminate bearing. Thus, in Euripides' *Bacchae,* when the young god makes his entry as a captive before the adolescent King Pentheus of Thebes, Dionysus asks, "What punishment do you propose?" The king replies, "First of all, I shall cut off your girlish curls" (line 492).

Hera, who personifies the primordial, destructive "witch mother," is unrelenting in her quest for vengeance. Upon discovering Dionysus, she places him under a curse of madness, causing him to embark on his global wanderings in the company of his mentor, Silenus, and a faithful following of satyrs and maenads. In the course of his travels he engages in repeated conflicts that end in his bodily mutilation and death, magically followed, however, by his regeneration. Thus, Dionysus became the symbol of infinite rebirth, foreshadowing the Christian myth of the Passion and Resurrection of the also divinely conceived Jesus Christ. (Incidentally, it was this aspect of the life of Jesus that intensely preoccupied Michelangelo in the last twenty years of his life.) The essence of Dionysus's mission was to make those who came in contact with him aware of the demonic life-forces that are the sources of fertility and creativity in all men.

In the best-known episode of the myth, which comprises Euripides' tragedy, Dionysus returns to Thebes—his mother's homeland and burial ground—intent on the destruction of the Thebans, who had repudiated Semele for her liaison with Zeus. In this instance, Dionysus's own rage toward his abandoning mother is projected onto the Thebans. Here, as throughout the myth, Dionysus's unacceptable impulses are projected onto others, whom he then destroys with a sense of moral justification. In his coming to Thebes, we intuit Dionysus's quest to rediscover his maternal origins and we also surmise the substitutive maternal function that is served by his increasingly large following of totally devoted women. The Dionysian rituals[8] promised women release from the inhibitions and limita-

7. The figure of Silenus in the *Dionysus* relief does not have the usual characteristics of a satyr—goat's legs or other bestial elements, or a perpetually erect penis. Nor does it have the usual characteristics specific to Silenus, who was traditionally represented as a plump and jovial old man under the influence of the grape. Rather, the figure in this tondo is a muscular, fully human young man.

8. Guthrie (1950) has summarized the Dionysian rituals: "They have almost one universal feature, namely that the god's vengeance takes the form of visiting with madness the women of the land where he has been spurned. This usually leads to their tearing a victim to pieces, either the king himself, who has been the opponent, or, when the women themselves have been the offenders, one of their own children. The two motives are combined in the Pentheus story" (pp. 165–66).

tions that attended their usual roles, including orgiastic excitement; but in reality they transformed them into destructive agents or objects of Dionysus's destructiveness.

The climax of the myth may also have held fascination for Michelangelo. Having established his worship throughout the ancient world, Dionysus is welcomed by Zeus to Olympus, to sit at his right hand. At this point, Dionysus embarks on his ultimate mission—to find and rescue his dead mother from the underworld, Tartarus, to which she has been condemned. He succeeds in this mission and returns with her to Zeus's palace. Thus, as in the case of Jesus and Mary, the reunion in eternity of the triumphant son and his lost mother marks the resolution of the central motif of the myth.

Great myths endure through history because of their resonances with the psychological experiences of most people of any epoch. Aside from this, in the myth of Dionysus there are a number of basic themes that may have specifically and deeply engaged Michelangelo. With the birth of Dionysus, an essential bisexuality is revealed in Zeus. The most powerful of the gods unifies male and female roles in the act of propagation. He is the agent of destruction of woman as sole giver of birth, assuming for himself the functions of gestation and parturition. Dionysus's birth from the body of Zeus represents propagation without the mutual participation of male and female—thus, the relatively independent capacity for self-perpetuation. To Michelangelo, a similar melding of the male and female pro-creative roles lay at the core of the artistic act. Indeed, he told Vasari that "my children will be the works I leave behind." He, too, could propagate without a partner, and in fact considered his creations as buffers against his lifelong dread of death.[9] With respect to sexuality, we have noted that Michelangelo's life was probably one of celibacy. As a sculptor, his primary definition of himself as artist, Michelangelo was able to balance his maternal creative component with the masculine tools and action of the hammer, chisel, and hand drill. As we shall see, these gender roles with respect to creativity were equally expressed in his painting. Rarely has there been a clearer monument to the bisexual nature and procreative aspirations of man than is found in the imagery and conception of Genesis on the Sistine Chapel ceiling.

A parallel also may be said to exist between Dionysus and Michelangelo in their ways of externalizing the feminine components of their self-representations. The principal means that Dionysus employed to ward off his femininity was to project it onto another. Thus, the *Bacchae* in the course of its action involves an exchange of masculine and feminine identities between Dionysus and young King Pentheus. Dionysus, by exciting Pentheus's curiosity about the secret rites in which his mother, Queen Agave, is immersed, is able to persuade him to assume the garments of a woman. At first Pentheus protests, "I would die of shame," but he is eventually persuaded to renounce his masculinity temporarily as the price for

9. Michelangelo's fear of death is discussed in depth in chapters 12 and 19.

viewing his mother's orgiastic activities. Once the transvestite transformation has occurred, the text continues:

PENTHEUS (*coyly primping*)
 Do I look like anyone,
 Like Ino or my mother Agave?
DIONYSUS
 So much alike
 I almost might be seeing one of them. But
 look: one of your curls has come loose. . . .
PENTHEUS
 Arrange it. I am in your hands
 completely.

Thus Dionysus for the moment purges his own femininity by forcing Pentheus to exchange his sexuality. Having succeeded, he brutally leads the king to his destruction at the hands of his own mother.

Michelangelo also externalized the androgynous aspects of himself by creating a separate object from his imagination. In this early period of Michelangelo's artistic life, the feminine component of his self-representation safely found expression in such androgynous creations as the *Bacchus* (fig. 6-3), the *Dying Slave* (fig. 12-1), Adam in the Sistine *Creation of Adam* (fig. 11-8), and the *Ignudi* of the Sistine Chapel ceiling (fig. 7-6).

Moreover, the abandonment of Dionysus by early maternal figures bears a remarkable resemblance to Michelangelo's childhood. Both the mythical god and the artist lost their mothers prematurely in death. Dionysus's first maternal surrogate, Ino, abandoned him through no fault of her own. Similarly, Michelangelo felt "abandoned" by his wet-nurse when he was removed from her care. Dionysus's underlying conviction that women are potentially murderous, based on his history of abandonment, was not confined to the goddess Hera. He mastered the anxiety associated with his passive position in relation to Hera's murderous intentions by actively staging filicide by other mothers in situations where he was in full control.[10] As I shall show in the analysis of Michelangelo's Taddei *Madonna* later in this chapter, his fear of danger from a murderous mother, here symbolized by Medea, was the controlling unconscious force in the creation of that particular work.

In a sense, Michelangelo was faced with the same choice as Dionysus. If the young god were to accept Zeus as his mother as well as his father, he would be left with the representation of himself as both woman and man by virtue of his identification with his bisexual father. The alternative was ultimately to resurrect his mother and bring her into his father's household, thereby establishing under one roof the two personae as separate and differentiated. In the myth this resolution is achieved. Similarly, as we shall see, Michelangelo's consuming artistic

10. The theme of filicide is dramatized in the *Bacchae* when Dionysus lures the decent Queen Agave into a state of madness, during which she unknowingly murders her son, the youthful Pentheus.

preoccupation in the last two decades of his life was the theme of the reunion of son and mother, as shown in the figures of the dead Christ and Mary in his final two Pietàs, now in Florence and Milan, in the series of drawings of the Crucifixion of Christ with Mary at his feet, and in his last drawings of the Madonna.

In the *Bacchae*, which is an extraordinary explication of the unconscious dynamics of sexual identification, the effeminate Dionysus of the beginning of the play relinquishes this identity only by directing his sadistic and murderous impulses against both a younger male rival who, at the outset, has all the characteristics of stability and order associated with the nuclear family, and against his mother. Although there are no descriptions of Michelangelo that suggest an appearance of effeminacy, we do know that he avoided relationships with women until his spiritual friendship with Vittoria Colonna, whom he met when he was sixty-one years old. From this we can infer that his feelings toward women were distrustful, fearful, and potentially vengeful, and that he defended against these feelings by adopting the social pattern of avoidance.

From the available data about the institution of wet-nursing in general, coupled with Michelangelo's expressed distrust and sense of deprivation, we can surmise that his actual experience of early mothering had been distorted in fantasy and transposed into an idealized form. His explanation that the milk from the stone-mason's wife had endowed him with talent as a sculptor is one element of this idealization. It corresponds with our consistent observation that children who have lost parents early in life, in later life recall, considerably distort, and idealize the parent, and their experience with the parent, into a wishful fantasy that also serves to deny their rage over the abandonment.

Just as Dionysus was prepared for the world by the sustaining presence of Silenus and other satyr mentors, so Michelangelo lived in an all-male immediate family and then moved for the rest of his life from one male to another—first mentors, later patron-protectors.

Michelangelo's recollection of the two years he spent in the household of Lorenzo the Magnificent emerges in Condivi's *Life* as the only period in his life when he came close to feeling unambivalently loved, cared for, and appreciated for his artistic gifts. As we know, this oasis of well-being at the Medici Palace ended with the death of Lorenzo in 1492, just as Michelangelo's stay with the wet-nurse presumably ended after about two years. Both separations were followed by his return to his father's house. The Medici Palace tondo, in which the infant Dionysus is cared for by a youthful, idealized representation of his debauched, old male companion and mentor, may be linked with Michelangelo's unconscious fantasy of Lorenzo as his unitary (that is, bisexual) parent. During the stressful years 1502–03, just prior to beginning work on the Doni tondo, when Michelangelo was without a powerful male patron or mentor, the image of the *Dionysus* tondo, which was associated with the relatively contented days in Lorenzo's household, could have reasserted its power and influence.

The two years preceding the Doni commission were basically a period of re-

trenchment and anxious anticipation. In 1501, while living in his father's house, Michelangelo signed the contract for the fifteen statuettes for the Piccolomini Chapel in Siena. As we have noted, this project lost its interest for him, particularly after the Piccolomini pope died in 1503, and by 1504 he dropped the commission with only four of the figures carved. We know of other projects he began and then turned over to other sculptors (for example, the bronze David [lost]), and some that were barely begun (the twelve Apostles for the Cathedral in Florence). His consummate accomplishment during this period was the carving of *David* (fig. 8-1), which he began in the autumn of 1501 and completed during April 1504.

Florence itself during those years was enjoying a period of relative stability as a result of its alliance with the French under King Louis XII. In November 1502, Piero Soderini, a champion of Michelangelo, was elected to a lifetime term as *gonfaloniere*. There was, however, no powerful paternal figure in Michelangelo's life such as the Medici, Aldovrandi, and Cardinal Riario and Jacopo Galli had been—and as the popes were to become, beginning in 1505 with Pope Julius II.

The *David,* which would firmly establish Michelangelo's reputation in Florence, was yet to be completed. In fact, he worked on the *David* in private, hidden from public view. So in 1503 the *David* was certainly an object of uncertainty and anxiety for him. His relationship with his patron, Agnolo Doni, was uneasy.[11] Moreover, during this period, the nature of Michelangelo's patronage was significantly different from his relation to the powerful secular and papal patrons of previous and subsequent periods in that most of the major projects of 1501–05 were municipal or corporate commissions.[12]

In sum, the period when the Doni tondo was conceived was a relatively calm one for Florence but uncertain and unprotected for Michelangelo. Such a psychological climate would foster his yearning to recapture the security he had felt in his teens, when he lived at the Medici Palace in the household of Lorenzo. This looking back carried with it associations to the Dionysus marble relief and the unconscious fusion of Dionysus and Silenus, on the one hand, and Michelangelo and Lorenzo, on the other.

The discussion of the Doni tondo up to this point has focused on the images of Mary and Jesus. The next step is to explore the other figures, as well as the unique composition of the entire panel, in order to see if they might be related to

11. Vasari writes that after a squabble over the terms of payment, in which Doni tried to acquire the painting at a lower price than had been agreed upon, the incensed Michelangelo forced Doni to pay double the original price before he would deliver the panel. It is possible, however, that Vasari invented this tale as a warning to future patrons not to bargain with artists.

12. The Board of Overseers of the Florence Cathedral commissioned the marble *David.* The Guild of Wool Merchants commissioned the twelve Apostles for the Cathedral. The Signoria commissioned the bronze *David* and the painting (*The Battle of Cascina*) for the Great Council Hall. Of these impersonal group commissions it is significant that Michelangelo completed only one himself —the marble *David.*

Michelangelo's specific conflicts in self and object representations that determined the artistic solution of the Madonna. The next figure to be considered is Joseph. Can he be related to the Dionysus myth? Even before Smith connected the Doni tondo to the Dionysus tondo, Tolnay (1943–60, vol. 1) stated: "The head of Joseph seems to have been derived from antique portraits of Euripides (cf. Naples, Museo Nazionale)" (p. 164).

If such a portrait (fig. 7-7) was indeed the inspiration for Joseph, we have additional weight for the argument of a programmed fusion of the Dionysus and Jesus myths in Michelangelo's conscious identification with Euripides, the ancient dramatist most associated with the myth of the god.[13] It must be admitted, however, that there is no proof that Michelangelo was specifically familiar with Euripides in connection with the Dionysus myth.

It is generally assumed from the detail of the book resting on Mary's lap that Joseph is in the process of handing Jesus to Mary. But this is unclear from the action taking place at her shoulder. The fingers of both her hands are clenched and therefore unreceptive to and unsupportive of the infant. If Jesus did not seem to be marching forward, the Virgin might be assumed to be passing him back to Joseph. This ambiguous representation once again bespeaks Michelangelo's conflicted and ambivalent view of mothering figures.

The division of the tondo into three separate planes, each with its own narrative only remotely related to the other two, may be compared to a dream that is manifestly divided into several parts. The artist, like the dreamer, can act out several self-representations through disguising the separate characters in each group of figures. Whereas, in their manifest content, dreams remain private symbols woven into a form that is incoherent unless clarified by knowledge of, or associations made by, the dreamer, the artistic image involves the organization of the latent elements of content into a logical and coherent story presented in a recognizable form for the viewer.

What part of Michelangelo's self-image is expressed by the child Saint John, isolated and half-hidden in the middle plane (fig. 7-8)? Traditionally, John is an integral part of the compositional unit of the Holy Family (compare Leonardo's painting and cartoon, figs 7-3, 7-4). Therefore, the single most striking aspect of Michelangelo's child John is his exclusion from the family group. Moreover, he is presented with Michelangelo's characteristic ambiguity both in facial expression and in action (is he departing from the scene?). It seems plausible to say that in this unit of the panel Michelangelo has identified with the child who was the outsider, unnoticed by parental figures totally engrossed with the other baby.

13. Michelangelo's conscious identification with the figure of Joseph is also suggested by an aspect of the *Pietà* in the Florence Cathedral (fig. 20-4), carved almost fifty years later and intended for his own tomb. In this *Pietà*, the figure of Nicodemus stands in a highly comparable position to Joseph in the Doni tondo—behind the dead Christ and Mary, bringing them together for their final union. In the *Pietà*, however, Michelangelo's identification with the figure and role of Nicodemus was explicit, for, as Vasari recognized, the face was Michelangelo's self-portrait.

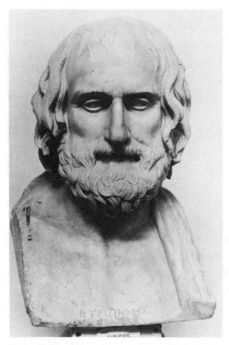

7-7. Roman copy, portrait of *Euripides*
(ca. 340–330 B.C.).

With respect to his father and brothers, Michelangelo carried the conviction in
adulthood of having been "turned . . . out of my own house" (letter 238, written
at age sixty-nine). So John may represent Michelangelo's sense of having been
the outsider—the foster child in the family of his wet-nurse and then again the
outsider when he rejoined his parents, probably about the time of the birth of his
brother Buonarroto. That the Doni tondo can be regarded as a personal document
is further borne out by the resemblance of the back of the font in the distal
plane to a stone quarry, which may have been the artist's notation for the atmo-
sphere of the stonecutter's household of his early childhood.

In this connection, a sheet of sketches from the years 1501–02 is revealing (fig.
7-9). This worksheet of studies for a Madonna includes a major figure of the
Virgin that evolved into the Taddei *Madonna* (fig. 7-15) along with variations of
the Christ child, including the principal one in the lower lefthand corner, which
has the reversed flexed-leg position of the Doni Jesus. This sheet, however, is also
highly significant because it contains the first known self-portrait of Michelangelo.
Placed between Mary and Jesus, it can be recognized by its broad, low forehead;
prominent cheekbones; broken, flattened nose; and short beard—all of which
characterized his self-portraits.[14] What bears on my theory is the interesting place-
ment of this picture of himself on the crowded sheet of sketches, between, but
behind, Mary and Jesus, gazing sideways at Mary with a forlorn, downcast expres-

14. Hartt (1970) has convincingly argued that this head was Michelangelo's self-portrait (drawing
10 in Hartt).

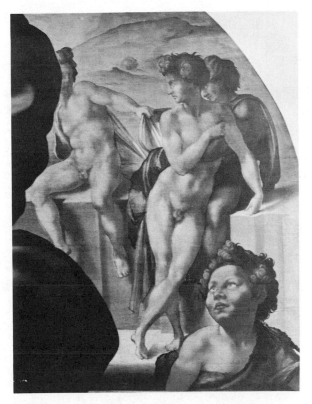

7-8. Detail of figure 7-1 (Child St. John and group of youths).

sion. This placement communicates the same poignant longing and feeling of exclusion with which Michelangelo endowed the Doni child Saint John.

For a more specific identification by Michelangelo with Saint John the Baptist, it is necessary to turn to the myth of the saint. The childhood of John receives only one sentence in the New Testament (Luke 1:80). It is mainly known to us through the apochryphal literature. According to the fourteenth-century version by Fra Domenico Cavalca (1320–42?), which was the standard authority for the subject during the Italian Renaissance, John, beginning at age five, spent more and more time by himself in the woods. At seven, he decided to leave his parents forever and embark on a life of lonely devotion in the desert. The myth of the childhood of John revolves around the universal fear of abandonment or parental loss during the helpless years of early childhood. John cannot allow himself to be cast out; he chooses to leave, thus mastering by action the anxiety associated with the passive state. In the process, his mortal parents are exchanged for an aura of divine guidance and protection. In addition, his consuming vocation—baptizing converts for the remission of sin—suggests the need for a ritual to relieve a burden of unconscious guilt, for which expulsion from home would indeed have been an appropriate punishment. Nonetheless, a life of purity, and even the ritual per-

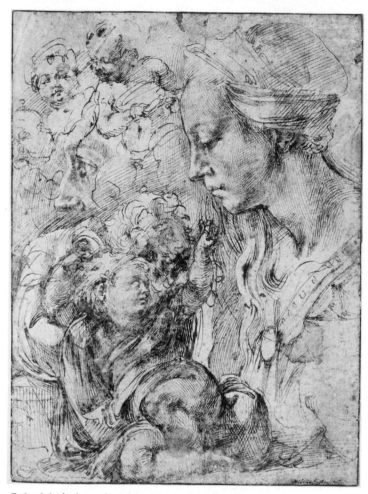

7-9. Michelangelo, sketches and life studies for a *Madonna; Self-Portrait*.

formance of the Baptism of Christ, were insufficient to ward off the destiny that originally spurred John's flight. Dionysus spent his lifetime warding off Hera's murderous efforts. John, however, was less fortunate. In the end, he met his death as a consequence of the murderous wishes of the reigning Queen Herodias, through the agency of her daughter, Salome.

Michelangelo might easily have identified with the child John in his temptation to live a lonely existence as well as in his struggle between self-sufficiency and reliance on some higher power (for instance, the popes and the Medici). Both of these patterns certainly did characterize Michelangelo.[15] None of the external glory

15. In 1495–96, several years before he began to work on the Doni tondo, Michelangelo carved a small statue of Saint John as a child. Whether the subject was dictated by the patron, a minor Medici, Lorenzo di Pierfrancesco, or was of special interest to Michelangelo is not known. In any event, the statue is lost and no copy of it exists.

that came to him nor his celebration in the papal courts could still his unrelenting loneliness. Like the child John, Michelangelo was a wanderer. Although he was sometimes compelled to move by the orders of popes or because of the prevailing political situation, he eventually chose to live the last thirty years of his life in self-exile in Rome, separated from his family and roots in Florence. Not even once during these years did he visit them.

John's mission in the wilderness illustrates the dynamic in the young child and adolescent where the choice of seclusion and penitence effectively functions as a defense against impulses of destructive rage toward the parents. This dynamic, too, may have unconsciously drawn Michelangelo to the myth of Saint John. On five occasions during his life Michelangelo precipitously took flight from where he was to another city. All five flights are best understood as related to his fear of the eruption of unmanageable aggressive impulses in him at those moments. Shortly, an examination of the Taddei *Madonna* and the Sistine Chapel *Expulsion from Paradise* will provide more compelling evidence of the strength and influence of Michelangelo's unconscious struggle with the theme of a murderous contest between mothers and children.

The general expression of John in the Doni tondo reappears several decades later in the faces of the two young Medici dukes—Giuliano (fig. 7-10) and Lorenzo (fig. 15-10)—in Michelangelo's Medici Chapel. From his tomb, each one gazes across the silent space toward the image of the *Medici Madonna* (fig. 7-11). While this device functions effectively to unify the separate sculptural units in the chapel into a cohesive whole, it also conveys the lonely and isolated quality of two young men, prematurely dead, trying to make visual contact with the Madonna, who is conspicuously oblivious to them. Nor does she offer much support to her infant. Her right arm hangs limply at her side, while the seemingly self-sufficient, Herculean Jesus turns in vain to her clothed breast.

Moving to the rear plane of the Doni tondo, I assume that the iconographical program was to create a moral contrast between the Holy Family (the world redeemed from sin by the triumphant arrival of Christ) and the five androgynous youths in homoerotic interplay (the world of sinners before redemption). In terms of the overall formal demands of the tondo's composition and spatial organization, these nudes serve an integrating function, but no more so than landscape, a procession of magi, or a group of shepherds could have done. Why, then, did Michelangelo give a homoerotic cast to his classical nudes? His ambivalence on the subject of their sin is clear. The official iconography designates them as "sinners," but at the same time, they are drawn with a sensual abandon and dramatic style that seem "outrageous." Moreover, they hardly appear to be penitent as they await baptism. In view of the strikingly unusual character of this part of the Doni tondo, we are led to wonder whether these nudes represent an image that was a central element in Michelangelo's fantasy life.

In chapter 16 I will explore the presentation drawing of the *Rape of Ganymede*

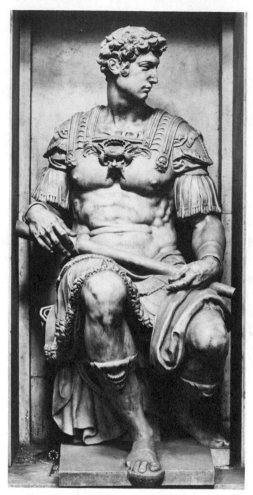

7-10. Michelangelo, *Giuliano de' Medici.*

for Tommaso de' Cavalieri, as well as Michelangelo's relationship with him. In the course of that discussion I will suggest that, for Michelangelo, respite from the earthly terror of death and the anxieties of daily existence was invested in fantasies of a beautiful, young male lover or an all-protective, powerful older man. It should be emphasized that it was the fluidity of his fantasy life and mental organization which enabled Michelangelo's genius to flower in many realms and also provided for several different, indeed contradictory, themes of fantasy as pathways for escape from the dreads that beset him.

In the Doni tondo, the motivational basis for the homosexual motif might be formulated as follows: The excluded child (John) attempts to cope with his inner rage at the rejection by his parents, particularly his mother, by leading a life of seclusive self-sufficiency and expiatory good works. Nonetheless, destiny cannot be altered; he is ultimately beheaded because of the vengeance of an evil queen-mother. Since the "John solution" does not succeed, another organization of

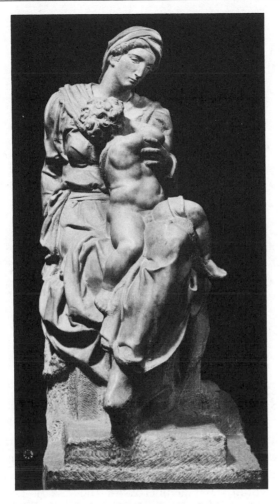

7-11. Michelangelo, *Medici Madonna.*

defenses and mode of adaption is required. Thus a world is created in which woman does not intrude and man is not vulnerable to her power to wound and betray. Such is the world of the distal plane of the Doni tondo. Parallel to the appeal of the bisexual aspect of Zeus in the Dionysus myth, these Doni tondo youths are conspicuously androgynous—that is, they have internalized and, to that extent, "become" the female. Hence, they neither need nor wish for females as real beings in their life space.

A connection with the theme of death and loss, which is the traumatic origin of the development of Michelangelo's homosexual self-representation, can be found in the reappearance of these youths in an early drawing of the plans for the Medici Chapel, sketched in 1520–21 (fig. 7-12). In this drawing the slender nudes are in comparable postures, leaning on a cornice, but *here cast as mourners.* In the original plan for the tombs there were to be two double wall-tombs: one for Lorenzo the Magnificent and his assassinated brother, Giuliano, the other for the

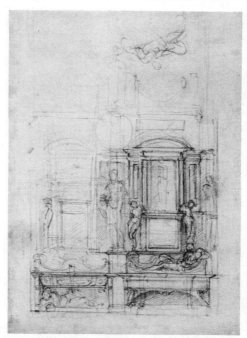

7-12. Michelangelo, study for the *Medici Tombs.*

two Medici dukes—Lorenzo the Younger, duke of Urbino, and Giuliano the Younger, duke of Nemours. However, the double tomb for Lorenzo the Magnificent and his brother was never executed. It is therefore possible that the double tomb pictured in this drawing was the one intended for Lorenzo the Magnificent and that the androgynous youths from the Doni tondo reasserted their presence in Michelangelo's creative imagination when he searched for mourners for Lorenzo, the parental figure whom he remembered for the rest of his life with singular warmth of feeling.

Artists' sketches often serve as unguarded "associations" to more finished paintings and statues, and therefore are of considerable value. A series of drawings from the years 1501–02, the period just before work on the Doni tondo, reveals parallels to the painting in the evolution from a position of being a frightened, excluded child in a family to a homosexual adaptation. I noted the location of Michelangelo's first self-portrait between, but behind, Mary and the child Jesus (fig. 7-9). His next self-portrait appears in a *Study of a Male Back, Four Heads, and a Self-Portrait* (fig. 7-13). (The self-portrait is in the center when the sheet is rotated ninety degrees clockwise.) Also on this sheet is a study of a young man nude to the waist, with long curls. Significantly, he appears to be the model both for the Madonna in the drawing shown in figure 7-9 and for the profile of the face of the standing nude on the right in the Doni tondo.[16] This same adolescent model, ac-

16. The fact that Michelangelo used male models for female figures cannot be assigned particular significance. This was standard practice during the Renaissance and therefore says more about the culture of the period than about the artist.

cording to Hartt (1970), is used again in the drawing of *A Nude Youth* and two self-portraits (fig. 7-14), in which his nude body is fully revealed. However, Michelangelo has inexplicably tapered all four limbs into a triton's serpentine fins and altered the youth's face to that of a craggy, middle-aged man wearing a winged helmet. The two self-portraits on this sheet are extraordinary in the frankness of their path of advance, so that the chin of one rests at the crotch of the youthful male body.

In these drawings from the 1501–02 period, there are two relevant lines of development. First, the model for the androgynous nude in figure 7-13 is used for the Madonna in figure 7-9, one of the Doni tondo nudes, and the nude triton shown in figure 7-14. Second, Michelangelo's head, with its taut and depressive set, moves sequentially from a position close to the breasts of the Madonna in figure 7-9 to near the undersized penis of the triton in figure 7-14. This change in placement suggests a renunciation of the breast and women as sources of nurturance and a tentative movement toward the penis and men as more reliable and satisfying providers. Finally, the figure of the triton bears striking similarities to the Silenus of the Medici *Dionysus* tondo (fig. 7-5). The three-quarter presentation of the muscular torso of the triton, the upraised right lower extremity, the acutely flexed knee, and the downward oblique cast of the left thigh are identical to the image of Silenus. This worksheet suggests, once again, Michelangelo's feeling of kinship with Dionysus, but here in the context of a clearer emergence of sexual elements. Goldscheider (1951) and Parker (1956) concluded that Michelangelo added the triton's fins as an afterthought, which is most apparent in the left arm. Perhaps Michelangelo introduced this bit of whimsy to divert and even ridicule the homosexual implications in the drawing. In analyzing self-portraits in this manner, there is always the danger of selecting details to fit a hypothesis. In this case, however, my analysis is strengthened by the fact that the three drawings are widely accepted as authentic, and there are no other drawings from this Florentine period that have been proposed as self-portraits.

A final important point needs to be made concerning the nudes in the Doni tondo. The haunting specter of painful exclusion persists in Michelangelo's contemplation of the homosexual adaptation. Of the three figures in the group on the right, the two at the far right appear to be lovers, while the third glares at them and agitatedly tugs at the drapery that connects them: he too is alone and jealous. Perhaps an awareness that the insistent power of his identity as the abandoned and excluded one would pervade any attempt to take part in a committed and sexual relationship was one of the principal causes of Michelangelo's probable abstinence from an overtly homosexual adult life.

Madonna and Child with St. John (Taddei Tondo)

I have postulated that if an unconscious conflict is sufficiently strong to be a major determinant of the distinctive aspects of any particular work of art, it will reappear as a discernible influence in other works by the artist. Unconscious conflict fires great art but is rarely resolved by successful artistic sublimation for long. In the

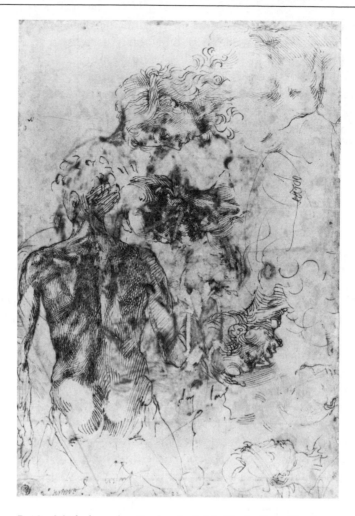

7-13. Michelangelo, *Study of a Male Back, Four Heads, and a Self-Portrait.*

discussion of the Doni tondo I referred to the themes of filicide and matricide as underlying concerns of Michelangelo. These themes reappear in the marble relief of the *Madonna and Child with St. John* (Taddei tondo, fig. 7-15), which was executed for a Florentine patron, Taddeo Taddei, shortly after the completion of the Doni tondo sometime during 1503–05.

In the Taddei tondo the child John holds before the child Jesus a goldfinch, foreteller of the Passion of Christ. For the first time in Renaissance art, Jesus is clearly frightened by the symbolic bird and tries to climb into Mary's lap for protection and comfort. Her facial expression is not the traditional, sadly averted gaze that conveys her premonition of her son's tragic fate. Rather, she has the same quality of detachment as the *Madonna of the Stairs* (fig. 2-1) and the *Medici Madonna* (fig. 7-11). Again, Michelangelo's need to integrate his conflicted inner

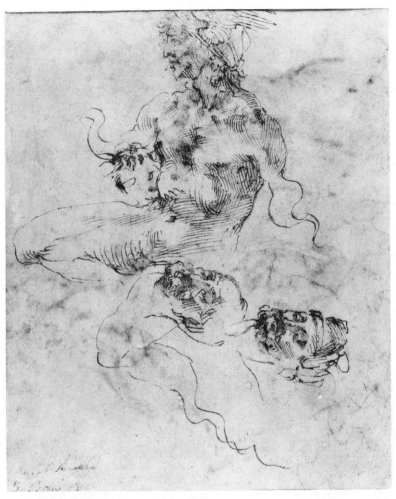

7-14. Michelangelo, drawing of A *Nude Youth, and Two Self-Portraits.*

representation of his experiences with his mother and wet-nurse into this work is
illuminated by tracing its sources.

It has been suggested that the compositional basis of the figures of Jesus and
John in the Taddei tondo derived from the antique Roman *Medea Sarcophagus*
(fig. 7-16), in which Medea's two sons are depicted as they are trying to escape
death at the hands of their mother.[17] The Taddei tondo is an example of Michel-
angelo's attraction to a visual representation of a specific moment in the narrative
of a manifestly terrifying myth and his subsequent transmutation of it into a work
that is closely related in form but opposite in motivational intent. Although Mi-

17. Panofsky (1939), Pope-Hennessy (1970), and Tolnay (1943–60, vol. 1) agree that the
Taddei Jesus and John derive from the *Medea Sarcophagus* at Mantua which was presumably known
to Michelangelo.

7-15. Michelangelo, *Madonna and Child with St. John* (Taddei tondo).

chelangelo has attempted to deny the concept of the murderous mother of the Medea myth by transposing it into a story of a traditionally nurturing mother-child relationship, the defensive aspects of the sublimation are incomplete. The anxiety connected with the original filicidal myth-fantasy persists and is reflected in the distinctive features of the Taddei tondo.

Thus, the Taddei tondo represents an attempt at resolution through creativity of one of Michelangelo's primary childhood conflicts. The child, terrified of death, seeks comfort—but in vain—from an emotionally unavailable mother. However, the anxiety remains manifest and therefore gives rise to an innovative artistic treatment of a most common subject.

The relationship of an artist's childhood experience to his later artistic treatment of a common motif is further illuminated by contrasting the Taddei tondo

7-16. Ancient Roman *Medea Sarcophagus* (detail of fleeing sons of Medea).

with Raphael's *Madonna of the Goldfinch* (fig. 7-17), painted in Florence about two years after Michelangelo carved the Taddei tondo. Raphael, eight years younger than Michelangelo, was in his early twenties at the time and was busy assimilating and condensing the art of Leonardo and Michelangelo into his own distinctive style. That Raphael had studied the Taddei tondo is clear from several of his drawings and from his painting *The Bridgewater Madonna*.[18]

In Raphael's *Madonna of the Goldfinch*, Jesus tentatively investigates the goldfinch while leaning against Mary for reassurance. This Mary, in contrast with Michelangelo's, exudes the easy and natural warmth and sentiment that characterize Raphael's many paintings of the Madonna. As in Leonardo's paintings, the delicate and harmonious background landscape sustains the tenderness of the mother-son relationship.

18. The drawings are: Raphael's *Sketches for a Virgin and Child* (Florence, Uffizi) and copy after Raphael, *Virgin and Child* (Paris, Louvre). *The Bridgewater Madonna* is at the National Gallery of Scotland in Edinburgh. Taddei was also a patron and friend of Raphael.

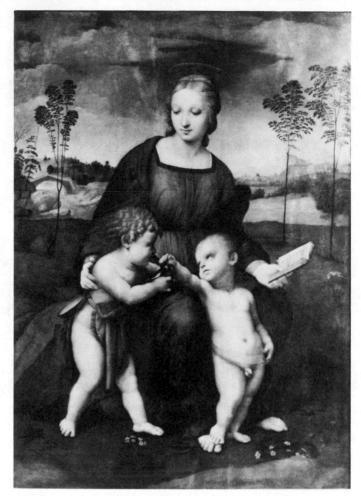

7-17. Raphael, *Madonna of the Goldfinch.*

Can Raphael's treatment of this goldfinch motif be explained in terms of his personal history? A brief description of his infancy and later personality argues persuasively for the relationship between these forces and the painting style so characteristic of Raphael in his Madonna series.

Probably because the circumstance was so exceptional for the times, Vasari (1568, vol. 2) wrote of Raphael's having been nursed by his own mother, owing to his father's deep concern for his welfare, counter to the prevailing middle-class practice of foster-mother wet-nursing:

> He [Raphael's father, Giovanni] knew how important it is that a child should be nourished by the milk of its own mother, and not by that of the hired nurse, so he determined, when his son Raphael . . . was born to him, that the mother of the child . . . should herself be the nurse of the child.
>
> Giovanni further desired that in his tender years the boy should rather be brought up in the habits of his own family, and beneath the paternal roof, than be sent where

he must acquire habits and names less refined, and modes of thought less commendable, in the houses of the peasantry. [p. 20][19]

With regard to the linkage of early mothering, later character structure, and artistic style, it is informative to quote Vasari in relation to Raphael's character:

No less excellent than graceful, he was endowed by nature with all that modesty and goodness which may occasionally be perceived in those few favoured persons who enhance the gracious sweetness of a disposition, more than usually gentle, by the fair ornament of a winning amenity, always ready to conciliate, and constantly giving evidence of the most refined consideration for all persons and under every circumstance. [p. 19]

Vasari's flowery prose is actually consistent with the gracious and amiable picture we have of Raphael from other contemporaries. It is an image that stands in dramatic contrast to the descriptions of Michelangelo, condensed in the term *terribilità* that came to be attached to him, communicating his unapproachable and frightening nature.

This brief comparison of the individual approaches of Michelangelo and Raphael to an identical motif executed at essentially the same time, in the same place, and at similar points in their careers, serves to demonstrate the relationship between the radically different artistic solutions of these two artistic giants and their divergent early histories of mothering and subsequent character development.

The Expulsion of Adam and Eve from Paradise

For Michelangelo, the subject of murderous impulses of mothers toward their sons and of sons toward their mothers continued to inform his art significantly. Up to this point I have emphasized the child's fear of abandonment and of the destructiveness of the mother. In the actual psychic life of a child, however, such fantasies are invariably only one component in the splitting of self and object representations, which also includes fantasies of oneself as destructive and as responsible for the loss of the mother, if that event has indeed occurred. Rage at the mother was suggested as one aspect of the defensive motivation underlying Saint John's boyhood retreat to a life of penitence in the desert.

That the theme of his own matricidal impulses remained a powerful unresolved conflict for Michelangelo can be demonstrated in another work of this 1501–09 period, *The Expulsion of Adam and Eve from Paradise* (fig. 7-18). The *Expulsion* is

19. Vasari goes on to describe how Raphael's father took him to study painting with Pietro Perugino, "though not without many tears from his mother, who loved him tenderly" (p. 20). This is, no doubt, a typical liberty that Vasari took with the facts, inasmuch as Raphael's mother is known to have died when he was eight years old. Nevertheless, as the information filtered down to Vasari (who was nine years old when Raphael died in 1520), the impression of nurturing maternal care was well established. Perhaps it was the Renaissance intuition that anyone who could paint such tender Madonnas must have been well mothered.

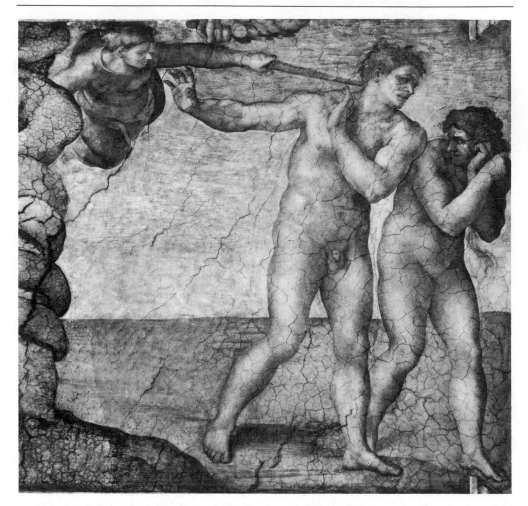

7-18. Michelangelo, Sistine Chapel ceiling: *The Expulsion of Adam and Eve from Paradise.*

actually only half of the panel *The Fall of Man,* the fourth of the nine "histories" painted on the ceiling of the Sistine Chapel, probably in 1509. The left side of the panel depicts *The Temptation of Adam and Eve,* in which they reach for the forbidden fruit from the Tree of Knowledge with the collusion of the Satan-serpent.

The *Expulsion* has long been recognized as deriving primarily from two earlier Renaissance treatments of the theme: Jacopo della Quercia's *Expulsion,* which Michelangelo knew from his stay in Bologna in 1494–95; and Masaccio's *Expulsion* (fig. 7-19) in the Brancacci Chapel in Florence, where Michelangelo spent long hours during his boyhood, assiduously copying the earlier Florentine master's monumental frescoes of 1427–28. Interestingly, Masaccio's image seems more dynamically communicative of the remorse and anguish of Adam and Eve at that

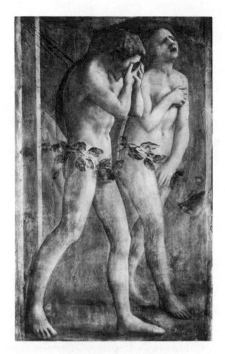

7-19. Masaccio, *The Expulsion of Adam and Eve from Paradise.*

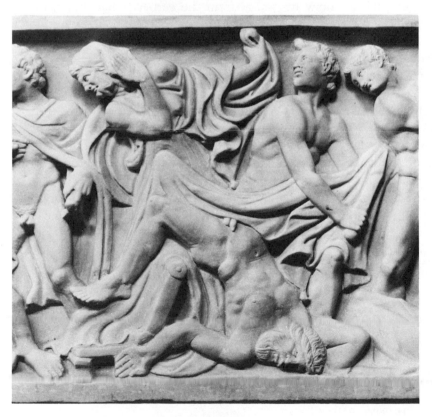

7-20. Ancient Roman *Orestes Sarcophagus* (Orestes fleeing the Furies).

irreversible moment than does Michelangelo's. Of critical importance, however, are some of the minor differences between the two works. Apart from a slight rotation of the bodies of Adam and Eve, and a shift in the positioning of the legs and head of Eve, Michelangelo's version differs from Masaccio's principally in the defensive gesture of Adam's arms—positioned as if to ward off the unrelenting banishing angel.

The face of Michelangelo's Adam expresses greater intensity and more inner torment than are to be found in any figure he had created up to that time. Michelangelo's elevation of man through his Fall to the stature of a moral and psychological being has led Tolnay (1943–60, vol. 2) to observe: "Adam flees, pursued not by the angel, but by his own inner remorse; the movement of his arms is a form of defense against the furies of his own conscience" (p. 32).

Upon what "sin"—that is, what elements of troubled conscience—could Michelangelo draw from within himself to create so compelling an image? Part of the answer to this question may be advanced by once again locating the formal source for the Adam of this panel and then examining its narrative meaning. Simply to note that the theme of Michelangelo's *Expulsion* derives from Masaccio's and from della Quercia's versions does little to illuminate the creative process in Michelangelo. In the crucial detail of the defensive gesture of Adam's arms, however, Michelangelo did not draw his image from the earlier Italian Expulsions; this is again a rather direct quotation from a pagan source, in this case an antique Roman *Orestes Sarcophagus* (fig. 7-20).[20]

In the sarcophagus relief, Orestes is attempting to fend off the Furies, who accuse and torment him for the murder of his mother, Clytemnestra. It is apparent from the position and gesture of Orestes' arms that Michelangelo has virtually copied them for his Adam. The dramatic moment in the myth of the House of Atreus represented on the sarcophagus occurs at the end of the second play of Aeschylus's *Oresteia* trilogy, *The Choephoroe*.[21] As in the case of Euripides' *Bacchae*, there is no evidence that Michelangelo had specific familiarity with Aeschylus's version, which was yet to be translated into Latin.

The trilogy begins with a social code of vengeance, of which the *Orestes Sarcophagus* partakes, in depicting Orestes being tormented for his crime. It evolves

20. The derivation of Michelangelo's *Expulsion* from the *Orestes Sarcophagus* was first traced by Walter Horn (cited in Tolnay, 1943–60, 2: 134). Tolnay himself, as well as Hartt (1964), supports Horn's thesis.

21. In the sarcophagus, Orestes appears to be represented at the following point in Aeschylus's text:

Orestes:

 Look! Do you see those women, like Gorgons,
 All clothed in black, their heads and arms
 entwined
 with writhing snakes! How can I escape?

Chorus:

 What imaginings are these. . . .

by the end, however, into a code of social and individual responsibility, aided by divine guidance, which allows for full forgiveness of Orestes' murder of his mother. Thus, the resolution of the *Oresteia*, with its justification and forgiveness of the murder of a mother, makes it understandable why Michelangelo was attracted to and used this particular sarcophagus as his model; it served as a counterforce to the Old Testament verdict of banishment represented in the Sistine Chapel *Expulsion*. Michelangelo's turning to the *Oresteia* lends strong support to the conclusion that his unconscious source of inspiration for the motif of the *Expulsion* was the unresolved and unneutralized residue of the murderous impulses he harbored toward his abandoning wet-nurse and mother.[22]

In this chapter I have attempted to isolate certain unconscious and unresolved early conflicts in Michelangelo as being among the basic determinants of the form and content of a group of paintings, sculptures, and drawings from an early period in his career. In this connection, the facts of special interest were his experiences of boarding with a wet-nurse from birth to about two years of age, and then, following his return to his natural parents, the death of his mother when he was six years old. The unconscious meaning and formative effects of those experiences are somewhat clarified by Michelangelo's own writings, other contemporary descriptions of him, and the nature of his adult relationships. Since we are interested in the man because of his creativity, it becomes important to find from within the products of that creativity an independent method of revealing the conflicts and fantasies that compose the latent meaning in his artistic statements.

Inasmuch as the content of the works of art tend to repeat the conventional motifs and stylistic conceits of the time in which he lived, only limited conclusions can be drawn from the representation of a popular theme itself. Clearly, one can say little about a Renaissance artist merely on the basis that he painted many

Orestes:

 Imaginings! They are real enough to me.
 Can you not see them? Hands of a mother's
 curse!

Chorus:

 It is the blood still dripping from your hands
 That confuses your wits, but it will pass.

Orestes:

 O Lord Apollo! See how thick they come
 and their eyes are oozing gouts of blood! . . .
 You cannot see them, and yet how plain
 they are!

They are coming to hunt me down. Away, away!

22. There is another theme in the *Oresteia* that may well have connected with Michelangelo's early wishful fantasies. In the third play of the trilogy, *Eumenides*, by virtue of Athene's divine intervention and persuasion, the Furies who have so vengefully tormented Orestes are transformed into benevolent deities—the Eumenides. So the murderous women of earlier consciousness become the source of blessings and, indeed, the protectors of the lives of young men.

Madonnas. However, in the case of many of Michelangelo's works, by locating the earliest source from which he derived aspects of the form of his own later creations, we have a promising starting point for understanding the distinctive and innovative qualities of his art. This is particularly true when the narrative underlying the early source is entirely different from the theme of his later derivative work. It has been my assumption that when Michelangelo was drawn to a specific ancient work of art as a source for his own, it was because the narrative theme of the early work deeply touched dominant unconscious chords in him which made it compelling as a model. Moreover, the conflict in the original work was sufficiently disturbing to him that he was impelled to master his inherent anxiety by transposing it to a theme ostensibly quite different. This is how Dionysus and a satyr could become Jesus and Mary, Medea could become the Virgin Mary, and Orestes could become Adam. To what extent this process operated consciously in Michelangelo we cannot say. However, the content of the pagan themes that he transmuted into sacred art informs us in a more specific and differentiated manner of the conflicts bearing on his creative outflow.

The works explored in this chapter emphasize the importance of splitting as a defensive measure that Michelangelo took in order to cope with the potentially disruptive affects connected with contradictory primitive representations of early maternal imagos. The representations are, on the one hand, an idealized, all-good image (the Madonna) and, on the other, a murderous and terrifying one (the Medea). The view of his mother as a Medea carried with it a complementary, affectively valenced self-representation as the murderous, avenging son (Orestes), just as the view of his mother as Madonna was accompanied by self-identification with Jesus—the martyred son who, resurrected, will rejoin his mother in the kingdom of God. On the basis of clinical work, we may infer that the six-year-old Michelangelo believed that his mother died *because* of his rageful thoughts and feelings, stemming largely from his early experiences of traumatic abandonments and sibling displacements. We may further venture that, had his mother not died when he was so young, the separate, primitive views both of his mother and of himself would have yielded to repression; their associated extremes of emotion would have been neutralized in the face of the corrective reality of his mother's living presence. Her death created an arrest in the normal developmental progression whereby diverse constituents comprising the mental representation of mother and of self, as well as attending positive and negative emotions and attitudes, would have become integrated.

Central to Michelangelo's creativity was a fluidity in the level of organization of the inner representations of himself and objects, and in the range of affects associated with each of these representations. This fluidity was the essence of Michelangelo's capacity to master and transform his tormented inner drama into art.

Chapter Eight

Michelangelo versus Leonardo: The Battle of Cascina, *1504–1505*

Michelangelo's artistic fascination with the possibilities of the nude male form dates back to one of his first known sculptured works, *The Battle of the Centaurs* (fig. 2-2, 1491–92). His continuing absorption with the problem was evident throughout his early period of work—in the lost (?) Christ of the Santo Spirito wood *Crucifix* (ca. 1492), the *Bacchus* (fig. 6-3, 1496–98), the Christ of the St. Peter's *Pietà* (fig. 6-4, 1497–1500), the lost bronze *David* (ca. 1502–03), and the marble *David* (fig. 8-1, 1501–04). In painting, the same fascination is reflected in the Christ of the unfinished *Entombment* (fig. 6-5, ca. 1500) and the bold experiment with the youths in the background of the Doni tondo (fig. 4-7, ca. 1503–04). It was not until 1504, however, in the cartoon for *The Battle of Cascina* (fig. 8-2), that the nude form underwent a revolutionary transformation which marked a turning point not simply in Michelangelo's own development but in the history of art. The *Battle* was Michelangelo's principal artistic effort during the year following the completion of the *David*.

The *David* was finished in April 1504 and was immediately embraced by the public as embodying the glory of Florence. The unusual moment in the biblical narrative of David that Michelangelo chose to depict portended a major element in the drama behind the *Battle of Cascina*. Traditionally, the youthful hero was represented *after* victory, with the head of Goliath at his feet (as, for example, in Donatello's bronze *David*, fig. 8-3). Michelangelo, however, chose the moment *before* battle and infused David not with the pride of conquest but, rather, with a single-minded intention. For Michelangelo, still in his twenties, the fresco painting of the *Battle of Cascina* was to be his personal battle with a "giant"—in this case his rival, Leonardo da Vinci, then fifty-two years old.

The unusual history of the *Battle* deserves mention. Michelangelo was commissioned by the Signoria of Florence to execute a fresco for the Great Hall of the Palazzo della Signoria, to share the wall with a fresco by Leonardo that had been commissioned several months earlier (fig. 8-4).[1] At the time (1503) Florence was in conflict with Pisa, and both artists were charged with choosing subjects that would glorify Florence's past victories over that city. In discussing the Doni tondo

1. See Wilde (1944) for the history of the plan for the two paintings in the Great Hall.

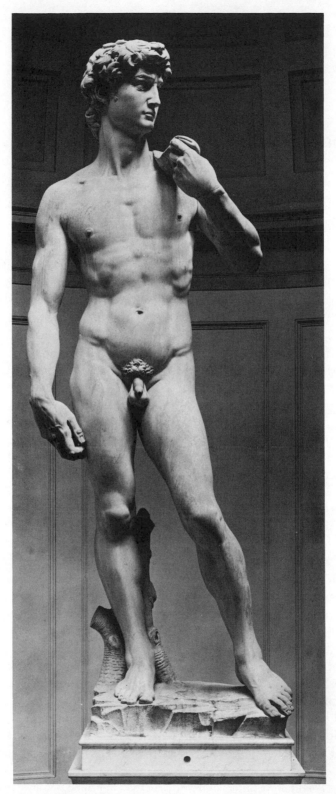

8-1. Michelangelo, *David*.

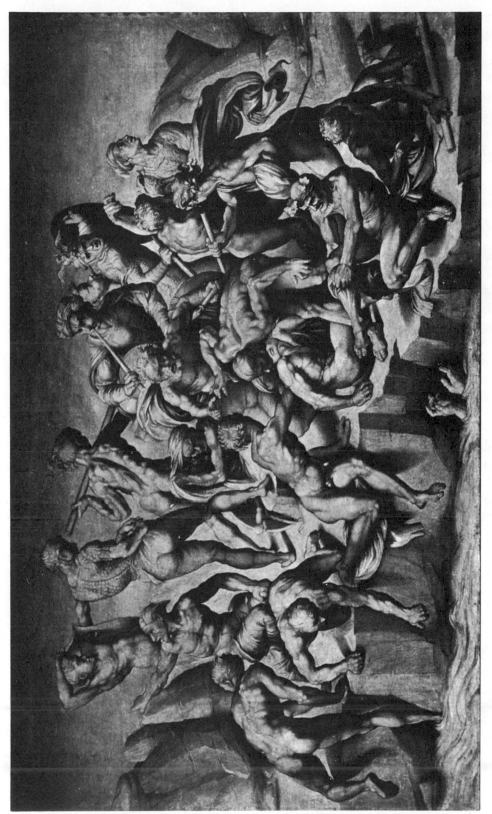

8-2. Aristotile da Sangallo, copy of the central section of Michelangelo's cartoon for the *Battle of Cascina*.

(chap. 7), I suggested ways in which Michelangelo's highly innovative treat-
ment of that common motif—the Madonna—was determined by his intense feel-
ings of rivalry with the venerable Leonardo. Now, in the Great Hall, Michelangelo
approached a confrontation with Leonardo in which monumental frescoes—60
feet long and 24 feet wide—by the two masters were to appear side-by-side, in a
position to be forever compared.

The juxtaposition of the works, however, was never to be. Leonardo's *Battle of
Anghiari* did not last for long, and Michelangelo's *Battle of Cascina* never materi-
alized on the wall. All we know of the works comes from some preliminary sketches
and from copies by other artists of parts of the cartoons for the whole of each
of the works. A copy of a section of Leonardo's *Battle of Anghiari* by Rubens
(fig. 8-5) reveals an equestrian battle scene unsurpassed in art in its combination
of raw energy, complexity of composition, and intensity of expressiveness of man
and horse. We know from Vasari's account that Leonardo experimented with a
new fresco technique for this work, with the disastrous result that the upper half
dried too dark and the lower half of the painting faded away as the plaster dried.
The unhappy outcome lingered on the wall for several years.

An interesting question presents itself in passing—did Leonardo, who of course
knew and had worked with the time-honored method of fresco painting, devise
this ill-fated technique with the unconscious motive of destroying his work on the
spot? On this point we can only consider the possibility, which remains beyond
proof or disproof, that Leonardo in his advancing years must have suffered consid-
erable anxiety over this huge project, feeling that he had little to gain and much
reputation to lose in this confrontation with Michelangelo in the Great Hall.

It is also interesting to note that in this particular composition Leonardo de-
picted violence on a scale unprecedented in his art. Although aggressive and bat-
tle motifs appear early in his drawings and are suggested in the unfinished back-
ground of the Uffizi *Adoration of the Magi*, here not only are men stabbing and
slashing at each other, but horses are engaged in fierce combat with gnashing
teeth. Leonardo may have been uneasy with the frank expression of aggressive
impulses that is the essence of this fresco. Freud stressed that Leonardo's aggressive
impulses were a source of primary conflict within him (1910). The successful
resolution of this conflict was the sublimation of these thoughts and feelings into
the mood of serenity that generally characterizes his art while, at the same time,
he found tolerable expression in his fascination with many elements of warfare.
Regardless of what may have been Leonardo's intrapsychic struggle while working
on his fresco, inasmuch as he started work earlier than Michelangelo, the younger
artist had access to Leonardo's cartoon of the *Battle of Anghiari* as a standard to
work against as he proceeded.

For our knowledge of the *Battle of Cascina* we have to rely largely on the
monochrome copy by Aristotile da Sangallo after the cartoon (fig. 8-2). This copy
is regarded as a faithful reproduction of the original because of its fidelity to the

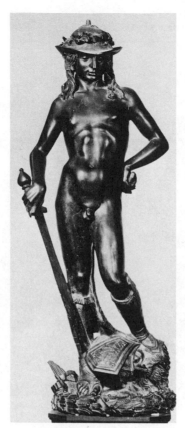

8-3. Donatello, *David.*

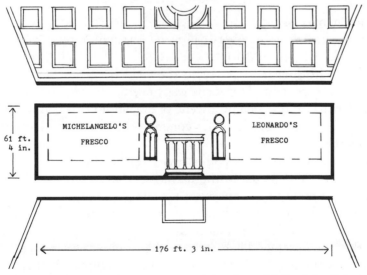

8-4. After Wilde's reconstruction of the Great Hall of the Palazzo della Signoria, Florence, at the time of the frescoes planned by Michelangelo and Leonardo.

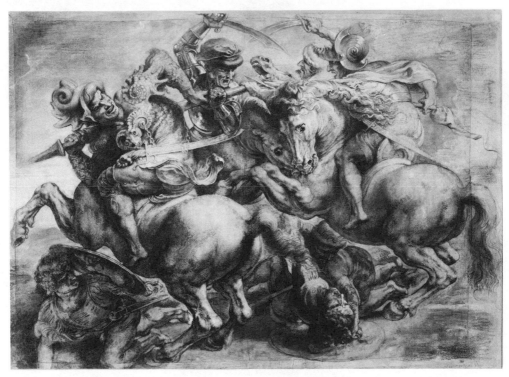

8-5. Peter Paul Rubens, free copy of the central section of Leonardo's *Battle of Anghiari.*

preserved preliminary sketches by Michelangelo, as well as to contemporary descriptions of the cartoon. It depicts eighteen seemingly intertwined soldiers on a rocky river bank. All are in extreme postures of torsion and exertion, in varying stages of frantic dressing in response to the sudden call to battle issued by the bearded man at center right. This scene was to be the middle section of the fresco. It was to be flanked on one side by a scene of preparation and on the other, by the battle itself.[2] The work was a specific commemoration of the Florentine victory over Pisa in 1364.

In Michelangelo's *Battle,* two points invite further inquiry: one, the dramatic moment chosen to be depicted in the narrative of the events; and the other, the bravura use of the nude to communicate meaning.

The moment was quite literally taken from a contemporary account of the battle (Villani, 1826 ed.). The chief of the Florentine army was ill and had taken to his bed, thus freeing the soldiers to leave their camp to swim and lie in the sun, oblivious to the approaching Pisans. One of the Florentines, seeing the imminent danger, shouted, "We are lost!" thus shocking his fellows into an awareness of their perilous situation. By the time the Pisans attacked, the Florentines were mobilized and able to rout them.

2. See Gould (1966) for a reconstruction of the entire *Battle* fresco.

Whereas Leonardo chose to depict the consummate moment in the struggle of 1441—the Florentines capturing the Milanese flag—Michelangelo selected an anti-heroic moment in the campaign—the Florentines literally caught with their pants down. In the *Battle of Cascina* the tension is between the impulse to disregard reality—with its life-threatening aspects, to lie naked and bathe in the sun in suspended time—and the necessity to face the enemy, the world of actuality. The first of these polarized impulses parallels the mood expressed by the background nudes in the Doni tondo.

How can we further relate the cartoon to the more immediate "battle" in Michelangelo's life—the competition against Leonardo in the Great Hall? The scene in the *Cascina* cartoon suggests the conflict taking place in Michelangelo in this situation. His impulse to yield to his strong passive and homoerotic yearnings is represented in the cartoon by the company of nude men sun-bathing together. This passive state, however, brought with it the anxiety associated with being defenseless against attack by male rivals (in this case, the Pisans). Thus, the cry of warning and sudden desperate activity of the men on the rock mirrored Michel-angelo's own internal drama. His resolution of this drama in the conducting of his life was through herculean work efforts, through which he conquered contem-porary rivals and attracted the recognition and gained the protection of such powerful parental surrogates as the popes and the Medici.

Here again we are fortunate to possess preparatory sketches that illuminate the artist's inner conflict. There is a sketch for *Cascina* (fig. 8-6; Uffizi, 18737-F) that bears on the struggle within Michelangelo between the passive-feminine and the active-heroic masculine. This drawing shows light lines of the artist's thoughts for the battle scene. There is also a more heavily drawn image of *Leda and the Swan*, in which Leda is depicted in a pose of total sexual abandon to the swan, who, as we know, is Zeus in disguise. (Some scholars argue that this is not Leda but the Trojan youth Ganymede, abandoning himself in the same manner to Zeus dis-guised as an eagle.) Although some thirty years later Michelangelo worked both on a painting of *Leda* (fig. 15-20) and on a presentation drawing of *Ganymede* (fig. 12-8), in 1504 there were no known commissions or, indeed, any external reasons for his concern with either theme. Therefore, this sheet might be said to suggest that the task of preparing for the *Battle* fresco also aroused in Michelangelo thoughts of the exquisite pleasure of passive sexual yielding to an omnipotent protective being. These polarities in the artist's personality, which come together side-by-side on the one sheet of sketches, are condensed in the final version of the cartoon.

The nude forms in the *Battle of Cascina* mark a break with Michelangelo's past and prepare us for the Sistine Chapel ceiling and the later *Last Judgment*, as well as for the distinctive *contrapposto*[3] of virtually all of the sculptured figures that were to

3. *Contrapposto* refers to a pose in which one part of the body is twisted in the opposite direction from its adjoining part. For example, the head is turned in one direction, shoulders in the opposite, and hips in the same direction as the head.

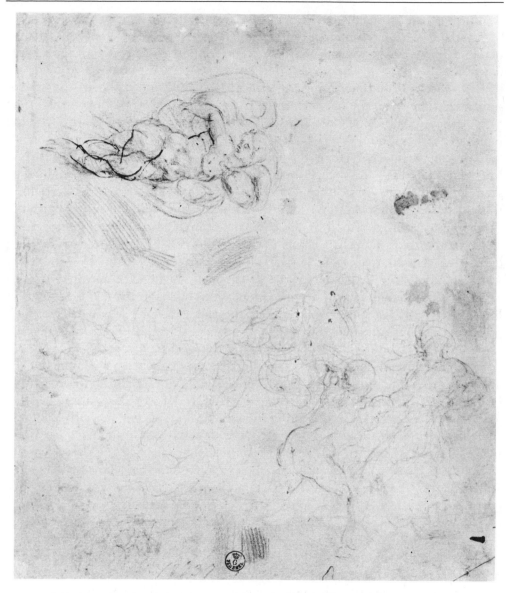

8-6. Michelangelo, sketches for *The Battle of Cascina,* and *Leda and the Swan* (or *Ganymede*).

follow. Michelangelo seems intent on unlocking the secret of some haunting but not fully perceived inner need by working out an infinite set of equations with new combinations of the human anatomy—more particularly, the nude male. In keeping with the late-fifteenth-century Neoplatonic teachings of Marsilio Ficino and his circle, which were assimilated by Michelangelo in his teens during their association at the Medici Gardens, the body is endowed with spiritual meaning

that transcends its everyday physical and carnal character. Thus, Neoplatonism provided both the rationale and the justification for Michelangelo's vocabulary of images. Nevertheless, the nude male held an obsessive attraction for Michelangelo that had had no counterpart since the sculptors of antiquity.

Because it is fundamental to his art, Michelangelo's central preoccupation with representing the idealized male body is a recurring theme throughout this book. At this point, however, some comments about the general problem of the development of a stable sense of the integrity of one's own body in early childhood and about Michelangelo's probable experience in this respect are appropriate.

In the normally developing infant and young child, objects in the world are first experienced as indistinguishable from one's own body. Similarly, in the beginning thought and bodily sensation are inextricably bound. It is largely through experiencing frustration in tolerable degrees, such as separation from the mothering one and unassuaged bodily discomfort, that the infant begins to learn and conceptualize the boundaries between himself and the outside world. The outside world was originally entirely represented by mother, who, in the usual course of events, could alleviate the principal discomforts. However, in a climate of either excessive maternal indulgence or deprivation and frustration, the normal process of development of a progressively individuated and integrated representation of the self will be compromised. As a result, the child will be left with a permanent reservoir of anxiety with respect to his internal image of the integrity of his body.[4] This untoward outcome may be observed later in such clinical phenomena as hypochondriasis, fear of death, symptoms of castration anxiety (e.g., fetishism), and fears of penetration and orgastic release in both females and males. In the course of further development, one's early mental representation of the integrity of his body will be refined and organized into clusters of complex concepts about the self, such as gender identity or the capacity for physical mastery of the environment—characteristics which, in the artist, affect the content and the form of his creations.

In the case of Michelangelo, we may posit that as a consequence of his early losses and inconstant care he was left with a fundamental uncertainty concerning the integrity of his body and its later, more refined aspects of self-representation. This unhappy state of affairs, coupled with the greater sensitivity to sensory stimulation and to his own body states which Greenacre (1957) has persuasively suggested is a basic characteristic of the creative talent, could only lead to a heightened level of fixed body narcissism. Yet, because of his inexplicable endowment with the visual-motor-conceptual pathways that allowed for the execution of his imaginative genius, he could draw on these haunting uncertainties and repeatedly reassure himself, for the moment, by making an external representation of and thus mastering the subject of his own uncertainty.

4. See the writings of Mahler and her coworkers for a full discussion of the early process of individuation (e.g., Mahler et al., 1975).

Thus, in the *Battle of Cascina* bathing scene, the harmonious symphony of active and powerful nude male bodies can be viewed as Michelangelo's reassurance to himself with respect to the fear and doubt expressed in this same scene by the two hands in the center of the foreground impotently reaching up out of the water—the failing grasp of a drowning man.

The dialectic between the concern with the destruction of the body and the restoration of it in idealized form operates throughout Michelangelo's art. It is illustrated in the drawing of the *Flagellation of Christ* (fig. 8-7), in which Christ, despite the physical torture to which he is being subjected, is depicted as a boyish, idealized nude. It is further suggested by Michelangelo's many drawings of the Resurrection of Christ, in which Christ, represented like some beautiful Greek athlete, effortlessly steps out of his sarcophagus (fig. 8-8) or soars upward in his

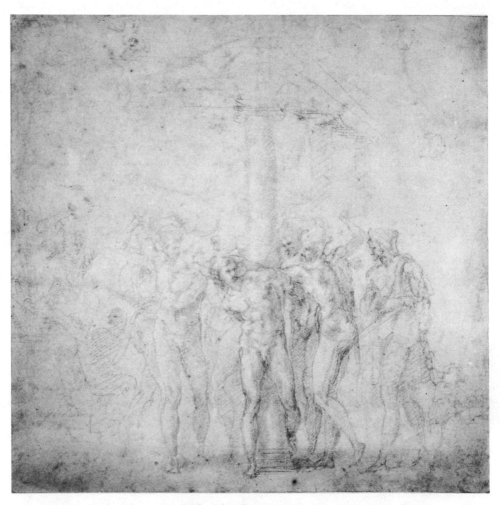

8-7. Michelangelo, drawing of *The Flagellation of Christ*.

conquest over death to a union with the Almighty Father (fig. 8-9). Perhaps the most telling example of the artistic resolution of this internal conflict is the statue of the *Dying Slave* (fig. 12-1), which I shall explore in detail in chapter 12.

The *Battle of Cascina* was never executed. Yet, its impact on sixteenth-century art was profound. Benvenuto Cellini (1562) later referred to the cartoon as "the school of the world" (p. 28). As for the competition between Michelangelo and Leonardo, after his effort disintegrated before his eyes, Leonardo gave up in disgust and asked to be relieved of his obligation. Michelangelo suspended his work on the project before he ever got to the wall in the Great Hall. For it was in March 1505 that he was summoned to Rome by Pope Julius II.

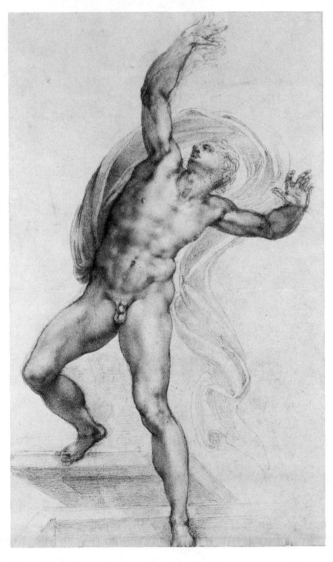

8-8. Michelangelo, drawing of *The Resurrection of Christ.*

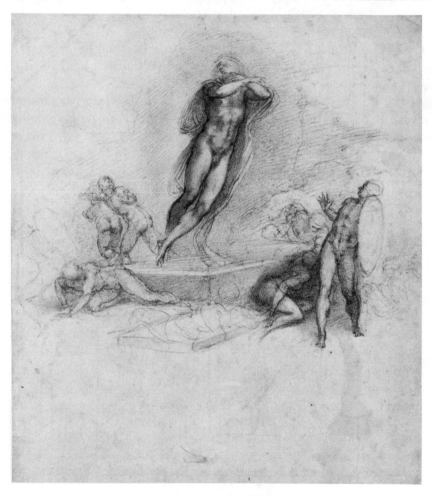

8-9. Michelangelo, drawing of *The Resurrection of Christ.*

Chapter Nine

The Tomb of Julius II, 1505–1513

In March 1505, Pope Julius II summoned Michelangelo to Rome to execute his tomb. This command by the pope marked what was to become for Michelangelo the consuming axis of his own concept of his creative mission for the next forty years, albeit through successive scaled-down revisions.[1] The final resolution of the tomb, now standing in the darkened basilica of San Pietro in Vincoli (fig. 9-1),[2] is the unhappy remnant of the original monumental concept. The tremendous obligation that Michelangelo imposed upon himself over the years of completing the tomb created a structure to his life wherein he felt—and indeed was—continuously forced to subordinate his own artistic intentions to the wishes of a succession of popes (Julius II, 1505–13; Leo X, 1513–21; Clement VII, 1523–34; and Paul III, 1534–49). So it was that, at sixty-seven, Michelangelo poignantly wrote to a high papal official: "I lost the whole of my youth, chained to this Tomb, contending, as far as I was able, against the demands of Popes Leo and Clement. An excessive honesty, which went unrecognized, has been my ruin. Such was my fate" (letter 227).

Any account of Michelangelo's life and art during the period 1505–13 must take heed of the effect that the personality and political agenda of Pope Julius had on Michelangelo. Interwoven with the character and aspirations of Julius were the complex vicissitudes of Italy's political fortunes—both internally, in the unstable relations between the papal state and the other courts and city-states, and externally, in the designs of France and Spain on Italian territories, which forced the Italian states to form shifting alliances with these nations in order to continue to survive independently.

At age thirty, in 1505, Michelangelo had established his preeminence in Florence, particularly with the *David*, completed the year before, and the cartoon for the *Battle of Cascina*. It is thought that Pope Julius was persuaded to bring Michelangelo to the papal court by his architect, Giuliano da Sangallo. Giuliano, a Florentine, had known the pope from the days when he was cardinal and also had been friendly with Michelangelo for several years. He had been active on the commission that selected the site for the *David*. In the stormy relationship be-

1. There were six different plans for the tomb (in 1505, 1513, 1516, 1525, 1532, and 1542) and five contracts. The tomb was actually completed in 1547.
2. It was to this tomb that Freud came year after year to contemplate the marble *Moses* (fig. 14-2), which became the subject of his essay "The Moses of Michelangelo" (1914).

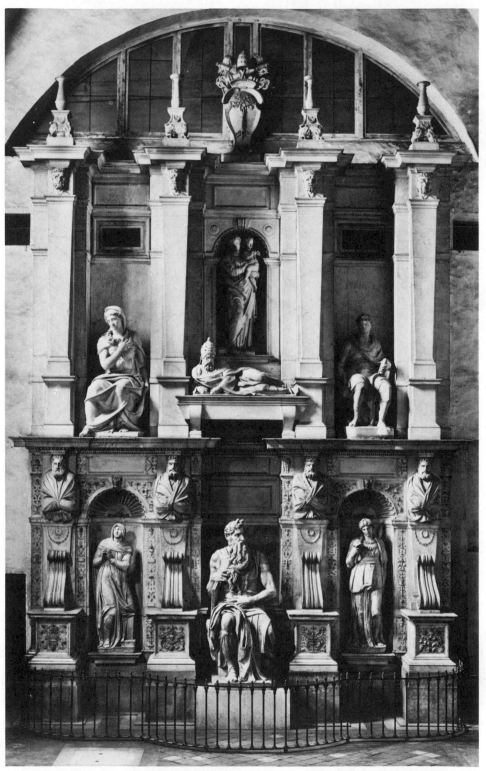

9-1. Michelangelo and assistants, Tomb of Julius II.

tween Michelangelo and Julius that ensued over the next year and a half, Giuliano was an indirect factor. He was bypassed by the pope, who instead charged Donato Bramante with the rebuilding of the basilica of St. Peter's in 1506. This treatment of Michelangelo's older benefactor by his new patron was very likely the source of considerable conflict in Michelangelo and was probably one of the sources of the bitterness he felt throughout his life toward Bramante and Bramante's young protégé, Raphael.[3]

To return to the history of the tomb, Michelangelo later recalled to Condivi that after he came to Rome, "many months passed before Julius II could decide in what way to employ him" (p. 29). This, however, is not in accord with the known facts, for only a month after his arrival at the papal court Michelangelo was dispatched to the marble quarries in the mountains of Carrara to choose the blocks of stone for the tomb project. He remained in Carrara for eight months, from April through December. Therefore, within a month of his arrival in Rome Michelangelo must have already executed drawings for the tomb that were acceptable to the pontiff.

Art historians have long wondered about Michelangelo's original conception of the monument. Inasmuch as no primary sources for the 1505 project remain, such as the contract, models, or reliably dated and completed drawings, nothing is certain. However, reconstructions based on secondary sources are believed to approximate the plan. Figure 9-2 gives us an idea of the 1505 project, which was to be a freestanding monument, about 36 by 23 feet, and three stories high. Integrated into the architectural design were to be approximately fifty larger-than-life-sized marble statues. In addition, there were to be bronze reliefs and many smaller decorative sculptures. All this was to be executed by Michelangelo's own hand and, as he stated in a letter to Giuliano de Sangallo in May 1506, to be completed within five years.

In Michelangelo's several accounts of the ill-fated history of the tomb, his failure to live up to these terms is attributed entirely to interference and self-interested demands made upon him from outside sources. The lengths to which the artist felt driven to acquit himself in this matter have prompted several Michelangelo scholars to regard the real purpose of Condivi's *Life* as Michelangelo's attempt to vindicate his behavior during the long history of the tomb.[4] That Michelangelo would have completed the tomb had it not been for outside interference was, however, clearly not the case from the very outset. In part because of the virtually incredible achievements of the Sistine Chapel ceiling and the *Last Judgment* on the altar wall, until recently most scholars have not seemed to

3. Michelangelo's resentment and disdain toward Bramante and Raphael are recorded in his letters and by Condivi.

4. Michael Hirst (1977) wrote: "It is difficult to avoid concluding that the real purpose of the book was to vindicate the artist's record over the affair of the tomb of Julius II. . . . The book is, above all else, an apologia and an act of self-defence" (p. 322). Also, see Wilde (1978, chap. 1).

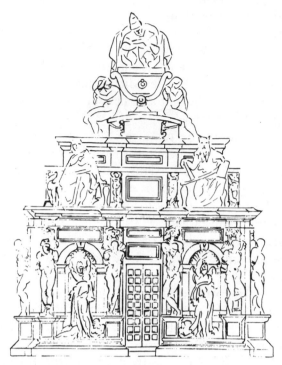

9-2. After Tolnay's reconstruction of the
frontal view of Michelangelo's 1505 plan for
the Tomb of Julius II.

recognize the utter impossibility of the task which Michelangelo set for himself in
the 1505 contract and which Pope Julius deluded himself into thinking attainable.
To begin with, close to a year had to be allotted to the task of quarrying the
marble. Then, in addition to the marble mausoleum, the bronze reliefs, and minor
marble sculptures, Michelangelo would have had to carve the major statues at the
rate of more than one a month—thereby producing more sculpture by far than he
actually carved in his more than seventy years of productivity. From what we can
deduce of his method of working, no one of the tomb statues could reasonably
have been expected to be carved in much less than a year. That Michelangelo
nevertheless undertook the 1505 tomb project reflects more than the total suspen-
sion of his own ability to judge reality in this situation; the project was a folie à
deux, in which Pope Julius was equally involved in the grandiosity and the
suspension of rational thought on the subject of his own tomb.

Because the fate of the tomb was so intimately connected to the pope himself,
it is appropriate to digress with regard to this most remarkable of pontiffs. At age
sixty, in 1503 Julius succeeded the corrupt and sinister Borgia pope, Alexander
VI.[5] Upon his election, Julius appears to have undergone a virtual spiritual conver-

5. There was actually a twenty-six-day pontificate (Pius III) between popes Alexander VI and
Julius II.

sion. Born of the Ligurian family of della Rovere, Julius, as cardinal, was the favorite of his powerful uncle, Pope Sixtus IV (1471–92) and rose to power largely through nepotism. A vivid description of Julius comes down to us from the contemporary Florentine historian Francesco Guicciardini, who wrote in 1540:

> Certainly everyone marvelled greatly that the papacy should have been granted with such widespread agreement to a cardinal who was *notoriously very difficult by nature and formidable with everyone: a man always restless,* who had consumed his years in *continual hardships and had inevitably offended many people and aroused the hatred and stirred up the enmity of many great men.* . . . The unusual loftiness of his spirit had won him not only a great many friends but also outstanding authority in the Roman Court, where he had gained the reputation of being the chief defendant of ecclesiastical dignity and liberty. But *his cause was promoted much more by the immoderate and infinite promises which he had made to cardinals and princes and barons, and anyone who might prove useful in* [his election as pope]. . . . And Julius, knowing that no one can more easily deceive others than one who usually had the reputation of never deceiving anyone, took care as soon as he won the pontificate not to blemish this encomium. [p. 172, my italics]

So Julius's election had virtually been achieved through the practice of simony (the buying of ecclesiastical preferment). Once he was pope, however, Julius issued a papal bull imposing harsh penalties upon any cardinal who sought to attain the papacy by the same means and declaring that any election resulting from simony would be null and void. Moreover, he eschewed the practice of nepotism—which had been so beneficial to him. Another contradiction in Julius that colored his whole pontificate was his policy toward France. As cardinal he had spent years in the court of France and had been instrumental in bringing the French to Italy. But once he was pope, his central purpose became to regain for the papacy all the territory in Italy that had ever belonged to the Holy See. In this mission his principal adversaries were the French under Louis XII.

Julius II is best known from Raphael's great portrait, now in London (fig. 9-3), in which the pope resembles a bearded Old Testament prophet. The beard itself symbolizes the spirit of Julius. He grew it in violation of Western canonical law and tradition, which prohibited beards among the clergy, following a major loss to the French on the battlefields of Romagna in 1510. The beard was a symbol of penance, a mortification of the flesh that would serve as a constant reminder of the presence of the French enemy in holy territory, and was to remain unshaven until the French were finally expelled from it (see Partridge and Starn, 1980; Zucker, 1977). The pope's faith was rewarded; in March 1512, at a time when it seemed that the French were on the brink of conquering Rome and disposing of Julius, a virtually miraculous combination of military and political events reversed the papal fortunes and the French were indeed driven from Italy.

In addition to his campaign against foreign domination, Julius waged a war against corruption within the church and brought public order, social reforms, and public works to Rome. During his nine years as pope, he left a record unequalled

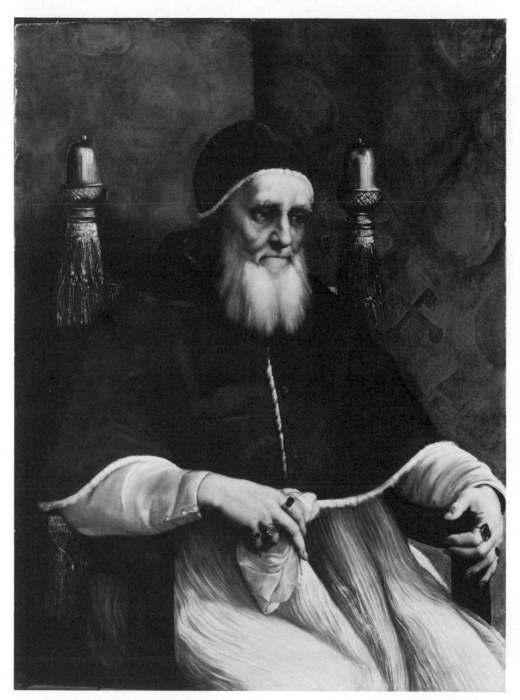

9-3. Raphael, portrait of *Julius II*.

since antiquity as a patron of the arts. He brought Michelangelo, Raphael, and Bramante to the papal court. He was boundless in energy, tempestuous in his outbursts, and fearless in leading his own troops on the battlefield. In short, he was possessed by the conviction of divine mission.

Needless to say, Julius II was not noted for his modesty. When he entered Bologna in November 1506, after defeating the antipapal regime there, he almost immediately summoned Michelangelo from Florence to Bologna to model a statue of himself to be cast in bronze. The work, done in a medium unfamiliar and uncongenial to Michelangelo, occupied him for a little over a year. The monument, placed on the façade of the cathedral in Bologna, proved to be ill-fated. Three years after the papal victory the antipapal Bolognese, with the help of French troops, regained the city. They immediately melted down the statue of the pope. Sadly, no reliable copy of this work, Michelangelo's only sculptured portrait, now exists.

What emerges from our sketch of Julius II, then, is a man of unlimited energies, who could not believe that anything he passionately wanted would be denied him because, quite simply, he was divinely graced and charged. I suspect that his conversion and his extraordinary career in his seventh decade of life were related to his dread of death and the afterlife. His extreme tendency toward self-glorification and his concern about approaching death served to propel him into the 1505 project for the tomb with no more governing sense of reality than Michelangelo possessed in the matter.[6]

Michelangelo's irrational grandiosity in conceiving the original tomb project may largely be ascribed to the fantasies he immediately invested in the pope. From his youthful stay in the household of Lorenzo the Magnificent to his last days, Michelangelo's quest for a powerful paternal protector was evident. In his inner mental representation of paternal figures a pronounced pattern of splitting was characteristic, as with his mother-figures: such figures were polarized into one of two images. One was an idealized, powerful public figure whom he believed to have an uncommonly strong personal, as well as artistic, investment in him. The other was a weak and denigrated figure—a role fulfilled, in the main, by his real father. Related to this mode of splitting was the consistent trend that the artist's creative capacity was enormously dependent upon the palpable encouragement of the idealized and devoted patron. The evidence for the reassertion of these controlling psychological dynamics in Michelangelo will mount as our narrative proceeds.

In the excitement of being called to the palace of Christ's vicar, Michelangelo felt compelled singularly to impress and outdo all of his formidable rivals in the papal court, thereby securing the special favor and protection of Julius. The

6. Julius's desire to be glorified during his lifetime is also evident in two of the rooms of fresco cycles he commissioned Raphael to paint in the Vatican Palace—the Stanza della Segnatura and the Stanza d'Eliodoro. In those rooms, Raphael prominently portrayed Julius in the *Disputa*, the *Approval of the Decretals*, the *Expulsion of Heliodorus*, and the *Mass of Bolsena*.

magnitude of this need contributed to the artist's regression to magical, wishful thinking with respect to his own omnipotent creative powers in planning the tomb project.

It seems, therefore, that quite apart from the external considerations of the mechanics of execution, cost, time, and so on, the project of the pope's tomb, to be erected during his own lifetime, was doomed to failure by the nature of the interaction of these two major figures of the High Renaissance.

It was only a month after being summoned by Julius to Rome that Michelangelo, with two workmen and one horse, departed for an eight-month stay in Carrara to quarry the marble for the tomb. Michelangelo's soaring spirits at Carrara can be inferred from his memory, late in life, of his wish at the time to carve out of a huge rocky crag that overlooked the sea "a colossus which would be visible from afar to seafarers" (Condivi, p. 29). Although he was to make several other journeys to Carrara and another quarrying site, Pietrasanta, many of them prolonged stays, these turned out to be such upsetting and frustrating missions that he may have regretted not having immortalized the innocence and hopefulness of those first months in 1505 when, identifying with seamen cast adrift and far away from home, he wanted to provide a beacon out of what was, for him, the basic substance of the earth—stone.

Michelangelo returned to the papal court from Carrara in December and remained there for four months, until his precipitous flight from Rome back to Florence in April 1506. What Michelangelo has recorded about those few months is most significant in our understanding of the tomb affair and the artist's unconscious drama with respect to paternal authority. The Carrara marble had arrived at the Vatican and Condivi describes it thus:

> So great was the quantity of the blocks of marble that, when they were spread out in the piazza, they made other people marvel and rejoiced the *pope, who conferred such great and boundless favors on Michelangelo* that, when he had begun to work, he would go more and more often all the way to his house to see him, conversing with him there about the tomb and other matters no differently than he would have done with his own brother. And, *in order to be able to go there more conveniently, he ordered a drawbridge built between the Corridor and Michelangelo's room, whereby he could go in there secretly*. [p. 30, my italics]

There is, however, no record of Pope Julius's undertaking construction of a drawbridge so that he might easily be able to visit the artist's bedroom. The circumstance also seems unlikely in the extreme. Therefore, we must assume that at seventy-eight, when fantasy and true recollection merged in this anecdote, what is recorded is Michelangelo's vestigial wish in the matter—that he had become the all-consuming object of Julius's thoughts and adoration. The next passage in Condivi conveys a recurring pattern in Michelangelo, the view that his skill engendered not only envy but more dangerous forms of retaliation from rival artists: "As very often happens at court, the many great favors thus conferred *gave rise to envy and, after envy, endless persecutions*. Thus the architect Bramante, who

was loved by the pope, made him change his plans by quoting what common people say, that it is bad luck for anyone to build his tomb during his lifetime, and other stories" (p. 30, my italics).

The account of what ensued with Bramante is reminiscent of what took place when Michelangelo spent a year in Bologna at age nineteen. There he was virtually adopted by a highly influential Bolognese aristocrat, Gianfrancesco Aldovrandi, in whose home he lived. As we saw in chapter 6, Aldovrandi secured commissions for the young sculptor to execute three statuettes for the tomb of Saint Dominic in the church of San Domenico—*St. Petronius, St. Proculus,* and an *Angel Bearing Candelabrum.* Just as Michelangelo's precocious sculptural achievements in Bologna were increasingly commanding recognition, he fled back to the safety of Florence because, according to Condivi, he believed himself to be in imminent danger of physical violence from envious and rivalrous local artists and craftsmen.

Although artistic rivalries were certainly a reality in the Renaissance, this general fact became the focus for the projection of Michelangelo's own fierce competitive and aggressive impulses toward his rivals. Experiencing himself as innocent and unfairly victimized, he proceeded to act upon the basis of this skewed version of reality. Such was the case in large measure with respect to Bramante and Raphael.

The first phase of the history of the tomb abruptly ended on April 17, 1506, when in the middle of the night Michelangelo fled Rome for the safety of a town in Florentine territory. Michelangelo's account of the events is given in a letter to Giuliano da Sangallo two weeks after the flight (letter 8), and is then repeated in detail in a letter to Cardinal Alessandro Farnese decades later, in 1542 (letter 227), and again in Condivi's *Life.* A few days before his departure the artist said that he had overheard the pope tell a group at dinner that he would not spend a cent more on stone for his tomb. Startled, Michelangelo asked Julius on the spot for money to pay the freight on stones that were due for delivery. As it was Holy Saturday, the pope instructed the sculptor to return for the money on Monday. According to Michelangelo, Julius had told him always to come to him directly for money, thereby avoiding unnecessary delay. On Monday, then again on Tuesday, Wednesday, and Thursday, Michelangelo was turned away and told that Julius was otherwise occupied. On Friday the pope's groom told Michelangelo, "Forgive me, I have orders not to admit you" (Condivi, p. 35). Michelangelo flared up and, on returning home, wrote to Julius: "Most Blessed Father—I was turned out of the Palace this morning by order of Your Holiness. I must therefore inform you that from now onwards, if you want me, you must seek me elsewhere than in Rome" (letter 227).

Michelangelo ordered his belongings in Rome to be sold to "a Jew" and departed that night. Julius sent five horsemen after him, and when they caught up with Michelangelo they delivered a letter from the hand of the pope stating, "Immediately on receipt of this, return to Rome, upon pain of Our displeasure" (letter 227). The artist sent word back to Julius "that in return for his good and faithful

service he did not deserve to be driven from the pope's presence like a villain; and that, since His Holiness no longer wished to pursue the tomb, he was freed from his obligation and did not wish to commit himself to anything else" (Condivi, p. 35).

Once he was back in Florence, however, Michelangelo's bravado dissolved, as is evident from his letter to Sangallo two weeks after the flight, in which he asks Giuliano to "inform His Holiness that I am more than ready to continue the work [on the tomb]" (letter 8). In the same letter he also pleaded to be allowed to continue work according to the provisions of the contract, but in Florence instead of Rome, and promised: "I am certain that if it is carried out, there will be nothing to equal it the world over." The letter makes it clear that the conflict with Julius over money was not the sole reason for Michelangelo's flight. He admits, "There was something else besides, which I do not want to write about," and then suggests that he had cause to think that, had he remained in Rome, his own tomb would be sooner made than the pope's. It can be inferred from Michelangelo's oblique reference that he feared some danger to his life from Bramante or Bramante's followers at the Vatican. Along these lines, in a letter on the subject of the tomb in 1542, Michelangelo concluded: "All the discords that arose between Pope Julius and me were owing to the envy of Bramante and Raphael of Urbino; and this is the reason why he did not proceed with the Tomb in his lifetime, in order to ruin me. And Raphael had good reason to be envious, since what he knew of art he learnt from me" (letter 227).

Pope Julius's interest in the tomb project became subordinated to other plans which directly involved Bramante, not Michelangelo. This situation was intolerable to Michelangelo, because it was in direct conflict with the imagined belief that he had a special relationship with the pope, as implied in his "drawbridge to his room" fantasy. Michelangelo had to contend with the genius of both Bramante and Raphael, and with the fact that Julius had the firm intention of utilizing their talents at the Vatican along with his own. The situation at the papal court replicated significant aspects of the artist's early family setting, in which any fantasy he might have had of an exclusive relationship with his mother was continually intruded upon by the claims of his four male siblings.

The date of Michelangelo's flight from Rome is particularly significant. It was on the eve of the ceremonial laying of the first stone for the new basilica of St. Peter's, to be built to the plan of Bramante, who had been selected for this singular honor over Michelangelo's friend and sponsor, Giuliano da Sangallo.

The idea and early work on the new basilica grew directly out of problems related to the tomb. One problem was where to locate the free-standing tomb. Upon approving the initial design for his tomb, Julius asked Michelangelo to select the place for it in the old St. Peter's. The basilica was built in the form of a Latin Cross, and Michelangelo indicated that the tomb should be placed at the head, where an incomplete choir had been started a half-century earlier by Bernardo Rossellino. However, before the tomb could be installed at that site, a roof would have to be built and the choir finished. The pope sent Sangallo to survey

the situation. He reported back that the Rossellino choir was inadequate for the proposed tomb and suggested that a new chapel be built. Plans for the new chapel were then submitted by a number of architects. However, very much in keeping with Julius's soaring spirit and irrepressible ambitions, the notion of a new chapel for his mausoleum snowballed into a program for the rebuilding of the entire church. Thus, in considering this bold idea of abandoning the form of the Latin Cross of the venerated old basilica and replacing it with a church based on a central plan and covered with a dome, Tolnay (1943–60, vol. 4) concluded that it "would be explained by the fact that the new St. Peter's was conceived on a gigantic scale as a funerary chapel to house the Tomb of Julius II as its center" (p. 21).

With the first stones of the new basilica placed in the ground, Julius suspended payments for work on his own tomb. Why? A more plausible explanation than Bramante's envious scheming against Michelangelo might be that Julius had become fearful that he had gone too far in preempting the focal point of Christian worship, St. Peter's, as a monument to himself rather than to Saint Peter, the prince of the Apostles. The old basilica was built over a cemetery that contained a tomb honoring Saint Peter. Certainly, when several years later Julius grew his beard in defiance of canon law, he had in mind an identification with the martyred Apostle. The resolution of Julius's ambivalent relationship with Peter was to relinquish his ambition to have the new dome placed over his own remains. Instead he directed Bramante to erect a martyrium to Saint Peter. At the very center of the new St. Peter's was to be the confession of St. Peter—that is, an altar built over the tomb of the Apostle whom Christ chose to build the first church. One of the great ironies in the evolution of the new St. Peter's is that it was Michelangelo who, at eighty-three, was finally asked to design the dome for the central crossing, which we may now see in Giacomo della Porta's subsequent modification (fig. 19-8).

There is little evidence to support Michelangelo's charge that Bramante convinced Julius it would bode ill to erect the tomb during his lifetime. It is true that Julius could not settle for anything less than preeminence. In this case, however, preeminence required a radical revision in the natural order of Christ and His spiritual descendents, which proved to be beyond the hubris even of Julius.

Although the similarly choleric temperaments of the pope and the artist tied them in an ongoing, stormy relationship, that relationship had largely the character of a struggle between two awesome wills. In contrast, Bramante, who was the same age as Julius, seems to have had a calmer, more intimate friendship with the pope, serving as his companion on trips and reading to him in the evenings. It may be said that in the end Bramante was Julius's chosen one, whereas the pope's relationship with Michelangelo never really crossed the boundary that naturally existed between a powerful patron and a major artist in the Renaissance. Michelangelo remained and was treated primarily as a highly valued craftsman, not as the towering figure he was later to become.

Not least of the problem for Michelangelo was Bramante's own genius as an

architect. It was Bramante who was responsible for the revolutionary introduction of High Renaissance architecture, with his achievement of coordinating the volumetric control of space with the modeling of mass. Bramante died in 1514, a year after the death of Pope Julius II. Interestingly, it was only after the death of Bramante that Michelangelo ventured into the field of architecture—first in 1515, with copies of details from ancient and contemporary Roman buildings from a larger architectural sketchbook known as the Coner Codex,[7] and then, in 1516, with his bid to do the façade of the church of San Lorenzo in Florence.

In sum, Bramante's talent and his intimacy with Julius II were painful features of Michelangelo's life in the papal court. It is hardly a coincidence that Michelangelo left for Florence on the eve of a ceremony honoring Bramante and the glory he shared with the pontiff of the new St. Peter's. With distance from this triangle and the revered position he held in Florence, Michelangelo felt free to resume work on the tomb, just as long (as he pleaded to the pope in his letter two weeks later) as he was allowed to continue his work away from the papal court. As for his fears of malevolence directed toward him, these were more a projection of his own competitive impulses than they were warranted by fact.

In this connection, the difference between Michelangelo's attitude toward Raphael and Raphael's toward him is striking. Throughout his life, Michelangelo expressed his contempt for and animosity toward Bramante's protégé and implicated Raphael in the factional plots he perceived as being hatched against him. In contrast, Raphael paid homage to Michelangelo in his Vatican masterpiece, *The School of Athens*. In depicting the immortal teachers of antiquity, Raphael portrayed Michelangelo, seated alone in the left-center foreground, as Heraclitus (fig. 9-4). The barely disguised portrait has a grandeur that was unusual for Raphael at this point in his artistic career (ca. 1511) and conveys the brooding, isolated character of Michelangelo, with his enormous strength even in repose. The choice of Heraclitus, the melancholic and introspective master of the enigma, must have been deliberate on Raphael's part.

Throughout the pontificate of Julius II, Michelangelo was forced into the passive position of having to execute the self-aggrandizing inclinations of the pope. During his seven months in Florence following the flight from Rome, Michelangelo was under continuous pressure from Julius to return to his service. The pope issued three briefs to the Council of Florence demanding that they turn the artist over to him. As Michelangelo recalled, the first was ignored in the hope that the pope's anger would abate. Finally, however, Piero Soderini, the Gonfaloniere of Florence, summoned the artist and said: "You have tried the pope as a king of France would not have done. However, he is not to be kept begging any longer. We do not want to go to war with him over you and place our state in jeopardy. Therefore, make ready to return" (p. 36).

7. The Michelangelo drawings after the Coner Codex are Casa Buonarroti nos. 1A r & v, 2A r & v, 3A r & v, 4A r & v, 8A; British Museum nos. W 18 r & v, W 19 r & v.

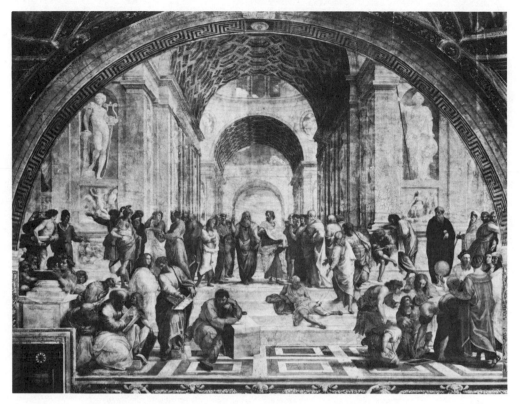

9-4. Raphael, *School of Athens.*

To assuage the artist's fears of harm or punishment if he returned to Julius's service, Soderini appointed him an official emissary to the Vatican, thereby assuring him diplomatic immunity. In the letter Soderini gave Michelangelo to present to his brother, the cardinal of Bologna, which was to be passed on to Pope Julius, the Gonfaloniere revealed his understanding of Michelangelo's deep sensitivity and hunger for genuine acceptance. He wrote, "His nature is such that with encouragement and kindness he will accomplish anything; show him courtesy and affection and he will accomplish things that will astonish the beholder."[8] Soderini well knew that Michelangelo's creative abilities were enormously dependent upon the encouragement of an idealized and devoted patron. So Michelangelo departed for Bologna on November 28, 1506, to make his submission to the pope and begin the bronze statue of him. As Michelangelo later reported his reunion with the pope, Julius was more intent on pacifying the artist than on punishing him.

Clearly, Michelangelo would have been content to remain in Florence. When he left later in the year for his fourteen-month stay in Bologna he felt coerced. The thirty-one extant letters to his father and brothers from Bologna demonstrate that his emotional investment lay with petty family affairs in Florence, not with

8. Translated by Ramsden (1963, 1:xxxii).

his sculptural task or court life in Bologna. Recalling the circumstances of his return to Julius, he wrote in a letter in 1524, "I was forced to go there [Bologna], with a rope around my neck, to ask his pardon" (letter 157).

Although a point of some disagreement among scholars, it appears that once the Sistine Chapel ceiling was completed and opened to public view in October 1512, Pope Julius, who was rapidly failing in health and only a few months away from death, ordered Michelangelo to resume work on his tomb. This can be reasonably inferred from a letter the artist wrote to his father, dated November 5, 1512, in which he stated, "I am well, thank God, and working" (letter 86), as there were no other artistic projects before him at the time. The della Rovere family purchased a house in Rome for Michelangelo, where he was to work on the tomb project. Then, two days before his death in February 1513, Julius decreed that the tomb was to be placed next to that of his uncle, Pope Sixtus IV, in the old Sistine Chapel. He provided in his will a large sum of money (10,000 ducats)[9] for its completion. Thus, with the passing of Julius II, Michelangelo's hopes for the completion of the tomb were again raised, only to end in bitter disappointment as the years unfolded.

9. An approximation of the value of a unit of currency used in one epoch with one used in another is, at best, a loose estimate. Nevertheless, H. Wohl, in 1975, has provided us with a guide by estimating that one ducat was roughly equivalent to fifty present-day U.S. dollars (Condivi, 1553, glossary).

Chapter Ten

Return to Florence and the St. Matthew, *1506*

During Michelangelo's seven-month respite from Pope Julius II's service during 1506, he devoted most of his energy to carving the Apostle *St. Matthew* (fig. 10-1) for the Cathedral of Florence. This work invites exploration because it marked a dramatic turn in the evolution of Michelangelo's artistic style.

The origin of the *St. Matthew* was that in 1503 Michelangelo accepted a commission from the Guild of Wool Merchants to execute twelve larger-than-life-size marble Apostles for the Cathedral, to be delivered at the rate of one a year. The block for the first of the series reached Michelangelo's hands in December 1504, while he was engaged with the cartoon for the *Battle of Cascina*. It is generally assumed that since Michelangelo left Florence to serve Pope Julius four months later, little, if any, work was done on the *St. Matthew* marble until his return in 1506. The statue is largely uncompleted. In contrast with many of Michelangelo's other unfinished sculptures, which remained so because of the artist's internal conflicts, the *St. Matthew* was left as it is because he was recalled by Julius II later in the year and was committed to serving the pope until the latter's death in 1513.

In the *St. Matthew*, Michelangelo introduces into his art a new level of contorted anatomy and extremes of muscular tension. This new image of the human figure may be viewed as a reflection of Michelangelo's agitated state of mind while he was doing the carving. In tracing the connection between the two it is illuminating first to examine a sheet of drawings from 1503–04, on which he sketched an early design for the Apostle (fig. 10-2). On the far left the figure is sketched nude; on the right, in the more finished version, with drapery. This original concept of a slow-moving, contemplative, grand figure is consistent in spirit with the tradition of Donatello's prophets of the mid-fifteenth century.

In 1506, when Michelangelo started carving *St. Matthew*, he was in a very different state of mind than he had been in the days when he made the first sketches. So, compared to the studied, deliberate approach of his earlier sculpture, the *St. Matthew* expressed an impassioned attack on the marble. One immediately senses Michelangelo's immersion in the work. This quality moved one Michelangelo scholar to say, "The statue is no longer something external to himself, but a projection of his total personality" (Pope-Hennessy, 1970, p. 14). Michelangelo has maintained some features of the early study—the exposed right arm and shoulder, the block to support one leg, and the large folds of drapery framing the

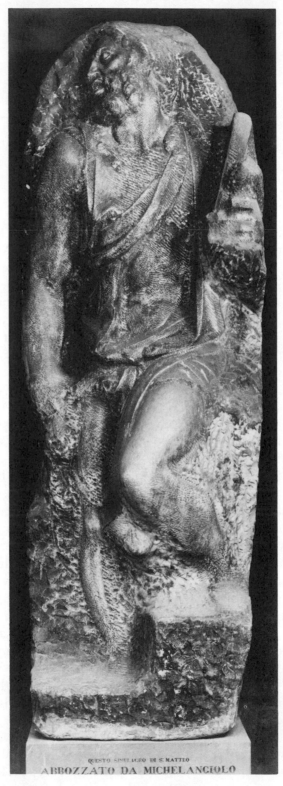

QUESTO SIMULACRO DI S. MATTEO
ABBOZZATO DA MICHELANGIOLO

10-1. Michelangelo, *St. Matthew.*

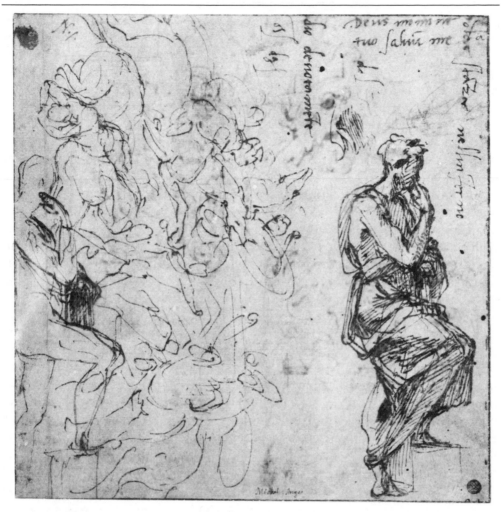

10-2. Michelangelo, studies for a battle scene and for a statue of an Apostle.

upper half of the figure. But in the carved work these have become incorporated into a distinctive new style that was thereafter to characterize most of his sculpture. The aesthetic tension is produced by the paradoxical opposition of related forces. The *St. Matthew* contains the extremes of *contrapposto* and expressive muscular effort. And yet effective action is never achieved and locomotion never takes place. The sculptured figures that follow, for all of their herculean strength, are immobilized. The internal forces, in the end, seem to neutralize one another. Whether they are the raging forces in *St. Matthew* or the melodious ones of the dreamlike *David-Apollo* (fig. 15-24), the ultimate effect is the same in this respect. The achievement of this new dynamic between muscular effort and inhibited movement is a statement of internal conflict that transcends the individual figure and the situation.

The change in Michelangelo's art marked by the *St. Matthew* raises certain

issues concerning aesthetics and the creative process. It has become axiomatic to regard all artistic productions as containing, in varying degrees, projections of thoughts and feelings of the artist that are not even conscious in him. Art, however, is only "art" when the creator is able to express his hidden mental life with such technical skill, as well as sublimation of the unconscious roots and generalization of the content, that the creation is transported from the limited province of dreams and fantasies to a realm of human experience which the behold-er can recognize and share. The artist, therefore, must steer a course between the sterility of being too programmatic and the sentimentality of undisciplined per-sonal statement.

We have inferred that during the seven-month period of carving the Apostle, Michelangelo was in a state of extreme anguish, fear, and anger as a result of his conflict with Pope Julius. Could it have been otherwise following his dramatic nighttime flight back to Florence, the pope's command that he return, his continu-ous refusal, and the Florentine *gonfaloniere* urging and then insisting that he obey Julius? Yet, with the *St. Matthew*, Michelangelo seemed freer to take a risk and allow his inner state of agitation to inform the character of the statue. As he worked on the block of marble day after day, the boundary between his own state of feeling and his concept of the figure he was engaged in creating was suspended and restored in repetitive cycles. In other words, Michelangelo fluctuated between being at one with the stone and being at a distance from it, where an extraordi-nary intellect guides the hammer and chisel. How illuminating it would be if we had Michelangelo's own description of what he experienced during the creative process! But in all his correspondence he avoided any mention of his inner experience as he worked. At most, he occasionally alluded to a mundane mechan-ical problem or to a financial obstacle that stood in the way of its execution. In the few references to his work in his verse, he tried to minimize the element of personal passion involved in creativity. For example, some years later (ca. 1535) he wrote:

> The best of artists never has a concept
> A single marble block does not contain
> Inside its husk, but to it may attain
> Only if hand follows the intellect.[1]

In these lines Michelangelo denies a creative role to his emotions in his artistic conception (*concetto*). The notion that his creation could be attained by a skilled hand under the executive guidance of the intellect may have been comforting, but I do not think he believed it about himself. He was keenly aware and fearful of his propensity for losing his sense of self-control and autonomy. As we shall see in chapter 16, it was only in his love sonnets and presentation drawings to Tommaso de' Cavalieri that Michelangelo felt able safely to express the exquisite pleasure associated with total abandonment in imagining a state of fusion with the ideal-

1. Gilbert and Linscott (1963, poem 149).

ized object of his affection. In real relationships, however, he was far more cautious. Thus, in Giannotti's *Dialogi* (1546), he expressed apprehension over his response when in the company of someone who possessed a talent or quality that he deeply admired. In such a circumstance, he said, "I am compelled to fall in love with him; and then I give myself up to him so entirely that I am no longer my own property" (p. 132). It was within the safety of inert stone that Michelangelo found a refuge where he could reveal his soul. And it was his capacity to lose himself in the stone, along with an everhovering inventive and critical intellect, that was intrinsic to his sculptural genius.

The formal conception of *St. Matthew* was largely inspired by the Hellenistic group *Laocoön* (fig. 10-3). This ancient work had been excavated from a vineyard in Rome in January 1506, shortly before Michelangelo fled the city. There is documentation that Michelangelo was deeply affected when he saw the statue immediately after its discovery. The artist's profound identification with the tragic narrative of the *Laocoön* group will be discussed in detail in chapter 12. Suffice it to say here that the *St. Matthew* is an example of the not infrequent pattern whereby Michelangelo adopted the formal aspects of an image from an antique source with a different narrative theme, which touched unresolved unconscious currents in him, and incorporated them into part of the formal design of his own piece of sculpture.

In the case of the *St. Matthew*, our knowledge that Michelangelo turned to the *Laocoön* for the formal basis of the image of the Apostle reveals something of the private meaning of the anguished image for him. The *St. Matthew* expanded the search for the means of expressing turbulent emotionality through the human figure, in a still, aesthetically disciplined way. It was a process that had gained momentum with the *Battle of Cascina*. The physical energy and dramatic excess of *Laocoön* also served as license from the ancients to continue his own evolving inclination.

It is interesting to note briefly the progression in the formal means of expressing extreme emotion that is initiated in the *St. Matthew*. The pose of the Apostle evolved some five years later into the unlikely figure of the crucified Haman in the Sistine Chapel spandral of the *Punishment of Haman* (fig. 10-4). One of Michelangelo's finest drawings is a preparatory study of Haman (fig. 10-5). Here the revolutionary beginning made in the *St. Matthew* is carried to the extreme in communicating excruciating affect. Haman and Matthew do not share identical positioning of body parts. The artist has, however, found a compositional formula that achieves a very similar impact. This extraordinary drawing of Haman prompted Hartt (1970) to write: "No more passionate embodiment of Michelangelo's tragic world- and self-view in human form can be seen in any of his drawings" (p. 84).

Before leaving the *St. Matthew*, I would like to venture another speculation about a possible identification on Michelangelo's part with the life and symbolism of the Apostle Matthew. We assume that an artist may find in a subject—even one that is assigned to him—themes that resonate with parallel concerns and

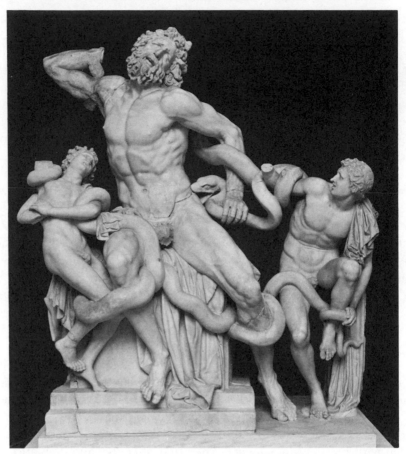

10-3. Agesandros, Polydoros, and Athenodoros of Rhodes, *Laocoön* (ca. 100–80 B.C.?).

conflicts within himself. The artist then imposes his own specific experience upon the work in the form of his distinctive representation. This fact is one of the cornerstones of a psychoanalytic approach to the understanding of the creative process in any given work of an artist. With respect to Michelangelo and Matthew, we find that Matthew, prior to his sacred calling of Apostle and subsequent recorder of the life of Christ, had led a secular life as a tax collector. The story of Matthew's conversion was still linked during the Renaissance to a medieval tradition according to which interest in money was equated with the deadly sin of avarice (see Vlam, 1977). It was, after all, a conflict with the pope over money that had precipitated Michelangelo's flight back to Florence in 1506. We may posit that Michelangelo's intense concern about money was also a source of guilt for him, which contributed to his identification with Matthew and the hope of redemption through good works.

The *St. Matthew* does not record a particular historical moment in the life of the Apostle but, again, Michelangelo's inner struggle. We are left with a statement in stone of the state of mind of the artist during the year 1506.

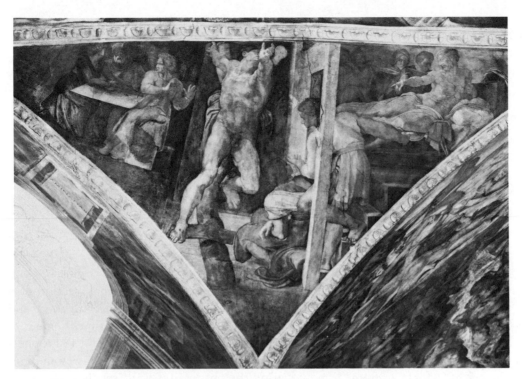

10-4. Michelangelo, Sistine Chapel ceiling: *The Punishment of Haman.*

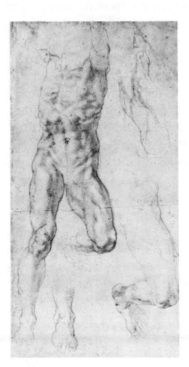

10-5. Michelangelo, studies
for the *Crucified Haman.*

Chapter Eleven

The Sistine Chapel Ceiling

One pushes his way through the narrow doorways of the crowded Stanze of Raphael into the undersized passageways, and then emerges from the little stairwell into the Sistine Chapel. The first response is confusion. The ceiling is so far away. No tilt of the head can enable one to see more than a small section at a time; the rest seems upside down (figs. 11-1, 11-2a, and 11-2b). Slowly and uncomfortably the images one has seen pictured in books so many times come into focus. Yes, there is the *Creation of Adam*! Other familiar "histories," the Prophets and Sibyls, and the Ignudi slowly emerge. One is distracted by the awesome *Last Judgment*, which, unframed and covering the entire altar wall, seems to draw the viewer into some unearthly world of space beyond the confines of the chapel. One is jostled by the roving little masses of guided tours. Soon one is saturated, yet lingers beyond the time when his faculties can assimilate the myriad images. On leaving one has a vague sense of failure—of having allowed the essence of that universe of swirling imagery to elude him. One has, however, grasped that the ceiling is a fantastic world of the imagination of a man who has deeply penetrated the mysteries of human existence. In it the images have become wedded to the complex architecture of the vault they inhabit. And the images themselves merge into a continuous symphony that culminates as it approaches the altar wall with *The Separation of Light and Darkness* (fig. 11-3), in which God is transformed into a whirling mass of generative energy emerging out of infinite chaos.

The history of the scholarship of the Sistine Chapel ceiling has run parallel to the quest for comprehension on the part of the individual viewer. Major scholars of Michelangelo have proposed an ideology that guided the artist in an effort to unite the whole into one coherent schema, but these efforts at synthesis—each erudite and persuasive when taken alone—are often at odds with each other. Tolnay (1943–60, vol. 2), for example, sees the ceiling within the context of the Neoplatonic thought of the time; Hartt (1950) advances a comprehensive explanation in terms of Franciscan theological doctrine; and Wind (1960), places it within the framework of Dominican theology and the influence of Savonarola. More recently, Dotson (1979) has interpreted the ceiling as a pictorial expression of the writings of Saint Augustine. Whatever organizing principle is espoused dictates a distinctive interpretation of the action and purpose of the figures. Thus, for example, Tolnay sees the Prophet *Jonah* (fig. 11-4) as being in a state of ecstasy, crying out his praise for the Lord who, having heard the cry of his affliction, led

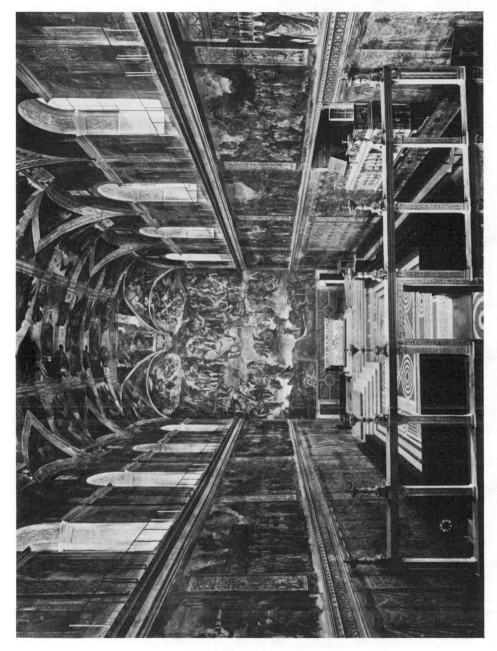

11.1. Michelangelo, Sistine Chapel: view looking toward the altar and *The Last Judgment.*

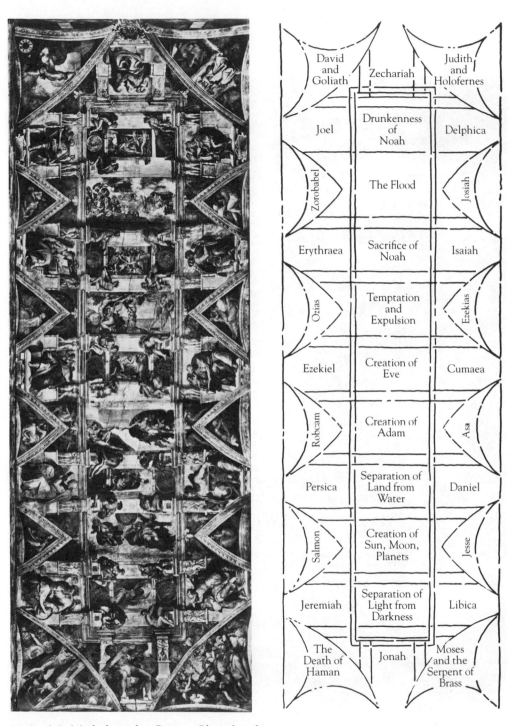

11-2. (a) Michelangelo, Sistine Chapel ceiling.
(b) Plan of the Sistine Chapel ceiling frescoes by Michelangelo.

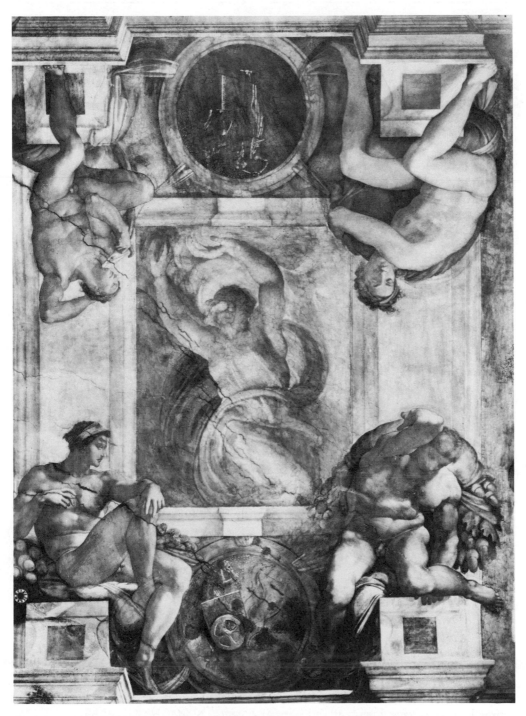

11 3. Michelangelo, Sistine Chapel ceiling *The Separation of Light from Darkness.*

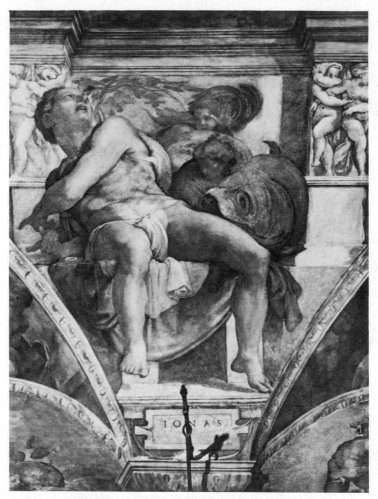

11-4. Michelangelo, Sistine Chapel ceiling: *Jonah.*

him into a state of grace (Jonah 2:2). Hartt, in contrast, sees Jonah as pulling in a net of fish from behind his right shoulder, and therefore as foretelling the New Testament episode of Peter called Simon Bar Jonah (the son of Jonah) and the Miraculous Draught of Fishes (John 21:6). For Wind, Jonah is here depicted in the midst "of arguing with God about justice and grace, demanding the destruction of the wicked" (Jonah 4:1–3). Finally, Dotson focuses on the whale and the withering of the shade of gourd vine behind Jonah. She then concludes that Michelangelo intended Jonah to be read as a "'sign' of the Resurrection" of Christ (Matthew 12:39–40) and the "salvation of nations."

Similarly, multiple interpretations of the twenty Ignudi which frame each of the nine histories have been offered over the years. None, however, has been sufficiently persuasive to become the standard for thought on the matter.

What can we conclude from this wide variety of interpretations? Documents on the planning and execution of the ceiling are virtually nonexistent. Michelangelo

later said that Pope Julius had given him a free hand in the program for the ceiling ("He gave me a new commission to do what I liked").[1] It is generally believed, however, that Michelangelo must have worked out the program in consultation with a papal theologian. Nevertheless, the final work gives ample evidence that in all of the categories of the ceiling he was allowed to take liberties with the biblical text in the service of asserting his artistic vision.

For example, in the very first of the "histories," *The Drunkenness of Noah* (fig. 4-3), Michelangelo introduced the manifest contradiction of painting Noah's three sons nude while covering their nude father out of shame. We can only conclude that, apart from the more personal meaning of the drama between nude father and sons, as Wölfflin (1899) pointed out, Michelangelo was claiming his right at the outset to tell his stories by means of nude figures. Thus, the ceiling is an inseparable amalgam of the biblical texts of Genesis, the sin and fall of man, the foretelling of redemption, and Michelangelo's own imagination.

Throughout this book I have referred to parts of the Sistine ceiling in the context of the discussion at hand, thus sacrificing appreciation of the relationship of the particular image under discussion to the ceiling as a whole. Such questions as how the image is related to surrounding themes, at what point the work was done in the sequence of painting the ceiling, what the artist's mood was at a particular time as can be inferred from his letters home—all must generally go unanswered. Rather, in this chapter I shall mainly address the larger issue of what meaning painting the ceiling held for Michelangelo. As we shall see, it seems to have been inextricably tied to his relationship with Pope Julius II. Furthermore, I shall address the manner in which that relationship helped to shape some of the principal imagery of the ceiling.

As I have already emphasized, Michelangelo's profound need to see himself as captive, forced against his will and better judgment to carry out the wishes of some more powerful male, pervades the account of the tremendous undertaking given by Michelangelo in Condivi's *Life*:

> When Michelangelo had finished this work [the bronze statue of Julius II in Bologna] he came on to Rome, where Pope Julius, still resolved not to do the tomb, was anxious to employ him. Then Bramante and other rivals of Michelangelo put it into the pope's head that he should have Michelangelo paint the vault of the chapel of Pope Sixtus IV, which is in the palace, raising hopes that in this he would accomplish miracles. And they were doing this service with malice, in order to distract the pope from projects of sculpture, and because they took it for certain that either he would turn the pope against him by not accepting such an undertaking or, if he accepted it, he would prove considerably inferior to Raphael of Urbino, whom they plied with every favor out of hatred for Michelangelo, as it was their opinion that Michelangelo's principal art was the making of statues (as indeed it was). Michelangelo, who had not yet used colors and who realized that it was difficult to paint a vault, made every effort to get out of it, proposing Raphael and pleading that this was not

1. Ramsden (1963, letter 157).

his art and that he would not succeed; and he went on refusing to such an extent that the pope almost lost his temper. But, when he saw that the pope was determined, he embarked on that work which is to be seen today in the papal palace to the admira-ton and amazement of the world, which brought him so great a reputation that it set him above all envy. [p. 39]

To arrive at some of the meaning of the ceiling project for Michelangelo it is useful to place Condivi's account in some perspective with respect to fact and distortion. Most of the documents surrounding the ceiling project were destroyed in the 1527 sack of Rome. There is no information independent of Michelangelo himself about what finally persuaded Julius to entrust the ceiling to him. From a letter by Piero Roselli (a stonemason who later prepared the ceiling for painting) to Michelangelo, dated May 10, 1506 (less than a month after the artist's flight back to Florence), it is documented that Pope Julius wanted to dispatch Giuliano da Sangallo to bring back Michelangelo for the explicit purpose of painting the chapel ceiling. Julius was dissuaded from this plan by Bramante, who, in Piero's presence, said to Julius: "he [Michelangelo] told me many times that he did not wish to have anything to do with the Chapel though you wanted to burden him with it, and that, moreover, you did not pay any serious attention either to the tomb or to the painting of the ceiling."[2] Bramante added that he thought Michelangelo a poor choice for so major an undertaking because of his virtually total lack of experience in painting, much less fresco technique, and in the particular requirements of ceiling painting with regard to foreshortening figures.

From this letter several important points emerge. First, the pope had the painting of the Sistine ceiling in mind for him while Michelangelo was working on the tomb project, well before the celebrated rebuff by the pontiff and flight by the artist. Moreover, the project had clearly been proposed to Michelangelo, who had repeatedly asked not to be burdened with the assignment. At this point one must conclude that Bramante, as the pope's trusted advisor, acted protectively toward Michelangelo, discouraging the pope's attempt to force him into the project against his will. His advice with respect to not entrusting so major a project, and one very dear to the pope, to a painter inexperienced in fresco work seems quite sensible, rather than grounded in malevolent motives.[3] Certainly Bramante could not have been trying to save the project for Raphael, as it was another two years before the young Raphael came to the papal court.[4]

Michelangelo's version describing Bramante's villainy and devious scheming in the matter must be rejected as highly improbable. There are no other data to support this view of Bramante's character. Moreover, it is untenable that Bramante would toy with the aging pontiff in dooming the chapel, which was in essence to be a monument to the della Rovere popes Sixtus IV and Julius II, by

2. Translated in Seymour (1972).
3. Michelangelo as a thirteen-year-old apprentice probably assisted Ghirlandaio in the fresco program for the Tornabuoni Chapel in Santa Maria Novella, and he may have done some beginning work on the wall for the *Battle of Cascina*, although whether the *Battle* reached this stage is unclear.
4. This conclusion about Bramante has been reached by Ackerman (1970) and Seymour (1972).

having it commissioned to an artist he believed would botch the job. We are then left with the question, why did Michelangelo maintain, nearly fifty years later, that the ceiling, which after all turned out to be gloriously successful, was the consequence of Bramante's evil motives?

In approaching the question of Michelangelo's later version of the ceiling story it is useful to review the forty-two letters he wrote during the four years in which he was working on the project. The most striking aspect of this body of correspondence is the omission of significant comment about his work in the chapel. There is absolutely no mention of any detail of aesthetics, iconography, formal solutions, guiding philosophical concerns, or the like. Rather, it is the monetary aspect of the project that is mentioned—again and again. At the end of January 1509, Michelangelo wrote to his father: "I am still in a great quandary, because it is now a year since I had a *grosso* from this Pope and I do not ask for anything because my work does not seem to me to go ahead in a way to merit it. This is due to the difficulty of the work and also because it is not my profession" (letter 45).

In fact it was only eight months since he had received funds from Julius, but he dealt with the pope's withholding attitude most effectively by suppressing his rage at his patron and, instead, denigrating himself with the comment that his work does not "merit" payment. Five months later Michelangelo wrote to his father that he had still not received money from the pope. His state of mind can be inferred from the agitated close to the letter: "Here I'm living ill-content and not too well, faced with an enormous task, without anyone to manage for me and without money. However, I have good hope that God will help me" (letter 46).

In another letter (no. 49) written during that period (quoted in chapter 5), the artist exploded in a postscript to his brother Giovan Simone about the twelve years of miserable life he had suffered, marked by every kind of humiliation and hardship.

Several months later, in October 1509, he wrote to Buonarroto: "I am living here in a state of great anxiety and of the greatest physical fatigue; I have no friends of any sort and want none. I haven't even time to eat as I should. So you mustn't bother me with anything else, for I could not bear another thing" (letter 51).

Although there is some uncertainty regarding the sequence of work on the ceiling (see chap. 3, n. 7), this last letter was probably written shortly after the scaffolding was taken down, marking the completion of the first half of the ceiling, which consisted of the three Noah histories, the *Temptation and Fall,* and the *Creation of Eve,* along with the adjacent Ignudi, Prophets and Sibyls, and lesser figures.[5]

5. Originally, in 1506, Pope Julius had in mind a ceiling that was but a modest precursor of what later was to be. From Michelangelo's first preparatory drawings in 1508 it can be deduced that the ceiling was to be composed of the Twelve Apostles in the twelve areas that carried the curved vault down to the wall between the chapel windows. The Apostles would be seated on thrones surrounded by geometric and ornamental decoration. See Sandström (1963) for a reconstruction of the first project for the ceiling.

It is beyond our capacity to speak with assurance about Michelangelo's state of mind during the period of the first half of the ceiling. To the extent that he could, he made the vault of the Sistine Chapel his private world. At the outset it was his plan to bring his boyhood friend Francesco Granacci and four other painters from Florence to assist him with the fresco. Vasari relates that they were also expected to teach Michelangelo aspects of fresco painting, in which they were experienced. The work they did, however, fell far short of Michelangelo's expectations, and within a few months he had them permanently barred from entry to the chapel. Thereafter, he did the painting entirely by himself, behind a locked door. The only assistants he is assumed to have had was someone to grind the pigments for the paint and another to mix the plaster for the fresco technique (in which pigments are applied while the plaster is still moist so that they dry inside the thin coat of plaster rather than on the surface). The fact is that Michelangelo was painting the largest mural ever commissioned, in a way no other artist ever had—alone. Furthermore, rather than following the usual method of painting ceilings, in which the painter would lie on his back on the scaffolding, Michelangelo painted much of the time in a standing position, looking up at the ceiling. The physical strain must have been formidable. In a satirical sonnet sent to a friend during the work he described it himself:

> My belly's pushed by force beneath my chin
>
> My beard toward Heaven, I feel the back of my brain
> Upon my neck, I grow the breast of a Harpy;
> My brush, above my face continually,
> Makes it a splendid floor by dripping down.
>
> My loins have penetrated to my paunch,
> My rump's a crupper, as a counterweight,
> And pointless the unseeing steps I go.
>
> In front of me my skin is being stretched
> While it folds up behind and forms a knot,
> And I am bending like a Syrian bow.[6]

This poem is also important in that it establishes a range to the light in which Michelangelo could regard himself. Although the content of the poem is his considerable suffering, the style does not convey the morbid, self-pitying martyrdom that so often erupts in his letters; rather, it is a whimsical exercise in ironic distance from himself, further illustrated by a wonderful caricature of himself and his ceiling subject matter in the margin (fig. 11-5).

It would be romanticizing to conclude that during the time the first half of the ceiling was being painted, Michelangelo lived in a continuous state of torment, locked alone in the huge, dark, cold chapel, communing only with the figures in the fantastic world he was creating. Though partially true, it is clear from his

6. Gilbert and Linscott (1963, poem 5).

11-5. Michelangelo, caricature of *Self Painting the Sistine Chapel Ceiling.*

letters to his family that his artistic concerns were counterbalanced by an ongoing interest in the more simple and practical matters which concerned them. For example, in 1509, the widow of his father's brother was suing Michelangelo, his father, and his brothers for recovery of her dowry. Concerning this matter, he wrote to his father:

> I learn from your last how the case is going. I am very concerned, because I'm sure that with these notaries one is bound to be the loser whatever happens and to be cheated all round, because they're all thieves.[7] Nevertheless, I suppose she herself will be paying out money too. If you are unable to come to a reasonable agreement, I urge you to defend yourself as well as you can. . . . In this affair we must not consider the expense. And when there is nothing left to spend God will help us. [letter 47]

By this time Michelangelo had clearly become the paterfamilias. His continuous concern for his family's welfare, despite his sense of often being drained emotionally and financially by them, and their apparent presence in his daily thoughts provided an essential sustaining sense of continuity with the familiar. This continuity in thought of family and the past served as the stable ballast that enabled him also to immerse himself fully into the world he was creating, with apparently few distractions in Rome. This peculiar balance between attentiveness to his

7. Ramsden, in a footnote to this letter, points out that notaries of the day were indeed notoriously dishonest.

family and absorption in his immediate task is another testimony to Michelangelo's exceptional ability to compartmentalize thought and psychic organization.

Other artists commissioned to execute large frescoes employed a staff of assistants and apprentices. Why not Michelangelo? The answer is probably related to the fact that he never discussed any of the artistic aspects of the ceiling program in his correspondence. One reason for this taciturnity was that he felt obliged to hide his feelings of profound involvement with the project. Michelangelo's tendency to mask his true feelings emerges in the satirical poem above, written to his friend Giovanni of Pistoia. The poem concludes:

> John, come to the rescue
> Of my dead painting now, and of my honor;
> I'm not in a good place, and I'm no painter.[8]

These words are ironic. From the description of the physical hardship in the earlier lines, one assumes that this undated poem was written when the painting was well under way. By then, Michelangelo must have acquired enough realistic confidence in his capacity to execute the work with grandeur in keeping with the demands of the visionary Julius. Thus, to call for rescue because he was "not in a good place" and "no painter" when he was in fact painting in the very center of Christendom, in the chapel where the sacred deliberations of the College of Cardinals and private services of the papal court took place, and, moreover, was witnessing the expansion of his technique and conception with each succeeding unit of the ceiling, must be interpreted as the need to deny publicly what he was experiencing: the possibility of realizing his own conflicted yet grandiose fantasies. Still, even in the ironic style of his denial he draws attention to his accomplishment. The Sistine Chapel ceiling, by this time, stood in marked contrast to the unrealistic and unrealizable plan for the tomb of Julius. To curb his inclination for the fantastic Michelangelo required an external structure. In the colossus of *David* the structure was provided by the preexisting block of marble, which perforce defined the limits of the figure. Similarly, in the Sistine Chapel project, the complex architecture of the ceiling and its overall finite dimensions defined the boundaries of the task.

What was the central element in Michelangelo's fantasies about the successful achievement of the ceiling, which made him experience it so ambivalently—indeed, as an act of one enslaved? I do not think it had very much to do with his desire to be regarded by the world as the preeminent artist. Nor did it particularly concern the expression in images of unneutralized, unconscious themes of an unacceptable sexual or aggressive nature. Rather, the conflict revolved around the work of art as the vehicle for an unrealistically fantasized relationship with the patron of the work.

In this regard, on the one hand, Michelangelo speaks of the pope's hovering interest. Condivi relates that during the painting "Pope Julius often wanted to go

8. Gilbert and Linscott (1963, poem 5).

and inspect the work; he would climb up by a ladder and Michelangelo would hold out a hand to him to help him up onto the scaffolding" (p. 57). From Michelangelo came other anecdotes describing banter with Julius over aspects of the painting and the pope's irritation with others. When the ceiling was complete, he wrote succinctly to his father, "I have finished the chapel I have been painting; the Pope is very well satisfied" (letter 83). On the other hand, documents reveal what must be construed as a deliberately sadistic and withholding attitude toward Michelangelo on the part of the pope. This seemed calculated to keep the artist in a continual state of anxious uncertainty, and was reflected when Michelangelo recalled a decade later:

> When the vault was nearly finished the Pope returned to Bologna; whereupon I went there twice for money that was owed me, but effected nothing and wasted all that time until he returned to Rome. When I returned to Rome I began to do the cartoons for the said work . . . in the expectation of having the money to finish the work. I was never able to obtain anything. [letter 157]

Finally, when he threatened to leave Rome, payment was arranged.

Michelangelo's feelings about Pope Julius II were subtly revealed in a sonnet he wrote to the pope during his work on the ceiling—probably toward the end:

> If any ancient proverb's true, my Lord
> This is the one, that those who can, don't wish.
> You have believed what's fabulous and false,
> And let truth's enemy have your reward.
>
> I am your faithful servant, as of old;
> I am to you as the sun's rays are his.
> My time does not disturb you or distress,
> I've pleased you less the more that I have labored.
>
> At first I hoped your height would let me rise;
> The just balance and the powerful sword,
> Not echo's voice are fitted to our want.
>
> But virtue's what the Heavens must despise,
> Setting it on the earth, seeing they would
> Give us a dry tree to pluck our fruit.[9]

In this poem of accusation and yearning, Michelangelo describes the power and miscarriage of power on the part of Julius, counterposed to his own abused virtue. At the center of the poem is Michelangelo's self-pitying image of his own subordination to the unworldly power of the pontiff, as the rays of the sun are no more than emanations from the energy of the sun. He believes that despite his great effort and accomplishment he has not pleased the pope. He represents himself as being passive in this effort, requiring the power of the pope to energize him. Instead of providing that generative encouragement, he accuses the pope of treat

9. Ibid., no. 6.

ing him in extension of an attitude shaped by the lies of the Bramante-Raphael camp ("You have believed what's fabulous and false").

The sonnet ends with the striking image of Michelangelo set on earth with only dead trees to nurture him. This image also finds its way onto the ceiling, in the representations of Paradise as a barren desert in the *Expulsion from Paradise* (fig. 11-6) and the prominent stump of a dead tree in the *Creation of Eve* (fig. 11-7). The poetic image suggests, first, Michelangelo's abiding sense of oral deprivation and, second, the transferral of his early childhood quest for nurturance to a strong male figure because the early maternal ones were so frustrating. Despite the shift from the usual course in the development of object relations, in this case of expectations from a female to an older male, what was intended to be restorative became an unwavering repetition of the frustrating early-childhood situation. The narcissistic, self-aggrandizing, and inconstant Julius was destined to be a source of intense disappointment for Michelangelo in view of the enormity of the artist's fantasized expectations. Moreover, Michelangelo's own eccentric and unpredictable behavior served to keep Julius at an emotional distance that then became a source of even greater frustration and despair.

In this connection, we have a revealing glimpse of the pope's view of Michelangelo in a 1512 letter from the artist Sebastiano del Piombo to Michelangelo. Sebastiano relates that in a conversation with the pope in which Julius, after noting that Raphael had changed his style in imitation of Michelangelo, said, "'But he is terrible, as you see; one cannot get on with him.' I answered to his Holiness that your terribleness hurt nobody, and that you only seem to be terrible because of your passionate devotion to the great works you have on hand."[10]

Another vignette that conveys the highly sado-masochistic tinge of the relationship between pope and artist is offered by Condivi. Although one is left with the feeling that of such incidents Michelangelo's recall over the many years has been shaped by dramatic license, such distortion of the events underscores the subjective meaning of what actually happened as well as the nature of the relationship between the participants. Referring to what must have been the later stages of work on the ceiling, Condivi wrote:

> Many other things happened to him during the lifetime of Pope Julius, who loved him with all his heart and with more concern and jealousy for him than for anyone else whom he had around him. This can be inferred quite clearly from what we have already written. Indeed, when the pope suspected one day that Michelangelo was annoyed, he sent someone at once to placate him. It happened in this way: Michelangelo, wishing to go to Florence for the feast of S. Giovanni, asked the pope for money. And, when the pope demanded when he would finish the chapel, Michelangelo answered in his usual way, "When I can." The pope, who was precipitate by nature, struck him with a staff which he had in his hand, saying, "When I can, when I can." However, after Michelangelo had gone home, he was making preparations to go without fail to Florence when Accursio, a young man much in favor, arrived from

10. Translated in Symonds (1893, 1: 347).

the pope and brought him five hundred ducats, placating him as best he could and making the pope's excuses. Michelangelo accepted the apology and went off to Florence. Thus it was evident that *Julius had no greater concern for anything than for keeping this man with him; and he wanted to employ him not only during his lifetime but also after his death.*

Thus, when he was approaching death, he commanded that Michelangelo was to be commissioned to finish that tomb which he had already begun. [pp. 58–59, my italics]

To dismiss this passage as another example of the interaction between two overwrought eccentrics is to obscure an element that both men were defending themselves against—the eruption of strong unconscious homosexual impulses toward each other. The passage describes a "jealous" pope, whom Michelangelo teases with a provocatively evasive answer, sensing the physically failing pope's anxious concern. The pope subdues him symbolically, with his staff. Wounded feelings, apologies and forgiveness, and a symbolic bond in the tomb beyond the reaches of life are all asserted. The passage gives us a glimpse of Michelangelo's vacillation between the idea of himself as "rebellious" slave and "yielding" slave— a dichotomy that dominated the first two statues Michelangelo actually completed for the Tomb of Julius—the Louvre's *Dying Slave* (fig. 12-1) and *Rebellious Slave* (fig. 12-2). The subject of homosexuality with respect to Michelangelo will be discussed fully in chapter 16. Suffice it to say here that the idealization of the nude male youth, which is dominant in the imagery of the Sistine ceiling and becomes a principal means for expressing a cosmology, represents an extraordinary achievement in the creative sublimation of homosexual longings.

To return to the progress of work on the ceiling, one can imagine Michelangelo's disappointment when the scaffolding was removed from the finished first half of his painting in August 1510 upon discovering that the pope had left Rome a week or so earlier in order to lead his troops against the French.[11] The pontiff did not return to Rome for six months and, for reasons that are not clear, did not view the finished half until August 1511, a whole year after its completion.[12] It was during this period that Julius was faring poorly in the field against the French and grew his beard. He had been seriously ill and was obsessed by his vision of driving the French from Italy, not concerned with fulfilling Michelangelo's psychological needs. The circumstance of being deprived of Julius's presence, not to mention approval, activated Michelangelo's associative links to childhood with its climate of maternal withdrawal and sibling displacement. In such a situation, Michelangelo was subject to more paranoia-tinged beliefs. In this case, according to Condivi Michelangelo's belief was that Bramante and Raphael were scheming to persuade Julius to commission Raphael to complete the second half of the ceiling. At that

11. Gilbert (1980) has challenged the traditional chronology of the ceiling by concluding that the *entire* curved portion of the ceiling was completed in August 1510.

12. The entries of August 14 and 15, 1511, in the diaries of Paris de Grassis, the papal master of ceremonies, establish the date of Julius's first viewing (translated in Seymour, 1972).

precise time, however, Raphael was in the midst of his own fresco cycle in the *Stanze*, and no scholar has considered this contention of Michelangelo as plausible. Rather, it suggests a replication in fantasy form of a younger sibling's usurping his position with the nurturing parent.

The sonnet to Pope Julius foreshadows the poem Michelangelo was to write on the death of his father years later (pp. 37–40), in which the same dialectic between the wish for loving union and the bitterness over abandonment is expressed.

The work on the ceiling was interrupted after the completion of the three Noah panels, in which, with partial success compared to his later panels, he portrayed the struggle and the tragedy of the human condition. On the first half he then continued with two of the three Adam and Eve histories—the *Temptation and Expulsion* (fig. 11-6) and the *Creation of Eve* (fig. 11-7). In these two panels man moves into a more direct relationship with divine power, one more clearly integrated into a mystical cycle of the recognizable and the incomprehensible. In the *Creation of Eve*, God the Father is explicit, but simply stated in solemn and quiet human form. Underneath his gesture of evocation, matter takes form in a posture of submission.

After several months' rest from painting, Michelangelo resumed his task in January 1511 (?) with *The Creation of Adam* (fig. 11-8). There is no satisfactory explanation to account for the leap in conception and form that is introduced in this panel and swells in the succeeding ones, as compared to those of the first half of the ceiling. Freedberg (1960) has perceptively written about *The Creation of Adam*: "For the moment Michelangelo's and God's roles merge: God acts as the classical sculptor. He has just shaped the first image of a man, giving him such beauty of physical being as should belong to an ideal ancestor from whom we imperfectly descend" (p. 26). No image in Western art has commanded the awe and popular response of this vision of an anthropomorphic God who, with transcendent grace and power, soars to the apogee of his celestial journey. He bestows his compassionate gaze and tender procreative gesture upon Adam, whose concave and receptive form languidly reaches out for the mysterious infusion of physical strength and spiritual purity already latent in him. The miraculous event-to-be exists outside of time, against the barren brown-blue of the earth, thereby placing in relief the feeling of devotion between the two. Beholders of this image cannot help but respond with a sense of rediscovering and reexperiencing some lost moment of their own innocence in the buried past, when there could be complete trust in an all-caring, omnipotent parent.

The triumph of the *Creation of Adam* poses the question: what were the sources of this image for Michelangelo? Aspects of it, such as the reclining Adam, loosely derive in form from earlier Renaissance versions of the *Creation of Adam* by Ghiberti and Jacopo della Quercia, and perhaps even more from certain reclining heroic images from antiquity. Clearly, however, this *Creation of Adam* bears the distinctive stamp of Michelangelo's imagination. Its presence on the ceiling makes

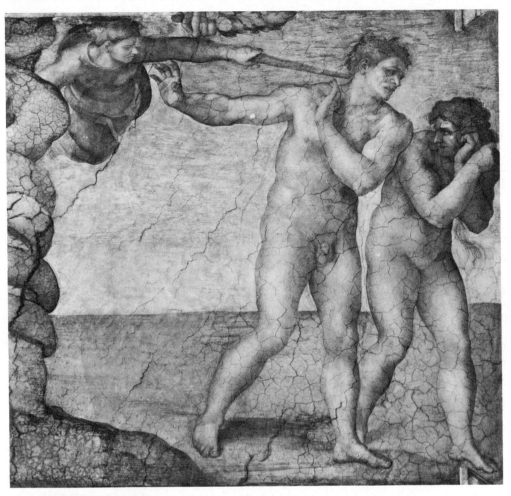

11-6. Michelangelo, Sistine Chapel ceiling: *The Expulsion of Adam and Eve from Paradise.*

the earlier histories all seem hesitant and static by comparison. I would suggest that one of the fountainheads for the *Creation of Adam* was the maelstrom of the artist's anxiety about Pope Julius's attitude toward and investment in him. Out of that emotion, Michelangelo was able to distill various wishful elements and to transform them into a single image of universal unconscious appeal. The image is stark, simply read, yet stops short of sentimentality. Here again is the essence of Michelangelo's genius—the ability to reach into his own turbulent preoccupations and unrealistic expectations and then, in shaping his artistic resolution, to cast aside individual neurosis and create an image addressed to universal experience. To say that his own neurosis was responsible for his art would be to parody psychoanalytic theory. While it is true that without his long hours of anguish his art as we view it could never have existed, nevertheless, the quality of his genius is attributable to the extraordinary strength of his ego, which enabled him to

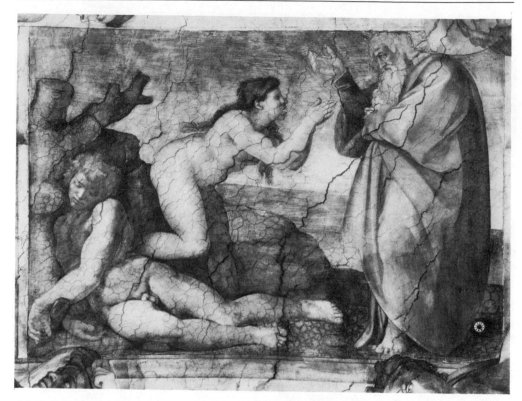

11-7. Michelangelo, Sistine Chapel ceiling: *The Creation of Eve.*

utilize, master, and resolve conflict in forms that transcended his unrelenting obsessions.

Yet if we look beyond the interaction of God and Adam to the complex arrangement of figures huddled within the embrace of the Almighty's purple mantle, we can see how Michelangelo again revealed the scars of his own childhood experience. The theme is the exclusion of the young child. In the right half of the cloak are two figures that make explicit the basic iconographic program of the ceiling—namely, that the episodes from the Old Testament prophetically foretell the episodes of the New Testament and the era of grace. The two figures under the backward-extended left arm of God are the Virgin Mary and the Christ Child.[13] Thus God, as he creates Adam, has also already initiated the means of his eventual redemption. His right forefinger is extended to Adam; His left forefinger, to Jesus. This strange Jesus, with his bewildered expression, nearly mirrors the Christ Child of the Doni tondo (fig. 4-5) in his bodily posture. A number of features, however, are striking. Jesus is clutching his Mother's leg and appears to be very much in danger of slipping off this heavenly train, barely noticed and

13. Some writers have concluded that the female figure is Eve (e.g., Tolnay, 1943–60, 2: 35), but I am persuaded by Hibbard (1974) that she is the Immaculate Virgin, Maria Aeterna, who, as Divine Wisdom, was with God at the Creation (Proverbs 8:22–25).

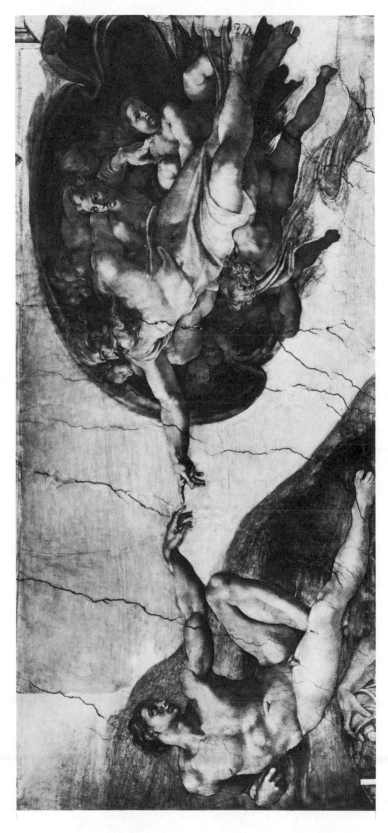

11-8. Michelangelo, Sistine Chapel ceiling: *The Creation of Adam.*

unsupported by his Mother or by God. Contrast the two hands of God: the right one is gently and lovingly extended to Adam; the left one is awkwardly positioned, bony, crooked, and languid. Fear and abandonment characterize this child, not holy or heroic prefiguration. For Michelangelo, the idea of parenting figures caring for one child carried with it the expectation of their neglecting the other. This theme was prominent in both the Doni tondo (fig. 7-1) and the Taddei tondo (fig. 7-15) and was suggested in drawings and other early works. Thus, in the *Creation of Adam*, the narrative dimension that is provided by having God span the era of humanity with one gesture toward Adam and the world under grace (*sub gratia*) with another gesture toward the child Jesus evolves in its particular artistic treatment out of the specific circumstances of Michelangelo's own childhood and his memory and reconstruction of it. In his mature years these memories were split into an idealized view of nurturing symbiosis with the "good" mother and the equally distorted feeling of abject neglect by the "bad" mother. It is not simply that this split in internal representation was portrayed in his art but, rather, that the power of this visual conception of the *Creation of Adam* lies in the creative expression of the force generated by the continuous tension between the two contradictory constellations of self and object representation.

Another interesting detail of the divine half of the panel is that God appears to be supported and guided through heavenly ether by a small band of wingless angels. So, for all of his monumentality, God Himself is dependent on the life-force of these nude servitors, both for His practical mission and for His effortless and weightless grace. The harmoniously balanced symbiosis expressed between these angels and God echoes the symbiotic fantasies that flowered in Michelangelo's poetry, in sentiments such as:

> And if two bodies have one soul, grown deathless,
> That, with like wings, lifts both of them to Heaven. . . .[14]

Such fantasies were a fundamental part of his relationship to Pope Julius. The extraordinary pope was to be the all-protective, all-loving patron, and in return Michelangelo was to achieve immortal recognition for the pope through the unrivaled majesty of his tomb, the bronze portrait of him in Bologna, and the Sistine Chapel. This theme was also directly expressed by the artist in the sonnet dedicated to the pope:

> I am your faithful servant, as of old;
> I am to you as the sun's rays are his.[15]

The sun without rays is impotent fire, and the rays have no existence but for their source. One senses that this symbiotic urgency was felt equally by the aging Julius and was reflected in his original charge to Bramante to rebuild St. Peter's as a mausoleum for himself, his commission to Raphael to paint the *Stanze* as an

14. Gilbert and Linscott (1963, poem 57).
15. Ibid., no. 6. In chapter 16 we shall observe many parallels in the sentiments expressed and the metaphors employed in the sonnets to Tommaso de' Cavalieri.

allegorical celebration of his papal political program, and his commands to Michelangelo with respect to his tomb, bronze statue, and the Sistine ceiling.

An additional element that elevates the *Creation of Adam* to greatness is Michelangelo's capacity to flow freely in his identification from one major figure to another, finding and using different parts of his "self" to mold each of the figures into living images. It is therefore not only Adam and the child Jesus and even the angels with whom the artist identified, but also God Himself. God as sculptor is suggested by the way in which Adam appears to be carved out of the rock beneath him. From his mid-torso to his toes, every indentation in the sweeping convex curve of his right side is filled by rock, so that flesh and earth are differentiated only by shades of brown. Adam waits for the sculptor to bring him into full being. This concept was expressed by Michelangelo in a madrigal:

> Just as we put, O Lady, by subtraction [carving],
> Into the rough, hard stone
> A living figure grown
> Largest wherever rock has grown most small. . . .[16]

A conscious identification with God in the act of painting became explicit in Michelangelo's conversation some years later with the Portuguese painter Francisco de Hollanda (1548), who quoted him as saying:

> The painting which I so much vaunt and praise will be the imitation of some single thing among those which immortal God made with great care and knowledge and which He invented and painted, like a Master . . . in my judgment that is the excellent and divine painting which is most like and best imitates any work of immortal God, whether a human figure. . . . [p. 276]

Inasmuch as the exhilarating fantasies of a relationship to a God-like figure that his Adam enjoyed were, for himself, destined to frustration, one restitutive pathway was for Michelangelo to identify with the image of the ideal parent. This process parallels the common dynamic of a person who felt deprived of care as a child. He may become a generous parent, giving to his child, with whom he vicariously identifies, what he believes to be impossible of attainment for himself. Michelangelo, as sculptor and painter, was able to perform a procreative function and create his private world of titans—particularly males—upon whom he showered the utmost devotion in his effort to make these beings breathe life. In this way he could merge with the idea of the God of the *Creation of Adam*. I would suggest that in the *Creation of Eve*, the prospect of creating Eve, a woman, could not unconsciously engage the artist in the same way as the creation of Adam. Therefore, the standing, immobile God of *Eve*, who derives from an earlier Renaissance tradition, is timid and uninteresting in contrast to the soaring God of *Adam*.

In the last three histories of the Creation, Michelangelo was so possessed by the

16. Gilbert and Linscott (1963, poem 150).

idea of an Almighty Father that God is revealed in forms that leave the viewer uncertain as to what was actually being created. Regarding the first of the three, generally called the *Separation of Land from Water* (fig. 11-9), Vasari reflected what must have been the confusion of the day when he called the panel "The Creation of the Fish of the Sea." In any case, Michelangelo was by this time liberated from all the art forms that preceded him and created a figure entirely foreshortened, so that head and arms emerge out of the concentric circles of His whirling mantle. The arms and hands are painted to give the illusion of protruding beyond the foreground into our space.

The next panel, the *Creation of the Sun and the Moon* (fig. 11-10), takes the form of a continuous narrative in which the figure of God is repeated in two successive stages of the same act of creation—approaching and departing. In addition to the bravura expansion of the formal aspects of the God figures, the approaching God in this panel is endowed with a fiery countenance, strikingly different from the benign and gentle expression, the misty beard and hair, of the God of the *Waters*. Michelangelo is not concerned with what can be expressed by movement and form alone; he forges ahead in exploring the communication by facial expression of extremes of emotion—in this case, wrath. The series of broad black lines slashed through God's hair give the impression of licking flames. Every facial muscle is contracted and boldly defined under the taut skin, thereby emphasizing the power of the gaze that peripherally includes us as it stares into some other unfathomable space, toward which He is pointing. Like an angry parent whose rage is followed by emotional withdrawal, the momentary presence of God on the right-hand side quickly fades into the receding God of the left. The contrast is dramatized by the powerful expansiveness of the gestures and posture of the frontal God, and the contraction of the receding one, in which only foreshortened feet, buttocks, and elbow remain articulated from this ball of energy.

Despite the radical leaps in style from one image of God to the next, in the four histories from *Eve* through *Sun and Moon*, each figure remains an anthropomorphic conception of the mysterious life-force of the universe. In the last of the nine ceiling histories, *The Separation of Light and Darkness* (fig. 11-3), which is actually the first act of creation in Genesis, anthropomorphism yields to abstraction, and the image is without material context that allows us to name the action. It is as though by some primordial effort God were creating Himself. His swirling mantle seems to blend indistinguishably into the infinite space beyond. This being is yet to be fully differentiated and still conspicuously retains the breasts of a woman. In this final effort to portray the essence of the concept of God, Michelangelo invented a transcendental image in which he shattered the tradition of God's paternal character to reveal the fountainhead of life—the maternal breast.

Similarly, each succeeding group of four *Ignudi* which frames each history progressed in daring and inventiveness as Michelangelo grew more confident. The final *Ignudo* (fig. 11-11) mirrors the artist's achievement in portraying the God of *Light and Darkness*. It is an image of man elevated to an ideal that surges to the

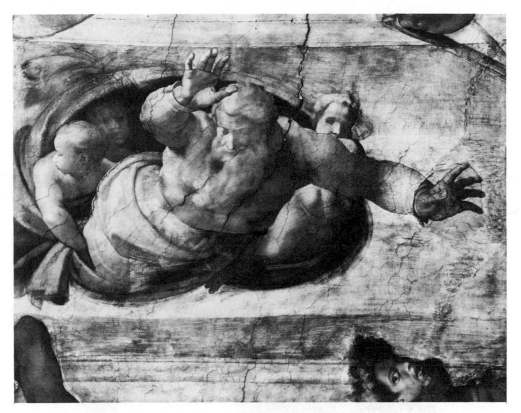

11-9. Michelangelo, Sistine Chapel ceiling: *The Separation of Land from Water.*

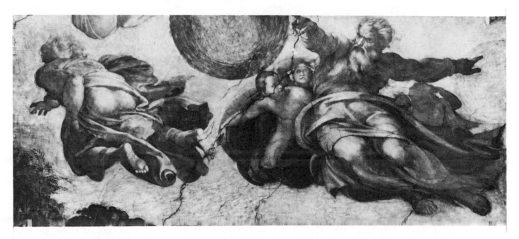

11-10. Michelangelo, Sistine Chapel ceiling: *The Creation of the Sun and Moon.*

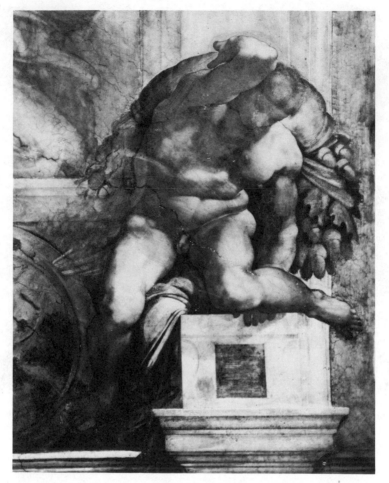

11-11. Michelangelo, Sistine Chapel ceiling: *Ignudo* over *Jeremiah*.

uttermost limit of plausibility. Significantly, his posture is the contrappostal mirror-image of God's. He seems, like Atlas, to support a burden. The burden, however, is a cornucopia overflowing with acorns and oak leaves—the emblems of the della Rovere family. This last nude, placed alongside the final image of God, is the terminus of the arc that began with the idealized relationship of Adam and God. Now the breasted, primordial God looks off toward and gropes in one direction, the *Ignudo* in the opposite one. So, in the last of the panels, God seems to merge with the void whence man came, leaving the titanic *Ignudo*—a symbol for Michelangelo himself—to bear forever the burden of the della Rovere cornucopia, overflowing yet deceiving in its promise.

As his four years of toil drew to an end in 1512, Michelangelo must have realized that Pope Julius was near death and that what energy remained to him had to be directed toward his struggle with the French. In this figure of the

Ignudo, the imagery of Atlas poignantly suggests the burden of the tie Michelangelo was to have to the pope for most of his life, through the project of the Tomb of Julius. With the frustration of his fantasies of an Adam-like union with the God/Pope Julius, the only restitutive course was to fall back on his own herculean strength as an artist and his illusory wish for self-sufficiency. This process was similar to the one discussed with respect to the conception of the Doni tondo nudes (see chapter 7) and was one of the inner causes of the process of expansion and growth of the Sistine Ignudi.

The Sistine Chapel ceiling was opened to public view at vespers on the Vigil of All Saints at the end of October 1512. Michelangelo wrote at that time: "I have finished the chapel I have been painting; the Pope is very well satisfied" (letter 83). Yet despite his accomplishment, the satisfaction of Pope Julius, and the awe and acclaim of all who beheld it, Michelangelo's spiritual exhaustion and depression were pronounced. He conveyed his despair to his father in a letter written that same October:

> I lead a miserable existence and reck not of life nor honour—that is of this world; I live wearied by stupendous labours and beset by a thousand anxieties. And thus have I lived for some fifteen years now and never an hour's happiness have I had. [letter 82]

In these lines Michelangelo expresses a common characteristic of the psychological state of depression—the conviction that the despair one is feeling is timeless and that it is the "real" or core state of being, which has always been and always will be.

In painting the Sistine Chapel ceiling, Michelangelo did not abandon his original investment in the Tomb of Pope Julius. As Freedberg has made clear, the vocabulary of forms that Michelangelo projected onto the ceiling represented the unfolding on a flat surface of what was designed for the three-dimensional tomb. In the complex architectural system of the vault, he painted figures that are sculptural in form and create the illusion of having been fitted into niches or set upon structural bases. This is particularly true of the Prophets, Sibyls, and Ignudi. The histories are presented framed within the architecture, as reliefs appear on the surface of a monument. The Prophets and Sibyls, with their attending putti, are analogues of the great enthroned figures planned for the tomb's second tier; the Ignudi are analogues of the Slaves who were to inhabit the niches on the first story. Throughout the ceiling Michelangelo retained the approach of a sculptor, not a painter, in his overriding emphasis on single-figure units. These units are dependent on the given architectural structure, and the units of architectural structure are woven into a totality of conception by the configuration of ever-varied human forms.

Thus, what has been left to us from the extraordinary and tempestuous relationship between Michelangelo and Pope Julius II is the transposition of major elements intended for an ill-fated death-commemorative into the theme of Genesis—

the creation of life and the world by an all-powerful male God. Sin and "Fall" are distinctly present, informed by Michelangelo's own inner doubts. The ultimate message of the ceiling, however, is the foretelling of redemption by the Prophets and Seers. This promise mirrored the unextinguishable unconscious hope that fired Michelangelo's imagination and physical labor for another half-century. Like the last of the Ignudi (fig. 11-11), Michelangelo believed that his encounter with the "dried-out fruit tree" of Pope Julius (as he described him in the sonnet) would, as reward for his devoted service, ultimately yield him the fruits of the cornucopia and the nurturing breasts of the final God.

Chapter Twelve

The Dying Slave

The *Dying Slave* (fig. 12-1) is one of the statues Michelangelo sculptured for the second plan (1513) for the Tomb of Julius II. In chapter 9 I discussed the origins of the tomb and the way this unrealistically monumental project grew out of the interaction between the pope and Michelangelo. The first plan (1505) never advanced beyond the stage of quarrying and delivering to Rome many large blocks of Carrara marble, at which point Julius redirected Michelangelo to paint the ceiling of the Sistine Chapel. Then, in 1513, shortly after the completion of the Sistine ceiling, the pope died. He was succeeded on the papal throne by a Medici —Pope Leo X.

During the first three years of his pontificate Leo gave painting commissions solely to Raphael, thereby freeing Michelangelo to resume work on the tomb. After Julius's death, however, his della Rovere heirs revised the contract, making it less a tomb for the pope and more a monument to the della Rovere family. Its size was increased, and it was changed from a free-standing monument to one backed against a wall. Michelangelo was given seven instead of five years to complete the work, and more money. On his part, he agreed not to accept any assignments that might substantially divert his attention from the tomb.

The new contract was signed on May 6, 1513, and the artist immediately began working on the first paired figures—the *Dying Slave* and the *Rebellious Slave* (fig. 12-2). He worked in his new quarters in Rome on the Via Macel de' Corvi. It was in this spacious house near Trajan's Column that Michelangelo made his home and workshop in Rome for the rest of his life.

It is not known which of the two *Slaves* was started first. Michelangelo worked on the figures concurrently. We can infer the intensity with which he immersed himself in his return to sculpture from a letter to his brother Buonarroto written shortly after the project began (July 30, 1513):

> I must tell you that I do not think I shall be able to come home this September, because I'm pressed in such a way in such a way [sic] that I haven't time to eat. God willing, I can bear up. [letter 92]

The two *Slaves*, along with the *Moses* (fig. 14-2), which was probably begun in the summer of 1515 and completed in 1542, comprise the three statues that Michelangelo executed for the 1513 project for the Tomb of Julius. The *Slaves*

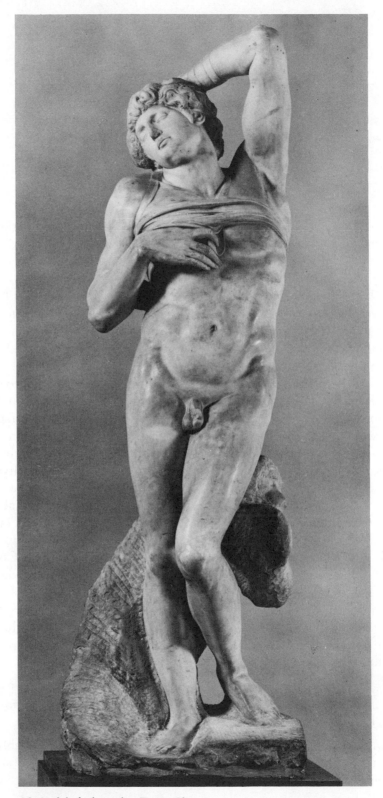

12-1. Michelangelo, *Dying Slave*.

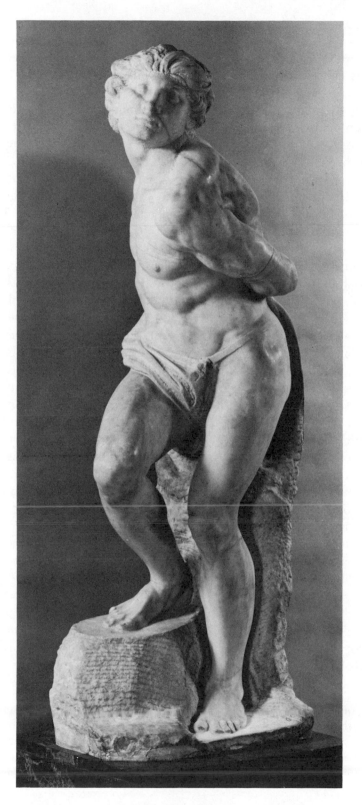

12-2. Michelangelo, *Rebellious Slave.*

were probably intended to stand in front of pilasters on the first level of the mausoleum.

If we survey the writings of Michelangelo's contemporaries and also of scholars of the past century, we are struck by the degree of their disagreement concerning the meaning of the *Dying Slave*. Vasari first spoke of it as symbolizing the provinces brought by Pope Julius into obedience to the Apostolic Church. It has been rightly pointed out, however, that in 1505, when the tomb program was originally conceived, the pope's campaign against the provinces had not yet begun. Condivi, on the other hand, wrote that the statue represented one of the Liberal Arts, which was, like Julius, a "prisoner of death . . . as [it] would never find another to favor and foster [it] as he did" (p. 33). Should we accept Condivi's interpretation as Michelangelo's true intention? Not necessarily. One enigmatic aspect of Condivi's book is the host of major errors in the description of the artist's works it contains. Moreover, many obviously wry and deliberately obscure explanations by Michelangelo were naïvely accepted by his adoring young Boswell as serious philosophical pronouncements.[1] Condivi's interpretation is belied by the tradition, both before Michelangelo and among his followers, of representing the Liberal Arts as female figures, never as slaves. Nonetheless, twentieth-century scholars like Janson (1952) and Pope-Hennessy (1970) support the view that the statue personifies a Liberal Art, specifically Painting or Sculpture, because of the partially carved ape behind the legs of the figure (fig. 12-3), which they argue signifies "Art as the Ape of Nature" (*Ars simia naturae*). In contrast, Panofsky (1939) fits the *Dying Slave* into a comprehensive Neoplatonic program for the tomb, citing the ape as symbolic of the subhuman impulses in man. He concludes that the *Slave* represents the sublime soul imprisoned in a base body, enslaved by matter. Janson, the preeminent iconographer of apes, rejects this interpretation, pointing out that the custom of depicting what was base in man in the form of an ape was a Northern European tradition not found in Italy. Tolnay (1943–60, vol. 4) is more ecumenical and proposes that the *Slave* combines the Christian concept of the triumph of the Apostolic Church over unbelieving pagans and the Neoplatonic concept of the "hopeless struggle of the human soul against the chains of the body" (p. 25).

The arena of uncertainty, however, is larger still. Although the work is usually called the *Dying Slave*, few present-day art historians take literally Herman Grimm's designation of the figure as being at the "moment" of death. In describing the statue (which he called the *Dying Youth*), Grimm (1860) epitomized nineteenth-century German Romantic art connoisseurship:

> What work of any ancient master do we, however, know or possess, which touches us so nearly as this,—which takes hold of our soul so completely as this exemplification of the highest and last human conflict does, in a being just developing? The last moment between life and immortality,—the terror at once of departing and arriving, —the enfeebling of powerful youthful limbs, which, like an empty and magnificent

1. See Wind's (1958) essay, "A Bacchic Mystery by Michelangelo," in which he discusses aspects of the artist's obscurantism and his relationship with Condivi.

12-3. Detail of figure 12-1 (the Ape).

coat of mail, are cast off by the soul as she rises . . . all has returned to that repose which indicates death. [p. 423]

If not "dying," what, then, is the activity of the figure? Despite its upright, standing position, one's kinesthetic intuition is that it really is, or should be, a recumbent figure that has been rotated from its natural position to fit the demands of a vertical architectural niche. Indeed, many scholars consider the work to be a study of a figure in some stage of sleep. But this too is unclear. In fact, the activity of the figure is so ambiguous that Tolnay (1943–60, vol. 4), in the same volume of his monumental study of Michelangelo's works, states on one page that it is "an adolescent . . . making instinctive movements to *awaken* from his dream" (p. 38) and, sixty-one pages later, says that it is "an exhausted young man *falling asleep.*" Symonds (1893) placed the figure in the middle of the dream stage of sleep: "the sleeping mind of immortal youth musing upon solemn dreams" (vol. 2, p. 87). Wölfflin (1899), who profoundly influenced art historiography by calling attention to the formal aspects of images, sees here "an unparalleled representation of the human body just beginning a movement. . . . He draws a deep breath as he awakens just before he reaches full consciousness" (p. 71). More recently, Kenneth Clark (1956) has proposed that the figure is a condensation of the polarities "of a sleeper, half sunk in the luxury of sleep, half anxious to struggle free from some oppressive dream" (p. 244).

What can be concluded from this brief survey of major interpretations of this statue? First, Michelangelo seems to have concealed his conscious intention.

Second, there appears to be little congruence between the themes that the image is purported to allegorize and the familiar activity, sleep, in which the *Slave* is said to be engaged. If he is in a state of sleep or reverie, where on the continuum from nightmare to simple and unconflicted wish-fulfillment is he? If one were to take the pose of the figure and hold it for a few moments while suspending critical judgment and passively yielding to kinesthetic awareness, and were then to free-associate to that mixture of feelings and thoughts, one would probably react like most of the students who have engaged in this exercise—that is, with a slight anxiety in response to the pleasure associated with the extraordinary passive and sensual abandon of this beautiful, femininely graceful, yet powerfully athletic youth, who is without either shame or intellectual restraint.

We are, then, uncertain as to the iconography of the image, but we are sure that it evokes a strong emotional response transcending knowledge of any precise meaning. In what direction might we turn for further clues to Michelangelo's intention? There is one point upon which virtually all students of Michelangelo agree: that the image of the *Dying Slave* was formally inspired by the late Hellenistic marble group of the *Laocoön* (fig. 12-4). This work, which was carved by three Rhodian sculptors, Agesandros, Polydoros, and Athenodoros, was excavated from a vineyard in Rome in January 1506. Pope Julius II, upon hearing of the find, sent Giuliano da Sangallo to examine the work. According to Giuliano's son, his father took Michelangelo along with him; the sculptor immediately recognized the work from Pliny's description and was deeply affected by seeing it, as is clearly reflected in the two *Slaves* for Julius's tomb. The *Dying Slave* is closely patterned after the dying younger son to the left of the father (fig. 12-5); the *Rebellious Slave* is modeled on the older son, on the right (fig. 12-6), who still appears to harbor hope of survival from strangulation by the serpents. And the third statue for the Tomb of Julius, the *Moses* (fig. 14-2), which was largely done during this same period, bears a close spiritual, if not positional, kinship to the father in the *Laocoön* group.

Given that the *Dying Slave* is modeled on an ancient source, we are once again faced with the question: was it only the formal aspects of this magnificent statue that attracted Michelangelo? Or were there elements in the narrative theme that so deeply touched dominant unconscious conflicts and fantasies in him that the *Laocoön* group was irresistible as a model? To be more specific, did the union of father and sons in death so dramatically portrayed in the ancient statue resonate with a profound unconscious conflict in Michelangelo?

The *Laocoön* comes from Greek myth. Laocoön was a Trojan priest of Apollo who realized that the Greek wooden horse contained armed enemies. He confirmed this by hurling a spear at the horse, causing the weapons hidden inside to rattle audibly. Nevertheless, his judgment was overruled by King Priam, which led to Troy's downfall. During the Trojan deliberations, Apollo sent two great sea serpents ashore. They immediately coiled around the sons of Laocoön, who tried in vain to rescue them but was himself entrapped. As the statue shows, father and

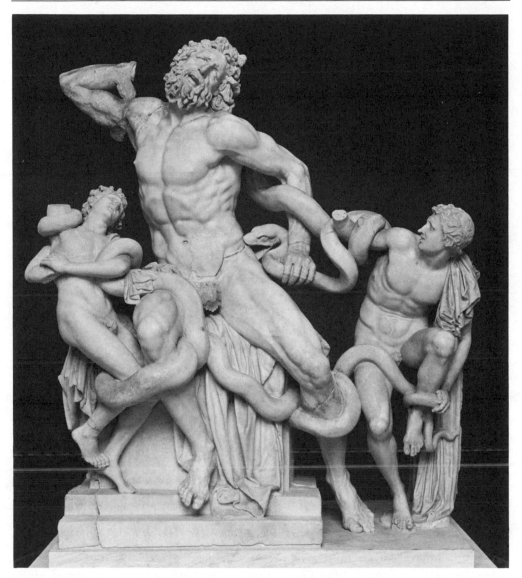

12-4. Agesandros, Polydoros, and Athenodoros of Rhodes, *Laocoön* (ca. 100–80 B.C.?).

sons were bound together in an agonizing death decreed by the god. The punish-
ment was not, as the Trojans thought, for hurling the spear or opposing the king.
Rather, Laocoön's hubris resided in his disregard of the priestly vows of celibacy.
The sons are both evidence of his crime and innocent victims in this poignant
drama of divine justice.

The power the Laocoön myth held for Michelangelo was related to the control-
ling fantasy which is so recurrent in his autobiographical myth and which deter-
mined the artistic images of many of his works. That fantasy involved the power-

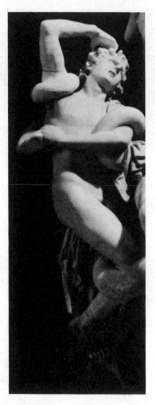

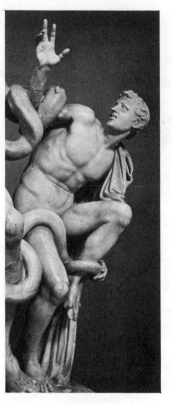

12-5. Detail of figure
12-4 (the Younger Son).

12-6. Detail of figure
12-4 (the Older Son).

ful transformation of his lost early maternal figures into paternal ones. This yearn-
ing, however, carried with it the dread of bodily disintegration and castration that
attended his concept of death and of fusion with the nurturing, powerful object
representation, respectively.

The image in the *Laocoön* group of the innocent sons bound in death to their
devoted, mighty father must have elicited a very special and highly conflicted
reaction in Michelangelo. Because of this personal meaning, he immersed himself
in the original theme and its representation and then emerged with an innovative
artistic image of his own that reflected his attempt to master the core of anxiety
residing in the theme. Michelangelo transformed the image of agonized dying in
the *Laocoön*, where the son makes a final, futile gesture of protest as he loses
consciousness, into something radically different. In Michelangelo's statue dying
has become a desirable state; death has become sleep; reality has become a dream.
The particular moment has become ahistoric. The excruciating immobilization of
the body seen in the original source has been transformed into sensual, serpentine
motion of the limbs, unfettered by the loose horizontal bond across the upper
chest.

Although here we are focusing on the relationship between the *Dying Slave* and

the *Laocoön* group, there are other statues from antiquity, familiar in type to Michelangelo, that very likely were also incorporated into the process of creating the *Dying Slave* with respect to form and theme. Specifically, the *Wounded Niobid* (fig. 12-7), from circa late fifth-century B.C. Greece, represents the "falling-fallen" motif which was known in the Niobe Sarcophagus type in Michelangelo's time and is similarly related to the *Dying Slave*.

To understand in greater depth why Michelangelo was so taken with the *Laocoön* it is instructive to examine a particular strand of the artist's autobiographical myth as presented in Condivi's *Life*. This strand is a lifelong series of variations on the myth of Ganymede. The ancient myth concerns the son of the king of Troy, who was the most beautiful of youths. Zeus, desiring him for his cupbearer and bed companion, swoops down in the form of an eagle and abducts Ganymede. To console Ganymede's hapless father, Zeus assures him that his son will have immortality in the role of service to the most powerful of gods. He also gives the father a pair of marvelous horses—an exchange of flesh for flesh.

Figure 12-8 is a copy after Michelangelo's drawing of the subject for presentation to Tommaso de' Cavalieri, which I shall discuss at length in the context of their friendship (chapter 16). In the drawing, Ganymede's ecstatically passive yielding to anal eroticism in the embrace of the disguised god is apparent. Eissler (1961) has astutely observed the anatomical distortion in Ganymede's genitalia. The scrotum appears to have a vaginal cleft from which the penis emerges. It is as though the penis were the eagle's and had passed through the youth's anal-vaginal canal. Although this drawing, now at Windsor Castle, is generally accepted as the most faithful copy of Michelangelo's lost original, there is no way of determining whether the anatomical distortion was in the original or is a modification by the unknown copyist. In a copy of the *Ganymede* at the Fogg Museum, distortion in the representation of the youth's genitalia is present but less apparent.[2] Again, we cannot be sure whether the copy is faithful or is the copyist's correction of the original by the master.

We have noted that Michelangelo's father brutally opposed his son's wish to pursue a career as an artist—a fact well documented in Michelangelo's letters and in many bitter anecdotes in Condivi's *Life*. The entrance of Lorenzo the Magnificent into the Condivi narrative has all the trappings of the Ganymede myth in Renaissance form:

> When he [Lorenzo] had come and noted the boy's goodness and simplicity, he laughed at him very much; but then, when he weighed in his mind the perfection of the thing [a bust of a faun carved by Michelangelo] and the age of the boy, he, who was the father of all *virtù*, resolved to help and encourage such great genius and to

2. Hirst (1975) tentatively proposes that the Fogg sheet is an autograph by Michelangelo himself. In a drawing of male genitalia done on a sheet of varied studies (Uffizi 598 E v), we find a hemaphroditic representation very similar to that of Ganymede in the Windsor copy. Although this sheet is rejected by the majority of students of Michelangelo's drawings, William Wallace, in a forthcoming study of the master's "instructional drawings," argues convincingly that the Uffizi study of the genitals is indeed by Michelangelo.

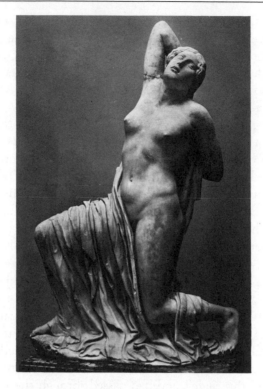

12-7. Ancient Greek, *Wounded Niobid*
(late fifth century B.C.).

take him into his household; and, learning from him whose son he was, he said, "Inform your father that I would like to speak to him." [p. 12]

Lorenzo then proceeds to humiliate Michelangelo's father in the course of negotiating the transfer of his son to Lorenzo's palace. Once there, Condivi describes how Michelangelo "was seated even above the sons of Lorenzo and other persons of quality," next to the prince. Moreover, "the Magnificent . . . would call for him many times a day." Because of this degree of supportive affection—and perhaps only because of it—whatever its balance of truth and fantasy, the sixteen-year-old sculptor was able to carve two reliefs: the *Battle of the Centaurs* (fig. 2-2) and the *Madonna of the Stairs* (fig. 2-1).

By this time, two important patterns in the structure of Michelangelo's object relations had emerged. First was a splitting of the paternal representation into two real men. One was an idealized, powerful public figure who had an uncommonly strong personal, as well as artistic, investment in him. The other was his weak and denigrated natural father, Lodovico, whom Michelangelo was to experience as an emotional drain and a financial burden, toward whom an unbreakable and ambivalent tie had to be rationalized as selfless filial duty. The other noteworthy trend was that the artist's capacity to create was enormously dependent upon the palpable encouragement of the idealized and devoted patron.

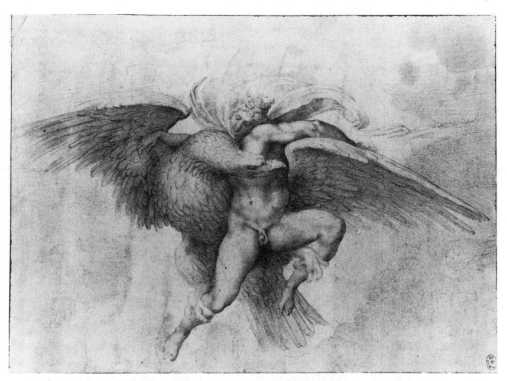

12-8. Copy after drawing by Michelangelo, *The Rape of Ganymede.*

What is conspicuously absent from the account of the artist's blissful two years spent in Lorenzo's household, however, is any mention of the fact that Lorenzo was already in the late stages of the disease that proved fatal at age forty-three. By the time Michelangelo arrived at the Medici Palace, Lorenzo had begun to curtail his public appearances. So the young artist's first, not simply "good" but "great" father image was in the process of dying a painful death when they met and indeed soon abandoned him by dying.

It was Lorenzo's successor, his son Piero the Unfortunate, whom Michelangelo had presumably displaced at his father's table. We have seen that the artist's precipitous flight from Florence to Bologna followed upon a nightmare, attributed to a friend but that I suspect was really Michelangelo's own, in which Lorenzo reappeared naked and foretold Piero's doom. Shortly thereafter, the nineteen-year-old artist, without funds, was called up before a magistrate for a minor traveling-visa infraction. Miraculously, a second "Zeus" appeared in the form of a Bolognese aristocrat, Gianfrancesco Aldovrandi, who bailed Michelangelo out, took him to his own home to live for a year, and was instrumental in securing commissions for him. Speaking of Aldovrandi, Condivi writes: "the aforesaid gentleman . . . treated him with great honor, as he was delighted with his intelligence, and every evening he had him read from Dante or Petrarch and sometimes from Boccaccio, until he fell asleep" (p. 19).

At this point Michelangelo fled Bologna in fear of physical harm from resentful local artists. To continue with the autobiographical myth, another pattern emerges: whenever the artist experienced a special relationship with a devoted, powerful patron, he grew anxious and acted on the conviction that he was in imminent danger from the malevolent intentions of rivalrous peers. Although artistic rivalries were certainly a reality in the Renaissance, this fact also became the focus for the projection of Michelangelo's own aggression which, if expressed in undisguised form, could have raised the threat of intrapsychic disorganization as the "Ganymede relationships" intensified. In this connection, Giannotti (1546) attributed a statement to Michelangelo that directly conveys the artist's own sense of the fragility of his ego boundaries in an instance when positive feelings toward others were aroused. Although I have quoted it in part earlier, it is an utterance so central to Michelangelo's personality that it deserves to be restated in full. In the context of declining to join his intimate circle of Florentine friends in Rome for dinner, Michelangelo says:

> You must know that I am, of all men who were ever born, the most inclined to love persons. Whenever I behold someone who possesses any talent or displays any dexterity of mind, who can do or say something more appropriately than the rest of the world, I am *compelled to fall in love with him*; and then *I give myself up to him so entirely that I am no longer my own property, but wholly his* . . . if I were [to dine with you] . . . *each of you would take from me a portion of myself* . . . and instead of being refreshed and restored to health and gladness . . . I should be utterly bewildered and distraught, in such ways that for many days to come *I should not know in what world I was moving.* [p. 132, my italics][3]

Michelangelo's flights, such as the ones to and from Bologna, as well as that from Pope Julius II to Florence, were in the service of adapting to the facts of the external world and defending against the loss of the stable internal organization of his concepts of himself and of the principal person with whom he was involved at that moment.

During the ten years following his flight to Bologna as a result of his "friend's" dream, Michelangelo established himself as preeminent among sculptors. This high repute culminated in 1505 with the command that he go to Rome to execute the tomb for Pope Julius. Condivi's account of Michelangelo's relationship to the pope is a reassertion of the Ganymede theme. The pope is described as bestowing immeasurable favors upon Michelangelo, treating him as a brother, and even ordering the construction of a drawbridge extending from his quarters to the artist's rooms so that he could visit him "secretly." Just as Zeus in the form of an eagle swooped down and carried off Ganymede as his chosen one, so the pope is imagined to have planned a special passageway to Michelangelo's bedroom so that he could achieve an exclusive intimacy with him.

When Michelangelo returned to the pope's service after his flight to Florence

3. Translated by Symonds (1893, vol. 2).

and his seven-month stay there, he explained that he was doing so only because of the pope's insistent coercion. In this way Michelangelo was able to see himself as enslaved by the powerful pontiff and forced to relinquish his own will and responsibility for his destiny.

During the forty-year history of the tomb, Michelangelo described *every* major work, in letters and in the Condivi text, as a reluctant submission to the commands of successive popes. He protested that each of them had detoured him from his life's artistic mission—the completion of the tomb. Hence, when Pope Paul III was elected in 1534, Condivi wrote:

> he sent for Michelangelo and requested that he enter his service. Michelangelo, who suspected that he would be prevented from going on with that work, answered that he could not do so because he was bound under contract to the duke of Urbino until he had finished the work that he had in hand. The pope grew agitated and said, "For thirty years now I have had this wish and, now that I am Pope, can I not gratify it? Where is this contract? I want to tear it up." Seeing that it had come to this, Michelangelo was on the point of leaving Rome and going away to Genovese country to an abbey of the bishop of Aleria . . . but fearing the power of the pope, as he had good reason to, he did not leave, and he was hoping to satisfy the pope with gentle words. [pp. 57, 59]

Still later, at sixty-seven, Michelangelo wrote the letter quoted earlier (chapter 9) which contained the outcry: "I lost the whole of my youth, *chained to this Tomb,* contending as far as I was able against the demands of Popes Leo and Clement" (letter 227, my italics).

Michelangelo's view of himself as an unwilling captive transcended the realities of the tomb affair and continued unabated for years after the final resolution of the tomb in 1547. Although in 1549 Pope Paul gave Michelangelo the singular honor of supervising the design and reconstruction of the new Basilica of St. Peter's, the artist wrote to Vasari in 1557: "I call God to witness that ten years ago I was put in charge of the fabric [construction] of St. Peter's by Pope Pagolo [Paul] *under duress and against my will*" (letter 434, my italics).

We should certainly inquire whether there is any direct evidence of Michelangelo's ambivalence toward the tomb project to support the hypothesis that the unconscious negative component of his feeling toward Julius and the tomb was displaced and projected onto subsequent powerful individuals in his life, who were then perceived as obstructing him. Pope Clement VII is prominent among those blamed for interfering with Michelangelo's work on the tomb. Although it is true that this tomb was not of high priority among the projects this Medici pope wanted Michelangelo to undertake, the artist's own ambivalence toward the tomb was directly expressed (again in the vocabulary of the Ganymede myth) in a letter to his agent in Rome written two months before the election of Clement in 1523:

> And if, as you tell me, the Cardinal de' Medici [Clement] now once again wishes me to execute the Tombs at San Lorenzo, you see that I cannot do so, unless he releases me from this affair in Rome [the Tomb of Julius]. *And if he releases me, I promise to*

work for him without any return for the rest of my life. It is not that I do not wish to execute the said Tomb, which I'm doing willingly, that I ask to be released, *but in order to better serve him.* [letter 152, my italics]

We are now in a stronger position to link what I proposed earlier regarding Michelangelo's unconscious fantasies as creatively expressed in the *Dying Slave* to these autobiographical themes. What consistently emerges from Condivi's text and Michelangelo's letters is his representation of himself as an innocent victim with noble intentions, submitting reluctantly and out of fear to great paternal figures that force him to execute their will. He felt in a constant state of bondage. Hence his creative efforts were experienced as neither autonomous nor pleasurable. For the last forty-eight of his eighty-nine years, Michelangelo continually wrote and spoke of his imminent death. Clearly, this obsessive dread masked his wish to experience death as the transcendental ecstasy suggested by the *Dying Slave.*

There is almost endless evidence of Michelangelo's obsession with death in his letters and poems. His anxiety was also openly expressed to friends, judging from Giannotti (1546), who attributed the following statement to the artist:

. . . to think on death. This thought is the only one that makes us know our proper selves, which holds us together in the bond of our own nature. . . . Marvelous is the operation of this thought of death; which, albeit death, by his nature, destroys all things, preserves and supports those who think on death, and defends them from all human passions. [p. 310][4]

In the last decades of his life, the all-pervasive obsession was dramatically and succinctly stated by Michelangelo in a letter to Vasari in 1555: "I conceive of no thought in which Death is not engraved" (letter 402).

In the context of Michelangelo's fantasy of the life-sustaining force of bondage to a greater power we can better understand his unprecedented outpouring of passion upon meeting young Tommaso de' Cavalieri in 1532 (see chapter 16). It is only within the past few years that a particular document has persuaded art historians that the date of Michelangelo's father's death was not 1534, as had always been thought, but rather 1531 (the year before he met Tommaso).[5] There was a strong unconscious attempt on the part of the artist to deny the reality of his father's death, as one can see from the following strange passage in Condivi: "when he was dead, according to Michelangelo, he retained the same color in his face as he had when living and appeared to be sleeping rather than dead" (p. 90).

Over the succeeding months, the power of the internal representation of the dead father diminished. The passion for Tommaso developed in response to the feeling of abandonment and emptiness, particularly in the absence of unqualified

4. Ibid.
5. See Ramsden (1963, vol. 1, app. 22) for a translation of the copy of the *ricordo* and an analysis of its implications, which was first recognized by Wilde (Popham and Wilde, 1949) and has led to the revision in the dating of Lodovico's death.

support from the incumbent Pope Clement VII or any secular patron. Michelangelo's mood during the period between his father's death and the meeting with Tommaso can be found in a sonnet fragment from those months:

> I live on my own death; if I see right
> My life with an unhappy lot is happy:
> If ignorant how to live on death and worry,
> Enter this fire, where I'm destroyed and burnt.[6]

Michelangelo's first letter to Tommaso is lost, but a draft of his second letter does exist and is remarkable for its openly expressed fantasy, particularly considering the difference in their ages and worldly positions:

> If . . . I were ever to have assurance of pleasing your lordship in anything, I would devote to you the present and the time to come that remains to me, and should deeply regret that I cannot serve you longer than with that future only, which will be short, since I am old.[7]

Michelangelo actually lived for thirty-two more years. But one main theme in the unconscious fantasy that determined his attraction to Tommaso is apparent. (It will become even more clearly apparent in the course of looking at Michelangelo's sonnets to him, in chapter 16). We can now begin to see why Michelangelo chose the myth of Ganymede for the presentation drawing. The other three presentation drawings that are generally accepted as having been intended for Tommaso are taken from mythological themes that revolve around issues of death and immortality (*Tityus*, 1532, fig. 16-4; *Children's Bacchanal*, 1533, fig. 16-9; and the *Fall of Phaethon*, 1533, in several versions, fig. 16-8).

The relationship between the death of Michelangelo's father and the onset and nature of his relationship with Tommaso sheds light on the evolution from the dying son in the *Laocoön* to the *Dying Slave*. Because of the death of his father and the absence of any appropriate surrogate, Michelangelo may well have developed an unmanageable level of anxiety over his unconscious expectation of being destroyed by the lost father—the object that, in fantasy, Michelangelo had "destroyed" with the sadistic component of his ambivalence. The lost object, in ceasing to be a sustaining internal psychological presence, assumes in the unconscious the role of external persecutor—hence the anxiety. This anxiety occurs during the transitional void, when there is no satisfactory replacement for the protective internal object representation. Left without recourse to a more neutralized and substitutive fantasy—in this case, the Ganymede myth—Michelangelo, driven by the need to restore his father as a vital inner presence, would feel himself subject to the dreaded, more primitive form of the Laocoön myth, in other words, helplessly bound to his father in a frightening death. The life-renewing,

6. Gilbert and Linscott (1963, poem 54).
7. See Ramsden (1963, vol. 1, draft 4) for the complete draft, as well as the later version that was sent to Tommaso (letter 191).

restorative fantasy was his symbiotic union with Tommaso, a handsome, highly cultured young nobleman, in which considerations of their actual respective ages were suspended. In part, Michelangelo's passion involved a process by which he unconsciously saw Tommaso as an idealized image of himself, drawn from a *family romance* construction of his own confused origins. At the same time, Michelangelo felt he could again become the son, achieving a Ganymede-like immortality in service and devotion to an eternally youthful master. The twenty-three-year-old Tommaso did not contain the threat of abandoning him by dying, which Michelangelo had so traumatically experienced with his mother, the stonemason's family, then Lorenzo, Pope Julius, his brother Buonarroto, and finally his father.[8] As one would expect, the passion and sense of rebirth he enjoyed with Tommaso soon subsided, and the artist's tormented struggle with death and the means of salvation continued to the end.

My consideration of the *Dying Slave* has underscored a major developmental pathway that led to the dominance of particular unconscious themes which form a part of Michelangelo's autobiographical myth. The fact that he never mentioned the early death of his mother, and the absence of any known significant other women from early childhood until late in life, bespeak a boyhood climate of prolonged and profound deprivation of maternal care. One solution to his increasing despair over never being able to recover the experience of warmth from the body of a maternal person was to transfer the need to the image of a powerful, caring male, which also contained the imago of the archaic phallic mother. Thus, one comes to understand how absorption in the Ganymede fantasy served well to stave off the terror of the child Michelangelo in the silent darkness of the motherless night.

8. In a forthcoming study of the representation of the Ganymede myth in art during the Renaissance, James Saslow correctly emphasizes that Michelangelo also identified with the role of Zeus. In this way, he could replace his recently lost father and care for the son, Ganymede, as he wished he himself had been cared for. This unconscious dynamic also contributed to the artist's bond with Tommaso.

Chapter Thirteen

Relationships with Other Artists

With the completion of the Sistine Chapel ceiling in 1512, Michelangelo's position as the single most powerful figure in sixteenth-century painting and sculpture was assured. Leonardo had completed only two canvases (the *Mona Lisa* and *St. Anne, Virgin, and Child Jesus*) in the previous nine years and was failing in health. In Venice, Giorgione had recently died (1510), and Titian was just embarking on his long career. In Florence, after the turn of the century, the late quattrocento master painters other than Leonardo—Botticelli, Ghirlandaio, Filippino Lippi, Perugino, and Signorelli—had either recently died or their creative powers had greatly declined. The next generation of Fra Bartolommeo, del Sarto, Rosso Fiorentino, and Pontormo had yet to reach their full stature. Raphael alone offered a challenge to Michelangelo's preeminence. He was, at the time, well advanced in his work on the fresco cycles for Pope Julius's private rooms (the *Stanze*).

As a consequence of Michelangelo's monumental achievements and inescapable presence, all the artists who followed him had to come to terms with the impact of his art in the course of their own development. Some were assimilated and lost their own innovative edge. Others tenaciously fought against assimilation and pursued their own distinctive pathways. All, however, had to engage in some form of dialectic with his work. Moreover, Michelangelo's personality engendered strong reactions ranging from idolatry to angry disdain, but more commonly an ambivalent combination of the two. He, in turn, responded to other artists in ways that often mirrored their response to him. Out of these complex reactions in all parties a number of important artistic and emotional relationships developed that comprise a fascinating theme in an account of Michelangelo's art, as well as, more generally, in sixteenth-century art history. Such were the relationships between Michelangelo and three noted collaborators, Sebastiano del Piombo, Jacopo Pontormo, and Daniele da Volterra, and with one younger rival, Jacopo Sansovino.

Michelangelo and his arch-rival, Raphael, could not have been more different in personality: Raphael was gentle, graceful, and obliging; Michelangelo, quite the opposite. Their styles of art also developed along different paths, so that, with Leonardo, each established one of the dimensions that define what is now called High Renaissance style. In Roman art circles, individuals gravitated to one or the other of what became two rival camps. Vasari, who grew up in the wake of this schism, described the situation:

Raphael of Urbino had risen into great credit as a painter, and his friends and adherents maintained that his works were more strictly in accordance with the rules of art than Michelangelo, affirming that they were graceful in colouring, of beautiful invention, admirable in expression, and of characteristic design; while those of Michelangelo, it was averred, had none of those qualities with the exception of the design. For these reasons, Raphael was judged, by those who thus opined, to be fully equal, if not superior, to Michelangelo in painting generally, and . . . decidedly superior to him regarding colouring in particular. These ideas, promulgated by many artists, were very widely diffused, and found favour among those who preferred the grace of Raphael to the profundity of Michelangelo, and who showed themselves on many occasions to be more favourable to Raphael, in their judgment, than to Buonarroti. [2:334]

The Michelangelo-Raphael rivalry was consolidated by 1513, when Pope Julius II was succeeded by Leo X, a son of Lorenzo the Magnificent. Although Michelangelo and Leo had known each other from boyhood, when Michelangelo lived in Lorenzo's palace, the gracious and epicurean Leo clearly preferred the charming Raphael as his court painter. Moreover, he recorded his uneasiness with Michelangelo. These circumstances, along with Michelangelo's construction of the years of bitterness under Pope Julius, which he largely attributed to the scheming of Raphael and Bramante, made Raphael the target of Michelangelo's unrelenting envy, contempt, and anger. Whereas competitive feelings toward the older Leonardo seemed to catalyze Michelangelo's efforts in the Doni tondo and the *Battle of Cascina,* for the remaining years of Raphael's life (he died at thirty-seven, in 1520) Michelangelo never painted another brushstroke himself. Rather, in this battle, he found a deputy to do his bidding in the young Venetian painter Sebastiano Luciani, subsequently known as Sebastiano del Piombo.

Sebastiano was twenty-six when he came to Rome in 1511. A student of Giovanni Bellini, then of Giorgione, he had established an early reputation for himself in Venice and was brought to Rome by his patron, Agostino Chigi, to paint at Chigi's suburban villa (later known as the Villa Farnesina). The origins of his style lay in the dreamy sensuality of Giorgione, but once in Rome, Sebastiano recognized that accommodations to Roman taste would be necessary. And it was to Michelangelo that he was drawn as his new model. Sebastiano's capacity rapidly to assimilate the Sistine ceiling figural style of Michelangelo and to blend it into his own Venetian idiom is evident in his *Death of Adonis* (fig. 13-1), painted within a year after he first viewed the ceiling.

Sebastiano and Michelangelo differed markedly in personality. Although Vasari clearly disliked Sebastiano, he nonetheless said of him: "Sebastiano . . . always facetious and amusing as he was; a better or more agreeable companion than himself, of a truth, there never lived" (vol. 2, p. 344). This view of him is consistent with the tone of Sebastiano's many letters to Michelangelo from 1512 to 1533—gossipy, witty, flattering, tactful, and ever loyal. Because of his great charm, Sebastiano moved easily among and had the ear of high papal and worldly personages. Thus, with a protégé who possessed all the personality traits he lacked, in

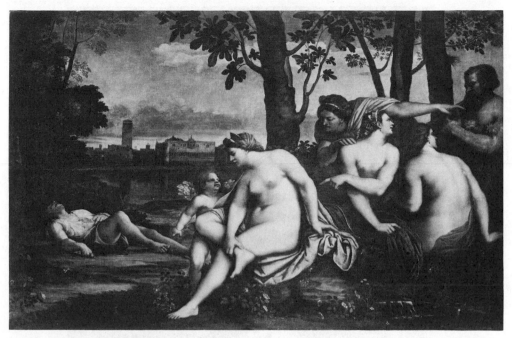

13-1. Sebastiano del Piombo, *Death of Adonis.*

addition to an uncommon artistic gift, Michelangelo was equipped to continue the struggle against Raphael.

Because of the strange form this symbiosis between Michelangelo and Sebastiano took, it appeared on the surface that, as Michelangelo was no longer painting, the contest in Rome for supremacy as an active painter was between Raphael and Sebastiano. The nature of the symbiosis was that Michelangelo would supply ideas and designs for paintings to Sebastiano, who then executed them in a manner that was a dramatic conflation of the master's inspiration and touches of *giorgionismo* from his Venetian past, and his own deeply felt thoughts. Their active collaboration began in 1514 with Sebastiano's great painting of the Lamentation (fig. 13-2), based on a now-lost drawing by Michelangelo. In this work the figures of Christ and Mary are starkly sculptural in concept—massive and set bluntly in a simple inverted-T composition. The painting, however, rises far above the work of a copyist in that the figures derive their full tragic and poignant dimension from the faraway landscape in the background, faintly lit in the misty night air. This part of the painting at least must be wholly Sebastiano's, since it is unlike any work of Michelangelo. The *Lamentation* succeeded in establishing Sebastiano as Raphael's primary Roman challenger.

By 1516, Sebastiano was ready for direct competition with Raphael. Both artists were commissioned by Cardinal Giulio de' Medici (later Pope Clement VII) to execute altarpieces for the Cathedral of Narbonne. Raphael's work was his *Transfiguration*, now in the Vatican Museum, and Sebastiano's was the *Resurrection of Lazarus* (fig. 13-3). Still preserved are some of Michelangelo's preparatory draw-

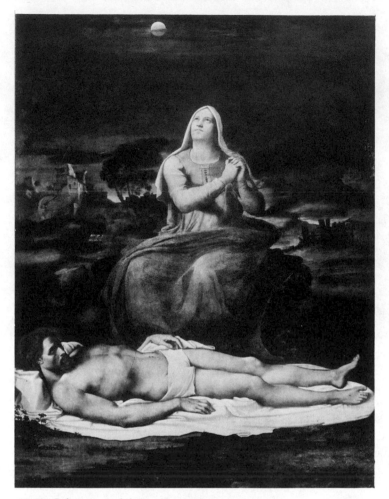

13-2. Sebastiano del Piombo, *Lamentation.*

ings for the *Lazarus.* In the one of *The Risen Lazarus, Supported by Two Figures* (fig. 13-4),[1] we see an example of the way in which Michelangelo and Sebastiano worked together. The power and posture of the figures flow directly from Michelangelo's imagination; Lazarus could well be one of the Sistine Ignudi. But again, the final painting is much more than a summation of Michelangelo's drawings. There is a harmonious flow to the complex composition of the large group of figures. Also, the color and treatment of background landscape make the work both worthy of comparison with Raphael's *Transfiguration* and uniquely Sebastiano's.

A similar process was the basis for Sebastiano's justly admired fresco at San

1. The attribution of this drawing has been disputed. Wilde and Barocchi consider it to be by Michelangelo's hand. Others (Dussler, Hartt, and Tolnay) attribute it to Sebastiano.

Pietro in Montorio in Rome, *The Flagellation of Christ* (fig. 13-5). According to Vasari, in 1516 Pier Francesco Borgherini commissioned Sebastiano to do the painting as a result of Michelangelo's persuasion and "thinking moreover that the latter [Michelangelo] would himself execute the drawing of the whole work, which, as the matter happened, was in fact the truth" (vol. 2, p. 335). In this case, we have the drawing for the overall conception (fig. 8-7). In the fresco Sebastiano reversed the figure of Christ and rendered him more manly than the rather sweet "St. Sebastian" with which Michelangelo, perhaps whimsically, supplied his Sebastiano.

When Raphael died suddenly in April 1520, the original motivation for the collaboration with Sebastiano no longer existed for Michelangelo. Just before his death, Raphael and his school of assistants had embarked on a program of painting the Borgia Apartments and the Hall of Constantine in the Vatican Palace. Sebastiano naturally hoped to move into the vacuum left by Raphael's death and thereby achieve preeminence. However, as yet he had little sense of his own autonomous powers as a painter, and he may well have doubted that the papal patrons would have full confidence in him unless Michelangelo voiced firm support. This new situation in Rome gave rise to a somewhat bizarre letter by Michelangelo that reveals some of the deeper currents of the relationship between the master and his protégé. It followed upon a letter to Michelangelo in Florence, written shortly after Raphael's death, in which Sebastiano told him that the assistants of Raphael were beginning work in the Hall of Constantine. Sebastiano then went on to appeal:

> I pray you to remember me and if I am the man to undertake the job, I should like you to set me to work at it; for I shall not disgrace you, as indeed I think I have not done already. I took my picture [*The Resurrection of Lazarus*] once more to the Vatican and placed it beside Raphael's [*The Transfiguration*] and I came without shame out of the comparison.[2]

This letter conveys Sebastiano's fearful and dependent attitude.

Michelangelo responded to the appeal by writing a letter to an old Florentine friend, Cardinal Bernardo Dovizi da Bibbiena, who was highly placed in the papal court:

> I beg your Most Reverend Lordship—not as a friend nor as a servant for I am unworthy to be either . . . but as a man of no account, poor and foolish, to obtain Bastiano Veneziano [Sebastiano], the painter, some share in the work at the Palace, now that Raphael is dead. But should Your Lordship think that the favour would be thrown away on a man like me, I think that one might find some pleasure in granting favours to fools, just as one does onions as a change of diet, when one is surfeited with capons. You are always granting favours to men of esteem; I beg Your Lordship to try out the change with me. The said Bastiano is a capable man and the favour

2. Translated by Symonds (1893), 1:353.

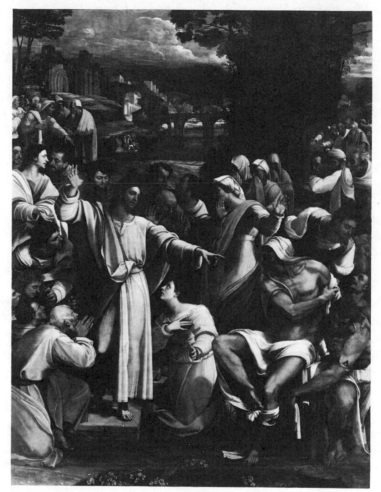

13-3. Sebastiano del Piombo, *The Resurrection of Lazarus.*

would be considerable, which, though it might be wasted on me, would not be so on him, as I'm sure he will do credit to Your Lordship." [letter 145]

This lampoonery of himself was so extreme that Michelangelo's letter was dismissed as a serious recommendation of his protégé, as is evident from Sebastiano's response to Michelangelo:

> The Cardinal informed me that the Pope had given the Hall of Pontiffs to Raphael's apprentices. . . . Then he asked if I had read your letter. I said "No." He laughed quite loudly, as though at a good joke. . . . Bandinelli . . . tells me that the Cardinal showed him your letter, and also showed it to the Pope; in fact nothing is talked about at the Vatican except your letter and it makes everybody laugh.[3]

During this period Pope Leo had instructed Cardinal Bibbiena to offer Sebastiano a commission to paint the lower level of the Borgia Apartments. In response to

3. Ibid., p. 355.

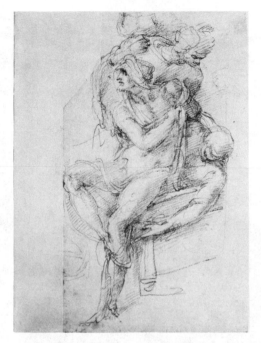

13-4. Michelangelo, drawing of *The Risen Lazarus, Supported by Two Figures.*

this, Sebastiano continued in his letter: "I replied that I could accept nothing without your permission, or until your answer came. . . . I added that, unless I were engaged to Michelangelo, even if the Pope commanded me to paint the hall, I would not do so." He then went on to rage in the letter because he had been commissioned to "paint the cellars, and they [Raphael's followers] to have the gilded chambers." Sebastiano refused the commission and concluded: "It has been my object, through you and your authority, to execute vengeance for myself and you too, letting malignant fellows know that there are other demigods alive beside Raphael da Urbino and his 'prentices."

The correspondence between the two artists about the Borgia Apartments reveals, on the one hand, Sebastiano's utter dependency upon Michelangelo and, on the other, Michelangelo's covert contempt for Sebastiano. For in his letter to Bibbiena, Michelangelo gave the papal court its good laugh only because of his secure position as the supreme painter in Italy, a fact beyond question now that Raphael was dead. This period, however, as we shall discuss in the next chapter, was a bitter time for Michelangelo; only one month earlier the Medici pope had canceled the contract for the façade of San Lorenzo, a project that had consumed three solid years, with absolutely nothing to show for the time spent. Moreover, Bibbiena had been a strong champion of Raphael,[4] which must have been a

4. A subtle and psychologically expressive portrait of Cardinal Bibbiena was painted by Raphael and is now in the Pitti Palace in Florence. Raphael also designed the frescoes of the cardinal's bathroom in 1516.

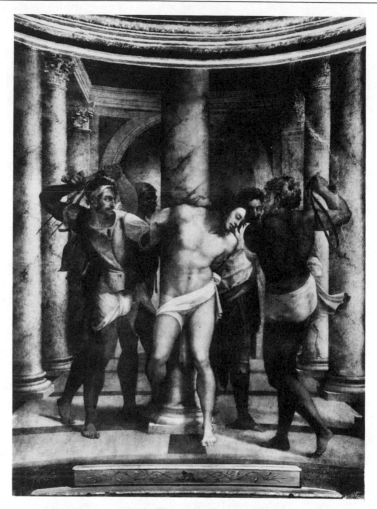

13-5. Sebastiano del Piombo, *The Flagellation of Christ.*

sticking point in Michelangelo's attitude toward him. In writing to the cardinal, who had long been secretary and then advisor to Pope Leo, Michelangelo's bitterness and anger very likely were activated, but, following the same dynamic pathway one finds in the clown and buffoon, he turned his vengeful feelings back onto himself in the form of self-debasing humor, thus successfully masking them. In the process, however, he undercut whatever serious consideration his letter of recommendation on behalf of Sebastiano might have elicited. The effect, then, was not only failure to champion Sebastiano but to expose him at the Vatican to the humiliation of being tied to Michelangelo's self-satire.

Once the collaboration had lost its central binding purpose with the death of Raphael, and without recent examples of Michelangelo's own art or specific designs for projects, Sebastiano's creativity foundered, losing its earlier distinctive character. The notable exceptions were the portraits he painted after 1520, in

which the live presence of the sitter seemed to energize and inspire him. His remarkable portrait of Pope Clement VII (fig. 13-6) from 1526, is the finest ever done of the pope and places Sebastiano alongside Titian in portrait art during this period. Sebastiano apparently became a particular favorite of Clement, who in 1531 named him *Piombotore* (the one responsible for placing the official seal on all papal documents), after which he was known as del Piombo. He acted as a principal intermediary between Michelangelo and Pope Clement, as well as between Michelangelo and the della Rovere heirs, who were pressing the master to fulfill the contract for the Tomb of Julius.

Recently, it has been persuasively proposed by Hirst (1961) that the series of fourteen studies by Michelangelo for a Risen Christ for a composition of the *Resurrection* were to be the basis for an altarpiece in the Chigi Chapel at Santa Maria della Pace, which had been contracted to Sebastiano in 1530. The altarpiece was never completed, which would explain why it is not referred to by Michelangelo's contemporary biographers. The reason Michelangelo labored so arduously over this composition might have been because it was to appear in the same chapel in which Raphael had earlier painted, in fresco, figures of Sibyls and Prophets. Thus, once more Sebastiano was able to be Michelangelo's deputy in battle with Raphael.

Before he gave up painting altogether in 1539, Sebastiano had a resurgence of his earlier powers in two works. One was the *Christ in Limbo* (Madrid, Prado, ca. 1532), which was once again based on the central design Michelangelo had supplied him with years earlier for his *Flagellation*. The other was his simple and deeply moving *Pietà* of Ubeda (fig. 13-7), which was explicitly commissioned in 1533 to be modeled after Michelangelo's statue of the *Pietà* in St. Peter's. In addition, Michelangelo supplied Sebastiano with a drawing for the figure of Christ. Thus, Sebastiano was a major figure in Roman art for several decades; but, with the exception of some of his portraits, his art was never fully his own, and his greatness rested on the shaky foundation of his capacity to suspend the boundaries between himself and his master to produce a work that expressed the strongest talents of both men. Without the sense of serving a master—Michelangelo or Pope Clement—Sebastiano had no moorings. With respect to this controlling psychological orientation of a master-servant character, he mirrored Michelangelo, who, although he was master in this instance, generally seemed to be capable of full creativity only when he could fantasize himself as captive, producing against his will.

In 1535, the relationship between Michelangelo and Sebastiano came to an abrupt and bitter end. Vasari recounts the circumstances. Sebastiano persuaded Pope Paul III to ask Michelangelo to paint the Sistine Chapel *Last Judgment* in oils. Michelangelo apparently neither said yes nor no, and the wall was prepared for oil painting. Michelangelo simply allowed the wall to remain in that state without doing any work. Then, according to Vasari, "when pressed on the subject, he declared that he would only do it in fresco, 'oil painting being an art only

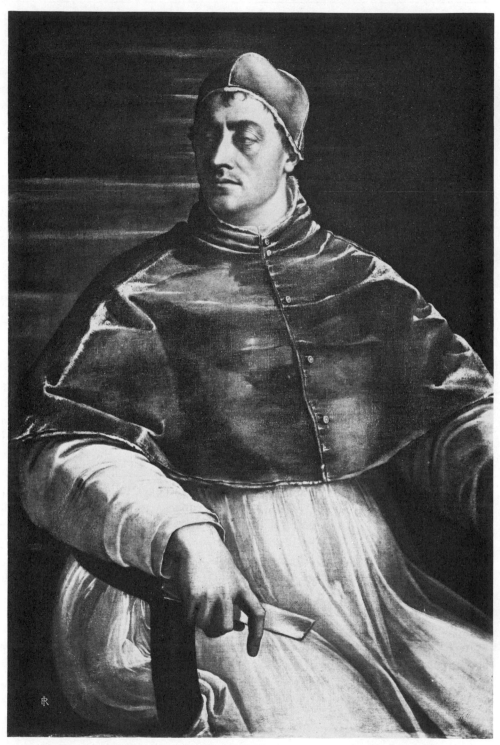

13-6. Sebastiano del Piombo, portrait of *Clement VII.*

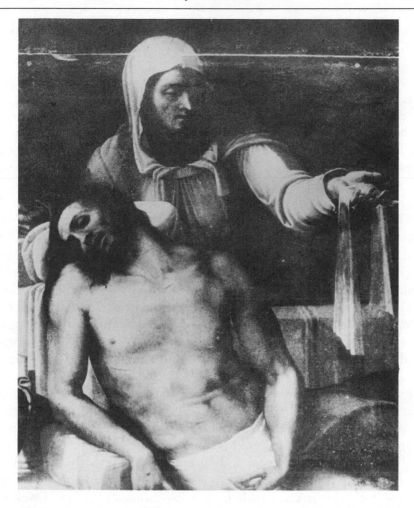

13-7. Sebastıano del Piombo, *Pietà*.

fit for women, or idle and leisurely people like Fra Bastiano [Sebastiano]'" (vol. 2, p. 345). The wall was then prepared for painting in fresco and, Vasari continues, Michelangelo "never forgot the affront which it appeared to him he had received from Fra Sebastiano, and maintained a feeling of hatred against him almost to the Frate's death."

Scholars have been at a loss to explain how the twenty-five-year collaboration and friendship between these two artists could have come to an end over such an easily avoidable ıssue, and one that dıd not seem to spring from any malevolent intent on the part of Sebastiano. There is no record of any contact between the two men after this incident.

It is precisely because it seemed so unwarranted that Michelangelo's behavior is revealing. One must assume that the preparation of the wall was readily under his authority. Therefore, it may be concluded that Michelangelo "needed" an inci-dent and allowed this particular one to unfold as it did in order to justify feelings

that had welled up in him and sought discharge in the form of a break with Sebastiano.

To the question of why the break occurred at that time instead of another, we can only respond speculatively. That year Michelangelo moved permanently to Rome. His move was inextricably tied to his evolving friendship with the young Tommaso de' Cavalieri. It is in the complex of feelings among the three men that I believe the explanation for the break between Michelangelo and Sebastiano can be found. In August 1533, Michelangelo wrote to Sebastiano from Florence: "If you see him [Tommaso], I beg you to commend me to him a thousand times, and when you write to me tell me something about him to put me in mind of him, because if he were to fade from my memory I think I should instantly fall dead" (letter 194).

Michelangelo's passion for Tommaso continued with unbroken intensity following his final move to Rome in late 1534. In the relationship with Tommaso, Michelangelo totally idealized the young Roman, as is abundantly clear from their correspondence and the artist's sonnets to him (see chap. 16). When this kind of idealization takes place, it involves a process of splitting, and there generally occurs a concomitant relationship which becomes invested with the negative elements of thought and feeling that would be natural components of a single full and unified relationship. This polarization is akin to the process discussed earlier, whereby the maternal imago was split into two contradictory images, a "Madonna" and a "Medea" (chap. 7). In 1534, the male transformation of Michelangelo's early love object became split toward, on the one hand, the new, "nurturing" Tommaso and, on the other, the old, "malevolent" Sebastiano. That is, in order to maintain an equilibrium that would permit the union with Tommaso, Michelangelo had to project the distrustful and other harsh attitudes that were intrinsic elements of his inner psychic organization onto someone else. In this case Sebastiano was the luckless victim. In Michelangelo's mind, Sebastiano's well-intentioned but misguided plan that the *Last Judgment* be done in oils underwent a paranoid distortion, so that what might have been simply poor judgment or a misunderstanding took on the aspect of sinister behavior.

Michelangelo's repudiation of Sebastiano could hardly have been less than devastating to Sebastiano. Although he produced a few more works in 1538–39, he put aside the brush and never painted again. He died in 1547.

The timing of the end of the friendship between Michelangelo and Sebastiano may also be related to the active working collaboration that developed during 1531–33 between Michelangelo and the most masterful of the next generation of Florentine painters, Jacopo Pontormo (1494–1557). Pontormo was a student of Andrea del Sarto, who established himself, in 1515, as a greatly gifted revolutionary talent with his *Joseph in Egypt* (London, National Gallery). He then, during his twenties, assimilated many features of Dürer and other Northern artists whose works were beginning to become available in Italy. Thus fortified, he turned back to Michelangelo for inspiration. The fruit of this artistic development was his

masterpiece, *Deposition* (fig. 13-8, ca. 1526–28). Pontormo's Christ was modeled on Michelangelo's *Pietà* in St. Peter's, and the kneeling figure holding his legs is in the spirit of the Sistine Ignudi. However, he wove these threads into a work that is singularly his, filled with a dreamlike inner anguish and rhythmic flow that draw in the beholder as an awestruck witness, joining the artist, who painted himself as the spectator on the far right.

At this point in his early thirties, a strange transformation occurred in Pontormo, who apparently came increasingly into contact with Michelangelo. Freedberg (1970) has aptly said about Pontormo: "It is not possible to recall another case in which an individuality so special and intense as Jacopo is so obsessed— possessed even—by another's art" (p. 124). Soon thereafter, Michelangelo chose Pontormo to execute two commissioned paintings for which he supplied the cartoons. The first was *Noli Me Tangere,* commissioned in 1531 by the governor of Florence and to be given to one of the commanders of the imperial army that had brought Florence to its knees in the previous year. The contract stipulated that Pontormo was to work in Michelangelo's studio, and therefore under his supervision. Both Michelangelo's cartoon and Jacopo's painting are lost, but several copies of the painting exist (fig. 13-9). Michelangelo, who had been superintendent of fortifications in the defense of Florence the year before, could not have been pleased at having to create a gift for the enemy, and the bland work that we infer from the copies distinguishes neither Michelangelo nor Jacopo.

The other painting was of *Venus and Cupid.* Again, both Michelangelo's cartoon and Jacopo's painting are lost. The painting was commissioned by a Florentine friend of Michelangelo's, Bartolommeo Bettino. But, according to Vasari, Pontormo was pressured into giving the painting to Duke Alessandro de' Medici, the ruler of Florence, instead of to Bartolommeo, who received only the cartoon. Vasari notes that Michelangelo "was exceedingly angry with Jacopo" (vol. 2, p. 282).

This regression on the part of Pontormo to the role of copyist for the master, along, perhaps, with the standard he felt he had to measure up to in light of Michelangelo's continuing monumental accomplishments, seemed to drain Pontormo of all his early promise. Although he continued to paint, Jacopo became increasingly isolated, hypochondriacal, phobic, and entirely eccentric—as we know from his own meticulously kept diaries[5] and Vasari's particularly rich description. (Vasari knew Pontormo and was very close to his student, Bronzino.) Jacopo's final eleven years were spent in a bizarre identification with Michelangelo. Surprisingly, he was given a major commission to paint the choir of San Lorenzo. Vasari tells how Jacopo locked himself in the choir so that absolutely no one could see what he was doing. The chapel mimicked Michelangelo's Sistine Chapel, in that one side contained Old Testament scenes from the lives of Adam and Eve and Noah, and the other, a Last Judgment. The unfinished chapel opened just after Pontormo's death. Vasari said of the *Last Judgment:*

5. See Cecchi (1956).

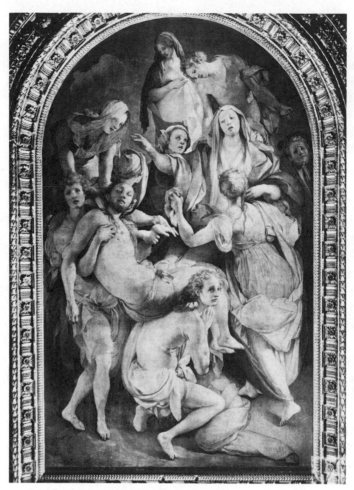

13-8. Jacopo Pontormo, *Deposition.*

I cannot say that I have myself ever been able to fully comprehend all the meaning of this story. . . . There is an absence of all variety in the heads too, the colouring of the flesh is all of one tint, and at a word, there is neither rule nor proportion. Even the laws of perspective have been neglected . . . the whole picture . . . all so melancholy, and giving little pleasure to those who examine this performance . . . I do not myself understand it, although I am also a painter. [vol. 2, pp. 289–90]

Pontormo's frescoes were destroyed when the choir was rebuilt in the eighteenth century. Numerous drawings of them have been preserved, but we cannot know what the frescoes themselves looked like, with their eerie single-tint flesh coloring. I suspect that during those last years of solitary work Jacopo must have moved in and out of a delusional level of obsession with the struggle to be "Michelangelo" or to be totally "himself." From this eleven-year tension emerged a group of paintings about which Clark (1967) has said, "It may well be that we have lost one of the great visionary works of European art" (p. 16).

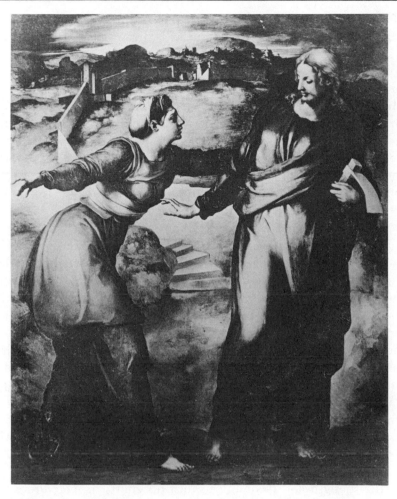

13.9. Jacopo Pontormo (?) after Michelangelo, *Noli Me Tangere.*

The ostensible basis for Michelangelo's active attachment to Sebastiano seems relatively straightforward. With Pontormo, the situation was less clear. Sadly, in the end the genius of Pontormo was largely consumed in the process of yielding to his need to be identified with the more celebrated powers of Michelangelo. On Michelangelo's part, he was quite willing to accept Jacopo's renunciation of his own autonomy and artistic will. Part of Michelangelo's motivation may have resided in the fact that he well recognized his own limitations as a painter of the more ordinary genre of pictures of the day. The impulse to execute ideas in this medium, however, remained. The convenient solution was to absorb a singularly talented younger artist, who could then serve as an extension of his sense of self-as-painter. More covertly, the process involved buffering the threat that he perceived as being posed by the rising younger rival. At the time their collaboration began, Jacopo had secured such a position in the art world. It is interesting that Vasari attributes Michelangelo with having said, upon seeing the

painting of the nineteen-year-old Pontormo: "This youth will be such . . . that if he lives, and should go on as he began, he will carry this art to the very skies" (vol. 2, p. 256).

Jacopo preferred being the loyal, serving "son" to playing the role of the vanquishing one. The collaboration was relatively short-lived, in part, for a practical reason—Michelangelo left Florence in 1534. In the end, however, the conflict over which "son" he really wanted to be proved unresolved and was a significant element in Pontormo's frenzied eleven years of isolated, secret work at San Lorenzo, an effort to surpass the master's Sistine Chapel painting. This effort, with its underlying dual motivation, was central to Jacopo's mental decline and persecutory and phobic fears, as the dynamics of these symptoms involve fear of retribution for unconscious destructive and rivalrous impulses.

A third major painter who came under the spell of Michelangelo like Sebastiano and Pontormo was Daniele da Volterra (1512/5–79). Like the other two, Daniele had achieved a major reputation for himself before encountering Michelangelo. This position was justified by his great *Deposition* (fig. 13-10), in which he fused a kind of Michelangelesque plastic energy with the elegant style of Mannerism. At about this time (ca. 1545) Daniele became both a good companion and an artistic protégé of Michelangelo.

Soon thereafter, during the period 1550–56, Michelangelo prepared drawings for four compositions that were subsequently painted by Daniele, three of which are in existence today. One of the collaborations was for a painting of *St. John the Baptist in the Desert* (figs. 13-11, 13-12).

Under the impact of Michelangelo, Daniele's painting increasingly took on the character of sculpture, for example, his *David and Goliath* (fig. 13-13), which is also based on preparatory drawings by Michelangelo. In the last decade of his life, Daniele's capabilities as a painter were quashed by his contact with the master, but he had the strength and flexibility to turn his efforts to sculpture while still maintaining a painting workshop. No more poignantly expressive image of Michelangelo has come down to us than Daniele's magnificent bust of the aging artist (frontispiece). It was also left to Daniele to execute the will of the Counter-Reformation by covering virtually all of the sexual organs of the multitude of naked figures in Michelangelo's *Last Judgment*, mostly after Michelangelo's death.

Michelangelo never had a workshop comprising assistants and apprentices in the traditional Renaissance way. Rather, he maintained special relationships with a series of major and minor painters and sculptors over the course of his career. They stood in awe of him. He, in turn, used the sculptors to put finishing touches on various statues and the painters, more vicariously, as the means by which he could see his pictorial ideas actualized. In some cases, like that of Sebastiano, Michelangelo had a particular objective—to do battle with Raphael without exposing himself personally. To his less talented but faithful assistants, like Antonio Mini, he could be paternal and deeply generous. With some younger, insignificant talents he could even, at times, idle away a few hours, allowing himself to be diverted and amused.

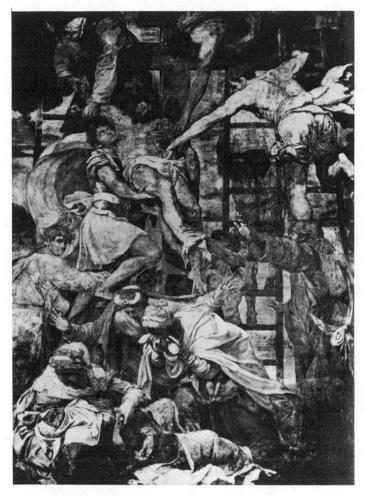

13-10. Daniele da Volterra, *Deposition*.

The story was quite different, however, with respect to the other contemporary artistic giants. We have dwelt at length on Michelangelo's relationship with Bramante and Raphael, and with Leonardo before them. In Condivi's *Life*, Michelangelo thoroughly denounced his early teacher of painting, Domenico Ghirlandaio. His response to Titian, according to Vasari, was equivocal. He spoke critically of Dürer and pointed out shortcomings in Donatello's technique. Scholars have debated how close to Michelangelo's actual words Francisco de Hollanda's recorded statements by the artist are, but in his *Dialogues* (1548) he quotes Michelangelo as making to Vittoria Colonna the following particularly mocking comments on Flemish painting:

Women will like it, especially very old ones, or very young ones. It will please likewise friars and nuns, and also some noble persons who have no ear for true

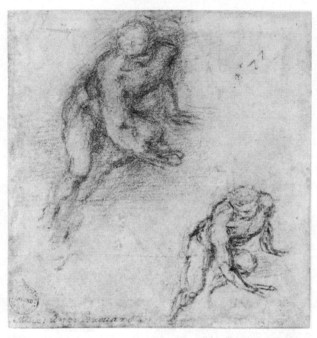

13-11. Michelangelo, studies for *St. John the Baptist in the Desert.*

harmony. They paint in Flanders only to deceive the external eye, things that gladden you and of which you cannot speak ill, and saints and prophets. Their painting is of stuffs, bricks and mortar, the grass of the fields, the shadows of trees, and bridges and rivers, which they call landscapes, and little figures here and there . . . [it] is in truth done without reasonableness of art, without symmetry or proportion, without care in selecting or rejecting, and finally without any substance or verve. [p. 240]

Thus, styles as well as individual artists tended to be evaluated by Michelangelo according to whether or not they entered into artistic devotion or personal subservience to him. His tolerance for alternative artistic visions was virtually nonexistent. This was clearly illustrated in his relationship with Jacopo Sansovino, eleven years younger than he and subsequently the leading Venetian sculptor of the sixteenth century.

A letter exists, written by Sansovino to Michelangelo in June 1517, which in its bitter reproach sheds light on Michelangelo's reactions to artists who did not incur his favor or come under his artistic influence. The letter was written after Michelangelo had barred Sansovino from participating in the design for the façade of San Lorenzo, as had been promised by Pope Leo X. Sansovino wrote:

I have done all I could to promote your interests and honour. Not having earlier perceived that you never confer a benefit on anyone and that, beginning with myself,

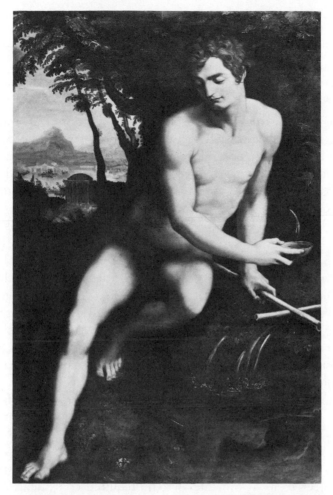

13-12. Daniele da Volterra, *St. John the Baptist in the Desert.*

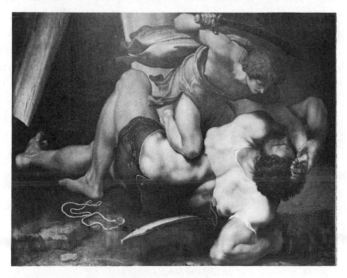

13-13. Daniele da Volterra, *David and Goliath.*

to expect kindness from you would be the same as wanting water not to be wet. I have reason for what I say, since we often had arguments and may the day be cursed on which you ever said any good about anyone on earth.[6]

Although the basis for this particular clash in 1517 is not clear, the background for the ongoing tension between the two sculptors may be rooted in Jacopo's earlier assertion of his own sculptural style, by which he detached himself from the style of Michelangelo that already gripped Florence. Specifically, in 1511, when it became clear that Michelangelo would complete neither the *St. Matthew* commissioned for the Cathedral in Florence nor the other eleven Apostles that he had been contracted to carve, commissions for these works were passed to other sculptors. One, *St. James the Great* (fig. 13-14), was given to the then twenty-seven-year-old Sansovino. He worked on a block of marble that had been quarried by Michelangelo, and by 1518 had completed a statue that clearly challenged the basic concept of Michelangelo's *St. Matthew*. Whereas Michelangelo's Apostle (fig. 10-1) derives its dramatic quality from the violent contrasts within the pose, accented by the forward thrust of the knee out of the block, Jacopo's *St. James* is based on a very different construct, a system of smooth articulation. Indeed, grace and classical restraint are the qualities of *St. James* that express a clear rejection of the style in which Michelangelo portrayed the inner experience of *St. Matthew*. Such an assertion by Jacopo of his right to make his own, very different, artistic statement was apparently felt by Michelangelo as a personal repudiation to which antagonism was an appropriate response.

Michelangelo's relationships with some of the artists he encountered at various points in his career seem to indicate that he required continuous affirmation of both his artistic and his personal worth by drawing to himself talent that he could respect—a common enough human tendency. Some of these artists, because of their own uncertainties and needs, strove to incorporate Michelangelo's powers and entered into varying degrees of symbiotic relationships with him, sometimes serving as extensions of him, executing his artistic will in combination with their own unique gifts. The fruits of these collaborations therefore contain some elements that were not within Michelangelo's own painting vocabulary. In the process, however, the collaborators were diminished as independent beings. Apart from the obvious benefits to the creative products of these cooperative efforts, the nature of this kind of collaboration had the inevitable effect of reducing talented, younger potential rivals to subordinate positions in the arenas of public regard and patronage.

Michelangelo's artistic supremacy never transported him beyond the reach of envy, rivalrous camps, and petty intrigues in the papal court and other Roman and Florentine art circles. The nature of his situation reinforced psychological links to his past and childhood family drama, with its continuous threat of sibling

6. Translated by R. Wittkower and M. Wittkower (1963), p. 73.

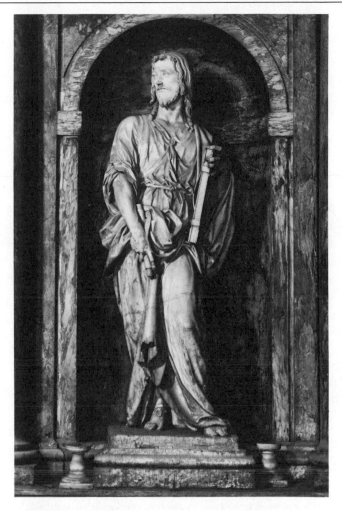

13-14. Jacopo Sansovino, *St. James the Great.*

displacement and parental rejection. Because of this, he experienced all established and upcoming artists as potential usurpers, to be dealt with either through open struggle or through assimilation.

Chapter Fourteen

The Pontificate of Leo X and the San Lorenzo Façade, 1513–1521

Following the death of Pope Julius II, Giovanni de' Medici, the second son of Lorenzo the Magnificent, was elected to the throne of Saint Peter. He assumed the name of Leo X. Self-indulgent, clever and nepotistic, appreciative of the arts and learning, and frivolously self-deluding with respect to the stability of the church, Leo was ill-equipped to deal with the woes that were to beset Catholicism in the second decade of the sixteenth century. Rarely in the history of portraiture has the character of the sitter been so vividly and searingly depicted as in the painting of Leo by Raphael, done in 1518–19 (fig. 14-1). Papal lore attributes to Leo the remark made to his cousin Cardinal Giulio, the future Pope Clement VII, upon his election, "God has given us the Papacy; let us enjoy it."

The great nineteenth-century historian of the popes, Ludwig Pastor (1906–07), wrote:

> With the dawn of the new century the cry for reform sounded louder and louder from both sides of the Alps, taking the shape of treatises, letters, poems, satires, and predictions, the theme of which was the corruption of the clergy, and especially the worldliness of the Roman Curia. . . . That a man who was not equal to the serious duties of the high office . . . should be raised to the Chair of St. Peter at a moment so fraught with danger was a severe trial permitted by God to overtake Christendom. [vol. 7, p. 4]

Raphael's portrait of Pope Leo leads us to understand in part why the eight and a half years of his pontificate evolved into the most barren and frustrating period of Michelangelo's entire creative life. The period began well. While Raphael was enjoying the favor of Leo as court painter and architect, Michelangelo was essentially left alone in his comfortable quarters in Rome to work on the first three statues of the revised 1513 project for an enlarged tomb of Julius. The three works were the *Dying Slave* (fig. 12-1), the *Rebellious Slave* (fig. 12-2), and the *Moses* (fig. 14-2). By early 1516 the two Slaves were in the near-finished state that we now see, and the *Moses* was substantially done. Close to four decades later, Condivi recorded Michelangelo's account of the pivotal turn his artistic activities took at this time. According to Michelangelo, Leo forced the unwilling artist to abandon work on the tomb and undertake the design and supervision of the façade

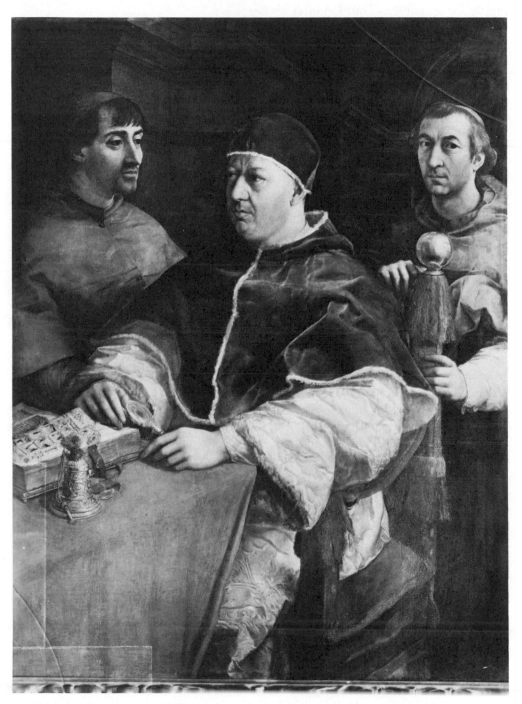

14-1. Raphael, portrait of *Leo X with Cardinals Giulio de' Medici and Luigi de' Rossi.*

of San Lorenzo in Florence, a church that had been built and used by the Medici family for a century. Thus Condivi wrote:

> he did not get very far with it [the Tomb of Julius] before he was interrupted, to his great distress, because Pope Leo, who succeeded Julius, conceived a desire to decorate the façade of S. Lorenzo in Florence with sculpture and marble work. This church was built by the great Cosimo de' Medici and was all completely finished except for the façade at the front. Pope Leo, then, when he decided to contribute this part, thought to employ Michelangelo; and, sending for him, he had him make a design, and finally he wanted him to go to Florence for this purpose and take on that whole burden. Michelangelo, who had begun to work on the tomb of Julius with great devotion, put up all the resistance he could, alleging that he was under obligation to Cardinals Santi Quattro and Aginense and could not fail them. But the pope, who had resolved upon this, answered him, "Let me deal with them, for I shall see that they are satisfied." So he sent for them both and made them release Michelangelo to the very great sorrow of both Michelangelo and the cardinals, particularly Aginense who was . . . the nephew of Pope Julius. However, Pope Leo promised them that Michelangelo would work on the tomb in Florence and that he did not want to obstruct it. So it came about that Michelangelo, weeping, left the tomb and went away to Florence. [pp. 59–60]

In a letter to an unidentified cardinal at the papal court detailing the history of the tomb, Michelangelo wrote: "At this time, Pope Leo, who did not want to execute the said tomb, pretended that he wished to execute the façade of San Lorenzo" (letter 227, October/November 1522). Thus, as we have noted before, Michelangelo apparently believed himself to be singularly committed to the execution of the tomb and further believed that he would have realized this goal had not successive powerful figures coerced him into their service. An examination of the situation in 1516, however, leads us to conclude that Michelangelo was, at the time, a willing and participating "victim."

First, one must consider where Michelangelo stood in relation to the whole tomb project after completing the two *Slaves* and the *Moses*. In May 1513, two months after the election of Leo to the papacy, Michelangelo entered into a new contract for the tomb with Julius's heirs. The "1513 project" provided for an enlarged version, with forty statues, all of colossal size. This contract, moreover, stipulated that Michelangelo could not engage in other projects that would divert him from work on the tomb, which was to be completed in seven years (by 1520). In 1516, after three years of work under optimal and uninterrupted conditions, Michelangelo had done only three of the forty statues called for. However satisfied he might have been with these outcomes of his labors, he surely could not help but realize the utter impossibility of the task ahead—thirty-seven larger-than-life-sized statues, the architectural body of the tomb, and smaller decorative sculpture, to be completed in four years. Therefore, the situation with the tomb had to be modified once again. On July 8, 1516, a new contract was drawn up between Michelangelo and the della Rovere heirs providing for a reduction in the total

number of statues from forty to twenty-two, a marked reduction in the scale of the tomb, and an extension of the completion date to 1522. Most important, Michelangelo agreed to accept no work that would interfere with his completion of the project by 1522.

In reflecting on the progress Michelangelo had made with the 1513 project by 1516, we see that in addition to the mechanical impossibility of fulfilling the contract, the pattern of Michelangelo's art, both before and after this period, suggests that dissatisfaction and restlessness were intrinsic elements in his creative process. It was nearly impossible for him to sustain interest in any particular project, especially in sculpture. This trait was noted by both of his biographers. Condivi wrote: "He also has the most powerful faculty of imagination, which gives rise in the first place to the fact that he has not been very satisfied with his works and has always belittled them, feeling that his hand did not approach the idea which he had formed in his mind" (p. 107). In a similar vein, Vasari commented: "His powers of imagination were such that he was frequently compelled to abandon his purpose, because he could not express by hand those grand and sublime ideas which he had conceived in his mind; nay, he has spoiled and destroyed many works for this cause" (vol. 2, p. 194).

The distinction between the imaginative concept and the finished work has a long tradition extending back to Plato. In the thinking of fifteenth-century Neoplatonists, the *concept* was revered as heavenly while the *material work* itself was merely of this earth and time.[1] Thus, after several years of labor on the *Slaves* and *Moses*, Michelangelo no longer felt the challenge of the unknown and unresolved nor the resultant tension that would enable him to concentrate on and be emotionally engaged in the separate parts of the tomb project. In his imagination it was already "done," leaving only the prospect of long years of effort with the hammer and chisel (even if he had believed that somehow all of the remaining work could be physically accomplished).

There is little evidence of interaction between Michelangelo and the pope before 1516, despite the fact that the two were only a year apart in age and had known each other from their adolescent years, when they lived under the same roof and ate at the same table with Leo's father, Lorenzo. Once he became pope, Leo's aesthetic needs were admirably served by Raphael and his assistants. Moreover, Leo was kindly disposed toward Michelangelo's commitment to the tomb contract of 1513 inasmuch as he had maintained excellent relations with the della Rovere heirs of Julius, particularly Francesco Maria della Rovere, the duke of Urbino. However, in 1515, the duke refused to support the pope's campaign against the French in Lombardy. The outraged pontiff responded by excommunicating Francesco and depriving him of his duchy. In his place, he installed his own nephew Lorenzo de' Medici (later commemorated by Michelangelo in one of the

1. The works of Schulz (1975) and von Einem (1959) stand out among the many attempts to explain why twenty-four of the forty-two marble pieces sculptured by Michelangelo are unfinished.

major statues in the Medici tombs, fig. 15-10). This shift in the relationship between the pope and the della Rovere family is important in that Leo no longer felt obligated to defend Michelangelo's freedom to work on the tomb of the late della Rovere pope. Also, because the della Rovere family, as a result of Leo's action, were stripped of their power and much of their wealth, a major ingredient in the motivation behind most of Michelangelo's works—the serving of a formidable patron—was gone.

At the time of the change in the relationship between Leo and the della Rovere, Michelangelo was approaching completion of the *Moses* (fig. 14-2). Although the final carving and polishing of the statue were not done until 1544, it is generally held that Michelangelo worked on it along with the *Dying Slave* and *Rebellious Slave*, between 1514–16, for the 1513 project of the Tomb of Julius II. Therefore, despite its late completion, any interpretation of the *Moses* must be rooted in the 1514–16 period.

The *Moses* achieves a monumentality that surpasses any other single piece of sculpture by Michelangelo. In the final version of the tomb (fig. 9-1), all else seems like a backdrop for the forward and centrally placed *Moses*. The 1513 project for the tomb, however, was intended to be on a scale unprecedented in the history of mausoleums. According to this plan, the *Moses* was to have been one of four statues of equal scale on the second story, along with Saint Paul and representations of the Active Life and the Contemplative Life. The torso of Moses is disproportionately long for his legs. This can be attributed to the originally planned elevated placement, which would create the illusion for the ground-level viewer of true anatomical proportion.

For centuries, students of the work have been divided on the question of whether Michelangelo intended to create a timeless character portrait or to dramatize the Hebrew leader at a specific moment in historical time. Condivi favored the former interpretation in his description: "*Moses*, the leader and captain of the Jews, who is seated in the attitude of a wise and pensive man, holding the tables of the law under his right arm and supporting his chin with his left hand like a person who is weary and full of cares" (pp. 77, 79). In contrast, many writers, beginning in the seventeenth century, saw this statue of Moses as being on the verge of a specific action in the course of a narrative—namely, just after he descended from Mount Sinai with the Tablets of the Law and saw the Jews dancing around the Golden Calf. Enraged, he is—in this view—about to rise and denounce the Israelites. It is this point in the controversy that Sigmund Freud addressed in his essay "The Moses of Michelangelo" (1914). From the time of his first visit to Rome in 1901, Freud was unusually fascinated by the *Moses*. His writings on the statue have an uncharacteristically personal tone:

> no piece of statuary has ever made a stronger impression on me than this. How often I have mounted the steep steps from the unlovely Corso Cavour to the lonely piazza where the deserted church stands, and have essayed to support the angry scorn of the hero's glance! Sometimes I have crept cautiously out of the half-gloom of the interior

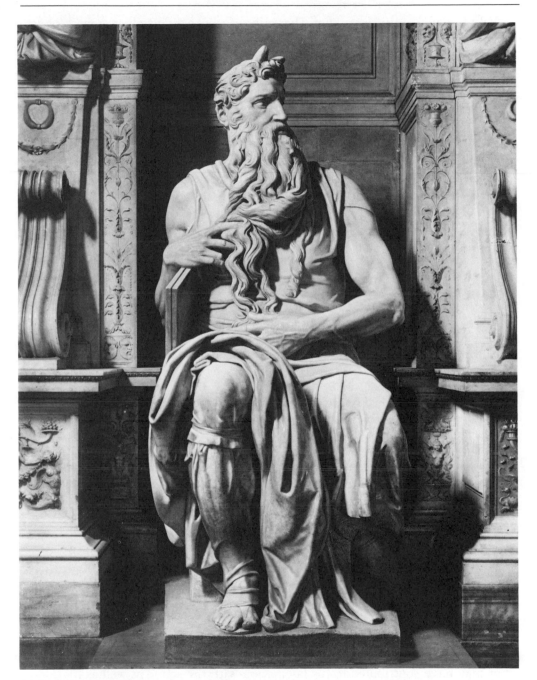

14-2. Michelangelo, *Moses.*

as though I myself belonged to the mob upon whom his eye is turned—the mob which can hold fast no conviction, which has neither faith nor patience, and which rejoices when it has regained its illusory idols. [p. 213]

Freud argued in this essay that what grips us so powerfully about a work of art is "the artist's *intention*, in so far as he has succeeded in expressing it in his work and in getting us to understand it." He then went on to say that for him it was necessary to understand the meaning and content of the work (i.e., to interpret it), in order to discover the artist's intention. Until he arrived at an interpretation, Freud said, he could not know why he had been so powerfully affected by the work.

Freud therefore undertook a detailed analysis of the figure, focusing particularly on two features that had received little previous attention: the fact that the tablets under the right arm of Moses are upside down from the perspective of the viewer; and the way in which the fingers of his right hand are holding certain strands of his flowing beard. From these details he reconstructed a highly feasible sequence of movements that might have immediately preceded the moment caught in the statue. Freud summarized:

> The Moses we have reconstructed will neither leap up nor cast the Tables from him. What we see before us is not the inception of a violent action but the remains of a movement that has already taken place. In his first transport of fury, Moses desired to act, to spring up and take vengeance and forget the Tables; but he has overcome the temptation, and he will now remain seated and still, in his frozen wrath and in his pain mingled with contempt. Nor will he throw away the Tables so that they will break on the stone, for it is on their especial account that he has controlled his anger; it was to preserve them that he kept his passion in check. In giving way to his rage and indignation, he had to neglect the Tables, and the hand which upheld them was withdrawn. They began to slide down and were in danger of being broken. This brought him to himself. He remembered his mission and for its sake renounced an indulgence of his feelings. His hand returned and saved the unsupported Tables before they had actually fallen to the ground. In this attitude he remained immobilized, and in this attitude Michelangelo has portrayed him as the guardian of the tomb. [pp. 229–30]

Freud concludes:

> Michelangelo has added something new and more than human to the figure of Moses; so that the giant frame with its tremendous physical power becomes only a concrete expression of the highest mental achievement that is possible in man, that of struggling successfully against an inward passion for the sake of a cause to which he has devoted himself. [p. 233]

How are we to assess Freud's analysis of the *Moses*? Ernest Jones (1953–57, vol. 2) has provided some personal themes in Freud's own life at the time of writing that may have contributed to his fascination with the statue as well as his conclusions about it.[2] Freud's essay reveals his extraordinary powers of analytic thought

2. Jones believes that Freud strongly identified with Moses the lawgiver. At the time when he wrote the essay, events were taking place in the psychoanalytic movement that he considered comparable to the Israelites' worship of the golden calf. Freud was faced with the "defection" of some of his closest followers—Jung, Adler, Stekel, and the Swiss School.

when confronted with a problem that engaged him emotionally. As to the "correctness" of his conclusion about Michelangelo's intention to represent that particular moment in history and the sequence of actions immediately preceding the chosen moment, I am doubtful. While his theory is plausible, so realistic a pose as part of a specific ongoing action does not conform with Michelangelo's style in single-figure sculpture, which was generally nonspecific in this respect. Moreover, in the context of the whole tomb project of 1513, it is unlikely that Moses would have embodied the specific action that Freud proposes. The figure of Moses was to have been paired with one of Saint Paul on the platform above the first story, as the two exemplars of Neoplatonic thought of the synthesis of action and vision. In this context, an idealized character portrait would have been more appropriate.[3]

That Moses gazes to his left can be simply understood as satisfying a dynamic spatial-compositional demand. In the 1513 schema, *Moses* was to be placed on the right front corner of the platform, above the *Rebellious Slave* (fig. 12-2). The turn of Moses' head to the left counterbalances the thrust of the *Slave*'s torso to the right.[4] Yet, Freud did capture the essence of Michelangelo's *Moses*—an expression of the highest ideal of mental and spiritual achievement through the controlled tension between potential action and restraint, portrayed on a monumental physical level.

Can we be more specific in suggesting some of the earlier models and inner concerns that contributed to Michelangelo's individual rendering of Moses? One apparent influence from earlier in the Renaissance was Donatello's bearded, seated figure of *St. John the Evangelist* (fig. 14-3, ca. 1410). This early work by Donatello anticipated the *Moses* by conveying John's intense visionary character through the figure's deep-set eyes and furrowed brow. The overall impression, however, is passive when compared to the energy and conflict that informs every inch of Michelangelo's figure. The *Moses* also evolved from Michelangelo's own figures of the Prophets and Sibyls (e.g., *Ezekiel*, fig. 14-4; and *Cumaea*), painted on the Sistine Chapel ceiling in the years immediately before.

Another natural place to look for a model for the *Moses* is in the *Laocoön* group (fig. 12-4). Since Michelangelo carved the *Moses* at the same time when he did the two *Slaves*, and since the *Slaves* are, as noted in chapter 12, direct reflections of the body postures of the two sons of Laocoön, it seems plausible that there might be a psychological connection between the third, paternal figure in each group, even though the compositional demands and iconography of the second

3. Hibbard (1974), Panofsky (1939), and Tolnay (1943–60, vol. 4), among others, argue convincingly for the probability of a character portrait.

4. Kavka (1980), following Tolnay's observation that the hands of the *Moses* are almost identical in position to the hands of the Virgin in the *Madonna of the Stairs* (fig. 2-1), has offered the thesis that the *Moses* represents, in part, an unconscious transformation of an angry early mother imago into the powerful male. The two stone tablets are regarded as symbolizing the breasts that she is inclined to withhold. One can, indeed, imagine an infant being cradled against Moses' chest wall by his left arm. Kavka's proposal is consistent with my thesis that Michelangelo's need for the warmth of a maternal person was largely transferred to the image of a powerful, caring male.

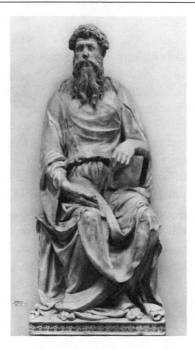

14-3. Donatello, *St. John the Evangelist.*

story of the tomb required that Moses be rendered in a manner quite different from Laocoön at the instant of a futile, violent contortion of his entire body when the serpent pierces his flesh. Nevertheless, in their extraordinary physiques and in the elaboration of their beards we find a formal kinship between the two figures. I believe that the *Laocoön* inspired all three of Michelangelo's tomb statues. It is a less obvious presence in *Moses*, for here elements of the father in *Laocoön* have been transformed into an image of restraint and nonspecific action. As with the *Slaves*, the narrative meaning of the ancient group, the agonizing union of father and sons in death, has been eliminated, giving us a timeless portrait. Yet the noble and powerful presence of Laocoön is still felt as one of the forces that shaped the *Moses*.

Inasmuch as the *Moses* was being carved for the tomb of the recently deceased Pope Julius, we may further speculate that the artist's intense and complex relationship to the pope would inform his representation of Moses. For instance, the dramatic rendering of Moses' beard links him to the pope, whose growth of a long beard in defiance of traditional papal canon was an object of considerable attention during his papacy. In Moses' piercing gaze, the harshness of his expression, and his enormous muscular power, the sculptor has memorialized Julius as the awesome and frightening figure he appeared to Michelangelo, as we can infer from Condivi's description and Michelangelo's own letters. Moreover, by transforming the dying father in the *Laocoön* group into Moses, the artist was able to resolve the destructive aspect of his ambivalence toward the pope. It is fitting that the *Moses*

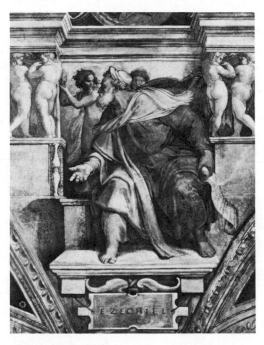

14-4. Michelangelo, Sistine Chapel ceiling: *Ezekiel.*

survived as the central work in the final version of the Tomb of Julius (fig. 9-1), boldly stating the thundering spirit of the Old Testament Prophet—which was also the character of the della Rovere pope.

As we have seen, as the *Moses* neared completion, Michelangelo's engagement in the tomb project was abruptly interrupted when, late in 1515, Pope Leo, who balanced his concern for the Apostolic Church with his concern for the Medici interests, decided to bring the Church of San Lorenzo to completion with the construction of a glorious façade, thus finishing what his forebears had begun a century earlier, with the design of Brunelleschi. A competition for the façade design was held, and plans were solicited from and submitted by the leading architects of the day—Giuliano and Antonio (the Elder) da Sangallo, Andrea and Jacopo Sansovino, and Raphael, as well as others. As yet, Michelangelo had done nothing at all in architecture. Nevertheless, through unknown means, by the autumn of 1516 Michelangelo, in collaboration with his weakest rival, Baccio d'Agnolo, had secured the commission. The leading scholar of Michelangelo's architecture, James Ackerman (1961), uses the word *intrigue* to describe the means employed by Michelangelo. It is certainly reasonable to conclude that Pope Leo did not at the outset command Michelangelo, an untried architect, to take charge of a project so dear to his heart. In choosing or agreeing to Baccio as his collabo rator, Michelangelo acquired an experienced "cover" for his new endeavor—as well as a second-rate artist whom he could ultimately control. In fact, by December 1516 Michelangelo had obtained permission to drop Baccio if necessary. He

did so three months later, after Baccio had constructed a wooden model of the façade based on Michelangelo's drawing. Michelangelo dismissed Baccio's model as "a mere toy" (letter 114). It has also been suggested that Michelangelo entered the arena with initial responsibility only for the sculpture that was to be fitted into the façade.

Regardless of the means by which Michelangelo came to be the sole designer of the façade, what defies belief is his rapid development over the course of a year from a complete novice, beginning with sketches based on Giuliano da Sangallo's competition proposal (fig. 14-5) to the final extraordinary design (fig. 14-6). According to his final plan eighteen statues (six on each of the three storys) and seven sculptured reliefs were to be included. The genius of Michelangelo is reflected in the unique equilibrium among the parts. Despite the complicated grid of verticals and horizontals, a sense of unity obtains. Ackerman (1961) summarized Michelangelo's contribution to the history of architecture in this first effort: "[he] brings to the architectural design a sculptural character previously unknown; his façade is not a plane cut up into rectangles but an organization of bodies that project and recede" (p. 68). One can scarcely imagine the effect the façade would have produced had Michelangelo been able to include the monumental statuary program in the architectural design.

As early as May 2, 1517, in a letter to Pope Leo's aide for the San Lorenzo project, Michelangelo conveyed his supreme confidence in the bold statement: "I feel myself able to execute this project of the façade of San Lorenzo in such a

14-5. Michelangelo, design for the Façade of San Lorenzo.

14-6. Michelangelo, design for the Façade of San Lorenzo.

manner that it will be both architecturally and sculpturally the mirror of all Italy, but the Pope and Cardinal would have to make up their minds quickly as to whether they wish me to do it or not" (letter 116).

Thus, the evidence to this point, early in 1517, contradicts Michelangelo's retrospective view of having been forced against his will to abandon the Tomb of Julius II and undertake the façade of San Lorenzo. I have cited a number of factors, ranging from the impossible magnitude of the tomb project to the artist's complex feelings toward the late pope, as well as the shift in power from the della Rovere family to the new Medici pope, which contributed to Michelangelo's desire to turn away from the tomb. Too, the exciting challenge of the new world of architecture to conquer now that Bramante was dead (1513), and the possibility of swift fame, both motivated Michelangelo to abandon the tomb and seek, by whatever means necessary, the commission for both the architecture and the

statuary of the façade. I must emphasize that, because Michelangelo had demonstrated in all his work—both in sculpture and in his painting of the Sistine ceiling, that he could only work alone, he had once again committed himself to a project that could not possibly be realized.

The extraordinary promise of Michelangelo's design of 1516 rapidly faded during the ensuing three-year period, the most frustrating and barren of Michelangelo's entire career. It terminated with the annulment of the façade contract by the pope in March 1520. So, except for some work on the *Christ Risen* (fig. 14-7) at Santa Maria sopra Minerva in Rome (the least satisfying sculpture of his mature years), there is no art by Michelangelo from this 1516–20 period.

It is beyond the scope of this book to consider in any detail Michelangelo's architectural accomplishments—some of which, like the San Lorenzo façade, never proceeded beyond the design stage.[5] It is striking that in all the extant writings of Michelangelo there is only one discussion of principles of architecture.[6] In a letter to an unidentified recipient, written in 1550 when he was seventy-five years old, Michelangelo reveals how deeply his abstractions about architectural structure were rooted in ideas about the human body:

> When a plan changes its form entirely it is . . . necessary to vary the ornament also and [that of] their counterparts likewise. The central features are always as independent as one chooses—just as the nose, being in the middle of the face, is related to neither one eye nor to the other, though one hand is certainly related to the other and one eye to the other, owing to their being at the sides and having counterparts.
>
> It is therefore *indisputable that the limbs of architecture are derived from the limbs of man.* No one who has not been or is not a good master of the human figure, particularly of anatomy, can comprehend this. [letter 358, my italics]

Michelangelo's architectural style was a radical departure from the fifteenth-century mathematical canons that equated the ideal building with the ideal Vitruvian body. He transformed what was a relatively static model based primarily on anatomy into one that emphasized movement and function. Thus, as Ackerman suggests, his particular organic approach introduced a principle of empathy into Renaissance aesthetics by establishing a physical and psychological bond between observer and object. This is basically a sculptural concept, in which the sculptural elements serve as the musculature that creates conflict and movement, while the walls serve as the stabilizing skeletal structure. Michelangelo's architecture was therefore nurtured and driven by the same interest that lay at the core of his sculpture and painting—the search to understand and express meaning in terms of the human body. As such, it reflects the same need to overcome weight and

5. Michelangelo's architectural projects include the Medici Chapel, the Library of San Lorenzo, and the fortifications of Florence (chap. 15); the piazza and palaces of the Capitoline Hill, the Farnese Palace, and the Basilica of St. Peter's (chap. 19); San Giovanni dei Fiorentini, the Sforza Chapel at Santa Maria Maggiore, the Porta Pia, and Santa Maria degli Angeli—all in Rome (chap. 20)—and several other minor projects.

6. Summers (1972) has offered a comprehensive critical review of the contemporary sources that shed light on Michelangelo's ideas about architecture.

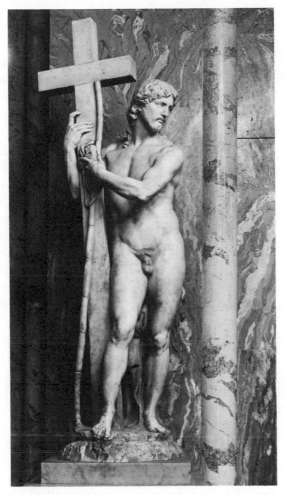

14-7. Michelangelo, *Christ Risen.*

inertia that distinguished his painted and sculpted figures from previous artistic tradition.

Two particular features of Michelangelo's corpus of architectural efforts deserve note. First, there was always a restricting condition to his design—a preexisting or unmodifiable factor—that provided his creative impulse with a defined structure. Thus, for example, the San Lorenzo façade had to be fitted to the front of the church; plans for the Basilica of St. Peter's and the Farnese Palace had to accommodate partially completed buildings designed by earlier architects; and the plans for Santa Maria degli Angeli involved altering for a new function buildings that already existed. It is highly improbable that all his ventures into architecture, covering a half-century, were only accidentally subject to these external controls. Rather, this reflected Michelangelo's self-protective choices in accepting commissions: he embarked only on projects in which the grandiose and monumental

impulses of his imagination could not soar off unharnessed. In this way he avoided repeating the frustration of his ambitions that he associated with the scale of the Tomb of Julius.

The need for external structure is one of the principal reasons Michelangelo could work steadily toward completion on his fresco projects for the Sistine Chapel ceiling, on the *Last Judgment,* and on the *Crucifixion of Peter* and the *Conversion of Paul* in the Pauline Chapel. In all these paintings not only did the finite two-dimensional architectural plane provide boundaries that dictated what he could and could not do with space, but the painting to some extent had to complement the architectural details.[7] Even at that, the *Last Judgment* is painted without any outer frame and appears to be contained only by abutting against the adjacent wall at right angles, as the pictorial narrative strains against its entrapment. Similarly, in his sculpture, the size and form of the marble block largely determined what could and could not be. In keeping with these observations, Ackerman (1961) has succinctly phrased what has been a widely held view about Michelangelo's work over the centuries: "Consciously or not, Michelangelo managed to convey in any art his view of the human body as the *carcer terreno,* the earthly prison that confines the flight of the soul" (p. 71).

The second notable feature of his architecture is Michelangelo's practice of continually changing the design for each project. Thus, of all the surviving architectural drawings, only a very few were executed without some final modification, sometimes of small details, with the result that no building stands exactly as he designed it. I agree with Ackerman's conclusion that in all his architectural projects Michelangelo's creative intensity demanded continuous revision, with the result that the drive itself became the ultimate obstacle to completion.

The fate of the façade project was determined by a number of complex factors. It was largely due to unforeseeable adverse circumstances related to the quarrying situation, which I shall discuss shortly. In addition, papal court machinations, the political situation, and the shrinking Medici treasury all played their parts. However, Michelangelo's feeling of being personally victimized was due in part to his own uncertainty and shifting commitment to the façade and to his guilt about his desire to abandon the Tomb of Julius.

We recall that, according to the terms of the 1516 contract for the Tomb of Julius, Michelangelo agreed to accept no work that would interfere with his completion of the project. It is clear, however, from a letter to Cardinal Giulio de' Medici from his treasurer Domenico Buoninsegni, written in November 1516, that Michelangelo had taken the initiative when they met in Florence by expressing his desire to execute the San Lorenzo façade. According to Buoninsegni, it was only then that he spoke to the cardinal, who spoke to Pope Leo, who immediately commissioned the façade to Michelangelo and Baccio. This and another letter from Buoninsegni to the artist later the same month suggest that

7. Steinberg (1975) delineates the relationship between elements of the *Conversion of Paul* and the *Crucifixion of Peter* and the architectural details of the Pauline Chapel.

Michelangelo had some misgivings at that time about leaving work on the tomb for the façade. Thus, we can conclude that by the latter half of 1516 Michelangelo was in considerable conflict between what had come to feel like an interminable bondage to the tomb project, which no longer absorbed his interest and was beyond the range of what possibly could be executed by 1522, and the excitement of the grand possibilities of the façade project.

Michelangelo spent the better part of the years 1517–19 at the marble quarries in the mountains of Carrara and Pietrasanta, gathering blocks for the façade of San Lorenzo. Consideration of this three-year period of frustration, rage, and waste as the artist lived for the most part in the mountains, supervising the quarrying, will lead us to the issue of Michelangelo's complex relation to stone itself. Until the time of the quarrying for the façade marble, virtually all important sculptural projects had used marble quarried in the mountains of Carrara. However, in 1515, the Republic of Florence acquired exclusive rights to quarry marble from the surrounding regions of the commune of Servezza, in Tuscan territory. It was, however, virgin land, and no adequate means existed for transporting sizable blocks from the quarries to the nearby ports for shipping.

In 1516, when Michelangelo was in Carrara still unearthing marble for the tomb, he sensed from the Carrarese storm clouds of what was to follow as a consequence of their loss of a monopoly. In September 1516, Michelangelo wrote from Carrara to his father: "I have met with some unpleasantness, so that I should remain with some misgiving" (letter 112). Other letters written that summer express Michelangelo's concern about the progress of the building of the road at Pietrasanta. A letter from Michelangelo's brother Buonarroto to the artist in January 1517 suggests that resentment was developing toward Michelangelo in Florence because it was felt that he favored the Carrara over the Tuscan quarries. In that same month Michelangelo went to Pietrasanta, where, as Condivi later recounted, he "found marbles which were very difficult to work and not really suitable; and, even if they had been suitable, it is difficult and very expensive to transport them to the coast, as it was necessary to build a good many miles of road. . . . When Michelangelo wrote this to the pope, he gave more credence to those who had written to him from Florence than to Michelangelo, and he ordered him to build the road" (pp. 61–62).

The pope was clearly displeased with Michelangelo's assessment of the situation, and his displeasure was promptly conveyed to the artist in a letter written by his cousin, Cardinal Giulio:

> We have received your letters and shown them to Our Lord [Pope Leo], and considering that all your proceedings are in favour of Carrara, you have caused His Holiness and ourselves no little surprise. . . . We have our suspicions that for some reason of your own you seek to favour the marbles of Carrara overmuch and to denigrate those of Pietra Santa. This you certainly should not have done, in view of the trust we have always placed in you. We therefore inform you that His Holiness, Our Lord, putting aside every other consideration, wishes the marbles . . . to be drawn from Pietra Santa and from nowhere else. . . .

Therefore see that you carry out the orders we have given you and fail not to do so, because if you do otherwise, against the will of His Holiness and ourselves, we shall have great cause of complaint against you. . . . Answer . . . quickly, banishing all obduracy from your mind. [Ramsden, 1963, vol. 1, p. 263]

This letter from the cardinal, apart from clarifying the Carrara-Pietrasanta situation at that moment, is remarkably revealing of the firmness of attitude of the papal powers toward artists, even Michelangelo, when conflicting political or economic interests were at stake. Here, the potential revenues to the Tuscan quarries preempted all other considerations, including the opinions on the matter of the master stonecarver of Italy, who was charged with executing the façade of the Medici church.

Nevertheless, some equivocation took place, as is reflected in the formal contract for the façade, which provided that the marble blocks were to be the "best," wherever they were from, Carrara or Pietrasanta. In Michelangelo's account of the years of quarrying, he recalls: "As the Carrarese were bent upon balking me, I went to have the said marbles quarried at Seravezze [Pietrasanta]" (letter 144, March 1520). Inasmuch as a number of his letters from the 1517–18 period contain comments about his harassment by the Carrarese, it appears that their hostility had more to do with Michelangelo's transference of quarrying operations to Pietrasanta than the pope's orders did. At this time, however, there was no way for Michelangelo to foresee the desperate situation that was immediately to follow.

On arrival at Pietrasanta, Michelangelo tried to master the primary obstacle to the functional use of the quarries—the lack of roads for transporting the blocks. He accepted the job as superintendent of road construction as well as quarrying, in exchange for the right for himself and his heirs to quarry marble for their own use in perpetuity. However, the workers were incompetent and the marble could not be transported once it reached the sea because the Carrarese had bribed all the bargemen along the coast. Many letters exist in which Michelangelo enumerated his woes. On April 18, 1518, he wrote to his brother Buonarroto:

The *scarpellini* [stonecutters] whom I brought from Florence know nothing on earth about quarrying or about marble. They have already cost me more than a hundred and thirty ducats and haven't yet quarried me a chip of marble that's any use. . . . In trying to tame these mountains and to introduce the industry into these parts, *I've undertaken to raise the dead . . .*

The barges I hired at Pisa have never arrived. I think I've been gulled, and so it is with everything I do. Oh cursed a thousand times be the day I left Carrara! It's the cause of my undoing. But I shall soon return there. [letter 123, my italics]

Despite the continuous misfortunes that befell Michelangelo, he remained hopeful, at least for a time. In a letter of August 1518, to an official in Florence, he wrote: "A great deal of patience will therefore be needed for some months, until the mountains are tamed and the men trained; then we shall get on faster. It is sufficient that what I promised *I shall perform without fail and shall produce the finest work that has ever been produced in Italy*—with God's help" (letter 129, my italics).

However, the problems did not resolve themselves, and shortly thereafter Michelangelo wrote to his good friend Lionardo the Saddler: "I'm dying of vexation through my inability to do what I want to do, owing to my ill luck" (letter 134).

On March 10, 1520, the pope annulled the contract for the façade of San Lorenzo and ordered that the marble that had been quarried be sent to the Cathedral of Florence to repave the floors. Michelangelo never received a coherent explanation for the termination of the project. Vasari later wrote that Cardinal Giulio's treasurer, Buoninsegni, had endeavored to enlist Michelangelo in a scheme to embezzle funds and defraud the pope. When he was spurned by the artist, Buoninsegni vindictively did what he could behind the scenes to discredit Michelangelo. In all probability, however, the project was canceled because it became apparent that it could not be realized in view of all the unforeseen obstacles. Furthermore, it was putting excessive strain on the papal treasury at a time of great financial pressure. Because of these factors, the pope and Cardinal Giulio decided to redirect Michelangelo's energies to the construction of a new sacristy at San Lorenzo for the Medici tombs. Michelangelo's state of mind at the end of the façade affair is revealed in his response to a papal order for an accounting of all of the disbursements connected with the ill-fated project. In March 1520, he concluded a long letter to a notary:

> I am not charging to his account, over and above, the space of three years I have lost over this; I am not charging to his account the fact that I have been ruined over the said work for San Lorenzo; I am not charging to his account the enormous insult of having been brought here to execute the said work and then of having it taken away from me; and I still do not know why. [letter 144]

In looking back on Michelangelo's career up to this time we see that he periodically spent extended periods of time in the mountains at the quarries of Carrara and, later, of Pietrasanta. In 1497–98, he spent six months at Carrara, seeking marble for the *Pietà* at St. Peter's; in 1505, eight months obtaining marble for the Tomb of Julius; in 1516–18, he spent periods of three months, seven months, and one month at Carrara in search of stones for the tomb and the façade; and finally, in 1518–19, he spent eighteen months at Pietrasanta. During these sojourns he was away from family, friends, the mainstream of art, patrons, and the familiarity of Florentine and Roman urban life. How can we understand these periods of isolation in the remote mountains? Clark (1964) has spoken of the months the sculptor spent at Carrara as a religious retreat in which "his love of marble was almost like a saint's love for some manifestation of God" (p. 437).

It is fair to assume that Michelangelo had a deeply vested interest in ensuring that the block of marble with which he was to enter into so intimate a relationship be free of veins and other obstacles to his carving. Yet the wish to oversee the selection and stages of the cutting does not seem a full explanation for his long immersions in the quarries.

A starting point for understanding Michelangelo's relationship to the quarries is his statement from Pietrasanta, "In trying to tame these mountains . . . I've

undertaken to raise the dead" (letter 123). This stark phrase suggests that Michelangelo's consuming absorption with these raw sources of marble had its origin in his earliest experiences—the first year or two of his life, spent with the stonecutter's family among the blocks at the farm in Settignano. Let us recall once again Michelangelo's statement to Condivi that his wet-nurse had been both the daughter and the wife of stonecutters and that his delight in the use of the chisel was transmitted to him through the milk of the foster mother, which possessed the power to shape the personality of the infant. I would postulate that the later retreats to the quarries also represented the search for his lost maternal and nurturing origins. The search was undertaken again and again, while most of his statues remained in some state of incompletion, and all his sculptural programs were far from finished.[8]

Michelangelo wrote a madrigal in 1544 in which he equated stone and maternal rejection in words that also convey the intensity of his ambivalence:

> . . . just as I am made by her,
> And always seem to take
> Myself for model, planning to do her.
> The stone where I portray her
> Resembles her, I might
> Well say, because it is so hard and sharp;
> Destroyed and mocked by her,
>
> .
>
> And yet if art can keep
> Beauty through time only if she endure
> It will delight me, so I'll make her fair.[9]

Thus Michelangelo states his conflict in identifying stone with woman; he sees as futile his attempts to convert this "stone-mother" into anything more nurturing, yet he cannot abandon hope. Out of his despair over ever finding "her," Michelangelo seems to state that he can only rely on himself.

At the deepest level of unconscious thought, the marble face of the mountain represented the maternal breasts. As Sterba and Sterba (1978) have suggested, the quest in the quarries for the intact, perfect block of marble was part of a restitutive process. An intrinsic component of this form of restitution was the venting of Michelangelo's rage at the oral and maternal deprivation to which he had been subjected. In contrast with the farmer who works the earth's surface by agricultural means to yield nourishment, Michelangelo had to attack this obdurate and intransigent material with sharp and harsh weapons to make it his. On a drawing for

8. In the earlier analysis of the Doni tondo (chap. 7), I concluded that the curious presence of a stone quarry in the background, peopled by androgynous youths in homoerotic interplay, was a symbol for the regressive yearnings of Michelangelo for his earliest feeding situation in the context of his subsequent traumatic experiences with mothering figures, which is the latent content of the fore- and middle-ground images.

9. Gilbert and Linscott (1963, poem 240).

the lost bronze statue of *David*, Michelangelo wrote, "David with his sling and I with my bow" (Daviete cholla frombe / e io chollarcho) (fig. 14-8). In this written fragment, the artist played on the word *bow*, which, in addition to being a weapon, was the term for the sculptor's hand drill. The bow, hammer, and chisel were Michelangelo's tools for attacking the block. By making an analogy with David, who with his weapon slew the hated enemy, Michelangelo reveals his unconscious view of mountain stone as something to be conquered and forced into relinquishing the image imprisoned within. Throughout his long life, the hope of recovering the idealized state of early union with his mothering figure brought him back to its most primitive symbolic origins—the buried sources in the earth—to reengage in the struggle to regain the unfulfilled promise. It was a struggle composed of exhilaration and fury. As the phrase "to raise the dead" implies, it was Michelangelo's inner imperative to breathe life and movement into this most inert of the earth's substances. Indeed, the most animated of all Michelangelo's images is found in one of the sketches from the series for *The Resurrection* (fig. 8-9), in which the tomb of stone has miraculously yielded up the soaring and triumphant Redeemer. Though more restrained, in the *Creation of Adam* (fig. 11-8) the languid form of Adam appears to rise from the blue-gray, barren stone mound beneath him. In 1871, Walter Pater perceptively wrote: "Carrara, those strange grey peaks . . . [Michelangelo] wandering among them month after month, till at last their pale ashen colours seem to have passed into his painting" (p. 87). Indeed, from the jagged, bare rock of the Doni tondo and the *Battle of Cascina*, to

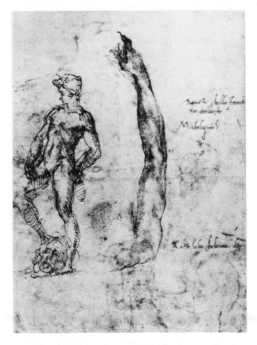

14-8. Michelangelo, studies for the bronze *David* and the marble *David*.

the *Noah* and *Adam* and *Eve* histories of the Sistine ceiling (where even Paradise is barren rock except for the Tree of Knowledge), through the *Last Judgment* and the final Pauline Chapel frescoes of the *Conversion of Paul* and the *Crucifixion of Peter,* even the smallest signs of vegetation are virtually nonexistent. Rather, Michelangelo's legions inhabit an earth paved with stone. Flesh and stone are the timeless dialectic of his art. Carrara not only provided him with marble for his sculpture; it also served as the model, only slightly modified, for the landscape we see in many of his paintings. In this context we recall the lines in his letter: "Oh cursed a thousand times be the day I left Carrara! It's the cause of my undoing. But I shall return there" (letter 123).

The constant presence of stone during his stays at the quarries may have functioned as an equivalent of *transitional phenomena* for Michelangelo. That is, just as a "security blanket" or other material object serves as a comforting substitute for the absent mother to the toddler and young child, a symbolic substitute until the child is cognitively able to achieve *object constancy* (the capacity to maintain an internalized mental concept of the mother even if she is not physically present), so I believe that the masses of marble at the quarries were comforting companions and representations of the sculptor's repressed or unremembered early childhood with the stonecutter foster family and wet-nurse.[10]

A question inevitably emerges from these considerations of Michelangelo's relationship to stone and the quarries: what was he trying to find, or refind, in transforming stone to life? I shall return to this question when exploring the Florence and Rondanini *Pietàs* and the artist's last drawings, in chapter 20.

In the present context, however, we may recall a striking fact about Michelangelo's work: two-thirds of his statues were never completed. The problem of *nonfinito* bears on the present question of the meaning of his relation to stone. While some of these works were left uncompleted for practical or external reasons (as in the case of the *St. Matthew,* abandoned because Michelangelo had to leave Florence for Rome at the summons of the pope), I believe, that most were left undone for more complex internal reasons. A central factor was that, for Michelangelo, to complete a statue was also to sever his bond with the block of stone. After so long and intense an involvement with the material substance as well as the idea of a statue, to bring this active relationship to an end held the prospect of evoking echoes of his early, profound separation anxieties. Moreover, the figure that emerged from the husk of marble could never really be the object of his relentless unconscious search. It was simply what it was—lifeless and unresponsive to him. Therefore, more often than not, Michelangelo avoided the pain associated with

10. The concept of transitional phenomena originates in the work of Winnicott (1971). He posits that the transitional object is the infant's first "not-me" object, which replaces the symbiotic mother. It is the forerunner of illusion, which bridges the infantile view, in which everything is an extension of oneself, and the emerging capacity to regard objects as separate from oneself. Winnicott believes that the fate of this early capacity for illusion plays an important role in adult creative and artistic experiences. I am grateful to Simon Grolnick (1977) for suggesting the relevance of some of these ideas in the present context.

that stark end. He turned instead to the next project, and the next, and finally, in the last fifteen years of his life, to one theme, the union of Son and Mother in the Pietàs.

Thus, the façade project was abandoned, bringing to a close one of the more disappointing chapters in Michelangelo's life. We shall now move on to the time that immediately followed, when his efforts were directed to the Medici Chapel in the same Church of San Lorenzo.

Chapter Fifteen

Pope Clement VII, the Medici Chapel, and Michelangelo's Final Departure from Florence, 1519–1534

In the years from 1519, when the San Lorenzo façade project was cancelled, to 1534, his final departure from Florence, Michelangelo's art was distinguished by the integration of sculpture and architecture. His principal achievement of this period is the Medici Chapel in the Church of San Lorenzo (fig. 15-1). By the end of this phase of his life the artist was fifty-nine years old, and in the austere, gray-white, unfinished space of the chapel we find, carved in stone, his meditations on the approach of his own old age and death, no doubt influenced by his feelings about such contemporaneous events as the death of his father and his brother Buonarroto, the fall of the Republic of Florence, and the mounting troubles that beset the Apostolic Church.

Following the termination of the San Lorenzo façade project in the summer or fall of 1519, Pope Leo directed Michelangelo to redirect his energies to the Medici Chapel and tombs. In the same year Charles V of Spain was crowned Holy Roman Emperor. Appreciating the strength of the Spanish, Leo X began secretly to plot with Charles for the expulsion of the French from Lombardy. This was eventually accomplished in November 1521 through the joint efforts of papal and imperial forces. Leo died suddenly on the first day of the following month. Symonds (1893) captured the sense of the time following Leo's demise:

> The Pope at that time in Italy had to perform three separate functions. His first duty was to the Church. Leo left the See worse off than he found it: financially bankrupt, compromised by vague schemes set on foot for the aggrandisement of his family, discredited by many shameless means for raising money upon spiritual securities. His second duty was to Italy. Leo left the peninsula so involved in a mesh of meaningless entanglements, diplomatic and aimless wars, that anarchy and violence proved to be the only exit from the situation. His third duty was to the higher culture which Italy dispensed to Europe, and of which the Papacy had made itself the leading propagator. Here Leo failed almost as conspicuously as in all else he attempted. He debased the standard of art and literature . . . breeding round him mushrooms of mediocrity. [vol. 1, p. 366]

Leo was succeeded in January 1522 by the Netherlander Pope Adrian VI, the choice of Emperor Charles, whose tutor he had been. Adrian was interested in

little beyond his religious mission and combating corruption in the church and in the papal court. Artistic splendor held no attraction for him—particularly the self-aggrandizing Medici projects.

During Adrian's pontificate, the della Rovere family regained much of its lost power, including the duchy of Urbino. This had a direct effect on Michelangelo. Under the pope's pressure in the form of a personal decree (*motu proprio*), the artist was directed to deliver the Tomb of Julius according to the terms of the 1516 contract or else return all the money he had received, plus interest, to Julius's heirs. Apart from causing him considerable agitation, this forced Michelangelo to stop the work in progress on the Medici Chapel and tombs and return to the Julius project. The fruits of his labors on the Tomb of Julius during Adrian's brief pontificate are the four partially carved *Boboli Slaves* (figs. 15-3, 15-4, 15-5, and 15-6), to which we shall return shortly.

Fortune soon smiled on the Medici, however. On September 14, 1523, Pope Adrian died of poisoning. His successor was Cardinal Giulio de' Medici,[1] who chose the name Clement VII. In Italy great elation greeted his election. Michelangelo shared in this response, as is evident in a letter to a friend: "You will have heard that Medici is made Pope, which I think will rejoice everyone. I expect for this reason, that as far as art is concerned many things will be executed here [Florence]" (letter 156; Nov. 25, 1523). Indeed, the Florentine historian Francesco Guicciardini (1561) recorded:

> There was certainly throughout the world the highest estimation for this new Pope . . . a person of highest value and prestige in the Papal See . . . and because for so many years during the period of Leo he had governed practically the entire pontificate, and because he was reputed to be a serious person, constant in his judgments; and since many things which had occurred during Leo's reign were attributed to him, everyone affirmed him to be a man full of ambition, lofty-minded, restless, and most eager for innovations; to these factors were added the fact that he abstained from pleasures and was assiduous in his duties. [p. 338]

However, despite these great hopes, Pope Clement's pontificate (1523–34) evolved into utter disaster. Guicciardini leaves the following epitaph:

> He died hated by the court, suspected by princes, and with a reputation which was rather heavyhanded and hateful than pleasing; being reputed to be avaricious, faithless, and not given naturally to benefit mankind. [pp. 440–41]

It appears that Clement was considerably less concerned with being the Vicar of Christ than ruler of the Papal See and guardian of the Medici interests. Over the course of his pontificate, the pope and Michelangelo had a highly complex and

1. The cardinal was captured in a seemingly unguarded moment in Raphael's triple portrait of him, Leo X, and Luigi de' Rossi from 1517–18 (fig. 14-1). Giulio is the standing figure on the left. However, Clement during his pontificate is best known through Sebastiano del Piombo's portrait of 1526 (fig. 13-6). Of this work, Freedberg (1970) has said: "The face is a remarkable characterization, shadowed and subtle, full of ambivalence, withdrawn in a poised hauteur" (p. 149).

ambivalent relationship, due in large measure to the political situation in Italy during those years.

The Medici Chapel

Clement viewed Michelangelo as his chief instrument for the glorification of the Medici in Florence. He therefore served as Michelangelo's protector during much of this period. The principal Medici project was the Chapel at San Lorenzo. With respect to its planning few documents survive. It was actually referred to as the New Sacristy and was to complement the Old Sacristy, designed by Filippo Brunelleschi almost a century earlier. Construction began on the New Sacristy before Leo X and Cardinal Giulio reached the decision that it was to contain the tombs of four members of the Medici family: Lorenzo the Magnificent; his brother Giuliano (father of Pope Clement), who was assassinated in the Pazzi conspiracy of 1478; and two recently deceased Medici, the last direct, legitimate male issue of the family—Giuliano, the duke of Nemours, and Lorenzo, the duke of Urbino. It was the death of Lorenzo in 1519, at age twenty-eight, that crystallized the tomb project. Along the way, in 1524, Pope Clement proposed that he and Pope Leo should also be buried in the chapel.

Only two of the tombs were executed, and they were left incomplete. One is for the younger Lorenzo (fig. 15-10), and the other, on the opposite wall, is for the younger Giuliano (fig. 15-9). Each of these wall tombs contains only three of the seven larger-than-life-size figures originally intended. The sculptural scheme is completed on the entrance wall (fig. 15-1) by the last of Michelangelo's five carved Madonnas, the *Medici Madonna* (fig. 7-11). This is flanked by the figures of two of the Medici patron saints, Cosmas and Damian, which were executed by followers of Michelangelo after his design. When we stand in this stark and awesome funereal chamber it is difficult to realize that it is only a rudimentary form of what Michelangelo visualized. Not only are the tombs and statuary fewer than was planned, but the chapel was to have included frescoes on the cupola and large lunettes above the tombs.

In contrast to the long labor of the actual carving, the design of the chapel and tombs went rapidly and offers striking evidence of the play of Michelangelo's imagination. It can be assumed that by the time he left for Carrara to quarry the marble in April 1521, the plans for the project were completed and approved. Fortunately, many of Michelangelo's working sketches are preserved, which has made it possible to reconstruct the evolution of his thought. These drawings bear testimony to the fluidity of his creative imagination as he moves from one solution to another, sometimes sketching alternatives on the same sheet. During this preparatory period the scheme evolved from wall tombs where the tabernacles are now placed, to free-standing block tombs joined by four arches in the center, to two double wall-tombs (fig. 7-12), and finally to single tombs for each of the dukes placed on the side walls and a double tomb on the entrance wall. These

15-1. Michelangelo, Medici Chapel, San Lorenzo: interior view of the entrance wall with the *Medici Madonna* and *Saints Cosmos* and *Damian*, and Tomb of Lorenzo de' Medici.

drawings are unencumbered by measurements—a characteristic of all but one of Michelangelo's entire collection of architectural drawings.

It is now generally accepted that Michelangelo alone was responsible for the architecture of the chapel in everything beyond the floor plan. In designing the structure of the chapel itself, he retained the basic Brunelleschian character of the Old Sacristy. However, he introduced two radical innovations: first, in the nature and depth of the separate sections of the marble and gray *pietra serena* moldings; second, in the effect of a dynamic upward movement through the three wall levels into the Pantheon-like grid of coffers, which creates the harmony of circular and radial accents that draws the viewer to an illusionary vanishing point at the lantern (fig. 15-2). Just as Michelangelo's inventiveness increased with each new unit of the Sistine ceiling, so his originality was increasingly evident as he ascended from the floor of the chapel to the lantern. The result is a structure rooted in tradition yet animated by bold and innovative concepts, so that it was, in Ackerman's (1961) words, "ultimately to create a unity of ornament and structure never surpassed in architecture" (p. 96).

The Medici Chapel represents a dialectic between Michelangelo and Brunelleschi. Michelangelo began by incorporating the concepts of the established master and then repudiated the source of his inspiration with his own radical invention, as he had done with Signorelli and Leonardo in the Doni tondo.

Work on the chapel structure advanced rapidly. The lantern was placed on the cupola in 1524. But with the election of Pope Adrian in January 1522, the carving of the tombs came to a standstill. Under pressure from Adrian to return to work on the Tomb of Julius, Michelangelo appealed to Cardinal Giulio de' Medici (the future Clement VII) to obtain a release for him from his obligations to the della Rovere heirs, with the "promise to work for him [Giulio] without any return for the rest of my life" (letter 152). But relief was not forthcoming during Adrian's pontificate. Michelangelo therefore returned to the Julius project and worked on the four figures known as the Boboli *Slaves*.

The Boboli Slaves

Although there are differences of opinion among scholars with respect to the dating of these sculptures, I am persuaded by Hibbard (1974), Pope-Hennessy (1970), and others that Michelangelo planned them in 1519 and worked on them principally during 1522–23 for the 1516 project for the tomb of Julius (in which the number of statues for the wall-tomb was to be reduced from forty to twenty-two). All four statues are quite unfinished and therefore give us a glimpse of the way Michelangelo approached the block and how his work looked at an intermediary stage. The figures of the *Young Slave* (fig. 15-3) and the *Bearded Slave* (fig. 15-4), which complement each other in posture, form a pair. They were intended to replace the *Dying Slave* (fig. 12-1) and the *Rebellious Slave* (fig. 12-2), which were, in turn, probably to be moved to a position in the lower niches originally

15-2. Michelangelo, Medici Chapel, San Lorenzo: interior view of the cupola.

intended for Victories. Similarly, the *Atlas Slave* (fig. 15-5) and the so-called *Awakening Slave* (fig. 15-6) were planned as a related pair. Each of the four *Slaves* is about eight feet high, a foot taller than the Louvre *Slaves* and considerably wider in depth. Moreover, the four Boboli *Slaves* reflect a more mature conception of the integration of architecture and statuary. Whereas the Louvre *Slaves* appear to be autonomous and independent of clear narrative meaning and structural purpose, the four later *Slaves* serve an architectural function and are designed to appear to support and bear the weight of the story above. Although the *Young Slave* is more advanced in execution than the other three, it seems that Michelangelo worked on all four concurrently.

The question of why the *Slaves* were left in this unfinished state remains unanswered. Was further work impeded by external circumstances? Or were the four

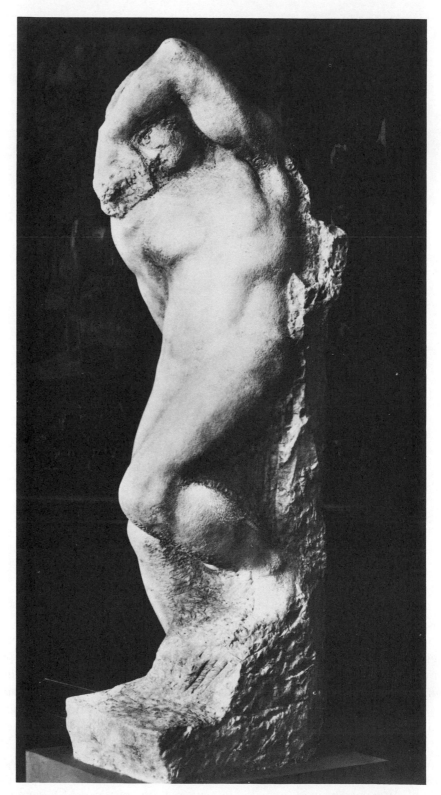

15-3. Michelangelo, *Young Slave*.

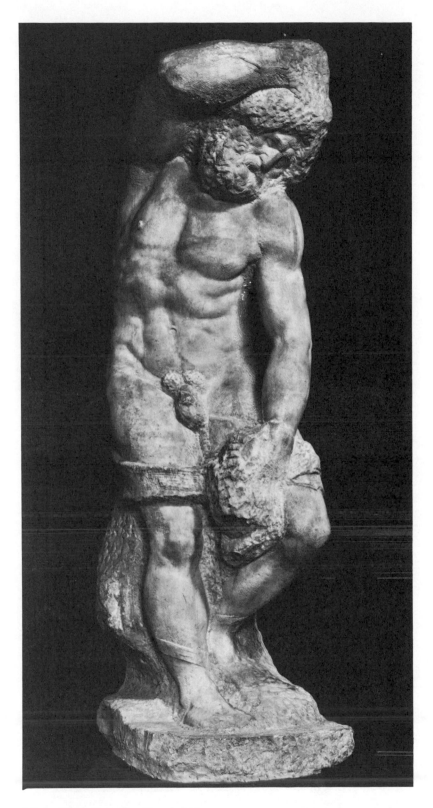

15-4. Michelangelo, *Bearded Slave.*

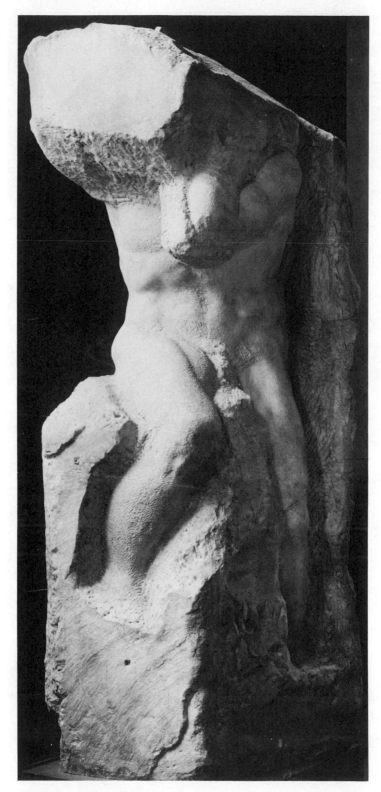

15-5. Michelangelo, *Atlas Slave.*

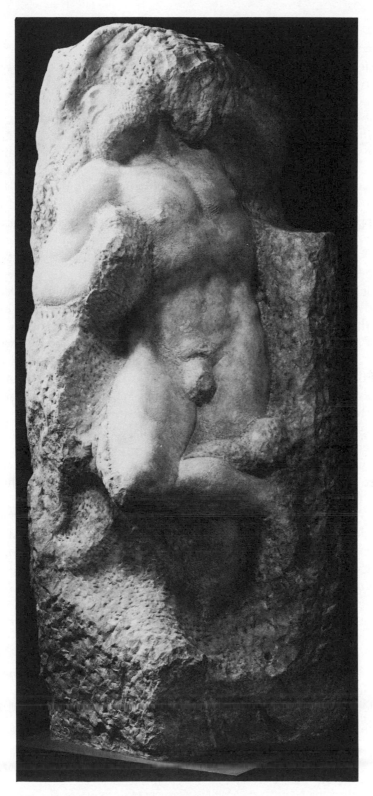

15-6. Michelangelo, *Awakening Slave*.

figures sufficiently revealed to his imagination that the labor of completion would have been an uninteresting chore for the master?

All the *Slaves* have clearly or faintly carved fetters across their torsos or legs. In their unfinished state, they appear to be engaged in a monumental struggle to free themselves from the marble blocks in which they are entombed or imprisoned. This fact gave rise to the Romantic notion, widely accepted in the nineteenth century, that the works were indeed considered complete by Michelangelo and were conceived by him to portray the spirit or soul straining to be free of its material and earthly prison.[2] Although twentieth-century scholars find little evidence to support this appealing notion, and regardless of the iconography of the works and even the uncertainty about their dating we can nevertheless intuit that the *Slaves* are a deeply personal statement by the sculptor. No one can walk along the entrance hallway to the Galleria dell'Accademia in Florence, where they now stand, two on each side, without empathizing with Michelangelo's powerful statement of man's need to struggle against the harsh conditions of human existence.

Whereas the earlier *Dying Slave* (fig. 12-1) is infused with a dreamy, sensual, androgynous quality that transcends pain or death, its intended substitute, the *Young Slave,* is weighty and plodding. The figure's oversized head and raised left arm are cast downward. Energy has waned and dreams are gone. Each of the other three Boboli *Slaves* can be described similarly. How different is the spiritual exhaustion of these figures from the lyrical mood of the Louvre pair: the carving on all four even stopped short of allowing differentiated genitalia to emerge from their rough-surfaced pubic mounds.

How can we explain such a dramatic shift in the second set of works, which were to be integrated into the same overall iconographic program as the first and were to be replacements for the Louvre *Slaves?* It may be that the change in Michelangelo's imaginative outlook reflected his weary and depressed mood during the later undertaking. The Louvre *Slaves* were the fruit of the period 1513–16, when he was working without interference and optimistically on the tomb and in general. In 1522–23, however, he was forced by a pope who had no use for him to return to fulfill a contract for an endeavor that was impossible to achieve and that no longer engaged his creative interest.

Michelangelo's depression was reflected in his letters from the period of the Boboli *Slaves.* In January 1521, he complained to a chaplain in Santa Maria del Fiore about a custom-made doublet that was cut too tight for him and then commented, "I don't know whether he skimped it in order to cheat me over the cloth." The letter closes with a line that resonates with the Boboli *Slaves:* "At the eleventh hour, each one of which seems to me a year" (letter 150). The letter is signed and has an accompanying drawing of a millstone.

2. Tolnay (1943–60, vol. 4) proposes the period 1530–34 for the carving of the four *Slaves*—later than the date of 1522–23, which I have accepted. He considers it possible that Michelangelo regarded the works as complete, since by 1530 it was an acceptable practice to separate *idea* from *execution,* and in the *Slaves* he had completed his statement of the idea.

There are no letters preserved from February 1522 until April 1523, when he wrote an agitated account of his plight, torn between the wishes of Cardinal Giulio and the dictates of Pope Adrian (letter 152). In June 1523, he wrote the last extant letter addressed to his father, which is filled with wrath and sarcasm. In it he instructs his aged father, "Don't write to me any more, because you prevent me from working, since I must make good what you have had from me for the past twenty-five years" (letter 154). In his next letter, the last one preserved from the pontificate of Adrian, he wrote to his dear friend Bartolommeo Angiolini, in July 1523, "I have a great task to perform, but I'm old and unfit; because if I work one day I have to rest for four in consequence" (letter 155). Thus, any one of the Boboli *Slaves* may be viewed as portraying the sculptor's own sense of weariness and eternal enslavement to the impossible project for the Tomb of Julius.

In light of the proposal in the previous chapter regarding Michelangelo's unconscious relationship to stone, it may be hypothesized that the statues were left partially embedded in the stones largely because Michelangelo at the time was sinking into an increasing state of depression. As a result, the unconscious temptation to maintain a relation between the figures and their primeval maternal source (the block of marble) was compelling. This motivation rose from the same matrix that governed his long immersions in the quarries in the Carrara mountains. The *Slaves* reflect Michelangelo's wish to remain connected to the transitional symbol of the stonemason's wife and her breast. In his state of depression, to finish the statues (to free the *Slaves* from the rock) carried with it the more dreadful symbolism of being ultimately alone. Unconnected to their elemental origin the *Slaves* (read: the artist himself) would be helpless children isolated in the dark of night—death.

The process involved in carving the Boboli *Slaves* was somewhat akin to an important aspect of dreams. In the manifest content of the dream, the dreamer can obscure the latent and forbidden wish through a manifestly unsuccessful opposing act (for example, being naked in public and trying unsuccessfully to find a hiding place or covering garments). Similarly, the Boboli *Slaves* are *apparently* struggling to be free. However, by working on all four at the same time, Michelangelo further assured the likelihood that they would remain incomplete—unseparated from their origins in the marble block. Thus, for all of their seeming struggle, the Boboli *Slaves* represent the artistic transformation of the deepest fears of Michelangelo and a poignant defense against the prospect of separation and aloneness.

With the murder of Pope Adrian VI and the ascension of Clement VII to the papal throne, Michelangelo's initial optimism (see p. 225, letter 156) receded as he met obstacles to the realization of his plans for the Medici tombs in the persons of the pope's two intermediaries in Florence, Buoninsegni and Niccolini, as well as the workmen themselves. With respect to the problem with Clement's deputies, the artist went so far as to resort to a breach of protocol by writing directly to the pope, stating, "If Your Holiness wishes me to accomplish anything, I beg You

not to have authorities set over me in my own trade, but to have faith in me and give me a free hand" (letter 160, January 1524). As to his problems with the workmen, later that month he touchingly wrote to a friend: "No one has ever had dealings with me, I mean workmen, for whom I have not wholeheartedly done my best. Yet because they say they find me in some ways strange and obsessed, which harms no one but myself, they presume to speak ill of me and to abuse me; which is the reward of all honest men" (letter 161).

In 1524, Pope Clement asked Michelangelo to name his own monthly salary. Michelangelo proposed the sum of 15 ducats (equivalent to approximately $750 today), which was considered ridiculously low by his friend and advocate in the papal court, Father Fattucci. Fattucci insisted that he take no less than 50 ducats— a stipend that he thereafter received regularly until the pope's imprisonment in 1527.

Despite the clear support of Clement to proceed and finish the Medici tombs, Michelangelo was continuously pursued by the della Rovere, who insisted on the delivery of the monument to their family. To rid himself of the Julius tomb, Michelangelo proposed that he make total restitution of the monies that had been advanced to him by Julius's heirs over the years. To his business agent in Florence, Giovanni Spina, he wrote in April 1525 that he was in the process of making such restitution so that he would "be able to give my mind to the Pope's concerns and get on with the work, since as it is *I do not live life at all, much less do I work*" (letter 168, my italics).

A month later, in a letter to Sebastiano, there was further evidence of the prolonged depression that had Michelangelo in its grip:

> Yesterday evening our friend Captain Cuio and several other gentlemen kindly invited me to go and have supper with them, which gave me the greatest pleasure, as *I emerged a little from my depression, or rather from my obsession.* I not only enjoyed the supper, which was extremely pleasant, but also, and even more than this, the discussions which took place. [letter 170, my italics]

Evidence that his cloud of depression was lifting is to be found in a whimsical letter, albeit about death, written to Fattucci a month later:

> I must tell you that Guidotto, who, as you know, had a thousand business concerns, died after a few days' illness and has left his dog free of debt to Donato, and Donato has bought a gown of masculine cut to wear as mourning, which you will see if he comes to Rome, as it's also suitable for riding. [letter 171]

Although we may infer that Michelangelo's black humor served well to diffuse his anxiety about the whole subject of death, a central element in depression, it also gives us a glimpse of his appreciation of an element of absurdity in the human condition. This kind of humor emerged now and then throughout his life, in letters, poems, and drawings.

The mood that finds expression in Michelangelo's letters is also quite insistent in the poetry he wrote during the period from 1522 to 1525 (the poems cannot be

precisely dated for the most part). Death emerges repeatedly as the central theme. One example is the following song:

> Whatever's born must come to death,
> As time flies on, and in the sun
> Nothing that's alive is left.
> Sweetness fades away, and pain.
>
> Every word and every brain,
> And our ancient family line,
> .
> Everything must come to death
>
> Once on a time our eyes were whole,
> Every socket had its light.
> Now they are empty, black and frightful,
> This it is that time has brought.[3]

In another, weariness and utter despair are sounded:

> Death at this age will be my sole defense
> From savage arm and from the biting darts,
> Cause of so many hurts,
>
> My soul, which is exchanging talk with Death,
> As she with him about herself consults,
> Enmeshed in new suspicions every hour.[4]

The final example is an unfinished sonnet, dated 1525:

> I live, dying for me, for sin alive,
> My life's indeed not of me, but of sin;
> .
> I am born to what unhappiness, what living . . .[5]

The Medici Tombs

Against this background of predominantly gray moods, ongoing frustrations, and specific concerns, Michelangelo worked during the years 1519–25 on the Medici Chapel and tombs. From a letter written to Fattucci in August 1525, we learn that "the said tomb is more than half finished and of the six figures mentioned in the contract, four are done as you know" (letter 172). However, from a letter the following June, we infer that the "four" were not yet done.[6] A clay model of one of

3. Gilbert and Linscott (1963, poem 19).
4. Ibid., no. 20.
5. Ibid., no. 30
6. The inference that the four figures were not completed comes from the following passage in Michelangelo's letter to Father Fattucci:

> I'm working as hard as I can, and in a fortnight's time I shall get the other "Captain" started; then of the important things, I shall have only the four "Rivers" left. The four figures on the

the River Gods is as far as he ever got with these four projected figures. Of the six figures that were well under way or near completion at this time, there is no documentation or clear consensus among scholars with respect to the order in which they were blocked out and carved. Sketches for the basic conception of the figures were almost certainly executed before Michelangelo left for Carrara in April 1521 to quarry the marble. By the end of 1526 or early in 1527, however, political turmoil and the threat of war in Rome and Florence necessitated a virtually total cessation of work on the tombs. Work was not resumed until 1531. These disruptive events will be addressed shortly.

During the years 1521–26, Michelangelo was distracted and agitated by constant pressures concerning the Tomb of Julius. Also, his concentration on the Medici tombs was disrupted by the immoderate demands of Pope Clement for glorification of the Medici name.

In January 1524 Clement proposed that Michelangelo construct a library at San Lorenzo for the great Medici collection of books and manuscripts. Upon being informed of this challenge, the artist wrote: "I learned from your last letter that His Holiness Our Lord wishes the design for the Library to be by my hand. I have no information about it nor do I know where he wants to build it . . . [I] will do what I can, although it is not my profession" (letter 159).

The only aspect of the Biblioteca Laurenziana (Laurentian Library) that I will note is the final, radical solution to the stairway in the library vestibule (fig. 15-7). A glimpse into the process of creation can be obtained from a sheet of sketches from 1525, on which Michelangelo experimented with several ideas (fig. 15-8). Pope Clement rejected the proposal for the double staircase in this sketch. What we now see was executed by Bartolommeo Ammanati, after a model that Michelangelo finally made in 1558–59 (when he was eighty-four years old). Standing at the foot of the stairway, one cannot help but wonder about the seemingly ironic challenge issued by the artist—it is as though one were being invited to mount this sculptured waterfall.

Pope Clement's other project for Michelangelo in late 1525 was simply absurd. It was, however, quickly aborted by Michelangelo's scathing lampoonery. On October 14, Clement wrote through an agent that he wanted Michelangelo to construct a colossus out of sculptured pieces that would be at least 25 braccia (47 feet high) and placed on the Piazza San Lorenzo, facing the Medici Palace, behind the palace of Luigi della Stufa and opposite a barber shop. Michelangelo did not respond and Clement sent him four follow-up letters. Finally, in December, Michelangelo wrote to his contact in the papal court:

> As to the colossus of forty *braccia* . . . at the other corner where the barber's shop is, it would in my opinion, look much better . . . since there might be some objections

coffers, the four figures on the ground, which are the "Rivers," the two "Captains," and "Our Lady," which is going into the Tomb at the top end, are the figures that I want to do myself. And of these, six are begun. [letter 177]

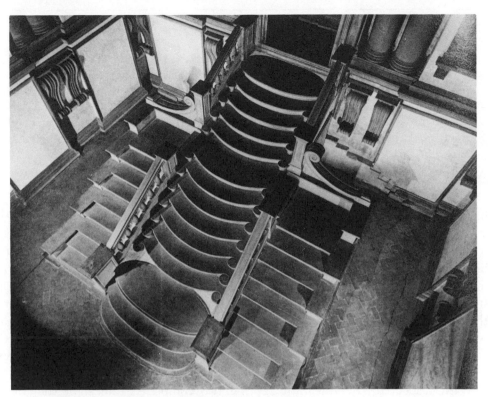

15-7. Michelangelo, Laurentian Library: stairs.

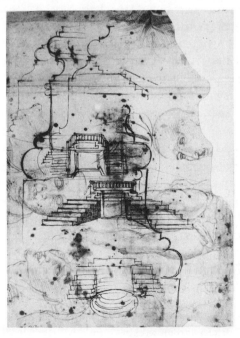

15-8. Michelangelo, drawings for the
stairs of the vestibule of the Laurentian
Library.

to doing away with the said shop, owing to the income it provides, I thought that the said figure might be made to sit down and the said work being hollow beneath—which can conveniently be done with blocks—its seat could come at such height that the barber's shop could go underneath and the rent would not be lost. And as at present the said shop has an outlet for the smoke, I thought of putting a cornucopia, which would be hollow inside, into the hand of the said statue to serve as a chimney. [letter 176]

The letter continues in relentless ridicule of the pope by suggesting that the head of the colossus be constructed to contain either a pigeonhouse or a belfry in its mouth: "[with] the sound issuing from the mouth the said colossus would seem to be crying aloud for mercy." The liberties taken by Michelangelo in a letter intended to reach the pope reflect the artist's awareness of the extent of their mutual need. As Beck (1975) commented, it also testifies to a bond of long standing between the two men, dating back to their teenage acquaintanceship in the household of Lorenzo the Magnificent, who took in Clement, the illegitimate son of his murdered brother, when the boy was six years old. In any event, the idea for the colossus was dropped upon receipt of Michelangelo's letter and was not heard of thereafter.

With respect to the "meaning" of the two completed tombs for the Medici Chapel, art historians have been divided. One camp proposes a highly articulated program based on contemporary Neoplatonic thought to explain the tombs in general and the statues in particular (see Panofsky, 1939 and Tolnay, 1943–60, vol. 4); another interprets them as "a grandiose allegory of princely and papal power" (Hartt, 1951); whereas a third (for instance, Hibbard, 1974 and Pope-Hennessy, 1970) find little support for so specific an iconography.

To approach the meaning of these tombs, one must be aware that there were two principal traditions in tomb iconography in the Renaissance. One glorified the deceased person; the other emphasized the transience of earthly existence. Vasari stressed the theme of glorification in the chapel. Condivi, however, who never saw the tombs and had to rely on the words of Michelangelo, wrote that the statues of Day and Night on Duke Giuliano's tomb (fig. 15-9) represented, "Time, which consumes all" (p. 67). In support of this theory, Condivi tells of Michelangelo's intention to carve a mouse on the statue of Day, "because this little creature is forever gnawing and consuming just as time devours all things." Moreover, two somewhat cryptic sets of writing by Michelangelo himself on preparatory drawings for the tombs support this theme of transience.[7]

After evaluating the arguments for the various interpretations, Pope-Hennessy properly reaches this conclusion:

7. On one drawing he wrote: "Fame holds the epitaphs resting. It goes neither forward nor backward because they are dead and their working is finished" (British Museum, W 28 recto). See p. 241 for the other notation.

Everything we learn from these sources [Michelangelo's letters and the two contemporary Dialogues] about his mental processes suggests that the imagery of the Chapel is likely to have been comparatively simple, intensely apprehended, and based on the principle of direct plastic communication, not on some elaborate intellectual theorem. Indeed, the vagueness of his intentions, the indefiniteness of his objective, the fact that by temperament he was an artist not an expositor, may have been among the reasons why he lacked the impulse to complete the tombs. [p. 25]

Thus, the two dukes were portrayed as highly idealized figures, not real beings. Michelangelo gave them postures that suggest activity in the one (Giuliano)[8] and contemplation in the other (Lorenzo, fig. 15-10). This contrast achieves the purpose of creating a basic polarity that is essential to the chapel's aesthetic tension. The personifications of the four times of day—two on the sarcophagus of each of the dukes—are far more projections of the artist's inner meditations at the time of their carving than representations of explicit ideas. The forms derive from antique models but are endowed with a completely new and dynamic quality, accentuated by the criss-cross of their limbs in a pattern of arresting oblique lines. Yet, for all their strength and muscularity, movement is thwarted, energy recedes, and they appear resigned without protest to their eternal fate. In one of his notes on a sketch for the tombs, Michelangelo wrote: "Day and Night are speaking, and they say: With our speedy course, we have led Duke Giuliano to his death; and it is right that he should take revenge for this, as he has done" (Casa Buonarroti, 10 A recto). What is unclear in the rest of the passage is what form this revenge really took. Does he mean that the forces of time are not simply measures of the arc of life but are the cause of death? In the artist's imaginative world they are here personified, vengefully sentenced to be eternal sentinels to the deceased and left helpless by blindness (they are all carved without pupils in their eyes).

The Medici tombs are Michelangelo's private inquiry into the nature of death. In the end, they are more a suspended confession of ignorance than a statement of religious or philosophical doctrine. There is no consensus as to what each of the figures is doing or expressing. Here, so clearly, spiritual meaning is translated into bodily language by Michelangelo. His protest against the terror of the unknown in death takes the form of the unyielding, idealized body of male youth. *Giuliano*, wearing only skin-tight, ancient shoulder armor on his torso, is the athlete of virtue, inspired by models from antiquity. Even the aging *Dusk* (fig. 15-11) in repose reveals a youthful muscularity. This quality of the body defying time and fate is most distinctly asserted in *Day* (fig. 15-12), closely modeled after the first century B.C. *Belvedere Torso* (fig. 15-13). Here, Michelangelo was interested primarily in the extraordinary carving of the torso and limbs of the figure; the face

8. The "real" Giuliano was thus described by Pastor (1906–07, vol. 7): "Licentiousness had exhausted his feeble body and weakened his ambition and mental activity" (p. 90).

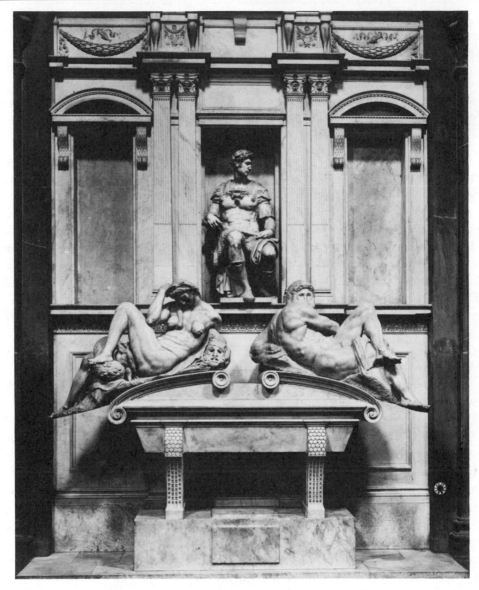

15-9. Michelangelo, Tomb of Giuliano de' Medici, Medici Chapel.

is left in a partially formed, inchoate state, which dramatically highlights the artist's main concern—the body.

It is my thought that Michelangelo deliberately left this face unformed because the uncut stone "hides" his self-portrait. The forehead, brow, and flattened nose seem to be a younger version of the face of Nicodemus in the Florence *Pietà* (1547–55, fig. 20-4), which is known to be an explicit self-portrait. Thus, it may be that in the statue of *Day*, Michelangelo was attempting to articulate an aspect of his idealized self-image. First, he incorporated from the ancient past a

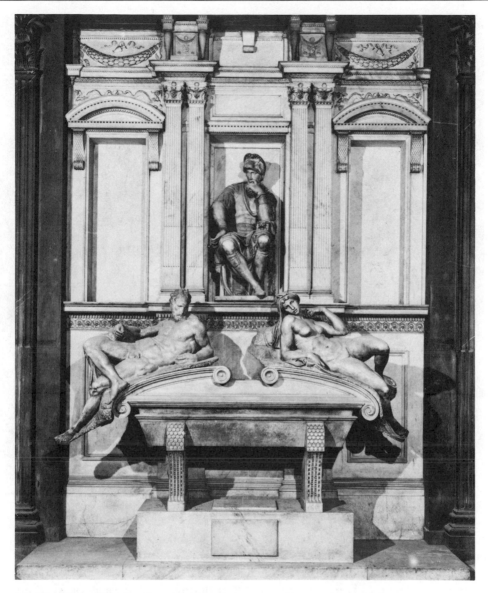

15-10. Michelangelo, Tomb of Lorenzo de' Medici, Medici Chapel.

revered work that probably exerted more influence upon his development than any other. He thereby links himself to the idealized prehistory of Christianity. Yet, in Michelangelo's hands, the ancient masterpiece is magically extended. Through the combined display of functional muscular anatomy, the strained limits of *contrapposto*, and the twisted positioning of the limbs, *Day* achieves a power unparalleled in a figure at rest. From Michelangelo's notes on the figures of *Day* and *Night*, it would appear that *Day* is condemned for his role in prematurely snuffing out the life of Giuliano. *Day*'s punishment is to lie beneath the idealized,

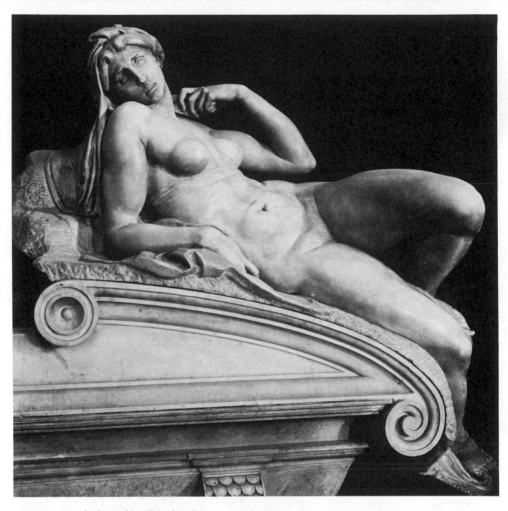

15-11. Michelangelo, Tomb of Lorenzo de' Medici: *Dusk.*

fallen hero bound in eternal service; in death they are forever linked. How close this comes to Michelangelo's "Ganymede fantasy" (pp. 173–80), which was to become attached to Tommaso de' Cavalieri during the last years of work on *Day* and the rest of the tombs! Did Michelangelo refrain from revealing the image of his own face in the uncarved marble of this figure because of aesthetic considerations or because he did not wish to betray his identification with the fantasy represented by *Day?*

Self-portraits by Michelangelo are found in a number of his major artistic efforts. He appears as Holofernes in the Sistine Chapel ceiling, in the flayed skin of Saint Bartholomew in the *Last Judgment* (fig. 18-11), as Nicodemus in the Florence *Pietà* (fig. 20-4). Other major figures, while not explicit self-portraits, are made to resemble him, such as both Saint Peter and Saint Paul in the Pauline Chapel frescoes and the fallen older man in *Victory* (fig. 15-14). It is therefore

quite possible that Michelangelo would also be inclined to include himself in so personally meaningful and monumental an undertaking as the Medici Chapel. However, a recognizable image of his face on so idealized a body in allegorical tomb statuary even he would have to reject as excessive hubris. His solution, therefore, might well have been to leave the face partially hidden by the mask of stone, thereby forever assuring his secret.

Earlier I suggested Michelangelo's identification with the four Boboli *Slaves*. *Day* represents a further step in the evolution of the statements made particularly by the *Awakening Slave* and the *Bearded Slave*. Although a piece of drapery rests on one thigh, the figure is unfettered. The quality of *terribilità* that contemporaries attributed to Michelangelo is brilliantly communicated in the detail of the primordial head, with its hollowed orbits half hidden behind the scapula group and hypertrophied deltoid muscle.

The other figure among the allegories of Time that is of particular interest in terms of Michelangelo's inner world is *Night* (fig. 15-15). Shortly after the completion of his work on the Medici tombs, Michelangelo wrote a sonnet on the subject of "Night," which we can consider as notes for the statue.

O night, O gentle time, however black,
Always at last plunges each work in rest:
He who exalts sees and discerns you best,
Who honors you is sound of intellect.

Each weary thought you cancel, or cut short,
Absorbed into damp shadow and all peace,
And often in dreams carry me from the lowest
To where I hope to go, the highest point.

O shadow of our death, by which the soul
Can erase the heart's enemy, distress.
The last of our afflictions, a good healer,

Our bodies that were weak you can make whole,
You dry our tears, put down all weariness,
And wrest from who lives well all vexing anger.[9]

This rather conventional sonnet represents night as a comforting refuge from the pain of day, even though it is also the prelude to death. Only the last line holds a surprise. The "vexing anger" would seem to be Michelangelo's personal burden, from which night offered welcome respite. In the statue of *Night*, however, Michelangelo departs from the traditional ancient personifications of the motif. Rather, he depicts the subject in the form of a particular female image with which he was familiar—the mythological figure of Leda. The model for *Night* appears to have been a relief on a Roman sarcophagus in which Leda is in the act of being deliciously seduced by Zeus disguised as a swan. The actual sarcophagus

9. Gilbert and Linscott (1963, poem 100).

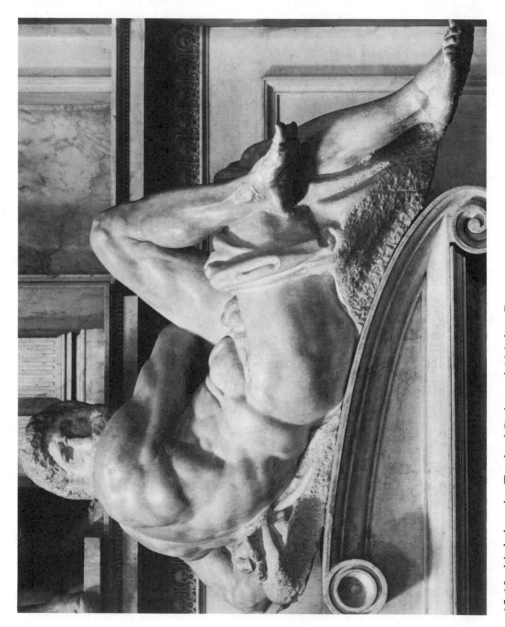

15-12. Michelangelo, Tomb of Giuliano de' Medici: *Day.*

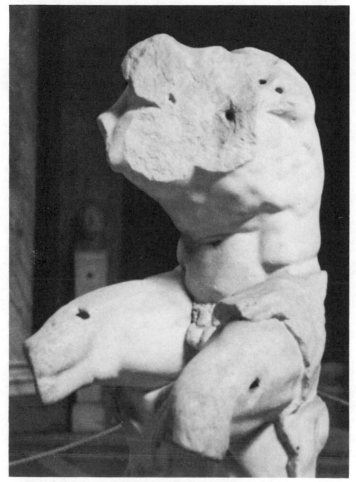

15-13. Apollonios son of Nestor, the *Belvedere Torso* (ca. 50 B.C.).

seen by Michelangelo is lost, although it is known through sixteenth-century drawings (fig. 15-16).[10] The only significant difference between the ancient model and *Night* is the left arm. In Michelangelo's work the left arm was apparently irreversibly damaged in the carving. He resolved this problem by having the arm appear to fall behind the carved mask. Further testimony to the power this ancient image of Leda exerted on Michelangelo is found in his 1529–30 painting of *Leda and the Swan* (fig. 15-17). Done for Duke Alfonso I d'Este of Ferrara, it is best known through a copy whose attribution has been questioned (see Wilde, 1957), but is usually given to Rosso Fiorentino. In form, the painted *Leda* is only a minor variation of the figure of *Night*.

10. Wilde (1957) argues persuasively that other models, with slight variations from the sarcophagus represented in this drawing, were also available to Michelangelo.

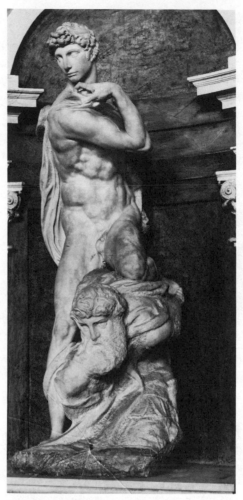

15-14. Michelangelo, *Victory*.

The Problem of Leda and the Swan

The problems in interpreting *Night* are eased if this work and the painting of *Leda and the Swan* are considered not simply as formal companion pieces but also as being psychologically related. In addition to several painted copies, Michelangelo's *Leda* is known through an engraving by Cornelius Bos (fig. 15-18), which includes the Dioscuri twins, Castor and Pollux, as well as an unhatched, transparent egg at Leda's feet, containing Helen. Inasmuch as both Vasari and Condivi refer to the motif of the birth of the twins in Michelangelo's painting, Bos's copy is probably the most faithful source for the original work.

A comparison of *Night* and the *Leda* reveals only minor formal changes; for example, in the latter work the breast is rotated to a profile view and the flexed right elbow has yielded to a position of relaxed abandon. However, in the amorous union of Leda and the Zeus-Swan an altogether different effect is achieved.

Leda is transported into a state of utter passivity and erotic ecstasy as the swan caresses her perineum with his feathers and slides his elongated neck from the crotch of her spread legs, along the contour of her belly, between her breasts, to meet her lips. Leda is easily the most sexual image ever created by Michelangelo. In this theme of sexual yielding to Zeus it must be classed with the drawing of the *Rape of Ganymede* (fig. 12-8), executed two years later for Tommaso de' Cavalieri.

Since *Night* derives from an ancient Leda and that prototype reasserted its influence shortly thereafter in a fully realized sexual manner in the painting of *Leda*, how can we understand the image of *Night*—so masculinely athletic, with grossly unanatomically accurate breasts that are like pasted-on rocky globes with extended phallic nipples?[11] In this connection, it is interesting to examine one of two preparatory drawings for *Night* (or perhaps for the *Leda*), in which Michelangelo used a male model (fig. 15-19). *Night* has a man's body, with a rather androgynous, downcast face and only the strange breasts and absence of male genitalia as evidence of her femaleness. Even her long hair is tapered into a phallic braid that hugs her chest. After looking at *Night* we are surprised by the easy femininity of Leda in Rosso's painted copy (fig. 15-17). Before accepting it as a faithful copy of Michelangelo's original *Leda*, however, we must examine Bos's engraving, as well as the cartoon for Rosso's painting (fig. 15-20). Even if we assume that the very medium of engraving contributed to the harshness of form and surface, Bos's *Leda* has the same extraordinary male musculature and atypical breasts as *Night*. This masculinized quality is less pronounced in the cartoon for Rosso's painting, although even here the left breast, in profile, appears to be continuous with the hypertrophied pectoralis muscle, thereby forming a resemblance to a disembodied, elongated phallus composed of arm, shoulder, and breast, with the breast as the glans. How do we account for the disparity between *Night* and Rosso's painted copy of *Leda*? Quite simply, I believe that Rosso smoothed out the muscle groups throughout the figure and transformed the troublesome breast into a conventionally sensual one. If we assume that so brilliant and inventive an artist as Rosso felt compelled to alter Michelangelo's *Leda* in order to render a traditional female nude, we are led to examine the question of why Michelangelo never presented his *Leda* to Duke Alfonso as planned. This inquiry should also help to clarify why the enigmatic figure of *Night* is as it is.

Michelangelo, as we shall see, provided his own explanation years later to Condivi, one having nothing to do with any aspect of the image of Leda in the painting. According to Condivi, the duke of Ferrara, when he heard that the

11. Hartt (1951) states that *Night*'s breasts are actively lactating, thereby establishing her primarily as a symbol of motherhood. Panofsky (1939) and Tolnay (1943–60, vol. 4), in suggesting *Night* as a symbol of fertility, allow the same explanation for the engorged appearance of the breasts. However, little else about her anatomy is consistent with this view. Moreover, it is unlikely that Michelangelo would have *Night* compete with the *virgo lactans* representation of the *Medici Madonna* in the same chapel.

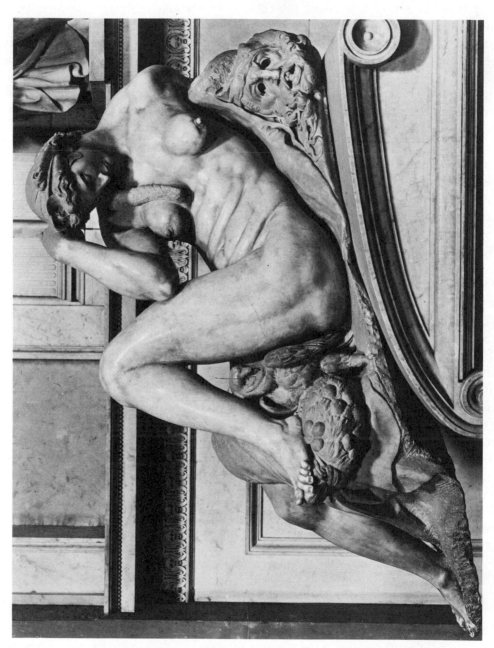

15-15. Michelangelo, Tomb of Giuliano de' Medici: *Night.*

15-16. Sixteenth-century drawing after an ancient Leda relief.

Medici had regained power in Florence, sent an envoy to Michelangelo to check on the state of the *Leda.*

> This man arrived at Michelangelo's house and, when he had seen the picture, he said, "Oh, this isn't much of anything." And when Michelangelo, who knew that everyone judges best that art which he practices, asked him what his profession was, he answered with a sneer, "I am a merchant." Perhaps he was disgusted by such a question and by not being recognized as a gentleman, and at the same time he was showing contempt for the industry of Florentine citizens, who for the most part have gone into trade, as if he were saying, "You ask me what my profession is; would you ever believe that I was a merchant?" Michelangelo, who understood the gentleman's words, said, "You will do bad business for your master; get out of my sight." In that way he dismissed the duke's messenger, and shortly thereafter he gave the painting to an apprentice of his [Antonio Mini] who had asked him for help as he had two sisters to marry off. It was sent to France, where it still is, and King François bought it. [p. 71]

Thus, Condivi attributed the fate of this painting to an impolitic piece of behavior on the part of an incidental individual, an explanation that must be rejected as unpersuasive—indeed, most implausible in the hurly-burly of life in the Renaissance. Condivi's explanation hardly seems sufficient to account for Michelangelo's impetuousness and apparent willingness to affront the powerful duke. The explanation makes particularly little sense because in the preceding passage Michelangelo describes the duke in uncommonly favorable terms. I propose, instead,

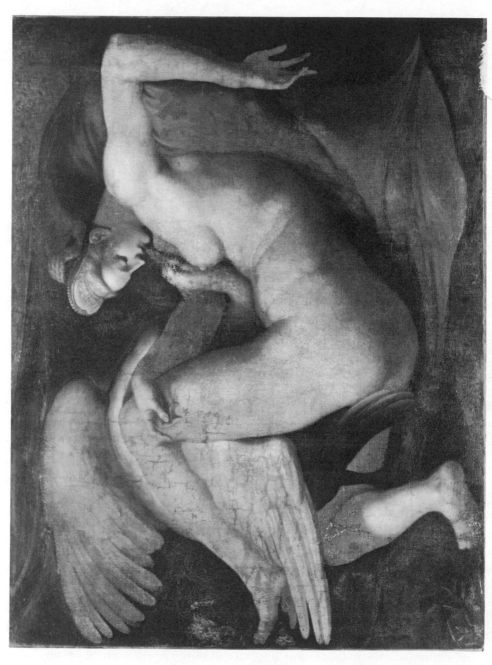

15-17. Rosso Fiorentino (?) after Michelangelo's *Leda and the Swan.*

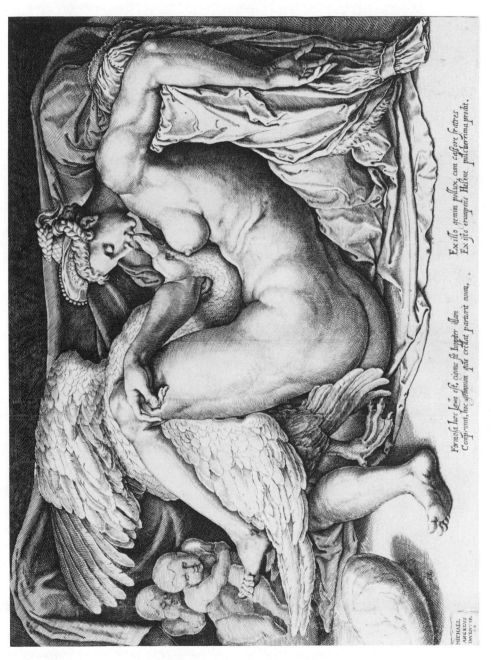

Formosa hæc Leca est, cuius sit Iupiter illan
Comprimens, hoc geminum quis credat parturit ouum,

Ex illo gemini pollux, cum castore fratres
Ex iste erumpens Hélene pulcherrima prodit.

MICHAEL
ANGELVS
INVENTOR.

15-18. Cornelius Bos, engraving after Michelangelo's *Leda and the Swan.*

15-19. Michelangelo, study for *Night* or *Leda*.

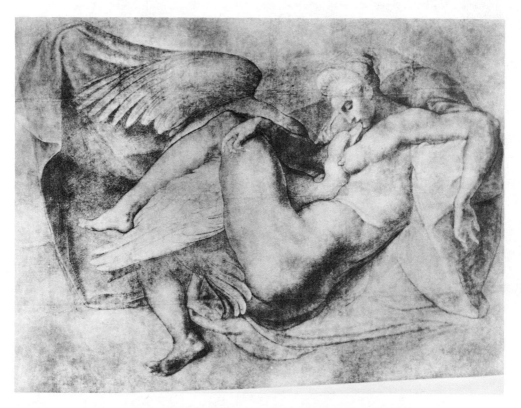

15-20. Rosso Fiorentino, cartoon after Michelangelo's *Leda and the Swan*.

that the painting was never delivered to the duke for reasons related to Michelangelo's expectation of the general response to his particular conception of *Leda*. That is, he was highly reluctant to have this work appear as his display piece in the Ferrarese court. In the course of exploring this issue, additional light will be cast on Michelangelo's inner conception of, and attitude toward, the female body. Moreover, this representation may be thought to reflect his own conflicted sexual identifications.

The circumstance that led to painting the *Leda* was the fact that Michelangelo was sent to Ferrara in 1529 after having been named superintendent of fortifications for Florence. He went in order to

> study the method used by Duke Alfonso to arm and fortify his city, knowing that His Excellency was very expert at this and most prudent in all other ways. The duke received Michelangelo with an expression of great joy on his face, both because of the greatness of the man and because his own son, Don Hercole, who is now the duke of that state, was captain of the Florentine *signoria*. He rode out in person with Michelangelo, and there was nothing relevant to the subject that he did not show him in the way of fortifications and artillery. Indeed, he opened all his storerooms to him, showing everything to him with his own hands, mainly some paintings and portraits of his forebears, by the hand of masters, and, considering the period in which they were painted, they were excellent. But, when Michelangelo had to leave, the duke said to him facetiously, "Michelangelo, you are my prisoner. If you want me to set you free, I want you to promise me to do something for me that is by your own hand, just as you like, sculpture or painting, whichever it may be." [Condivi, p. 70]

Given this highly favorable view of Alfonso, recorded years later by Michelangelo, it is improbable that he would so calculatedly incur the displeasure of the powerful duke. The passage even includes the jest that the duke threatened to hold the artist prisoner in order to coerce him to do the work, and we know that imagined enslavement served as a facilitative precondition for many of Michelangelo's artistic projects. How, then, can we explain Michelangelo's action in denying the duke the *Leda*?

We infer from Michelangelo's account to Condivi that he was given a free choice of subject matter. In selecting Leda and the Swan he chose one of the most erotic of pagan themes. And by so doing he also placed himself in direct competition once again with Leonardo, who had painted a *Leda* some twenty-five years earlier. I shall argue that the outcome was not successful for Michelangelo and that for this reason he wished to disavow the painting.

Leonardo's *Leda and the Swan* was lost during the seventeenth century. It is, however, known through several copies, although controversy exists concerning which is the most faithful.[12] All extant copies are essentially identical with respect to Leda and the Swan, but they differ in the details of the eggs and the twins. As

12. Clark (1939) argues for the copy by Cesare de Sesto. Heydenreich (1954) favors the copy by an unknown artist in the Galleria Borghese. Eissler (1961), on the basis of psychological reasoning, also favors the Borghese copy.

Raphael copied either the cartoon for the painting or a large preparatory drawing by Leonardo[13] when he was in Florence before 1504, Michelangelo must also have been familiar with Leonardo's conception. As we see in Cesare de Sesto's copy of Leonardo's *Leda* (fig. 15-21), Leonardo conveys, not lust or even ecstasy, but mystery, sensuality, and conflicted desire. Leda's *contrapposto* is not simply a formal exercise. It unifies the modest turning away of her face with her reaching back to caress the neck of the imploring swan. The supple curve of the lower half of her body and the subtle movement of her left leg further contribute to rendering this image the most lyrical ode to female sensuality that had yet been achieved in the Renaissance. Leonardo's *Leda* is also remarkable in that it was his only known nude female except for a lost cartoon for an *Adam and Eve*. Leonardo's *Leda* is a standing figure, and is thus in the tradition of the highly sexual Hellenistic treatments of the subject.

In contrast, Michelangelo was drawn to sepulchral versions of the theme, in which Leda is represented in a reclining position (see fig. 15-16). Ancient Roman sarcophagi frequently portrayed the amorous adventures of the gods, generally involving an act of love between a god and a mortal—for example, Zeus and Leda or Ganymede, Bacchus and Ariadne, Diana and Endymion. The underlying psychological purpose was to allay the human fear of death by showing the achievement of eternal life through the love of a god. This subject was treated in writings by the Florentine Neoplatonic circle of the late fifteenth century.[14] Even Lorenzo the Magnificent addressed the topic in a commentary on some of his own poetry: "The beginning of the *vita amorosa* proceeds from death, because whoever lives for love first dies to everything else."[15] Lorenzo went on to trace this theme back through Homer, Virgil, and Dante. Thus, in the Renaissance, as Wind shows: "The idea of Eros as a power that loosens or breaks the chains that bind the soul to the body is identified with Death itself, in its painful no less than its joyous aspect" (p. 160).

Against this background of sarcophagal tradition and Neoplatonic thought concerning the union of Eros and Death, we can better understand the images of *Night* and *Leda and the Swan*. *Night* is the image of a woman, derived from an ancient Leda but hardly an erotic figure lightening the bitter fact of death in a funereal chapel; rather, she is closer to symbolizing death itself. In place of the seductive swan, an owl, symbolizing night, rests close to her vagina. Even in his effort to create the traditional sarcophagal dialectic between Eros and Death, Michelangelo's overpowering inhibition against representing the female form as sensual or frankly erotic prevails. To achieve a sensuous view of woman, he apparently had to hold on to the concept and experience of her as a male. The extent to which *Night* conveys a sleepy, languid, sexual mood, has little to do

13. Raphael's drawing of *Leda*, Windsor, Royal Library, no. 12795.
14. Wind (1958), in his essay "Amor as a God of Death," gives a scholarly exploration of the subject.
15. Lorenzo de' Medici (trans. Wind, 1958, p. 157).

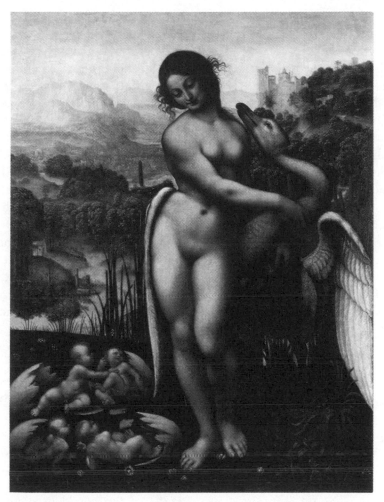

15-21. Cesare da Sesto after Leonardo's *Leda and the Swan.*

with the figure's being specifically denoted as female. Nor can the difficulty be attributed simply to the Renaissance custom of using only male nude models. Michelangelo's inhibition in converting a male model to a convincing female one contrasts dramatically with the accomplishments of Titian, who, for example, transformed the relaxed figure of Mars in Giovanni Bellini's *Feast of the Gods* (Washington D.C., National Gallery) into his wonderfully sensuous *Danae* (Naples, Museo Nazionale).[16]

In the year 1529-30, when Michelangelo painted the *Leda,* work on the Medici Chapel was suspended. The statue of *Night* awaited his final touches. Michelangelo's choice of Leda as a subject may have reflected more than a programmatic reconciliation of the fertile and morbid aspects of Leda mythology. Let us suppose

16. See Watson (1978) for a refutation of the thesis that Titian's *Danae* was modeled from and intended to compete with Michelangelo's *Leda.*

(although there is no direct evidence) that he was displeased with the result of this "male-female" *Night*. He might, therefore, have seized the opportunity to create for the duke a thoroughly "Leda-like" Leda. That her form is so nearly identical with that of *Night* could then be regarded as an attempt to undo (to "paint" over) the *Night*. With, as far as we know, no experience as a sexual lover of women, Michelangelo could only imagine himself in the experience of sexual union. In the painting the pleasure in yielding to barely disguised fellatio is heightened to an extraordinary degree. In this connection, we must note that the most traditionally feminine sensual painted figure in all of Michelangelo's art—Eve in the Sistine Chapel ceiling *Temptation* (fig. 15-22)—is placed, while plucking the forbidden fruit, in a position that can hardly fail to suggest fellatio. The powerful sexual impact of the *Leda* comes largely from a sense of abandon not seen since the *Dying Slave* (fig. 12-1). We may cautiously conclude that Michelangelo could most freely represent the sexual and sensual abandon of a woman if he imagined her—even identified with her—in the act of fellatio. Nevertheless, to render his Leda feminine in the way that Leonardo had was too conflicted a task for Michelangelo. Whereas, in his drawing of the *Rape of Ganymede* (fig. 12-8), Michelangelo expressed the fantasy of yielding to Zeus and incorporating the god's power anally, in the *Leda* the same fantasy is expressed through fellatio. Thus, Leda remains masculinized—a projected and only partially transformed inner representation of himself.

Michelangelo's compromise in his identification with Leda by representing her clearly as a woman, but with phallic attributes, is more than simply the ultimate equation of womanliness with castration. Rather, as I think will become clearer in the study of the last two sculptured *Pietàs* (chapter 20), the concept of a woman as being tender and soft elicited regressive fantasies in Michelangelo of union in death with his mother (as the dead Christ is reunited with His Mother). Therefore, a tender, soft woman could not be a relatively anxiety-free object for loving sexual union. On the contrary, once aroused, desire would progress to a point where his autonomous sense of self would be threatened. The highly masculinized woman or male object of desire served to retard this kind of regressive fantasy of a symbiotic reunion. We can infer that Michelangelo's world of sexual fantasy involved men making love to men, men incorporating the power and nurturance of other stronger men. But men, regardless of role, remained men. The tension and compelling quality of much of his art arise from the sufficient but far from complete sublimation of these themes into Neoplatonic, political, and even religious ideologies. In the Bos engraving of Michelangelo's *Leda*, the homoerotic elements are so strong that the work almost assumes the character of a private fantasy.

The homosexual motif is present not only in the form of Leda and the particular image of her lovemaking with the Zeus-Swan; it also inheres in the part of the myth included in Michelangelo's lost painting although omitted in the later painted copies—the infant twins, Castor and Pollux. These brothers are prominent in mythological portrayals of sublimated homosexual relationships. In most

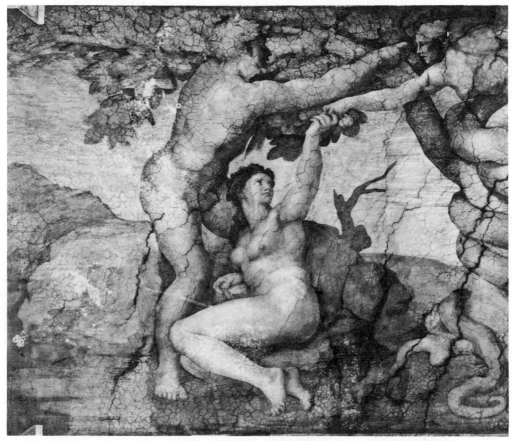

15-22. Michelangelo, Sistine Chapel ceiling: *The Temptation of Adam and Eve.*

versions (see Rose, 1959) Pollux is the son of Zeus, while Castor is the son of Leda's mortal husband, Tyndareos. The twins excelled in athletics and as warriors, and were also devoted and inseparable companions in many adventures and expeditions. In one exploit, however, Castor was killed, whereupon Pollux pleaded with his father, Zeus, to allow him to share his privilege of immortality with his fallen brother. Zeus consented and allowed the twins to remain together—but half the time in Heaven and the other half in Hades. As reward for their faithfulness to each other, Zeus placed them among the stars, where they became known as the constellation Gemini, or the "Heavenly Twins."

This wonderfully Platonic tale of brotherly love and eternal union would certainly find a receptive ear in Michelangelo. Thus, the coupling of Leda with Zeus and the birth of the twins—both of which appear in the painting—represented different aspects of the sublimation of Michelangelo's homosexuality.

It is interesting once again to compare the *Ledas* of Michelangelo and Leonardo with respect to the treatment of the twins. In de Sesto's copy of Leonardo's rendering, two sets of twins—one male and one female (Helen and Clytem-

nestra)—are bursting forth from their shells in a spirit of joyful frolic. In contrast, Michelangelo's Dioscuri huddle in a cavelike recess at the edge of the picture, in most awkward postures and seemingly unrelated to each other. The figures derive from those wretched Ancestors of Christ who inhabit the crowded spandrels of the Sistine Chapel vault (see fig. 3-1). Their attention is focused solely on the unbroken egg containing the outlines of one of their unborn twin sisters. Yet their eyes appear to be unseeing, empty sockets. Consistent with my interpretations of the children on the stairs in the *Madonna of the Stairs* (fig. 2-1) and the Child St. John in the Doni tondo (fig. 4-5) and the Taddei tondo (fig. 7-15), Castor and Pollux register their displeasure and resentment toward the younger sibling about to be born. In his treatment of the twins Michelangelo is unable to depict freely the homoerotic idyll he achieved in the background plane of the Doni tondo. There is little attempt to idealize them. Rather, they are clearly unhappy and oppressed. This mood may well have been produced by the death a year earlier of Michelangelo's closest brother, Buonarroto, who fell victim to an outbreak of plague in 1528.

Whereas the masculinity of many of Michelangelo's earlier painted women, for instance, in the Doni tondo and the Sistine ceiling, may have been acceptable to him within their religious, nonsexual context, the masculinized image of Leda at such an erotic moment may have struck Michelangelo as inappropriate and made him unwilling to have it placed on view in the Ducal Palace in Ferrara. If this was so, Alfonso's envoy's remark gave Michelangelo his "out." He was able to unload the work he wished to disavow by sending it to France, where he himself had never set foot. In so doing he was able to mask his real motivation by being generous in expressing his appreciation to his departing assistant, Mini. According to Condivi, Michelangelo knew that Mini would sell the painting to raise dowries for his two sisters. I assume he also knew that Mini was leaving soon thereafter for France.

Another question about the *Leda* is: did Michelangelo's conscious and unconscious feelings for the duke influence his choice of theme and its solution? Alfonso, one year younger than Michelangelo, was one of the great Renaissance princes—a connoisseur and patron of both Raphael and Titian and a skilled bronze caster and designer of artillery, as well as an adept statesman. Perhaps the artist's encounter with Alfonso and exposure to the traditions and power of the house of Este reawakened memories of his days as the favorite of Lorenzo the Magnificent and his happy life in the house of the Medici. The hypothesis that rises from this line of thought is that in the troubled years of 1529–30, following the plague of 1527–28 in which some 30,000 Florentines died, with the Republic about to fall to the imperial forces, and with his brother Buonarroto dead and his father approaching death, the artist's need to recover the kind of security his life with Lorenzo had offered was strong. Pope Clement, allied with Charles V against Florence, was for the moment the enemy. He had no secular patron in Florence. Thus, the fantasy of submission to the power of Alfonso may have been an insistent one.

We see two years later, in the presentation drawing for Tommaso de' Cavalieri of the *Rape of Ganymede* (fig. 12-8), the ease with which Michelangelo could draw a representation of frank homosexual submission to Zeus. Whereas in the Ganymede drawing there is little disguise, Leda remains a woman in the formal sense despite the masculinity of the figure, so that the "homosexual submission" latent in this presentation painting is somewhat less obvious, though underscored by the presence of Castor and Pollux. Michelangelo sensed that in expressing his wishes toward Tommaso more explicitly he could trust Tommaso neither to withdraw from their friendship nor to exploit him. However, he probably had no basis for such confidence in the duke of Ferrara if he were to introduce the same theme in this presentation painting. In any event, *Ganymede* looked as a Ganymede should, but *Leda* did not look as a Leda should. Liberties could be taken with the statue of *Night* as a generalized allegorical figure. The *Leda*, however, had a specific narrative and therefore did not allow for such latitude. Rather than expose himself to possible ridicule, and worse, to unfavorable comparison with Leonardo and his *Leda*, Michelangelo withdrew from the competition and "exiled" the painting. The offense on the part of the Ferrarese envoy can be compared to the insult of the groom of Pope Julius II in 1506, which "caused" Michelangelo to flee Rome immediately. We recall, however, that on closer scrutiny the flight had seemed causally related more to the ceremonial honoring of Bramante and the laying of the cornerstone of St. Peter's, scheduled for the next morning, than to the insult.

Political Turmoil and Michelangelo's Last Days in Florence

Throughout 1526, Michelangelo worked rather steadily on the Medici Chapel and tombs and the Laurentian Library. The rapidly deteriorating political situation in Italy, however, erupted violently in 1527, with the result that Michelangelo's life was dominated during the years from 1527 to 1530 by political rather than artistic concerns.

On May 6, 1527, the barbarous Sack of Rome took place. Emperor Charles V was intent on revenge against Pope Clement VII for his papal alliance with the French in the Spanish-French struggle and for his participation in the "Holy League" that was formed to oppose Charles. With the help of German *Landsknechte*, Rome was ravaged; St. Peter's was pillaged; murder, rape, and plundering were rampant. Clement was forced to remain a prisoner in his Castel Sant'Angelo for seven months. During this period Rome was an occupied city.

In Florence, with the pope reduced to powerlessness, the populace immediately seized their advantage and on May 17 expelled the Medici family and papal representatives from the city, reestablishing the Republic of Florence. This reassertion of self-rule was, as we shall see, to cost Florence very dearly once Clement regained power and was in a position to avenge the defection.

After seven months of imprisonment in Castel Sant'Angelo, the pope fled to Orvieto and then again to Viterbo. Clement did not return to Rome until October 1528, a year and a half after the sack. The pope negotiated a reconciliation

with the emperor, and the two forces thereupon entered into an alliance to crush the upstart Republic of Florence. Once this had been accomplished, the pope's illegitimate son, Alessandro, was designated to be duke of Florence and to marry the emperor's illegitimate daughter, Margaret. The Republic of Florence, however, did not fall until August 12, 1530, and only after withstanding a ten-month siege.

With this situation of upheaval and apprehension in Florence, Michelangelo could hardly pursue work on the Medici projects. Rather, he was pressured into channeling his imagination and efforts into military design. From hiding in Orvieto during 1528, Pope Clement wrote to Michelangelo beseeching him to continue to work for him. On the other hand, in August 1528, the Signoria of the Republic of Florence offered Michelangelo a commission to complete a colossal *Hercules* group that had been started by his rival Baccio Bandinelli in 1525. The *Hercules* group was to be a companion piece to Michelangelo's *David*, which already stood in the Piazza della Signoria. This particular work had been the subject of considerable bitterness toward Clement on the part of Michelangelo. In 1525 the Florentines had wanted him to execute the same work. The Pope, however, wishing Michelangelo to expend his energy only on Medici projects, and not on works that would fire patriotic ardor, redirected the commission to Bandinelli. Michelangelo was originally so eager to do the *Hercules* that in 1525 he offered to make the statue a gift to the republic. However, in 1528, because of the gathering storm clouds, he did not progress with the colossal block of marble. The outcome of the *Hercules* story was that, after the fall of the republic in 1531, Pope Clement insisted that Bandinelli, not Michelangelo, execute the work, the *Hercules and Cacus* that now stands in the Piazza della Signoria.

By October 1528, Michelangelo was being consulted on designs for the fortifications of Florence. On April 29, 1529, he was officially named superintendent of fortifications (*governatore generale*) for the republic. Following his appointment he was sent, over the next four months, to inspect fortifications at Pisa, Leghorn, and Ferrara.

It is difficult to picture Michelangelo in this new role, which included his being a member of the *Nove della Milizia*, the nine-man military council that set policies. The conflict aroused in the artist by this charge to be a leading military adversary of Pope Clement and the house of Medici, as well as to be so directly involved in acts of aggression, proved to be so great that he fled from Florence to Venice on September 21, less than two weeks after his return from a six-week inspection of Ferrara. Characteristically, he externalized the internal conflict he felt about this situation, as is suggested by a passage in Condivi. It states that the artist was sent to Ferrara "upon the advice of certain citizens who favored the Medici interests and who wanted craftily to prevent or prolong the fortification of the city, they wanted to send him to Ferrara on the pretext that he was to study [the system there]" (p. 70). Even if this were so, such covert wishes would echo Michelangelo's own ambivalence and afford him the opportunity to remove himself from

the immediate execution of his task, with its attendant anxiety. Once the safety-valve effect of these inspection trips was eliminated, Michelangelo's inner pressure to flee became uncontrollable. Nevertheless, the drawings for the fortifications that are preserved from those months in 1529 are another testimonial to the genius of Michelangelo.[17]

Although the fortifications were never completed, they exerted a pivotal historical influence, becoming the prototype for fortifications in the seventeenth century. So we are once again left in awe of the range of Michelangelo's faculties—in this case, in mastering functional problems and making innovations within so specific a system of design—and in less than a year. However, an issue that invites speculation is whether the defensive weakness in the bastions he designed might have been determined in part by the conflicts within Michelangelo that were activated by this task. Any sculptor who works with hammer and chisel has the opportunity to sublimate aggression in the physical act of carving a statue (as the surgeon in the act of cutting the patient's body effects relief from disease). The aggressive impulse is unconscious and may be evident only in the manifest or latent content of the image (for instance, David slaying Goliath). The sculpture itself is not an instrument of aggression. In contrast, the fortifications of Florence were designed explicitly for purposes of warfare. Furthermore, they were to be employed against the forces of two major lifelong patronizing institutions and figures of Michelangelo—the house of Medici and the papal leader of Christendom. As I have indicated (see n. 17) the designs stressed offensive potential but contained weaknesses in their defensive aspect. Could it be that these weaknesses reflect Michelangelo's need to undo or cancel out the offensive advantage over the enemy that he had designed and thereby to open the way to Florence's ultimate weakness and possible defeat? Although it is not possible to assert that this was the case, Michelangelo's subsequent behavior did demonstrate that it was unbearable for him to be placed in so delicate a position between the republic and the Medici pope.

When he fled Florence, only twelve days after returning from Ferrara, it was Michelangelo's intention to go to France. He stopped in Venice, however, after being told of the danger of passing through German territory en route to France (letter 184). When he arrived in Venice, Michelangelo wrote to a Florentine

17. The major problem in designing fortifications in the era of artillery warfare was to balance two incompatible needs—offense and defense. Maximum security against attack meant minimal offensive maneuverability, and vice versa. As Ackerman (1961) explains in detail, after the introduction of heavy artillery around 1450, the fortifications of most cities were overbalanced on the side of defense. Michelangelo's designs, however, are the first to allow for the full offensive capacity of the defenders. Their primary concern is the placement and trajectory of the offensive artillery mounted in this defensive structure. They are the only military designs of the Renaissance, except for a few by Leonardo, that indicate the trajectories of the cannons (fig. 15-23). However, Michelangelo failed to pay sufficient attention to the fact that the enemy would also be equipped with heavy artillery which the bastions would have to withstand, in other words, they were curved and angled in such a manner as to allow the enemy to set up firing positions at close range that would be invisible and so unable to be fired at by the defenders.

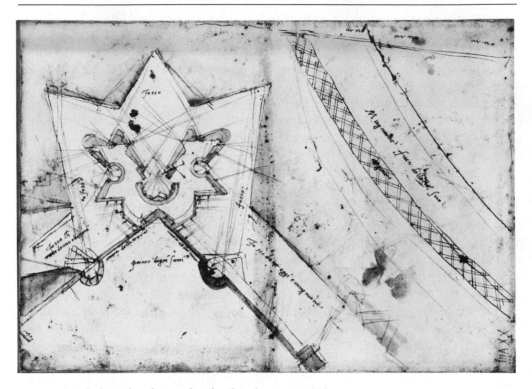

15-23. Michelangelo, design for the fortifications of Florence.

friend, Battista della Palla, that it had been his resolve to see the war through "without any fear whatsoever." Then the letter continues with a fantastic explanation for his flight:

> On Tuesday morning, the twenty-first day of September, someone came out from the San Niccolò gate to the bastions where I was, and whispered in my ear that to remain any longer would be to risk my life. And he came home with me, where he had dinner, and he brought me mounts and never left me till he got me out of Florence, assuring me that this was for my good. Whether he were god or devil I know not. [letter 184]

Ramsden justifies Michelangelo's action by positing that the strange whisperer was sent by the Florentine military commander, Malatesta Baglioni, who wished to be rid of Michelangelo as part of his own plan of eventual treachery. This explanation is unlikely. After Florence fell on August 12, 1530, following a ten-month siege, Baglioni came to be regarded by the Florentines as a diabolical traitor. For several months before the fall he had secretly negotiated with the enemy and, in the end, strongly urged the republican government to surrender. The facts, however, are more in accord with Schevill's (1936) conclusion: "Florence fell not on account of Malatesta's betrayal . . . or any other single incident of the siege, but because the completely isolated republic could not sustain itself in

the long run against the overwhelming strength of the two allied world-powers, the pope and the emperor" (pp. 495–96).

Baglioni was a professional soldier. Recruited from Perugia and not of Florentine heritage, he must have seen the inevitable outcome of the siege dispassionately when he began his secret negotiations a month or two before the fall. It is unlikely that a year earlier, before the siege had even started, he was plotting the outcome and therefore wanted Michelangelo out of the way.

Thus, we still must explain the warning of the stranger and the precipitous flight of the artist. Although no precise date is given, Condivi offers an anecdote that bears on the matter. Michelangelo related that he learned, as he moved among the troops and fortifications of the city, that there was foreboding of attack and a feeling of unpreparedness. "He went to the *signoria* and revealed to them what he had heard and seen, pointing out to them the danger in which the city found itself and saying that there was still time for them to take measures if they wanted to. But, instead of being rewarded with gratitude, he was insulted and reproved for being fainthearted and unduly suspicious" (p. 64). This passage follows shortly after a statement explaining why he had been appointed superintendent of fortifications: "As the *signoria* had no doubt that the Pope would do everything to reinstate the Medici, they fully expected war" (p. 64). Here we find a clear contradiction with respect to the stated attitude of the Signoria. It sounds as if Michelangelo was most anxious and tried to convey to the Signoria his feelings about a danger of which they were certainly aware. In those difficult days for the republic, the Signoria could not be expected to take kindly to what might be considered Michelangelo's implied reproach that they were negligent in facing up to the political reality of the moment. By his behavior, Michelangelo was able to provoke and recreate his lifelong feeling of being misunderstood and ill-treated by the very persons who held power over his life. In this case, it was the governing Council of Florence. The alleged accusations of timidity and undue suspicion may be regarded as projections of Michelangelo's actual psychological state. The story that his precipitous flight to Venice and ultimately to France was undertaken because a stranger had advised him to avoid personal danger simply cannot be accepted at face value. Who was this stranger? Is it likely that Michelangelo, with all his eminence and many contacts in Florence, would not further investigate the stranger's warning rather than immediately turn his life around on the basis of this brief encounter?

My own conclusion is that Michelangelo was in a state of panic. The tale of the stranger was probably a conscious fabrication to disguise what would have appeared to all Florentines as sheer cowardice and abdication of a grave responsibility in defense of the republic. There is also the remote possibility that the stranger was an invention delusionally fused with an auditory hallucination in which Michelangelo heard voices whispering to him to flee immediate danger. Whatever the truth, this flight just before the onset of the siege recalls another precipitous flight that he made from Florence to Bologna at age nineteen, when

the republic was about to fall to the French. At that time, according to Condivi, Michelangelo acted on the basis of a friend's dream foretelling the doom of Piero de' Medici (see pp. 63–64). For all of Michelangelo's eccentricities, mood swings, suspicions, and unrealistic goals, the one feeling that seemed most taxing to his capacity to cope and resolve was his ambivalence toward adversaries in an open or potentially violent conflict.

When word of Michelangelo's plan to move to France reached King Francis I, he was delighted and wrote to the artist in Venice, offering him generous support. The letter, however, arrived only after Michelangelo had returned to Florence, following a month of dramatic negotiations between the artist and the Signoria. A week after Michelangelo's flight, the Signoria decreed that all Florentines who had fled the city were to be declared "rebels" and that if they did not return within a week, their property was to be confiscated by the republic. Word of the decrees in Florence reached Michelangelo belatedly. Through the offices of the Florentine ambassador to Ferrara, he offered to return to the city if he would be granted clemency. The Signoria agreed, and Michelangelo, after a brief stay in Ferrara, returned to Florence around November 20, by which time the siege had been under way for over a month.

There are no letters written by Michelangelo preserved from the two-year period between the "tale of the stranger" letter in September 1529 and the summer of 1531. This is also a period for which we have little direct information about Michelangelo's activities and state of mind. It appears, however, that he executed his duties as director of fortifications with diligence until Florence surrendered on August 12, 1530. Thereupon, Pope Clement named a Florentine, Baccio Valori, commissioner of Florence. Under Valori's direction, all of the leading anti-Medici republicans were rounded up and imprisoned. Michelangelo, once again fearing for his life, went into hiding. Pope Clement, who felt betrayed by Michelangelo's republican activities in the face of his offers of support and requests for continuing work while Clement himself was imprisoned and in hiding, ordered a search for the artist. But the pope's vengeful attitude was short-lived; in three letters of November 1530, he ordered his delegates in Florence to treat Michelangelo with the utmost respect. Michelangelo came out of hiding and by the end of 1530 was back at work in the Medici Chapel, receiving the same monthly stipend from the pope as before the disruption in 1527.

The major event for Michelangelo in 1531 was the death of his father, probably in the spring.[18] (It will be discussed more fully in the next chapter, in connection with the artist's relationship with Tommaso.) By the end of that summer Michelangelo appeared to be in such a state that his friends were concerned for his life, as he seemed to have overworked himself to the point of illness.[19] I infer that

18. See Ramsden (1963, vol. 1, app. 22) for a discussion of the dating of Michelangelo's father's death.

19. Excerpts from a letter by Giovanni Mini (Sept. 28, 1531) are quoted by Tolnay (1943–60, 4:12).

Michelangelo's initial and unsuccessful attempt to adapt to his father's death was to immerse himself in a frenzy of work, mainly on the Medici Chapel tombs. By this time, however, he was experiencing the resumption of the Medici Chapel project as stale and creatively uninteresting.

During this period after the fall of the republic, other artistic demands were made upon Michelangelo, which could only have been a source of rage and frustration. One of the works is the unusually poetic, unfinished statue of *David-Apollo* (fig. 15-24). A detailed history of this work, even for whom or where it was intended, is unknown. Originally, it was apparently supposed to be a statue of David with the head of Goliath at his feet. Then, according to Vasari, in 1530 Valori demanded it, or some other work, from Michelangelo. In response, Michelangelo transformed the figure from David to Apollo; in the final version, the figure's left hand is reaching for an arrow, not a sling. Valori, however, left Florence before the figure was finished, and it went to the Medici family instead.

As a result of these demands on Michelangelo, Pope Clement, on November 21, 1531, issued a *breve* (papal brief) forbidding the artist, upon threat of excommunication, to work on anything other than the pope's projects and the Tomb of Julius. At the same time, through a letter to Sebastiano (letter 186), Michelangelo appealed to Clement to facilitate a final settlement of his commitment to the Tomb of Julius that would allow him to extricate himself from the never-ending project. This was actually effected in June 1532. It was agreed that Michelangelo would supply a model or drawing for a final wall-tomb which would then be principally carried out by other artists. He was also granted three years to repay monies that had previously been advanced to him, and he was to assume all expenses for the future work. In addition, the pope agreed to let Michelangelo work on the tomb for about two months a year for the next three years, in Rome. This 1532 contract, though in the form of a negotiated agreement between the artist and the della Rovere heirs, was really a resolution dictated by the pope.

To all Michelangelo's miseries was added the presence in Florence from July 1531 of Pope Clement's illegitimate son, Alessandro de' Medici. Alessandro, by virtue of his engagement to the illegitimate daughter of Emperor Charles V, was assured the position of ruling prince. He immediately exercised great authority, which was formalized on May 1 of the following year, when he was named "Duke of Florence." Alessandro soon thereafter became increasingly eccentric in his behavior. In fact, it was suspected that he was demented. One manifestation of this was the apparently irrational hatred he bore Michelangelo. This time, with the city in the hands of an unpredictable tyrant who had absolutely no inclination to be a patron of the artist, and with Pope Clement's health failing, Michelangelo had good reason to fear for his future in Florence.

Starting in the spring of 1532, Michelangelo began to spend increasing amounts of time in Rome. These visits culminated in September 1534 with his final departure from Florence to take up permanent residence there. It was also in the spring of 1532 that he was to meet Tommaso de' Cavalieri. As he forged ahead in

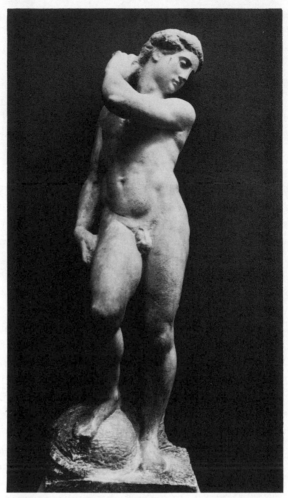

15-24. Michelangelo, *David-Apollo.*

1533 with his work on the Medici Chapel and the Laurentian Library between journeys to Rome, Michelangelo's determination to make the move must have crystallized. With his father and brother Buonarroto dead, only his two "strange" brothers, Giovan Simone and Sigismondo, remained—the former in Florence and the latter on the farm in Settignano. Thus, the binding fabric of a structured family had disintegrated. The two Medici projects, which had started out as monuments to a family name associated with the earlier glory of the republic, turned out to be monuments to a name now identified with crushing the republic and replacing it with an oppressive monarchy. Moreover, the chapel and the library would take further years of work to complete. And, as I have suggested, work on the tomb statues themselves probably had become a tedious chore. As he approached sixty years old, Michelangelo may well have regarded remaining in Florence as tantamount to accepting the end of both his creative inspiration and

his opportunities. In addition, it involved the prospect of subjection to the hostile will of Duke Alessandro once Pope Clement died. This bleak picture was dramatically altered with the entry of Tommaso de' Cavalieri into his life, as is explored in the next chapter.

As the outcome of Michelangelo's work over the twelve years of the turbulent pontificate of Clement VII, the Medici Chapel and tombs stand as the expression of his ongoing inner response to personal frustration, pain, and discontinuity. The tombs and the decoration of the chapel were left uncompleted. Yet the six figures of the two tombs convey a stillness and a resignation to an eternity of the unknowable that Michelangelo himself was not ready to accept. When he left Florence in 1534 the statues were still strewn over the chapel floor. He never saw the final assembly which we behold today.

Chapter Sixteen

Tommaso de' Cavalieri and Other Young Men

Two days after Michelangelo returned to Rome to live permanently, on September 25, 1534, Pope Clement VII died, bringing to a close the artist's forty-five-year-long relationship with the Medici as his patrons. The grief and distress that Michelangelo might have experienced as a result of his final leavetaking from Florence were overshadowed by the joy that accompanied his reunion with Tommaso de' Cavalieri.

In the course of discussing the *Dying Slave* (chapter 12), I offered an explanation for Michelangelo's unprecedented experience of passion for a young man, addressing his need to fill the void and attenuate the anxiety that followed upon the death of his father a year before he met Tommaso. Several young men are known to have been the objects of Michelangelo's affection, both before and after his meeting Tommaso. However, the relationship with Tommaso, because of its intensity and its legacy of presentation drawings, sonnets, and letters, affords unique access to a central component of the artist's fantasy and unconscious life. This chapter will also explore Michelangelo's attachments to other young men at various points in his life.

Considering that Tommaso was of aristocratic origins, held civic offices, and remained a close and loyal friend of Michelangelo for thirty-two years, until the artist's death, surprisingly little is known about him. He was twenty-three years old when Michelangelo, then fifty-seven, encountered him in Rome. The circumstances of their meeting are not known to us. Judging from contemporary descriptions, Tommaso was uncommonly handsome. The only painted portrait Michelangelo is believed to have undertaken was of Tommaso and reached the stage of a life-sized cartoon.[1] The cartoon is lost and is known only through a description by Vasari, who, in referring to it, noted that Michelangelo "hated to take anything from life unless it presented the very perfection of beauty" (vol. 2, p. 195). The prominent Florentine humanist Benedetto Varchi (1590), said that he recognized in Tommaso "not only incomparable physical beauty, but so much elegance in manners, such excellent intelligence, and such graceful behavior, that he well deserved, and still deserves, to win more love the better he is known" (p. 183).

1. The manner of the portrait is surprising. Tommaso was represented in classical dress, holding a medal in his hand.

Tommaso married in 1538 and fathered two sons. One predeceased him and the other, Emilio, became a composer and musical figure of eminence. Over the years Tommaso held a number of civic offices. In one, as a member of the Conservatori, he shared in the responsibility of overseeing architectural projects in the Capitol. In this post he was charged with carrying out Michelangelo's Capitoline designs. In addition, Tommaso was well educated in the Humanist tradition. He was a connoisseur of art and the possessor of fine antique and contemporary collections. His letters to Michelangelo attest to his literary facility. Tommaso died in 1587, at the age of seventy-eight.

Two of Michelangelo's letters to Tommaso and several from him to the artist are preserved. Michelangelo's first letter is lost. Nevertheless, from Tommaso's reply we learn that it was accompanied by two drawings. His tactful letter makes it clear that Michelangelo had written lavishly of Tommaso's admirable qualities. In response, Tommaso wrote that these praiseworthy qualities were "insufficient to cause a man of such excellence as yourself and without a second, let alone a peer on earth, to write to a youth—a mere babe and therefore as ignorant as can be. . . . I promise you truly that the love I bear you in exchange is equal or perhaps greater than I ever bore any man, neither have I ever desired any friendship more than I do yours. . . ."[2]

Michelangelo immediately answered Tommaso's letter. Earlier (p. 179), I quoted a passsage from the draft of Michelangelo's reply, in which he openly and without restraint expressed the wishful fantasy of spending his remaining days serving and pleasing Tommaso. In the letter that was actually posted, Michelangelo wrote:

> Far from being a mere babe, as you say of yourself in your letter, you seem to me to have lived on earth a thousand times before. But I should deem myself unborn, or rather stillborn, and should confess myself disgraced before heaven and earth, if from your letter I had not seen and believed that your lordship would willingly accept some of my drawings. [letter 191]

The letter closes with the enigmatic passage, "Though it is usual for the donor to specify what he is giving to the recipient, for obvious reasons it is not being done in this instance." Ramsden (1963) concludes from this that Michelangelo was sending a portfolio of drawings from which Tommaso was free to choose those he liked. Testa (1977), on the basis of the more literal translation of the phrase *per buono rispetto*, as "out of a sense of what is proper" rather than "for obvious reasons," argues that Michelangelo was not referring to the drawings but, rather, to passions that cannot be named in writing and that were the inspiration for the series of presentation drawings. Regardless of the meaning of these lines, there are sonnets and drawings that clearly reveal Michelangelo's thoughts and struggles over his attraction to Tommaso.

2. Ramsden (1963, 2:xviii).

In a sonnet written shortly after meeting Tommaso, Michelangelo expresses his concern about what others may think of his attraction to the young Roman:

> Therefore, alas, how will the chaste wish
> That burns my inward heart ever be heard
> By those who always see themselves in others?
> .
> In fact, the unbelievers are the liars.[3]

In these lines, Michelangelo not only proclaims his own pure motivation but also shows his awareness of the mechanism of *projection*, whereby the conflicted and forbidden impulses in others will be attributed to him. Indeed, as Gilbert (1963) suggests, Michelangelo must also have been concerned about the way in which Tommaso would "hear" his expressions of love—whether as frankly sexual or as spiritual.

The sonnets to Tommaso directly express a flow of loving feelings, free of ambivalence and reproach, which had not been heard before from this essentially private man. The first of the sonnets begins:

> If a chaste love, if an excelling kindness,
> If sharing by two lovers of one fortune,
> Hard lot for one the other one's concern,
> Two hearts led by one spirit and one wish,
>
> And if two bodies have one soul, grown deathless,
> That, with like wings, lifts both of them to Heaven,
> If love's one stroke and golden dart can burn
> And separate the vitals of two breasts,
>
> Neither loving himself, but each one one each
> With one delight and taste, such sympathy
> That both would wish to have a single end, . . .[4]

These lines express the basic fantasy that motivated Michelangelo in this relationship—the yearning to merge with Tommaso's youth and beauty and thereby conquer aging and death ("if two bodies have one soul, grown deathless").

In his next sonnet to Tommaso, the desire to dissolve boundaries between the two is reasserted:

> If the hope you have given me is true,
> And true the good desire that's granted me,
> Let the wall set between us fall away,
> And there is double power in secret woe.
>
> If I in you love only, dear my Lord,

3. Gilbert and Linscott (1963, poem 56).
4. Ibid., no. 57.

> What you love most in you, do not be angry;
> The one's enamored of the other spirit.[5]

Michelangelo's yearning to merge with Tommaso was nevertheless accompanied by the anxiety that generally attends such symbiotic fantasies. To abandon one's own sense of a separate identity means the "death" of the self. As we shall see, this conflict in the artist was to become a dominant presence in his work during the last two decades of his life. Thus, in this same sonnet in which Michelangelo expresses the wish that the wall between the two would fall away, he continues:

> What in your beautiful face I have wished and learned
> Human intelligence can grasp but badly,
> He is required to die who wants to see it.

In the next sonnet to Tommaso, Michelangelo states the hope that: "I'd be renewed by fire, in which I burn."[6] Later in this poem he continues the thought that he has seen: "In the eyes of this single happy angel / That I shall be at peace, rested and safe."

The metaphors of "fire" and "ice" recur throughout Michelangelo's poetry. They represent life and intense feeling, on the one hand, and bodily decay, death, and isolation, on the other. In the search for unifying themes in Michelangelo's verse, Nesca Robb (1935) provided a critical guideline: "No man perhaps ever made the human body so eloquent a language, and no one can have felt more keenly the bitterness of its decay. One must remember that if one is to feel the full force of his poems" (p. 250).

At age fifty-seven, with his father and brother Buonarroto dead, Florence no longer a republic, and dear friends forced into exile, Michelangelo was drawn to the "fire" in which he might burn. For him, beauty was the divine ideal. At this point in his life, Tommaso, whatever in truth his physical appearance and character were, became the embodiment of that ideal. As a consequence, both the letters to Tommaso and the poetry, for all their searing passion, are rather impersonal in the sense that they seem to leave Tommaso bereft of any uniquely identifiable characteristics. Rather, he emerges as a tabula rasa, a blank figure whom Michelangelo could endow with the qualities that would enable him to experience the "fire" he felt he required to survive.

In addition to the threat that uncontrolled "fire" held for Michelangelo in terms of the loss of his sense of self, it had the potential to extend into overt sexuality, which he sensed would drive Tommaso away. This fear is expressed in another sonnet to Tommaso, at first with assurances of his chaste love:

> Perhaps your spirit, gazing at this chaste
> Fire that consumes me . . .[7]

5. Ibid., no. 58.
6. Ibid., no. 59.
7. Ibid., no. 70.

then ending in the frankly physical image:

> That I may have, though it is not my due,
> My so much desired, my so sweet lord,
> In my unworthy ready arms for always.

Bridging these two thoughts is a stanza in which he states his feeling that, if Tommaso returns his love, "the hours will be stopped, time, sun, the days." Thus, *time,* the devourer of all things, including Michelangelo's life, will be arrested by mutual love.

By the end of 1533, in another sonnet to Tommaso, there is a sense of Michelangelo's dawning awareness that his magical expectations can never be realized. Time will, once again, move forward. Thus, he concludes this sonnet with the lines:

> Who gazes on high beauty in great grief
> Draws from it sharp and sure distress and torture.[8]

Michelangelo's reparative and protective fantasy is the familiar and recurrent one of being enslaved. This is evident in his next sonnet to Tommaso, in which the sentiment is embedded in a pun on Tommaso's name:

> If capture and defeat must be my joy,
> It is no wonder that, alone and naked,
> I remain prisoner of a knight-at-arms.[9]
> ["Prigion resto d'un Cavalier armato"]

The sentiments expressed toward Tommaso illuminate major elements in the form and meaning of Michelangelo's statue of *Victory* (fig. 15-14). The sonnets have led many authors over the years to conclude that the subjugated older man in the sculpture is a self-portrait and the youthful victor is Tommaso. However, most scholars now follow Wilde (1954) in placing the execution of the work (for which no documents exist) between 1527 and 1530, *before* the artist met Tommaso. The *Victory* was intended for the 1526 project of the Tomb of Julius. However, the older man, bearded and with a mildly flattened nose, certainly bears a "type" resemblance to the artist. Moreover, he is represented in the conquered position seemingly as much through his own will as through any force being exerted by the handsome nude athlete who parts his legs and distractedly kneels on his back. Thus, the drama that unfolded with Tommaso in real life, beginning in 1532, had been a powerful fantasy in the preceding years and in major respects dictated the form of the *Victory*. This statue is an eloquent example of the way an artist's private fantasy can be expressed through official iconography for a public monument.

Most of Michelangelo's poetry takes the form of private thoughts and feelings

8. Ibid., no. 82.
9. Ibid., no. 96.

expressed in the traditional Petrarchan verse of the day. While informative about his personal meditations, there is little of his verse that would merit preservation beyond his time were it not for his artistic fame. Yet the depth of his feeling for Tommaso inspired Michelangelo in 1533–34 to write one of the finest examples of lyric verse of the sixteenth century:

> I with your beautiful eyes see gentle light,
> While mine are so blind I never can;
> With your feet, on my back can bear a burden,
> While mine are crippled, and have no such habit;
>
> Having no feathers, on your wings my flight,
> By your keen wits forever drawn toward Heaven,
> As you decide it I am flushed and wan,
> Cold in the sun, at the cold solstice hot.
>
> My wishes are within your will alone,
> Within your heart are my ideas shaped,
> When you have taken breath, then can I speak.
>
> It seems that I am like the lonely moon,
> Which our eyes fail to see in Heaven, except
> The fraction of it that the sun may strike.[10]

Once Michelangelo was settled in Rome, the writing of letters and sonnets to Tommaso virtually ended. One sonnet, however, which was written in the late 1540s, is preserved. The sentiments expressed in that verse are consistent with the earlier ones we have examined.

Michelangelo's passion for Tommaso in the early days of their relationship was by no means kept secret. In a letter to Sebastiano del Piombo in August 1533 (quoted in chapter 13), Michelangelo pleaded: "when you write to me tell me something about him to put me in mind of him, because *if he were to fade from my memory I think I should instantly fall dead*" (letter 194, my italics). In a draft of a letter dated July 28, 1533, Michelangelo confided to his friend in Rome Bartolommeo Angiolini, "And since the heart is in truth the abode of the soul, and my heart being for the first time in the hands of him [Tommaso] to whom you have confided my soul . . ." (letter 195). Angiolini apparently acted as a carrier of messages between Michelangelo and Tommaso while the artist was in Florence. On August 11, 1533, he wrote to Michelangelo:

> I gave your letter to M. Tomao, who sends you his kindest remembrances, and shows the very strongest desire for your return, saying that when he is with you, then he is really happy, because he possesses all that he wishes for upon this world. So then, it seems to me that while you are fretting to return, he is burning with desire for you to do so. Why do you not begin in earnest to make plans for leaving Florence?[11]

10. Ibid., no. 87.
11. Translated in Symonds (1893, 2:144–45).

Tommaso was married several years later. Although there are virtually no details of the ongoing nature of their friendship for the rest of Michelangelo's life, from a letter written by Tommaso to Michelangelo in 1561, when Michelangelo was eighty-six years old, it is clear that their bond remained intense. Tommaso wrote this letter in response to what he perceived as Michelangelo's displeasure with him over some incident that is now unknown:

> Very magnificent, my Lord—For some days I have been under the impression that you have some grievance against me, I know not what, but yesterday I was convinced of it when I called at your house. . . . But I assure you, if you do not want me for a friend you can say so, but you will never prevent me from being a friend to you and always seeking to serve you . . . for I know that you know that I have always been a friend to you without any self-interest whatever. . . . I cannot imagine in any way what you have against me. But I beg and adjure you by the love that you bear towards God that you will tell me, so that I may be able to undeceive you. . . .[12]

This letter expresses the same tact and consideration Tommaso exhibited at the beginning of their relationship twenty-nine years earlier. As stated before, we know very little about Tommaso himself or the essence of their friendship. Nor do we know what role the relationship played in Tommaso's life. It does not appear that Tommaso ever exploited Michelangelo either in terms of worldly gain or emotions. Nor, for that matter, did Michelangelo ever exploit Tommaso. Thus, although we have public documents from which we can infer some of the inner meaning of the friendship to each of them, particularly to Michelangelo, the relationship is basically shrouded in mystery. Yet, it was extraordinary and mutually nurturing. Moreover, it is surprising that Michelangelo, with his history of stormy relationships and friendships ending in disenchantment and reproach, could move out of the early phase of obsessive preoccupation and passionate feeling into a long-standing, ongoing friendship without feeling exposed or betrayed. Vasari later wrote, after listing many of Michelangelo's friends, "But more than all the rest did he love Master Tommaso de' Cavalieri" (vol. 2, p. 195).

The Presentation Drawings

In his presentation drawings for Tommaso, Michelangelo turned to mythology and expressed themes in an artistic vocabulary that were recognizable and acceptable within the currents of the Neoplatonic philosophy of the day.[13] This art form represented their "public" level of meaning. However, even before this century the drawings were recognized and described by Wickhoff (1882) as "one coherent confession." The drawings were not in the usual form of preliminary ideas for some other painted or sculptural project. They were complete works in their own right.

12. Ramsden (1963, 2:xix–xx).
13. Panofsky (1939, pp. 212–19) has offered a learned discussion of the drawings in terms of their Neoplatonic iconography.

Four drawings are universally accepted as having been gifts to Tommaso—the *Rape of Ganymede* (fig.16-1), the *Punishment of Tityus* (fig. 16-4), the *Fall of Phaethon* (fig. 16-8), and the *Children's Bacchanal* (fig. 16-9). Tommaso refers to the first three of these directly in letters to Michelangelo. It has generally been inferred that the *Ganymede* and the *Tityus* were presented as a related pair in December 1532, and the *Phaethon* in the summer of 1533.[14] Vasari refers to the *Children's Bacchanal* as a presentation to Tommaso. Its date is generally accepted as 1533. In addition, there are several other drawings, particularly the *Dreamer* (fig. 16-12) and the *Archers*, which may have been intended for Tommaso. There is no documentation to this effect, but they bear sufficient thematic and stylistic kinship to the first four to warrant such consideration.

The original *Ganymede* is lost. Thus, we are forced to rely on copies by unidentified follower(s), the most reliable of which is the one at Windsor Library. Inasmuch as Michelangelo drew three versions of the *Phaethon*, and included rather obsequious notes on the first two, offering to redo them if they did not fully please Tommaso, it is possible that he also drew several versions of the *Ganymede*,[15] which would account for the differences among various copies of it, such as the ones at Windsor and at the Fogg Museum.

The myth of Ganymede was discussed earlier in connection with the *Dying Slave* (chap. 12) but deserves to be briefly summarized again at this point. Ganymede, son of the king of Troy, was the most beautiful of youths. Zeus, desiring him for his cup bearer and bed companion, swooped down disguised as an eagle and abducted Ganymede. To console the hapless father, Zeus assured him that his son would have immortality in the role of service to the most powerful of the gods. He also gave him two fine horses.

Graves (1955) notes: "The Zeus-Ganymede myth gained immense popularity in Greece and Rome because it afforded religious justification for a grown man's passionate love of a boy" (vol. 1, p. 117). The myth was employed by Plato in *Phaedrus* to justify his own attraction toward his students. Over the course of the Middle Ages it was reinterpreted in keeping with Christian morality. Thus, a parallel was drawn between the ascension of Ganymede to Olympus and that of Saint John the Evangelist to Heaven.[16] Dante, in *Purgatory* (9.19), compares a vision of himself being borne aloft by an eagle to the experience of Ganymede.

14. The *Ganymede* and the *Tityus* are almost certainly the pair of drawings referred to by Tommaso in his first letter to Michelangelo in December 1532. The *Phaethon* is mentioned in his letter of September 6, 1533.

15. Hirst (1975), in the course of proposing the Fogg Museum drawing of Ganymede as an autograph, reiterates what has long been recognized, that there are several versions of this theme by or after Michelangelo. Rosand (1975) has argued persuasively on an iconographic basis that the Windsor copy, but not the Fogg, could be suitably paired with the *Tityus*. Therefore, the Windsor copy must reflect the original sent to Tommaso.

16. Sebastiano del Piombo teased Michelangelo in a letter of July 7, 1533, suggesting that for the cupola of the New Sacristy at San Lorenzo, Michelangelo should do a fresco of Ganymede, but with "a halo so that he would appear as St. John of the Apocalypse carried to Heaven." Sebastiano, of course, knew of the *Ganymede* drawings.

The prevailing commentary on Dante in the Renaissance was by Cristoforo Landino (1529), who provided the transition to the Neoplatonic concept of the myth in Michelangelo's day. According to this, Ganymede represents the more spiritual realm of the Christian soul—the mind—leaving behind earthly and corporeal elements, to ascend to a state of ecstatic contemplation. Thus, over the course of many centuries, by Michelangelo's day the Ganymede myth's original, frankly homosexual message had become subsumed into a spiritual abstraction. The contemporary version of the myth gave Michelangelo license to exploit the theme with impunity in communicating to Tommaso his feelings and fantasies, which were rooted in the pagan beginnings of the myth.

Michelangelo's Ganymede, with eyes closed and right arm limply draped over the eagle's wing, is enraptured as the eagle spreads his legs and buttocks. The figure of this athletic youth is a masterful rendering of the ecstasy of passive yielding to anal eroticism in the embrace of a more powerful being.[17] As noted earlier, in the Windsor copy, Ganymede's scrotum appears to have a vaginal cleft from which the eagle's penis emerges. It is as though the penis were the eagle's and had passed through the youth's anal-vaginal canal. However, the fundamental element in Michelangelo's choice of the myth of Ganymede is, I believe, the rewards given this mortal youth for his sexual surrendering to Zeus—immortality and eternal youth.

The imagery of being borne aloft by a winged figure occurs several times in the poems for Tommaso. Over a decade later, Michelangelo used this metaphor in a sonnet to Tommaso in the course of expressing the intensity of his love for him. This sonnet is particularly interesting in two respects: first, in its justification of this love as being the force that readily opened him to the deep religious commitment that took place several years before its writing; and, second, in its emphasis, in the final two stanzas, on the spiritual value of homoerotic love in contrast to the degrading consequences of heterosexual love.

> Violent passion for tremendous beauty
> Is not perforce a bitter mortal error,
> If it can leave the heart melted thereafter,
> so that a holy dart can pierce it quickly.

17. The unrestrained anal eroticism in Michelangelo's *Ganymede* seems to have affected both Rembrandt and Caravaggio sufficiently to cause them to paint their own versions of the subject, which are direct repudiations of Michelangelo's sensibility. The Dutch master's *Ganymede* (fig. 16-2) is an unattractive child, vociferously protesting his abduction. Rembrandt clearly states his view of the theme by depicting his Ganymede in the middle of urinating. The relation of this Rembrandt painting to that of Michelangelo has been traced by Clark (1966). Rembrandt's strong response to the Michelangelo drawing is interesting in light of his apparently complex relationship with his own father, which, Held (1969) has demonstrated, continuously informed his art. Michelangelo's drawing, with its Neoplatonic façade, seems to have irritated Caravaggio. Thus, in Caravaggio's *Love Victorious* (fig. 16-3), the naked youth is posed like Ganymede triumphantly standing over the fallen icons of the values of higher Western culture, while with his left hand he brazenly invites the viewer to sodomize him.

Not hindering high flight to such vain fury,
Love wakens, rouses, puts the wings in feather,
As a first step, so that the soul will soar
And rise to its maker, finding this too scanty.

The love for what I speak of reaches higher;
Woman's too much unlike, no heart by rights
Ought to grow hot for her, if wise and male.

One draws to Heaven and to earth the other,
One in the soul, one living in the sense
Drawing its bow on what is base and vile.[18]

To understand Michelangelo's state of mind fully, the *Ganymede* cannot be considered apart from its companion drawing, *Tityus* (fig. 16-4). Michelangelo knew the myth of Tityus specifically through Ovid (*Metamorphoses* 4. 456) and as a general part of his humanist education. The giant Tityus, a mortal son of Zeus, was one of the four notorious sinners tortured in Hades. His sin had been trying to rape Leto, mother of Apollo and Artemis, as she performed a sacred devotion. Apollo and Artemis slew him with a volley of arrows. Tityus was then further punished by being stretched out over nine acres in Hades with his arms and legs pegged to the ground while two vultures perpetually devoured his liver—the seat of carnal desire. Thus Tityus symbolized the agony that debasement of the soul through sexual overindulgence was thought to deserve. Panofsky sees the *Ganymede* and the *Tityus* as Michelangelo's version of the theme of "Sacred and Profane Love." In this context, the gift of *Tityus* was ostensibly intended to reassure Tommaso: Michelangelo understood that the love he felt, and the fantasies he enjoyed, could not and would not move out of the precinct of the mind. In his treatment of Tityus, however, the artist took considerable liberties with tradition, with the result that, rather than two drawings representing a well-programmed statement, we have a revealing document of Michelangelo's inner fantasies.

It is interesting to look at Titian's painting of *Tityus* (fig. 16-5), in which the violent spirit of torment is powerfully stated, and then contrast it with Michelangelo's. Michelangelo has introduced the following departures from the myth, and other anomalies. Meting out punishment are not two vultures but rather a single eagle. Moreover, only Tityus's right arm and right foot are tied to the rock. His left leg is free from bonds and is relaxed. There are no scars from the bird's pecking on his supple abdomen. His facial expression is ambiguous. The brow is furrowed (like that of *St. Proculus* [fig. 6-2], *David* [fig. 8-1], and *Brutus* [fig. 20-1]), but there is no clear exposition of pain. This relative freedom from external restraints has been interpreted as signifying spiritual rather than physical enslavement.[19] Thus, the question is left open whether Tityus is suffering at all.

18. Gilbert and Linscott (1963, poem 258).
19. This interpretation is subscribed to by Gere (1975), Goldscheider (1951), Hartt (1970), Panofsky (1939), and Wilde, the last of whom implicitly accepts the interpretation by quoting Panofsky at length (Popham and Wilde, 1949).

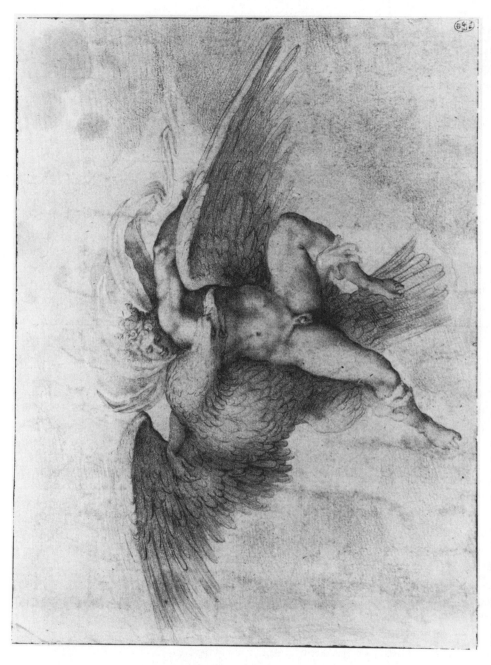

16-1. Copy after drawing by Michelangelo, *The Rape of Ganymede.*

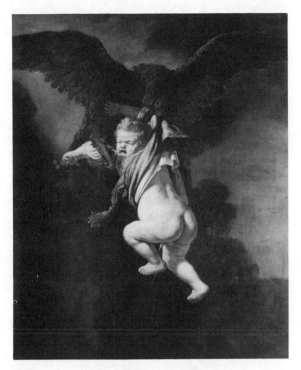

16-2. Rembrandt, *The Rape of Ganymede.*

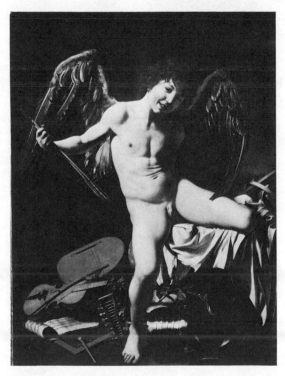

16-3. Caravaggio, *Amor Victorious.*

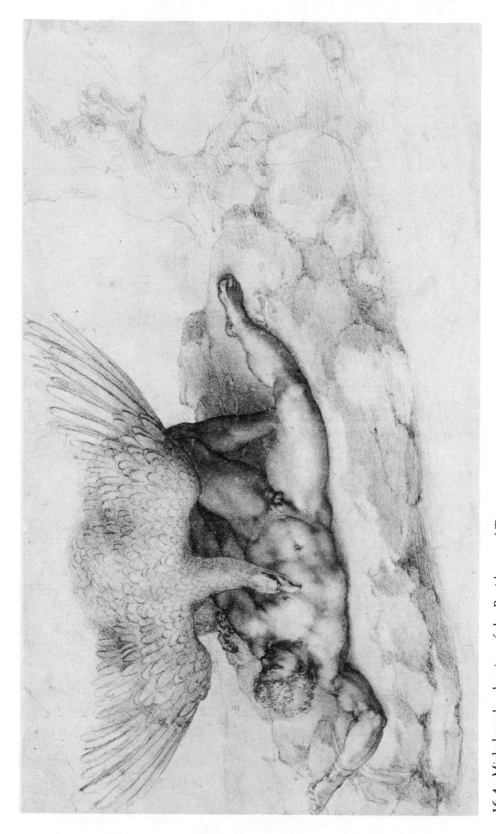

16-4. Michelangelo, drawing of the *Punishment of Tityus*.

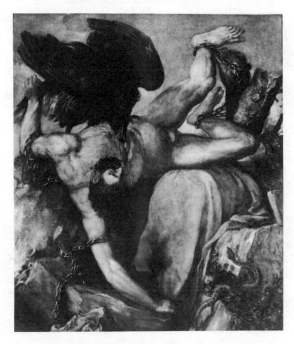

16-5. Titian, *The Punishment of Tityus.*

With respect to Tityus's position, it is similar to Ganymede's, rotated 90 degrees to the left. It also derives from Adam in the *Creation of Adam* (fig. 11-8). Thus, Tityus is submitting to the eagle in a passive and receptive pose that echoes Adam's moment of animation by God. The spread of Tityus's legs and the frontal presentation of his genitals also mirror the figure of Ganymede. It is significant that the positioning of Tityus and Ganymede also bears a close resemblance to that of Venus in the *Venus and Cupid* (fig. 16-6), which is known only in a painted copy based on Michelangelo's lost cartoon, executed either just before or shortly after the Tityus drawing. Therefore, in Michelangelo's substitution of an eagle for two vultures, the underlying fantasy of sexual yielding to a disguised form of Zeus must be considered. Moreover, the choice of the eagle for *Tityus* is even more interesting because in ancient bird symbolism the eagle alone is masculine.

The choice of the fate of Tityus for presentation to Tommaso is striking in that Tityus was punished for the sin of destructive heterosexual lust. Michelangelo has not paired the *Ganymede* with a myth expressing the destructive and tragic consequences of homosexual love, such as Apollo and Hyacinthus. Thus, the moral of Tityus is, in a literal sense, irrelevant to the conflicted motivation for the *Ganymede*. We can assume that at some level of his unconscious, Michelangelo feared death and castration as the consequences of sexual love for a woman. Moreover, such sexual desire contained unacceptable aggressive impulses. But with respect to the situation at hand with Tommaso, the message of the drawing was rather misleading. The *Tityus* does not signify a renunciation of the pleasures of the

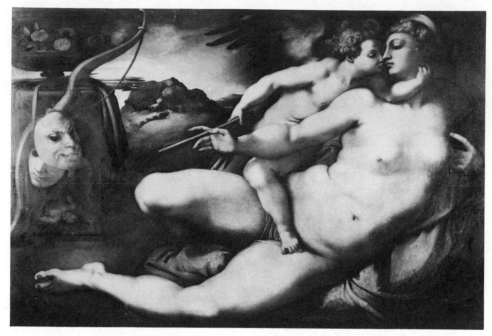

16-6. Jacopo Pontormo after Michelangelo's *Venus and Cupid.*

Ganymede or fear of their consequences. Rather, Michelangelo preserves the fantasy of himself as Ganymede by making a moral statement about some other "crime."

Pursuing this train of thought, one can speculate that Michelangelo was gripped by the myth of Tityus because of his own conflicts over early feelings of rage toward mothering figures who favored their other children. In the myth of Tityus, Leto is the mother of Apollo and Artemis, who are half-siblings of Tityus (all being children of Zeus). Perhaps the myth is associated more specifically for Michelangelo with his first two years in the household of the wet-nurse, who may have favored her own children over him. If this is the case, we can tentatively conclude that love and desire for a woman must be defended against lest the angry substratum of Michelangelo's early experience rear itself in the form and with the consequences symbolized by Tityus. The safer alternative to that drama was the espousal of pure love for an idealized man. To the extent, however, that the Tityus theme remained a part of Michelangelo's psyche, his unique drawing of *Tityus* reflects the compromise solution of taking erotic pleasure in the punishment. This means of resolution is central to many clinically observed forms of masochism.

One of the most remarkable occurrences in Michelangelo's corpus of drawings is what he did with the reverse side of the *Tityus* sheet. He virtually traced the outline of the figure of the recumbent and helpless Tityus but, by turning it 45 degrees, transformed it into the figure of Christ Risen (fig. 16-7), in the act of

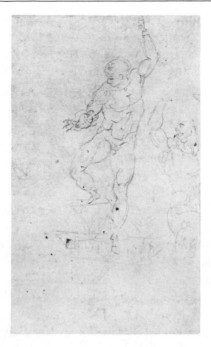

16-7. Michelangelo, study for
The Resurrection of Christ.

triumphal ascension.[20] How can we account for this extraordinary transformation of a sexual sinner undergoing torment into the resurrected Christ?[21] The latter theme held great fascination for Michelangelo and was the subject of approximately fifteen extant drawings—more than we have of any other single motif—as well as of the statue of *Christ Risen* in Santa Maria sopra Minerva Rome (fig. 14-7). The unfinished and seemingly idly sketched resurrected Christ on the back of the *Tityus* drawing[22] again testifies to the artist's dread of death and the wasting of the mortal body. It reflects his deep unconscious wish for the magical undoing of the suffering that awaited the sinner after death.

Thus, as a pair, the *Ganymede* and *Tityus* presentation drawings reveal not simply Michelangelo's passion for Tommaso, his guilt, and his attempt at renunciation. They also reveal his homosexual interest as a means of suspending the passage of time, of warding off death with its awesome mystery and fear, which

20. Hartt's (1970) contention that the Christ was drawn earlier, in 1528–20, is not plausible. To convert Tityus into Christ is in the spirit of redemption, whereas it would be blasphemous to turn Christ into Tityus.

21. The transformation of a sinner into Christ recurred later, when Michelangelo used as a principal inspiration for the figure of Christ in the Florence *Pietà* (fig. 20-4) the figure of a sinner being tormented in Hell from Lorenzo Maitani's *Last Judgment* (fig. 20-5) on the façade of the cathedral at Orvieto.

22. The position of the head was slightly altered later, and the right arm was also tried out in slightly varying positions.

feelings were especially pronounced following the death of his father the year before meeting Tommaso. Ganymede achieved immortality and eternal youth by acceding to Zeus. Tityus seemingly wards off the horror of eternal damnation by the act of suggestively yielding to the eagle, a symbol of Zeus. The conflict is, however, not resolved. Thus Michelangelo falls back on widely accepted Christian miracle, and the unfortunate Tityus becomes the heroic Christ emerging from his tomb, resurrected—triumphant over death. We recall again that Michelangelo wrote for Tommaso: "And if two bodies have one soul, grown deathless, / That, with like wings, lifts both of them to Heaven."

The third drawing of the series, the *Fall of Phaethon* (fig. 16-8), has an unusual history. In its first version (British Museum, W 55) it bears Michelangelo's written offer to Tommaso: "if this sketch does not please you, tell Urbino so that I might have time to have another done by tomorrow evening as I promised you, and if you like it and want me to finish it send it back to me."[23] We do not know what Tommaso's response was. Michelangelo, however, did not finish this first sheet. He worked on a second version (Venice, Accademia, no. 177), which also contains a note offering to redraw the work.[24] Again, Tommaso's response is not recorded. However, judging from his expression of gratitude and awe upon receiving the drawings of Ganymede and Tityus only a few months earlier and the tone of unwavering respect and humility in all his other letters to the artist, it is improbable that Tommaso rejected the earlier versions of *Phaethon* because they displeased him in any way. Therefore, it was probably Michelangelo himself who felt dissatisfied with the first two versions, as is reflected in the changes in composition and narrative on each sheet.

The first version, in which three scenes of the narrative are presented, is the most faithful to Ovid (A.D. 8, 2. 1 ff.). The myth involves Phaethon, mortal son of the sun-god Phoebus. Every morning Phoebus rode his four-horse-drawn sun chariot through the skies from east to west in order to provide the light of day for the world. At the end of his journey he returned by river ferry in the darkness of night to his palace in the east to prepare anew for his daily mission. The basis for the action in Ovid's version of the myth is Phaethon's doubts about his paternity, despite his mother's reassurance. He therefore travels to Phoebus's palace and approaches his father, a stranger to him, with this question. Phoebus insists that he is indeed Phaethon's father. To seal the assurance, he offers to grant his son any

23. Translated by Hartt (1970, p. 250).

24. Perrig (1964) alone among students of Michelangelo's drawings has rejected the attribution of the Venice sheet to the master. He argues that this drawing is by Tommaso, after a model supplied by Michelangelo. Perrig believes that the note in Michelangelo's hand on the sheet, to the effect that he is "sending yours back," refers to the same sheet and is consistent with his conclusion that Michelangelo sent Tommaso drawings which the young Roman then used as models for his own study of drawing. But, as William Wallace has reasoned (personal communication), the daring and magnificence of the drawing of the two pairs of horses, locked in seemingly human copulatory embraces as they plunge toward death, could hardly be by any other hand than Michelangelo's.

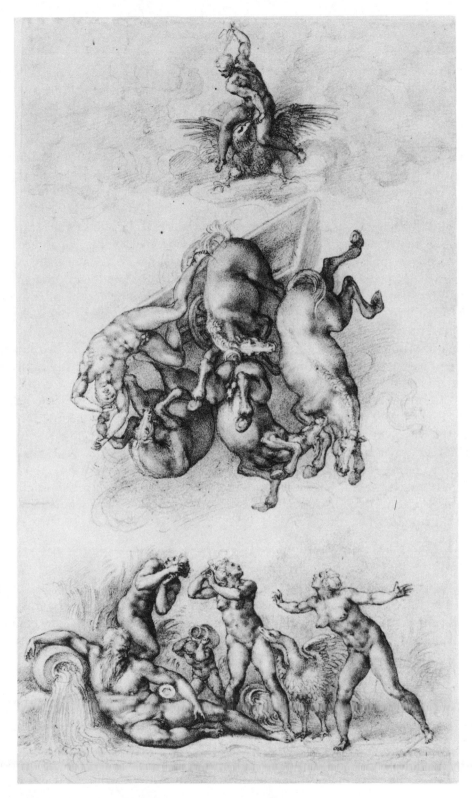

16-8. Michelangelo, drawing of the *Fall of Phaethon*.

single wish. Phaethon boldly asks to drive the sun chariot across the sky. Phoebus feels obliged to honor his promise but tries to dissuade Phaethon from this awesome venture, which is well beyond the capacities of the youth. But Phaethon persists. Once Phaethon embarks he cannot control the wild stallions, who soar downward, scorching the earth, burning people, and drying up the waters. Earth pleads with Jove (Zeus) to intervene. Jove throws a lightning bolt which immediately kills Phaethon, and sends the youth, chariot, and horses plummeting to earth. The dead youth is received by a river-god, Eridanus, far from home.

In his first drawing Michelangelo also shows further elements of the story relating to Phaethon's mother, Clymene, who wanders the world in grief searching for the grave of her son. When she finds it, she is joined by her daughters, who also deeply mourn. However, after four cycles of the moon, Clymene's daughters are turned into poplar trees before her eyes. As she desperately struggles to help them, she succeeds only in breaking off their twigs and drawing blood. In addition, Phaethon's cousin and spiritual brother, Cygnus, the young king of Liguria, is represented in the drawing. He abandoned his kingdom to lament his lost kinsman at the river bank. His fate was to be turned into a swan, and he remained on the water, forever distrusting the skies from which Jove had unjustly hurled his thunderbolt. By implication, Cygnus is Phaethon's lover, as Tolnay (1943–60, vol. 3) concludes, or at least his "passionate admirer," as the Hellenic scholar H. L. Rose (1959) put it. Panofsky (1939) has pointed out that the erotic interpretation of the myth was at the time not only implicit in Michelangelo's drawing but explicit in other contemporary works, such as a sonnet by the poet Francesco Molza, who moved in Michelangelo's Roman circle.

In the end, Phaethon's temerity in attempting to drive his father's sun chariot, with its overtones of oedipal rivalry, is celebrated rather than condemned in Ovid. Thus, Ovid gives Phaethon

> . . . these carved words upon his tomb:
> HERE PHAETHON LIES WHO DROVE HIS FATHER'S CAR;
> THOUGH HE FAILED GREATLY, YET HE VENTURED MORE.[25]

In a manner that complements the *Tityus* drawing, Panofsky (1939) has proposed a meaning for the *Phaethon* sheets that has met with widespread acceptance. According to Panofsky, as the myth of Phaethon "symbolized the fate of every *temerius*, presumptuous enough to overstep the bounds of his allotted 'state and situation'" (p. 219), Michelangelo expressed his expectation of deserved punishment for daring to express the forbidden sentiments embedded in the *Ganymede* presentation for Tommaso. In addition, the choice of this myth is striking with respect to the parallel between Phaethon and Michelangelo the son. Michelangelo, as son, aspired to an act opposed by his father—being a painter.

In the evolution of the *Phaethon* series from first to final version, several details are worthy of note. By the final drawing (fig. 16-8), the falling Phaethon has

25. Ovid (A.D. 8, bk. II).

assumed a pose that relates him to Ganymede and Tityus. His legs are similarly parted by the flexion of one knee, emphasizing the crotch, and his torso follows similar lines of torsion. Phaethon's sisters, although clearly anguished, have not yet begun their metamorphosis into trees, whereas Cygnus, as a swan, receives prominent treatment. Finally, the river god Eridanus, who looks on with interest in the first version and in protest in the second, is in the last drawing besotted with drink and totally oblivious to the tragic end of Phaethon.

These changes over the course of the series point again to the link between death and the passive, homoerotic vocabulary that Michelangelo had developed in the lower extremities and torsos of Adam, Ganymede, Tityus, and Phaethon. Michelangelo feared that the loss of the object of his love would render him paralyzed with grief, the fate of Cygnus. Given his childhood history, the expectation of loss as an accompaniment to love was uncommonly strong. Moreover, the indifference of the river-god once again suggests the expectation of abandonment and the undependability in this respect, be it from Tommaso, the popes in Rome (far from his home), and even ultimately from Christ or God himself. Finally, the motive that originally brought the mythical Phaethon to his father—the quest for certainty about his parental origins, bears a relation to Michelangelo's own quest for illustrious forebears and powerful parental surrogates. This concern about his origins may have been intensified in the period following the death of his father, leading to the unconscious search for a replacement.

The last drawing that is universally accepted as having been a presentation to Tommaso is the *Children's Bacchanal* (fig. 16-9). Here thirty muscular putti, inhabiting a cave, are feverishly engaged in five sets of activity. In the left foreground, two nurse at the withered breasts of a disinterested old female satyr. In the right foreground, four laugh and teasingly dance around a young man in a drunken slumber with his arms and body positioned like Christ in a Deposition or Entombment. In the center, seven children are carting away the carcass of a dead deer; it is clear from examining the actual drawing, though not mentioned in any catalogue, that one of them is vigorously tugging at the deer's penis. The last two groups consist of nine putti tending a large cauldron in which an animal is cooking, and eight children actively work a grape press. Michelangelo's capacity for irreverence is expressed in the figure of the youngster who is urinating into the bowl of wine. The unity and fullness of composition and finish throughout elevates this work to a position of highest achievement among Michelangelo's drawings. Yet it is based on no known mythological source, which has left scholars perplexed as to its meaning. Panofsky (1939) speculates that the *Bacchanal*, "which is entirely devoid of amorous tension, might thus be the image of a still lower sphere [than the *Ganymede*, *Tityus*, and *Phaethon*]: the sphere of a purely vegetative life . . . beneath specifically human dignity" (p. 223). It is my belief that by keeping the narrative deliberately obscure, Michelangelo was all the more able to fill the sheet with products of his own imagination.

The connection between the *Bacchanal* and Michelangelo's feelings toward Tom-

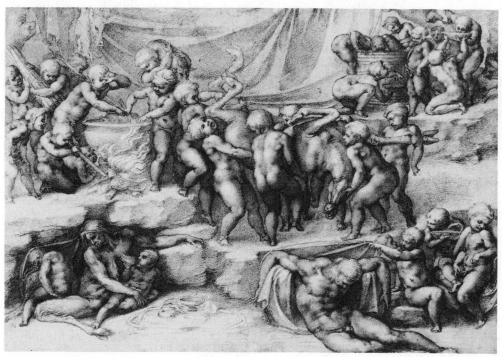

16-9. Michelangelo, drawing of the *Children's Bacchanal.*

maso is far less evident than in the three earlier drawings. Here, the artist has
created a childhood world of self-sufficiency and satisfaction. Like some primeval
cave tribe, the putti unselfconsciously hunt, harvest the vineyard, cook, eat, and
drink. What can be said about the two more enigmatic scenes in the foreground?
The drunken, slumbering man on the right, being covered by four putti, appears
to be a parody of the *Drunkenness of Noah* (fig. 4-3) and therefore reiterates the
shame Michelangelo felt over the inadequacy and disappointing nature of his
fathering. The paternal figure is mocked, not only by the impish attitude of the
children, one of whom appears to be focused on his own penis (in contrast with
the internalized conflict in Noah's sons, painted some twenty-five years earlier),
but also in the choice of a pose for the drunken man usually reserved for Christ in
scenes from the Passion. The other half of the foreground is a comparable indict-
ment of mothering. The nursing child has to grasp the sagging, dried-up breast
himself, as the old satyr wet-nurse is totally disinterested in or unaware of him.

 In the context of the *Bacchanal* as a personal narrative, the foreplane is a
reflection, couched in the form of his own mythology, of Michelangelo's subjec-
tive childhood experiences of deprivation by wet-nurse and mother and the failure
of his father as an admirable model or emotionally available, supportive figure.
Given this foundation, the paths open to him were to squeeze by marginally, like
his brothers, or to become self-sufficient by dint of his extraordinary powers.
Michelangelo chose to follow the latter course. A Herculean self-sufficiency char-

acterizes the Infant Jesus in the artist's sculptured Madonnas and in the Doni tondo. In the *Bacchanal,* children have formed a community in which adults, specifically women, are not needed or included. This is a renunciation of the conventional social order and a substitution of a fantasized all-male world in which lewdness and aggression are accommodated. In significant respects, the *Bacchanal* echoes the Doni tondo, in which the conflicts expressed in the foreplane family scenes evolved into the background solutions. Both in this particular community of boys and in the tondo, the homoerotic interplay of the male youths is strongly stated.

In regarding the *Bacchanal* as a "communication piece" to Tommaso, one finds oneself on highly speculative ground. My impression is that it expresses Michelangelo's wish that he could retreat with Tommaso into this all-male world, where time has no forward movement and aging is unknown. In this sense, the themes of the immortality achieved by Ganymede and the eternal erotic existence of Tityus are restated in the *Bacchanal.* Again, in the face of his own aging, the death of his father, and his impending final departure from Florence, immortality and homosexuality are the recurrent prominent thoughts intrinsic to Michelangelo's relationship with Tommaso.

At the time of the Doni tondo (1503–04), Michelangelo's homosexual impulses were probably far less close to being acted upon than they were at the time of the *Bacchanal.* Therefore, painting the background nude youths as he did presented considerably less conflict than it would have thirty years later. It is possible that Michelangelo was subsequently uneasy with the frankness of the *Ganymede* drawing and felt safer in a world of prepubertal children, where mature sexual coupling was not a possibility and such impulsive satisfactions as seizing the dead deer's penis, perhaps masturbating, or urinating exhibitionistically could get by. In all of this, the struggle with impulses forbidden by the church is operative. In the *Bacchanal,* the representation of the drunk, sleeping man posed like the Christ of a Deposition or Entombment (or even of the deer as the Christ of an Entombment) may be considered a derisive expression of Michelangelo's resentment against the controlling force of belief.

In sum, then, the four presentation drawings to Tommaso de' Cavalieri have a unified and coherent meaning on the surface that was comprehensible to any man of the day schooled in Neoplatonic thought. For this reason Tommaso did not keep the drawings secret or hidden. On the contrary, they were immediately well known. They could be accepted as symbolizing, on the one hand, the ecstasy of mind transcending bodily urges (*Ganymede*) and, on the other hand, the punishment and fate of those who indulge their carnal instincts or grandiose ambitions (*Tityus* and *Phaethon*). And finally, the more obscure *Bacchanal* offered a picture of what virtually amounts to infrahuman existence in which instinct is given free play.

On the private level of meaning, the drawings convey Michelangelo's intense struggle, in the face of his consuming preoccupation with Tommaso, to find an

acceptable outlet and justification for his feelings. Michelangelo's most urgent anxiety related to death and the progressive betrayal by the body as a fact of aging. Because of his particular early history, women offered little prospect of real or imagined comfort at this time. Tommaso personified Michelangelo's aesthetic ideal of youth and beauty. The *Ganymede* conveys Michelangelo's unconscious solution. In it he has identified with the handsome youth. By homosexual submission and incorporation of the power of Zeus, who alone had the right to confer immortality, Michelangelo sought to allay his fears of aging and death. He did not, however, in reality act on the basis of his rich fantasy life and unconscious thought. To act out the Ganymede fantasy would lead to annihilation of the self. The other three drawings are variations on the cost of his wishful thoughts about Ganymede, but each shows a struggle in the artist to find a way to turn the harsh consequences into a state that either has hidden or not so hidden erotic gratification (the *Tityus* and *Bacchanal*), or the redeeming epitaph of *Phaethon*, who is so beloved that a whole following of family and even a male lover are willing to endure their own harsh fates from Jove rather than relinquish the grieving tie to him.

Homosexuality in Renaissance Florence

Study of the letters, poems, and presentation drawings to Tommaso raises the question: did Michelangelo and Tommaso have an overt sexual relationship? And even if they did not, did Michelangelo have sexual relationships with other young men?

Throughout the Renaissance, public proclamation and law frowned upon the overt practice of homosexuality, particularly involving minors. Yet, in keeping with the general duality of Renaissance ethics and life, in many quarters open homosexuality was accepted. For example, from the Medici circle in the middle of the fifteenth century anecdotes were recorded which, in a light and gossipy tone, describe Donatello's amorous involvements and escapades with some of his handsome apprentices.[26] On the other hand, in 1476, when Leonardo da Vinci was twenty-four years old, he was alleged by an anonymous person to have had sexual relations with a seventeen-year-old male prostitute. Leonardo and two others were given two hearings on the matter, after which the charges were dismissed because of insufficient evidence. Similarly, in 1502, at age fifty-seven, Botticelli was charged with sodomy. The charge was also dismissed after a hearing. The data, however, fluctuate with respect to social attitude. Thus, at the peak of his power in 1494, Fra Savonarola admonished the priests of Florence: "Abandon, I tell you, your concubines and your beardless youths. Abandon, I say, that unspeakable

26. The relevant text from this collection of contemporary anecdotes is translated by Janson (1957, p. 85). Donatello's bronze *David* (fig. 8-3) exudes a homoeroticism that can hardly have been overlooked at the time. The feathers from Goliath's helmet are caressing the inside of David's thigh and extend up into his crotch.

vice, abandon that abominable vice that has brought God's wrath upon you, or else: woe, woe to you!"[27] Nevertheless, contemporary Florentine historians record that upon Savonarola's death "A certain Benvenuto del Bianco, a member of the Council of Ten, turned to one of his colleagues and said; 'And now we can practice sodomy again.'"[28]

In 1502 laws were passed in Florence that were designed to limit the practice of homosexuality. Four years later, the laws were made more severe and included penalties ranging from a fine to the loss of a hand for procuring. There were also penalties against fathers who allowed their sons to engage in homosexual relations. The law provided that a house in which homosexuality was practiced could be destroyed. There is, however, little evidence that this penal code was enforced. The likely reason for nonenforcement is summarized by the Wittkowers (1963): "This came partly from a general apathy towards transgressions in a world used to crime, violence, and excesses of every description, and partly from the tolerance of the humanist-inspired educated classes, for whom homosexual love had the sanction of the Greek philosophers" (p. 170). In Rome, the artist Giovanni Antonio de' Bazzi (1477–1549) became known as "Il Sodoma." This contemporary of Michelangelo was described by Vasari as having come by his nickname "because he always surrounded himself with boys and beardless youths whom he loved beyond measure." Despite his predilection, Sodoma was renowned in Siena, Milan, and Florence, and received papal commissions at the Vatican Palace and an honorary title from Pope Leo X. Cellini (1562), in turn, gives an amusing account of Vasari, in which Giorgio, as Cellini's overnight guest, slept with one of Benvenuto's apprentices. The anecdote relates how Vasari, who had uncommonly long fingernails, scratched the skin off one of the young man's legs during the night. Though the tale is not explicitly sexual, to the Renaissance audience its meaning must have been unmistakable.

The convoluted state of attitudes on homosexuality is well illustrated in the person of the powerful and notorious Venetian "Scourge of Princes," Pietro Aretino. In a celebrated letter to Michelangelo of 1546 (?), Aretino tried to extort some drawings from the artist for his own collection by stating: "for this act of courtesy the gift of drawings would silence the envious tongues which say that only certain Gerards [Perini] and Thomasses [de' Cavalieri] dispose of them."[29] Ironically, Aretino himself was well known to be actively bisexual in the years before he came to Venice. Furthermore, in 1538 he was charged with sodomy, although nothing ever came of the allegation.[30]

From this seemingly contradictory material it appears that ecclesiastical and secular officials unequivocally condemned homosexuality, particularly when minors were involved. Moreover, there were harsh laws on the books that could be

27. Villari and Casanova (1898).
28. Ibid.
29. Translated by Symonds (1893, 2:53).
30. Cf. Labalme (1981).

invoked when it suited those in power. On the other hand, the practice of homosexuality seemed to be an acceptable fact of life for many men in artistic and literary circles, although such inclinations often elicited some degree of derision.

Friendship with Tommaso de' Cavalieri

As to whether Michelangelo had an overt sexual relationship with Tommaso or other young men, it must be stated at the outset that there is no documentary evidence which provides an answer. The issue is simpler concerning Michelangelo and Tommaso. All the early correspondence, the love sonnets, the presentation drawings, the sharing of feelings by both men with intermediaries, and their making the drawings public bespeak their love for each other in the first few years of their relationship. Tommaso unquestionably perceived the nature of Michelangelo's unspoken sexual fantasies. Indeed, they may have excited and gratified him. Nevertheless, he seemed consistently to have exercised a restraint that helped to maintain the boundary between thoughts and action for Michelangelo. I find it highly unlikely that their love was ever consummated.

Certain facts, however, leave the question open. For a period of about six months, from November 1533 to May 1534 (that is, beginning about a year after their first meeting), during which time Michelangelo stayed in Rome, virtually nothing is known about his activities. There are no letters, dated poems, works of art, or even work on a particular project that are documented. One might therefore speculate that Michelangelo spent most of his time alone with Tommaso. If so, one might further speculate that the usually sufficient barriers between fantasies and action might have fallen during that period of ongoing intense contact. I think not. If the relationship had become one of active sexuality, I would expect that in time both would have recoiled from the intimacy. For Michelangelo it would have caused great emotional upheaval to witness in himself the failure of the Neoplatonic ideology through which he could filter out the need for actual sexual consummation. While it is true that Michelangelo to a large extent did indeed relinquish Neoplatonism as a controlling ideology during the following year or two, turning instead to a purer Christian belief, there is nothing to suggest that he ever looked back with shame upon his friendship with Tommaso. The fact that his sonnet to Tommaso written in the late 1540s[31] contains the same Neoplatonic imagery strongly supports the conclusion that nothing had ever taken place between the two that would make the poem false. Moreover, from the viewpoint of Michelangelo's psychic constitution, an actual sexual encounter with someone by whom he felt emotionally enslaved would have overwhelmed him with anxiety. In sum, the information we have suggests that Michelangelo's means of expressing his innermost thoughts regarding Tommaso were the sublimated forms of artistic imagery, verse, spiritual kinship—but not sexuality.

31. Gilbert and Linscott (1963, poem 258).

It is interesting to note that during the same period, in addition to lofty platonic sentiments, Michelangelo was capable of humorous and direct statements about homosexuality. One such example comes from a letter of 1533 to a friend (Niccolò) who had recommended the son of one of his friends as an apprentice to the artist. Michelangelo wrote, after noting that he had explained to the father why he could not engage the lad:

> Your friend should not leave his son here, expecting anything from me. But he did not see the point and answered, saying, that if I were but to see him I should pursue him not only into the house, but into bed. I assure you that I'll deny myself that consolation, which I have no wish to filch from him. Therefore, will you get rid of him for me? I'm sure you'll know how to do it, and will do it in such a manner that he won't go away disgruntled. [letter 195]

Friendships with Other Young Men

I conclude, then, that Michelangelo's friendship with Tommaso was platonic. There were, however, a number of other young men over the years with whom Michelangelo was closely involved for varying lengths of time. From about 1520 through 1534, there was always a young man present to whom Michelangelo was deeply attached. The first of these was Gherardo Perini, about whom little is actually known.[32] According to both Vasari and Aretino, Michelangelo presented Gherardo with several drawings. Vasari described them as "three drawings of most beautiful heads." In February 1522, Michelangelo wrote to Gherardo a letter that began: "To the prudent young man, Gherardo Perini, in Pesaro—All your friends, including myself, are delighted, my dearest Gherardo, and especially those who you know are especially fond of you, to learn from your last letter . . . of your good health and well being" (letter 151).

This letter has a casually affectionate tone. More curious, however, is a particular drawing—of a putto urinating into a cup (fig. 16-10). On the sheet Michelangelo has copied the opening line of a sonnet by Petrarch and then written below it, "I pray you that you do not make me draw this evening because Perino is not here." In other words, Michelangelo yearns for the company of Gherardo and, if deprived of it, will reluctantly have to spend the evening drawing. Apparently, Gherardo did not visit him. The state of tension in the disappointed artist was transformed into this whimsical caprice (*ghiribizzo*). Michelangelo's thoughts turned to the image of a nude boy with penis in hand, representing an amalgam of voyeuristic curiosity and a regressive retreat from the impulse to masturbate by substituting an earlier sexual forerunner of masturbation—a young boy exhibitionistically urinating. (This image recurs in the *Children's Bacchanal* drawing for Tommaso.)

32. Ramsden (1963, vol. 1) refutes Papini's (1951) claim that Gherardo was a Florentine in his early forties at the time of the letter. Ramsden does not believe that he was the individual Papini had in mind. Rather, he was a scion of the banking family of that name.

16-10. Michelangelo, drawing of *Putto Urinating into a Cup.*

Clements (1965) who, although occasionally insightful, is at other times quite tendentious on the subject of Michelangelo and homosexuality, maintains that the relationship with Gherardo continued as late as 1524 and that some of Michelangelo's verse from that period, expressing the pangs of frustrated love, were based on his unreciprocated infatuation with him. This is pure speculation, however, as there is no further mention or record of Gherardo Perini in Michelangelo's life after 1522.

It seems that Gherardo disappeared when Michelangelo's apprentice Antonio Mini entered the artist's life. In the autumn of 1522, the sixteen-year-old Mini moved into Michelangelo's house, where he lived continuously until he left for France in November 1531, bearing the gift of Michelangelo's painting of *Leda and the Swan.* Whatever artistic promise Mini may have had as a teenager never materialized. Many drawings from those years contain portions that were executed by Mini, whose style could rarely be confused with his master's. At the bottom of one study for a *Madonna and Child* (British Museum, W 31, recto), Michelangelo wrote, "Draw, Antonio, draw, Antonio, draw and don't waste time." This droll piece of paternal advice captures a significant quality of their relationship. Young Mini was talentless and therefore presented no threat, as Michelangelo's successful contemporaries did. But he was loyal and probably good company. As reward, Michelangelo let him share in his most personal art—his drawings—in a way he never allowed anyone else to do. And his final gift of the *Leda* when Antonio left was generous indeed. There are no intimations of a sexual element in their

relationship, although obviously there is no definitive evidence on this issue. In all likelihood, Michelangelo treated Mini as an adopted son and derived pleasure and comfort from his presence during that very difficult nine-year period of his life under the reign of Pope Clement VII.

There had been other apprentices before Mini who spent several years in Michelangelo's service and enjoyed special favor. One, Piero d'Argento, left in 1509 but remained in friendly communication for many years. Another, Silvio Falcone, was with Michelangelo for several years but was sent away in 1517 for some now unknown misconduct. Shortly after his dismissal, he wrote to Michelangelo: "I am and shall always be a good servant to you in every place where I may be. Do not remember my stupidity in those past concerns, which I know that, being a prudent man, you will not impute to malice."[33] Fifteen years after he left Michelangelo's household and shop Silvio wrote, "When I remember the love you bore me while I was in your service, I do not know how I could repay it."[34] One must consider the possibility that he had ulterior motives for playing up to the master, namely, to advance his career by eliciting Michelangelo's support and favorable recommendation. His letter suggests that he understood Michelangelo's receptivity to words that partook of the ideational vocabulary of the Ganymede myth. Here again, the full nature of the artist's relationships with his earlier apprentices remains beyond our knowledge.

Several years before Mini left Michelangelo's household for France, the artist was drawn to Andrea Quaratesi, the teenage scion of a distinguished Florentine banking family. The *only* finished surviving portrait by Michelangelo is a drawing of Andrea (fig. 16-11), which is generally dated 1532 and corresponds with the appearance of a twenty-year-old man. Michelangelo had been friendly with the Quaratesi family for some years. Three letters from 1530–32 from Andrea to Michelangelo express a childlike affection, and one from Michelangelo to Andrea in 1532 deals with routine business concerns. From a time between 1525 and 1530, we have a drawing-exercise sheet on which Mini apparently copied eyes in profile and full view, head profiles, and curly locks of hair, from examples by Michelangelo. In the corner of this sheet are written Michelangelo's musings or perhaps notes for a letter to young Quaratesi: "Andrea, have patience. Love me, great consolation." On another exercise sheet (British Museum, W 42 verso), which contains a screaming satyr, a man squatting and defecating, and other heads, one finds a sensitively drawn face of an early adolescent boy who looks very much like a younger version of the later portrait of Andrea. Hartt (1970) is probably correct in suggesting that this is a portrait of Andrea at about age fourteen. If it is Andrea, it is indeed striking that he should be in company with a satyr and a man crudely defecating (the only other sketches on the sheet that Hartt attributes to Michelangelo). The juxtaposition suggests that Andrea was associatively linked with satyrlike lust and thoughts of anal functions—though not without obvious

33. Translated by Symonds (1893, 2:341).
34. Translated by Ramsden (1963, 1:xlvi).

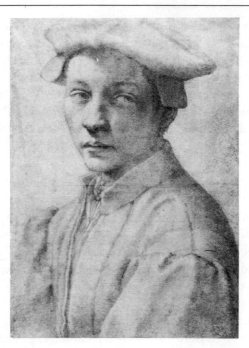

16-11. Michelangelo, drawing of *Andrea Quaratesi.*

humor—in Michelangelo's fantasies. There is, again, nothing to indicate that these fantasies ever became overtly sexual. Quaratesi remained in some kind of contact with Michelangelo for several more decades, to judge from a casual mention of him in a letter written in 1551 by Michelangelo to his nephew.

Another glimpse of Michelangelo's attraction to certain idealized youths comes from Benvenuto Cellini's irrepressible autobiography (1562). (Cellini's own predilection seems, incidentally, to have been for ladies of easy virtue, although he was twice formally charged with, and once convicted and jailed for, sodomy). Although usually irreverent, Cellini was filled with unbounded admiration for Michelangelo. He wrote:

> Luigi Pulci . . . was the son of one of the Pulcis, who had been beheaded for incest with his daughter . . . the youth possessed extraordinary gifts for poetry . . . was graceful in manners, and of surprising personal beauty. . . . While he was yet a lad and living in Florence, they used in certain places of the city to meet together during the nights of summer on the public streets; and he, ranking among the best of the *improvisatori,* sang there. His recitations were so admirable, that the divine Michel Agnolo Buonarroti, that prince of sculptors and painters, went, wherever he heard that he would be, with the greatest eagerness and delight to listen to him . . . Piloto, a goldsmith . . . together with myself, joined Buonarroti on these occasions. [pp. 73–74]

I have reached the conclusion that the friendships Michelangelo enjoyed with early apprentices and then with Gherardo, Mini, Quaratesi, and Tommaso, were

never sexually consummated. However, about Michelangelo's relationship with the young Florentine Febo di Poggio during 1533–34 there is more doubt. Nothing is known about Febo except what can be inferred from one letter written from each to the other, a sonnet by Michelangelo alluding to Febo, and the timing of their relationship. In Michelangelo's letter to Febo of September 1534, he stated that he was leaving Florence the next morning, "And I shall not return here anymore." (This letter, incidentally, has been important in dating Michelangelo's final departure from Florence.) What concerns us at this juncture is the opening of the letter:

> Febo——Although you have conceived for me a great hatred—I do not know why—I certainly do not believe that it is owing to my affection [*amore*] for you, *but owing to what other people say, which you ought not to believe, having made trial of me* . . . I want you to understand that as long as I live and wherever I may be I shall always be ready to serve you with loyalty and affection, as much as any other friend you may have in the world. [letter 198, my italics]

Although there is some ambiguity here, the letter suggests that Febo spurned Michelangelo, who insists upon his continuing love[35] and willingness to serve him. Apparently Febo did not answer this letter; but he did respond to a subsequent one (lost) from Michelangelo. Symonds describes Febo's letter as being in an "illiterate hand and badly spelt." Therefore, we may assume that it was not Febo's high quality of mind that attracted Michelangelo. What stands out in Febo's letter, however, is an element of soft "blackmail." Febo wrote:

> you know well that I could not be angry with you, since I regard you in the place of a father. Besides, your conduct toward me has not been the sort to cause in me any such effect. . . . Next morning I came to your house, and you were already gone, and great was my disappointment at your leaving Florence without my seeing you.[36]

Up to this point, Febo's letter, along with Michelangelo's to him, would strongly suggest that there had been no cause for either gossip or concern about moral compromise. However, Febo's letter then goes on to say, "I am in want of money, both to clothe myself and to go to the Monte." He describes how he went to the bank in Florence and was surprised that Michelangelo had left no money order for him. He outlines how Michelangelo can get the money order to Florence in five days by messenger. Febo concludes:

> So then, if you give him orders, he will not fail. I beseech you, then, to provide and *assist me with any sum you think fit, and do not fail to answer.*
> I will not write more, except that with all my heart and power I recommend myself to you, praying God to keep you from harm—*Yours in the place of a son,*
> > Febo di Poggio [my italics]

35. Clements (1965) criticizes Ramsden for translating *amore* as the much milder "affection" in the letter to Febo. Ramsden, like Symonds, vigorously argues that Michelangelo's interest in young men was no more than platonic.
36. Translated by Symonds (1893, 2:158).

What can we make of Febo's brazen demand for money, capped with what could be interpreted as a veiled threat ("do not fail to answer")? The answer relies on a reconstruction of their relationship based on clues from Michelangelo's poetry to and about Febo and inferences drawn from the circumstances of Michelangelo's life at the time when he and Febo crossed paths. Michelangelo appended a sonnet to his letter, in which Febo di Poggio is changed to "Phoebus of the Hill" (in Italian, *poggio* means "hill"):

> I truly should, so happy was my lot,
> While Phoebus was inflaming all the hill
> Have risen from the earth while I was able,
> With his feathers, and made my dying sweet.
>
> .
>
> His feathers were my wings, his hill my steps,
> Phoebus lamp for my feet, and dying then
> For me no less my safety than my marvel.
>
> Dying without, no soul to Heaven leaps,
> Heart is not freshened by remembering them,
> For late, after the hurt, who will give counsel?[37]

In this lyrical confession of love, Michelangelo intertwines two mythical personages—Phoebus the sun-god and Ganymede in his heavenly ascent on the feathered wings of Zeus as an eagle ("risen from the earth . . . with his feathers"; "His feathers were my wings"). So the same unconscious motifs dominated his thoughts about Febo as were expressed in the *Phaethon* and *Ganymede* drawings for Tommaso earlier that year. At about the same time, two other sonnets dwelt on the Phoebus theme. In one, he alludes to the myth of Phaethon, who sought the unattainable (as Michelangelo did with Febo) and plunged in despair:

> O happy bird, surpassing us in this,
> That Phoebus' beautiful face [è Febo e 'l suo bel volto] to you is known
>
> And, more than the great sight, the extra boon
> To fly to the hill [poggio] from which I fall and crash.[38]

We are immediately struck with how physical the imagery here is. In Michelangelo's day, as well as now, "bird" (*uccello*) is a vernacular term for the male genitals. Similarly, "hill" (*poggio*) has always been associated both with the mound of Venus and the male pelvic area, especially the buttocks.

The other sonnet begins:

> Since Phoebus does not twist and stretch his bright
> Arms all around this damp and chilly earth,
> The name that the common people wished
> To give that sun, not understood, was night.[39]

37. Gilbert and Linscott (1963, poem 97).
38. Ibid., no. 98.
39. Ibid., no. 99.

These verses counterpose love for Febo to night and death. The desperation in Michelangelo's attraction to this inappropriate young man is poignant testimony to the sense of impending doom he must have felt in leaving Florence and severing continuity with his past. We can sympathize with his apprehension, embarking at age fifty-nine on the life of an exile.

Perhaps the most startling aspect of Michelangelo's infatuation with Febo is that it follows so closely upon his outpouring of passion for Tommaso. After sending his last preserved letter to Tommaso in July 1533, Michelangelo spent only a few more months in Florence before joining Tommaso in Rome in November. He was in Florence again for his last stay between May or June and September of 1534. It may be that Michelangelo's involvement with Febo dates back to 1533 and that the *Phaethon* drawings done for Tommaso were a confession of guilt, not for the temerity of loving Tommaso, but for "falling" for Febo (Phoebus). Since we know nothing about Febo or even exactly when Michelangelo first met him, the hypothesis that the choice of the Phoebus-Phaethon theme for the drawing was determined by Michelangelo's conflicted involvement with Febo cannot be proven.[40] If true, it means that the relationship with Febo was at least a year old, since Tommaso acknowledged receipt of the last version of the *Phaethon* drawing in early September 1533. Looking back from the point in late 1534 when Michelangelo alluded to Febo in terms of Phoebus in three poems, it does seem more than coincidental that Michelangelo would encounter a "Febo" in this way, after recently struggling through three or more versions of the *Phaethon*. Thus, I tentatively conclude that Febo was an emotional presence in Michelangelo's life for more than a year.

If it is true that Michelangelo was intensely attached to both Tommaso and Febo concurrently, how can we explain this? The simplest answer is that Febo was in Florence, where Michelangelo spent several consecutive months during that period, and Tommaso was in Rome, where the artist also lived for several months at a time. Beyond this, it is not uncommon to bestow frustrated passion for an idealized love-object upon a less appropriate love-object. Since in doing so part of the self is withheld, there is less danger of being engulfed. Moreover, as Michelangelo's feeling for Tommaso shifted from extraordinary idealization to a more realistic attraction, it lost the magical aspect of salvation that runs through the sonnets and the *Ganymede* drawing. The same longings, however, were reasserted in the sonnets to and about Febo. Thus, Tommaso gradually assumed the role of enduring friend rather than passionate ideal, but Michelangelo's need to invest some young man with that role remained constant.

The question then arises: why did Michelangelo choose Febo—someone with little more than beauty to recommend him, and who was also quite clearly capable of exploitative behavior? The answer is perhaps related to the same forces in Michelangelo that determined his pairing of the opposing themes of Ganymede

40. Both Clements (1965) and Testa (1977) have argued that the *Phaethon* drawings are a statement about Michelangelo's "fall" with Febo.

and Tityus. The *Tityus* may be assumed to have been motivated by Michelangelo's sense that, despite all the Platonic rationalizations supporting them, his feelings and fantasies surrounding Tommaso were loathsome—the equivalent of Tityus's moral turpitude. If no punishment was to accompany the pleasurable investment in Tommaso, some other counterbalancing agent of pain had to be sought out. He may have been drawn to this alter-ego of Tommaso, who would humiliate him and punish him for his forbidden pleasure in the "Ganymede fantasy" relationship with Tommaso. Febo was well suited for this role dictated by Michelangelo's superego. Rejection and humiliation by Febo would be the price he paid for Tommaso.

As to the question of whether Michelangelo ever enjoyed an overtly sexual relationship with Febo, there is no way to demonstrate that he did not. I think that the passage in Michelangelo's letter to Febo, "but owing to what other people say, which you ought not to believe, having made trial of me," comes as close as any written words to implying that there was not a sexual relationship, regardless of what some people said.[41]

My own belief is that Febo was a street youth or perhaps a model in Michelangelo's Florence studio. Being opportunistic, he knew what role to play and what approach to take in luring Michelangelo into the romantic fantasy that they had a "father-son" relationship. His purpose was financial gain, and perhaps also the sadistic satisfaction of having so awesome a father-figure as Michelangelo groveling at his feet—a predisposition in Michelangelo's psyche that we saw graphically portrayed in the *Victory* (fig. 15-14). The admonition "do not fail to answer" is, in that case, an assertion of dominance in response to Michelangelo's statement "as long as I live and wherever I may be I shall always be ready to serve you." If this reconstruction is correct, there is no need to assume that a sexual relationship existed. Rather, the question concerns Michelangelo's injudicious choice of object for his infatuation, in contrast with what we know about the other young men who elicited his love. Thus, once again, the available data concerning the relationship with Febo yield insights about Michelangelo's inner life and fantasies but do not answer the question of overt homosexuality.

I think that if it is the fact that Michelangelo and Febo did not have an openly sexual relationship it has less to do with moral restraints on Michelangelo's part than with the potentially disorganizing impact that open sexuality would have had upon him. The glorious arena of his life was imagination, where beauty reigned and anything was possible. In contrast, orgasm, with its loss of boundaries and immediate reduction in tension, would have been, for him, a bodily analogue of death. Indeed, the conflicts surrounding orgasm were among the factors that led Michelangelo to a life of sexual abstinence.

One other youth should be included in this discussion. Cecchino de' Bracci was

41. However, if Febo was openly homosexual, the passage carries less weight in that he would presumably not be so concerned with what "other people say." In that case, what they were saying might have been that Febo was sleeping with Michelangelo only for the money.

the nephew and "adopted son" of Michelangelo's close friend and advisor in Rome, Luigi del Riccio. He died at age fifteen in 1544. Michelangelo wrote forty-eight epitaphs, a sonnet, and a madrigal on his death. They were written one or a few at a time, over the course of close to a year, principally to comfort and cheer his grief-stricken friend Luigi. Cecchino, who from all reports was a boy of extraordinary beauty and grace, had become a symbol for the older generation of Florentine exiles of their hope for the rebirth of their lost, beloved republic. Despite the large number and continuous flow of verses devoted to the dead youth, the sonnets are repetitive in their minor variations on the theme of the lad's beauty and his living on in the hearts of those who loved him. At the same time, they are so devoid of any personal expression of grief or love on the part of the poet as to reinforce the conclusion that these poems were offerings to console Luigi.

The following two epitaphs—quatrains that would be appropriate for inscription on the tomb of Cecchino—are representative of the large group:

> The beauty lying here did so transcend
> In all the world every most lovely creature,
> That Death, being at enmity with Nature,
> Killed and destroyed it, so to make a friend.[42]

and

> My fate too early here would have me sleep;
> I am not dead, although I change my home.
> Since one in love takes on the other's form,
> I stay alive in you, who see and weep.[43]

Clements (1965), in his study of Michelangelo's poetry, dwells for nineteen pages on the Cecchino verses in an effort to demonstrate the artist's homosexual relationship with the boy as well as his overtly homosexual practices in general.[44] Clements's argument is based on a gross misreading of the poems in terms of who the surviving lover was. Upon Cecchino's death (the cause of which is unknown), del Riccio wrote to Donato Giannotti:

> our Cecchino is dead. . . . All Rome weeps for him. Messer Michelangelo is doing me the design for a simple marble tomb, and you, would you deign to write the epitaph and send it to me with a consoling letter—if it arrives in time, for he has reft my soul from me. Alas! Alas! Living each hour I die a thousand deaths . . .
>
> Your forlorn Luigi del Riccio[45]

42. Gilbert and Linscott (1963, poem 181).
43. Ibid., no. 192.
44. Oremland (1980), in a recent psychoanalytic study of the effects of mourning on Michelangelo's art, further develops Clements's argument and also concludes that the artist in his late sixties had a sexual relationship with Cecchino.
45. Ramsden (1963, 2:257).

Giannotti obliged with three sonnets commemorating Cecchino's virtues. Other major figures in the humanist circle also penned memorial poems. Del Riccio wanted Michelangelo to design the tomb and then carve a bust of Cecchino, based on a drawing (lost) that he had done of the youth. Michelangelo, however, gracefully declined. One sonnet in the series of Cecchino verses offers in the final two tercets Michelangelo's excuse for not executing the bust:

> Therefore, Luigi, to make in living stone
> Cecchino's matchless form (it's he I mean)
> Eternal, seeing he is dust among us now,
>
> If lover turns into beloved one,
> And lacking that my art must be in vain,
> I needs must, to portray him, draw from you.[46]

Considering that Michelangelo never carved a portrait of a contemporary (except for the bronze equestrian portrait commanded of him by Pope Julius in 1506), the reason he offered Luigi is of interest. It is a concept that is present throughout the sonnets for Tommaso—that lover and beloved merge and take on one identity as a result of their love. Because of the intensity of Luigi's love for Cecchino, Michelangelo states that the soul of the boy could be captured only if he were to do a portrait of Luigi.

Earlier in this sonnet, Michelangelo implies that he had not had the opportunity sufficiently to know, and therefore to desire and love, Cecchino that Luigi had. Lines such as these and similar ones in the epitaphs about Luigi's love for the boy point to the conclusion, stated by Gilbert (1963), that Luigi had a strong homoerotic interest in the boy.

There would be little more to say about Michelangelo and Cecchino were it not for a letter from Michelangelo to del Riccio written in May 1542, almost two years before the boy's death. This letter contains the following strange passage:

> Also, I would ask another favour of you—that is, would you resolve a certain doubt in which I was left last night, because, when in a dream I greeted our idol [Cecchino] he seemed to me both to smile and to threaten me. Not knowing which of the two to hold by, I beg you to find out from him, and when we meet on Sunday to resolve it for me.
>
> Yours, with infinite obligation and always.
>
> (unsigned)
>
> [letter 215]

There are always limitations in interpreting the deeper meaning of a dream without knowing the context in which it was dreamt as well as the dreamer's associations. Nevertheless, this dream clearly suggests Michelangelo's anxiety that he will be rebuffed by Cecchino because of impulses or desires that would occasion reproach. In begging Luigi to find out from Cecchino which of the dream attitudes

45. Gilbert and Linscott (1963, poem 191).

is the correct one, Michelangelo sidesteps the conflict within himself as to the nature of his interest. What does emerge, however, is that how Cecchino felt about him was very important to Michelangelo. Thus, we are left once again with evidence of Michelangelo's emotional and erotic attachment to youths of exceptional beauty and gifts, and, once this attachment was formed, of his feelings of extreme vulnerability. At the same time, there is little basis for arguing that Michelangelo ever had a sexual relationship with Cecchino.

A footnote to the Cecchino poems concerns Michelangelo's capacity for nonsensical humor. Apparently, Luigi was wont to send gifts of food to Michelangelo at the artist's home. Michelangelo would then return the epitaphs to Cecchino in groups, with covering notes such as: "I didn't want to send this one, because it is very awkward, but the trout and truffles would force Heaven itself." On other occasions he wrote: "For the salted mushrooms, since you will have nothing else," and "This the trout say, not I; so, if you don't like the verses, don't marinate them again without pepper." These and other similar notes are obviously attempts to cheer up the grieving del Riccio. They also serve to devalue the meaning of Michelangelo's epitaphs by implying that they are being bartered for mundane gifts rather than being the product of any deep feeling. They do, however, indicate that, even in his seventieth year of life, Michelangelo retained a fine sense of the absurd.

In contrast with Cecchino and the imaginative realm of physical beauty was the real world of bodily function. Bodies and their physiology were also treated quite sardonically in Michelangelo's poetry. The most notable example of this lyric derision, which, significantly, is directed against himself, can be found in a poem from the late 1540s.

Then I have made acquaintance too with urine
And the tube it comes out of, through the slit
That summons me before it's day each morning.
. .
My soul has this advantage of the body,
That if a purging made the smell diminish,
Bread and cheese would not keep her company.

Only my cough and cold prevent my death;
If she does not go out the lower gate
My mouth can scarcely just emit my breath.

I am broken up, ruptured and cracked and split
From my labors so far; death is the inn
Where I by paying rent can live and eat.
. .
My pale blue eyes are powdered into grounds,
My teeth are like keys on an instrument,
So, when they move, my voice is still or sounds.

My face has the shape that causes fright;

In wind when there's no rain my clothes would scare
Crows from the seed, without another dart.

A spider web is nestled in one ear,
All night a cricket in the other buzzes;
With spitting breath I do not sleep, but snore.[47]

This poem suggests that Michelangelo, particularly in his later years, would have feared humiliation if he were actually to reveal his body in making love to an idealized partner. Whereas safety and pleasure accompanied the world of Ganymede-like fantasy, anxious vulnerability would have surrounded real possibility. Moreover, by his own admission of his sense of the danger of losing his boundaries in a situation in which he was overwhelmed by feeling in the presence of someone he intensely admired (see the quotation on page 176), we can posit that the ultimate form of this vulnerability would be in the explosive psychophysiological experience of orgasm with a partner. As suggested earlier, the danger inherent in this act of total abandon of the body and the feelings, without the control of intellect, was another factor that was to lead Michelangelo to a life of sexual abstinence.

With respect to the issue of sexual abstinence, there is an intriguing marginal note in a copy of the first edition of Condivi's *Life* that was apparently written by a contemporary of Michelangelo and was based on a direct quote from the master himself, who offered comments on the text. There are twenty-four of these notes in all (Procacci, 1966). Next to Condivi's passage that Michelangelo was "healthy above all both by nature and as a result of physical exercise and his *continence with regard to intercourse* and food" (p. 108), the marginal note says: "as far as coitus, this [i.e., practiced continence] is what I always did; and if you want to prolong your life don't do it at all or as little as you possibly can."

The interest in the nature of Michelangelo's sexuality has also included consideration of an enigmatic exchange of letters from 1521 to 1522 between Michelangelo and an older friend known as Lionardo the Saddler, who was caretaker of the artist's house in Rome. In December 1521, Lionardo advised Michelangelo "to abandon practices harmful to the body and the mind, in order that they may not hurt the soul."[48] It is not clear whether these "practices" had been confided to Lionardo by Michelangelo or had reached him through gossip. Michelangelo must have responded promptly and reassuringly, because on January 4, 1522, Lionardo wrote, "One piece of news among the others you give me surpasses all the rest, and that is that you are cured of a malady from which few men recover, but I am not surprised, on the other hand, because few are like you. Persevere."[49] Two weeks later Lionardo followed with, "I am delighted you are free of a malady dangerous to soul and body."[50]

It has at times been suggested that the "malady" was syphilis (Papini, 1951);

47. Ibid., no. 265.
48. Ramsden (1963, 1:xlviii).
49. Ibid., p. xlviii.
50. Ibid.

but, as Ramsden (1963) points out, syphilis was not understood to be a venereal disease until several years after these letters were written. Therefore, the moral issue in Lionardo's exhortations could not be accounted for by positing syphilis. This leaves homosexuality, masturbation, and excessive drinking as the three most likely contenders for the subject of Lionardo's concern. Testa (1977) leans toward the view that masturbation was the issue of concern. The subject of masturbation raises the question of whether or not Michelangelo could allow himself any form of orgastic relief, if indeed my conclusion that he led a largely or completely abstinent life with respect to both homosexual and heterosexual relations is correct. More specifically, would masturbation provide a pleasurable, acceptable outlet for him? Or would it loom as a threat to discharge the precious life of fantasy or to energize those impulses which he felt were better suppressed? I find Testa's suggestion untenable. It is unlikely that at age forty-six Michelangelo would have confided conflicts over such inclinations to Lionardo, or that rumors would reach Lionardo that Michelangelo was masturbating. It is certainly possible that the issue was homosexuality and that some of the recurrent rumors that Michelangelo was sexually involved with one or another young man had reached Lionardo. Perhaps Lionardo, as caretaker of Michelangelo's house, even had suspicions based on his own observations. It is noteworthy, however, that in the second letter Lionardo refers to Michelangelo's reassurance that he is "cured of the malady," whereas in the last letter he is "free" of it. "Cured" implies an admission that he *had* engaged in whatever the "practice" was but no longer did so. Would Michelangelo have acknowledged open homosexuality in a letter? It is doubtful. This leaves the third possibility—excessive drinking. I believe some bouts of heavy drinking by Michelangelo are the subject of Lionardo's concern. Getting drunk would be "harmful to the body and the mind," a "malady" from which many men did not "recover," and which could simply have been a time-limited episode for the artist. It also was an activity that it was permissible to mention, albeit indirectly, in writing. Interestingly, in a postscript to a letter written years later (1545), Michelangelo bristled at an engraved portrait of him which he felt depicted him as a "drunkard" (see p. 365). Thus, we are left with no more information about Michelangelo's sexuality as a result of our inquiry into Lionardo the Saddler's three letters.

The Drawing of the Dreamer

One further drawing is of interest in the context of Michelangelo's sexuality—the *Dreamer* (fig. 16-12). This drawing has the same character as the presentation drawings for Tommaso. Its recipient, however, is not known, and its date is generally considered to be 1533–34. It may have been drawn for Tommaso and, if so, it is interesting in that it completes the series of the *Ganymede, Tityus,* and the last version of *Phaethon*. The principal figure in all four drawings has virtually the same position of the torso and lower extremities (in two the left knee is flexed and in the other two, the right). The four figures, however, comprise a full rotation of

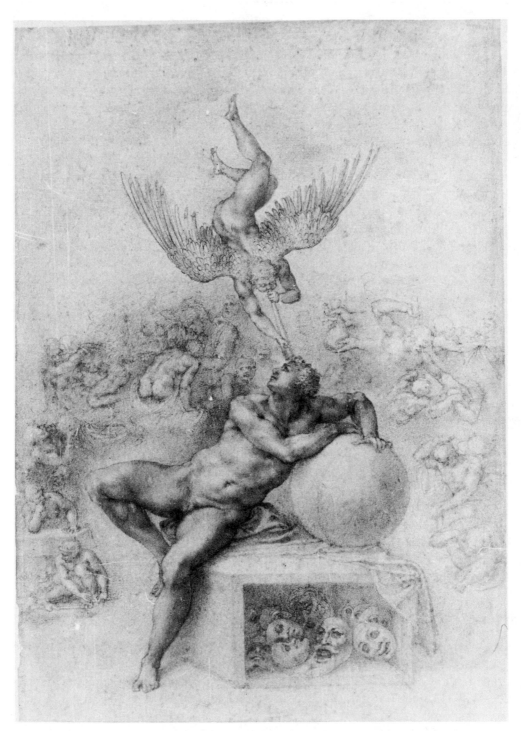

16-12. Michelangelo, drawing of the *Dreamer*.

16-13. Nicolas Beatrizet, engraving after Michelangelo's drawing of the *Dreamer*.

forms—upright in *Ganymede*, upside down in *Phaethon*, left to right in *Tityus*, and right to left in the *Dreamer*.[51] Moreover, inasmuch as Michelangelo had eschewed wings on angels after his *Angel Bearing Candelabrum* of 1494 (fig. 6-1), the fact that the angel in the *Dreamer* blowing his trumpet into the ear of the young man is endowed with the wings of an eagle links this work to the *Ganymede*.

Although scholars vary with respect to the particular text that served as source for this work, all agree that it is a dreamer surrounded by groups of figures representing six of the seven deadly "sins." The particular sin that bears on our discussion is Lust, located on the left-hand side of the sheet in the area above the right knee and shoulder of the dreamer.

Lust is portrayed by four details—a man with an erection climbing upon a passively reclining woman, a hand holding an erect penis, which is far larger in scale than the rest of the rather uniformly sized figures, another free-floating erect penis and scrotum, and a clothed woman pressing kisses upon an awkwardly drawn nude male, who is smaller than she. In Michelangelo's drawing, the erect penis of the man mounting the woman, the disembodied penis and hand, and the second

51. Testa (1977) was the first to articulate the formal program of the four drawings based on the position of the primary figure. See also Testa (1979) for an illuminating study of Michelangelo's drawing of the *Archers*.

penis and scrotum have been almost entirely erased but can be seen with careful attention or a magnifying lens. These elements are, however, clearly evident in contemporary copies of the drawing, such as the engraving by Beatrizet (fig. 16-13). Understandably, with the much more censorious morality of the Counter-Reformation on the horizon, followers of Michelangelo would protectively play down the more obviously sexually provocative elements in his work. I assume that the hand grasping the erect phallus was intended as a comment on the sinfulness of masturbation. What is curious, however, is that the hand is grasping the penis with the thumb and forefinger toward its base. This would require an unusual "backhand" method of masturbation. This backhand grip may represent an unconscious error. But as Michelangelo was usually too careful a draftsman to make a mistake of this sort in functional anatomical relations, the image probably represents one of his subtle jokes. Rather, it is a hand firmly grasping the erect penis of someone else. Thus, whether unknowingly or deliberately, in an image depicting masturbation, he portrayed the wish to masturbate another man (or be masturbated himself), which suggests a significant component in his own masturbatory fantasies. My assumption that this is a man's hand is based on the rugged, knotty, rather than delicate quality of the remnants of the drawn fingers on the original sketch.

Another noteworthy element in the *Dreamer* is the angel sounding his horn in the ear of the reclining nude youth. The "official" meaning of this image is stated in a late sixteenth-century work by Ripa (1593): "The trumpet of fame awakes the mind of the virtuous, rouses them from the slumber of laziness, and makes them stay awake in permanent vigil." However, Michelangelo must also have been aware of the tradition of the Immaculate Conception and the Church Fathers' explanation of how Mary was impregnated by the Holy Ghost: she received the Word of God through her ear. This insemination was often depicted in art as a divine ray of light passing through unbroken stained glass onto the head of Mary in the chamber. More commonly, however, it was represented as the "Annunciation," always made by the Angel Gabriel to the Virgin. Being an announcement, it involves her taking in the fact that she is to conceive a child by the Holy Spirit, the word (*logos*), and therefore through the ears. So when Michelangelo used the secular "trumpet of fame" iconography, he was also expressing the fantasy of a passive, slumbering youth (in the position of Adam of the Sistine ceiling, Ganymede, and Tityus) being inseminated by the agent of some greater paternal power through a long tube leading into his ear. Like Ganymede, the dreamer bears no responsibility for his passive homoerotic and feminine yearnings. Although we do not have the documentation for the *Dreamer* that we have for the *Ganymede*, *Tityus*, and *Phaethon* drawings, it seems as much a companion to the *Ganymede* as the *Tityus* does. It is therefore my belief that this was also a presentation drawing for Tommaso and contains themes reinforcing those I have elaborated upon in discussing the other presentation drawings.

The issues of gender identity and object choice have been the focus of energetic research and theorizing in the behavioral sciences over the past two decades. Yet much about the determinants of gender identity, choice of sexual partner, and preferred modes of activity remains unknown. What is clear, however, is that the specific qualities of Michelangelo's sexual orientation cannot be adequately under-stood apart from his relationships with women—the subject to be considered in the next chapter. Implicit in this viewpoint is that the nature of his sexuality derived largely from his early losses of and disappointments with mothering figures, which has been stressed throughout this book as a profoundly formative basis of his character and his art.

Chapter Seventeen

Vittoria Colonna

Michelangelo had one significant relationship with a woman in his adult life. In 1536, when he was sixty-one, he met Vittoria Colonna, the Marchesa di Pescara, who was then forty-six. What passed between the two from their meeting until her death in 1547 was unique and intense. Her influence upon him was profound. The internal battle between the Platonic and the Christian that had long been waged within Michelangelo was resolved during their association into a deep belief in, and identification with, Christ as the sufferer and the Redeemer.

By the spring of 1535 plans were under way for Michelangelo to paint the *Last Judgment* on the altar wall of the Sistine Chapel. For the purpose of securing Michelangelo's exclusive services, Pope Paul III, in the previous September, had issued a brief appointing the artist to the unprecedented position of "Supreme Architect, Sculptor and Painter of the Vatican Palace." Following the preliminaries of erecting the scaffold and preparing the wall, Michelangelo began work on the fresco in May 1536. Soon thereafter, he was introduced to Vittoria. The exact time and circumstances of their meeting are not known. Tolnay (1943–60, vol. 5) allows that they may not have met until 1538, but this late date is most improbable. (Vittoria's travels rule out 1537 as the year of their meeting.)

No other period in Michelangelo's life encompassed so dramatic a change in his artistic concerns and world-view as the shift from his 1532–34 obsession with Tommaso and Neoplatonism to the somber Christian devotion that evolved from 1535 to 1538, which speaks to us through the *Last Judgment* and elevated Vittoria to a central position in his life. We know of their relationship through the preservation of two of his letters to her and five of hers to him, many sonnets and madrigals that he wrote for her, three or four presentation drawings, and a characterization of the two of them during Sunday afternoon visits in 1538 by the Portuguese artist Francisco de Hollanda, in his *Dialogues* (1548).

Vittoria was a fitting woman to be paired with Michelangelo. In her day she approached mythological dimensions. Marguerite D'Angoulême, the queen of Navarre, said of her, "Not only does she surpass all other women, but, moreover, she seems to show to the most serious and celebrated men the light which is a guide to the harbor of salvation."[1]

Born in 1490, Vittoria came from one of the most illustrious bloodlines in Italy.

1. Translated by Tolnay (1943–60, 5:52).

Her father was the Grand Constable of Naples, and her maternal grandfather was the renowned duke of Urbino, Federigo da Montefeltro. A pope and thirty cardinals could be counted among her kinsmen. At age four, Vittoria was betrothed by her parents to another four-year-old, the only son of the Marchese di Pescara. They were married when they were nineteen years old.

The Marchese catapulted from the wedding bed into a glorious military career, seeing his wife only rarely from the time of their marriage in 1509 until 1522, when they last met. No children were born of the marriage. The Marchese was a thoroughgoing rogue who involved himself in numerous infidelities, schemes, and, ultimately, double treachery conducted on a grand scale between the Emperor Charles V and the duchy of Milan. He died in 1525 after having been branded a traitor by both sides. Thus, the relationship between the Marchese and Vittoria scarcely rose to the heights of passion so often celebrated in Renaissance verse. Yet, after the death of her husband, Vittoria retired to a life largely spent in convents, "to be able to serve God more quietly." She devoted her existence to two ends—preserving her husband's memory and doing Christ's work in this world. This is reflected in her turning to writing poetry. She began her *Canzoni Spirituali* (1525–45), which are divided between poems evoking the virtues of her deceased husband and meditations on religious and moral issues. In referring to her poetry, she said, "I write only to free myself from my inner pain."[2]

Recognizing Michelangelo's dedication to the portrayal of the human form in its idealized state in his art and his concern with it in his poetry, we are naturally curious about the physical appearance of this woman who commanded his special interest. In a portrait by Agnolo Bronzino (1503–72), which has been proposed to be of Vittoria in her later years (fig. 17-1),[3] we can observe strength and determination. However, hers was a visage far from beautiful, or even traditionally feminine.

In Rome, Vittoria became a friend of the major thinkers of the day. During the years 1534–41, she was at the center of a group known as the "Spirituali," which called for reform within, but remained deeply committed to, the Apostolic Church. The group originally formed around the Spaniard Juan Valdes, who lived in Rome from 1531 to 1534 and then in Naples until he died in 1541.

The guiding creed of the Spirituali was twofold. First, justification and salvation can be obtained only through total belief in the completeness of Christ's sacrifice on the cross for all of mankind (*justitia imputata*). Thus, it is through total faith, not good works or religious practices, that one receives deliverance. Second, justification takes place at the moment when man, through the spirit of the Holy Ghost, becomes conscious of his sin and turns totally to God (*justitia inhaerens*).

2. Ibid., p. 51.
3. See Heil (1941) for the identification of the sitter of the Bronzino portrait as Vittoria. This identification has been contested. But the likeness is sufficiently close to other medals and engravings known to be of her that, at the very least, the sitter for this portrait could easily be mistaken for the Marchesa.

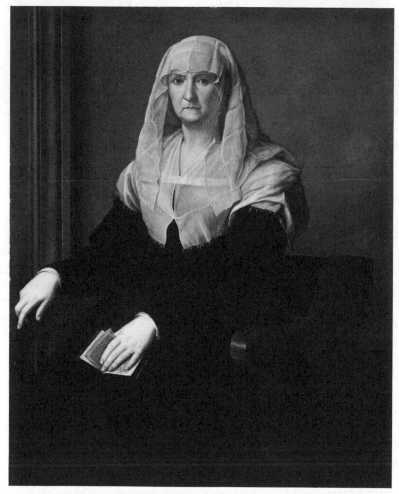

17-1. Agnolo Bronzino, portrait of *Vittoria Colonna* (?).

Vittoria's religious fervor was such that late in her life she chastised herself through mortification of the flesh and fasting to such an extent that one of her spiritual companions, Pietro Carnesecchi, described her as having "almost nothing but skin on her bones." Apparently Cardinal Reginald Pole slowly persuaded her that mortification of her body was more offensive than pleasing to God, and Vittoria thereafter relinquished these practices.

When, in 1542, the Counter-Reformation began with the establishment of the Holy Office of the Inquisition, most of the leading figures in the Spirituali followed their foremost member, Cardinal Pole, and joined the Protestant movement. Vittoria, however, broke with the circle and remained a devout Catholic and supporter of the Counter-Reformation. In fact, she turned over letters she had from another leader of the Spirituali, Bernardino Ochino, to the Holy Court during the Inquisition as incriminating evidence. When the Holy Court tried her

friend Carnesecchi, Vittoria expressed the opinion that "the Saints do not intercede."[4] She left Rome in the spring of 1541 in the midst of a struggle between her brother and Pope Paul III over a papal decree concerning salt-marketing practices. The conflict ended in the confiscation of Colonna estates. She spent most of the time from 1541 until 1544, when her health was declining, in the quiet of monasteries in Orvieto and then Viterbo. Vittoria lived her last years at a Benedictine monastery in Rome.

Despite her break with the Protestant elements among the Spirituali, in the years between the beginning of the Counter-Reformation and her death in 1547, at age fifty-six, Vittoria was regarded with some suspicion in church circles. Although Michelangelo remained committed to his pre-Inquisition, humanistic brand of Catholicism, the two remained faithful friends until Vittoria's death. Three years after she died, in a letter to his old friend Fattucci, Michelangelo wrote, "the Marchesa di Pescara . . . was devoted to me and I no less to her. Death deprived me of a very great friend" (letter 347).

From one of Vittoria's letters to Michelangelo we can infer that they engaged in extensive correspondence during the years of their friendship. Unfortunately, however, only two undated letters by Michelangelo and five by Vittoria are extant. The first of the two letters written by Michelangelo is thought by Ramsden to come from the winter of 1538–39:

> Before taking possession, Signora, of the things which Your Ladyship has several times wished to give me, I wanted, in order to receive them as little unworthily as possible, to execute something for you by my own hand. Then I came to realize that the grace of God cannot be bought, and that to keep you waiting is a grievous sin. I confess my fault and willingly accept the things in question. And when they are in my possession I shall think myself in paradise, not because they are in my house, but because I am in theirs; wherefore I shall be under even greater obligation to Your Ladyship than I am, if that were possible. [letter 201]

Inasmuch as it is clear from the Hollanda dialogues that by 1538 Michelangelo and Vittoria knew each other well, the letter is striking in its formality. Ramsden (1963) reasons quite plausibly that the gifts from Vittoria were religious pictures and icons that she had brought back from a pilgrimage and given to Michelangelo to inspire him in his religious devotions. Michelangelo's approach to Vittoria is one of extreme supplication—a penitent beseeching forgiveness and acceptance by a woman who is viewed as touched by God. The tone of the letter is underscored by a sonnet appended to it:

> So that I might at least be less unworthy,
> Lady, of your huge high beneficence,
> To balance it, my poor wits at first
> Took to plying my own wholeheartedly.

4. Quoted by Tolnay (1943–60, 5:58).

But then, seeing in me no potency
To clear the way to grasp that goal exists,
My evil fault for its forgiveness asks,
And the sin makes me wiser constantly.

And well I see how anyone would stray
Who thought my flimsy, transient work could equal
The grace pouring from you, which is divine.[5]

Throughout the ten poems explicitly written for Vittoria that are preserved (and also in others which, while not clearly designated for her, are generally believed to be directly inspired by or written for her) sentiments are expressed by Michelangelo which indicate that he saw Vittoria as his spiritual mentor and guide to salvation. This motif dominates the following passages of verse:

Now on my right foot, now upon my left one
Toward my salvation shifting in my searches,
Between vices and virtues
My heart wearies and burdens me, distraught
Like one who sees no Heaven
And upon every road is lost and late.
I offer a clean sheet
To take your sacred inks:
Let love inform me, truth be inscribed in pity;
. .
My short time left; let me not live so blindly.
Tell me, high sacred Lady,
Whether in Heaven less honor is bestowed
On humble sin than on the sovereign good.[6]

and

While still I shun and hate myself the more,
The more, Lady, with proper hope I call
On you; in me the soul
Is less afraid, as I to you draw near.
In your face I aspire
To what I am pledged from Heaven,
And in your beautiful eyes, full of all safety.[7]

and

A man, a god rather, inside a woman,
Through her mouth has his speech
And this has made me such
I'll never again be mine after I listen.

5. Gilbert and Linscott (1963, poem 157).
6. Ibid., no. 160.
7. Ibid., no. 161.

. .
Her beautiful features summon
Upward from false desire,
So that I see death in all other beauty,
You who bring souls, O Lady,
Through fire and water to felicity,
See to it I do not return to me.[8]

and finally,

. . . to be reborn from you,
High worthy Lady, a thing high and perfect;

If you in mercy trim my surplus down
And build my little, what is my fierce fire due
As penance, when you punish and correct?[9]

Why did Michelangelo, at this time in his life, turn with such urgent expectations to a woman? What qualities did Vittoria possess that suited her for this role? And how can we account for the nature of the asymmetry of Michelangelo's perception of her loftiness and power to redeem, and his own impotence and unworthiness? In short, what unconscious scenario was being enacted for the artist in this friendship?

Michelangelo's only other surviving letter to Vittoria was written in the spring of 1539:

Signora Marchesa—Seeing that I am in Rome, I do not think it was necessary to have left the Crucifix with Messer Tommao [de' Cavalieri] and to have made him an intermediary between your ladyship and me, your servant, to the end that I might serve you; particularly as I had desired to perform more for you than for anyone on earth I ever knew. But the great task [the painting of the *Last Judgment*] on which I have been and am engaged has prevented me from making this known to Your Ladyship. And because I know that you know that love requires no task-master, and that he who loves slumbers not—still less had he need of intermediaries. [letter 202]

This letter betrays Michelangelo's sensitivity to being slighted by Vittoria. It is akin to the wounds that he felt and complained about over and over again to his family. He reproaches her for not fully honoring the depth and priority of his servitude toward her, in her breach of the exclusivity of their relationship by bringing in Tommaso as an intermediary. Even the trusted Tommaso reawakened his ever-alert sensitivity to being displaced in the concerns of the one he viewed as the source of nurturance or power. This is an unwavering theme extending from childhood through the years with Lorenzo the Magnificent, the popes, and now to Vittoria.

The awe and admiration were by no means solely on Michelangelo's side. Vit-

8. Ibid., no. 233.
9. Ibid., no. 234.

toria was unrestrained in her feelings about Michelangelo's art and his importance as a friend; but he never achieved the fantasized position of holding the key to her destiny that she did for him. Her letters are undated but, as Symonds (1893) comments, "this matters little, since they only turn on literary courtesies exchanged, drawings presented, and pious interests in common" (vol. 2, p. 103). In one letter she writes:

> Unique Master Michelangelo, and my most singular friend—I have received your letter, and examined the crucifix, which truly hath crucified in my memory every other picture I ever saw. Nowhere could one find another picture of our Lord so well executed, so living, and so exquisitely finished. Certes, I cannot express in words how subtly and marvellously it is designed. Wherefore I am resolved to take the work as coming from no other hand but yours, and accordingly I beg you to assure me whether this is really yours or another's. Excuse the question. If it is yours, I must possess it under any conditions. In case it is not yours, and you want to have it carried out by your assistant, we will talk the matter over first. I know how extremely difficult it would be to copy it, and therefore I would rather him finish something else than this. But if it be in fact yours, rest assured, and make the best of it, that it will never come again into your keeping. I have examined it minutely in full light and by lens and mirror, and never saw anything more perfect.—Yours to command,
>
> The Marchioness of Pescara[10]

How can we understand Vittoria's lengthy puzzling over whether the drawing was by Michelangelo's hand or another's? She, of course, knew that it was drawn by him. It was almost certainly an unfinished version of *Christ on the Cross* (fig. 17-2). If she gave her approval, it would be completed and presented to her. She may, however, have feared that because he was so occupied with painting the *Last Judgment*, he would have an apprentice add the final touches (which is what Tolnay, 1943–60, vol. 5, believes actually occurred). By flattery, wit, and a bit of guile, Vittoria hoped to persuade Michelangelo to work on the remaining portion himself. This guileful quality in Vittoria immediately impressed Hollanda during his attendance at three Sunday afternoon visits with the Marchesa and Michelangelo in the garden of the cloister of the Church of San Silvestro a Monte Cavallo. Vittoria and a few companions were trying to devise a way to induce Michelangelo, who had not yet arrived, to talk about the art of painting, which they feared he would refuse to do if directly confronted. Hollanda describes how Vittoria approached Michelangelo upon his arrival:

> I sat a little way off, but the Marchioness, remaining a while without speaking, not wishing to delay her practice of honouring those who conversed with her, and the place where she was, commenced, with an art that I could not describe, to say many things very well expressed, and with thoughts most graciously stated, without ever touching on painting, in order to ensure the greater painter to us; and *I saw her as one wishing to reduce a well armed city by discretion and guile*; and we saw *the painter*

10. Translated by Symonds (1893, 2:103).

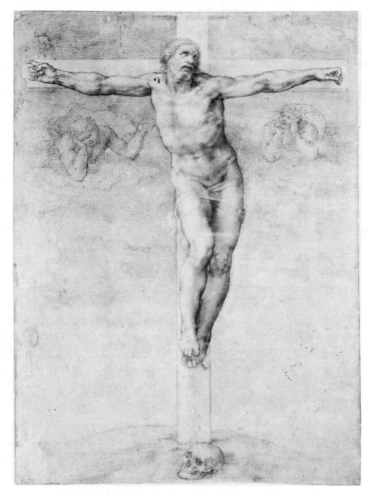

17-2. Michelangelo, drawing of *Christ on the Cross.*

[Michelangelo], *too, standing watchful and vigilant, as if he were besieged,* placing sentries in one place and ordering bridges to be raised in another, making mines and defending all the walls and towers; but *finally the Marchioness had to conquer, nor do I know who could defend himself against her.* [p. 235, my italics]

Indeed, the mood throughout Hollanda is one of Vittoria's regarding Michelangelo as a great catch to be steered to her purposes by means of her considerable intellect, social grace, and shrewdness, while at the same time, she basked in his glory. Despite the display of her cool facility in handling Michelangelo, the first *Dialogue* concludes with an expression of Vittoria's underlying reservoir of depression and grief. In discussing the subject of the painted portrait, Vittoria says:

It leaves a memorial of the present times for those who come after. . . . To one who dies it gives many years of life, his own face remaining behind painted, and his wife consoled, seeing daily before her the image of her deceased husband, and the sons

who were left little children rejoice when men to know the presence and the aspect of their dear father, and fear to shame him.

As *the Marchioness, almost weeping,* made pause here, M. Lactancio, *in order to draw her out of her sorrowful imagination and memories,* said: . . . [p. 246, my italics]

I think one of the forces that drew Michelangelo to Vittoria was his need to break through her seemingly impenetrable barrier of saintliness and verbal ease, to reach and relieve the core of sadness that she herself could not dissolve. He appears to have been continuously attempting to please her. One way, of course, was with poems and drawings that reflected her religious convictions. And she, in turn, viewed him as a repository of divine inspiration. Thus, in her next letter to Michelangelo, she refers to the finished drawing of the *Christ on the Cross.* The letter, although awkwardly worded, makes clear the programmatic nature of the drawing, which they both understood in terms of the tenets of the Spirituali. She wrote:

> Your works forcibly stimulate the judgment of all who look at them. My study of them made me speak of adding goodness to things perfect in themselves, and I have seen now that "all is possible to him who believes." I had the greatest faith in God that He would bestow upon you supernatural grace in the making of this Christ. . . . I am mighty pleased that the angel on the right hand is by far the fairer, since Michael will place you, Michelangelo, upon the right hand of our Lord at that last day. Meanwhile, I do not know how else to serve you than by making orisons to this sweet Christ, whom you have drawn so well and exquisitely, and praying you to hold me yours to command as yours in all and for all.[11]

The *Christ on the Cross* is the last of Michelangelo's meticulously finished drawings in the manner of the Cavalieri presentation pieces. The work was described by Condivi as follows: "For love of this lady, he also did a drawing of Jesus Christ on the cross, not in the usual semblance of death, but alive, with His face upturned to the Father, and he seems to be saying, 'Eli, Eli.' Here we see that body not as an abandoned corpse falling, but as a living being, contorted and suffering in bitter torment" (p. 103).

Christ, alive and suffering on the cross, had not been portrayed in Italy from the thirteenth century until Michelangelo's drawing *The Three Crosses* (British Museum, W 32, early 1520s?). The Colonna drawing is one of Michelangelo's great graphic achievements in the refined surface treatment, the tension between the hands and feet nailed in place and the muted *contrapposto* that energizes the rest of the body, while the unforgettable, expressive countenance speaks the Seven Last Words: "My God, my God, why hast Thou forsaken me?" The focus is overwhelmingly on Christ's active suffering. And it was through total belief in His suffering and sacrifice that Vittoria and the Spirituali thought that man's salvation could be attained. This drawing is also the first we possess of the long series of Crucifixion drawings that Michelangelo created during the remaining years until

11. Ibid., pp. 104–05.

his death. These drawings became not simply an act of worship but a reaching out for mystical union with his Redeemer.

Vittoria's last preserved letter to Michelangelo must have been written in late 1542 or early 1543, before she became seriously ill. From the Convent of Santa Caterina in Viterbo, where she stayed from October 1541 until the summer of 1544, Vittoria wrote:

> Magnificent Messer Michelangelo,—I did not reply earlier to your letter, because it was, as one might say, an answer to my last: for I thought that if you and I were to go on writing without intermission according to my obligation and your courtesy, I should have to neglect the Chapel of S. Catherine here, and be absent at the appointed hours for company with my sisterhood, while you would have to leave the Chapel of S. Paul [the Pauline Chapel at the Vatican, where Michelangelo was in the early stages of his fresco of the *Conversion of Paul*] and be absent from morning through the day from your sweet usual colloquy with painted forms, which with their natural accents do not speak to you less clearly than the living persons round me speak to me. Thus we should both of us fail in our duty, I to the brides, you to the vicar of Christ. For these reasons, inasmuch as I am well informed of our stead-fast friendship and firm affection, bound by knots of Christian kindness, I do not think it necessary to obtain the proof of your good-will in letters by writing on my side, but rather await with well-prepared mind some substantial occasion for serving you. . . .[12]

From this we can infer that Vittoria felt somewhat inundated by the flow of letters and poems from Michelangelo in Rome. With grace and discretion, she tried to stem the tide, or at least to prepare him for her decision not to respond in kind. One senses in her letter an inconsistency between what each wanted from the other. Vittoria states her position—her first priority is Christian duty. Subsumed under that is "steadfast friendship and firm affection, bound by knots of Christian kindness." In contrast to Michelangelo's poems for Vittoria, according to Papini (1951), there are at most two allusions to Michelangelo in all of her poetry. Clements (1965), however, points out several instances where the verse of each was probably influenced by the other, judging from the similarity in phrasing.

Because of the separation resulting from her residence at the convent in Viterbo, Vittoria probably increasingly became for Michelangelo an idea personified. His reaching out, like the forsaken Christ in the presentation drawing, is for some elusive, lost being. In the years of their friendship, Michelangelo was acutely aware of his aging and waning strength. Although, according to Condivi, "She often traveled to Rome from Viterbo and other places . . . [for] no other reason than to see Michelangelo" (p. 103), Vittoria could not be possessed or diverted from her first calling. Therefore, the question of what she symbolized to the artist evokes our curiosity.

12. Ibid., pp. 106–07.

In discussing Michelangelo's bond to Tommaso, I postulated a magical, uncon-scious belief in the arresting of the passage of time and the approach of death through an erotic union with this idealized, eternally youthful male. Since, how-ever, time passed and reality brought disenchantment to the controlling fantasy, the artist's underlying fears demanded a new and different resolution. The new means of salvation was to be sought through his dedication as a Catholic.

The painting of the *Last Judgment* occupied the years 1534 to 1542. One can easily imagine how this daily confrontation with the theme of the eternal destiny of the soul stirred in the artist a continuous preoccupation with his own ultimate fate. In this transition from the world of Tommaso and Ganymede to justification by faith, Vittoria was both his guide and an idealized personage in her own right, whom he could never quite grasp and hold. Physically unattractive, decidedly asexual, and capable of coolly setting limits on the degree of intimacy they were to share, she was "safe" with respect to the possibility of arousing lustful or even simply sensual feelings in him. Michelangelo's denial of Vittoria's gender as well as her sexuality is suggested in a letter written after her death, in which he described her as "a very great friend," using the masculine form, *un grande amico.* Moreover, by keeping him second in importance to her duties as a Christian and by being away from Rome during much of their friendship in pursuit of her calling, she echoed significant aspects of Michelangelo's experiences early in life with mater-nal figures.

In this context, it is interesting to look at the other presentation drawing made for Vittoria that we have, the *Pietà* (fig. 17-3). This drawing was described by Condivi: "At this lady's request, he made a nude figure of Christ when He is taken from the cross, which would fall as an abandoned corpse at the feet of His most holy mother, if it were not supported under the arms by two little angels. But she, seated beneath the cross with a tearful and grieving countenance, raises both hands to heaven with open arms, with this utterance, which is inscribed on the stem of the cross: *Non vi si pensa quanto sangue costa* (They think not there how much blood it costs)" (p. 103).[13]

In this drawing, Michelangelo's emphasis on the formal elements—the place-ment of the figures to form a cross—forces the group into rather wooden and awkward composition that is very different from any of his other, deeply human, sculptured Pietàs. The programmatic quality of the relationship between creator and recipient led Tolnay (1953) to comment: "The harmonious beauty of the group of the first *Pietà* of San Pietro [fig. 6-4] is absent in the Colonna versions. These are no longer artistic translations of a concrete and human situation into a plastic group, but religious symbols" (p. 62). The religious symbolism is repre-sented by the foreground prominence given to Christ, which is in keeping with the doctrine that the sacrifice of Christ is the foundation for the belief in justifi-cation by faith alone.

13. From Dante (ca. 1315, *Paradiso,* 29. 91).

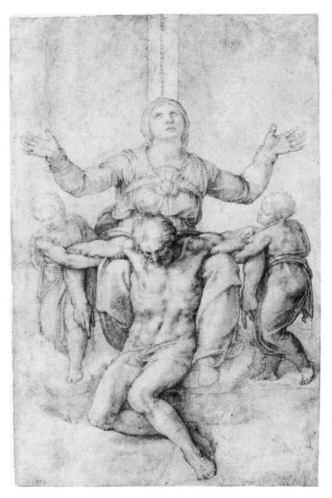

17-3. Michelangelo, drawing of *Pietà*.

Along with the many letters and poems that Michelangelo wrote for Vittoria, there must have been other presentation drawings besides the ones that are known, since Vittoria expressed such deep pleasure at these gifts. A drawing of *Christ and the Samaritan Woman* is mentioned in their correspondence and is known from copies. And several students of Michelangelo's drawings think it quite possible on the basis of dating, style, and content that *The Madonna of Silence,* in the collection of the duke of Portland, was executed for Vittoria.[14]

Vittoria returned from Viterbo to Rome in the summer of 1544 in a state of seriously declining health. She died on February 25, 1547. Condivi, writing six years after her death, recorded that Michelangelo "bore her so much love that I remember hearing him say that his only regret was that, when he went to see her as she was departing this life, he did not kiss her forehead or her face as he kissed

14. The group includes Dussler (1959), Hartt (1970), and Tolnay (1943–60, vol. 5).

her hand. On account of her death he remained a long time in despair and as if out of his mind" (p. 103).

Vittoria's death occurred only four months after the death of Michelangelo's dearest friend of those years and his trusted advisor on most business matters, Luigi del Riccio. The seventy-two-year-old artist openly acknowledged his grief a few weeks after Vittoria's death in a letter to his old friend Father Fattucci, in Florence:

> Having been very unhappy lately, I have been at home and in going through some of my things a great number of these trifles [poems], which I formerly used to send you, came to hand, from among which I'm sending you four, which I may perhaps have sent you before. You'll say rightly that I'm old and distracted, but I assure you that only distractions prevent one from being beside oneself with grief. So don't be surprised about it. Reply to me about something, I beg of you. [letter 281]

These lines, simple and touching, express Michelangelo's indomitable insistence on going forward with life whatever his misfortune or loss might be, by whatever means possible. At the time he was working on his last fresco, the *Crucifixion of Peter*, in the Pauline Chapel of the Vatican, in which, as we shall explore in chapter 19, the struggle between extreme weariness and the refusal to renounce life was dramatically represented.

A madrigal and a sonnet Michelangelo wrote upon the death of Vittoria again reveal a deep, yet strangely impersonal, involvement. In the madrigal, he underscores the meaning of her writing to him:

> . . . in a second, God
> From the unwatchful earth
> Again has seized it [beauty], from our eyes removed.
> But memory cannot fade,
> Despite the body's death,
> Of all she has written, sacred, sweet, belov'd.[15]

In the sonnet, the imagery consists of the rather time-worn symbols of fire and ashes from the Petrarchan lyric tradition. Here, Michelangelo presents himself, as he had done so often in the past, as reliant upon the power and energy of another for his existence. What is lacking here, however, is the individualized nuance of thought which, for example, marked the verse on the death of his father (pp. 37–40).

> But Heaven has taken away from me the splendor
> Of the great fire that burned and nourished me;
> I am left to be a coal, covered and burning
>
> And if Love will not offer me more timber
> To raise a fire, in me there will not be
> A single spark, all into ashes turning.[16]

15. Gilbert and Linscott (1963, poem 263).
16. Ibid., no. 264.

Looking back, how can we account for this devoted friendship between the artist and Vittoria Colonna, particularly on the part of Michelangelo? There was no comparable relationship in his life before or after. Although Michelangelo spent so much of his creative energy in drawing to himself the love and approval of powerful male protectors, they stood as compromise transformations of the original maternal sources of nurturance. The fantasy of a powerful female in his past was manifest in the myth he created of his ancestry—descent from the Countess Matilda of Canossa (discussed in chapter 3); in the first God of the Sistine Chapel ceiling history of the Creation, the *Separation of Light and Darkness* (fig. 11-3), who is endowed with a primeval androgyny; and elsewhere in his art. Michelangelo's day-to-day life was rather isolated and lonely. Nevertheless, he enjoyed warmth and intimacy with a number of male friends during his lifetime. But it was not until he was sixty-one and met Vittoria that he could allow himself a comparable experience with a woman.

Because she was intellectual, childless, not sexually attractive, and had renounced desires of the flesh in this world, he could regard her with minimal concern about his own sexuality. Yet she held a fascination for him *because* she was a woman, though a woman who, in his mind, was almost interchangeable with a man. Thus, he referred to her in the masculine gender, presumably without being aware of doing so. He found it possible to feel a close bond with her that did not arouse his full potential for rage toward "women." These traits, however, do not define Vittoria as a positive being; rather they are attributes which did not mobilize Michelangelo's reflex defenses of avoidance and are, in that sense, negative. He also felt safe in that, although she treasured his gifts of art and revered his genius, Vittoria was truly an aristocrat who would not be swept off her feet either by his renown or his admiration for her. Her inner commitment to her beliefs and her work was unswerving. We can talk of Michelangelo's respect for her intellect, their common interest in poetry, and his fascination with her conversational wit and grace. Above all, however, Vittoria was his spiritual guide and mentor. This relationship began at a time when the reasonable equilibrium between his religious beliefs and his secular interests which Michelangelo had long been able to maintain had started seriously to waver. In the school of the Neoplatonic philosophy of Marsilio Ficino and Pico della Mirandola, which Michelangelo had absorbed during his two years at the Medici Gardens, Christian doctrine and classical teachings were reconciled in a single system of thought. The effect of this early inculcation was profound and led Panofsky (1939) to observe: "Among all his contemporaries Michelangelo was the only one who adopted Neoplatonism not in certain aspects but in its entirety, and not as a convincing philosophical system, let alone as the fashion of the day, but as a metaphysical justification of his own self" (p. 180). Panofsky's statement has, I feel, the ring of hyperbole. Nevertheless, the harmony between Michelangelo's inner life and unconscious needs, on the one hand, and a formal ideology, on the other, apparently began to fail after his arrival in Rome and reunion with Tommaso. As mentioned earlier, his joining Tommaso was

quite probably followed by disenchantment, as his hopes for "magical" rebirth were dashed. Tommaso, although unfailingly loyal and devoted to Michelangelo, was moving toward his own independent life of marriage and family. The master's humiliation at the hands of Febo di Poggio in 1534–35 must have shaken him. Both these experiences may have impressed Michelangelo with the futility of his homosexual yearnings and his emotional vulnerability in this connection. Unable to consummate his desires, partly because of the guilt that he internalized from the social code of the day and from Christian teachings, he may have resolved to purge himself of this increasingly disturbing area of thought and interest. He was, after all, dwelling day in and day out on issues of judgment and eternal afterlife in connection with his work on the *Last Judgment.* So, as the harmony between Christian and classical thought shifted to antagonism, the obvious solution was to surrender to one or the other. With body failing and death approaching, and the image of a harsh "Christ the Judge," so central in the *Last Judgment,* already uppermost in his mind, Michelangelo surrendered to belief in the teachings and sufferings of Christ rather than to love for another mortal male. Even as early as the Doni tondo of 1503–04 (fig. 7-1, 7-8) we can see evidence of Michelangelo's guilt and moral condemnation of homosexuality, albeit expressed quite ambivalently. As we recall, he represented the group of background nudes as homosexuals presenting themselves at the baptismal font to be cleansed of their sin. In the wake of Michelangelo's renunciation of homosexuality, it is understandable that he would turn to the relative safety of a female guide, although he perceived her as an unwomanly woman. In this respect, Vittoria could serve better than any male theologian, shepherding him toward what was to absorb him throughout the last seventeen years of his life—the Passion of Christ. As we shall see in chapter 20, it can be inferred from his late works, and particularly from his unrelenting labors over those years on the Florence and Rondanini *Pietàs,* that the ultimate goal of Michelangelo's identification with the crucified Christ was the union between Jesus and the Virgin so poignantly expressed in those Pietàs. Perhaps Vittoria Colonna may be regarded as the transitional figure in this increasingly intense artistic quest for the loving union between son and mother.

Another element in Vittoria's personality which I believe created a sense of kinship in Michelangelo was the fact that she lived most of her adult life as a mourner. As unwarranted as this grief may seem, given her husband's character and the nature of their marriage, it was nevertheless her subjective reality. For Michelangelo, loss and grief at an early age were cornerstones for his later character structure. In his attempts to serve and please her, there is a sense of his trying to lift her underlying depression. He could sympathize with her chronic grief and with the relief that he fantasized she would gain through his efforts. One may commonly observe the mechanism whereby a donor identifies with the recipient of his generous behavior.

Michelangelo's friendship with Vittoria Colonna revolved around their common intellectual interests and strong bond in religious thought. We can infer from

Vittoria's letter, in which she gently chides Michelangelo for his unceasing flow of correspondence that she feels is beyond her capacity to reciprocate, that Michelangelo wanted more from her than was possible for her to give. Yet to demand more or to express anger directly at what was not forthcoming would probably have jeopardized his relationship with this self-sufficient and strong-minded woman. Michelangelo's sense of unfulfillment and rejection are expressed in the series of madrigals he wrote over the period of his friendship with Vittoria. These poems bear the form of traditional love poems in the style of Petrarch and his followers. But whereas Dante had his Beatrice and Petrarch his Laura, there was no such woman to whom Michelangelo could dedicate his verses of passion. I must assume, despite the fact that they are abstract and do not refer to attributes of any particular woman or describe any particular incident, that Michelangelo's poems nevertheless served as an outlet for the frustration he felt in regard to Vittoria.

There are numerous expressions of this theme of disappointment and hurt in love in the madrigals. For example:

This woman here is bound,
In her ungoverned rage,
That I'm to burn, and change
To what won't even weigh an ounce, and perish,
My blood lets, pound by pound,
Unnerves my body, for my spirit worthless;[17]

The stone where I portray her
Resembles her, I might
Well say, because it is so hard and sharp;
Destroyed and mocked by her,[18]

I see your only pleasure is my ill
And ask you nothing else for all my love;
There is no peace for you unless I grieve,
For you the worst you do me is not to kill.[19]

One woman's fresh new beauty
Unchains, whips, spurs me on:[20]

In reading these four examples we may recall Michelangelo's last sonnet for Tommaso (chapter 16), in which he contrasts love for man and woman. Whereas the love for a man [Tommaso] "draws to Heaven," love for a woman is "Drawing its bow on what is base and vile."[21]

Inasmuch as the madrigals were written over the entire period of the relationship with Vittoria, they do not reflect disappointment over a particular incident,

17. Ibid., no. 170.
18. Ibid., no. 240.
19. Ibid., no. 244.
20. Ibid., no. 261.
21. Ibid., no. 258.

but rather the constant frustration of Michelangelo's deeper needs from a woman. He seemed content simply to seek spiritual guidance, intellectual kinship, and mutual respect. He was too shy and uncertain of his contradictory impulses, and she was too aloof, for greater intimacy to have been possible. Michelangelo's comment to Condivi that he regretted not having kissed Vittoria's face as he had her hand as she was dying is a touching expression of his yearning to break through the barrier of austere convention. Despite this omission, the circumstances of his life and the personal qualities of Vittoria allowed for a new boldness in Michelangelo's moving toward a woman. While in major respects the friendship was satisfying, it was also destined to reenact his despairing view of what necessarily unfolds in a close relationship with a woman. The part of Michelangelo's subjective experience that found expression in this series of madrigals was an extension of his deepest feelings in response to his early maternal figures.

Those feelings expressed directly to Vittoria, which were admiring and positive, and those expressed in poems not explicitly intended for her, which conveyed his pain and resentment, coexisted, but probably in separate and alternating states of consciousness. In this respect they echo the splitting of the representation of his early maternal imago into contradictory images of the idealized Madonna and the terrifying and murderous Medea, which I postulated in discussing the artist's early works—the *Madonna of the Stairs,* the Doni tondo, the Taddei tondo, and the *Expulsion.* Vittoria's austere personality, her devotion to Christ above all else, and her pattern of taking up residence outside of Rome for long periods resonated with Michelangelo's expectation of abandonment. Yet the sad nature of his ambivalence toward women was such that, had he tried to be close to an emotionally available, appropriate woman, he would probably have been filled with anxiety because of the deep rage he would bring to her from his past—a rage that could not help but be disruptive. In Vittoria he found, in later life, a comfortable fit for his preexisting attitudes and feelings and, paradoxically, sufficient distance to achieve a new and significant degree of intimacy.

There are just a few other women who had sufficient contact with Michelangelo for their names to have been recorded. Some were the wives of good friends with whom he had minor friendships. Laura Battiferri, for example, was an accomplished poet and the wife of Michelangelo's follower, the sculptor and architect Bartolommeo Ammanati. Then, in his eighties Michelangelo befriended a young woman painter, the daughter of friends, Sonfonisba Anguissola, while she was in Rome for two years.

Two instances of loyalty and kindness toward women deserve to be included in our discussion. The first concerns a servant, Mona Margareta, who cared for Michelangelo's father during the last years of his life. Shortly after his father's death, Michelangelo wrote to his brother Giovan Simone: "I should be very glad if you would settle down there [the family house at Settignano], so that Mona Margareta could stay there too, because when he was dying my father commended

her to my care, and I'll never abandon her" (letter 185). From two letters written in 1532 and 1533 to Giovan Simone, it can be inferred that after his father's death in 1531 Michelangelo retained Mona Margareta in his own household in Florence until he finally departed in 1534 (letters 189 and 197). Mona Margareta remained in his mind, and in 1540, in a letter to his nephew Lionardo, he wrote of the failing woman: "Encourage Mona Margareta to keep up her spirits, and see that you treat her kindly in word and deed, and try to be a man of honour yourself— otherwise, I would have you understand that you'll inherit nothing of mine" (letter 203). Four months later, Mona Margareta died. Michelangelo wrote movingly to Lionardo:

> The news of Mona Margherita's death has been a great grief to me—more so than if she had been my sister—for she was a good woman; and because she grew old in our service and because my father commended her to my care. God is my witness that I intended before long to make some provision for her. For this He has not pleased that she should tarry. Alas! [letter 206]

It appears that Mona Margareta was a devoted and caring woman in her service to father and then to son. In this capacity she struck a particularly receptive chord of warmth and gratitude in Michelangelo. Yet, out of some basic guilt, possibly stemming from an unarticulated sense of failure to have "rescued" his own mother, Michelangelo censured himself when Margareta died for not having properly provided for her, despite the likelihood that he had indeed been generous toward her. Michelangelo, incidentally, in general had by no means an easy time with servants. Ramsden's examination of the records reveals that maids came and went with high frequency. For instance, in 1550, he wrote to Lionardo: "If, in the meantime, you could find me a maidservant who is clean and respectable—which is difficult because *they are all pigs and prostitutes*—let me know . . . I live poorly, but I pay well" (letter 350, my italics).

The other woman who evoked a generous and protective response from Michelangelo was also related to him through devoted service. Cornelia Amatore was the widow of Urbino, Michelangelo's faithful servant and assistant for twenty-six years until his death in 1555, when the master was eighty years old. Cornelia married Urbino in 1551. They had a son whom they named Michelangelo, and the artist was his godfather. The grief that Michelangelo expressed over the death of Urbino exceeds anything he wrote about any other person who died in his lifetime. I shall come back to Urbino when discussing Michelangelo's final years. At this point, suffice it to state that Michelangelo remained in continuous touch with Cornelia after she returned to her home in Castel Durante. When, in 1559, Cornelia remarried and became enmeshed in disputes over her dowry provisions, the aged artist actively intervened on her behalf.[22] Also, his interest in his little godson remained undiminished.

22. See Ramsden (1963, letter 453).

So it seems that only in the years following his sixtieth birthday was Michelangelo able to open himself to any companionship with women. He began the painting of the *Last Judgment* in the late spring of 1536—at about the same time he and Vittoria Colonna first met. In a sense, the bond with her and the theme of the painting represented different facets of the concern for salvation that became increasingly insistent not long after he settled in Rome. Although it would be difficult to trace any direct influence by Vittoria on Michelangelo's conception of the *Last Judgment* (chapter 18), of interest in this connection is Tolnay's (1943–60, vol. 5) theory that Vittoria is portrayed in the painting in the figure of the woman wearing a widow's veil, seen behind the martyr Saint Lawrence (fig. 17-4), which I believe to be correct. Although the ladder Saint Lawrence is holding obscures part of her face, the remaining portion does indeed resemble the portraits of the Marchesa that have come down to us on medals, in engravings, and in the painting by Bronzino. It is fitting that Michelangelo honored her in this guise—linked to a martyr of the church, wearing a look of compassion, and placed at the feet of the Virgin Mary in the center of that monumental statement of the ultimate human destiny.

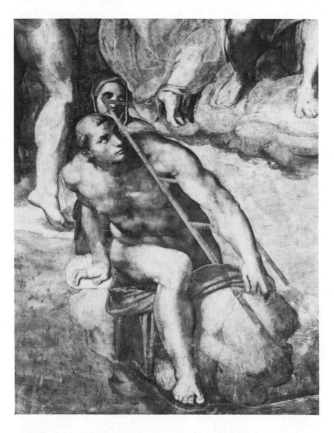

17-4. Michelangelo, *Last Judgment* (detail of St. Lawrence and unidentified woman).

Chapter Eighteen

The Last Judgment

No work in Western art approaches Michelangelo's *Last Judgment* (fig. 18-1) in monumentality of conception and awesomeness of personal vision. Condivi attributes the idea of a painting of the *Last Judgment* on the altar wall of the Sistine Chapel to Pope Clement VII. The evidence is strong, however, that late in 1533 Clement commissioned Michelangelo to paint, not the Last Judgment, but the Resurrection of Christ on that wall, and The Fall of the Rebel Angels on the opposite, entrance wall. We have an idea of the sort of fresco Michelangelo had in mind for the Resurrection from one of the several surviving drawings for the project (fig. 18-2). This more modest proposal would have occupied only the upper section of the wall and would have been integrated with Perugino's *Assumption*, which had been painted on the lower part of the wall a half-century earlier.[1] On looking at the *Resurrection* drawing we are impressed with how different is Michelangelo's vision of the slender resurrected Christ, effortlessly floating upward, from the mass of figures in the *Last Judgment*, who are imbued with weightiness and agitation. The buoyant mood in this drawing of the soaring Christ may mirror the artist's own sense of joyous rebirth at the prospect of joining his beloved Tommaso in Rome. In contrast, the *Last Judgment*, as we shall see, reflects not only Michelangelo's marked change in personal outlook but also the contemporaneous mood of the Catholic church, which was rapidly moving toward the moral austerity of the Counter-Reformation.

By March of 1533, the scaffolding for the painting of the *Resurrection* was in place. The fate of the project, however, came into question six months later when Clement VII suddenly died. His heavy-handed and self-interested conduct had made him the object of hatred in the papal court and in secular quarters as well (see Guicciardini's description of 1561, quoted on page 225). The cardinals convened without delay and elected Cardinal Alessandro Farnese as supreme pontiff. Alessandro assumed the name Paul III.

The new pope was described by Guicciardini as "a man gifted with learning, and to all appearance good morals." Guicciardini, who began writing his *History* shortly after the election, was accurate in this early assessment. Pope Paul, who was seven years older than Michelangelo, had been given an excellent humanist

1. The Resurrection of Christ was intended to cover two frescoes by Perugino, the *Birth of Christ* and the *Finding of Moses*, which were ruined when the draperies on the wall caught fire in 1525.

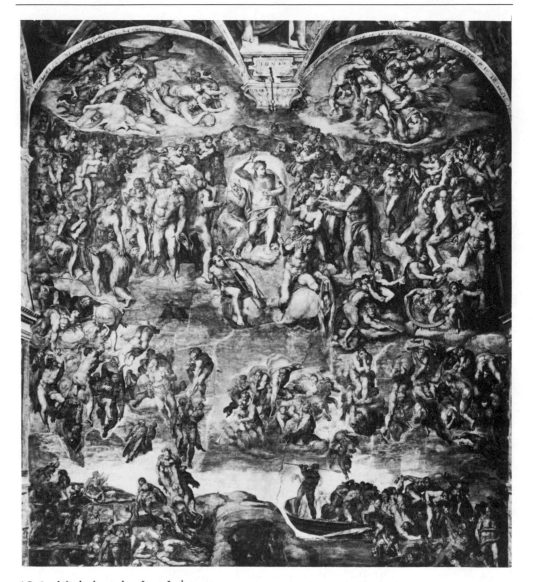

18-1. Michelangelo, *Last Judgment.*

education. In fact, he had studied in the same Medici Gardens as Michelangelo before his early appointment as cardinal. It seems that the appointment, made by the notorious Borgia pope, Alexander VI, was intended to please Pope Alexander's mistress, Madonna Giulia, who happened to be the young Farnese's sister.

The destiny of Michelangelo for the next fifteen years was inextricably tied to the new pontiff. Paul was sixty-six years old when elected pope. He was thought to be in poor health and therefore was not expected to live much longer. However, his reign extended for fifteen years, until his death in 1549. During his pontificate he established a reputation as a great patron of the arts while also

affirming the sacred and moral nature of the church. In politics, until shortly before the end of his life he managed to maintain a position of relative neutrality between the competing Spanish and French designs on Italy. Titian's portrait of Pope Paul (1543) is a deeply probing human image that also conveys Paul's majesty, wisdom, and dignity (fig. 18-3). In relation to Michelangelo, Paul was unwavering in his support and tolerance of the artist's sometimes eccentric behavior. Paul had a concept of a humanistic Christianity that did not blend easily with the shifting mood of the Counter-Reformation.

With the death of Clement and the elevation of Paul, the plan for a painting of the *Resurrection* was abandoned, largely because of the evolving religious struggle in Europe. Luther and Calvin were stirring up the Reformation north of the Alps, and the new pope deemed it necessary to remind his flock dramatically that Heaven is reserved only for those who live by the Faith. In keeping with this

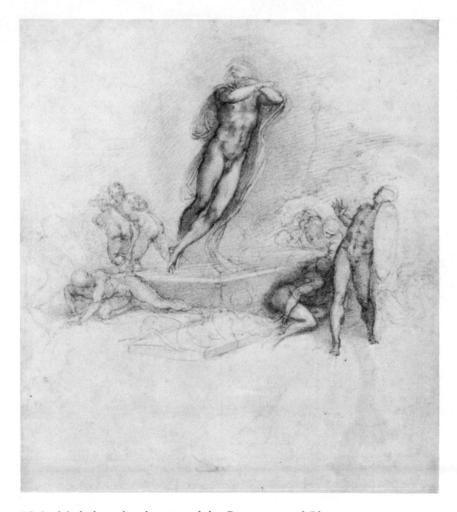

18-2. Michelangelo, drawing of the *Resurrection of Christ.*

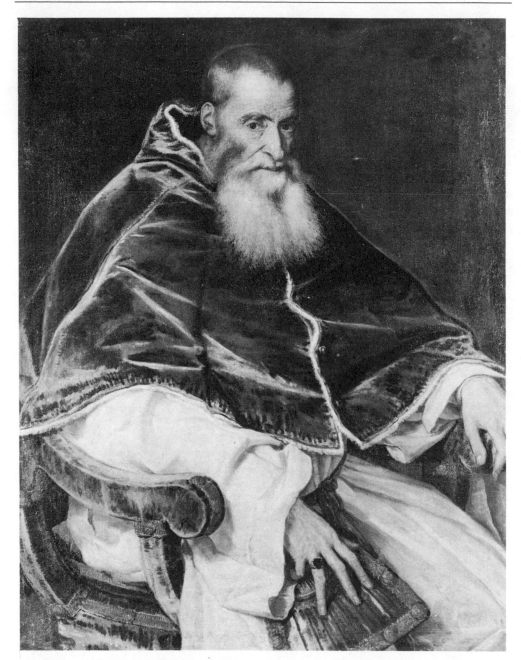

18-3. Titian, portrait of *Pope Paul III.*

spirit, he commanded Michelangelo to cover the entire altar wall with the *Last Judgment*—a subject that had been painted on the entrance wall of many medieval churches in Italy, but had become an infrequent motif during the Renaissance.

Michelangelo has provided a fascinating account of his first encounters with the

new pope. According to the artist, Paul sent for Michelangelo and requested that he serve him. Michelangelo declined, stating that he had to fulfill his contract with the della Rovere duke of Urbino to complete the Tomb of Julius II. The pope, however, was not to be dissuaded. Earlier, I quoted Condivi's account (p. 177) in which Paul angrily told Michelangelo that he had waited thirty years for the services of the artist and now that he was pope he would command them. Paul threatened to tear up the contract for the tomb. This led Michelangelo to consider moving to a territory under della Rovere protection. But in the end he submitted to Paul out of fear of his power and in the hope of placating the pontiff with "gentle words."

Thus, once again, Michelangelo held to the view of himself as an unwilling captive submitting reluctantly and out of fear to the power of a pope. In executing Paul's will by painting the *Last Judgment,* he could continue to experience what seemed to him a state of bondage.

Since the *Last Judgment,* like all of Michelangelo's mature works up to this time, was, to his way of thinking, in antagonistic relation to his commitment to work on the Tomb of Julius, mention should be made of the fate of the tomb during the years of Paul's pontificate. According to Condivi, the pope paid a visit to Michelangelo's home and studio at Via Macel de' Corvi to examine the works for the tomb that were already completed or in progress. After looking at the statue of *Moses* (fig. 14-2), Paul exclaimed, "This statue alone is sufficient to do honor to the tomb of Pope Julius." Michelangelo, however, steadfastly insisted on fulfilling the contract. The pope then said, "I will see to it that the duke of Urbino contents himself with three statues by your hand and that the other three which remain to be done are given to others to do" (p. 77).

Paul's directive created a problem, in that the terms of the contract in force from April 1532 stipulated that Michelangelo was to do six statues by his own hand, allowing that the remaining ones could be finished by others. As a result of Paul's firm stand on the matter, three of the six statues that were to be done by Michelangelo—the *Virgin,* the *Sibyl,* and the *Prophet*—were eventually assigned to another sculptor, Rafaello da Montelupo, in the final tomb contract of February 27, 1542. Later, in July 1542, Michelangelo petitioned Paul for a papal mandate that would also allocate to Montelupo the completion of the statues of *Rachel* and *Leah,* which had been substituted for the pair of *Slaves* in order to accommodate the reduced size of the tomb. This would have left only the *Moses* for himself. Pope Paul acted in accord with Michelangelo's wish in the matter. The duke of Urbino, however, refused this latest request for reassignment. Thus, in the completed tomb that we now view (fig. 9-1), three of the statues—*Moses, Leah,* and *Rachel*— were carved by Michelangelo. So much for Pope Paul's participation in the sad ending of the monument that the artist himself had predicted would be "the mirror of all Italy."

Michelangelo began the actual painting of the *Last Judgment* in May 1536. To free him from possible interruptions, Paul, on November 17, 1536, issued a

motuproprio (the personal edict of a pope) declaring that the artist was released from all obligations to the della Rovere heirs in regard to the tomb until the *Last Judgment* was completed. Thus, a year and a half passed between the conclusion of the plan to have the subject painted and the start of the actual painting.

The fresco is 56 feet high and 44 feet wide. Because of its great size, the cartoon for the work must have been in sections that were integrated in accord with a master design; neither sections of the cartoon nor the master design have survived. Before that stage, however, the artist must have executed hundreds of preparatory drawings, ranging from sketches of small details of anatomy to large compositional groups of individual figures. Of this corpus of drawings, all but about two dozen have disappeared. Yet, from these few we can deduce that from the beginning the general conception was largely as it is in its final, painted form. However, that certain particular elements in the work were changed in form from the preparatory drawings suggests the inner struggles that Michelangelo was undergoing as a result of his conflicted identifications with particular figures and actions in the work.

There are a number of literary sources for the subject of the Last Judgment. Michelangelo's vision of the Second Coming, however, is basically rooted in the description in Matthew 24:30–31:

> And then shall appear the sign of the Son of man in heaven; and then shall all of the tribes of the earth mourn and they shall see the Son of man coming in the clouds of heaven with power and great glory. And he shall send his angels with a great sound of a trumpet, and they shall gather together his elect from the four winds, from one end of heaven to the other.

Before Michelangelo, the early tradition in paintings of the *Last Judgment* had been to present the macrocosm ruled by Christ in a static, symmetrical, and hierarchically ordered composition, with Christ the Judge centered on a throne, extending his arms in a gesture which emphasized a new order of justice. This image received a slightly more dynamic treatment in Giotto's great fresco at Padua (fig. 18-4), in which the judge turns toward the elect, thereby indicating the bliss that will come to the Chosen after their resurrection. Following the Black Plague of 1348, paintings of the *Last Judgment,* as Meiss (1951) has shown, assumed a harsher and more punitive character, reflecting the general view that the plague was God's punishment of man for sinfulness. This view was shown in the greater expressiveness of the Judge, who turns his attention toward and gestures damnation to the sinners below, though with no alteration in the layered, static composition.

Insofar as Michelangelo often looked back to the early Renaissance for inspiration rather than to the immediately past generations of artists, he was very probably inspired by Francesco Traini's *Last Judgment* (fig. 18-5) from the post-Plague period of the 1350s. Michelangelo would have become acquainted with that masterpiece during his lengthy stay in Pisa in the spring of 1529. In the earliest sketch we have by Michelangelo for his fresco (fig. 18-6), the Christ appears to be

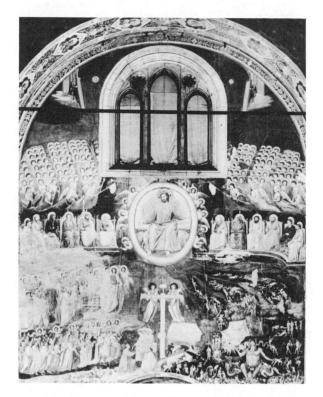

18-4. Giotto, *Last Judgment.*

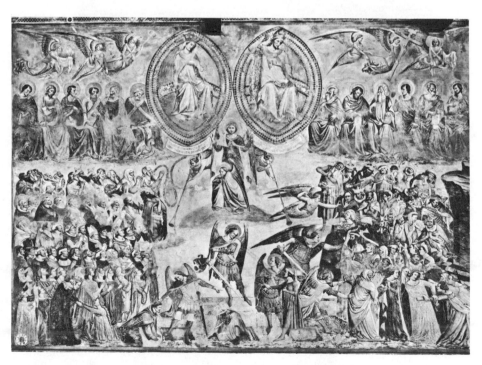

18-5. Francesco Traini, *Last Judgment.*

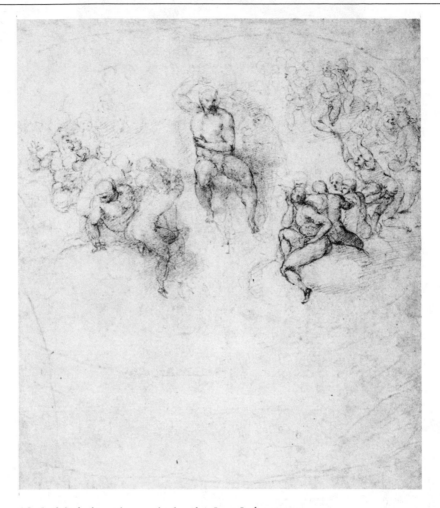

18-6. Michelangelo, study for the *Last Judgment*.

closely derived in almost all respects from Traini's angry Judge, who was concerned with the damned alone. The few Last Judgments that were painted in the quattrocento (such as those by Fra Angelico and Fra Bartolommeo) continue to maintain the tradition of a rigid zonal structure. Michelangelo, however, broke with this invariable tradition by inventing a radically original composition that consists of revolving chains of ascending and descending figures to create the sense of a swirling force.

The viewer who is not familiar with Michelangelo's *Last Judgment* is likely to have difficulty at first in comprehending both the overall narrative and many individual figures. Condivi's description of the painting serves as a guide to the locations of the elements that were traditional in Gothic and Renaissance representations of the Second Coming and the Last Judgment. It also reveals some of Condivi's interpretive attitude toward the work.

The whole is divided into sections, left and right, upper, lower, and central. In the central part of the air, near the earth, are the seven angels described by St. John in the Apocalypse, who with trumpets at their lips summon the dead to judgment from the four corners of the earth. Amongst these there are two other angels holding an open book in which everyone reads and recognizes his past life, so that he must almost be his own judge. At the sound of these trumpets, the graves on earth are seen to open and the human race to issue forth in various and amazing attitudes; although some, according to the prophecy of Ezekiel, have their skeletons merely reassembled, some have them half-clothed in flesh, and others, completely. Some are naked, some are clad in the shrouds or winding-sheets in which they were wrapped when carried to the grave and which they are trying to struggle out of. Among these there are some who do not seem to be quite awake yet, and they stand looking up toward heaven as if in doubt as to whither divine justice may be calling them. Here it is delightful to see some human beings emerging with strain and effort from the earth, and some with outstretched arms taking flight toward heaven, some who have already begun to fly, who are aloft in the air, some higher, some lower, in various attitudes and postures. Above the angels with their trumpets is the Son of God in His majesty, with His arm and mighty right hand raised in the manner of a man who wrathfully damns the guilty and banishes them from His presence to eternal fire; and, with His left hand held out toward His right side, it seems as if He is gently gathering the righteous to Him. At His command, the angels appear between heaven and earth as executors of the divine judgment; at the right they hasten to the assistance of the elect whose flight might be impeded by evil spirits, and at the left side they rush to fling the wicked back to earth, who might have raised themselves already by their audacity. However, these sinners are dragged down by evil spirits, the proud by the hair, the lascivious by their pudenda, and each sinner correspondingly by the part of his body with which he sinned.

Below these evildoers, we see Charon with his bark, exactly as Dante describes him in his *Inferno,* in the muddy waters of Acheron, raising his oar to strike any laggard soul; and, as the bark touches the bank, all those souls can be seen vying to hurl themselves out, spurred by divine justice so that "fear," as the poet says, "is changed to desire." After receiving their sentence from Minos, they are dragged by evil spirits into the depths of hell, where they display amazing attitudes of the grave and hopeless emotions which the place inspires. In the central section, the blessed who are already resurrected form a circle or crown in the clouds of the sky around the Son of God; but His mother, set apart and near her Son, slightly timid in appearance and almost as if uncertain of the wrath and mystery of God, draws as close as she can beneath her Son. After her are the Baptist and the Twelve Apostles and the Saints of the Lord, displaying to the terrible Judge that instrument whereby each of them, confessing His name, was deprived of life: St. Andrew the cross, St. Bartholomew his skin, St. Lawrence the grate, St. Sebastian the arrows, St. Blaise the iron combs, St. Catherine the wheel, and others, other things by which we may recognize them. Above these, at the right and left sides in the upper section of the wall, groups of little angels appear in singular and lovely postures, presenting in heaven the cross of the Son of God, the sponge, the crown of thorns, the nails, and the column where He was flagellated, in order to confront the wicked with God's benefactions which they most ungratefully ignored and to comfort and give faith to the righteous. [pp. 83–87]

Condivi's description does not convey the overall stylistic character of the work, in which Michelangelo has blended fourteenth-century Italian tradition with the formal language of antiquity. It is this merging of styles that led Tolnay (1943–60, vol. 5) to describe the painting as having "the character of a mythical Greek event" (p. 25). Indeed, the beardless Son of God in the center of the work has no precedent in earlier Christs in Judgment. Rather, He looms as a magnificent Greek athlete. The swirl of human energy embodied in the frantic ascension of the elect and the desperate struggle waged by the damned, as well as the flux in the groups to Christ's right and left, are in the spirit of an ancient depiction of the battle between the gods and the Titans (as, for example, in the Hellenistic *Great Altar of Zeus* at Pergamon, fig. 18-7).

Given the new mood of the Counter-Reformation, the strong pagan quality of Michelangelo's painting, particularly in its display of the male nude, engendered harsh criticism in many quarters. One result of this was that over the decades following the completion of the work, subsequent popes ordered the painting of drapery over the exposed genitals of thirty-six of the figures. In addition, one figure—Saint Blaise—was changed in position. He originally stood naked directly behind Saint Catherine, who, in turn, was naked and bending over in such a way that the image suggested the possibility of Saint Blaise entering her from the rear (fig. 18-8). The response to Michelangelo's representation of the saintly couple, ranging from mirth to outrage, was dampened when Michelangelo's follower Daniele da Volterra was charged in 1565 with rotating Saint Blaise's position to the one we now see (fig. 18-9), where he turns back to look at Christ, and with clothing the voluptuous Catherine in full drapery. The provocative aspects of these and other features of the original painting were such that an anonymous contemporary was inspired to publish the following verse:

> Here's St. Catherine bent over head first,
> Naked as nature made her,
> And the rest of the saints neatly disposed
> To show their butts to Don Paolini [i.e., Pope Paul III]:
> .
> Another stands strapped in the Inferno
> With a serpent biting his cock . . .[2]

A striking contrast exists between the "scandalous" subjects depicted and the overall pagan style, on the one hand, and, on the other, the pious descriptive rhetoric that Michelangelo's followers subsequently applied to the work. Leo Steinberg (1975) offered a persuasive explanation for this seeming contradiction—namely, that Michelangelo conceived and executed the *Last Judgment* in a period of more permissive religious attitudes, whereas its completion took place on the threshold of the new repressive era of the Counter-Reformation.

In addition to the curious blend of pagan imagery and sacred theme, Miche-

2. Translated by Steinberg (1980).

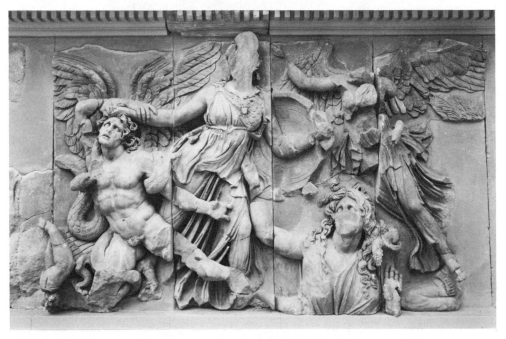

18-7. Hellenistic period, *Great Altar of Zeus* at Pergamon, east frieze (detail of goddesses battling the Titans).

langelo also introduced calculated ambiguity in his representation of the principal figures in the painting. He thereby successfully masked his own private drama, which is also being enacted in the work. The private level of meaning of the *Last Judgment* is communicated largely through some of the central images.

As Steinberg (1975a) has noted, the character of the entire event depicted hinges on the intention that is imputed to the pivotal figure of Christ (fig. 18-10). Michelangelo's Christ is suffused with ambiguity. Is He standing, or rising from an invisible throne, or moving forward? Are His arms and hands engaged in one coordinated significant gesture or two independent ones? Most important is what interpretation may be given to His facial expression. Indeed, it is on this very point that students of the work from the sixteenth century to the present day have been in marked disagreement. Condivi and Vasari left a deep imprint on all future readings of the painting by their description of the "wrath" of Christ. This view was restated in the nineteenth century by Stendhal and Delacroix. To this day major scholars view Christ in ways that have roots in the early description. For example, Hartt (1964) sees Him as "frightening"; Meiss (1951) writes that He is "moved to denunciation"; and Clark (1956) stresses His "imperious" character. In contrast, Christ's face is regarded as utterly impassive by such observers as Hibbard, Panofsky, Steinberg, and Tolnay. My own reading of the face is in accord with that of this latter group.

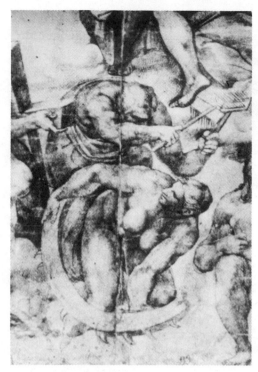

18-8. Gaspar Becerra, detail of drawing after Michelangelo's *Last Judgment* (St. Blaise and St. Catherine).

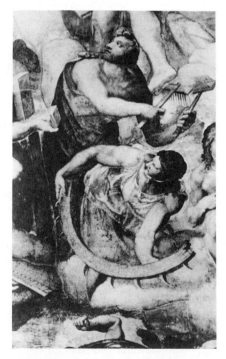

18-9. Detail of figure 18-1 (St. Blaise and St. Catherine).

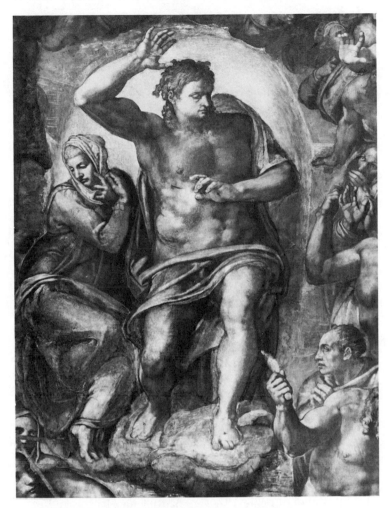

18-10. Detail of figure 18-1 (Christ the Judge).

Moving on to the large figure of Saint Bartholomew, just below and to the right of Christ, we come to the most startling detail in the entire work. For here Michelangelo has starkly asserted the personal dimension within the public narrative by painting his self-portrait on the sheet of flayed human skin the martyr is holding in his left hand—which is, incidentally, in the direct line of sight of Christ (fig. 18-11). This self-portrait is a searing emblem of self-revelation. Yet it was not actually identified as the face of Michelangelo until as late as 1925, and then by an Italian physician, Francesco La Cava (1925). However, that the portrait on the skin was not of Saint Bartholomew himself, as one would expect since he was martyred by being flayed, was apparently recognized at the time. Evidence for this comes from a letter by a Florentine clergyman, Don Miniato Pitti, to his friend Giorgio Vasari, written on May 1, 1545: "there are a thousand heresies here, and above all in the beardless skin of St. Bartholomew, while the

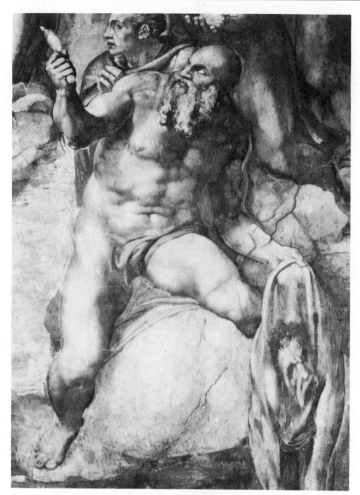

18-11. Detail of figure 18-1 (St. Bartholomew).

[figure that is not flayed] has a long beard; which shows that the skin is not his, etc. [*sic*]."[3]

There are other indirect suggestions that contemporaries knew the identity of the face portrayed. Why, then, was this fact kept secret? Steinberg (1980a) concludes that Michelangelo's followers did indeed know whose portrait was on the skin but realized that, in the cold climate of the Counter-Reformation, there would be little sympathy for such heretical egocentrism as placing one's own self-portrait in the central section of a *Last Judgment*. So they joined together in a conspiracy of silence that influenced what viewers "saw" for the next four centuries, "because the visual data alone defied expectation."

In addition, I believe that recognition of the identity of the portrait was impeded because of reluctance on the part of viewers to accept this self-mutilating

3. Translated by Steinberg (1980a).

statement as the one the artist would choose to leave about himself for posterity. It could be argued that this self-portrait might have been interpreted as a genuine act of confessional piety. The stronger operative force, however, was that Michelangelo "the Divine" had to be conceived of by his public as heroic, not as a pathetic rumpled skin stripped from flesh and bone, and tenuously held in a position in the composition of the painting that clearly suggests the possibility of its being condemned to Hell at the impending moment of judgment. So the visual data defied expectation on two counts: first, the dissonance between the central placement of the self-portrait and the sacred theme of the work; second, the dissonance between the peculiar nature of the self-portrait and the collective need in any culture to preserve an image of genius in heroic terms.

Since the work of Giotto two centuries earlier, no single project influenced the future course of art as much as the Sistine Chapel ceiling. With the *Last Judgment,* Michelangelo dictated the new direction in which artistic imagery was to evolve. In its formal aspects the *Last Judgment* represents an emphatic renunciation of the art of the High Renaissance. Rather than refine and advance the two-century-long style in Italian art which he, Leonardo, and Raphael had shaped into its highest form, Michelangelo, now in his sixties, chose to suspend the cherished canons of the era—idea expressed through physical beauty, space defined by perspective and palpable existence, figures drawn in normative proportions, and an underlying sense of classical harmony. Even in the two upper lunettes, each of which contains a wonderfully choreographed group of beautiful and athletic angels clinging to the instruments of Christ's Passion in a tornadolike swirl (fig. 18-12), the figures in the *Last Judgment* are by and large weighty, lumpish, and lacking in conventional beauty. The Patriarchs on either side of Christ—particularly Saint John the Baptist on His right and Saint Peter (holding the keys) on His left, are poorly proportioned, with tiny heads and massive bodies, and too large in relation to the group of martyrs just below them. The spatial organization suspends perspective and realistic consideration. Rather, the blue, gray, and brown areas between the figures impart an eerie interface between palpable space and void. Except for the central image of Christ and the Virgin, little in the fresco conveys harmony or serenity.

The work expresses a bitter effort on the part of Michelangelo to renounce the culture in which he lived. His discontent was not simply a criticism of the prevailing artistic climate, the sorry state of Christendom, or the new tyrannical rule of the Medici in Florence. That is, it was not merely a judgment of the external world. It also represented bitterness of a more inner-directed nature—perhaps over the failure of his platonic homosexual adaptation, which had focused on Tommaso, to achieve the magical goal of suspending time, with its unrelenting process of aging.

While working on the *Last Judgment* Michelangelo wrote to his nephew in November 1540, "I'm old and having great difficulty in managing for myself" (letter 206). How different in tone this statement is from the spirit that imbued

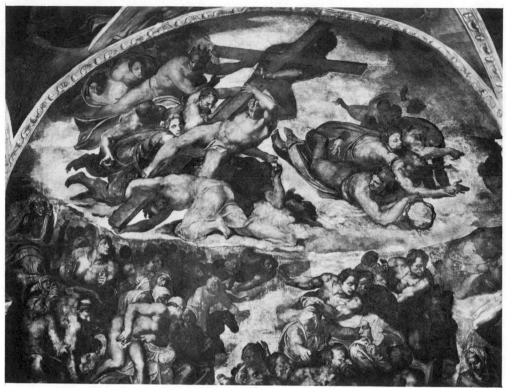

18-12. Detail of figure 18-1 (the left lunette).

the *Ganymede* drawing (fig. 16-1) and the lyric verse for Tommaso only six years earlier! It was also this failure of the homoerotic adaptation to still the tide of anxiety which, as we have seen in the preceding chapter, greatly contributed to Michelangelo's turning to a woman, Vittoria Colonna, for a spiritual union.

It should be noted in passing that the stylistic leap taken in the *Last Judgment* removed it from the tradition of the Renaissance. It bestowed, in effect, Michelangelo's blessing on, as well as laying a foundation for, the Mannerist style that was to dominate art for much of the remainder of the sixteenth century in both Rome and Florence.

As one might well expect, overall interpretations of the *Last Judgment* are many, widely varied, and often contradictory. Most suggest something of Michelangelo's faith and his position on eschatological questions. For example, Hall (1976) has argued that the fresco stresses the optimistic theme of resurrection. She has written that the work expresses: "tension between man's nobility and his absolute dependence upon God, between free will and divine predestination. . . . *Each figure responds with self-assurance, not resignation;* clearly they do not feel themselves pawns in the hands of fate. Yet this whole structure rises and falls inexorably around the pivotal Christ" (p. 92, my italics).

Steinberg (1975a, 1980, 1980a) regards the painting as a protest against the

evolving, pessimistic church position that was soon to become dogma. This new position did not allow for the survival of human nature after the Judgment and therefore precluded the possibility of redemption. In other words, Michelangelo's attitude was one of hope, a denial of finality. Steinberg details eight features of the fresco which, when considered together as a coherent pattern, reveal what he sees as the artist's program. For example, the attitude of hope is reflected in two of the angelic trumpet choir who are not blowing their horns, suggesting that the "Last Trumpet" is yet to be sounded (fig. 18-13). Moreover, a number of features of Hell point to the possibility of reprieve from damnation. This view was also proposed by some members of Michelangelo and Vittoria's loyal reform circle before the Inquisition and the Council of Trent.

These aspects of the painting do indeed express the struggle within Michelangelo over what becomes of mortal remains and the soul after death. His fascination with this subject and his resistance to any easy explanation or dogma had been increasing since 1519, when he began work on the Medici Chapel. This concern becomes fully evident in the *Last Judgment*.

The primary personal drama in the painting, however, is enacted by three figures—Christ, the Virgin, and Saint Bartholomew (fig. 18-14). The rest of the close to four hundred figures largely serve as a supporting cast. They and the compositional organization clarify and elaborate upon the narrative established by the three principals. Richard and Edith Sterba (1978) were the first to explicate the interaction of Christ, the Virgin, and Saint Bartholomew in terms of "the most important conflict in his troubled soul: the aggression against the rejecting mother and the condemnation with which his Superego met this aggression" (p. 175). Thus, they see Bartholomew, with whom Michelangelo identified, as directing an accusation specifically at the Virgin:

> It is unmistakable that he points the knife and his reproachfully staring eyes at her, as if he indicted her for all the martyrdom and injustice which he had to suffer from her in his childhood and, through her, throughout his life. . . . The intensity of the reproaches has struck her so hard that she moves nearer to the Savior and half hides behind him for protection and her face she turns away in shame and guilt. [p. 176]

The Sterbas conclude that Bartholomew, who stands for Michelangelo, is punished for his reproachful attack on the mother of God. This accounts for the pronouncement of severe condemnation by Christ under which Bartholomew is cringing.

Exploration of this central drama between Christ, the Virgin, and Saint Bartholomew must also be placed in the context of a striking compositional detail. As Steinberg (1980a) has pointed out, the self-portrait on the flayed skin is centered on a Hell-bound diagonal axis that runs from the upper left Crown of Thorns in the lunette, downward through the wound in Christ's side (the source of the Sacraments which, according to Saint Augustine, are the foundation of the church); through the knife that Saint Bartholomew brandishes; through the center of the

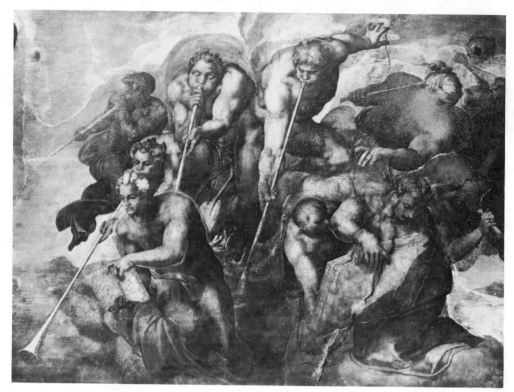

18-13. Detail of figure 18-1 (the trumpeting Angels).

self-portrait; then through the face of the uppermost sinner being dragged down into Hell; and finally through Minos, the prince of Hell himself, whose penis is being fellated by a serpent. Most striking is that on this diagonal line through the painting, the midpoint of the artist's face falls exactly at the halfway mark. As this can hardly be attributed to coincidence, it must be assumed that Michelangelo was subtly placing himself at the fulcrum of the drama.

There have been various interpretations of Bartholomew's flayed skin. A number of scholars favor its basis in texts in the Bible and the church fathers (e.g., Tertullian). These origins, however, seem belabored to me. I favor the different path taken by Edgar Wind (1958) in his study of pagan mysteries in the Renaissance. Wind traces the image of Bartholomew's flayed skin back to the ancient myth of Apollo and Marsyas.

This myth, in brief, relates how the satyr Marsyas came upon a flute that the goddess Athena had thrown away because whenever she played it her face would become unattractively distorted. Marsyas, in time, grew so accomplished at playing this instrument that he became a worthy rival to Apollo, who was renowned for his skill with the lyre. Marsyas then had the hubris to challenge Apollo to a contest. Apollo agreed—under the condition that the winner could do as he chose with the loser. Apollo, by virtue of his divine gifts, performed more beautifully

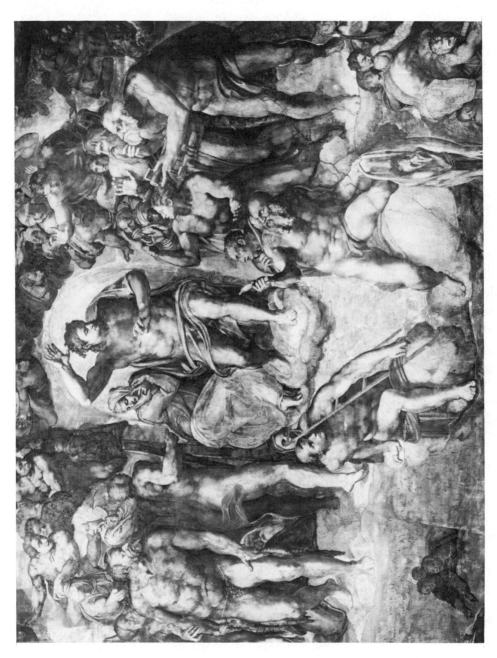

18-14. Detail of figure 18-1 (Christ, the Virgin, and St. Bartholomew).

than Marsyas, causing the panel of Muses to judge in favor of the god. Where-upon, Apollo, though the deity of rationality, sublimation, and the higher cre-ative accomplishments of social order, wrought a gratuitously sadistic revenge upon Marsyas: he had the satyr flayed alive and his skin nailed to a tree.

The myth of the flaying of Marsyas appears to have been a compelling one during the Renaissance. For example, Raphael painted it on the ceiling of the Stanza della Segnatura (fig. 18-15). It was also the subject of one of Titian's greatest paintings (fig. 18-16). Done in his eighties, the work has been described by Freedberg (1970) as "Titian's most technically radical late work, and the most complex in its inhabiting idea" (p. 352). The personal meaning of the myth to Titian is graphically stated by his self-portrait in the painting as the contemplative and melancholy witness to the eruption of impulses in Apollo that seem antithet-ical to art and reason, and yet are an integral part of the complexity of the creative imagination. That the other two crowning figures of sixteenth-century painting, Raphael and Titian, rendered the theme of the flaying of Marsyas by Apollo suggests how powerful a motif it was in that culture.

Flaying itself was a word bandied about Michelangelo's household, according to an anecdote related by Benvenuto Cellini (1562). Cellini described a visit he made in 1553 to Michelangelo for the purpose of persuading him to return to Florence:

> While I was pressing Michel Agnolo with arguments he could not answer, he turned round sharply to Urbino [Michelangelo's servant and assistant of many years' stand-ing], as though to ask him his opinion. The fellow began to bawl out in his rustic way: "I will never leave my master Michel Agnolo's side till I shall have *flayed him* [scorticherò lui] or he shall have *flayed me* [scorticherà me]." These stupid words forced me to laugh. [p. 452, my italics]

Cellini then goes on to recount his subsequent audience with Cosimo de' Medici, the duke of Florence:

> so I went on talking about Michel Agnolo Buonarroti. At this he the Duke showed displeasure; but Urbino's stupid speech about the *flaying* [scorticamento] made him laugh aloud. Then he said, "Well, it is he who suffers!" [i.e., Michelangelo, by not returning to Florence]. [p. 453, my italics]

There are other reasons for assuming that the myth of Apollo and Marsyas was a source for the image of the self-portrait on the flayed skin. Two major writers with whom Michelangelo was certainly most familiar, Ovid and Dante, treated the theme. In Ovid's *Metamorphoses* (6. 385–87), as Marsyas awaits his "living death," he cries out to Apollo, "'Why do you strip myself from me?' he cried 'O I give in, I lose, forgive me now, No hollow shin-bone's worth this punishment.'" In the *Paradiso*, Dante has escalated the agony and the plea for forgiveness of Ovid's Marsyas into a transcendental state. For Dante, the fate of Marsyas became a ritual image of the means by which he, the poet, could receive the laurel of Apollo and ascend to the consecrated peaks of Parnassus. Thus, Dante speaks:

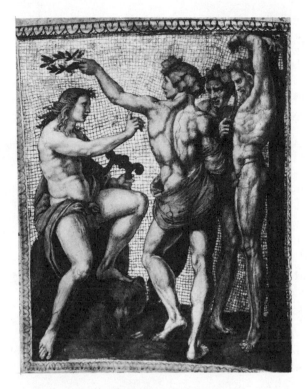

18-15. Raphael, *The Flaying of Marsyas.*

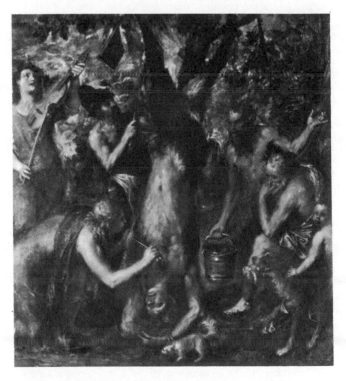

18-16. Titian, *The Flaying of Marsyas.*

"Enter into my breast and breathe there as when you drew Marsyas from the sheath of his limbs. O divine Power, if you do so lend yourself to me that I may show forth the image of the blessed realm which is imprinted in my mind, you shall see me come to your beloved tree and crown me with those leaves of which the matter and you shall make me worthy." [canto 1, lines 19–27]

In addition to all this, Michelangelo was familiar, from his youthful days among the Neoplatonic philosophers at the Medici Gardens, with Pico della Mirandola's attempt to reconcile the Christian and pagan worlds, in the course of which he concluded, like Dante, that through his hideous excoriation, the mortal Marsyas could achieve divine ecstasy.

Further insight into Michelangelo's concern with the idea of shedding the skin may be obtained from a sonnet he wrote in the 1530s known as *The Silkworm*. In it he emphasized the necessity to become aware of one's true identity, hidden beneath the skin, even at the cost of death.

With grace to all, to itself only scorn,
A wretched beast is born in grief and pain,
Clothes other's hands, but its own hide unskins,
And only in dying may be called well born.

So too I'd want to have my fate adorn
My Lord, while living, with my dead remains;
As on the rock the serpent sheds its skin,
Only in death can my condition turn.[4]

If we accept the primary importance of Marsyas as the latent object for identification on the part of Michelangelo, it becomes comprehensible why he elevated Saint Bartholomew, not among the more celebrated martyrs of the church, to a central position in the painting.[5] Bartholomew's fate of being flayed alive served as a vehicle for expressing in a sacred work the personal significance the theme of flaying held for the artist.

In the painting, Saint Bartholomew is intensely engaged with Christ. Michelangelo's image of Christ is clearly identified with Apollo the sun-god. Indeed, the majority of writers on the *Last Judgment* agree that this Christ is modeled on ancient Apollo types. The golden light behind Him symbolizes the solar energy that is the basis of *sol justitiae* and has its foundation in John 8:12: "Then spake Jesus again unto them, saying, I am the light of the world." There was also another tradition from the Middle Ages through the Renaissance of representing *sol justitiae* as an Apocalyptic avenger rather than the merciful judge. This vengeful image can be exemplified by an engraving by Dürer (Bartsch, 1803–21, no. 79).[6] Michelangelo's Christ the Judge is, however, spiritually much closer to an ancient classical Apollo than to any previous Renaissance Christ.

4. Gilbert and Linscott (1963, poem 92).

5. In a survey of 1,796 religious paintings in Italy dating from 1420 to 1539, Saint Bartholomew was not among the twenty saints most frequently represented (see Burke, 1972, pp. 145–52).

6. See Panofsky (1955, chap. 6) for a discussion of the iconography of *sol justitiae*.

That the myth of Apollo held particular interest for Michelangelo is suggested by evidence from his art in the years shortly before he embarked on the *Last Judgment*. We have noted that in 1531, during the last stage of what was conceived and largely executed as a statue of David, Michelangelo transformed the image of David into one of Apollo (*David-Apollo*, fig. 15-24). Though political considerations would explain Michelangelo's not wishing to present a David to the anti-republican governor of Florence, no satisfactory argument has been advanced to account for why Apollo was chosen instead. In the absence of such an explanation, we assume that the image of Apollo held some personal meaning for Michelangelo. His interest in the god asserts itself, too, in the presentation drawings for Tommaso from 1532–33. In the *Fall of Phaethon* (fig. 16-8), the central character, Phaethon, is the son of Apollo. Here, the narrative concerns Apollo's role as sun-god (Phoebus). The other drawing that commands our attention in this context is that of the *Punishment of Tityus* (fig. 16-4), whose crime was attacking Apollo's mother, Leto, and whose punishment was meted out by Apollo and his sister Artemis.

In exploring the possible basis for Michelangelo's interest in Apollo, I shall again, as in the earlier discussion of the Doni tondo (chapter 7), consider the work of art in a way that has proved useful in relation to dreams and fantasies— namely, as a whole in which the various parts reflect different—sometimes contradictory—aspects of its creator. Each of the principal actors in this drama of the *Last Judgment*—not only Bartholomew, but Apollo as well—may be understood, in part, as an expression of one aspect of the artist's inner world. Several significant themes in Apollo's "history" could have struck chords in Michelangelo.

First, Apollo was born of the union of Zeus and Leto. However, Zeus's enraged wife, Hera, became intent on the destruction of Leto and decreed that she should not be delivered of her child in a place where there was sunlight. Therefore, Apollo was born on the shaded, floating island of Delos and was soon thereafter abandoned by his mother, never having been nursed by her, to a nurse, Themis, who fed him on nectar and ambrosia. The parallel between Apollo's abandonment by Leto and Michelangelo's abandonment by his mother is clear. In the myth, jealous Hera is assigned the responsibility for Leto's action. The myth, however, as Deutsch (1969) has noted, abounds with episodes reflecting Apollo's distrust of and vengeful attitude toward women. His destructive impulses against Leto are defended against and displaced onto other symbols of matriarchy. For example, in one episode Apollo slays the python who is pursuing Leto at its home shrine of the temple at Delphi. Then, after a series of events, Apollo takes over the Delphic Oracle for his own service and aims. This usurpation of the woman's role at Delphi signals the transition from the matriarchal rule of the earth-goddesses (Demeter and Persephone) to his own. We might say that Apollo wards off his own destructive impulses toward his mother, embodied in the python, by slaying it. This episode parallels another in which Apollo slays the giant Tityus as he is about to rape Leto. These python and Tityus incidents mirror a commonplace process in

dreamlife—the displacment of one's own unacceptable impulses onto someone else. The dreamer then assumes the attitude of opposing the other actor in the dream, onto whom these impulses have been projected.

There are other episodes in the myth of Apollo in which the god's aggression toward maternal figures is clearly evident. In one, he loves Coronis, a Thessalian princess, who is pregnant with his child. He learns, however, of her unfaithfulness to him and promptly slays her. As she is being consumed by flames he plucks his son, Asklepios, from her womb, to rear him as a single parent. In chapter 7, in relation to the Sistine Chapel *Expulsion from Paradise* (fig. 7-18), I discussed Aeschylus's *Oresteia*, in which the matricide committed by Orestes was under the auspices of Apollo. Indeed, at the climax of the drama, it is Apollo who defends Orestes before the tribunal of Athenians. In Michelangelo's painting of the *Expulsion*, Adam's gesture derives from an *Orestes Sarcophagus* (fig. 7-20) which shows Orestes warding off the Furies. I concluded that Orestes' crime of matricide was the theme that attracted Michelangelo to this particular source of inspiration for his Adam. In this connection, it is striking that for the gesture of the Virgin in the *Last Judgment*, Michelangelo returned to his earlier Eve. This link between the Virgin and the *Expulsion* indirectly suggests Michelangelo's unconscious concern with the Orestes-Apollo crime of matricide.

One final episode in the myth of Apollo deserves mention, that of Apollo and Hyacinthus, which Michelangelo knew through Ovid (Met. 10. 162–219). Apollo is the lover of the beautiful youth Hyacinthus, who is killed as a result of an accident at play, when a discus thrown by Apollo bounces off a rock. The grief-stricken Apollo asks over the body of his fallen love: "Or was my love to blame—the guilt that follows love that loves too much?" These sentiments are remarkably close to those expressed by Michelangelo to Tommaso, in both words and drawings, only a few years earlier.

The central motifs in the myth of Apollo—early maternal abandonment, matricidal impulses, and homosexual inclinations—would have held deep significance for Michelangelo. Perhaps most important is that after many other coarse adventures, Apollo tames the frenzied Muses and thereafter devotes himself to the principles of order, moderation, and sublimation through creativity. These were precisely the precepts that governed the life of Michelangelo the artist.

To return to the painting itself, the central drama that takes place among Christ, the Virgin, and Saint Bartholomew on the surface represents only one level of narrative. These images also contain the latent narrative of the Apollo-Marsyas encounter. I have suggested that we can better understand the relation of artist to image by assuming that parts of Michelangelo's inner mental representation of himself and significant objects are invested in or, more accurately, projected onto, each of these three actors. In their relation with one another, then, is shown a part of Michelangelo interacting with another part, reflecting the ongoing conflict within his psyche between different mental structures, emotions, thoughts, and impulses.

With respect to the primary figure of Christ, we accept him as "Christ" without

question because of his position and gestures in the context of the subject matter of the painting. But he is *also* Apollo. The artist has presented us with an amalgam of types, and we are free of the necessity to identify him as one or the other. The central figure in this painting *must* be Christ in order to provide religious iconographic coherence. Similarly, the figure placed where Bartholomew stands must also provide iconographic significance. That the choice was Saint Bartholomew rather than any other martyr primarily hinged on his particular form of martyrdom—flaying—which provided the bridge to the persona who really engaged Michelangelo's fantasy, the satyr Marsyas. In this way, at the private level of meaning, Michelangelo could express, through the confrontation between "Christ-Apollo" and "Bartholomew-Marsyas," his own inner conflict between forbidden impulses and guilt, reproach and fear of retribution. One specific theme in this regard may well have been Michelangelo's identification with Marsyas *as an artist* committing the hubris of aspiring too greatly (as did Phaethon). He anticipated punishment for the competitive and grandiose fantasies underlying his creative achievements.

The pagan substratum of the painting's central drama is further supported by the observation of Tolnay (1943–60, vol. 5, p. 113) that the form and position of the Virgin are largely modeled on the ancient prototype of the "crouching Venus" (fig. 18-17).[7]

The meaning I attribute to the Apollo-Marsyas interaction is largely rooted in the timing of this work in the course of Michelangelo's life. The conception of the *Last Judgment* and the unfolding of solutions began in late 1534, immediately after Michelangelo's permanent move to Rome. The move and his reunion with Tommaso were inseparably fused phenomena for Michelangelo. The fantasies that shaped the intense, immediate attachment to Tommaso have already been explored at length but deserve brief mention once again in the attempt to understand further why the *Last Judgment* subsequently evolved into the particular form it did. As he clearly expressed in the *Ganymede* drawing for Tommaso, Michelangelo yearned for immortality through homosexual surrender to a youthful god. This desire, however, was also experienced as deserving of punishment. In the *Tityus* drawing, the punishment is portrayed as eternal in time and erotic in form. Again in the *Phaethon* drawing, the theme of swift punishment for the hubris of daring to reach beyond one's capacity and prescribed station is dramatically illustrated. It should be noted that in the last two drawings the ultimate fates of Tityus and Phaethon resulted from confrontations between them and Apollo. Thus we might speculate that among his multiple views of Apollo, Michelangelo regarded the god as a symbol of a punishing, parental figure in relation to his feelings toward Tommaso.

The friendship between Tommaso and Michelangelo prevailed throughout the

7. The modeling of the Virgin after the crouching *Venus* raises the question in passing of whether the ancient work also served as model for the head and arm position of Eve in the *Expulsion from Paradise* (fig. 7-19).

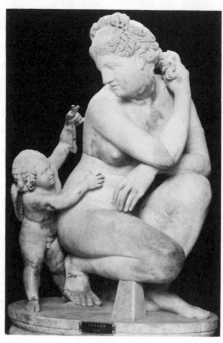

18-17. Ancient Roman, *Venus and Amor.*

period of work on the *Last Judgment* and indeed to the end of Michelangelo's life, some thirty years later. This fact is indeed a testament to Tommaso's sensitivity and Michelangelo's adaptability, inasmuch as he was, of course, to be frustrated in his unconscious fantasy of finding a lasting renewal through the young Roman.

By 1536, when Michelangelo began the actual painting of the fresco, the shift from a high degree of Neoplatonic influence in his art and thought to a more devout Christianity was already pronounced. Moreover, the names of handsome youths were no longer linked with the artist in the way they had been before. Instead, at about the time when work on the *Last Judgment* began, the relationship between Michelangelo and Vittoria Colonna began.

Thus, the years of work on the *Last Judgment* were marked by extreme flux in Michelangelo's inner life and ideological outlook. In fact, it can be said that the years from 1534 to 1537 witnessed the most radical change in his thought of any comparably short period of his adult life. This phenomenon leads to the question at hand: how, if at all, did this shift in Michelangelo's concerns and attachments find expression in his sole creative enterprise of the period 1534–41?

With these issues as background, let us return to Saint Bartholomew. His is painted with the same kind of ambiguity that characterizes Christ. It is not clear whether Bartholomew is angrily brandishing the knife he holds in his right hand at Christ or whether he is pleading with Christ for a more merciful dispensation for himself or, perhaps, for all the sinners who are falling along the oblique

compositional axis descending into Hell. Most prominent among these, of course, is Michelangelo himself, on the flayed skin.

Whereas Saint Peter (holding the keys to the right of Christ) could be read as "imploring," as he reaches forward with both hands to Christ, I do not believe the same could be said of Bartholomew. Bartholomew's right hand tightly clasps a knife pointed at Christ, which seems to be a clear gesture of rage and vengeful intent. Bartholomew, whose head, incidentally, bears a marked resemblance to Moses' (fig. 14-2), appears to be accusing Christ of having betrayed him. The saint's faith, apostolic mission, and painful sacrifice have not led to eternal bliss in Michelangelo's conception. Rather, the threat of damnation and eternal torture is imminent. Bartholomew's hand is thrust toward Christ but, significantly, the point of the blade curves in the direction of the Virgin. Perhaps the more conscious and intended tension is between Michelangelo and the omnipotent male, whereas at the deepest level, as the Sterbas (1978) propose, the artist's indictment is against the mother—the original abandoning figure. In his identification with Marsyas, Michelangelo seems to be saying that in submitting to the ritual of flaying that Apollo commanded, his hope, articulated by Dante, was that the spirit of the youthful god would enter and transform him. In Michelangelo's life experience this idea corresponded to his fantasy of incorporating Tommaso's life-enhancing energies and characteristics through service and submission to him. The disappointment must have been profound as passion evolved into reality-bound friendship. Perhaps the delay of Michelangelo's disappointment until late 1535 or 1536 explains why the figure of Saint Bartholomew is not present in the first compositional drawings for the Last Judgment (fig. 18-18). Rather, Bartholomew seems to have been a later idea. Judging from the drawings of the saint in which the knife is visible but not the flayed skin (fig. 18-19), I assume that the idea of having the saint hold his skin with the artist's self-portrait on it was an even later thought.

In speculating about the late development of the figure of Bartholomew, one line of inquiry we may take is to follow the course of the primary relationship in Michelangelo's life during the early years of work on the painting—that between the artist and Tommaso. In this reconstruction we must fill in areas where facts are not obtainable with probabilities based on the facts that are known and on what we have concluded thus far about Michelangelo's characteristic pattern of adaptation. The documents are lost, but Ramsden dates Tommaso's marriage in the year 1538. Details of his betrothal and courtship are lacking. It is nevertheless fair to say that these events in the life of Tommaso must have brought about a change in his emotional investment in Michelangelo. The effect of this change on Michelangelo would very likely be significantly to attenuate the fantasy that so consumed the artist in the few years before and during the beginnings of the Last Judgment.

Michelangelo's frustration with the homosexual "solution" to the pain of his existence yielded to the deep religious commitment that was to dominate his

18-18. Michelangelo, study for the *Last Judgment.*

thought and art in his remaining years. Yet throughout this transition certain images remained constant, although the manifest meaning assigned to them was different. Thus, in a sacred madrigal for Vittoria Colonna, which Michelangelo composed in the late stages of work on the *Last Judgment,* he employed the skin metaphor and then drew a religious parallel to Dante's identification with Marsyas and his plea to Apollo for salvation.

> Although *I change my skin*
> For short years toward the end,
> I cannot change old ways to which I'm used,
> That with more age push and compel me more.
> To you, Love, I must own
> My envy of the dead.
> I am frightened and confused,
> Such, for myself, my soul's convulsive fear.
> Lord, in the final hour,
> Stretch out thy pitying arms to me, take me
> Out of me, make me one that pleases Thee.
> [my italics][8]

Ultimately, the question of why Michelangelo felt that he was particularly

8. Gilbert and Linscott (1963, poem 159).

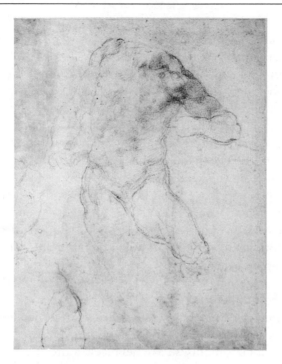

18-19. Michelangelo, study for *St. Bartholomew.*

vulnerable or deserving of damnation is central to the painting. The answer is determined by many factors. In terms of the recent currents in his life, there is little doubt that his homosexual impulses, despite attempts to integrate them into an acceptable Neoplatonic framework, remained both unacceptable to him and suffused with guilt. Had it not been so, presumably Michelangelo would have led an ongoing, active homosexual life. In the drawings of *Tityus* and *Phaethon* he made for Tommaso, we find graphic documentation of his conflict. Perhaps a subordinate component of the Christ-Apollo and Saint Bartholomew narrative is the reproach being expressed by Michelangelo, through the saint, at the beautiful figure of the heroic nude Judge for being the symbolic object of homosexual temptation.

A second possible cause for the self-damnation of the artist may be inferred from the interaction between Bartholomew and the Virgin. Here, there is evidence, in the curving of the knife blade toward the Virgin, of Michelangelo's rage against the consummate maternal image. This degree of primitive filial rage, although sublimated into highly individualistic conceptions of women in both his sacred and his secular art, was not without considerable guilt. The theme of betrayal by the maternal figure is reaffirmed as the Virgin averts her gaze (which would naturally have been straight ahead from her body position) from the area of the painting that contains the saint. She is depicted as *not* intervening on behalf of Bartholomew-Michelangelo. At the same time, she seems to yield her body to

a melting away of boundaries between herself and Christ-Apollo, thereby entering into a physical union that excludes Michelangelo. This theme of exclusion has been frequently seen as one that informed his works from the very beginning.

The final wellspring of guilt I want to mention in connection with the *Last Judgment* involves Michelangelo's relationship to paternal authority. Earlier I stressed the split in Michelangelo's attitude toward his denigrated actual father and various idealized, powerful, protective father-surrogates. Ultimately, all of these father figures "failed" him. Lorenzo the Magnificent died prematurely, leaving the seventeen-year-old artist adrift. Then, in Bologna, Aldovrandi was not able to protect young Michelangelo from the vindictive plots of jealous local artists. A few years later, Michelangelo had to share Pope Julius's favor with Bramante and Raphael. Moreover, the pope's ambivalence about the grandiose project for his own tomb placed Michelangelo in the unenviable position of being endlessly and hopelessly fettered to the uncompletable project. The disappointments for Michelangelo continued into the papal reigns of Leo X and Clement VII. Thus, the longed-for nurturance from a paternal transformation of the early mothering figures was destined never to be fulfilled.

I have traced three principal psychological motifs that demanded a reduction in tension through retributive fantasies of damnation: guilt attending homosexual, matricidal, and patricidal impulses. Michelangelo's dread of the "deserved" punishment existed in a deeply felt struggle with fervent but less optimistic wishes for salvation. It is this inner dialectic that underlies the very center of the drama which constitutes the center of the *Last Judgment*.

Chapter Nineteen

The Last Years of the Pontificate of Paul III, 1542–1549

On Christmas Day 1541, the public was first admitted to view the *Last Judgment*. Michelangelo's characteristic state of mind upon the completion of his major works can be inferred from a passage in a letter he wrote less than a month later to an old friend in Florence, Niccolò Martelli: "I am a poor fellow, and of little worth, plodding along in that art which God has assigned to me, in order to prolong my life as long as I can" (letter 212).

Because of Pope Paul's prodigious energies, Michelangelo was not to be given a moment's respite. Even before the plaster had dried on the final segment of the *Last Judgment*, the pope wrote of his plan for a fresco program for his newly finished private chapel.[1] By the end of 1542, Michelangelo had started work on the principal paintings for the two side walls of the Pauline Chapel, the *Conversion of Paul* (fig. 19-2) and the *Crucifixion of Peter* (fig. 19-3). These two frescoes were to occupy the artist continuously through the decade until the death of the great pope in November 1549.

For Michelangelo this period was extremely productive. In addition to the Pauline frescoes, he resumed activity in architecture with designs for two monumental projects—the rebuilt Basilica of St. Peter's, and the piazza and palaces of the Capitoline Hill. The Tomb of Julius II was finally erected in 1545 at San Pietro in Vincoli. In the late years of the decade Michelangelo also began carving the *Pietà* that is now in the Cathedral of Florence (fig. 20-4). We are fortunate that his thoughts and activities during the years 1542–49 are well documented through the preservation of 130 letters and about 100 poems. Also, the revealing *Dialogue* by his close friend Donato Giannotti dates from 1546.

During the eight remaining years of Paul's pontificate following the *Last Judgment*, Michelangelo's creativity was accompanied by great personal loss. He was deeply affected by the progressive illness of Vittoria Colonna and her death in February 1547, and by the death of his dear friend and advisor Luigi del Riccio only four months earlier. Furthermore, the artist himself was seriously ill on two occasions. In these years he felt the approach of his own death. His commitment

1. In 1535–36(?) Paul commissioned Antonio da Sangallo the Younger to design and supervise the construction of the Pauline Chapel. By January 1540 the chapel was sufficiently finished that mass was held in it.

to the republican ideals of Florence had faded, yielding to an abiding concern with his own spiritual fate. Two issues—salvation and perpetuation of the Buonarroti bloodline—were uppermost in his thoughts.

Political and Theological Strife

As with the preceding popes, the political and theological struggles that gripped Paul III in the 1540s could not help but affect Michelangelo, particularly since all of his artistic and architectural activities, with the exception of the beginnings of his *Pietà* and the finishing touches on the Tomb of Julius, were under the direct commission or control of the pontiff. Just as the *Last Judgment* cannot be properly appreciated without considering the religious strife of the 1530s, so the Pauline Chapel frescoes and some of the architectural designs cannot be separated from the climate of the 1540s.

In the political sphere, the period was marked by Pope Paul's efforts to continue his policy of maintaining a neutral position between the powerful Holy Roman Empire and the less powerful French in order to preserve peace and the political integrity of Italy. In this effort he was only successful until 1542,[2] although following the signing of the Treaty of Crespy in 1544, lasting peace was achieved between the Spanish and the French. The political situation was made even more difficult by the complex relationships within Pope Paul's immediate family.[3] Yet, despite all of the troubles that beset him, to the end Paul remained fiercely loyal to Michelangelo.

The other historical force that weighed heavily in the course of the decade was the continuing confrontation between the Protestant reform movements and the Catholic Counter-Reformation. Although Protestant thought never took firm root in Italy, it did have the effect of imbuing Catholicism with a new spirit of internal reform and doctrinal reexamination. In the late 1530s efforts were initiated to reach a reconciliation of views between the Catholic church and the Lutherans. These attempts failed, partly because of resistance from vested-interest groups in the church which feared that the emperor Charles would gain excessive secular and ecclesiastical power because of his large body of Protestant subjects, but mainly because of irreconcilable differences between the tenets of the two theologies.

2. In 1542, to the distress of the Christian world, the French, under Francis I, entered into an alliance with the infidel Turks. The Turkish fleet sailed to the mouth of the Tiber, reawakening in all Romans memories of the barbarous sack of their city in 1527. Minor skirmishes took place outside Rome until the Treaty of Crespy in 1544.

3. Before his elevation, Paul had fathered several illegitimate sons. In the midst of his pontificate he began vigorously to pursue a policy of nepotism, much in the tradition of the earlier Borgia and Medici popes, who freely established secular duchies with their kinsmen at the head of them. Thus, in 1545 Paul named his son Pierluigi as duke of both Parma and Piacenza. Emperor Charles V, however, refused to recognize these duchies. Pierluigi then turned to the French, which Charles considered sufficient justification to order the seizure of the duchies. In the course of the action, Pierluigi was murdered (in 1547), to the profound grief of his aged father. The Spanish appropriated Piacenza but allowed the Farnese to retain Parma. Rumors of an imperial invasion of Rome then

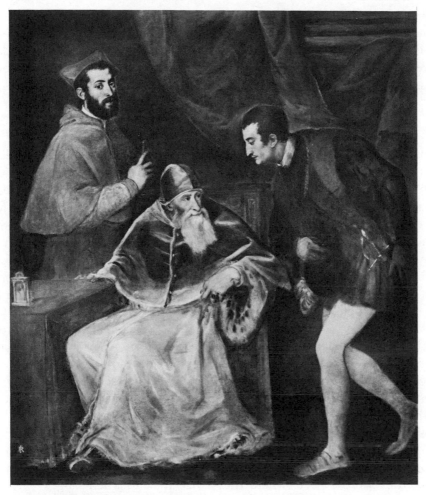

19-1. Titian, portrait of *Pope Paul III and His Grandsons, Alessandro Cardinal Farnese and Ottavio Farnese.*

pushed the pope to break his neutrality and enter negotiations for an alliance with the French. In the course of this crisis, the pope's grandson Ottavio, son of Pierluigi, conspired with his father's murderer to turn the duchy of Parma over to the Spanish. Pope Paul adamantly refused. He then discovered that Ottavio was supported in his intention by his other grandson, Cardinal Alessandro Farnese. Upon hearing this the pontiff was so distraught it is said that he lapsed into illness and died a few days later, in his eighty-second year. Some foreboding of this dark drama is captured in one of the masterpieces of psychological portraiture. Titian, the year *before* the betrayal (1546), had painted the pope and his two traitorous grandsons (fig. 19-1). This portrait, as Rosand (1970) suggests, "would seem to indicate that the painter was intimately aware of the political dissension and scheming that divided the family . . . the tired pontiff bowed, his left hand extraordinarily tense, flanked and even apparently threatened by his grandsons, especially by the predatory obsequiousness of the approaching Ottavio" (p. 124). The detached and rather flaccid Cardinal Alessandro stands as counterpoint to the overtly sinister Ottavio. Pope Paul is said to have confessed to his sin of nepotism on his deathbed; but in life, as we see, he suffered dearly for it. In comparing Titian's portrait of Paul done in 1543 (fig. 18-3) with this one painted three years later, we observe in the pontiff the rapid deterioration of both body and spirit.

In 1537, Pope Paul convened the Council of Trent to formulate unequivocally the church's doctrinal system. The council did not actually meet until 1545. By 1546, it had laid down the basic dogma of Catholicism that stands to this day. Its clear repudiation of the main articles of Luther made unity with the Northern reformers impossible.[4]

Michelangelo and Luigi del Riccio

Michelangelo's feeling of depletion, expressed in his letter to Niccolò Martelli, continued for the year following the completion of the *Last Judgment*. This can be seen in an incident from the spring of 1542. Two of the artist's apprentices were involved in a quarrel over who was to do what on the architectural frame for the Tomb of Julius. Although Michelangelo had long been able to deal firmly with his assistants, he had to appeal to Luigi del Riccio for help in this petty, in-house dispute. After spelling out the nature of the contention, he wrote: "Messer Luigi, I have made this statement to you in writing, because to make it in front of these fellows by word of mouth completely exhausts me, so that I have no breath left to speak" (letter 214).

This letter, albeit concerned with a trifling matter, conveys some of the quality of Michelangelo's reliance on del Riccio at the time. The formal basis for the relationship between the two men was that for six years following the death of Bartolommeo Angiolini in December 1540, del Riccio served as Michelangelo's business manager and advisor. But their relationship was much more—a dedicated friendship.

Luigi del Riccio's birthdate is not known, but he may be judged to have been close in age to the artist. Although a Florentine, he held the position of managing director of the Strozzi-Ulivieri bank in Rome. He and his wife lived in an apartment at the Strozzi Palace, where they twice took in Michelangelo and nursed him through serious illnesses, in 1544 and in 1545–46. Himself childless, Luigi raised his nephew, Cecchino Bracci, whose death at age fifteen in 1544, as we recall (see chapter 16), left him grief-stricken.

Luigi's service to Michelangelo in a business capacity was not restricted to negotiating with the della Rovere heirs over the Tomb of Julius. He also dealt with papal officials and handled other difficult matters. He frequently intervened with Michelangelo's nephew Lionardo, exhorting the youth to behave in ways that would be more pleasing to his uncle. In 1542, Luigi wrote in a letter to Michelangelo, "How much I desire to serve you is known to everyone acquainted with me."[5] And indeed, Luigi faithfully executed this intention.

4. The principal points to emerge from the council were: the reaffirmation of divine revelation, with the pope as head of the church; the condemnation of the Lutheran position of justification by faith alone; the assertion of the validity and authority of the seven sacraments; and the establishment of both Scriptures and tradition as equally acceptable sources of religious truth, with the Vulgate being established as the only authoritative text of the Scriptures.

5. Translated by Ramsden (1963, 2: 244).

But one unpleasant eruption in their friendship has come down to us in a letter from Michelangelo to Luigi of January 1545. In it Michelangelo accuses Luigi of knowingly having acted contrarily to his clear request. He goes on to write:

> It is still within the power of one who delivered me from death to insult me; but now I do not know which is the heavier to bear—this insult or death. I therefore beg and entreat you by the true friendship which exists between us to have that plate [stampa] which I do not like destroyed. . . . But if you shatter me utterly, I shall do exactly the same, not with you, but with your things [cose].
>
> <div align="right">MICHELANGELO BUONARROTI</div>
>
> Not a painter, or a sculptor, or an architect, but what you will; but not a drunkard, as I told you when I was with you. [letter 244]

What the "plate" referred to in the letter actually was has been the subject of varying opinions over the years. The most likely suggestion, originally made by Milanesi (1875) and then argued persuasively by Ramsden (1963, 2: 247), is that it was an engraved portrait of Michelangelo in profile by Giulio Bonasone, from 1545. Indeed, in the British Museum print of the portrait, Michelangelo looks rather scraggly, which may explain the artist's postscript comment, "but not a drunkard."

The threat to "shatter . . . your things," brings into question the accuracy of Condivi's statement that the *Dying Slave* and the *Rebellious Slave* were given as gifts to the artist's "great friend Messer Roberto Strozzi," presumably in appreciation for having been cared for at the Strozzi Palace during his two serious illnesses. It was Strozzi who eventually brought these two statues to France, where they remain to this day. Ramsden's argument, which I find more persuasive, is that the Louvre *Slaves* were a gift from Michelangelo to Luigi for having cared for him in the del Riccio apartment at the Strozzi Palace. Indeed, in a letter to his nephew in 1547, Michelangelo wrote: "As regards my being ill, in the Strozzi house, I do not consider that I stayed in their house, but in the apartment of Messer Luigi del Riccio, who was a very great friend of mine" (letter 291). This act of gratitude would hark back to a sentiment expressed earlier, in a 1542 letter to Luigi: "I presume too much on your kindness. God grant I may be able to repay you" (letter 218). Upon Luigi's death in 1546, Michelangelo may have requested that the statues be given to Strozzi, partly because they were already in the Strozzi Palace. That so priceless a gift as the *Slaves* would be given to del Riccio makes sense and seems to be supported by the threat in the anguished letter to "shatter" some material objects that Luigi might feel he had a claim to.

In a sonnet to Luigi, which can be considered as a continuation of the letter under discussion, Michelangelo wrote:

> Often, in the pleasure of tremendous kindness,
> Some attack on my life and dignity
> Is masked and hidden, and it is so heavy
> That it can make my health become less precious.

To give the shoulders wings, then draw the noose
At the same time . . .

All gratitude disdain can learn to master,
And, if I've learned to know why friends are true,
A thousand joys can't match a single torture.[6]

This poem dramatizes how deeply Michelangelo felt any wound inflicted, however unintentionally, by an intimate. The artist's tendency to idealize friends, with its potential for the extreme of disillusionment, is conveyed in his image of giving the shoulders wings (that is, creating an angel) while drawing a noose. The final line, "A thousand joys can't match a single torture," suggests Michelangelo's uncompromising and not easily forgiving character, which made every relationship a fragile thing. Nevertheless, in this instance, the two friends resolved the problem. Unfortunately, Luigi died a year and a half later, in September or October of 1546. Michelangelo's grief is described in a letter from the bishop of Casale to Pierluigi Farnese, son of Pope Paul III: "Now that Luigi del Riccio is dead, who used to manage his affairs, he is so stunned that he can do nothing but give himself up to despair."[7] Thus, this touching and devoted friendship of relatively few years' duration between two elderly Florentines living their last years in Rome came to its end.

Further Losses

As noted, the death of Luigi was followed only four months later by that of Vittoria Colonna, at fifty-seven. Michelangelo's enduring mourning for Vittoria was recorded by Condivi several years later, in a passage quoted earlier (p. 323). In it he spoke of his love for her and his lasting regret that as she was dying he had not kissed her face or forehead. The passage concludes by speaking of his prolonged despair and feeling "as if out of his mind" as a result of Vittoria's death.

The artist's state of mind following the deaths of Luigi and Vittoria also emerges in a stark and agonized passage of a letter to Luca Martini, a friend in Florence, written a few weeks after the death of Vittoria: "I am an old man and death has robbed me of the dreams of youth—may those who do not know what old age means bear it with what patience they may when they reach it, because it cannot be imagined beforehand" (letter 279). From this period comes a madrigal that further testifies to Michelangelo's grief and despair:

My age is now detached
From desire, blind and deaf;
I make my peace with death,
Since I am tired and near the end of speech.[8]

6. Gilbert and Linscott (1963, poem 249).
7. Translated by Ramsden (1963, 2: 250).
8. Gilbert and Linscott (1963, poem 266).

A letter from October 1547, to Lionardo, communicates the extent to which Michelangelo had detached himself from the Florentine political community of the *fuorusciti* (exiles) for whom the Strozzi Palace in Rome served as a center. The letter must also be read in the context of an impending decree by the government in Florence which threatened penalties to any Florentines and their families who conducted business with the *fuorusciti*. Michelangelo wrote:

> But since he [Luigi del Riccio] died I no longer frequent the said house [Strozzi Palace], to which all Rome can bear witness, and to the kind of life I lead, as I am always alone; I go about very little and talk to no-one, least of all to Florentines; but if I'm greeted in the street I cannot but respond with a kindly word and pass on—though, if I were informed as to which are exiles, I would make no response at all. But, as I've said, from now on I'll be very much on my guard, particularly as I have so many other anxieties that life is a burden. [letter 291]

Thus, in this state of melancholy, and perhaps some cowardice, Michelangelo underwent the transition that rendered the ties to homeland subordinate to his sense of Christian duty. It was at about this time that, in addition to painting in the Pauline Chapel and designing architectural projects, Michelangelo began carving a *Pietà* for his own tomb.

It is likely that Michelangelo's concentration on his artistic projects served as a major diversion from his grief and despair. Then, on January 1, 1547, Michelangelo was appointed by Pope Paul as the architect for the construction of the new Basilica of St. Peter's. In the remaining years of his pontificate, the pope demanded not only designs for the basilica but also completion of the *Crucifixion of Peter*—and these while the artist was concurrently working on the first stages of his *Pietà*. We have no week-by-week or even month-by-month record of Michelangelo's work. In 1548 and 1549 he suffered intermittently from renal stones and urinary obstruction, which must have diminished his energies. In spite of this, he seems to have worked consistently and with considerable dedication. The impact of his state of mind can be seen in the *Crucifixion of Peter* and the *Pietà*, as I shall shortly note. But work and, perhaps, the hope that through good works salvation could be achieved gave purpose to what life remained to him and offered respite from the loneliness and fear that otherwise beset him.

The Completion of the Tomb of Julius II

The Tomb of Julius II once again returned to haunt Michelangelo throughout the year 1542, during the last of the negotiations with the della Rovere. In November of that year, when he began work in the Pauline Chapel on the *Conversion of Paul*, he conveyed his feelings on the matter to del Riccio:

> Let it suffice that this is all I deserve [having disbursed large sums of money without the reimbursement that would accompany ratification of the final contract] in return for thirty-six years of fair dealing and ungrudging devotion to others. Painting and

sculpture, hard work and fair dealing have been my ruin and things go continually from bad to worse. [letter 226]

At that same time, Michelangelo wrote the well-known letter in which he catalogued his version of the entire tomb history to a high papal official: "I lost the whole of my youth, chained to this Tomb, contending, as far as I was able, against the demands of Popes Leo and Clement. An excessive honesty, which went unrecognized, has been my ruin. Such was my fate" (letter 227).

By the end of 1544, Michelangelo had done the final carving and polishing of the *Moses* (fig. 14-2), which was probably begun in 1514 and largely completed by 1516. He also finished the *Rachel* (the Active Life) and the *Leah* (the Contemplative Life) for the tomb. His assistants completed the dull second-tier statues of a *Prophet* and a *Sibyl*, the strange effigy of Pope Julius in an Etruscan manner, and the *Madonna*. With the architectural structure done, the tomb was assembled and the final touches applied in January and February of 1545.

The Pauline Chapel Frescoes

In major respects the two frescoes in the Pauline Chapel, the *Conversion of Paul* (fig. 19-2) and the *Crucifixion of Peter* (fig. 19-3), are more revealing graphic statements of Michelangelo's state of mind during the period of their creation than any of his other paintings. The two works, which covered a span of seven working years, received little attention in their day.[9] Condivi devoted three sentences to them and they drew two paragraphs from Vasari. Vasari, however, made an interesting comment in passing: "They were painted in his seventy-fifth year, and as he told me himself, at great cost of fatigue, seeing that painting, and especially fresco, is not the work of those who have passed a certain age" (vol. 2, p. 158).

The Pauline Chapel was intended as the Chapel of the Sacrament as well as the chapel for the conclave of cardinals in papal elections. The themes of the paintings—vocation and martyrdom—were to be consistent with this dual purpose. Although there is no documentation of the order in which the frescoes were done, nearly all major Michelangelo scholars assume on the basis of style that the *Conversion* was first. Only a handful of preparatory drawings survives, and none of them is universally attributed to the master. Thus, unlike the *Last Judgment*, there is no record of the evolution in concept for either work. This is regrettable. It would have been interesting to trace the *Conversion* from its beginning, in the midst of the conflict over the final agreement on the Tomb of Julius, to its completion during a period of stability for Michelangelo. The exact date of the

9. Leo Steinberg (1975) has given a history of the two paintings and a summary of critical responses to them in his searching study, *Michelangelo's Last Paintings*. It is only in this century that there has been a significant emergence of curiosity and scholarly concern about them. Their general familiarity has also been limited by the fact that they can be viewed only by special arrangement with the papal offices.

resolution of the final plan for the tomb is not clear, but it was probably in January or February of 1543. Following this, the remaining period of work on the *Conversion,* completed in July 1545, was relatively free of external contractual and work conflicts, and preceded the deaths of Luigi, Vittoria, Giovan Simone and the pope himself. During this period, however, he was acutely aware of his age and the aging process, an awareness which informs the fresco.

Michelangelo's feeling about embarking on the first of the Pauline frescoes is expressed in the letter he wrote in the preliminary phase, in October or November 1542, to a papal official, recounting the history of the tomb. In it, he wrote:

> Your Lordship sends to tell me that I should paint and not worry about anything else. I reply that one paints with the head and not with the hands, and if one cannot concentrate, one brings disgrace upon oneself. Therefore, until my affair [the tomb negotiations] is settled, I can do no good work. . . . But to return to the painting. It is not in my power to refuse Pope Pagolo anything. I shall paint ill-content, and shall produce things that are ill-contented. [letter 227]

Michelangelo clearly expresses his lack of inspiration for the project, his preoccupation with other matters, his sense of enslavement to the wishes of Pope Paul, and his grim outlook on what he is capable of creating at this time.

Michelangelo moved from the completion of the *Last Judgment* (December 1541) to the preliminary designs for the *Conversion* with no more than a few months' hiatus. Yet, the change in style is dramatic. The rupture with the Renaissance canons of perspective, order, and beauty dramatically occurred in the *Last Judgment* and continued in the Pauline frescoes. As Friedlaender (1957) emphasized, space is treated as starkly unreal in the *Conversion of Paul.* There are allusions to depth, such as the foreshortened Christ and the horse leaping into the distance, but structure is expressed primarily through bodily volume and groups of figures clumped together. Gone is the bravura virtuosity in the presentation of the human figure and the urgency of narrative that virtually assaults the viewer of the *Last Judgment.* The change in the concept of the human body as vehicle for the statement of idea is perhaps most clearly seen in the way Michelangelo has treated the arms of the sixty-odd witnesses to the conversion of Paul. As Steinberg (1975) has detailed, the arms shrink and dwindle and are largely engaged in abortive and nonfunctional gestures. The only exceptions are Christ's right arm and the extension of its line of motion down to the right arm of Paul's helper. The treatment of the arms typifies the mood of confusion and loss of personal will that pervades the *Conversion.* The result of Michelangelo's invention is to emphasize by contrast the inner, spiritual narrative portrayed by Paul. The historical moment represented is when Paul, then called Saul, a fanatical persecutor of the early Christians, was struck blind on his way to Damascus by heavenly light accompanied by a voice asking, "Saul, Saul, why persecutest thou me?" (Acts 22:7). Subsequent to the action in the painting, Paul was led to Damascus, where his sight was restored and he became the leading preacher of the teachings of Christ.

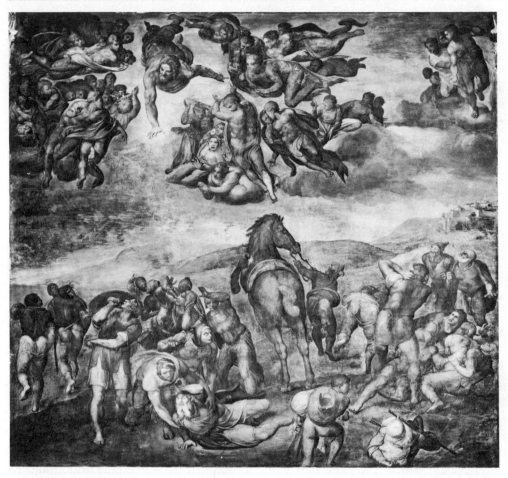

19-2. Michelangelo, *The Conversion of Paul.*

In this fresco, the depiction of Christ is in odd contrast with the spirituality of Paul. Christ is shown as a celestial guide, pointing with one hand to Paul and with the other signaling him to Damascus. How much less interesting and original He is than the Christ in the *Last Judgment* or the much earlier soaring God of the last three panels of the Sistine Chapel ceiling!

Paul has been widely recognized as a spiritualized self-portrait of the artist, with his identifying features of flattened nose and forked beard. Although modeled in the tradition of Michelangelo's earlier heroic reclining nudes, Paul does not possess their implications of boundless physical vigor and fertility. Awkwardly balanced and unable to support his own weight, he seems rather to symbolize inner vision and revelation. Thus, with the figure of Paul, Michelangelo repudiates a central force in his art—the expression of idea and spirit through the strength and magnificence of the human form. Although physical power was reinvested in the image of Peter in the second Pauline fresco, Paul can be seen as reflecting the

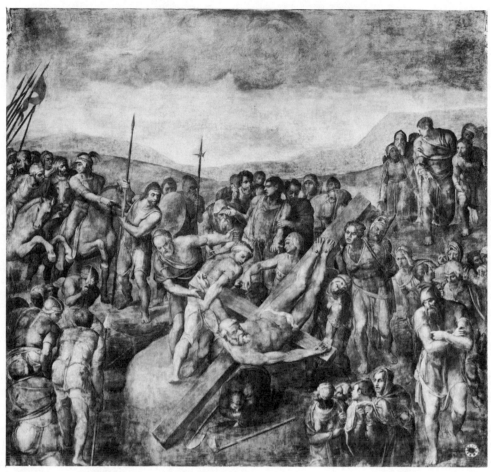

19-3. Michelangelo, *The Crucifixion of Peter.*

artist's mounting concern during his late sixties about his own failing body and strength. His hope, therefore, was for salvation through a profound transformation and achievement of faith. Perhaps to counterbalance the diminution of the figural form as the primary vehicle for the statement of ideas, in the *Conversion* one finds a new sensuality and subtlety of color in the interplay of pale greens, lilac, soft blue, and shades of burnt yellow.

One of the most curious aspects of the *Conversion* is the formal artistic source for Paul. As mentioned, he developed from Michelangelo's own style in *Adam, Dawn,* and the *River God.* The most direct source, however, is Raphael's fallen figure of Heliodorus from the *Expulsion of Heliodorus from the Temple* (fig. 19-4) in the Vatican Stanza di Eliodoro. This raises two questions: first, why should Michelangelo use a figure by Raphael as model when he never lost an opportunity to denounce Raphael as one of his betrayers and a second-rate imitative painter? Second, why should the Apostle Paul be drawn from the historical Heliodorus, an

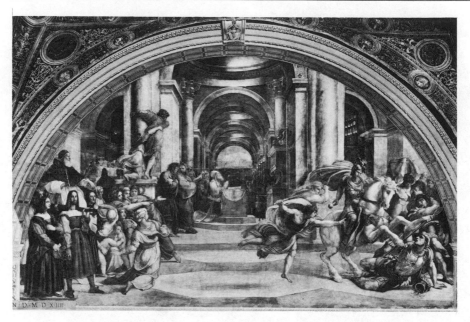

19-4. Raphael, *The Expulsion of Heliodorus from the Temple.*

infamous profaner of the Temple? It is easier to speculate on the latter question. Many such transformations in content occur in Michelangelo's art, as we have seen. In this case, he chose to portray Raphael's Heliodorus at the instant just before he is to be trampled by the horse as punishment for his sacrilege. Michelangelo, because of his nagging doubt with respect to the purity of his own motives and faith, was attracted to a situation in which imminent punishment and death are transformed, so to speak, into a momentary scare, which then miraculously leads to a faith of heroic magnitude and therefore salvation. Thus, once again, a theme that bears a personal meaning for the artist is mastered by altering it into its opposite and psychologically acceptable form.

The reason for Michelangelo's choice of a figure painted by Raphael is obscure. It would be gratifying to think that it was a gesture of reconciliation on the part of the older master toward his deceased younger rival after a lifetime of enmity. There is, however, little to support this notion. Michelangelo's mistrustful and ungenerous attitude toward Raphael was expressed some years later in Condivi's account. In fact, in the *Conversion*, Michelangelo was competing with and surpassing Raphael, who had done the cartoon for a large tapestry of the *Conversion of Paul* (fig. 19-5). Raphael's Paul does not approach Michelangelo's in power and inner drama. I must assume, therefore, that Michelangelo wanted to demonstrate with how much more narrative power he could invest a formal pose than Raphael could.

The *Conversion* was completed in July 1545. From the record of a payment to Michelangelo's assistant, Urbino, in August 1545 for the preparation of the wall for the *Crucifixion of Peter*, we infer that work in the Pauline Chapel continued

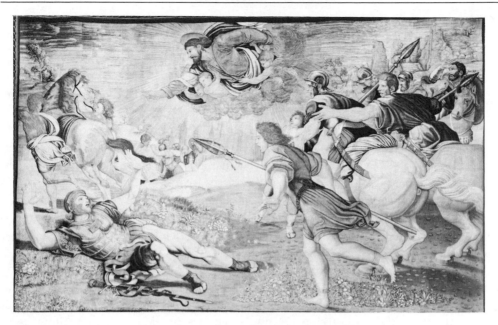

19-5. Tapestry after Raphael's cartoon for the *Conversion of Paul.*

without a significant break. There is nothing to suggest that Michelangelo was any more enthusiastic or willing to undertake this second fresco than he was the first. Whereas the years of work on the *Conversion* were harmonious ones in Michelangelo's life once the final tomb contract was ratified early in 1543, those spent on the *Crucifixion* were marked by personal loss and external conflict.

In the same month he began painting the *Crucifixion,* Michelangelo's income was reduced by half as a result of the loss of his share of the revenues from the Po Ferry, near Piacenza, a part of the Holy See, which had begun to suffer from competition with new rival ferry companies. The complex details of this affair need not concern us here.[10] The circumstance did, however, activate the artist's ever vigilant anxiety about his economic security and involved Pope Paul, who was perturbed by any incursions into Michelangelo's peace of mind while he worked on papal projects.

A few months later Michelangelo was quite upset by a letter from Pietro Aretino, the powerful and often venomous Venetian man of letters. A masterpiece of epistolary malevolence, this letter attacked Michelangelo for his sacrilegious treatment of the *Last Judgment.* Whatever the degree of its sincerity, Aretino's attack is more than simply an ad hominem diatribe. It may be presumed to build upon a much more generally voiced Counter-Reformatory critique:

> As a baptized Christian, I blush before the license, so forbidden to man's intellect, which you have used in expressing ideas connected with the highest aims and final ends to which our faith aspires. . . . Your art would be at home in some voluptuous

10. See Ramsden (1963, 2: 166–68) for a summary of the matter of the Po River Ferry.

bagnio, certainly not in the highest chapel of the world. Less criminal if you were an infidel than, being a believer, thus to sap the faith of others.[11]

In August 1546, Michelangelo's life took on a dramatic new dimension when Antonio da Sangallo, the architect for the new Basilica of St. Peter's, died, and Pope Paul assigned Michelangelo the task of carrying on the design of this project. This new responsibility placed Michelangelo in the middle of a long, bitter factional struggle, to which we shall return.

Serious illness late in 1545 and the deaths of Luigi, Vittoria, his longtime friend in the papal court, Sebastiano del Piombo in June 1546, and his brother Giovan Simone in January 1548 all occurred during the years of Michelangelo's work on the *Crucifixion*. Each left its mark, as the artist, now in his seventies, was increasingly confronted with his own aging and the limited span of time remaining to him. These realizations led him to begin the Florence Cathedral *Pietà*, in 1547, for his own tomb.

With respect to the planning of the *Crucifixion of Peter*, Steinberg (1975) marshals evidence to suggest that Michelangelo originally intended the theme of Christ Giving the Keys to St. Peter for the wall. Early on, however, the subject was changed to the Crucifixion. Again, there are no drawings that allow us to reconstruct the evolution in Michelangelo's thought about the work. In depicting the Crucifixion of Saint Peter, he addressed himself to a problem which had up to that time defied a satisfactory aesthetic solution. Peter had to be represented as being crucified upside down as he had requested, out of a conviction that he was unworthy of sharing the same fate as Christ. Bernard Berenson (1896) felt that Michelangelo's *Crucifixion of Peter* was an impossible task and therefore a failure. He wrote: "Art can be only life-communicating and life-enhancing. If it treats of pain and death, these must always appear as manifestations and results only of living resolutely and energetically. What chance is there, I ask, for this, artistically the only possible treatment, in the representation of a man crucified with his head downwards?" (p. 42).

Regardless of whether Berenson is correct in principle, he is surely wrong with respect to Michelangelo's solution to the challenge. The essence of the problem is that all expression in a face is lost to the viewer when he has to look at it upside down. Michelangelo's treatment of Peter is a radical departure from the traditional representation (fig. 19-6) of the saint martyred on the cross in the vertical, upside-down position.[12]

11. Translated in Symonds (1893, 2: 51–53).
12. The only biblical reference to Peter's crucifixion is in John 21:18 f., where the Evangelist quotes Jesus as foretelling the manner of Peter's death by crucifixion "to glorify God." However, in Jacopo da Voragine's medieval text, *The Golden Legend* (1266), which commanded wide popularity in the Renaissance, the crucifixion was described as follows:

And when Peter came in sight of the cross, he said: "My Master came down from Heaven to earth, and so was lifted up on the Cross. But I, whom He deigned to call from earth to Heaven, wish to be crucified with my head toward the earth and my feet pointing to Heaven. Crucify me head downwards, for I am not worthy to die as my Master died." And so it was done. . . . At

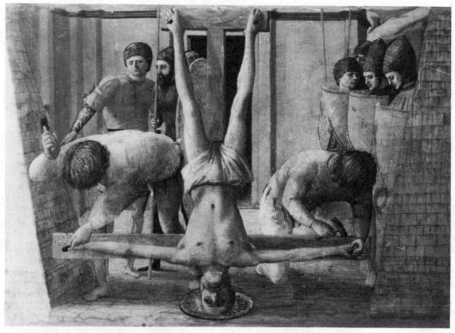

19-6. Masaccio, *The Crucifixion of Peter.*

Michelangelo's Peter (fig. 19-7) is a Herculean figure, nailed to a cross that has yet to be raised and implanted in the earth. With a movement of extraordinary strength, Peter has elevated his torso some 45 degrees so that, with its foreshortened treatment, he lies on a horizontal axis and projects toward the viewer. His head is turned to the right and upward; from its three-quarter presentation, Peter's eyes glare at the viewer. His facial expression, contrary to the Christian myth of his acceptance of martyrdom in complete humility, communicates fury and reproach. In this last paroxysm of physical energy and spiritual protest, Peter does not accept his fate but renounces humility and willing sacrifice and cries out against death itself. We can only conclude that this image represents the artist's deeply personal statement, not simply because it is so at variance with traditional iconography but particularly because it contradicts hagiographical tradition.

The magnificent creation of Peter at this final moment of life contrasts dramatically with the other fifty or so figures who inhabit the fresco. There is no evidence that Peter's followers are on the brink of rebellion, ready to attack the Romans. Rather, the mood is one of mournful resignation and detachment. Apart from the gesture of futility of the follower in the blue-green tunic directly behind Peter, arms and hands signify little. The lack of energy is summed up by the haggard, unseeing giant in the right corner of the foreground (traditionally reserved in Renaissance art for the option of self-portraiture), whose monumental

this the crowd was enraged, and wished to kill Nero and the prefect, and deliver the apostle; but he besought them not to hinder his martyrdom. [p. 337]

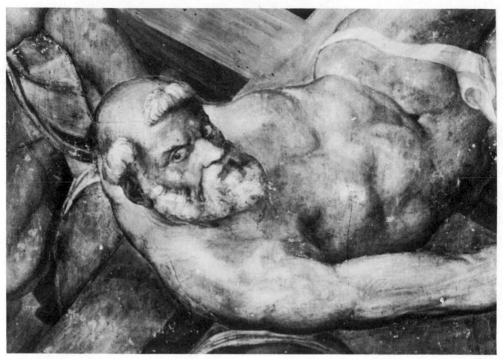

19-7. Detail of figure 19-3 (St. Peter).

strength collapses in the folded position of his arms.[13] The executioners rotate the cross in a circular arc that suggests the inexorable course of fate, the predetermined movement of time. All others bear silent witness to Peter's tragedy except for the four women in the right foreground, the last figures to be painted in the picture and thus the last ever to be painted by Michelangelo. These four women bring a frantic and unearthly quality to the work. Two look back at Peter and two gaze out into our world, as if to communicate to us their helplessness and terror.

Except for the figure of Peter himself, which must be considered one of Michelangelo's great achievements in painting, the work bears the signs of the artist's age and fatigue, and other painful concerns. One senses a tiredness in large sections of the fresco. Yet, it remains a poignant testimony to the heroic spirit of Michelangelo. Like Peter, the artist protests death and the end of his labors. Indeed, he lived on for fourteen years after the completion of the fresco and achieved some of

13. Steinberg (1975) considers the giant, as well as the man wearing the turban directly behind the prefect on the horse (left, middle-ground), to be self-portraits. On the basis of compositional axes and organization, iconography, and speculative identification of the figures, he interprets the fresco as a narrative of the "moral history" of the artist, in which the aged artist confesses his guilt for his earlier years as a nonbeliever and idolizer of pagan beauty. Too late, he becomes aware of the dreadful consequences of his younger years. While Steinberg's reading is plausible, it imputes to the artist a self-referential design and specificity that do not jibe with Michelangelo's usual way of thinking in such compositions. Moreover, it remains to be explained why Michelangelo would give his turbaned figure a red beard—not the color of his own hair.

his highest accomplishments in architecture as well as in sculpture, carving the Florence Cathedral and Rondanini Pietàs.

The Basilica of St. Peter's

The decade of the 1540s was distinguished by the beginnings of Michelangelo's two most important architectural contributions, the design for the Basilica of St. Peter's (fig. 19-8) and the plan for the Campidoglio, or the Capitoline Hill (fig. 19-9), both of which he labored on until the end of his life. In addition, his plans for the continuation of the unfinished Farnese Palace (fig. 19-10) in 1546 affected subsequent palatial architecture.

The history of Michelangelo's involvement in the rebuilding of St. Peter's is complex. The impact of his achievements in this project is evident on the course of architecture during following centuries. Yet, the work was pursued in the face of continuous conflict, disappointment, and, finally, posthumous changes in design that would have caused him pain. Michelangelo was seventy-one years old when he was called upon by Pope Paul to assume the responsibility of chief architect of the project. With respect to this assignment, Michelangelo wrote to Vasari ten years later: "I call God to witness that ten years ago I was put in charge of the fabric [building] of St. Peter's by Pope Paul, under duress and against my will" (letter 434). This passage echoes Condivi's earlier recounting that when Sangallo died and Paul wanted to replace him with Michelangelo, the artist: "firmly refused the position, alleging that it was not his art; and he refused it in such a way that the pope was compelled to order him to take it, granting him a very extensive *motu proprio*, which was later confirmed by Pope Julius III, by the grace of God our present pontiff, as I have mentioned. Michelangelo has never wanted anything in return for this service of his, and he wanted a statement to that effect in the *motu proprio*" (p. 101).

The original basilica had been begun in the fourth century under Constantine. By the Renaissance it was in sorry condition. In 1505 Pope Julius II chose Bramante to design a new one on a magnificent scale. Bramante's brilliant concept dictated the spirit of what was to follow over the more than a century of design and construction. After Bramante's death in 1513, Giuliano da Sangallo, Fra Giocondo, and Raphael succeeded him for brief terms. On Raphael's death in 1520, Antonio da Sangallo the Younger shared responsibility with Baldassare Peruzzi but gradually took over the post entirely, which he held for twenty-six years in all. It was not, however, until 1539 that any serious construction got under way. When Sangallo died, Pope Paul first tried to persuade Raphael's protégé Giulio Romano to take the post. But, Giulio, who was seriously failing in health, did not accept. Thus, the stage was set for the pope's command of the reluctant Michelangelo. Indeed, one would not expect Michelangelo—who was in the midst of painting the *Crucifixion* fresco, mourning the death of Luigi del Riccio, and aware that Vittoria Colonna was in the terminal phase of her long

19-8. St. Peter's: view from the Vatican gardens.

illness—to be pleased with the prospect of so awesome a task. Nevertheless, again, once relieved of a sense of choice in the matter and able to proceed as if enslaved, Michelangelo quickly warmed to the new project.

His initial spirited view of the situation was expressed right after the pope's

command, in a letter of January 1547. To a Deputy of the Fabric of St. Peter's Michelangelo wrote:

> One cannot deny that Bramante was as skilled in architecture as anyone since the time of the ancients. He it was who laid down the first plan of St. Peter's, not full of confusion, but clear, simple, luminous. . . . It was held to be a beautiful design, and manifestly still is, so that anyone who has departed from Bramante's arrangement, as Sangallo has done, has departed from the true course. . . .
>
> He [Sangallo], with that outer ambulatory of his, in the first place takes away all the light from Bramante's plan; and not only this, but does so when it has no light of its own, and so many dark lurking places above and below that they afford ample opportunity for innumerable rascalities, such as the hiding of exiles, the coining of base money, the raping of nuns and other rascalities, so that at night, when the said church closes, it would need twenty-five men to seek out those who remained. [letter 274]

Thus, with an uncharacteristic expression of admiration for Bramante, followed by delightful lampoonery of Sangallo (reminiscent of his ridicule of Pope Clement's plan for a colossus in Florence, pp. 238, 240), Michelangelo displayed a rush of excitement about his new post. The rest of the letter addresses more serious design and cost problems. Michelangelo's decision not to accept pay for this work was in all likelihood dictated by political, rather than devotional, motives—namely, to disarm his critics from the Sangallo camp. Yet, it is difficult to believe that he was not in some profound way inspired and energized by the words of Jesus to Peter: "Thou art Peter and on this rock I will build my Church" (Matthew 16:18).

Sangallo had a powerful following in the papal court, and when Michelangelo ordered the dismantling of some of the structures that Antonio had designed, they rose up in anger and fiercely attempted to malign his motives and discredit his plans. This situation, which may only have intensified Michelangelo's identification with the Apostle who was commanded by Christ to build His Church and, even informed the manner in which he depicted Peter in the *Crucifixion*, led Pope Paul to issue a brief on October 11, 1549, granting Michelangelo absolute powers in all matters pertaining to the new basilica. As Ramsden (1963) commented, "Never in the history of art can such powers as these have been granted to any architect" (vol. 2, p. 307). The document is interesting in that it gives evidence of the depth of the pope's affection and absolute belief in Michelangelo's abilities.

The brief begins:

> Motu proprio etc., Forasmuch as our beloved son, Michael Angelo Buonarroti, a Florentine citizen, a member of our household, and our regular dining-companion, has remade and designed in a better shape, a model or plan of the fabric of the Basilica of the Prince of Apostles in Rome, which had been produced by other skilled architects, and has done the same to the building itself or its plan without accepting the reward or fee which we have repeatedly offered to him, but has done so because of the unfeigned affection and single-minded devotion which he has for that church.
>
> We ratify and confirm the matters aforementioned, desirous that they be respected

and put into effect in perpetuity, since they contribute to the grace and beauty of that church, and because they will have been executed at our request and on our clear orders, as by those present we fully and unambiguously testify and affirm.[14]

In effusive language, the document then sets out in detail the unlimited powers in all aspects of the planning and building of the basilica that were being granted to Michelangelo.

Paul III died one month later. And Sangallo's followers seized upon the pope's death as an opportunity to exert sufficient pressure to topple Michelangelo from his position. The openness of the conflict finally led the new pope, Julius III, to conduct an inquiry into the matter, over which he presided himself. Vasari gives something of the flavor of the circumstances, and particularly of Michelangelo's unflinching forthrightness in them:

> Scarcely had Vasari returned to Rome, and the year 1551 had not well commenced before the Sangallican faction had formed a plot against Michelangelo, making interest to prevail on the Pope to assemble all concerned in the building of San Pietro, declaring with false calumnies that they could show His Holiness how Michelangelo was spoiling the edifice. . . . All being assembled accordingly, the Pope told Michelangelo that the deputies declared that part of the church to be unduly deprived of light, when the master replied that he would like to hear those deputies speak.
>
> "We are the deputies," replied Cardinal Marcello; and Michelangelo rejoined, "Monsignore, in the vaulting above, and which is to be of travertine, there are to go three other windows." "You have never told us so," returned the Cardinal; to which Michelangelo responded, "I neither am nor will be obliged to tell either your lordship or any other person what I intend or ought to do for this work; your office is to procure money, and take care that thieves do not get the same; the designs for the building you are to leave to my care." Then turning to the Pope, he said, "Holy Father, if the labours I endure do not benefit my soul, I am losing my time vainly for this work"; to which the Pope, who loved him, replied, laying his hands on the shoulders of the master, "You will be the gainer both for your soul and in the body; do not doubt it." [pp. 168–69]

Julius III shared the protective and highly respectful attitude toward Michelangelo that had characterized his predecessor. His five-year pontificate ended, however, when he died in March 1555. He was followed by the Cardinal Marcello, the critic in the passage just quoted from Vasari. Marcello assumed the name Pope Marcellus II. With this puritanical pontiff on the throne, the Sangallo faction felt that their moment to displace Michelangelo had finally arrived. Once again, however, Michelangelo was fortune's child by virtue of Marcellus's death only three weeks after his election. In May 1555, the Caraffa pope, Paul IV, became pontiff, and Michelangelo once again had a staunch supporter. Nevertheless, Michelangelo's troubles remained constant. A glimpse of this comes from a letter in 1557 to Vasari. In this letter Michelangelo, who was eighty-two years old, explains that he had hoped by now to be at a stage of progress that would have

14. Translated by Ramsden (1963, 2:308–09).

permitted him to return to Florence (after a twenty-three-year absence). He then goes on to write: "But through lack of money the work has been retarded and is being retarded, and it has reached the most toilsome and difficult part, so that if I were to abandon it now, it would result in nothing but the uttermost disgrace and the loss of the whole reward for the pains I have endured for the love of God during the said ten years" (letter 434).

The harassment and obstacles never ceased, and as late as 1562, when Michelangelo was eighty-seven years old, Vasari recounts another incident reflecting the artist's distress. In this instance, the deputies were going to appoint a new construction foreman without Michelangelo's approval. Vasari writes:

> Being made acquainted with this proceeding, Michelangelo repaired to the Pope, whom he found on the piazza of the Capitol, and speaking somewhat loudly, His Holiness made him enter a room, when the master exclaimed, "Holy Father! a man of whom I know nothing has been placed by the Commissioners in San Pietro as my substitute, but if they and Your Holiness are persuaded that I can no longer fulfill my office, I will return to take my rest in Florence, where I shall be near that great Prince [Cosimo de' Medici] who has so often desired my presence, and can finish my life in my own house; wherefore I beg the good leave of Your Holiness to depart." The Pope, whom that did not please, sought to pacify the master with kind words, and bade him come to Araceli on the following day to talk of the matter. [p. 191]

Michelangelo worked on the plans for St. Peter's until he was near his death. His model for the main dome was constructed as late as 1558–61. As was true of a number of his major endeavors (among them the Medici Chapel), he did not live to see the fruits of his labors. The dome of St. Peter's was not started until 1588. It was constructed under the direction of Michelangelo's follower, Giacomo della Porta, who took liberties in design that would not have met with the master's approval. The construction of the basilica was finally completed in 1626.

When we behold the basilica now, the only features that are completely true to Michelangelo's design are the main drum of the dome and the vaulting of the ends of the semicircular arms. Michelangelo's achievement and contribution to architectural history in his work on St. Peter's may best be summarized by quoting James Ackerman (1961):

> Michelangelo, by merely walling off the entrances to each of Sangallo's disconnected spaces, made one church out of many; he surpassed the clarity that he admired in Bramante's plan in substituting for the concept of major and minor crosses a more unified one of an integrated cross-and-square, so that all circulation within the Basilica should bring the visitor back to its core. The solution was strikingly simple, and far more economical than any proposed before: it even seems obvious, once it is familiar; but in a generation distinguished for great architects, it took one trained as a sculptor to discover a form that would express the organic unity of the structure.
>
> Unity was Michelangelo's contribution to St. Peter's; he transformed the interior into a continuum of space, the exterior into a cohesive body. . . . [pp. 205–06]

There can be no stronger testimony to Michelangelo's genius than the creation

of the masterpiece of St. Peter's in his late seventies and eighties, particularly since ventures into architecture had been only a minor and intermittent part of his career.

These years of work on the basilica also served important functions in Michelangelo's psychic life. His fortitude in creating the edifice at the symbolic center of Christendom would, to his mind, please and perhaps appease God. This high intellectual challenge maintained his vitality in the face of physical pain and the process of aging in his last years. Moreover, it enabled him to continue to feel that he was the enslaved but devoted son to a succession of popes. On a more worldly note, it also provided him with a base of power and influence in the papal court. And finally, it served the convenient function of furnishing a "reason" why he could not return home to Florence for his last days, a prospect that he consciously desired but about which he was deeply ambivalent.

The Capitoline Hill and the Farnese Palace

The account of Michelangelo and St. Peter's has taken us well past the reign of Pope Paul III. During the years of his pontificate, there were two other architectural projects that warrant discussion: the Capitoline Hill and the Farnese Palace. The Piazza del Campidoglio on the Capitoline Hill (fig. 19-9) involved the transformation of a cow pasture and two decaying public buildings into a site for major public ceremonies and the symbolic civic center for the city of Rome. The spectacular oval piazza itself was to be bounded on three sides by a trapezoidal arrangement of three palaces. The piazza is paved in a complex geometric design related to an ancient cosmological schema. In the center stands a great bronze equestrian statue of Marcus Aurelius symbolizing Rome's era of imperial glory. One ascends to the narrow end of the piazza by a wide stairway, at the top of which are a pair of statues of the Horse-tamers, Castor and Pollux (the Dioscuri), which also represent Rome's past glory. The two extant palaces were radically rebuilt and a third was added. Michelangelo's designs for the Campidoglio are of uncertain dating but probably extended from the late 1530s through the 1550s. The project, with only minor variations from his plans, was not finished until the mid-seventeenth century. Howard Hibbard (1974) has summarized his contribution as follows: "It is the intimate yet monumental grandeur of the Capitol, the unity of diverse parts, the focus within divergent systems—oval, trapezoid, longitudinal—which make this an almost holy space, the most resonant and impressive piece of city-planning ever built" (p. 296).

Michelangelo's other architectural assignment of the 1540s was to complete the Farnese Palace (fig. 19-10). The palace had been commissioned by Pope Paul III, on behalf of his family, to Antonio da Sangallo. When Antonio died in 1546, the pope commanded Michelangelo to complete it. It was little more than one-quarter done when Michelangelo took over. The palace was to become the largest private residence in Rome.

19-9. Michelangelo's project for the Capitoline Hill, after engraving by E. Dupérac (1569).

19-10. Michelangelo's plan for the façade and square of the Farnese Palace, after engraving by N. Beatrizet (1549).

Michelangelo was seventy-four years old when Pope Paul III died, on November 10, 1549, after a fifteen-year reign as leader of the Catholic world. The artist described his feelings a month later in a letter to his nephew, Lionardo:

> It is true that the death of the Pope has been a great sorrow to me and a loss no less, because I received many benefits from His Holiness and hoped to receive still more. But it has pleased God that it should be thus and we must be resigned. He died a beautiful death and was conscious to the last. May God have mercy on his soul. [letter 341]

Thus, the passing of the great Farnese pope brought to an end the fifteen-year bond between these two elderly figures—the one, unwavering in his affection and fidelity to the artist, the other, inspired within the context of this protection to achieve in art and architecture works of unprecedented originality.

Chapter Twenty

Old Age, 1550–1564

Michelangelo was seventy-five years old at the time of the death of Paul III. His own journey on earth was to continue for another decade and a half. He worked unceasingly to the end, carving the Rondanini *Pietà* until six days before his death on February 18, 1564.

The fifteen years discussed in this chapter are, once again, relatively well-documented: 140 of Michelangelo's letters are preserved from this period, along with a number of his poems. Also, there are many letters addressed to Michelangelo as well as others about him written between contemporaries. For much of the richness of our knowledge of these years we are indebted to Giorgio Vasari, who was in Rome and in constant contact with Michelangelo from 1550 to 1554. Thereafter, when back in Florence as principal court painter and architect to Duke Cosimo de' Medici, he remained in continuous correspondence with the master, and visited him intermittently, until the end of Michelangelo's life.

Born in Arezzo in 1511, Vasari recorded that he first had contact with Michelangelo when he was twelve years old. He claimed, after Michelangelo's death, to have briefly studied with the master, but this is almost certainly Vasari's personal myth. When Michelangelo was summoned to Rome by Clement VII, Vasari was sent to be an apprentice in the workshop of Andrea del Sarto. Later, in the 1540s, when Vasari was in Rome he courted Michelangelo assiduously and consulted with him about his art and other matters. Vasari idolized him. The first edition of his *Lives of the Artists*, published in 1550, concluded with an apotheosis of Michelangelo, the only living artist to be included. The second edition (1568), the one universally used, was enlarged to include other contemporaries as well as an autobiography of Vasari (see chapter 1, note 3).

It seems certain that Vasari had Michelangelo's trust and confidence. Moreover, as an artist and architect himself, he was in a position to appreciate the more technical aspects of the master's work. Our understanding of Michelangelo's last years is enriched by reference to the frequent correspondence between Michelangelo and Vasari, as well as by the *Lives*.

A passage in a letter from Vasari to Duke Cosimo, written on April 8, 1560 (when Michelangelo was eighty-five years old), reveals the bond between the two artists:

I reached Rome, and immediately after the most reverend and illustrious Medici [Cosimo's second son, Giovanni] had made his entrance and received the [cardinal's]

hat from our lord's hands . . . I went to visit my friend, the mighty Michelangelo. He had not expected me, and the tenderness of his reception was such as old men show when lost sons unexpectedly return to them. He fell upon my neck with a thousand kisses, weeping for joy. He was so glad to see me, and I him, that I have had no greater pleasure since I entered the service of your Excellency. . . . He also expressed his sorrow at being unable to wait upon the Cardinal, because he now can move about but little, and is grown so old that he gets small rest, and is so low in health I fear he will not last long, unless the goodness of God preserves him for the building of S. Peter's.[1]

Michelangelo, the Popes, and the Political Situation

The last fifteen years of Michelangelo's life were less affected by Italy's constantly stormy history than were earlier decades. His central task during these years was the rebuilding of the Basilica of St. Peter's. It was this project that kept him in the service of four more popes, until his death. Florence was under the firm rule of Cosimo de' Medici, with whom the artist maintained cordial relations. Now that politics no longer seriously engaged Michelangelo's thoughts, the duke's generous and unending invitations to return to Florence stirred a deep yearning in him to do so. For years Michelangelo spoke of his desire and intention to return—a desire that was frustrated by his commitment to the basilica project, which could not conceivably approach completion during his life span. In this last period his nonarchitectural artistic activities—drawings and sculpture—were of a deeply personal, devotional nature.

Julius III, the first of four popes under whom Michelangelo was to serve in these final years, was elected on February 8, 1550, after a several-month-long struggle between the French and Spanish factions at the conclave of cardinals. Julius had the reputation of being a progressive churchman and a liberal in life-style. He was, however, temperamentally and intellectually ill suited for the delicate task of mediating between the French and Spanish and defending the Holy See from encroachment. He remained allied with the Spanish, who were less than wholly supportive of the papal forces against the aggressive designs of France. During his five-year reign he unsuccessfully tried to mediate between the Sienese and the combined forces of the Spanish and the Florentines, with the result that Siena was brutally ravaged in 1555.

The papacy of Julius was followed by that of the puritanical Pope Marcellus II, whose antipathy toward the artist we noted earlier. Had Marcellus not died unexpectedly only three weeks after his election, it seems certain that Michelangelo would soon have been forced to leave the papal court, to return to Florence.

Marcellus was succeeded by the seventy-nine-year-old Caraffa pope, Paul IV. Fernand Braudel (1973) said of him, "A preacher and theologian, he lived more in the world of his dreams and ideas than in the real world around him" (vol. 2, p. 938). This fiery old man zealously pursued the reform of the church. Earlier, in

1. Translated by Symonds (1893, 2: 293–94).

1542, he had held the principal responsibility for the reorganization of the Inquisition, which as pope he continued to implement mercilessly. He had a lifelong antipathy to the Spanish and to Emperor Charles V and naïvely dedicated himself to expelling the Spanish from Italy. As the French were unwilling to breach their 1555 alliance with Spain, the effect of Paul's attitude was merely to goad the Spaniards to attack Rome. The siege lasted from the autumn of 1556 through the spring of 1557. Romans, remembering the Spanish sack of their city in 1527, were in a state of terror.

The attack on Rome prompted Michelangelo to take refuge in the mountains of Spoleto for five weeks, from September 25 to October 31, 1556. He returned to the Holy City, however, for the remainder of the siege. The Spanish forces, under the duke of Alva, of Naples, were less intent on occupying Rome than on asserting their strength and embarrassing the pope. Thus, they allowed a treaty to be negotiated without entering the city. Of this treaty, Braudel (1973) writes:

> I need not stress the importance of this peace between Spain and the papacy; it marks the turning point in western history. . . . It was an alliance which was to last until 1580–90, for the greater protection of Catholicism and the Church, for the triumph of the Counter-Reformation, which but for this alliance of temporal and spiritual forces would never have been assured. [vol. 2, pp. 941–43]

By the time of his death on August 18, 1559, after a little more than four years on the throne, Paul IV was the object of much hatred on the part of the Roman citizenry and the papal court. In fact, he was at first buried in a secret grave to thwart the mobs that would have liked to snatch his body and either burn it or toss it into the Tiber.

Despite the turmoil that surrounded Paul's papacy, he was, like Paul III and Julius III before him, unwavering in his support and regard for Michelangelo. A strong spiritual kinship must have existed between these two passionate old men.

Pope Paul was succeeded by the Milanese cardinal Gian Angelo de' Medici, elected in December 1559. As Pope Pius IV, he reigned for six years, until the year after Michelangelo's death. He reversed the anti-imperial stance of his predecessor and succeeded in maintaining peace throughout Italy during his pontificate. His most notable achievement was the reconvening of the Council of Trent in 1562, which finally concluded its work in 1563. This assembly resulted in lasting definitions of Catholic doctrine, as well as policies for the rectification of some disreputable aspects of the functioning of the church.

Michelangelo was eighty-four years old when Pius was elected. This concerned and capable pope continued to give the artist his protection and support. At the outset of his pontificate, Pius issued a brief forbidding any deviation from Michelangelo's plans for St. Peter's after the artist's death (a command ignored by those who were later charged with the completion of the basilica).

Thus, except for the three-week pontificate of Marcellus, Michelangelo enjoyed the unqualified and deeply committed support of the popes for the last thirty years of his life, despite the marked differences in personality and objectives among the

respective pontiffs and the turbulent times for Italy and the church during those decades.

Cosimo de' Medici, the Brutus, and Florence

There was one other dominant personage in Italy whose rule exerted a force on Michelangelo's life during his last two decades. This was Cosimo de' Medici. Cosimo became the hereditary duke of Florence in 1537, at the age of seventeen, when the increasingly autocratic Duke Alessandro de' Medici was murdered by his cousin Lorenzino. The counselors to the murdered duke prevailed in the choice of a new leader, bypassing the duke's bastard son and instead transferring leadership to a new Medici line. Thus Cosimo, the son of a soldier-hero, Giovanni delle Bande Nere, who had fallen in the defense of Florence during the siege of 1530, became head of the republic. Cosimo embarked on a course of absolute rule that was to last for thirty-two years. Brilliant, coldly logical, at times ruthless, Cosimo was as close to the personification of the ideal prince that Machiavelli (1514) had immortalized as could be. He was married to Eleonora de Toledo, the daughter of Charles V's viceroy of Naples. Strengthened by this tie, he remained close and constantly loyal to Spain. Under his rule, the political unit was expanded from the city of Florence to all of Tuscany, Florentine citizenship being extended to any Tuscan. In 1569, Cosimo proclaimed himself grand duke of Tuscany. He obliterated the system of hierarchical privilege that had existed for centuries with the distinction in rights drawn between major and minor guildsmen, and between those who belonged to guilds and those who did not. The effect of these changes was to reduce the entire Tuscan population to a relatively homogeneous mass under Cosimo's single command. Once Tuscany was under his control, he devoted his energy to restoring vitality to commerce and industry and to instituting new means of cultivating the soil.

Cosimo's despotic rule made him the object of hatred on the part of the Roman community of Florentine republican exiles. According to Vasari, it was at the request of Cardinal Ridolfi, the leading figure among the *fuorusciti,* that Michelangelo carved the bust of *Brutus* (fig. 20-1). The history of the *Brutus* is uncertain, but most scholars date the work at around 1539–40. It is of particular interest because of the light it sheds on Michelangelo's ambivalence toward the duke and the artist's inner conflict over his patricidal impulses.

Brutus, an assassin of Julius Caesar, had become to the *fuorusciti* a symbol of the moral justification for tyrannicide. Every Florentine who attempted to assassinate a Medici was hailed as a "nuovo Bruto." Michelangelo's *Brutus* is an idealized representation of heroic and resolute resistance to moral compromise. Based on an ancient prototype, it carries on the motif of indignant moral fervor expressed in *David* (fig. 8-1) and *Moses* (fig. 14-2). Thus the work itself at first seems to be an unambiguous statement of anti-Medici, republican ardor. There are certain facts, however, that belie so straightforward an interpretation. Principal among them is that Michelangelo never completed this work despite its small size. There is no

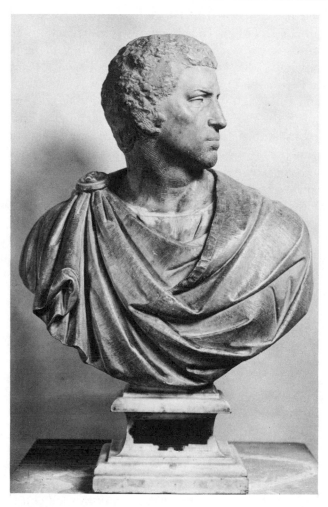

20-1. Michelangelo, *Brutus.*

known reason for his abandoning it. He turned the bust over to his pupil Tiberio Calcagni to finish carving the chin, neck, back, and drapery.

We might speculate that to have finished carving the few remaining details of the work would have been experienced by Michelangelo as giving closure to the acceptance of murderous impulses toward Duke Cosimo, the ruler of his homeland and the current head of the Medici—the family that had been such a controlling influence in his life for half a century.[2]

Michelangelo's conflict over tyrannicide more clearly emerged in another source from that period, Giannotti's *Dialogue* (1546). In the *Dialogue* there is a discussion between Michelangelo and his republican friends concerning Dante's relegation of Brutus and Cassius to the Inferno (*Inferno*, canto 34). After Giannotti reasons

2. An enigmatic problem is presented by an epigram inscribed on a bronze plaque at the base of the bust. It states that, in the course of his work on the bust, Michelangelo was reminded of the

that they deserved to be honored in Paradise and that every Roman citizen was duty-bound to kill Caesar, Michelangelo replies with irritation: "Did it not lead to disaster? We cannot know what will follow. What line of emperors succeeded him? Would it not have been better to let him live—even if it meant his becoming king? Doing ill—murdering—is not the only way of bringing good about. Times change, and persons, and there is always hope that good may come."[3]

This passage raises the problem that always accompanies our reliance on statements ascribed to individuals in dialogues. Did Giannotti accurately report Michelangelo's sentiments on the matter? In his introduction to the *Dialogue*, Redig de Campos argues convincingly that Michelangelo must have said this because there is no conceivable reason why Giannotti, an ardent republican, would have imputed these words to the hero of the piece, who is otherwise treated so respectfully.

Michelangelo's conservative attitude, expressed in the Giannotti passage, would be consistent with the submissive though grumbling stance he characteristically adopted toward popes and secular leaders. That is, with a few exceptions, such as his 1506 flight from Julius II, whatever the nature of the demands made upon him, Michelangelo suppressed behavior that would be antagonistic enough to disrupt the bond with his powerful patron. (See letter 291, p. 367, in regard to his avoidance of the *fuorusciti* in 1547.) This suppression was in the service of the fantasy that ultimately "good might come" and he would then be rewarded. I need not belabor the relation of the artist's ambivalent attitude on the subject of tyrannicide with the clusters of contradictory attitudes that he held toward his father throughout his life.

Michelangelo's split in attitude toward Duke Cosimo, expressed by the contradiction between the heroic rendering of the image of Brutus, on the one hand, and the failure to complete the work, on the other, was to characterize his actual relationship with Cosimo until the end of his life.

As early as 1546, while Michelangelo was at work in the Pauline Chapel, letters reveal that the duke offered to make him one of the forty-eight senators "and to give him any office he may ask for"[4] if he would return to Florence. It was in the following year that Cosimo decreed harsh penalties against any Florentine who

crime of tyrannicide and therefore abandoned the work:

 M. Dum.Bruti.Effigiem A.
 Sculptor de Marmore Ducit
 In Mentem Sceleris Venit
 B. Et Abstinut. F.

(M.A.B.F.: Michel Angelus Buonarotus Fecit)
This inscription, however, was probably added later by order of the grand duke Francesco de' Medici, who acquired the bust between 1574 and 1584, to discredit republicanism and present Michelangelo as a supporter of the Medici. It is highly doubtful that it reflects any specifically acknowledged position of Michelangelo with respect to the *Brutus*.

 3. Translated by Gordon (1957, p. 292).

 4. See Symonds (1893, 2: 189) for translation of sections of the letter from the duke's emissary, Bishop Tornabuoni, to another intermediary in Rome, Lottini.

had dealings with the *fuorusciti*. Michelangelo was never in any formal sense a member of the *fuorusciti*, but he was clearly identified with the cause because of his close social relations with them in Rome. Had Cosimo induced the artist to enter his service, it would not only have made his talents available for projects desired by the duke but would also have deprived the *fuorusciti* of the elevation of morale and the imprimatur of moral legitimacy resulting from Michelangelo's presence and implied support. At that time, however, Michelangelo certainly had no serious intention of leaving the service of Pope Paul III.

Apparently, no further pressure was exerted on Michelangelo to come back to Florence until 1552. A passage in Cellini's *Autobiography* (1562) betrays Michelangelo's derisive attitude toward the duke at that time. Cellini, who enjoyed the favor of Cosimo, was sent to persuade Michelangelo to return home. He wrote:

Then I went to visit Michel Agnolo Buonarroti, and repeated what I had written from Florence to him in the Duke's name. He replied that he was engaged upon the fabric of St. Peter's, and that this would prevent him from leaving Rome . . . I added much about future favours, in the form of a message from the Duke. Upon this he looked me hard in the face, and *said with a sarcastic smile*: "And you! to what extent are you satisfied with him?" Although I replied that I was extremely contented and was very well treated by his Excellency, he showed that he was acquainted with the greater part of my annoyances. [pp. 451–52, my italics]

There followed eight years of unrelenting efforts on the part of the duke to bring Michelangelo back to Florence. On September 19, 1554, Michelangelo responded to a plea from Vasari on behalf of the duke: "From your letter I realize the love you bear me and you may be sure that I should be glad to lay my feeble bones beside my father's, as you beg me. But if I were to leave here now, it would be the utter ruin of the fabric of St. Peter's, a great disgrace and a greater sin" (letter 390). Close to a year later he repeated to Vasari that if he were to depart it would be the ruin of the St. Peter's project, adding, "It would disgrace me utterly throughout Christendom and would lay a grievous sin upon my soul." He then continued, "Therefore, my dear Giorgio, I beg you to thank the Duke on my behalf for the splendid offers of which you write me, and to beg his Lordship to allow me to continue here with his kind permission until I can leave with a good reputation, with honour and without sin" (letter 398). Two years later, in 1557, Michelangelo wrote directly to the duke:

I now have another letter from Your Lordship urging me to return earlier than I anticipated, which caused me no little consternation, because I am in a state of greater anxiety and difficulty over the affairs of the said fabric than I have ever been. . . . Now to return to the subject, I beg Your Lordship to concede the required time of another year on account of the fabric. [letter 433]

In his final letter to the duke, written on April 25, 1560, Michelangelo, age eighty-five, first made a number of comments criticizing and praising elements in designs for alterations in the Palazzo Vecchio in Florence that had been sent to

him. He concluded: "As regards the Church of the Florentines [San Giovanni dei Fiorentini][5] here, it grieves me that, being so old and near death, I am unable to satisfy Your desire in everything. However, while I live I will do what I can" (letter 450).

What are we to make of Duke Cosimo's long courtship of Michelangelo, fed by the artist's implied and explicit promises that he would eventually return? Michelangelo throughout his life grossly underestimated the time that any project would take. But in this case, despite his "one more year" view of the point at which his efforts would no longer be needed for the completion of the basilica, he must have known that this project would require his attention as long as he lived. So, just as everything else stood between him and the completion of the Tomb of Julius II for forty years until 1545, so the St. Peter's project assumed a comparable psychological function. Michelangelo could express the part of his divided feelings toward Florence that dearly wanted to return. On the other hand, he provided himself with a viable reason for spending his remaining days in self-imposed exile, separated from his remaining family and his intellectual and artistic roots. We could assume that Michelangelo adopted this somewhat obsequious and promising posture toward the duke as insurance against the ascension to the throne of an unsympathetic pope (like Pope Marcellus) or that he wanted to ensure a benign attitude on the part of the duke toward all the Buonarroti who still lived in Florence. But there is also evidence that he did seriously nurture the fantasy of returning to Florence during these years. His intention is clearly stated in a letter from 1557, in which no hidden plan was probable, to the widow of his faithful servant and assistant of twenty-six years, Urbino. To Mona Cornelia, who lived at Castel Durante, he wrote: "Having arranged my affairs, and yours as regards the Public Funds, I shall leave for Florence this winter for good, since I am an old man and time will not remain for me to return to Rome anymore" (letter 431).

The return to Florence was complicated by the fact that the project delaying it—the rebuilding of St. Peter's—had a singular symbolic meaning in the Christian world. Michelangelo's many references to "grievous sin upon my soul" and "disgrace" if he were to leave the project prematurely suggest that he viewed a successful outcome to his labors as a principal means toward his own redemption. Moreover, having found a way to prevent his return home, he could maintain his lifelong image of himself, based on actual experience in childhood, as the one cast away.

A sonnet of 1554 sheds some light on Michelangelo's view of the construction of the basilica as a means toward redemption. In it he repudiates his life's accomplishments in painting and sculpture as being sufficient to have earned him grace.

5. San Giovanni dei Fiorentini was planned as a national church for Florentines in Rome. It was begun in the 1520s, but for financial reasons work was suspended after the foundations were laid. Late in 1559 Michelangelo was asked to design the church. He worked on this into 1560. More will be said of his plans for it (pp. 394–95), although they were not used in the end.

So that the passionate fantasy, which made
Of art a monarch for me and an idol,
Was laden down with sin now I know well,
Like what all men against their will desired.

. .

There's no painting or sculpture now that quiets
The soul that's pointed toward that holy Love
That on the cross opened Its arms to take us.[6]

When Michelangelo speaks of "that holy Love / That on the cross opened Its arms to take us," he reveals his yearning to merge with Jesus—a desire that makes his artistic efforts of this last period more comprehensible.

His dedication to St. Peter's and other artistic endeavors, however, coexisted with an ever-present worldly concern for his nephew Lionardo and the Buonarroti interests in Florence. This is abundantly evident from the 113 letters to Lionardo that have been preserved from these years. As detailed earlier (pp. 53–55), after six years of Michelangelo's counseling Lionardo on the choice of a bride, in May 1553 the young man was finally married to Cassandra di Donato Ridolfi, to the joy of his seventy-eight-year-old uncle. The exasperated, carping tone that Michelangelo characteristically had taken in his letters to Lionardo mellowed dramatically into genuine concern for the couple's welfare, generosity toward Cassandra, and unbridled pleasure at the birth of healthy children who would carry on the Buonarroti name.

Michelangelo's wiry frame was to know the pains that visit the body of one so old. Although he suffered from a number of ailments, he seems to have been spared any major diseases. Kidney stones were an intermittent problem, with their associated episodes of acute colic pain. Also, in a letter to Lionardo from the summer of 1555, Michelangelo speaks of "the cruelest pain I've had in one foot, which has prevented me from going out. . . . They say it's a kind of gout" (letter 403).[7] In 1553, Michelangelo wrote to Vasari that he had "no thought in which Death is not engraved" (letter 402). But it was only after the death of Urbino in 1555 that his own end often seemed to him near at hand. For example, in May 1557 he wrote to Lionardo: "I've many bodily disabilities which make me feel that death is not far off, so that I should be glad if you would come here this September, if I'm alive, in order to settle my affairs and ours" (letter 432).

A few months later he wrote to Vasari, "My brain and my memory have gone to await me elsewhere" (letter 439). However, apart from the normal changes in mental status that inevitably accompany the aging process, the evidence is that Michelangelo retained his capacity for complex and critical thought until the end. In 1559, in a letter to the architect and sculptor Bartolommeo Ammanati, which accompanied a small clay model he had made for the staircase to the Laurentian Library at San Lorenzo (fig. 15-7), Michelangelo elaborated on his plan in clear,

6. Gilbert and Linscott (1963, poem 283).
7. Kidney stones are commonly associated with gout, a disease of disordered uric acid metabolism.

well-thought-out terms, although he concludes, "I'm all yours, old, blind, deaf and inept in hands and in body" (letter 448). From 1560 we have a letter to the executor and guardian of the widow and children of Urbino containing a highly informed and detailed discussion of legal and real estate matters that pertained to Cornelia (letter 453).

The next to last letter to Lionardo, written less than a year before Michelangelo's death, has an impatient and irritated tone. In it, the old man energetically lashes out at those he believes would have designs on his drawings and personal possessions after his death: "Spurn them as envious, scandalmongering, low-living, rascals" (letter 479). The letter continues, in his characteristic highly cultivated syntax, to convey organized thoughts with respect to his living situation at Via Macel de' Corvi. Spunky to the end, he concludes: "Therefore look after yourself and don't worry about my affairs, because I know how to look after myself, if I need to, and I am not an infant. Farewell."

Michelangelo's Late Architecture

Not to slide into the progressive loss of critical thought in old age is one matter. But it is quite another to retain the level of creative genius that marks Michelangelo's architectural achievements after the age of eighty-five. In 1560 he completed his design for San Giovanni dei Fiorentini and executed plans for the Sforza Chapel at Santa Maria Maggiore. To these two projects, Michelangelo did not simply apply past formulae. At San Giovanni (fig. 20-2) the expressiveness emerges from the great masses in the overall structure and not from the more articulated components. Rather than creating a spirit of ascension from ground to dome, the forces seem to move downward. Ackerman (1961) has commented:

> Nothing in Michelangelo's previous architecture prepares for what might be called the resignation of this late project. It is surely another manifestation of the profound religious experience of his last years, an architectural version of the Pietàs and Passion drawings of the 1550's, where again the forms sink gravely earthwards. [p. 240]

Similarly, in the design for the Sforza Chapel Michelangelo departed from any previous model and offered a radically innovative solution.

From 1561 to the end of his life, Michelangelo was involved in a project for Pope Pius IV—the reconstruction of the central halls of the old Roman Baths of Diocletian into the church and monastery of Santa Maria degli Angeli. Virtually nothing of his plan can be seen in the present structure. Even if it is not so innovative as San Giovanni and the Sforza Chapel, however, his plan was a solid architectural solution.

The final architectural project I shall mention is the great gate to the city of Rome, the Porta Pia (fig. 20-3), commissioned in 1561 by Pope Pius. The gate was to be part of the wall to the city at the top of a dramatically wide avenue, the

ORTHOGRAPHIA EXTERIOR ET INTERIOR ✠ DESIGNATI TEMPLI SANCTI IOANNIS BAPTISTÆ NATIONIS FLORENTINORVM IN VRBE ☽ MICHAELE ANGELO BONARROTO ARCHITECTO

20-2. Engraving by V. Régnard after Michelangelo's wooden model for San Giovanni dei Fiorentini.

Via Pia. Vasari commented: "About this time Pope Pius required from Michel-Angelo a design for the Porta Pia, and the master made him three, all singularly beautiful. Of these the Pontiff chose the least costly, and this has been erected to the great credit of the artist" (vol. 2, p. 188).

As Ackerman points out, the effect of the gate is painterly, not sculptural. Rather than asserting the tension between strongly individualized components, a technique that characterized his earlier architecture, here Michelangelo relied on more subtle visual effects created by patterns of rhythmic interplay between the components. Yet the portal contains the most complex elements. There is a poignant aspect to the preparatory drawings: they seem to express a desperate race against what little time was left to the aged master, in that each sheet contains a number of superimposed designs. It must also be remembered that while working on these several late architectural projects Michelangelo continued his designing and, though less and less, his supervision of the work on the new basilica of St. Peter.

20-3. Engraving after Michelangelo's design for the
Porta Pia, Rome, 1568.

The Death of the Master

On February 14, 1564, Tiberio Calcagni sent the following urgent account of the
master's physical condition to Lionardo:

> Walking through Rome to-day, I heard from many persons that Messer Michelangelo
> was ill. Accordingly I went at once to visit him, and although it was raining I found
> him out of doors on foot. When I saw him, I said that I did not think it right and
> seemly for him to be going about in such weather. "What do you want?" he answered,
> "I am ill, and cannot find rest anywhere." The uncertainty of his speech, together
> with the look and colour of his face, made me feel extremely uneasy about his life.
> The end may not be just now, but I fear greatly that it cannot be far off. [vol. 2,
> p. 318][8]

On February 18, Michelangelo died at home after a week's illness, attended by his
physician and a few close friends, among them Tommaso de' Cavalieri and Da-
niele da Volterra. Resisting death to the end, he left no written will. Vasari records
the following oral request made on his deathbed:

> Retaining perfect self-possession, the master at length made his will in three words,
> saying he left his soul to God, his body to the earth, and his goods to his nearest

8. Translated by Symonds (1893).

relations. He recommended his attendants to bethink themselves, in the passage from this life, of the sufferings endured by Our Savior Christ. [vol. 2, p. 193]

Lionardo arrived in Rome three days later. At Michelangelo's request, arrangements were made for his burial in Florence. Inasmuch as Rome had come to regard the artist as its own, to avoid incident his body was transported to Florence in secret. Thus in death he was able to return, as he could not in life, to his native city. His tomb, designed by Vasari, stands in the church of Santa Croce, only a few blocks from his boyhood home.

The Florence Cathedral Pietà

In Michelangelo's art of this last period—the Florence Cathedral *Pietà*, the Rondanini *Pietà*, and his drawings of the Crucifixion—the concerns at the core of his soul are revealed.[9]

Our understanding of Michelangelo is deepened if we consider these last two Pietàs as one continuous artistic effort. It has been generally assumed that he began work on the Florence *Pietà* (fig. 20-4) in 1547, shortly after the death of Vittoria Colonna. He was at the time in the middle phase of painting the Pauline Chapel *Crucifixion of Peter*. The statue has become known as a Pietà, but it may have been intended as a Deposition, as both Condivi and Vasari called it. The group really condenses traditional elements of a Pietà, a Deposition, and an Entombment. It was uncommissioned and, significantly, was intended for his own tomb. According to Vasari, Michelangelo wanted at that time to have his tomb erected at Santa Maria Maggiore in Rome. It was not until the middle of the seventeenth century that the *Pietà* was transferred to Florence—not, however, to Michelangelo's tomb at Santa Croce but to the Cathedral.

The group consists of the dead Christ sinking in a rhythmic *serpentinata* pose and supported from behind by the hooded figure of Nicodemus[10] and by the Virgin on his left side and the Magdalene on his right. Christ's head falls to his left, not

9. The Palestrina *Pietà* in the Accademia in Florence had been considered by some to be a work by Michelangelo. That the work is not by his hand now seems to be a settled issue. See Pope-Hennessy, 1957; and Tolnay, 1943–60, 5: 152–54.

10. Most art historians have followed Condivi and Vasari in identifying the hooded figure as Nicodemus. A smaller number have maintained that the figure is Joseph of Arimathea, the powerful Israelite and secret disciple of Jesus who, upon the death of Christ, obtained permission from Pilate to take the body so that He could be buried before the Sabbath. Joseph also provided the linen shroud and the sepulchre in which Christ was entombed. Stechow (1964) reviewed the arguments and convincingly concluded that the figure was intended to be Nicodemus, largely on the basis of John 3:1–15, which tells of the visit by Nicodemus, a Pharisee, to the body of Christ on the eve of His Entombment. He is told by Jesus that "except a man be born again, he cannot see the kingdom of God." Nicodemus asks, "How can a man be born when he is old? Can he enter the second time into his mother's womb and be born?" How close these questions are to the anxieties the aging artist expressed again and again in his verse! To them, Jesus answered, "That which is born of the flesh is flesh; and that which is born of the Spirit is spirit. Marvel not that I said unto thee, Ye must be born again." It was this hope that helped to sustain Michelangelo over the years of work on the two Pietàs.

simply meeting but fusing with the barely carved face of his Mother. His face, after his torment, is serene. Earthly pain in Son and Mother has been transformed into a timeless, beatific union. It is the triumph of sacred love. Few images in art can approach the poignant intimacy of these heads of Christ and Mary.

It is fascinating to trace the origin of Michelangelo's sublime image of this Christ. Hartt (1968) has convincingly suggested that it derives from an image familiar to Michelangelo—that of the damned figure in Lorenzo Maitani's *Last Judgment*, to be found at the ground level of the magnificent early fourteenth-century façade of the Cathedral at Orvieto (fig. 20-5). Michelangelo's Christ is virtually the mirror image of Maitani's stark and tormented sinner, who is too weary to resist the hideous fate of being devoured by a serpent. Why would Michelangelo choose a sinner as model for the Savior? We remember his earlier choices of Orestes, the murderer of his mother, as the model for Adam, of Medea for the Madonna, of Tityus for the Risen Christ, and other similar transformations. I can only assume that Michelangelo's late devout belief in and increasing desire for identification with Christ were largely motivated by his profound sense of guilt and consequent need to stave off the fate of an eternal Hell by performing good works for Christianity, such as designing the new basilica of St. Peter's, and embracing personal faith.

The *Pietà* in Florence is unique in that it is the only work that Michelangelo actually tried to destroy and then abandoned. After years of work he mutilated the group, apparently beginning in the right lower frontal section, from which Christ's left lower extremity is now missing (fig. 20-6). His left forearm and hand and right forearm were also broken and subsequently repaired by Michelangelo's young follower Tiberio Calcagni. As the story comes down to us, it appears that Michelangelo would have completed the destruction had he not been dissuaded.[11]

Why would the eighty-year-old master try to destroy this particular creation in such a frenzied way? In order to understand why he indulged in such strange behavior at that time not some other, and in that form rather than another, we must probe into the unconscious meaning of the image for Michelangelo. Inasmuch as this group had a deeply personal meaning and purpose (to be part of his own tomb), my inquiry into the latent meaning of the group will, I hope, illuminate the central motifs in his unconscious thought.

Vasari at first gives alternative explanations for Michelangelo's mutilation and abandonment of the work, one technical, the other aesthetic: "But he broke up the block at last, either because it was found to have numerous veins, was excessively hard, and often caused the chisel to strike fire, or because the judgment of this artist was so severe that he could never content himself with anything that he

11. Vasari writes: "he not only broke the group, but would have dashed it to pieces, if his servant Antonio had not advised him to refrain, and to give it to someone even as it was. Hearing this, Tiberio spoke to Bandini, who desired to have something from his hand. And by means of the latter, Antonio received the offer of two hundred crowns of gold on condition that he should prevail on Michelangelo to permit that Tiberio, aided by the models of the master, should complete the group for Bandini" (2:176).

did" (vol. 2, pp. 175–76). Vasari then goes on to introduce a third reason, much more curious and personal. One day at Michelangelo's house, where the broken statue remained, Tiberio asked Michelangelo why he had smashed the *Pietà*. The artist replied "that he had been moved thereto by the importunities of Urbino, his servant, who was daily entreating him to finish that work" (vol. 2, p. 176).

Vasari's explanations are not persuasive. Instead, Steinberg (1968 and 1970) has proposed an iconographic explanation for Michelangelo's act by focusing on the now-missing left leg of Christ. Judging from the hollowed groove in the Virgin's thigh, as well as engraved copies, the missing leg was draped across her thigh, with the foot touching the ground. Steinberg's explanation is based on the assumption that Michelangelo felt the composition, with its strong sexual connotations, had compromised the purity of his sculpture. The crux of Steinberg's argument is that this "slung leg" was recognized as an "unmistakable symbol of sexual aggression or compliance," usually involving mythological couples and confined to "a few prints, drawings, and small cabinet pictures." In Steinberg's view, the *Pietà* employed a direct sexual metaphor on a scale unprecedented in Christian devotional art. He concluded that Michelangelo "destroyed it in despair" when he found that he had pushed the rhetoric of carnal gesture beyond the limits of acceptable expression, leaving him with a group that represented a consciously unintentional but nevertheless unacceptable meaning.[12]

Steinberg has thus provided an explanation that makes comprehensible what otherwise would seem to be irrational behavior. But the question remains: even if we fully agree with Steinberg's historical and iconographic data, to what extent can we derive a causal relationship between these data and Michelangelo's act of mutilation? In other words, although the "slung leg" theory provides an explanation for the act, there might still be some other explanation, given the same or other known facts and conditions, that is more convincing—one that fits in better with the artist's psychological state at that period in his life.

A fundamental assumption made by Steinberg is that Michelangelo destroyed the left leg of the intact body of Christ. However, scholars are by no means in agreement in regard to the state of the "missing leg" at the time of the mutilation. For example, Tolnay (1943–60, vol. 5) concludes that the leg "was originally made from a separate piece of marble" (p. 149). He reasons that the groove in the Virgin's thigh was provided for the insertion of this separate limb. Wilde (1978) also thought that the leg was carved from a separate piece of marble. This

12. In Steinberg's theory, intrapsychic conflict in Michelangelo or his response to other than the manifest iconography is perhaps implied but is not stated. It is useful to distinguish motivations that stem from *external* considerations from those that grow out of *internal* forces. In this case, Michelangelo could have been motivated by (1) *external* factors—e.g., fear of attack from Counter-Reformatory critics or (2) *internal* factors—e.g., anxiety stemming from the emergence into consciousness of unacceptable impulses and wishes. Steinberg proposes an external explanation, based on the artist's sensitivity to cultural norms and public criticism: "Now, with the reformist atmosphere settling in Rome, Michelangelo may have feared that his intentions would be misread by censorious and prurient men" (1970, p. 253).

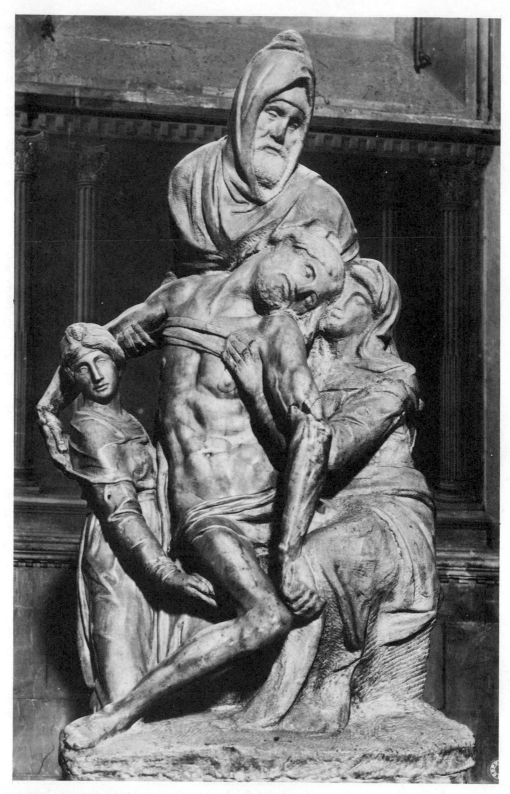

20-4. Michelangelo, Florence Cathedral *Pietà*.

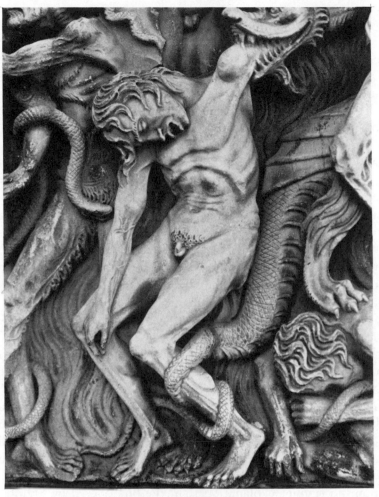

20-5. Lorenzo Maitani, *Last Judgment* (detail of one of the Damned).

20-6. Detail of figure 20-4 (area of Christ's missing left leg).

"separate leg" theory is supported by the unbroken surface of the Virgin's left thigh and by the groove made in it to receive Christ's left thigh, whose chiseled surface is characteristic of Michelangelo's work with the *gradina* and not of Tiberio's flat-chiseled style. If the leg was originally part of the block, it is difficult to imagine how Michelangelo could have impulsively chopped it off so cleanly, leaving the Virgin's thigh and drapery unscathed. On the other hand, the original block of marble was obviously of sufficient size and shape to have included the left leg. Thus, we must reject the assumption that Michelangelo would consider adding a separate crucial part to the main marble block unless an accident had occurred in the carving of the original leg, since to add to it would be at total variance with his creative philosophy, which stressed the integrity of the block of stone. That the leg was originally part of the main block is supported by both Condivi and Vasari. Condivi wrote: "a Christ deposed from the cross, whose dead body is sustained by His mother, as she slips her breast, arms, and knee under His body in a remarkable pose. . . . The released Christ falls with *all his limbs slackened*" (pp. 87, 90; my italics). Vasari recounted a visit to Michelangelo's house, during which he "meanwhile turned his eyes on a leg of the Christ on which Michelangelo was working and endeavoring to alter it. And to prevent Vasari from seeing it, he let the lamp fall from his hand, and they remained in darkness" (vol. 2, p. 202). We assume that Vasari was referring to Christ's left leg, as Michelangelo later removed it. His anecdote leaves unanswered the question of whether Michelangelo was ashamed of the leg because of its iconographic implications or because of imperfect technical execution. I conclude that during an earlier stage of work on the *Pietà*, the left leg was carved out of the original marble.

At this point, a simpler explanation than the one offered by Steinberg or the one that I will give might be sufficient. It is possible that, for whatever reasons, Michelangelo had reached a point in his carving of the leg at which it had become irreversibly flawed and therefore sculpturally unacceptable. He may then have carefully removed the leg with the reluctant intention of inserting a new, separately carved one. This sequence of events would account for his own chisel marks on the groove in the Virgin's thigh. With the passage of time, however, the breach in the integrity of the carved block might have proven so alien to him that in frustration and rage he tried to destroy the entire work. The problem with this relatively simple explanation is that it does not take into account Michelangelo's own reason for his decision at a particular moment to reverse his intention of completing the work.

A psychoanalytic inquiry into Michelangelo's destruction of the *Pietà* must focus on two specific issues: first, why the mutilation occurred at the time it did; and, second, how to regard Michelangelo's own explanation of the act—that he was so vexed by Urbino's nagging that he attempted to destroy a group for his own tomb.

It is often assumed that the mutilation took place late in 1555 but before December 3, the date of Urbino's death, since Michelangelo's explanation of his

destructive act implicates Urbino.[13] To the question of whether there was any extraordinary circumstance or preoccupying worry in Michelangelo's life during those months, we can respond with considerable certainty on the basis of the artist's letters and a sonnet, Vasari's description, and Varchi's funeral oration. For at least five months, Urbino had been bedridden and declining as the result of a terminal illness. Vasari relates that during those months, Michelangelo "had loved him so much that, although old, he had nursed him in his sickness, and slept at night in his clothes beside him, the better to watch for his comforts" (vol. 2, p. 174). In September of 1555, Michelangelo wrote to his nephew of his "great anxiety" regarding Urbino's continuing illness (letter 405). Then in November he wrote at length of his desperation, stating, "I'm as upset about it as if he were my own son" (letter 407). When Urbino died Michelangelo wrote two letters that express a level of grief that exceeds anything he wrote about any other person who died during his lifetime. The day after his old friend died he wrote to Lionardo:

> I must tell you that last night, the third day of December at 9 o'clock, Francesco, called Urbino, passed from this life to my intense grief, leaving me so stricken and troubled that it would have been more easeful to die with him, because of the love I bore him, which he merited no less; for he was a fine man, full of loyalty and devotion; so that owing to his death I now seem to be lifeless myself and can find no peace. [letter 408]

Three months after Urbino's death, Michelangelo wrote to Vasari:

> You know that Urbino is dead, through whom God has granted me his greatest favour, but to my grievous and infinite sorrow. The favour lay in this—that while living he kept me alive, and in dying he taught me to die, not with regret, but with the desire for death . . . nothing is left to me but the hope of seeing him again in Paradise . . . the greater part of me has gone with him, and nothing but unending wretchedness remains for me. [letter 410]

The following year, 1556, Michelangelo wrote in a sonnet to his old friend Bishop Beccadelli:

> So I thereby am constantly with you,
> And weep, and speak of my Urbino dead,
> Who now might be there with me, were he living,
> As I had had in mind. His dying, too,
> Hurries and draws me down a different road,
> Where he awaits, that I may share his lodging.[14]

13. All scholars accept the fact that the mutilation occurred before the death of Urbino on December 3, 1555. In the absence of documentation, however, none has attempted to pinpoint the exact date. Schapiro (1956) has offered the challenge that when the psychoanalyst enters the arena of art history, "he must venture, too, some opinions about dates of works which professional historians were still unable to decide" (p. 177). The theory I am proposing would make the act considerably more comprehensible if indeed it occurred late in 1555. To the extent that my idea accommodates other known facts in the situation, it is offered in support of the narrower period of time during which Michelangelo took this action.

14. Gilbert and Linscott (1963, poem 298).

Thus, at the time when the mutilation presumably took place, Michelangelo was overwhelmingly preoccupied with the imminent loss of his beloved Urbino and his apprehension regarding his own capacity and will to survive that loss. We cannot exclude the possibility that during those same months he also became consciously aware of the sexual implications of the "slung leg"—but it must be pointed out that this iconographic significance was so esoteric and subtle that Vasari did not see its role in the drama when he wrote a decade later, nor did subsequent engravers, who respectfully restored the missing leg (see fig. 20-7). Perhaps this gesture was so acceptable an expression of the view of Mary as Bride of Christ that no one took offense. Given this fact, we might explore further, to see if there is an alternative explanation that relates the image in the *Pietà* more closely to what I believe to be the psychological state of the artist at the time.

Considering Michelangelo's anxious concern for Urbino, it is not surprising to learn that the sculptor invoked something about Urbino to explain the destructive act. But how do we make sense of the specific content of the explanation—that it was his exasperation at Urbino's continuous nagging at him to finish it that led him to mutilate the statue? Let us assume that Urbino was saying something like, "Please finish it before I die." This would produce a conflict in Michelangelo because, on the one hand, he would want to gratify the wish of the dying but still live Urbino, while, on the other hand, to finish the group would be to acknowledge and accept the imminence of the dreaded event. On a more magical and unconscious level of thought, for Michelangelo to complete the work would make him, in his own mind, an active agent in bringing about Urbino's death.

Returning to the point that the *Pietà* was intended by Michelangelo for his own tomb, we realize that the prospect of completing the work was also loaded with symbolic meaning and feeling in connection with contemplation of his own death. In the letter to Vasari quoted earlier, Michelangelo wrote of having been "taught to die . . . with desire" (letter 410). Yet, for the previous thirty-nine years he had unrelentingly expressed a yearning for death in his poetry as well as in conversation.

There is, nevertheless, much to indicate that Michelangelo was not at all ready to die. In my discussion of the *Crucifixion of Peter* (fig. 19-3) I suggested that the image of Peter represented Michelangelo's furious protest against death itself. Remembering that the execution of the *Crucifixion* overlapped the first years of work on the *Pietà*, let us turn to his magnificent late drawings of the Crucifixion of Christ.[15] In this series of seven drawings, we have poignant evidence that Michelangelo struggled over and over again with the theme of the dying and dead Christ and His Mother.

The dating of the individual drawings is uncertain. Most scholars place them

15. The seven Crucifixion drawings are catalogued as follows: Paris, Louvre, 700; Windsor, Royal Library, 12775 and 12761 recto; Oxford, Ashmolean, P 343 recto; London, British Museum, W 81 and W 82; and London, Count Antoine Seilern. In Hartt (1970) the Crucifixion drawings are figures 421, 423, 424, 425, 426, 428, and 430.

20-7. C. Alberti (?), engraving after Michelangelo's Florence *Pietà*.

between 1550 and 1560—that is, during the later years of his work on the *Pietà* and in the years immediately following. The link in Michelangelo's thought between the St. Peter fresco and the Crucifixion drawings is unquestionably established by his insistent use in this series of drawings of four of the figures from the fresco, no fewer than eight times, as the models for the pose of either the Virgin or Saint John.[16] Looking at what is generally thought to be the last in the series (fig. 20-8),[17] which was therefore probably drawn after the mutilation of the *Pietà*, we see Mary gently pressing her cheek and lips against Christ's thigh while also softly touching the same thigh with her hand. This image is important in evaluating the Steinberg thesis. When discussing the Florence *Pietà*, Steinberg (1968) states, "An erotic energy . . . invests Michelangelo's group" (p. 345). Such a conclusion requires a similar reading of the *Crucifixion* in the British Museum—

16. See R. Wittkower (1941). The drawings referred to are: Louvre, 700; Windsor, Royal Library, 12761 and 12775; British Museum, W 81. In Hartt (1970) these are nos. 421, 423, 424, and 425.

17. *Christ of the Cross between the Virgin and Saint John* (British Museum, W 82) is considered the last of the series of late Crucifixion drawings by Berenson (1938), Brinckmann (1925), Gere (1975), Hartt (1970), Tolnay (1943–60, vol. 5), and Wilde (1953). It should be stated, however, that there is no material basis for this conclusion. Rather, it follows only intuitively from the subjective sense of closure which this drawing gives to the series.

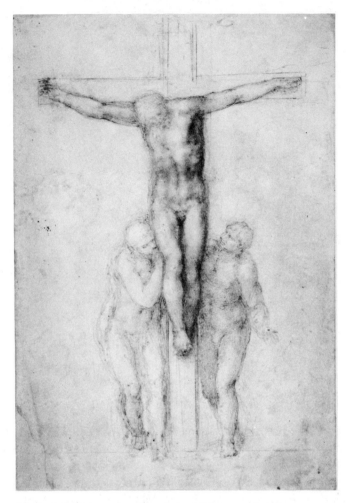

20-8. Michelangelo, drawing of *Christ on the Cross
between the Virgin and St. John.*

that it is suffused with incestuous eroticism. Regardless of Michelangelo's uncon-
scious motivation or conscious intention, the fact is that he created and left us
with this hauntingly intimate image, which can also be interpreted as frankly
carnal. If the implied carnality of the position of Christ's leg on the Virgin's lap in
the *Pietà* so disturbed Michelangelo that he felt impelled to destroy and abandon
the entire work, why did he continue to draw "carnal" and even incestuous poses
such as this? The obvious answer is that these poses were not explicitly sexual to
the usual viewer or even to Michelangelo himself. The seven Crucifixion drawings
exhibit an unrelenting pursuit of an acceptable artistic solution to the artist's ob-
session with death, as well as to his close identification with Christ and His tragic
destiny. I shall return to the Crucifixion drawings shortly.

 In order to link Michelangelo's paradoxical statement about Urbino's nagging
and the destructive act itself to Michelangelo's thoughts on death and his artistic

treatment of the subject, it is instructive to bring to bear clinical observations of people who have lost the objects of their love either recently or earlier in life. Such observations consistently yield evidence of unconscious and unexpressed rage toward the abandoning loved one. Indeed, Freud (1917) elaborated on this mechanism as the central dynamic in mourning reactions. It is in this psychological process that we find the explanation for the irritation and blame, otherwise not easily comprehensible, that Michelangelo directed toward the dying Urbino.

On a deeper level, it is even probable that during the twenty-six years of his service Urbino increasingly became an unconscious surrogate and external representation of Michelangelo's lost mother, who died when he was six years old. This pattern conforms to a general psychological law concerning the ways in which we all reenact our unfulfilled past throughout life, albeit in disguised forms and with disguised actors. Thus, if earlier crucial needs—in this case, for adequate mothering—have not been met, one seeks individuals and situations in which the childhood setting is unconsciously reexperienced and the other person is unconsciously perceived as replicating the role of the significant figure from childhood. The aging artist feared that he would not survive being abandoned by Urbino. Such a profound crisis would naturally stir up long-repressed conflicts deriving from his mother's premature death. Indeed, these repressed conflicts shaped Michelangelo's most basic relationships. Inasmuch as he apparently avoided relationships with women until his friendship with Vittoria Colonna, we can infer that his feelings toward women were distrustful, fearful, and potentially vengeful, and that Michelangelo defended against these painful feelings by his social pattern of avoidance. In the Florence *Pietà*, Michelangelo created on the surface a beatific union between the dead Christ and His Mother; but for Michelangelo such an image necessarily carried with it feelings of rage and aggression toward the mother who in his real life had left him frightened and alone.

Questions concerning the nature of Michelangelo's tie to his own mother might lead us to suppose—if the meaning of the "slung leg" played any role at all in the motivation for the mutilation—that Michelangelo's primary associations with the leg's presence in the *Pietà* were to his own earlier use of this compositional scheme in sculpture and in drawings of the Madonna, rather than to its meaning in works by other artists that might have been known to him. Variants of this motif are present in three of his five sculptured marble Madonnas.[18] In all five of these groups the coldness and detachment of the Virgin have been repeatedly noted. Thus, it might be argued that the "slung leg" in the *Pietà* brought to the surface once again the personal bitterness that seems to have consistently influenced Michelangelo's conception of the Madonna. I do not find this line of reasoning persuasive,

18. In the Taddei and Medici Madonnas (figs. 7-15 and 7-11), Jesus straddles the Virgin's thigh. In the Bruges *Madonna,* Jesus' left arm caresses her thigh. Similar images are presented in six drawings of the Madonna (Louvre, 689 r; Albertina S.R., 152 v; British Museum, W 31 r; *Madonna of Silence,* duke of Portland; Casa Buonarroti, 71 F; Windsor, Royal Library, 12772 r). In Hartt (1970) these drawings are nos. 58, 59, 177, 437, 438, and 439.

however, as it is confined to the compositional poses of linked extremities of the figures and does not address the broader issue of the deep personal implications of the complete drama represented in the two classes of subject.

If my psychoanalytic postulate regarding our ambivalence toward loved ones who have died is true, then we are in a better position to understand why, having created this image of loving union between Christ and Mary, Michelangelo also felt strong destructive impulses. In his identification with Christ, which was so pervasive in those years, he must have reexperienced the range of his conflicting emotions and fantasies associated with his own past. All these reactions, leading to the act of mutilation, were forced to the surface by Urbino's impending death. The Nicodemus in the Florence group is, as Vasari recognized, Michelangelo's self-portrait. Here is an instance in which the image that has been created follows laws that parallel dreams. Dreams are a mental activity in which conflicted and repressed impulses and wishes are allowed relatively anxiety-free expression because of their disguised form. In the Florence *Pietà*, the explicit first-person presentation of the self as one of the actors in the narrative permits the artist to act out another identifications in other characters, as in a dream. He can do this because the direct representation of himself as one of the figures draws the awareness of both the creator and the viewer away from the fact that more latent and conflicted themes are being expressed concurrently by the other figures.[19]

Further, the creation and destruction of the Florence *Pietà* can be viewed as part of a continuous process that took place over the last two decades of Michelangelo's life. During this period his creative preoccupation with the reconciliation of the dead Christ and His Mother in the Crucifixion drawings and in the Florence and Rondanini Pietàs was an effort to resolve the frightening prospect of his own death, with its associated fantasy of recapturing the warmth—however little he had actually experienced it—of his mother. Having mutilated and abandoned the first group, he continued the quest for a solution in the Rondanini marble, which he worked on until six days before his death.[20]

The Late Crucifixion Drawings

In the seven Crucifixion drawings, Michelangelo is also possessed by the subject of the reconciliation of the Son and His Mother. In the drawings of Christ himself, the aged artist's hand is unsteady: lines are often erased; borders are misty; positions of the head are altered and redrawn; features of the face are undefined. A physical presence fades into a haunting poem to be spoken only in the softest

19. See S. Freud, "The Interpretation of Dreams" (1900), Standard Edition, vols. 4 and 5.

20. Oremland (1978) has suggested that the two Marys in the Florence *Pietà* are Michelangelo's representations of his two "mothers," the Virgin being the real mother and the Magdalen his wet-nurse. He goes on to postulate that, with death drawing increasingly near, Michelangelo's impulse to fuse with the natural mother intensified; this yearning resulted in his abandoning the Florence version and embarking on the dyadic conception of the Rondanini *Pietà*.

whispers. Here, in the reworking and reconceiving of the Redeemer perhaps more than in any other work, Michelangelo is at one with the Man of Sorrows.[21]

Michelangelo also struggled with the figures of Mary and John the Evangelist, who stand at the feet of Christ. Their positions change from drawing to drawing. On each sheet they are filled with *pentimenti* and left unresolved. Incomplete erasures reveal revisions of their poses. In some cases their heads are bowed and arms crossed in passive acceptance of divine fate. In others, such as fig. 20-9, John angrily glares outward, his lips parted in protest. In one (fig. 20-10), the naked John and Mary march forward, drawn like uncomprehending primeval beings. All the earlier drawings set the stage for the final version, in which Mary and John turn to the limp body of the Son and the faintly and unsteadily drawn Mother embraces and kisses Jesus (fig. 20-8). Thus, again, the identification with the crucified Christ allows for the unconscious motif of reconciliation between mother and son. Perhaps the fact that this final Mary is so faint and incompletely drawn reflects how lost in memory Michelangelo's own mothering figures were.

The image of Mary in the last Crucifixion drawing (fig. 20-8), with only minimal changes, becomes the Madonna of the drawing that is quite possibly the last we possess from Michelangelo's hand (fig. 20-11).[22] Mother and Child are nude in their total embrace. In the shadow of death, Michelangelo returned to his original concern in the *Madonna of the Stairs* (fig. 2-1). In the Florence *Pietà*, having carved a beatific union between the dead Son and His Mother, he went on to mutilate it. In the last Crucifixion drawing, having portrayed a similar union, he had, in a sense, to reject it by moving on from dead Son and Mother to the Mother with a full-bodied, vigorous Child—thereby, to the end, affirming life and protesting death. Freud (1913) wrote of the tripartite view of the role woman plays in the life of man that recurs throughout myth and literature: the giver of life, the companion for life, and, finally, the destroyer of life—death itself. Michelangelo resisted the last, just as he had rejected belief in the first two.

The Rondanini Pietà

We do not know when Michelangelo began carving the Rondanini *Pietà* (fig. 20-12), but it is generally assumed to have been shortly after the mutilation of the Florence *Pietà*, in 1553.[23] Condivi makes no reference to the work. The piece we see, in which the slender, unfinished Christ is fused with the incomplete Mary, is

21. Rosand (1978a) suggests with great sensitivity that the very act of drawing in the *Crucifixion* series involves a process akin to sculpture—that is, "of groping, caressing, almost evoking form out of the depths of the paper" (p. 51). The old man seems unable to put down each sheet, as if he were surrendering to a direct tactile union with the body of Christ.

22. Wilde (1953) and Hartt (1970) both suggest that this drawing of the Madonna is the last extant drawing by Michelangelo.

23. Frank (1966) has written with insight from a psychoanalytic point of view about the Rondanini *Pietà*. She also presents a compelling analysis of the drawing of the *Madonna of Silence* (London, duke of Portland).

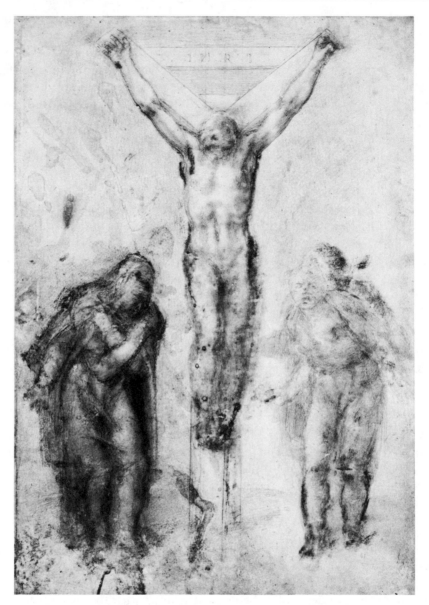

20-9. Michelangelo, drawing of *Christ on the Cross between the Virgin and St. John.*

the outcome of a series of drastic refinements from the Herculean proportions of the original conception suggested by the sheet with five studies now at Oxford (fig. 20-13). Tolnay (1934) has persuasively reasoned from the third and fourth studies (from left to right) on the sheet, which in chronology were the first and second, that the Rondanini group was originally intended to be an Entombment. In these sketches Christ is carried to his sepulchre by Mary and Joseph of Arimathea. The statue was then transformed into a vertically composed Pietà,

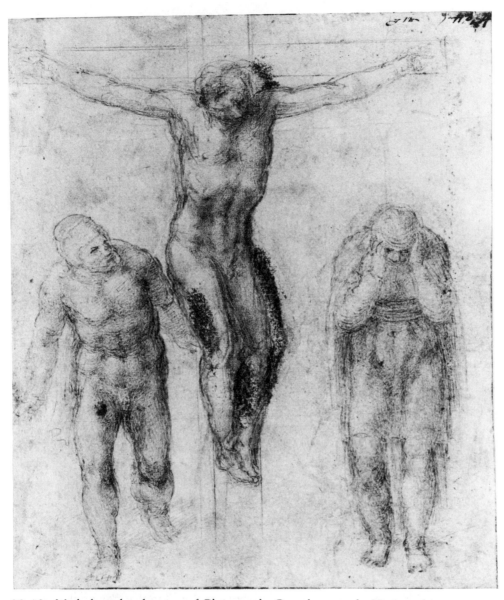

20-10. Michelangelo, drawing of *Christ on the Cross between the Virgin and St. John.*

as can be inferred from the chronological sequence of the second, fifth, and first studies (from left to right) on the Oxford sheet. In 1973, Mantura (1973) reported the recovery of a buried fragment of the head and upper torso of the Rondanini Christ, which Michelangelo had chopped off at an earlier stage of its evolution (fig. 20-14). Scholars have generally rejected the recovered fragment as being by Michelangelo's hand. It has, however, a muscularity consistent with the suspended right arm (to the left of Christ and Mary) and both lower legs of the final

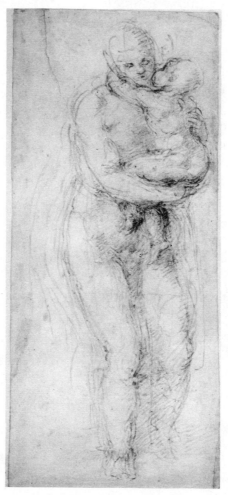

20-11. Michelangelo, drawing of *The Virgin and Child.*

version of Christ. It is also akin to the Florence Christ. Although its authenticity is in doubt, this copy nevertheless gives us a clearer idea of the probable appearance of an earlier stage of the Rondanini.

Thus, as we look back at the years of labor on the Florence *Pietà,* the series of Crucifixion drawings, and the long period of whittling down the Rondanini to its present skeletal form, we also witness the visual images of this continual process of cycles of artistic creation, dissatisfaction, destruction, and re-creation within the context of the motif of union between mother and son. This ambivalent and tormented struggle in Michelangelo, embodied in his Marys and dead Christs, drove him, in the Rondanini, to his final transcendent image of the fusion of the Son and Mother, each consisting of parts carved out of the other, in which even the forces of gravity are disregarded, boundaries are obliterated, and the two are timelessly reunited.

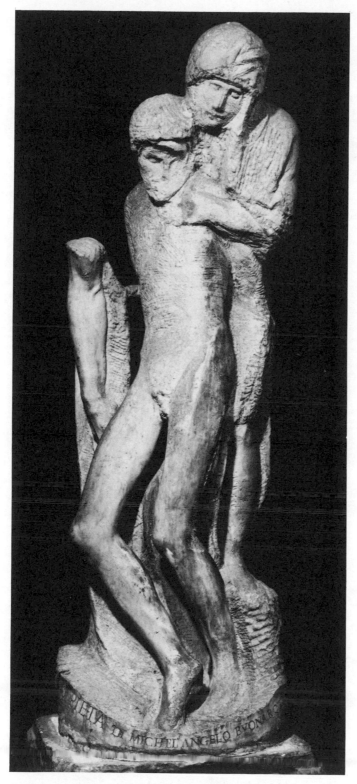

20-12. Michelangelo, Rondanini *Pietà*.

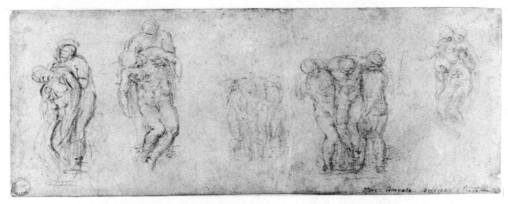

20-13. Michelangelo, studies for a Pietà and a Deposition.

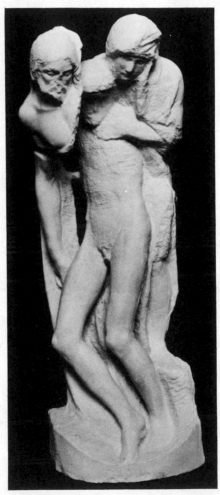

20-14. Michelangelo (?), fragment of head and torso of Christ with cast of the Rondanini *Pietà*.

Michelangelo's identification with Christ was profound and complex, and the almost twenty-year chain of doing and undoing, of continuous rethinking of this subject, superseded any specific iconographic associations. The dramatic contrast between the rejecting Virgins in the works with the live Child Jesus and the warm, enveloping Virgins of the Pietàs attests to his unconscious belief that the only condition for comforting union with a woman was death. In life, as in his own experience, love was withheld. Perhaps his conviction that this was true made his departure from life in his ninetieth year tolerable.

Chapter Twenty One

Conclusion

We cannot account for Michelangelo's extraordinary endowments as a sculptor, architect, painter, and poet. No one in the Buonarroti family line had ever before been involved in such pursuits, and Michelangelo's early inclinations toward art were actively opposed by his father. We can, however, address ourselves to the content and the form his art assumed by reconstructing his childhood and, more importantly, its later psychic representation.

Michelangelo was profoundly shaped by the early terror which filled the void left by maternal disappearances. The bewilderment of what happens to the body—to his own as the abandoned, helpless child and to all of ours after death—haunted him and in time became translated into artistic imagery in which meaning was expressed largely through the representation of the nude male. In contrast to the spirit conveyed by these Herculean beings, Michelangelo endured an unrelenting preoccupation with death. His hope and sustaining unconscious belief, which informed so much of his art from first to last, resided in the reconciliation of mother and son. From the *Madonna of the Stairs* to his final Rondanini *Pietà*, waves of yearning, pity, and rage gathered and erupted in creative rushes, only to recede again. Each time they returned, it was with renewed intensity, artistry, and wisdom.

In this study I have tried to isolate certain unconscious and unresolved early conflicts in Michelangelo that were among the basic determinants of the meaning and style of his art, architecture, and poetry. The first requirement in this task was a partial reconstruction of his childhood on the basis of known facts about his particular developmental history, as well as about the usual child-rearing practices in late fifteenth-century Florence. In this connection, two special circumstances were his experience of boarding with a wet-nurse from birth to about two years old and then, following his return to his natural parents, the death of his mother when he was six. The unconscious meaning and formative effects of those experiences were somewhat clarified by his own writings, contemporary descriptions of him, and the nature of his adult relationships. The early losses and the absence of any known significant women in Michelangelo's life from childhood until his late relationship with Vittoria Colonna bear witness to a boyhood climate of prolonged and profound deprivation of maternal care. One solution to his increasing despair that he would never recover the experience of warmth from the body of a mater-

416

nal woman was to transfer his need to the image of a powerful, caring male, which also contained the imago of the archaic mother.

This transferral of psychic investment to paternal figures shaped Michelangelo's intense, complex, and often seemingly contradictory relationships with the Medici and successive papal patrons throughout his life. Michelangelo's art and architecture cannot be understood apart from the real and fantasized relationships he had with those patrons. The unique character of Michelangelo's passionate friendship with Tommaso de' Cavalieri derived largely from these nuclear yearnings for protection and sustenance from an idealized male endowed with tender qualities. Finally, this dynamic provided much of the energy for specific images in painting and sculpture and for the overall program of such major projects as the Sistine Chapel ceiling frescoes and the Tomb of Pope Julius II.

For all the awesomeness of the Sistine Chapel, St. Peter's, and the Campidoglio, Michelangelo regarded himself first and foremost as a sculptor, not as a painter or architect. It was in stone, that unformed and obdurate substance of the earth, that this foster child of a stonemason's family searched for the figures who might satisfy his profound need. Most of the carvings were left unfinished. What he sought in the blocks of stone remained elusive. Pain continued and time could not be held back by the procession of heroic beings he created. Yet, inner necessity, tempered by courage and an unwavering vision, drove him from one task to the next.

It is sad indeed that Michelangelo could never accept and find solace in the prospect of one symbolic pathway to immortality—that his works would stand for century after century, undiminished among the most glorious achievements of man.

Chronology

Year	Political-Social Events	Michelangelo's Life	Michelangelo's Works
1475	Pontificate of Sixtus IV (della Rovere) 1471–84	Born in Caprese (Mar. 6)	
	Lorenzo the Magnificent is head of House of Medici, 1469–92	Boarded with wet-nurse in Settignano (Mar. 1475?– 1477?)	
1477		Returns to natural parents in Florence (date?)	
1481		Mother dies	
1484	Pope Sixtus IV dies (Aug. 12) Pontificate of Innocent VIII (Ciba), Aug. 1484– July 1492		
1485		Father remarries Attends grammar school (1485– 88)	
1488		Apprentices in workshop of Domenico and David Ghirlandaio (Apr. 1)	
1489		Studies sculpture at school in Medici Gardens; exposed to leading Neoplatonists and Humanists	
1490		Lives in the household of Lorenzo de' Medici (1490–92)	
1491	Fra Savonarola's period of influence in Florence begins		*Madonna of the Stairs* *Battle of the Centaurs*
1492	Lorenzo the Magnificent dies (Apr. 6). His son Piero becomes head of the House of Medici Pope Innocent VIII dies (July 25) Pontificate of Alexander IV (Borgia), Aug. 1492– Aug. 1503		*Crucifix of S. Spirito* (lost?)

Year	Political-Social Events	Michelangelo's Life	Michelangelo's Works
1493			*Hercules* (lost)
1494	Expulsion of Piero and the Medici from Florence (Nov. 7)	Flees to Bologna and Venice (Oct.); then lives and works in Bologna for about a year (1494–95)	*Angel Bearing Candelabrum* *St. Petronius* *St. Proculus*
	French troops enter Florence (Nov. 17)		
1495		Returns to Florence late in the year	*St. John* (lost, 1495–96?)
			Sleeping Cupid (lost, 1495–96?)
1496		Arrives in Rome (June 25). His life is centered at the court of the Humanist Cardinal Riario	*Bacchus* 1496–97)
1497	Savonarola's power in Florence rapidly declining	Leaves Rome to quarry marble at Carrara for *Pietà* (Nov.)	
1498	Savonarola executed for heresy (May)	Returns from Carrara to Rome (Apr.?)	*St. Peter's Pietà* (1498–1500)
1500		In Rome; no records of his activity for the year	*Entombment* (1500?)
1501		Returns to Florence (spring) Signs contract for 15 figures for the Piccolomini Chapel in Siena (May 22)	
		Signs contract for the *David* (Aug. 16)	*David* (1501–04)
1502	Piero Soderini elected gonfaloniere of Florence for life		
1503	Pope Alexander IV dies (Aug.)	Signs contract for 12 Apostles for the Cathedral of Florence	*Doni Tondo* (ca. 1503–05)
	Pontificate of Pius III (Piccolomini), Sept. 22– Oct. 19		*Bruges Madonna* (ca. 1503–05)
	Pontificate of Julius II (della Rovere), Nov. 1, 1503–Feb. 13, 1513		*Pitti Tondo* (ca. 1503–05)
			Taddei Tondo (ca. 1503–05)
			David (bronze, lost, 1503–05)
1504		Completes the *David* (Apr.) Commissioned to paint the *Battle of Cascina* (autumn)	Cartoon for the *Battle of Cascina* (1504–05)
			St. Matthew (1504–08)

Year	Political-Social Events	Michelangelo's Life	Michelangelo's Works
1505		Pope Julius II summons M to Rome to execute his tomb (Mar.)	Tomb of Julius II (1505–47, with interruptions)
		Leaves Rome to quarry marble for the tomb at Carrara (Apr.–Dec.)	
1506	Cornerstone laid for the new Basilica of St. Peter's (Apr. 18)	Flees from Rome to Florence (Apr. 17)	
		Makes his submission to Pope Julius in Bologna (Nov. 29)	
	Pope Julius triumphantly enters Bologna (Nov. 21)	Commissioned by Pope Julius to execute a larger-than-life bronze statue of himself (Dec.)	*Pope Julius II* (bronze, 1506–08) destroyed (Dec. 30, 1511)
1507		In Bologna at work on the statue of Pope Julius	
1508		Completes the statue of Julius and returns to Florence (Feb.)	
		Summoned to Rome by Pope Julius to paint the vault of the Sistine Chapel (May)	Sistine Chapel Ceiling (1508–12)
1510		Completes first half of the Sistine Ceiling (Aug.?)	
		Goes to Bologna to obtain money from Pope Julius, who is leading papal troops against the French (Sept.)	
		Returns to Rome (Oct.)	
		Goes to Bologna to obtain further payments from Pope Julius (Dec.)	
1511		Returns to Rome and begins work on the second half of the Sistine Ceiling (Jan.?)	
		The Sistine Ceiling is unveiled; lunettes as yet unfinished (Aug. 14)	
1512	Papal forces rout French from Italy (Mar.)	Unveiling of the completed Sistine Ceiling (Oct. 31)	
	Sack of Prato by Spanish troops (Aug. 29)		
	Piero Soderini resigns as gonfaloniere of Florence and the Medici return to power		

Year	Political-Social Events	Michelangelo's Life	Michelangelo's Works
1513	Pope Julius II dies (Feb. 21) Pontificate of Leo X (Medici), Mar. 11, 1513– Dec. 1, 1521	Contracts with della Rovere heirs of the pope for the second project of the Tomb of Julius (May 6)	*Dying Slave* (ca. 1513–15) *Rebellious Slave* (ca. 1513–15)
1514	Bramante dies (Mar. 11)	Contracts for the *Risen Christ* (June 24)	
1515	Pope Leo excommunicates the della Rovere duke of Urbino, installing his nephew, Lorenzo de' Medici, as the new duke		*Moses* (ca. 1515–16, 1542–45?)
1516		Contracts with the della Rovere for greatly reduced third project of the Tomb of Julius (July 8) In Florence (July and Aug.) In Carrara to quarry marble for the Tomb of Julius (Sept.–Dec.) Pope Leo commissions M and Baccio d'Agnolo to design the façade of San Lorenzo (Oct.) Returns to Rome from Carrara to confer with Pope Leo on design of the façade (Dec. 5) Returns to Florence from Rome to oversee the clay model of the façade and inspect the existing structure of the church (Dec.)	
1517		In Carrara to quarry marble for the façade of San Lorenzo (Jan.–Aug.) Returns to Florence from Carrara (Aug.)	Designs for the façade of San Lorenzo (1517–20)
1518		Contracts for façade of San Lorenzo (Jan.) Opens new quarries at Pietrasanta and Seravezza in Florentine territory (Feb.)	*Risen Christ* (ca. 1518–20)
1519	Leonardo da Vinci dies (May 2)	In Rome (July) At quarries in Pietrasanta (Aug.) At quarries in Carrara (Aug.–Sept.)	

Year	Political-Social Events	Michelangelo's Life	Michelangelo's Works
1519		Returns to Florence (Sept. 12)	
1520	Raphael dies (Apr. 6)	Pope Leo cancels contract for the façade of San Lorenzo (Mar. 10)	The four *Boboli Slaves* (1520–23?)
		Pope Leo commissions M to design the New Sacristy of San Lorenzo (Nov.)	New Sacristy (1520–29)
1521	Pope Leo dies (Dec. 1)	In Carrara to quarry marble for the New Sacristy (Apr.)	
1522	Pontificate of Adrian VI (Dedel of Utrecht), Jan. 9, 1522–Sept. 14, 1523	Suspends work on the New Sacristy during Adrian's pontificate	
	Pope Adrian restores the della Rovere to power in Urbino		
1523	Pope Adrian dies (Sept. 14)	Pope Adrian orders M to deliver Tomb of Julius (1516 project) or return money advanced	
	Pontificate of Pope Clement VII (Medici), Nov. 19, 1523–Sept. 25, 1534	Goes to Rome for audience with Pope Clement. Clement renews proposal for a new library at San Lorenzo (Dec.)	
		Antonio Mini engaged as apprentice to M (Dec. 12)	
1524–26		At work on Medici tombs, interior architecture of the New Sacristy, and the Laurentian Library	Medici tombs (1524–34)
			Laurentian Library (1524–34, 1549–50, 1558)
1527	Sack of Rome by Spanish-directed troops (May 6)		*Victory* (ca. 1527–30)
	Expulsion of the Medici from Florence (May 17)		
	Plague in Florence (summer)		
	Pope Clement imprisoned by imperial forces at Castel Sant'Angelo in Rome (June 7)		
	Pope Clement escapes to Orvieto (Dec. 9), then to Viterbo		
1528	Plague in Florence	Accepts commission from the Republic of Florence for colossus of *Hercules* (Apr.)	
	Pope Clement returns to Rome after reconciliation with the emperor (Oct.)		

Year	Political-Social Events	Michelangelo's Life	Michelangelo's Works
1528		Brother Buonarroto dies in the plague in Florence (July 2) Engaged in preparations for possible siege of Florence (Oct.)	
1529	Florence under siege by Papal and Spanish troops (Oct.)	Appointed superintendent of fortifications of Florence (Apr. 29) Inspects fortifications at Pisa and Leghorn (May–June) Visits Ferrara to study fortifications (July–Sept.) Alfonso I (d'Este), the duke of Ferrara, commissions M to paint *Leda and the Swan* (Aug.–Sept.?) Flees Florence for Venice (Sept. 21) Declared rebel by the Republic of Florence (Sept. 30) Is pardoned and returns to Florence (late Nov.) Francesco d'Amadore (Urbino) begins his 26 years of service with M (1529–30?)	Fortifications of Florence (1529–30) *Leda and the Swan* (ca. 1529–31)
1530	Florence surrenders to the papacy (Aug. 12) Reign of terror against leading republicans follows surrender	Declared political enemy by papal commissioner and goes into hiding (Aug.) Pope Clement forgives M and commands him to resume work on Medici Chapel	*David-Apollo* (ca. 1530)
1531		Father dies at age 87 (spring?) Antonio Mini leaves M after 8 years of service with gift from M of *Leda and the Swan* (Nov.) Pope Clement issues brief forbidding M to work for anyone other than him and on the Tomb of Julius (Nov. 12)	Cartoon for *Noli Me Tangere* (ca. 1531)
1532	Alessandro de' Medici (Pope Clement's illegitimate son) named duke of Florence (May 1)	Visits Rome (Apr.) Contracts with della Rovere new project for the Tomb of Julius (Apr. 29)	Cartoon for *Venus and Cupid* (ca. 1532–33)

Year	Political-Social Events	Michelangelo's Life	Michelangelo's Works
1532		Meets Tommaso de' Cavalieri in Rome (spring or late summer) Visits Rome (Aug.)	
1533		Briefly visits Florence (Mar.), then returns to Rome Returns to Florence (July–Nov.) Meets with Pope Clement, possibly to discuss painting a Resurrection in the Sistine Chapel (Sept. 22) Returns to Rome (Nov.). No record of his activities from Nov.–May/June, 1534	
1534	Pope Clement dies (Sept. 25) Pontificate of Paul III (Farnese), Oct 13, 1534– Nov. 10, 1549	Returns to Florence for his last stay (May/June) Returns to Rome to take up permanent residence (Sept. 23)	
1535		Preparation of the altar wall of the Sistine Chapel for fresco of the *Last Judgment* (spring) Angrily terminates 25-year-long friendship and collaboration with Sebastiano del Piombo (spring/summer) Appointed by Pope Paul "supreme architect, sculptor and painter" of the Vatican (Sept. 1)	Sketches and cartoons for the *Last Judgment*
1536		Begins painting the *Last Judgment* (April/May) Pope Paul releases M from obligations to the della Rovere for Tomb of Julius until the *Last Judgment* is finished (Nov. 17) Meets Vittoria Colonna in Rome (date?)	*Last Judgment* (1536–41)
1537	Alessandro de' Medici, duke of Florence, assassinated by his cousin Lorenzino de' Medici (Jan. 6) Cosimo de' Medici elected duke of Florence (Jan. 9). He rules until 1574	At work on the *Last Judgment*	

Year	Political-Social Events	Michelangelo's Life	Michelangelo's Works
1538	Francesco Maria della Rovere, duke of Urbino, dies (Oct. 20)	Meetings with Vittoria Colonna recorded by de Hollanda in his *Dialogues* (Oct. 13, Oct. 20, Nov. 3)	
		Work on *Last Judgment* interrupted (Nov.)	
		Begins plans for civic center on Capitoline Hill (date?)	Campidoglio (1538–64)
1539		Resumes work on the *Last Judgment*	*Brutus* (ca. 1539–40?)
1540		At work on the *Last Judgment*	
		Bartolommeo Angiolini, M's friend and business advisor, dies (Dec. 28)	
1541	Conflict between Pope Paul and the Colonna family over salt tax	Vittoria Colonna moves to monastery in Orvieto (Mar.)	
		Vittoria Colonna returns to Rome (Aug.), then leaves for monastery in Viterbo (Oct.)	
		Unveiling of completed *Last Judgment* (Oct. 31)	
1542	France enters into alliance with the Turks	Contracts with the della Rovere for the final version of the Tomb of Julius (Aug. 20)	*Conversion of Paul* (1542–45)
		Begins work in the Pauline Chapel on the *Conversion of Paul* (Nov.)	
1543		Vittoria Colonna ill at Viterbo	
		At work in Pauline Chapel	
1544	Treaty of Crespi between Spain and France (Sept.)	Cecchino de' Bracci dies (Jan. 8)	
		Rejects request to carve bust of Cosimo de' Medici (Mar.)	
		Vittoria Colonna returns to Rome (June)	
		Seriously ill. Cared for by Luigi del Riccio at his quarters at the Strozzi Palace (July–Aug.)	
1545	Council of Trent convenes (Dec.)	Tomb of Julius completed (Feb.)	*Crucifixion of Peter* (1545–50)
		Completes the *Conversion of Paul* (July)	
		Preparations begin for the painting of the *Crucifixion of Peter* (summer)	

Year	Political-Social Events	Michelangelo's Life	Michelangelo's Works
1545		Ill. Cared for by Luigi del Riccio at his quarters at the Strozzi Palace (Dec. 1545–Jan. 16, 1546)	
1546	Antonio da Sangallo (architect of St. Peter's) dies (Aug. 3)	Honored with Roman citizenship (Mar. 30)	Farnese Palace (1546–50)
		Luigi del Riccio dies (Sept./Oct.)	
		Appointed architect of the unfinished Farnese Palace (fall)	
		Donato Giannotti's *Dialogues* are published	
1547	Spanish siege of the papal duchy of Piacenza	Pope Paul appoints M as architect of the Basilica of St. Peter's (Jan. 1)	Basilica of St. Peter's (1547–64)
	Pope Paul's son, Pierluigi, is assassinated	Vittoria Colonna dies (Feb. 25)	Florence Cathedral *Pietà* (1547–55)
		Sebastiano del Piombo dies (June)	
		Begins work on *Pietà* for his own tomb (Florence Cathedral *Pietà*) (date?)	
1548	Pope Paul breaks neutral stance and enters negotiations with the French for an alliance	Brother Giovan Simone dies (Jan. 9)	
		Has attack of kidney stones (May)	
1549	Pope Paul III dies (Nov. 10)	Has attack of kidney stones (Mar.)	
		Pope Paul appoints M "Supreme Architect of St. Peter's" (Oct. 11)	
		Designs sections of the Laurentian Library (1549–50)	
1550	Pontificate of Julius III (del Monte), Feb. 8, 1550–Mar. 23, 1555	Completes the *Crucifixion of Peter* (Mar.?)	
	Publication of the first edition of Vasari's *Lives of the Painters, Sculptors and Architects*	Vasari moves from Florence to Rome (date?)	
1551		Pope Julius III reconfirms M as Supreme Architect of St. Peter's after a hearing before the deputies	
1552		At work on Basilica and *Pietà*	
1553		Nephew Lionardo is married to Cassandra di Donato Ridolfi (May 16)	

Year	Political-Social Events	Michelangelo's Life	Michelangelo's Works
1553		Condivi's *Life of Michelangelo Buonarroti* is published (July)	
1554		Vasari returns to Florence from Rome and enters service of Duke Cosimo de' Medici	
		Nephew Lionardo and Cassandra have son Buonarroto (Apr.)	
1555	Pope Julius III dies (Mar. 23)	Corresponds with Vasari about returning to Florence during the pontificate of Marcellus II	
	Pontificate of Marcellus II (Cervini), Apr. 9– May 1		
	Sack of Siena by the Spanish (Apr.)	Servant and assistant, Urbino, is bed-ridden with serious illness (June)	
	Pontificate of Paul IV (Caraffa), May 23, 1555– Aug. 18, 1559	Has attack of gout (summer)	
		Designs staircase for the Laurentian Library (Sept.)	
		Brother Sigismondo dies (Nov. 13)	
		Mutilates the *Pietà* (Florence Cathedral) and abandons the work (before Dec.)	
		Urbino dies (Dec. 3)	
1556	Charles V abdicates Spanish throne; succeeded by his son Phillip II	Begins work on the Rondanini *Pietà* (date?)	Rondanini *Pietà* (1556–64)
		Retires to Spoleto (Sept.– Oct.) during Spanish threat to Rome	
1557		Makes clay model of the dome for St. Peter's	
1558		Redesigns staircase for the Laurentian Library (Dec.)	
1559	Pope Paul IV dies (Aug. 18)	Begins designs for S. Giovanni dei Fiorentini in Rome (Oct.)	Designs for S. Giovanni dei Fiorentini (1559– 62)
	Pontificate of Pius IV (Medici), Dec. 25, 1559– Dec. 9, 1565		
1560		Designs Sforza Chapel at S. Maria Maggiore (date?)	Sforza Chapel (ca. 1560)
1561		Begins designs for the Porta Pia (early 1561)	Porta Pia (1561–64)
		Designs remodeling of the Great Hall of the Baths of Diocletian for S. Maria degli Angeli (date?)	S. Maria degli Angeli (1561–64)
1562		At work on the Basilica of	

Year	Political-Social Events	Michelangelo's Life	Michelangelo's Works
1562		St. Peter's and the Rondanini *Pietà*, with secondary attention to other design projects	
1563		Elected first academician after Duke Cosimo of the Accademia Fiorentina (Jan. 31)	
		Last letter (to nephew Lionardo, Dec. 25)	
1564		At work on the Rondanini *Pietà* (Feb. 12)	
		Taken ill (Feb. 14)	
		Dies at home in Rome (Feb. 18)	

Bibliography

ACKERMAN, J. (1961), *The Architecture of Michelangelo*. Harmondsworth: Penguin.

——— (1970), Notes on Bramante's Bad Reputation. In: *Studi Bramanteschi: Atti del Congresso Internazionale*. Milan, Urbino, and Rome, pp. 339–49.

AESCHYLUS (ca. 458 B.C.), *The Oresteia Trilogy*, tr. G. Thomson. New York: Dell, 1965.

APOLLODORUS (50 B.C.–A.D. 100?), *The Library of Greek Mythology*, tr. K. Aldrich. Lawrence, Kan.: Coronado Press, 1975.

BARDESCHI CIULICH, L. & BAROCCHI, P. (1970), *I ricordi di Michelangelo*. Florence: Sansoni.

BAROCCHI, P. & RISTORI, R. (1965–79), *Il carteggio di Michelangelo*, posthumous edition of Giovanni Poggi, 4 vols. Florence: Sansoni.

BARTSCH, A. (1803–21), *Le Peintre-graveur*. Vienna: Degen.

BECK, J. (1975), *Michelangelo: A Lesson in Anatomy*. New York: Viking.

BERENSON, B. (1896), *Italian Painters of the Renaissance*, 2 vols. New York: Phaidon, 1952.

——— (1938), *Drawings of the Florentine Painters*. Chicago: University of Chicago Press.

BRAUDEL, F. (1973), *The Mediterranean and the Mediterranean World in the Age of Philip II*, 2 vols. New York: Harper & Row.

BRINCKMANN, A. E. (1925), *Michelangelo-Zeichnungen*. Munich: R. Piper & Company.

BURCKHARDT, J. (1860), *The Civilization of the Renaissance in Italy*, 2 vols. New York: Harper & Row, 1958.

BURKE, P. (1972), *Culture and Society in Renaissance Italy: 1420–1540*. New York: Scribner.

CAVALCA, D. (1320–42?), La Vita di San Giovanni Battista. In: *Biblioteca scelta di opere italiane antiche e moderne*, ed. D. Manni & A. Cesari, vol. 4. Milan, 1829.

CECCHI, E. (1956), *Jacopo da Pontormo Diario*. Florence: F. Le Monnier.

CELLINI, B. (1562), *Autobiography of Benevenuto Cellini*, tr. J. A. Symonds. New York: Dolphin Books, 1961.

CLARK, K. (1939), *Leonardo da Vinci*. Cambridge: Cambridge University Press.

——— (1956), *The Nude: A Study in Ideal Form*. Princeton, N.J.: Princeton University Press.

——— (1964), Michelangelo Pittore. *Apollo*, 80: 437–45.

——— (1966), *Rembrandt and the Italian Renaissance*. London: John Murray.

——— (1967), *A Failure of Nerve: Italian Painting 1520–1535*. Oxford: Clarendon Press.

CLEMENTS, R. J. (1965), *The Poetry of Michelangelo*. New York: New York University Press.

COLONNA, V. (1525–45), *Rime e lettere*. Florence: Barbera, 1860.

CONDIVI, A. (1553), *The Life of Michelangelo*, tr. A. S. Wohl, ed. H. Wohl. Baton Rouge, La.: Louisiana State University Press, 1975.

D'ANCONA, M. L. (1968), The Doni Madonna by Michelangelo. *Art Bulletin*, 50: 43–50.

429

DANTE ALIGHIERI (ca. 1315), *The Divine Comedy*, tr. C. S. Singleton. Princeton, N.J.: Princeton University Press, 1970.

DEUTSCH, H. (1969), *A Psychoanalytic Study of the Myth of Dionysus and Apollo*. New York: International Universities Press.

DOTSON, E. (1979), An Augustinian Interpretation of Michelangelo's Sistine Ceiling. *Art Bulletin*, 61: 223–56, 405–29.

DUSSLER, L. (1959), *Die Zeichnungen des Michelangelo*. Berlin: Mann.

EISSLER, K. R. (1961), *Leonardo da Vinci: Psychoanalytic Notes on the Enigma*. New York: International Universities Press.

EURIPIDES (ca. 415 B.C.), *The Bacchae*, tr. W. Arrowsmith. Chicago: University of Chicago Press, 1959.

FAIRBAIRN, W. R. D. (1938), The Ultimate Basis of Aesthetic Experience. *British Journal of Psychology*, 29: 167–281.

FARRELL, B. (1963), Introduction to S. Freud's *Leonardo da Vinci and a Memory of His Childhood*. Harmondsworth and Baltimore: Penguin.

FRANK, G. (1966), The Enigma of Michelangelo's Pietà Rondanini: A Study of Mother-Loss in Childhood. *American Imago*, 23: 287–315.

FREEDBERG, S. J. (1970), *Painting in Italy: 1500–1600*. Harmondsworth: Penguin.

FREUD, S. (1899), Screen Memories. *S. E.*, 3: 303–22.

———— (1900), *The Interpretation of Dreams*. *S. E.*, vols. 4 and 5.

———— (1909), Family Romances. *S. E.*, 14: 236–41.

———— (1910), Leonardo da Vinci and a Memory of His Childhood. *S. E.*, 11: 59–137.

———— (1911), Formulation on Two Principles of Mental Functioning. *S. E.*, 12: 218–26.

———— (1913), The Theme of Three Caskets. *S. E.*, 12: 291–301.

———— (1914), The Moses of Michelangelo. *S. E.*, 13: 211–36.

———— (1917), Mourning and Melancholia. *S. E.*, 14: 243–58.

FREY, K (1899), *Sammlung ausgewählter Briefe an Michelagniolo Buonarroti*. Berlin: K. Siegismund.

FRIEDLAENDER, W. (1957), *Mannerism and Anti-Mannerism in Italian Painting*. New York: Columbia University Press.

GERE, J. A. (1975), *Drawings by Michelangelo*. London: British Museum Publications.

GIANNOTTI, D. (1546), *Dialogi di Donato Giannotti*. Florence: Sansoni, 1939.

GILBERT, C. (1962), Review of R. J. Clements's "Michelangelo's Theory of Art." *Art Bulletin*, 44: 347–55.

———— (1980), On the Absolute Dates of the Parts of the Sistine Ceiling. *Art History*, 3: 158–81.

———— & Linscott, R. N. (1963), *Complete Poems and Selected Letters of Michelangelo*. New York: Random House.

GILMORE, M. (1952), *The World of Humanism: 1453–1517*. New York: Harper & Row.

GOLDSCHEIDER, L. (1951), *Michelangelo Drawings*. London and New York: Phaidon.

GOMBRICH, E. (1954), Psycho-Analysis and the History of Art. In: *Meditations on a Hobby Horse and Other Essays on the Theory of Art*. New York: Phaidon, 1963, pp. 30–44.

GORDON, D. J. (1957), Giannotti, Michelangelo and the Cult of Brutus. In: *Fritz Saxl, 1890–1948: A Volume of Memorial Essays*, ed. D. J. Gordon. London: Thomas Nelson & Sons.

GOULD, C. (1966), *Michelangelo: Battle of Cascina*. Newcastle upon Tyne: University of Newcastle upon Tyne Press.

————— (1974), Michelangelo's *Entombment*: A Further Addendum. *Burlington Magazine*, 116: 31–32.

GRAVES, R. (1955), *The Greek Myths*, 2 vols. Baltimore: Penguin.

GREENACRE, P. (1957), The Childhood of the Artist. In: *The Psychoanalytic Study of the Child*, 12: 47–72.

GRIMM, H. (1860), *The Life of Michelangelo Buonarroti*, 2 vols. Boston: Little, Brown, 1894.

GROLNICK, S. (1977), Discussion of Paper by R. Liebert. Meeting of the American Psychoanalytic Association, New York City.

GUICCIARDINI, F. (1561), *The History of Italy*. New York: Macmillan, 1969.

GUTHRIE, W. K. C. (1950), *The Greeks and Their Gods*. Boston: Beacon Press.

HALL, M. B. (1976), Michelangelo's "Last Judgment": Resurrection of the Body and Predestination. *Art Bulletin*, 58: 85–92.

HARTMANN, H., KRIS, E., LOEWENSTEIN, R. M. (1951), Some Psychoanalytic Comments on Culture and Personality. In: *Psychoanalysis and Culture*, ed. G. B. Wilbur & W. Muensterburger. New York: International Universities Press.

HARTT, F. (1950), Lignum Vitae in Medio Paradisi: The Stanza d'Eliodoro and the Sistine Ceiling. *Art Bulletin*, 32: 115–45, 181–219.

————— (1951), The Meaning of Michelangelo's Medici Chapel. In: *Essays in Honor of Georg Swarzenski*. Chicago: Henry Regnary Company, pp. 147–55.

————— (1964), *Michelangelo*. New York: Abrams.

————— (1968), *The Complete Sculpture of Michelangelo*. New York: Abrams.

————— (1970), *Michelangelo Drawings*. New York: Abrams.

HEIL, W. (1451), A Portrait by Bronzino. *Pacific Art Review*, 1: 1–5.

HELD, J. S. (1969), *Rembrandt's "Aristotle" and Other Rembrandt Studies*. Princeton, N.J.: Princeton University Press.

HEYDENREICH, L. (1954), *Leonardo da Vinci*, 2 vols. New York: Macmillan.

HIBBARD, H. (1974), *Michelangelo*. New York: Harper & Row.

————— (1975), Footnotes to the Sistine Chapel. Symposium on the 500th Anniversary of Michelangelo's Birth. Columbia University, New York City.

HIRST, M. (1961), The Chigi Chapel in Santa Maria della Pace. *Journal of the Warburg and Courtauld Institutes*, 24: 161–85.

————— (1975), A Drawing of *The Rape of Ganymede* by Michelangelo. *Burlington Magazine*, 117: 160.

————— (1977), From the Mouth of the Oracle. *Times Literary Supplement*, 3: 18.

HOLLANDA, F. DE (1548), *Michel Angelo Buonarroti*, tr. C. Holroyd. London: Duckworth, 1903.

JANSON, H. W. (1952), *Apes and Ape Lore in the Middle Ages and the Renaissance*. London: University of London, Warburg Institute.

————— (1957), *The Sculpture of Donatello*. Princeton, N.J.: Princeton University Press.

JONES, E. (1953–57), *The Life and Work of Sigmund Freud*, 3 vols. New York: Basic Books.

KAVKA, J. (1980), Michelangelo's Moses: 'Madonna Androgyna.' In: *The Annual of Psychoanalysis*, 8:291–316. New York: International Universities Press.

KERNBERG, O. (1966), Structural Derivatives of Object Relations. *International Journal of Psycho-analysis*, 47: 236–53.

KRIS, E. (1952), *Psychoanalytic Explorations in Art*. New York: International Universities Press.

KRIS, E. (1956), The Personal Myth. *Journal of the American Psychoanalytic Association*, 4: 653–81.

———— & KURZ, O. (1934), *Legend, Myth and Magic in the Image of the Artist*. New Haven: Yale University Press, 1979.

LABALME, P. (1981), Personality and Politics in Venice: Pietro Aretino. In: *Titian: His World and His Legacy*, ed. D. Rosand. New York: Columbia University Press.

LA CAVA, F. (1925), *Il volto di Michelangelo in Giudizio finale*. Bologna: N. Zanichelli.

LANDINO, C. (1529), *Commedia di Dante Alighieri . . . con l'espositione di Cristoforo Landino*. Venice.

LEVEY, M. (1970), *Michelangelo's "Entombment of Christ": Some New Hypotheses and Some New Facts*. London: National Gallery.

LISNER, M. (1964), Michelangelos Crucifix aus S. Spirito in Florenz. *Münchner Jahrbuch für bildende Kunst*, xv.

LUSTMAN, J. (1977), On Splitting. In: *The Psychoanalytic Study of the Child*, 32: 119–54.

MACHIAVELLI, N. (1514), *The Prince*. Harmondsworth: Penguin, 1961.

MACK, J. (1980), Psychoanalysis and Biography: Aspects of a Developing Affinity. *Journal of the American Psychoanalytic Association*, 28: 543–62.

MAHLER, M., PINE, F., & BERGMAN, A. (1975), *The Psychological Birth of the Human Infant*. New York: Basic Books.

MANTURA, B. (1973), Il primo Cristo della *Pietà Rondanini*. *Bollettino d'arte*, 58: 199–201.

MEISS, M. (1951), *Painting in Florence and Siena after the Black Death*. Princeton, N.J.: Princeton University Press.

MILANESI, G. (1875), *Le lettere di Michelangelo Buonarroti*. Florence: Coi tipi dei successori Le Monnier.

OREMLAND, J. (1978), Michelangelo's *Pietàs*. In: *The Psychoanalytic Study of the Child*, 33: 563–91.

———— (1980), Mourning and Its Effect on Michelangelo's Art. In: *The Annual of Psychoanalysis*, 8: 317–51. New York: International Universities Press.

OTTO, W. (1933), Dionysus Myth and Culture. Bloomington and London: University of Indiana Press, 1965.

OVID (A.D. 8). *The Metamorphoses*, tr. H. Gregory. New York: Viking Press, 1958.

PANOFSKY, E. (1939), *Studies in Iconology*. New York: Harper & Row, 1972.

———— (1955), *Meaning in the Visual Arts*. New York: Doubleday.

PAPINI, G. (1951), *Michelangelo, His Life and His Era*, tr. L. Murnane. New York: Dutton, 1952.

PARKER, K. T. (1956), *Catalogue of the Collection of Drawings in the Ashmolean Museum*, vol. 2. Oxford: Clarendon Press.

PARTRIDGE, L. & STARN, R. (1980), *A Renaissance Likeness: Art and Culture in Raphael's "Julius II."* Berkeley: University of California Press.

PASTOR, L. (1906–07), *The History of the Popes from the Close of the Middle Ages*, 40 vols. London: Routledge & Kegan Paul, 1950.

PATER, W. (1871), *The Renaissance*. New York: World, 1961.

PERRIG, A. (1964), Bemerkungen zur Freundschaft zwischen Michelangelo und Tommaso de' Cavalieri. *Stil und Überlieferung in der Kunst des Abendlandes: Akten des 21. Internationalen Kongresses fur Kunstgeschichte*, 2: 164–71. Berlin: Mann, 1967.

POMEROY, S. (1975), *Goddesses, Whores, Wives, and Slaves*. New York: Schocken.

POPE-HENNESSY, J. (1968), The Palestrina *Pietà*. In: *Essays on Italian Sculpture*. London: Phaidon, pp. 121–31.

———— (1970), *Italian High Renaissance and Baroque Sculpture*. London and New York: Phaidon.

POPHAM, A. E. & WILDE, J. (1949), *The Italian Drawings of the XV and XVI Centuries in the Collection of His Royal Majesty, the King at Windsor Castle*. London: Phaidon.

PROCACCI, U. (1966), Postille contemporane in un esemplare della vita di Michelangiolo del Condivi. In: *Atti del Convegno di Studi Michelangioleschi*. Rome: Edizione dell'Ateneo, pp. 277–94.

PROVENCE, S. & LIPTON, R. (1962), *Infants in Institutions*. New York: International Universities Press.

RAMSDEN, E. H. (1963), *The Letters of Michelangelo*, 2 vols. London: Peter Owen.

RANK, O. (1909), *The Myth of the Birth of the Hero and Other Writings*. New York: Vintage Books, 1959.

RIPA, C. (1593), *Iconologia di Cesare Ripa*. Venice: C. Tomasini, 1645.

ROBB, N. (1935), *Neoplatonism in the Italian Renaissance*. New York: Octagon, 1968.

ROSAND, D. (1975), Michelangelo's Love in Context. Symposium on the 500th Anniversary of Michelangelo's Birth, Columbia University, New York City.

———— (1978), The Elusive Michelangelo. *Art News* 78: 48–51.

———— (1978a), *Titian*. New York: Abrams.

ROSE, H. J. (1959), *A Handbook of Greek Mythology*. New York: Dutton.

ROSS, J. B. (1974), The Middle-Class Child in Urban Italy, Fourteenth to Early Sixteenth Century. In: *The History of Childhood*, ed. L. de Mause. New York: Harper & Row.

SANDSTRÖM, S. (1963), *Levels of Unreality: Studies in Structure and Construction in Italian Mural Painting during the Renaissance*. Stockholm: Almquist and Wiksell.

SCHAFER, R. (1980), Narration in the Psychoanalytic Dialogue. *Critical Inquiry*, 7: 29–53.

———— (1980a), Action and Narration in Psychoanalysis. *New Literary History*, 12: 61–85.

SCHAPIRO, M. (1953), Style. In: *Anthropology Today*, ed. A. L. Kroeber. Chicago: University of Chicago Press.

———— (1956), Freud and Leonardo: An Art-Historical Study. *Journal of Historical Ideas*, 17: 147–78.

SCHEVILL, F. (1936), *History of Florence from the Founding of the City through the Renaissance*. New York: Harcourt Brace.

SCHULZ, J. (1975), Michelangelo's Unfinished Works. *Art Bulletin*, 58: 366–73.

SEGAL, H. (1952), A Psychoanalytic Approach to Aesthetics. *International Journal of Psycho-Analysis*, 33: 196–207.

———— (1964), *Introduction to the Works of Melanie Klein*. New York: Basic Books.

SEYMOUR, C. (1972), *Michelangelo: The Sistine Chapel Ceiling*. New York: Norton.

SHEVRIN, H. & TOUSSIENG, P. (1965), Vicissitudes of the Need for Tactile Stimulation in Institutional Development. In: *The Psychoanalytic Study of the Child*, 20: 310–39.

SMITH, G. (1975), A Medici Source for Michelangelo's Doni Tondo. *Zeitschrift für Kunstgeschichte*, 38: 84–85.

SPITZ, R. (1965), *The First Year of Life: A Psychoanalytic Study of Normal and Deviant Development of Object Relations*. New York: International Universities Press.

STECHOW, W. (1964), Joseph of Arimathea or Nicodemus? In: *Studien zur toskandischen*

Kunst: Festschrift für L. H. Heydenreich. Munich: Prestel-Verlag, pp. 289–302.

STEINBERG, L. (1968), Michelangelo's Florentine *Pietà*: The Missing Leg. *Art Bulletin*, 50: 343–59.

———— (1970), The Metaphors of Love and Birth in Michelangelo's *Pietàs*. In: *Studies in Erotic Art*, ed. T. Bowie. New York: Basic Books, pp. 231–335.

———— (1975), *Michelangelo's Last Paintings.* New York: Oxford University Press.

———— (1975a), Michelangelo's "Last Judgment" as Merciful Heresy. *Art in America*, 63: 48–63.

———— (1980), A Corner of the "Last Judgment." *Daedalus*, 109: 207–73.

———— (1980a), The Line of Fate in Michelangelo's Painting. In: *The Language of Images*, ed. W. J. T. Mitchell. Chicago: University of Chicago Press.

STEINBERG, R. M. (1977), *Fra Girolamo Savonarola, Florentine Art, and Renaissance Historiography.* Athens, Ohio: Ohio University Press.

STERBA, R. & STERBA, E. (1956), The Anxieties of Michelangelo Buonarroti. *International Journal of Psycho-Analysis*, 37: 7–11.

———— ———— (1978), The Personality of Michelangelo Buonarroti: Some Reflections. *American Imago*, 35: 156–77.

STOKES, A. (1951), *Smooth and Rough.* London: Faber & Faber.

———— (1955), *Michelangelo.* London: Tavistock.

SUMMERS, D. (1972), Michelangelo on Architecture. *Art Bulletin*, 54: 146–57.

SYMONDS, J. A. (1893), *The Life and Work of Michelangelo Buonarroti*, 2 vols. London: Scribners.

TESTA, J. A. (1977), Interactions of Art, Poetry and Personality: The Intimate Iconography of Michelangelo's Cavalieri Drawings. Unpublished manuscript.

———— (1979), The Iconography of the *Archers*: A Study of Self-Concealment and Self-Revelation in Michelangelo's Presentation Drawings. *Studies in Iconography*, 5: 45–72.

TOLNAY, C. (1934), Michelangelo's Rondanini *Pietà*. *Burlington Magazine*, 65: 146–57.

———— (1943–60), *Michelangelo*, 5 vols. Princeton, N.J.: Princeton University Press.

———— (1953), Michelangelo's *Pietà* Composition for Vittoria Colonna. *Record of the Art Museum Princeton University*, 12: 44–62.

VARCHI, B. (1590), *Lezzion*, tr. J. A. Symonds. In: J. A. Symonds, *Renaissance in Italy*, vol. 2. New York: Modern Library, 1893.

VASARI, G. (1568), *The Lives of the Artists*, 2 vols., tr. Mrs. J. Foster. New York: Hermitage Press, 1967.

VILLANI, F. (1826 ed.), *Cronaca*, book II, chap. 97. Florence: pp. 286 ff. In: C. Tolnay, *Michelangelo*, 1: 218. 5 vols. Princeton, N.J.: Princeton University Press, 1943–60.

VILLARI, P. & CASANOVA, E. (1898), *Scelte di prediche e scritti di Fra Girolamo Savonarola* (Florence), tr. R. Wittkower and M. Wittkower. In R. Wittkower and M. Wittkower, *Born under Saturn—The Character and Conduct of Artists: A Documented History from Antiquity to the French Revolution.* New York: Norton, 1963.

VLAM, G. (1977), The Calling of Saint Matthew in Sixteenth-Century Flemish Painting, *Art Bulletin*, 59: 561–70.

VON EINEM, H. (1959), *Michelangelo.* London: Methuen, 1973.

VORAGINE, J. (1266), *The Golden Legend.* New York: Longmans, Green, 1941.

WAELDER, R. (1965), *Psychoanalytic Avenues to Art.* New York: International Universities Press.

WATSON, P. F. (1978), Titian and Michelangelo: The *Danae* of 1545–46. In: *Collaboration in Italian Renaissance Art*, ed. W. S. Sheard & J. T. Paoletti. New Haven: Yale University Press.

WICKHOFF, F. (1882), Die Antike im Bildungsgange Michelangelos. *Mitteilungen des Instituts für oesterreichische Geschichte*, 2: 408–35.

WILDE, J. (1944), The Hall of the Great Council of Florence. *Journal of the Warburg and Courtauld Institutes* 7: 65–81.

—— (1953), *Italian Drawings in the Department of Prints and Drawings in the British Museum: Michelangelo and His Studio*. London: Trustees of the British Museum.

—— (1954), *Michelangelo's 'Victory.'* London: Oxford University Press.

—— (1957), Notes on the Genesis of Michelangelo's *Leda*. In: *Fritz Saxl, 1890–1948: A Volume of Memorial Essays*, ed. D. J. Gordon. London: Thomas Nelson & Sons.

—— (1978), *Michelangelo: Six Lectures*. Oxford: Clarendon Press.

WIND, E. (1958), *Pagan Mysteries in the Renaissance*. New York: Norton.

—— (1960), Michelangelo's Prophets and Sibyls. *Proceedings of the British Academy*, 51: 47–84.

WINNICOTT, D. W. (1971), *Playing and Reality*. New York: Basic Books.

WITTKOWER, R. (1941), Newly Discovered Drawings by Michelangelo. *Burlington Magazine*, 78: 159–61.

—— & WITTKOWER, M. (1963), *Born under Saturn—The Character and Conduct of Artists: A Documented History from Antiquity to the French Revolution*. New York: Norton.

WÖLFFLIN, H. (1890), Die Sixtinische Decke Michelangelos. *Reportorium für Kunstwissenschaft*, 13: 264–72.

—— (1899), *Classic Art*. London and New York: Phaidon, 1952.

ZUCKER, M. (1977), Raphael and the Beard of Pope Julius II. *Art Bulletin*, 59: 524–33.

Index